MW01258963

MONDRIAN

MONDRIAN

His Life, His Art,
His Quest for the Absolute

Nicholas Fox Weber

ALFRED A. KNOPF
New York
2024

THIS IS A BORZOI BOOK
PUBLISHED BY ALFRED A. KNOPF

Copyright © 2024 by Nicholas Fox Weber

aaknopf.com

Library of Congress Cataloging-in-Publication Data
Names: Weber, Nicholas Fox, 1947– author.
Title: Mondrian : his life, his art, his quest for the absolute / Nicholas Fox Weber.
Description: First edition. | New York : Alfred A. Knopf, 2024. |
 "This is a Borzoi Book published by Alfred A. Knopf." |
 Includes bibliographical references and index.
Identifiers: LCCN 2023052890 | ISBN 9780307961594 (hardcover) |
 ISBN 9780307961600 (ebook)
Subjects: LCSH: Mondrian, Piet, 1872–1944. | Painters—Netherlands—Biography.
Classification: LCC ND653.M76 W37 2024 | DDC 759—dc23/eng/20240509
LC record available at https://lccn.loc.gov/2023052890

Jacket photograph: Piet Mondrian in New York, January 17, 1942
 (detail) by Arnold Newman / Getty Images
Jacket border image based on *Composition with Large Red Plane, Yellow, Black,
 Gray, and Blue*, 1921, by Piet Mondrian. Photograph © Fine Art Images /
 Bridgeman Images
Jacket design by Jenny Carrow

Manufactured in the United States of America
First Edition
1st Printing

For Wilder and Beau

Art, it would seem, is to accomplish what nature cannot.

—HONORÉ DE BALZAC, *The Quest of the Absolute*

In the true painters, writers, musicians, there was a power which drove them to such complete absorption in their work as to make it inevitable for them to subordinate life to art. . . . They were merely dupes of the instinct that possessed them, and life slipped through their fingers unlived.

—W. SOMERSET MAUGHAM, *Of Human Bondage*

Contents

Preface

When I was ten years old, I attended an exhibition opening at the Wadsworth Atheneum. In Hartford, Connecticut, it is the oldest public art museum in America, a treasure house of great art ranging from seventeenth-century American furniture to a Caravaggio to major works by Picasso, Miró, and other modernists that were acquired when the paint was still fresh. My presence in the large gallery at ground level was obligatory; my mother had won a prize in the annual show of the Connecticut Watercolor Society.

After a few minutes which seemed interminable, I needed to escape. Shorter than the crowd of grown-ups who were babbling away while looking at mostly tame and academic watercolors, I detested the mushy, crustless tea sandwiches. I longed for crunch and texture, and action. I saw the curved white staircase that leads to the Atheneum's permanent collection and asked my father if I could skedaddle.

Fifteen minutes later, I ran down, grabbed my father by the arm, and said, "Daddy, there is something upstairs I like as much as I like mountain-tops and skiing! You have to come up." He did, and I led him to my find. Looking at the simple compendium of black vertical and horizontal lines on a white background—one pure blue rectangle, way off center, being the only other element—my father said, "Very good, Nicky. That is by an artist called Mondrian. Mommy and I have a book about him at home if you want to look at it."

We went downstairs together, and I felt invigorated by my discovery of new and fantastic territory. I consider my father the hero of the story. He was brought up by a poor glass cutter who had never been inside a museum. But Dad had become sufficiently sophisticated so that, in 1958, when my friends' fathers would have said that any child could do such a painting, or even cuffed their sons for liking something so ridiculous, my father, a printer, had a particular regard for Mondrian, whose work had such an impact on graphic design. And from my mother he had acquired respect for the courage of artists to lead their lives independently and without the expectations of domesticity and fortune that governed the lives of most of their friends.

Love without excessive information or analysis is one of the greatest luxuries of youth. My profound sense of well-being in front of a painting by an abstract artist whose name or history meant nothing to me is the genesis of this book.

Then, in 2006, I was having a conversation with Sir Nicholas Serota, director of the Tate, a friend as well as an attentive reader of my biographies of Balthus and Le Corbusier. I asked him who remained among the modern masters about whom no biography had been written. He named Léger and Mondrian. I like Léger's work a lot, but Mondrian's name was magic to hear.

Over half a century later, after that initial thrill thanks to *Composition (N° IV) White-Blue*, I decided it would be wonderful to understand why a painting by Mondrian can alter one's existence and intoxicate its viewer. To comprehend why the artist's work has its impact and to know more about the man who developed this unique art are the goals of this book.

Having known people who were firsthand acquaintances of Mondrian, and having had access to copious information about the painter, I also feel a strong obligation to correct the errors that have already come to create his myth. Beyond that, with the excitement of seeing grandchildren start their lifetimes as I approach the end of my own, I want for them what I desire for everyone: the chance to savor the rich fortune of earthly existence as long as one has freedom and health and life's necessities. This is Mondrian's salient meaning for the world. Let beauty get inside you! Exult in sheer joy! Take risks, do it your own way, in order to taste the wonder of seeing. Understanding is secondary to emotion. Know that blue and white, and rhythm, are miracles.

MONDRIAN

26, Rue du Départ

Paris, September 8, 1926

The correspondent for *De Telegraaf*, Amsterdam's most widely read daily newspaper, anticipated that the studio of his country's best-known living painter would be a cross between a laboratory and a monk's cell. He knew that Piet Mondrian lived where he worked and was a recluse, albeit a friendly and agreeable one. Even while inhabiting one of the busiest and noisiest neighborhoods in Paris, being a regular in his chosen cafés and dance halls, and attending lots of other artists' openings, Mondrian famously isolated himself when he repaired to his solitary lair. He kept his surroundings modest and simple, and eliminated disturbances in what he saw, in the same way that he simplified his personal life, to concentrate on his painting and writing.

Mondrian was not averse to publicity, however. The journalist had read accounts by several other writers who had visited the artist's studio. He already knew that it was basically a large room with high white walls on which the fifty-four-year-old abstract artist had hung small panels of vibrant primary colors that he regularly moved around. One day Mondrian would raise a yellow square by five centimeters; the following afternoon he would edge a larger blue vertical rectangle ever so slightly sideways. Each variation would alter the beat and change the rhythm of the entire space.

Nothing, however, had prepared the eager journalist for the shock of these living quarters inhabited by the man who declared "Art has to be forgotten: Beauty must be realized."

The *Telegraaf* correspondent was struck first by "the squalid yard behind the clamor of the Gare Montparnasse" where one entered the "dingy staircase" which led to Mondrian's door on the third floor. The sound of clanking trains arriving from the Paris suburbs or announcing their imminent departure for Bordeaux with loud whistles had now subsided. He anticipated a surprise as the door opened, but this was not the one he imagined. The writer was enjoying a refreshing calm as the hustle and bustle behind him faded

and the clean-cut artist in workman's overalls greeted him amiably. Then he entered a milieu that bowled him over. "What a contrast! No Thousand-and-One Nights here, opening up a treasure-filled cave to the poor camel driver. Instead of riches, this lonely ascetic offers a dazzling purity, causing everything to be bathed in a pristine glow."

While the journalist caught his breath after walking up the dilapidated stairs and Mondrian opened the shabby wooden door to the white cavern with its panels of bold color vibrating from unexpected locations, the impression of sheer originality staggered him. He faced a unique combination of poetry and toughness.

The studio had a pervasive quietude, yet transmitted decisiveness and certainty. Every stick of furniture, the colors with which each panel had been painted, the few books and ashtrays and utensils, the absence of anything else, were without compromise. Other artists and designers and patrons of the epoch lived in related styles, but no one else had the rigor, the mix of finesse and roughness, the flair to make plywood more elegant than travertine. And the paintings, while as ethereal as clouds, emitted an extraordinary force. Here was power made friendly and welcoming. While clearly the products of refinement and discipline, they were playful and joyous. Their ebullience and spirituality were all the more plausible for being rooted in logic.

No one else lived like this; no one else painted like this. Many imitated his style, some of his contemporaries copied him, and in time the motifs he invented would appear on dresses and ladies' shoes, from discount stores to haute couture, just as his name would be used to confer a certain panache on hotels and apartment buildings, but none of that was the same thing. The artist's existence on the rue du Départ, and the art he made there, harnessed manic enthusiasm with exquisite control, both at their extremes. Most people live by half measures, or follow someone else's ideas. Mondrian had created, in his rudimentary living quarters and bright airy workspace, a private sanctuary, suited only for its sole inhabitant. What to others would be self-denial was for him the pathway to nirvana.

Mondrian had recently been asked to do set designs and a house interior which, like his own living space, obliterated the usual distinction between "fine art" and the total environment. With the Bauhaus flourishing in Weimar, Le Corbusier's sparkling villas starting to proliferate around Paris, airplanes crossing the skies on a daily basis, and furniture becoming leaner in form and devoid of ornament, buildings and paintings and household objects had acquired unprecedented clarity and élan all over the map. But Mondrian's interiors, while belonging to their era, were completely original. The compositions for the walls he put into theaters and people's houses were aus-

tere but jocular. Their luminous backgrounds were predominantly a meticulously chosen grayish white, or two such tones that were ever so slightly different, while most viewers discerned them as being identical. They were constructed of a few black horizontal and vertical lines, as refined and carefully calculated as the components of an airplane engine but clearly handpainted, with small powerful areas of one, two, or all three primary colors. The reds, yellows, and blues were at impeccably determined intervals from one another—creating rhythm and expressing energy and joie de vivre in a way that boggles the mind. These radically modern stage sets and living rooms have the same power as certain Romanesque church interiors and the grandest Baroque staircases. What we take in through our eyes penetrates our entire being.

The stunned journalist visiting Mondrian in his happy exile had never before known an occasion where art and its setting merged into one. His past experience of going to artists' studios inclined him, initially, to treat the finished paintings as focal points, with the setting and work in process as secondary. But after a few minutes he had come to realize that that approach was beside the point. Still following the instinct that had led him to anticipate a "treasure-filled cave"—the vision which accords prime importance to individual and finite artworks, with the sort of hierarchy that makes gold more valuable than silver, rather than allowing that the cave, made of ordinary rock, is as valuable as the treasures—he then took into account the group of paintings which Mondrian had hung at different heights all over the studio. After all, identifiable "pictures," some already known through their printed reproductions, should count above other sights. He needed a new way of thinking, however. Mondrian's lust for color and shape called for something different. The artist's intoxication with seeing, which had its origins in his appreciation of the offerings of nature—trees, flowers, the dunes, the sea, the sky—when he was young, and that now focused on man-made hues and shapes, was all-inclusive. The flurry of colored rectangles which Mondrian had hung in the white spaces remaining between the paintings were like stars in the universe, none having greater or lesser merit than the others. The correspondent writes:

The artistic conception of the wall, however, seems to render the canvas redundant, superfluous. I therefore ask Mondrian's views about the interrelation. "There are no absolute differences for me, not like Léger, who makes a distinction between the easel painting as compressed inwardness, and the pleasing outward effect of the decorative wall. Just as my painting is an abstract surrogate for the whole, the abstract plastic wall is part of the profound content of the entire room. Instead of being super-

ficially decorative, the whole wall conveys the impression of an objective, universal mentality, displayed in the strictest of stylistic forms."

The interior where Mondrian had most recently put this concept to work was for the adventurous collector Ida Bienert in Dresden. And he was currently creating sets for Michel Seuphor's play *The Ephemeral Is Eternal*. For this theater piece with singing and ballet in it, he was equipping the shallow rectangular stage with three screens that were raised in sequence to make a different set for each of the three acts, all of which take place in eternity rather than on earth. The journalist talked with Mondrian about these backdrops. They revealed the artist's "aversion to depth," which he considered "far too naturalistic." Of the actors, Mondrian declared, "As far as I am concerned, they are unnecessary." Mondrian would have preferred for them to be "behind screens so that the audience wouldn't have to look at them and could just follow the text."

This was what Mondrian would do with his own art. He would construct walls—beautiful, salubrious ones—to screen out human behavior, which was intrinsically troubling.

II

In 2011, the octogenarian Ben Sanders described a sense of surprise similar to the shock felt by the journalist for *De Telegraaf*. Ben Sanders's father, Paul Sanders, a Dutch composer and music critic born in 1891, was one of Mondrian's loyal young acquaintances. When Ben was approaching adolescence in the mid-1930s, he went with his mother to see Mondrian on the rue du Départ. Mondrian was sufficiently close to the family for the boy to call him "Uncle Piet," but he always felt that the artist was standoffish. When they arrived, Uncle Piet, as usual, gave Ben the impression that he did not like children. Now more than ever, Ben was feeling irrelevant in Mondrian's presence, without realizing that this was because of Mondrian's focus on Mrs. Sanders without Mr. Sanders present. Then, less than five minutes after they arrived, Mondrian asked Ben's mother to dance with him. She agreed without hesitation. Ben sat there stupefied while Mondrian put a disk on his gramophone and whirled his partner onto the studio floor as if they were in a ballroom. They danced for about half an hour—waltzes, two-steps, even something approximating a tango—while the boy simply watched. When Mondrian and Mrs. Sanders stopped, they had a brief conversation, but Ben's mother had barely caught her breath when she said goodbye to her husband's friend and led Ben to the door, and they left, with Mondrian at the

last minute giving Ben a cordial but distant handshake. That was the entire visit.

Sometimes, Mondrian would dance alone. Michel Seuphor witnessed this:

> These dancing exhibitions were torture for me: I had to avert my eyes to avoid bursting into tears, because all that jumping about made such a pathetic contrast with the nobility of the paintings. But Mondrian, like every truly pure creature, had no sense of the risible. He had no suppleness whatsoever, but was utterly wooden in his movements, although he was tall and well built.

The painter allowed to Seuphor that not only did he perform in this way for visitors but this was his regular habit when no one else was there to observe. What he looked like when he lacked an audience will never be known. But it was essential for him to experiment with the very latest steps being done in popular dance halls; anything that was the rage was worth doing well.

Mondrian's ballroom dancing often attracted comment. Peter Alma, a Dutch painter fourteen years younger than Mondrian, observed that Mondrian "was not, in any case, an ascetic on principle; it was his empty purse and the inevitable scrimping that often obliged him to adopt such an attitude. Dancing, for Mondrian, was sheer delight, but at the same time a serious activity; there was a certain correspondence between the rhythm of dance music and the rhythmic motion within his paintings."

The Dutch architect J. J. P. Oud would, in 1962, recall of Mondrian, "I have seen him dance with a lively girl to the modern musical rhythms he liked so much (jazz in particular), and while following the rhythm of the music, he seemed to be producing a cross-rhythm of his own. Lost in thought, yet ever in perfect time, he was in fact creating an aesthetic, or rather an aestheticized, dancing figure: an 'abstract' dancing figure, you might say."

Oud was a modernist of the generation younger than Mondrian's. He was one of many visual artists enamored of straight lines and right angles for whom Mondrian as a painter was a hero. But Mondrian as a person was an enigma to him. On one of their first encounters, Oud was more than slightly puzzled when he arrived at the rue du Départ studio and Mondrian opened the door half-shaved, his face divided in two by a vertical line. Apparently this was his usual procedure. Mondrian would imagine a boundary that separated the left and right sides of his face and then, both above and below his mouth, proceed to shave one half. Once the first side was absolutely smooth,

without a millimeter of whisker, he would stop and take a break. Then he would continue.

Oud watched while the artist applied cream and brushed it into a lather on the second half. Mondrian shaved it with such fastidiousness that the task took half an hour. Working the razor—a long thin blade—with his right hand, he continuously used the left to check for the slightest stubble. It was a serious operation that had to be executed with military precision.

Oud observed that Mondrian ate a pear with a similar meticulousness and reverence for geometry. He would begin by peeling it. Next he would cut it into matched segments. They were remarkably close in scale and form, given that he did not use any measuring device other than his eye. Only then would he eat the pieces of fruit, slowly and attentively.

Shortly after Mondrian's death, Oud would recall that the painter he had known for over a quarter of a century was "one of those rare cases of man and artist, habit and work forming one indivisible whole." In the everyday acts of his life, as in painting and dancing, he depended on straight lines and right angles, carefully measured and manipulated, to provide a sense of harmony and balance. It was as if he had to calibrate everything with a ruler to stay sane.

Mondrian ordered his existence according to his precise needs and unequivocal goals. Austerity suited him. He would no sooner have lived lavishly than he would have put one of his paintings in a gilded rococo frame. He needed only enough money to survive as a full-time artist. He always lived alone. He accepted the inevitability of food and sex, and determined what he needed of both in a highly controlled way. He enjoyed clothing—he dressed elegantly, and was neat and stylish in his appearance—but everything was secondary to making art. His daily habits were like the grid that positions the pulsing yellows and blues and reds in his paintings, a refined system that gives priority to what matters. Mondrian's regimentation and lean lifestyle were no burden to him; they were a choice that made him happy.

"How refined and fastidious he was; how seriously and devotionally he treated everything," Oud recalled. "How strong he was in his conviction, and how mild in his judgment."

Mondrian was, Oud tells us, "a character not only averse to compromise, but also, in its ingenuous purity, not even capable of conceiving the possibility of compromise."

Beginnings

Pieter Cornelis Mondriaan entered the world in a small red-and-white city at the precise center of the Netherlands. Amersfoort might have been positioned at that midpoint with calipers and a measuring tape, halfway between the North Sea to the west and the German border to the east, and equidistant from the Belgian border to the south and the Netherlands' jagged northern coastline.

As a result of its location, Amersfoort, a city of narrow canals, is a major railway junction. A key stop on one of the Netherlands' primary north–south lines and one of its most important east–west ones, the train station was the most frequented structure in town when Mondrian was born there in 1872. If travelers from all over the country walked out from that station, the two churches whose steeples towered over everything else were where the locals spent most of their time; Amersfoort was a bastion of devout Christianity.

The steel rail tracks crisscrossing Mondrian's hometown have the bold decisiveness of the straight lines and right angles Mondrian would use to parse up the surfaces of his abstract compositions. The ambient colors of Amersfoort, however, were more muted than the vibrant whites, confident blacks, and sparkling blues and yellows and reds he would eventually make the vocabulary of a new visual language. Except for a rare summer day, or the occasions when a fresh snow blanketed the frozen canal opposite the Mondriaan family's house, Amersfoort was rarely bright. The skies were generally gray and appearances subdued. It rained a lot. Most of the six thousand men and seven thousand women who were there did not complain, however. Their lives were devoted to work and righteousness in all they did, and they pursued both goals without quibble.

The senior Pieter Cornelis Mondriaan, our artist's father, had moved with his new bride in 1869 to this town, where they initially knew no one else, because he had taken a new job there. Amersfoort was home to many members of the recently created Orthodox Protestant sect. In 1868, the God-fearing devotees of this new movement had founded the "Union for the Promotion of a Christian National Education." The sect leaders had

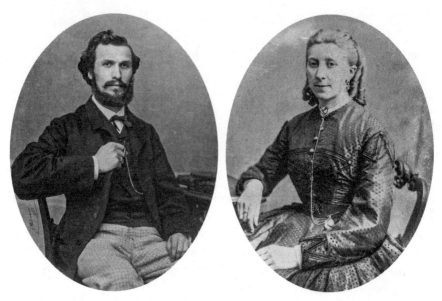

P. C. Mondriaan Sr., 1867; Johanna Christina Mondriaan-Kok, 1868. Mondrian's parents adhered to the strict tenets of Orthodox Protestantism in every aspect of their lives.

bought a double dwelling on Kortegracht, a short street along a canal in the center of town, to start a school and give its headmaster a place to live. There were already Roman Catholic schools in town, as well as state institutions without a strong religious affiliation, but this was the first educational establishment in Amersfoort exclusively for the new Protestant entity whose members' restricted lifestyle made the most devout Catholics seem lax by comparison. Eager for a head of school who could enforce the strictures essential to a life of virtue, the Orthodox Protestants invited the twenty-nine-year-old Pieter Mondriaan, who had already made a name for himself in their arch-conservative movement, to come the sixty miles from The Hague, where he had been born and had lived until then.

The Orthodox Protestants adhered to the most extreme tenets of Calvinism. They insisted that their many rules, and their list of forbidden activities, apply to political governance as well as to a person's everyday conduct. Pieter Mondriaan practiced the new religion scrupulously and was determined that others join him in adhering to its principles. The sect's leaders were impressed with his intense conviction and mettle, and his appointment to the post of headmaster gave him an important role in politics as well as education. Beyond heading the school, he would be responsible for recruiting candidates for parliament to "defend and disseminate protestant policy." Convinced that it was God's will that he pursue this agenda, and that he

was sufficiently pure in thought and steadfast in demeanor to execute God's wishes, Pieter Mondriaan was pleased to accept the powerful job.

At the start of 1869, the year of his summons to Amersfoort, this upright leader of the strict new order had married Johanna Christina Kok, who also came from The Hague. They had been neighbors at birth, and their birthdays were only two days apart: Johanna Christina Kok's was June 16, 1839; Pieter Cornelis Mondriaan was born on June 18 of the same year. They were unusually old to be still unmarried.

On June 26, 1869, just after their thirtieth birthdays, the newlyweds moved from The Hague to Amersfoort, into the school annex that served to house its headmaster. Even in the summer months, their new dwelling was cold and damp. It immediately had bad effects on the bride's health, but Pieter Mondriaan was on his chosen path. Johanna, too, accepted her situation in spite of her physical discomfort. A daughter was born in 1870. She was given the name Johanna Christina, exactly the same as her mother. Then, on March 7, 1872, came the first son. Like his father, he was named Pieter Cornelis. There was no distinction whatsoever between the names of the two generations; "Senior" and "Junior" was used for neither mother and daughter nor father and son. It was intended to be a seamless life.

The house where Piet Mondrian—as we call him, while referring to his father as Pieter Mondriaan—first saw daylight was a modest two-story structure. Its ground floor was faced in off-white plaster, under a steeply sloped roof covered in mottled terra-cotta tiles of the chalky salmon color in which so much of the Netherlands is constructed. The roof had large mansard windows protruding from it, while the ground floor had double-hung sash windows that were exceptionally wide and tall. These vertical rectangular fenestrations, divided into ample panes and running practically from floor to ceiling, were more typical of the school that was the structure's main purpose than of a private residence. Because of all the glass, from the outside the house presented a lot of grayish reflections—of the canal that runs just a few meters in front of it, the sky, and the houses opposite it on the other side of the canal. Inside, the schoolmaster's residence was brighter than the average domestic dwelling.

The other houses in the neighborhood, being purely residential rather than dual-purpose, had less glass on their façades. Predominantly wall rather than window, they were cozier and more private than the Mondriaans'. The headmaster's family lived in the public eye.

Certain things were, however, of a piece all over town. The main materials everywhere—in domestic and public buildings, in the crisp vertical sides of the canals, in the quays and the cobblestone walkways—were brick, natural

stone, and pale plaster mixed in a range of off-whites, warm grays, and dusty reds. The mélange had the same warm, muted tonality as the Dutch towns in paintings by Vermeer and De Hooch. The indigenous architecture has the calm equilibrium and underlying orderliness intrinsic to Dutch culture. The older precinct of Amersfoort reflected a balanced, thoughtful vision in all its details. The building façades, shop signs, and canal bridges had the pleasant but taciturn character that proliferated throughout the Netherlands. When Pieter Mondriaan arrived there in 1869 to teach the local children the path of righteousness, it was a prosperous place with lively brasseries, good shops, and a reasonably high standard of living.

The comforts of Mondrian's childhood—the pleasant locale, the amenities enjoyed by the Dutch bourgeoisie in a period of prosperity—would determine his expectations, and his idea of the norm, forever after. So did the stoicism and absolutism of his father's emphatic religiosity. Yet, even as he would echo and reflect the givens of his youth, the individual who ultimately lived surrounded by panels of vibrant color, not just on the rue du Départ but in similarly orchestrated settings elsewhere in Paris, and eventually in London and New York as well, would be one of those rare people who invents his own life. Mondrian's reds would eventually be brighter than any in his childhood. His yellows would be the vibrant and pure hue of tropical sunlight, unlike any tone he witnessed even on the hottest Dutch summer day. His blues would be punchier and more electric than the Netherlandish skies of Jacob van Ruisdael's landscapes and Gerrit Berckheyde's city views, however clear and luminous those painters made them. Above all, Mondrian's spirit would be more exuberant, more devil-may-care than that of anyone else in his family or the rest of the local citizenry. Much as he would be like them in his devotion to a sacred purpose, he would be groundbreaking in his definition of pleasure and his notion of what it was that was sacred.

II

When the senior Pieter Mondriaan assumed his position in Amersfoort, it was the market town for its rural surroundings. The landscape formed by those vast expanses of perfectly flat fields, well irrigated and hospitable to farming, was the setting of Mondrian's first encounters with nature. Punctuated by rows of poplars and other orderly trees, the scenery was neatly divided, the result of careful planning and rational thinking, rather than landscape in a more savage form. One presumes there were occasions when Pieter and Johanna and their young children went on outings into this gridded countryside. It would have imprinted on them its logic, and inspired belief in the human capacity to control the forces of the earth.

The townspeople, by and large, were country types, less couth than the scenery. They were known for their no-nonsense speaking manner, and were less polished and urbane than the men and women with whom Pieter and Johanna had grown up in The Hague. The locals were famously gruff, but also friendly and kind. It was not, however, a homogeneous society. The Orthodox Protestants, with their black clothing and somber demeanor that conspicuously declared their denial of everyday pleasures, stood out among the rest of the Dutch Reformed community. And they could hardly be confused with the Catholics and the Jews. The new sect was the only group in town whom everyone immediately recognized by sight. They brandished their extreme rectitude not just in their dour costume and abstemiousness but also in their rigid observance of the Sabbath. As the children named Johanna and Pieter reached the ages of four and five and began to notice other people's responses, they began to feel like outsiders as members of a sect apart.

But to be in an awkward situation, or odd-person-out, would never faze young Pieter. In their independence and devotion to their chosen cause, Mondrian's parents were role models for the person he would willingly become. He would adhere to their conviction that you must stick to your beliefs at any price. The similarities stopped there. Neither his mother nor his father placed a premium on creativity; neither valued the cultivation of pleasure. And even those of Mondrian's relatives and ancestors who enjoyed the aesthetic aspects of life more than his parents did would not be able to fathom Mondrian's eventual willingness and desire to devote his life, at considerable personal sacrifice, to spreading a sense of plenitude.

Still, a dedication to the visual was central to the profession of Mondrian's paternal grandfather. He coiffed people's hair and made wigs, which meant that he understood proportion, balance, and issues of color. And Frits, Pieter Mondriaan's younger brother, would, late in life, manage the rare feat of surviving financially as an artist. Frits earned a handsome income as a portraitist and tepid landscapist who adhered scrupulously to the taste preferences of the affluent bourgeoisie who gladly bought his work to decorate their homes without ruffling feathers. At the same time, no one in the family was the sort of person to renounce marriage, parenting, and material comfort to pursue a risky course and daring aesthetic that had few supporters and many attackers. Mondrian would be unlike the rest.

III

Mondrian's rigor, his life choices, and his retreat into an abstract universe, as well as the nature of that realm of gridded color, had their origins in the

personalities of his two parents. He both mirrored them and reacted against them.

Pieter Mondriaan's absolute convictions governed the life of his growing family. Holier-than-thou, he was rigid and uncompromising about every aspect of the existence of his wife and young children. Mondrian would struggle lifelong with the issue of being the son of a man whom he closely resembled in his unwavering confidence about what was right and what was wrong, but from whom he was profoundly different in the essential nature of his beliefs. The son's faith was rich in pleasure; the father's was fraught with anguish. And while Pieter Mondriaan could be despotic, Mondrian had no sense of himself as virtuous or superior; he never tried to ram his beliefs down other people's throats. Unlike his father, he did not threaten hell to those who did not follow his ideas, much as he thought that their adherents stood to gain a great deal. Mondrian promulgated a form of beauty that could be enjoyed universally, but he was not like his father in insisting on his credo.

What was even harder for Mondrian during his childhood than Pieter's absolutism was that he came to know his father in two very different stages. The first, in Mondrian's early childhood, was when Pieter Mondriaan was confident he would change the world. The second was when he was profoundly unhappy. Mondrian's father would descend from an abiding assuredness to a profound sense of failure and disillusionment. His son, in the years of his own psychological formation, stood witness.

Initially, the schoolmaster's program was on target, and in the first years in Amersfoort, Pieter Mondriaan was successful in advancing Orthodox Protestantism. While he flourished professionally, the family grew. In 1874, four-year-old Johanna and two-year-old Pieter were followed by Willem Frederik; in 1877, Louis Cornelis was born. The digs next to the school were now, in addition to being perpetually damp, too small and crowded, but living conditions were of less importance to Pieter Mondriaan than was his ever-hardening faith. The will to survive with only the most rudimentary personal comforts was at the core of the beliefs with which he ruled his young family and that had a strong following within his expanding sect.

Pieter Mondriaan became increasingly involved in political activities. In 1871, a preacher who was a prominent Dutch theologian and editor of the daily newspaper *De Standaard*, Dr. Abraham Kuyper, had taken over the leadership of the Orthodox Protestants from the parliamentarian Groen van Prinsterer. Kuyper believed that church and state must function in tandem, and in 1879 he would found the Anti-Revolutionary Party, closely connected with the sect.

Abraham Kuyper and Pieter Mondriaan endorsed a strict, emphatically

moralistic belief system. Its rigorous mandates took Calvinism back to its original extreme. Certain that the Dutch Reformed Church was too liberal, Kuyper endorsed practices that fit more into the rubric of "Neo-Calvinism," advocating rules based directly on the gospel John Calvin had preached in the sixteenth century. The emphasis was on the role of God and of divine grace in every act of life. Kuyper declared, "Oh, no single piece of our mental world is to be hermetically sealed off from the rest, and there is not a square inch in the whole domain of our human existence over which Christ, who is Sovereign over *all*, does not cry: 'Mine!'"

For Kuyper, the universe was continuously in the process of re-creation through God's acts of grace. Pieter Mondriaan, who embraced that belief wholeheartedly, did his utmost to instill it in his children. His oldest son, more than any of the others, would devote himself to the idea that everyday life could be transformed by the connection with a larger spiritual force. And Mondrian would echo his father's all-encompassing immersion in his faith.

Those convictions—that each day is an occasion of birth and creation, that some sort of universal force exists, and that balance and equanimity are possible—would govern Mondrian's existence. The positive, life-endorsing elements of Abraham Kuyper's thinking, which was central to the way Pieter Mondriaan brought up his children, had a lifelong impact on the artist.

The more repressive elements of the harsh Calvinism which Pieter Mondriaan actively proselytized to students and family alike would, however, play out differently in his oldest son's life. When Mondrian would dance to

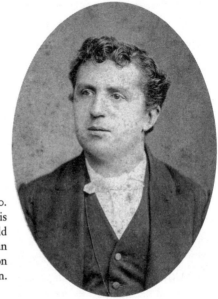

Abraham Kuyper, c. 1870.
Kuyper's Neo-Calvinism and his
belief that Christian values should
dominate every element of human
life had an indelible impact on
Pieter Mondriaan.

the latest jazz, it was not simply a slight straying from his father's rules but a conspicuous violation. There is also a strong possibility that he had sex with female prostitutes and the likelihood that he was intimately involved with other men; if so, he violated the tenets of Orthodox Protestantism even more flagrantly.

Still, Mondrian would adhere to aspects of the code instilled in others by his father and Kuyper. One dressed correctly, but not flamboyantly. As an avant-garde artist, he would wear his well-pressed dark suits when in society, and don an immaculate white smock for working. He would speak his mind with quintessential Dutch forthrightness; to conceal his views was as out of the question as it was for his forebears. He would become a worldly cosmopolite, at home in the most sophisticated milieus, but he never exhibited an iota of pretentiousness. Mondrian rejected the repressiveness of the world that nurtured him, yet adhered to its rigor so as to embrace life. Kuyper's notion that restrictions and a self-imposed discipline facilitated one's ability to see and celebrate "God's acts of grace" was intrinsic to Mondrian's being.

IV

Pieter Mondriaan believed that portraits of pious, stalwart individuals from the past could transport their viewers into the realm of God. He made paintings, prints, and sculpture of those role models of virtue he deemed capable of persuasion and transformation. The abstract compositions, with their rectangles of pure color, that his firstborn son would produce half a century later would look nothing like what Pieter Mondriaan produced in his damp house in Amersfoort, but the father's faith in the seeable to convey the spiritual would have a direct impact on his namesake. One's art could express one's personal gospel.

The men and handful of women Mondriaan portrayed were all hardworking, self-sacrificing characters. Uniformly dour, enduring considerable physical discomfort in their starched white shirts and black jackets, these socially and politically conservative exemplars of goodness have all the qualities Mondrian's father considered essential to serving God and the Netherlands. Presenting these noble individuals, he intended to teach the world at large the same values as those he consistently preached at home.

His son's eventual passion for large expanses of uninterrupted white counteracted that overstatement. Mondrian would replace his father's encyclopedic frenzied imagery with ambient calm. Whereas Pieter Mondriaan could not stop proselytizing, Mondrian would savor the luxuriance of pure, snowy space. But in both instances the artist was supremely conscious of the viewer, and determined to communicate effectively.

With the popularity of his art as well as his school, Pieter Mondriaan became a local hero in Amersfoort. The schoolmaster had constructed his life, and that of his wife and children, with the goal of making the institution on Kortegracht a bastion for devotees of Orthodox Protestantism. Consumed by their ardor for the new faith and its concomitant politics, his coreligionists felt supported by the small but powerful institution to which they brought their children every day. Since his arrival in 1869, Pieter Mondriaan had become something of a cult figure, with his young family basking in the glory of his position even as they had limited material niceties.

Then, in 1878, the dream was shattered. That year, a petition was drawn up opposing denominational education in the Netherlands. After nine years of ever-increasing success in Amersfoort, Mondrian's father became embroiled in a conflict that undermined all his hard work.

The idea of a school entirely for practitioners of Orthodox Protestantism in the Netherlands was the basis not just of what Pieter Mondriaan had achieved on Nobelstraat but also of the sectarian schools he and Kuyper were trying to promulgate nationwide. It was to serve as a shining example of what could be done throughout the country, with Pieter Mondriaan considered the supreme authority on the educational program that would enforce his strict, hidebound Calvinism. When both houses of parliament acceded to the demands of the petition by passing a bill which denied all future financing to single-religion schools, while improving the funding of state schools, the project ground to a halt and the future of the Amersfoort school was in serious jeopardy.

Piet, age six, and his eight-year-old sister were old enough to feel their father's anguish and the sudden uncertainty of the entire family's existence. Yet hope remained. A large number of people continued to support what Pieter Mondriaan and Kuyper and their allies were trying to do. All proponents of single-religion schools united. It was the first time in Dutch history that Protestants and Roman Catholics became allies. On May 2, 1878, a petition, signed by over three hundred thousand Protestants and one hundred and fifty thousand Roman Catholics, was handed to King Willem III in Loo Palace. The document with its pages upon pages of names requested the king not to sanction the new bill even though parliament had passed it.

The king announced his personal support for this second petition. Yet, at the same time, he declared himself a stickler to the rules of democracy. He made clear that he could not countermand the constitution, which accorded a parliamentary majority ultimate authority in such matters. He recognized his obligation to sign the bill despite his own opposition to it. The new law went into effect.

There was no point in Pieter Mondriaan's remaining in Amersfoort. Overwhelmed by this personal defeat, he went from disappointment to rage. Abraham Kuyper was no less upset, yet remained determined to move forward. How could they give up on a cause vital to human destiny? The service of their Almighty God had to continue.

The outpouring of support for what Kuyper and Mondriaan had tried gave them reason to hope that the Anti-Revolutionary Party and Orthodox Protestantism might still flourish independently. After all, over three hundred thousand people had signed the petition. Yet now that the government denied financial support for full-fledged denominational education, Pieter Mondriaan needed to find a new institution where he could teach his beliefs.

This meant accepting the idea that not everyone in the school community would be an Orthodox Protestant. Kuyper, always a bit less rigid and more accommodating than his acolyte, arranged for him to become headmaster at the School for Christian National Education in Winterswijk, a rural town at the German border. Mondrian's father was relieved to have a job and some hope. But he also felt that he was being relegated to as remote a point in the Netherlands as one could find. He was not wrong.

Winterswijk

A chterhoek—the name of the region in the Netherlands of which Winterswijk was the largest and oldest town—means "rear corner." Surrounded by woodland with some of it cleared for primitive farming, it was a world apart, isolated within a region that was itself far from everything. Although the Netherlands is relatively small, even today, with transportation far faster than when the Mondriaan family lived there, it still feels distant, requiring four trains with three prolonged waits during the changes to get there from Amsterdam.

The Achterhoek is in form like a protrusion on a jigsaw puzzle piece that clips into the void of an adjacent piece. Jutting out from the main body of the Netherlands, the area is surrounded by Germany on three of its four sides. Winterswijk itself, with its seventy-six hundred people, was a pretty place, dominated by St. Jacob's Church, built in the Middle Ages and ultimately transformed into a Protestant house of worship. But the people seemed foreign, and many spoke only the local dialect, coarse-sounding and incomprehensible. The young family felt as if they were being relocated to a different country.

But even if the schoolteacher with his young family was bitter at the necessity of being so far away from all that was known to him, at least he had a good job and could continue to promulgate the principles of Groen van Prinsterer in which he believed so deeply. And despite its hardships, the move to distant Winterswijk brought some unexpected advantages. The father and mother and four children were given, as a perk of Pieter Mondriaan's new job, a wonderful large house from which they faced a lovely landscape. It would not be long before the bucolic surroundings inspired the oldest son to draw and paint.

The house on Zonnebrink, one of the grandest thoroughfares in town, was at odds with the other mansions on the street, just as the Mondriaan family's life was different from everyone else's. The rest of the houses had front doors facing the street, making them accessible via a shared sidewalk. The Mondriaans' house turned its side to the street. The front door faced

the schoolyard, opposite the school entrance across the way. That position was a declaration of Pieter's role as headmaster. The intertwining of domestic and professional life was clear to see. The head of the household could come or go from his work at any hour of the day or night.

Piet and his sister and their brother Willem immediately entered that school, and while their classmates came at a distance from farms in the outlying region or flats over local shops, their walk was so brief that they did not even need to put on coats in a blizzard. Later in life, it would not occur to Mondrian to question the integration of his profession with how and where he partook of everyday needs and pleasures; it had always been that way.

The grand and luxurious dwelling that was patently the headmaster's house conferred importance on its inhabitants by being even larger than the school building it faced. However pleasure-denying and Calvinistic the family was, Mondrian grew up with a sense of privilege and well-being. Even though he subsequently would live in circumstances of personal hardship, his art would always reflect the sense of comfort with which he was nurtured.

In a part of the Netherlands where the summers are warmer and the winters tougher than in Amsterdam, the headmaster's residence was designed to assuage the impact of both seasons. It had large windows that opened easily in hot weather, and a good heating system—dependent on coal stored in the basement—that made it pleasant even in the cold wet weather that afflicts the eastern Netherlands from November through March. Built in 1869, the house is a square, ten meters by ten meters, impeccably divided inside. Its balanced shape and the formal precision with which the windows are organized lend it a sense of harmony that you intuitively perceive as you approach the front door. Once you are inside, the neat proportions have a soothing effect, and imbue a feeling of equilibrium. The aura of propriety, of a life governed by rules, with which the dour Pieter Mondriaan and the agreeable Johanna brought up their family, was reinforced by this well-regulated geometry, and in the symmetry of the spacious, high-ceilinged rooms—all broad rectangles, neither too long nor too narrow—arranged with consummate logic within the overall square.

The house had initially been built as a one-story structure. The second floor and the large third-floor attic had been added in 1875. When the Mondriaans arrived, if the new family home was not quite a mansion, it was substantial. When Pieter and Johanna Mondriaan and their young children walked into it, they crossed a large foyer with a marble floor. Dark, shiny wood surrounded them. On the far side of the front hall, there was a steep staircase with an ornate newel post and a handsome carved banister, their

varnish glistening. Wide paneled doors to the left and right opened to large rooms that were sheathed in wooden wainscoting below and white plaster above. The room to which the substantial entranceway opened on the left was a fine sitting room with a fireplace that gave onto the library. To the right of the vestibule there was another big room, intended originally for dining, but that the Mondriaans used as a playroom. The graciousness and ample scale of these places devoted to everyday pleasure were surprising given Pieter Mondriaan's disapproval of any form of hedonism.

The large kitchen was at the back of the house, behind the playroom. It was well suited both for food preparation and family meals. It and the playroom were the two rooms where the children and their mother spent most of their time together, while the more formal spaces were used for meetings between Pieter Mondriaan and his fellow Neo-Calvinists, or for him to read by a fire once his long workday was over.

The handsome staircase that faced the front door led to a floor with four high-ceilinged and airy bedrooms. Each was a square within the larger square of the house's footprint. They had large windows and white plaster walls, the only darker tone coming from the wooden floor and a wooden closet door. The bathrooms were spacious. The roomy attic above was of full height. Throughout the house, what today may seem unexceptional represented a high standard of living for the time.

If you picture where Mondrian spent most of his childhood and formed his expectations of everyday life, and where his future memories were born,

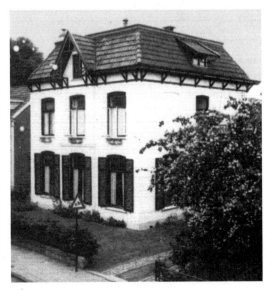

The Mondriaan family house in Winterswijk. The large room on the ground floor that was initially a playroom for all five children was turned into a studio for Piet alone.

his subsequent life choices become all the more dramatic. Mondrian grew up in a comfortable home, even if it was one that came with his father's job. His happy willingness to spend most of his life in modest studio spaces has new meaning when you stand on the marble floor of the grand foyer on Zonnebrink. One of the most noticeable features of the places where Mondrian eventually elected to reside was the decrepitude of their entrances. Visitors to the rue du Départ were invariably astonished by the stairs and hallway, like those of a run-down tenement. Even after they walked past the front door with its peeling paint and entered Mondrian's visually remarkable living space, the creature comforts were negligible. To cook on a two-burner hot plate was a major change for someone whose childhood house had a large iron stove, capacious ovens, and ample supplies of firewood and coal to keep them going. The house in Winterswijk took the sting out of daily life; the studio apartment in Paris, as well as his subsequent dwellings, accentuated it.

II

There was one aspect of the house on Zonnebrink which penetrated Mondrian's being as if entering his DNA. This was the grid formed by black lead mullions in the large windows. Eventually, in his abstract art, Mondrian would echo both that structure and its opening to the luminous universe beyond. Making paintings that represent nothing but their purest selves, he, too, would use vertical and horizontal black lines meeting at precise right angles to contain light and color.

Arranged in a taut grid of narrow strips, organized like the lines of demarcation on a tic-tac-toe board, those crisscross windows do not have an iota of decoration. In the Mondriaans' house, the mullions were matte black lead, supporting stacked rows of squares of marvelously clear hand-blown glass. It is the same splendid glass, as pure as water in a mountain stream, that lets light into the Netherlands' sixteenth- and seventeenth-century churches. These windows do their job impeccably. Unlike so many elements of the house, they have no aspect alien to their straightforward purpose, which is to bring sunshine into the living space.

The idea that these windows had such an impact on Mondrian is based only on visual evidence, but it makes sense that this crisp grid provided balance and stability in an otherwise confused hodgepodge of forms. How direct these straight horizontals and verticals were. How refreshing to see something with its appearance integral to its purpose. Going from window to window on the first floor of the house on Zonnebrink is like looking at the future. Thin and crisp, the undecorated mullions were clearly the seeds

of the dividing lines of Mondrian's great abstract compositions from 1912 onward. Surely young Piet, looking at the windows, and beyond them to the outdoors, felt their imprint. For he would repeat their achievement in hundreds of variations: the enclosing of whiteness with blackness, the locking of light and color into a grid that positions it rigidly and permanently.

What was solid enabled the ethereal to thrive. To abet weightlessness with a sturdy structure was an act of alchemy worth perpetuating.

III

Pieter Mondriaan imposed his iron will on family life with quirks that other people noticed and commented on. It was normal for fathers to reign over their wives and children with absolute authority, but his domination took odd forms. The citizens of Winterswijk were struck by the schoolmaster's "habit of leading his offspring in a prearranged order in Sunday walks through the village, while mother Mondriaan remained at home in the kitchen." The regimentation conformed to the code of behavior Abraham Kuyper had put forth in his book *Antirevolutionary Also in Your Own Family*. Published in 1880, Kuyper's doctrine primarily addressed the roles of husbands and wives concerning their children.

A wife's primary function was service as a good mother. As such, she attended to all details essential to a well-oiled domestic milieu, and accepted her position as second in command. The father of the family, who made all important decisions, kept his distance. The mother served as an intermediary between her children and their father. This structure, which in early years had been prevalent throughout Dutch society but which had begun to evaporate in many households, remained essential to Orthodox Protestantism. Its proponents proudly contrasted it to the decadence that prevailed in the current era. Kuyper writes,

> Families such as those whom one encounters so often nowadays, in which the wife has become number one and her husband is subservient, are sinfully composed families . . . going against the word of God. . . . A man who lets his wife be the boss at home is not just cowardly and unmanly; . . . but he is in direct contravention . . . of the will of God. . . . He simply has no right to do that. . . . But since God saw fit to say to women: "your will shall be subject to that of men!," it is proved once and for all and in the most categorical manner that the Lord God has entrusted part of his divine might over the wife to the husband, who thus rules over the family according to the will of God.

IV

In Amersfoort, the first drawings Mondrian ever saw were the pictures Pieter Mondriaan drew for the children's Christmas parties. In Winterswijk, his father continued to use white chalk on the classroom blackboard to draw images of the Nativity, Simeon in the temple with Anna, and the Flight into Egypt.

Mondrian himself never referred to this skill of his father and the pleasure his impromptu sketches brought the local children. As the second-oldest child, he had more direct experience than the younger three boys did of their father's seasonal outpouring and the festive atmosphere around them. But it was only two years after Mondrian's death, when devotees were scrambling to find out more about the artist's past, that the youngest brother, Carel, described these lively illustrations and invoked the happy ambiance in which they were seen. The images rendered in white on black and depicting the story of Jesus's beginnings "were intended as decorations for the parties, where sandwiches, coffee and cocoa were served, and the children were given books."

Even if he never chose to recall this happier side of his youth, those circumstances had an impact on the teenage Mondrian. In a milieu where it was unusual to have fun, and daily life was dominated by the grind of studies and chores, here he experienced art as the transmission of a joyful spiritual message in festive conditions. The pleasures of those Christmas parties—conviviality, treats to eat other than the everyday porridge and soup, gifts of books, which opened up unknown territory—were inextricably linked with the creation of art. What human beings might make visible through drawing or painting could evoke a rare and wonderful feeling of celebration.

V

During the summers, Pieter Mondriaan's youngest brother stayed with the family in Winterswijk. Uncle Frits spent most of his time making art. This was long before Piet and Frits developed their differences, and the teenage Piet reveled at the sight of his uncle happily engaged in producing pictures intended for aesthetic enjoyment rather than religious instruction. Besides, it was visible to all that Frits was having a thoroughly good time.

Frits Mondriaan was the antithesis of Pieter Mondriaan. Immersed in worldly pleasures, the prosperous businessman's goal as a painter was to embellish people's homes. Unlike Pieter Mondriaan's proselytizing art that taught the Bible and celebrated the triumphs of Dutch royalty, his canvases were of the fertile fields and gentle rivers of the Dutch countryside, the con-

tented affluent men and women who commissioned him to paint their por-
traits, and the fruits and flowers in their prime that he assembled gracefully
for his still lifes.

Frits, the baby of the family, had initially been a wig maker, as was Willem
Frederik Mondriaan, his and Pieter's father. After Willem died in 1878, he
had taken over the family store in The Hague. In the same years that Pieter
Mondriaan was struggling to maintain the Orthodox Protestant school in
Amersfoort and inculcate Neo-Calvinism in as many as possible, Frits had
been devoting himself to the fashionable shop in the cosmopolitan capital.
The enterprise at 39 Lange Poten had been flourishing when Frits took over,
and Frits had made the most of a good thing. In 1880, the year the Pieter
Mondriaans moved to Winterswijk, he relocated the thriving establishment
to a new address, at 45 Spuistraat, and in 1887 he enlarged the premises and
expanded its line of luxuries. The elegant salon and shop began to adver-
tise itself as "F. H. Mondriaan, Hairdresser, specializing in wigs, toupees for
Ladies and Gentlemen. Sale of Gentlemen's articles, perfumery, traveling
and bathing items, a large and refined selection of Cravats."

As they ate their modest evening porridge, the household in Winterswijk
knew that the chic and prosperous family business on the other side of the
Netherlands facilitated a very different lifestyle for the relatives who ran it.
How the Pieter Mondriaans felt about it, and whether they had any finan-
cial reward from what was presumably an inheritance shared by all of Wil-
lem Mondriaan's children, is unknowable. But what is sure is that they were
closest to Frits of all their relatives. And while he lived and worked in The
Hague most of the year, it was when he was with them in Winterswijk each
summer that he did most of his painting. Enjoying lengthy stays with Pieter
and his family, often using the rural setting as his subject matter, he made
the art he exhibited and sold with such success in richer parts of the country.

During those summer idylls, Frits also gave art lessons to his oldest
nephew. A stocky man with a handlebar mustache and pointed beard, he
would sit on his folding camp stool in front of his traveling easel while Piet,
lean and lanky, stood at his side. Holding his palette with his left hand on his
left knee, he dabbed paints and applied them judiciously to the canvas, with
Piet studying his method. When Piet turned fifteen, Frits gave the boy some
materials so he could do further experimenting on his own.

Observing his uncle, the enraptured young Mondrian saw painting as
a ceremonial act. The model of a gentleman painter, Frits made his hobby
into an event. He sported one of the wide-brim hats that were a specialty of a
fine shop neighboring his own, and almost always had a well-turned wooden
pipe, handcrafted by a distinguished Hague tobacconist, in the left side of his
mouth. On these outings to paint in the countryside near the Winterswijk

house, he normally wore a double-breasted dark suit, starched white shirt, silk necktie, and elegant high lace-up boots. The flat box in which he carried his tubes of oil paints was a mess inside, but it was impeccable when closed. Piet enjoyed studying the processes and materials of painting.

Teaching Piet basic drawing technique according to the style of the day, Frits emphasized the need to articulate the subject clearly while maintaining a lightness of atmosphere. Frits showed the boy which pencil to use, how sharp to have it, and how forcefully to apply it in order to achieve both goals. When they did not pack up their equipment and go off into the fields or nearby forest, uncle and nephew would work together in the playroom of the large house. Piet enjoyed a sense of companionship he experienced with no one else—as did Frits, whose own children were very small.

The time inside with his uncle, and their short excursions into the surrounding region, were the best moments of Piet's everyday life. They countered the annoyance of his gardening chores. He delighted in observing nature in depth and making pictures, instead of wielding a hoe and being indoctrinated by his father on all that was forbidden in life. And he discovered a skill in himself and an activity at which he felt comfortable. Not at ease in sports, never as rough and tumble as his brothers and most of his schoolmates, with a drawing implement or paintbrush in his hand, the teenage Piet felt a new safety and competence.

Frits Mondriaan spoke to his adolescent nephew about his work as a provider of luxuries for fashionable people as well as his joy in the act of making art. His dour father's ebullient brother introduced unanticipated pleasures, and as the nephew began to emerge from his repressive childhood, it suited both Piet and Frits to have their reputations intertwined. As long as he lived in the Netherlands, which would be until he was forty years old, Mondrian's work would be continuously compared to his uncle's. Initially, there was a marked similarity. Piet was a good student and made his teacher proud. Once Mondrian left home at age twenty to study at the Rijksakademie—the State Academy of Fine Arts—in Amsterdam and began to show for the first time in public, in group exhibitions that presented the leading artists of the day, the work of his better-known uncle was also on view. While Frits's pictures adhered to current fashions and taste, and Piet's reflected greater independence, their differences were not conspicuous, and there was a rapport between their pictures.

This would only change in about 1900. It was then that Mondrian would start to use bolder brushstrokes and punchier colors than almost anyone else in the Netherlands. Frits would continue to paint in the same pleasant but tepid style he, and most other Dutch artists of the era, had always used. The critics would quickly focus on the difference between Frits's traditionalism

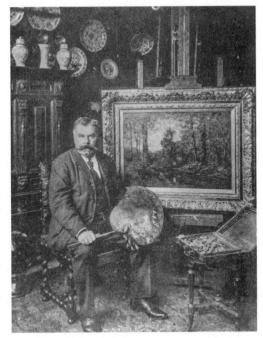

Mondrian's uncle Frits, c. 1902, at home in The Hague. Frits had a great influence on Piet, teaching him how to paint and demonstrating that it was possible to make a living as a professional artist, but eventually made him drop the second "a" of the family name because he considered his nephew's work so bizarre that he didn't want their work confused.

and his nephew's new approach. To most, Mondrian's choices were incomprehensible. The journalists thrived on the contrast, with the majority preferring Frits hands down. And, commercially, for the rest of Frits's lifetime, the uncle would be the winner. Mondrian would have to take commissions to survive, while Frits would make a lot of money selling almost everything he produced. Not only would Frits have clients while Piet did not, but the uncle's collectors were in the upper echelons of Dutch society, the aristocracy as well as the same fashionable members of the mercantile class who frequented his wig and hairdressing salon. The royal family would acquire his pictures, as would museums in Russia and Germany.

Most of these wealthy and enthusiastic buyers would flock to the landscapes of the same Winterswijk countryside that had been the subject of paintings Piet made when his uncle was training him. If Piet had chosen to continue in the competent Academic style they shared, he would have been assured a steady income and an easy life. But there was no deterring the nephew from the violent colors and unorthodox brushwork that sundered him from his uncle.

Frits was so determined that they be disassociated that he would eventually force Piet to take the "a" out of the family name. In 1914, five years after Mondrian began to use the new version minus the second "a," he would write to one of his supporters, H. P. Bremmer, that he had initially made the change because his uncle "thought that it was to his disadvantage to have the

same name." Frits's insistence hurt; in Piet's adolescence, his uncle had been everything to him.

The way their relationship eventually played out was a defining event in Mondrian's life. He knew he was violating the standards of the mentor to whom he felt such fealty. The consequences stung. Mondrian would always maintain that, while his father taught him rudimentary drawing, it was thanks to Frits that he refined it and learned the craft of painting that mattered far more to him. In total conflict with Frits as to how that craft should be used, Mondrian did not flinch. He did not waver in his will to reject Frits's artistic style, which was pure "Hague school" in its traditionalism. But Frits was appalled by Mondrian's wild colors and radical style with patently visible brushstrokes. It hurt to be cut off by the uncle who had introduced him to the art of painting and the pursuit of visible beauty.

VI

Pieter Mondriaan thought it was fine to paint as a hobby but that artists should have day jobs. Frits was still running the family's shop in The Hague and making good money at it; Pieter himself made drawings and lithographs, but earned his living as a teacher. Mondrian's father laid down the law: his son could not become a professional artist. Rather, he had to train to become a schoolteacher. Piet had no choice but to follow his father's directive, even if at that early age he already knew what he wanted above all else and insisted that, if he had to teach, his subject would be drawing.

With his father's approval, the fourteen-year-old Piet found out the requirements for the diploma necessary to teach drawing at the primary school level nationwide. He enlisted both his father and Uncle Frits to step up the frequency and intensity of their lessons. His parents obligingly transformed his and his siblings' playroom into a studio so that he could more easily devote himself to developing the technical proficiency requisite for him to pass the exam given by the Dutch state.

Initially designed to be the dining room of the house on Zonnebrink, this large space, to the right of the entrance of the hall and en route to the kitchen, made an ideal workshop for Mondrian to make anatomical drawings and develop his knowledge of how to render perspective. He obtained permission to borrow plaster casts from the Rijks Hoogere Burgerschool, the school he would have attended had he pursued his education in the normal way. On the other side of the wide street, the ornate mid-nineteenth-century building was only a block away, and the fourteen-year-old lugged home colossal plasters of Moses's and Laocoön's heads, from which he made charcoal drawings in his new studio. He also mastered the technique for

drawing different types of flowers, capturing their varying structures precisely and accurately. Piet's determination to make meticulous art began to define him.

Pieter Mondriaan was a competent teacher. He devised exercises to train his son to organize complex compositions. There was no talk of imagination or emotional expression, only of technical mastery, and he was determined for the boy to acquire the necessary skills. The father set up a kitchen chair with a pail on the seat and a broom leaning against the back, and gave Piet the task of rendering it with maximum accuracy. Piet's assignment was to capture the relative scale and proportion of each object, and to situate them in his drawing with maximum fidelity to the way they were arranged in actuality. Pieter Mondriaan was as doctrinaire and rigid in his ideas of right and wrong draftsmanship as in all of his other beliefs. Still, in his devotion to training Piet to develop the capacity to teach art, and to pass the exam, he supported his son's ambition wholeheartedly.

To his younger brothers, this pursuit made Piet even more of an oddball than before. Previously, he had been simply cautious about his eyes; now he was obsessed. Carel would recall that once their father was training him, Piet's "maniacal fear of injuring his eyes" intensified. "At the slightest danger, he would close his eyes or cover them with his hands, turning his head away. This fear seemed absurd to other members of the family; they often joked about it." Yet Willem, Louis, and Carel respected the compulsive recluse who perpetually retreated into his studio. When they saw him in the kitchen at meals, or during his breaks for coffee as he started to develop his lifelong dependence on strong doses of caffeine, he was someone apart, but he was cordial and agreeable in his isolation. It was the role he would always have in the family.

Pieter Mondriaan was right to believe that his namesake had a talent worth nurturing. At sixteen, Piet made an extraordinary charcoal and crayon drawing, *Woods with Stream*. His earliest surviving work, 19 by 24 inches, this rendition of a rushing stream in dense woods was a tour de force. The vigorous composition testifies to the authority the boy had already developed thanks to his father's and Uncle Frits's tutelage and to all those exercises at home. Piet had the rare knack to take a flat piece of paper and evoke three-dimensional space authentically. He transformed the white surface into a clear window beyond which a marvelous series of natural occurrences unfolds in bright sunshine. The stream flows convincingly into the distance; a light breeze blows palpably through the thick foliage. This woodland scene reflects the aspiring artist's intense effort and astonishing flair. In spite of one area in the upper left that is articulated less clearly than the rest—the only hint that the draftsman was still a novice—it succeeds in making the

subject lush and verdant, and in charging it with energy and rhythm. This drawing breathes. It conveys the simple love of air that would be manifest in Mondrian's art in every incarnation. Treating a subject traditional in Netherlandish painting going back to Jacob van Ruisdael and the other seventeenth-century masters, Mondrian, even before he was fully formed, was by nature jaunty and celebrative. Unlike the people around him, he had the same will as Rembrandt and Van Gogh and all the greatest Dutch painters to celebrate life's complexity and reveal it with heart as well as spectacular craftsmanship.

In teaching Mondrian drawing, his father and uncle had adhered to the method laid out by a French art educator, Alexandre Dupuis, and prevalent throughout northern Europe at the time. In 1836, Dupuis, a professor at the Collège Saint-Louis in Paris, had published his *Teaching Drawing from an Industrial Point of View*. This manual for art instruction challenged the traditional approach to drawing which made it "a privileged science"—difficult to understand and accessible only to "elite troupes"—and presented a program to teach the large public. The most radical break from the past was that the new method abandoned the usual practice of sketching from a live model. This meant that it was less costly and did not risk offending Calvinist morality: two leaps welcomed by the Mondriaan brothers and other art teachers with the same mindset.

The Dupuis method taught students to draw human figures in bold out-

Woods with Stream, 1888,
Kunstmuseum Den Haag

lines. Like figures in a child's coloring book, they had no shading within. These simple contour drawings at their best captured the essential form of the subject without surface details. Like all Dupuis followers, Mondrian had drawn from those plaster busts rather than actual people to facilitate that capacity.

Mondrian adhered to Dupuis's counsel that artists begin "with three-dimensional, geometric shapes." Initially, these should be angular, based on rectangles; then they can be rounded as necessary. *Woods with Stream* goes beyond simple outlines, but it is still emphatically geometrical in its decisive rendering of the tree trunks as muscular forms rising from the earth, and in its bold penetration of the space with a machine-like movement in concord with the "industrial point of view" that was Dupuis's goal.

Unlike a mere act of slavish copying, either of another artwork or of a natural scene, *Woods with Stream* soars with passion for both the natural world and the process of making art, harnessed by steadfast discipline and sense of craft. There is a rich chiaroscuro, and remarkable precision in the placement of each tree trunk in the receding space. The ardor is all the more powerful because of the underlying control.

Later in his life, when Mondrian was at the height of his fame, there would be at least three occasions in Paris when he was at friends' for lunch—the Arps, the Gleizes, and the Kandinskys—and insisted on being seated

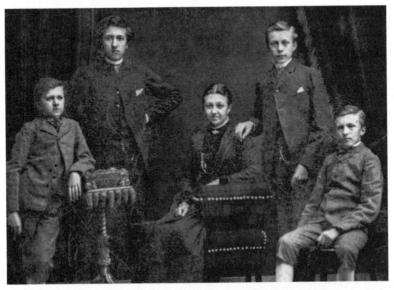

Left to right: Carel, Piet, Johanna Christina, Willem, and Louis Mondriaan. Johanna Christina was the firstborn, and Piet was the oldest of the four brothers. When he was fourteen, the children's playroom was converted into a studio exclusively for him. Photograph taken c. 1889.

with his back to a window lest he have even the smallest part of a tree in his line of vision. Those events became central to his myth, and Mondrian's adamant refusal to see so much as a single leaf during the meal is cited time and again as an example of his profound aversion to nature. Most people mock Mondrian's peculiarity and use it as an example of neurosis.

The behavior was eccentric of course, but the interpretation of it is fallacious. It is more likely that Mondrian could not look out the window at trees because the sight of them transfixed him totally. Love, not aversion, overcame Mondrian if he even glimpsed tree branches in the sunlight. *Woods with Stream* is the first of many encomia to trees that he drew or painted over the years. The delicate pencil drawings of single trees with which he filled sketchbooks, his close-ups of large apple trees bathed in pink light, sing with sheer pleasure. Mondrian's infamous social quirk of needing to be reseated at luncheons developed because trees moved him to distraction.

VII

Mondrian continued his training under his parents' roof until the end of 1889. If he socialized or had any sort of private life outside the family home during those three and a half years after he left his father's school at age fourteen, we know nothing of it. Then, four months shy of his eighteenth birthday, he went to Amsterdam to take the exams he had to pass to become a primary school teacher.

They were administered over a three-day period, from December 9 to 11. The facts are scant, but it is likely Mondrian had never been in the metropolis before, and that his father had to arrange his trip and accommodations.

A committee of twelve teachers judged the exam results. The main task on which the students were evaluated was "the proper designing of a shaded drawing of a simple object and of a not too complicated relief-ornament, to be copied from nature." Other qualifications included a clear understanding of perspective and "knowledge of the demands of group instruction in drawing in general and of a good method in particular." The dozen academicians determining success or failure were looking both for technical capability and the personal traits required of an effective teacher. They interviewed the candidates to gauge their communication skills and other characteristics vital for successful human interaction.

Out of the one hundred and twenty-three young men who took the test that year, Mondrian was among the fifty who passed. Fewer women tried, but a greater percentage succeeded, with twenty-three out of forty-two making the grade.

Mondrian proudly held on to the certificate conferring on him the right

to teach. Once he was well known, he would show off the diploma to almost every journalist or friend or art collector who called on him. His visitors were astonished. No one expected a groundbreaking abstractionist who had gone against almost every societal norm to flaunt something so traditional and comparatively insignificant.

It was incongruous for the jazz-loving pioneer of abstraction to present this document from his past, covered with signatures and stamps and seals. Having pared down his life to a minimum of possessions, and eschewed all the strictures of academia, why did he want the few people he deemed important enough to let into his private domain to see this evidence of official approval? Was it as a joke? Even if he did, occasionally, teach in his father's stead, the only actual use he made of the degree was as a stepping stone to the next degree, which in turn assured him entry into the Rijksakademie.

Still, the diploma represented Mondrian's acquisition of technical skill, and his ability, at a young age, to play according to the rules. It was important to him as an avant-garde artist that others know that he had won the approval of the academicians. Yet rarely has someone been so uninterested in his past, so focused on the present, so anti-authority and lacking in nostalgia. Mondrian cared neither about children nor about teaching. Why was he so proud of this accreditation of his capacity to instruct young people to draw in a style that he had rejected completely?

Besides, while the receipt of his diploma meant that "Pieter Cornelis Mondriaan"—his name still undifferentiated from his father's—could teach drawing at any primary school in the Netherlands, he decided to remain at home.

It was abnormal to decline the opportunity to move on. His finances would have been covered by the government. For the last two years of his schooling, he had been living in near solitude as the oldest student, the only person in his age bracket, with his father the one in charge and the school building only a minute from the family house. But Piet was not like other teenagers. He rarely ventured anywhere—except to paint with his uncle.

With the degree for which he had trained intensely over nearly four years, the seventeen-year-old could now have found a job anywhere in the country. It was the freedom of which most young men dream. Mondrian could readily have put himself somewhere more amusing than Winterswijk. On a teacher's salary, it would have been impossible to match the studio space he had by remaining in his parents' house, but he was at an age when most young people want mainly to spread their wings. The sole occasions when Mondrian saw people other than family members were when he taught drawing to the older students at his father's school on the other side of the courtyard. Otherwise, with that primary school teaching degree under his

belt, he focused all of his energy on working his way up the academic ladder. He now labored to get the secondary school certification, its requirements far more stringent than for that first diploma.

At nearly eighteen, Mondrian recognized that he needed instruction more professional than his uncle's or his father's. Jan Braet von Überfeldt, a successful full-time artist, lived in Doetinchem, a town thirty kilometers away from Winterswijk. Uncle Frits told Piet that Braet, together with his college friend and fellow painter Valentijn Bing, had in the 1860s educated numerous drawing teachers. They knew exactly what Piet should focus on to earn his certificate.

Braet and Bing had developed a new way of teaching drawing and had made a textbook codifying it. Frits, who knew Braet and Bing from several painters' societies in Amsterdam and The Hague, wrote Braet asking if he might bring his nephew to meet him. Uncle and nephew took the steam train for the journey that for three-quarters of an hour passed through the rural landscape of the Achterhoek. From the Doetinchem station, his latest drawings under his arm, Piet, accompanied by his devoted uncle, walked through the village to Braet's house at the Grutstraat. The eighty-two-year-old Jan Braet von Überfeldt looked at the teenager's portfolio and agreed to take him on as a student.

Mondrian began to make regular excursions to Doetinchem for his lessons with Braet. The octogenarian was unlike anyone else he knew. Having had severe polio as a child, Braet walked with a pronounced limp, but emitted fantastic verve. Spirited and energetic, while physically crippled, he was defeated by nothing. He dressed flamboyantly, always with a foulard or cape. He attracted attention whenever he ventured out, especially when he was accompanied by his wife and their large pet goat. Braet's wife was his cousin, Maria Augusta Überfeldt, twenty-one years younger than him. They were childless, but treated the oversized goat as a member of the family.

The threesome lived well. Braet, now retired from painting, had made a fortune with his Romantic-realist portraits and genre scenes, his lithographic illustrations for a book on Dutch regional costumes, and the royalties from the two-volume text he had coauthored with Bing. Their method for teaching drawing in primary schools was followed nationwide. Braet's own art, executed with panache, had enjoyed its great success above all because of its shimmering surfaces. Braet worked in the manner of Ingres, and the expensive silks and damasks of his bourgeois portrait subjects were rendered with finesse. And the draftsmanship was impeccable.

Mondrian's teacher was a fount of information about the making of art. He had a substantial collection of Dutch nineteenth-century painting as well as stacks of reproductions of art by the Old Masters. The pictures he chose

exemplified his belief that artists must work directly from nature. It was essential to master and apply the rules of perspective.

Braet was content to take his private tutee under his wing. He improved Mondrian's draftsmanship by helping him develop the capacity to shade his subject matter. This was lacking in the technique Mondrian had learned at home. But Braet offered Mondrian a far more significant gift. The elderly artist encouraged him to believe in his own intrinsic talent. He made the eighteen-year-old believe that his chosen course in life, to make his own art rather than teach others, was valid.

The dynamic Braet brought the tall, lean teenager out of his shell. Quiet and pensive, with his shock of smooth black hair and the large dark eyes he protected so vigilantly, Mondrian was used to functioning in isolation. Even with his siblings and parents in the same house, he had developed into a loner. Braet helped him increase his ability to master his technical capacity and to develop the confidence to paint as he wanted. Learning which brush to use and with what weight to apply the paint, Mondrian became emboldened to orchestrate the overall composition artfully while capturing the reality of appearances.

VIII

Approaching the age of twenty, Mondrian painted his most impressive painting to date. It was a still life of a dead hare. The animal hanging from its right hind leg is a feat of verisimilitude. The setting—the space above a wooden plank that recedes into a black background—is a triumph of austere elegance. The contrast between the luminous subject and the rich black presages Mondrian's later abstractions.

The canvas belongs above all to the tradition of Dutch still lifes as well as to pictures of freshly killed game by the French eighteenth-century painter Jean Siméon Chardin, but it is not a mere pastiche. It has a zing that goes far beyond the slavishness of a copy. The sharp focus with which Mondrian renders the hare, and the elegance of the matte black background, have assurance without arrogance. With his renewed determination to be a painter, Mondrian had become his own man and developed his capacity to paint with a punch that energizes the viewer.

Mondrian's confidence shines in several paintings of fruit baskets and earthenware pitchers that he made that year. Adhering to the same historical traditions as when he painted the hanging game, he focused on the art of the past that was the most tough and truthful, imbuing his own painting with that same rigor and candor. He had already developed the attitude toward art-making he would have lifelong. The young painter concentrated his sub-

ject, reduced the elements, and eliminated anything superfluous. He made the straw of a basket the perfect blend of supple and taut, and the skin of an onion microscopically thin. Having mastered weightiness as well as ethereality, he rendered a stone slab so that it is heavy and firm. He would not have dreamed of dipping his hat toward the lyricism and prettiness that were the vogue of the era, and kept anything personal invisible. The only revelation of himself is his consuming love for the act of painting.

Unsurprisingly, when these canvases were exhibited the following year, a critic in the Utrecht daily paper disapproved of Mondrian's straightforwardness. The anonymous "expert" opined, "He can . . . do more than he gives us here. . . . There is something lacking which we cannot do without: poetry, mood." Mondrian was pitted against that prevailing taste. Even though he was training to pass exams that upheld the current standards for artistic knowhow, he refused to use the devices of Romantic painting requisite to garner critical approval. The overt sentimentality and gratuitous atmospheric effects demanded by the preferred style of the era were anathema to him.

Mondrian had to be tough to remain so independent and out of sync with the current taste. To be accused of lacking poetry, and of not giving enough of himself, were stinging insults. But what he rejected was not the central issue. Mondrian's discovery of a vision he could trust provided solace in his lonely life.

Dead Hare, 1891,
Kunstmuseum Den Haag

He had the force within him to be undaunted by the slams. He needed it. Mondrian would wait many years until his unusual choices found an audience that recognized just how poetic they actually were. He was lucky to have his father's stubbornness and tenacity. Mondrian's goals were elusive, but he would not dream of wavering in his quest for a new form of spiritual beauty.

IX

In November 1891, Mondrian made a painting of a puppy that is an anomaly— one of his works where few people would guess the authorship. The subject, by its very nature, assumes a quality of "cuteness," even adorability. Still, the nineteen-year-old artist approached it with the same boldness as his still lifes.

In its tender rendering of a fetching animal, this small canvas exudes the sheer warmth that was vital, lifelong, to Mondrian's work. The simple happiness it provides is all the more remarkable given the absence of the sort of playful joy afforded by household pets in Mondrian's own childhood. The young dog's portrait is enlivened by qualities that Mondrian developed in a radically different form in his abstractions thirty years later. What is remarkable is that he already recognized them as a way to impart well-being to the viewer. The crisp black of most of the dog's hair, which shines brilliantly in the sunlight coming from the upper right, plays against the bright white of his muzzle, chest, and paws. It is the same counterpoint that will occur in Mondrian's spectacular gridded diamond compositions and other geometric constructions. What was probably a commissioned portrait of someone's pet proves that from the start Mondrian was viscerally charged by the interplay of neatly confined precincts of black and white.

Puppy, simply and eloquently, is a reminder that the sight of things— whether young dogs or abstract patterns—can penetrate our souls. Looking begets enchantment. Analysis is a secondary issue. We don't know precisely why the contrast of black and white or the appearance of puppies elevates the human spirit, but when articulated properly, they do so.

X

In February 1892, once the family learned that Piet had passed the exams, Pieter Mondriaan wrote the queen regent requesting a royal subsidy for his son to study art at the national academy in Amsterdam.

Having closely observed Mondrian's obsessive dedication to his own art-making, Pieter Mondriaan may have recognized that there was little chance that his son would succeed as a teacher. He also may have had the wisdom

to see that Piet did not have the right sort of personality to be an effective educator. Piet was too insular. He focused on his own desires; if he was aware of anyone else's needs or aspirations, he did not show it. Besides, Piet's obsession with his eyes was an eccentricity that would not bode well for him as a teacher.

Beseeching the queen regent to grant the stipend that was essential to cover the cost of tuition at what was presumably the greatest art school in the country, Pieter Mondriaan had relented from his earlier stance. Piet's diligence and tenacity had turned him around. He would do everything he could to help his son, now nearly twenty years old, realize his own fate. And possibly Mondrian's parents both recognized that it was high time that Piet moved out of the house.

Pieter's tactics worked. On March 1, Mondrian received a yes from the queen regent that she was willing to pay the course costs, were he to be accepted at the Rijksakademie. But Mondrian still had to pass one more set of exams to obtain the degree required for admission to the renowned art school.

XI

At the end of August, Mondrian returned to Amsterdam to sit for the initial series of examinations. The setting for these tests was the Rijksmuseum. There could have been no more auspicious location for this grueling five-day process to try for the advanced degree which promised to change his life. A week later, he had to reappear there for two more days of tests. A committee of academicians reviewed the candidates' performances throughout both stages of the process.

The tests were intense and exacting. Mondrian had to draw flowers and leaves, as well as the human skeleton and human musculature in correct anatomical detail. He made highly specific studies to demonstrate his knowledge of perspective. He did elaborate sketches to prove his ability to use light and shade to build three-dimensional form convincingly. He also wrote and illustrated essays on various topics. These included a history of ornamental styles, stating what motifs appeared in what time periods. His lack of interest in the subject was irrelevant.

When the results of the demanding process were announced, an even smaller percentage of students passed than for the primary school teaching exam he had taken two years earlier. Of the eighty-one people who took the tests, Mondrian was one of thirty-five candidates to make the grade. At last he would leave the security of home and head to Amsterdam.

Amsterdam

Mondrian's life had taken a radical turn. In Winterswijk, as in Amersfoort, he lived in the shadow of a father who was the most prominent figure in the community. In the two quiet and remote enclaves he had inhabited until now, his family noticed every time he went in or out of the house. Most of the townspeople he passed on the narrow streets recognized him, even if he avoided conversation. Now he was in the big city.

The change in the twenty-year-old's life was, however, only superficial. His goals and priorities had not altered. Nothing could distract him from developing his art. He had the chance, for the first time in his life, to be anonymous, and the city offered infinite diversion, but Mondrian still kept to himself; he concentrated on his drawing and painting, to the exclusion of almost anything else.

Amsterdam in 1892 was a booming metropolis of about half a million people. Most of the population was reveling in a new prosperity thanks to the recent growth of industry. Sugar refining and beer brewing had taken off, and the upper echelon of society either ran the new companies or thrived in the fields of trading, shipping, and banking that served them. The enormous Central Railroad Station, which had been completed five years prior to Mondrian's arrival, brought visitors not just from all over the Netherlands but from every major country on the European continent.

Amsterdam's return to wealth enabled it again to become an art center of international importance, as it had been in the seventeenth century. The national art academy to which Mondrian had been admitted had, in 1875, moved to elaborate new headquarters that befit its monarchical sponsorship. In 1885, the Rijksmuseum, a national museum, also under the aegis of the royal family, had opened. Its collection included masterpieces by Rembrandt, Vermeer, Hals, and other Dutch masters. In 1888, the city had inaugurated its impressive concert hall, the Concertgebouw, and work had begun on the Stedelijk, a museum intended for recent and contemporary art and scheduled to open in 1895. The city was also a flourishing publishing center; an

abundance of daily newspapers and weekly magazines rolled off the presses, and new books appeared in profusion.

Painters were national heroes. One knew this just by walking around. There were city streets named Ruysdelkade, Saenredamstraat, Jan Steenstraat, and Albert Cuypstraat; one square in the city center was the Rembrandtplein, and another was the Johannes Vermeerplein. The making of art was revered in a way unequaled elsewhere in the world; pictures were deemed essential rather than peripheral to earthly existence.

A circle of younger artists was flourishing. In the mid-1880s, George Hendrik Breitner, Isaac Israëls, and other painters from all over the Netherlands, almost all of them male, had converged at the Rijksakademie, where Mondrian was now studying, and their approach had an impact on him. Unlike their predecessors, who painted mostly bucolic scenes according to the tenets of the Hague School, they focused on the city in all its modernity. Their style was overtly bold and contemporary, their subject matter the new buildings and fast-paced life around them. While they continued the tradition of copying works by the masters in the Rijksmuseum, they set the example of focusing on the here and now, and of advancing artistic technique and the themes of painting into uncharted territory.

II

Pieter Mondriaan had made sure that his twenty-year-old namesake had a safe and secure situation amid the wilds of the big city. The schoolmaster had maintained his connection with a mutual friend of his and Abraham Kuyper's even after he broke with Kuyper in 1886. J. A. Wormser ran two publishing houses and the bookstores connected to them. He owned the one which specialized in books pertaining to the beliefs of the Reformed Church of the Netherlands, while the other, which was owned by Wormser's father-in-law, Henricus Höveker, had books promulgating the views of the Dutch Reformed Church. Initially, they had been part of a single publishing house, with Höveker and Wormser as partners. But then the schism erupted between the sects, and Höveker forced Wormser to go off on his own to maintain a strict separateness between the literature of the two faiths.

When Höveker died in 1889, with his daughter as his heir, Wormser had become responsible for both companies. In 1892, he reunited the two houses in a lovely three-story building at 154 Kalverstraat, the most fashionable shopping street in Amsterdam. Two of Wormser's sons, Johan Adam and Henry, bachelors two years older than Mondrian, ran the companies

that had been their grandfather's. They lived in an apartment above the bookstore.

Pieter Mondriaan arranged for Mondrian to move in with the Wormser brothers, whose household included their housekeeper, a second servant, and one of their shop assistants. The Rijksakademie was about a twenty-minute walk away, making this an ideal locale for Mondrian once he began his studies on November 7. The young visitor from Winterswijk would live comfortably in this well-situated apartment for the next three years; his father could not have made much better provision for him.

When he started his classes at the Rijksakademie, Mondrian also began to study the catechism of the Reformed Churches in the Netherlands, as the Reformed Church—in the singular—had recently been renamed. In July 1893, following nine months of attending religious classes and doing the requisite reading, he was officially admitted into the roster of this denomination his father opposed, and to which Kuyper and Wormser both adhered. Mondrian's name would be on the church register for the next twenty-two years, even after he had become a member of the Theosophical Society and moved from Amsterdam to Paris. His membership in the sect was only nullified when the church officials detected his long absence. That allegiance to the Reformed Churches established his independence from his father, but otherwise they were birds of a feather.

On December 17, 1892, a major Van Gogh exhibition went up at the Kunstzaal Panorama, a local exhibition space. Having been in Amsterdam for all of six weeks, during which he diligently followed the rules of painting as it had long been taught at the Academy, Mondrian suddenly had his eyes opened to an artistic bravery and originality he had never remotely imagined.

Mondrian admired not only the honesty of the art but the simple straightforward presentation that amplified the candor. Van Gogh's paintings were shown in nothing but thin wooden strips, narrow in profile, as opposed to the ornate frames usually put on canvases. The lightness and understatement of this new way of showing paintings, so that nothing detracted from the art itself, was life-changing for Mondrian. The courage redolent in the pictures and in the way they were shown opened young Mondrian's eyes in new ways.

III

The first canvas Mondrian painted after enrolling in the art academy is a still life of herring. Dated January 1893, it makes its subject knowable and real,

with an added dimension of soul. Mondrian concentrated on the hard truths of physical matter, yet because of the humble nature of these fish, a simple nutritional staple in many cultures, and because of a certain tenderness in Mondrian's rendering of them, these herrings represent the bounty of life. Mondrian evokes his modest subject so that they embody the abundance of the sea. The implicit universality is consonant with his later abstractions.

As in the still lifes he painted in Winterswijk, he upheld the tradition of Chardin and the Dutch still-life masters, while he was also showing the benefits of his instruction at the Academy. Mondrian displayed a new capacity to use light and dark to model demanding subject matter. The slithering fish and the copper pot are all plausible. Some of the herrings lie inert, contained in that vessel that is the dominant element of the painting. Others cascade out of it. The viewer is convinced that, whatever their position, they all have weight; they are not just paint on canvas. The inside of the hand-beaten pot reflects precisely the sort of light that bounces off metal, while the wooden barrel tilted against it has a more muted sheen. The copper is palpably thin, strong, and finely tooled; the wood has all the properties inherent in that fascinating material.

In this still life, which Mondrian painted at age twenty, it isn't only the stone and copper that seem real. The halved oranges read so true that we know the precise texture of the membranes separating their segments and of their pith and rind. The handle of the knife—part of it in sharp light, the rest in shadow—is authentically wooden, while the blade, with one bright streak of illumination along its edge, has the density and sharpness of steel.

Beyond deploying light effectively and rendering materials and objects convincingly, Mondrian imbues the overall assemblage with rhythm. Composing with curves and straight lines and working colors against one another, he animates all that is allegedly "still." That movement—and the assurance that is apparent in his handling of difficult surfaces—gives the canvas the energy and robustness that would become Mondrian's hallmarks.

It is a virtuoso performance. Reality and truthfulness underlie every detail. The pot and barrel sit on a hard and substantial stone ledge of which we readily apprehend the texture and density. As the young Mondrian's canvas is a depiction of objects, both natural and man-made, it also testifies to the power of light. That weightless wonder provides information about each element of the canvas, facilitating vision and possessed of a spiritual force.

Mondrian may merely have been doing the expected exercise of a first-year student, but he had a rare will toward concision. Over the next few years he would focus on the ordinary subjects favored by many Hague School painters and exhibited by the art societies that proliferated all over the Neth-

erlands, but he would render laundry hanging in courtyards, farm buildings, sheds alongside a river, apples and ginger pots on a tablecloth, and the other usual themes with exceptional flair. His paintings are both more animated and more compact than those of his confreres; he has concentrated his prodigious energy to give everyday sights their verity.

Approaching the age of twenty-one, Mondrian lived mostly in solitude. He and the Wormser brothers went their different ways. They ran their bookshop, while he went off to the Academy, where he spent long days. There are no traces of friendships with his fellow students.

Little more is known about the young artist's life away from the easel, but he seems to have denied himself the range of pleasures available in the metropolis. He stuck to the priorities he had developed in Winterswijk and would maintain lifelong. Possibly he focused on painting in order to avoid something that made him uncomfortable. Or he made sacrifices because he deemed them essential for him to excel in his work. Regardless, his art mattered more than anything else.

IV

The school Pieter Mondriaan headed in Winterswijk was soon to have its twenty-fifth anniversary. To celebrate the event, Mondrian's father decided to design an enormous canvas that his son would come home from Amsterdam to paint. Pieter Mondriaan devised the overall scheme for a Christian allegory titled *Thy Word Is Truth*. He drew it in outline on a semicircular canvas that measured 150 by 250 centimeters (roughly five feet by eight feet). It would be Piet's task to apply color and use his new skills at shading and tonality to bring the complex scenario to life.

Along the circular top, "Thy Word Is Truth" (in Dutch) is written in Gothic lettering that appears like glowing flames in a tale of sorcery. Pieter Mondriaan was determined to reinforce the belief that all wisdom comes from God Himself, and everything that matters has been declared by Him to the world through Jesus Christ as His spokesman. The imagery below illustrates this message triumphantly. Pieter Mondriaan had originally written a longer text in smaller lettering underneath the essential message of the painting. "I am persuaded that neither life, nor things present nor things to come" is still partially visible, and entirely legible with the modern technology of ultraviolet light. Whether he or Piet was the one who opted for the shorter, four-word statement, they probably assumed that the people looking at the canvas would understand the reference to verses 38–39 from Romans 8: "For I am persuaded that neither death, nor life, nor angels, nor

principalities, nor powers, nor things present, nor height, nor depth, nor any other creature, shall be able to separate us from the love of God, which is in Christ Jesus our Lord."

The composition illustrates its message indubitably. Faith in God through Jesus is superior to all other forces in human existence. In the middle of the canvas, there is a Bible that is open to Paul's epistle to the Romans 5:1. It reads: "Therefore being justified by faith, we have peace with God through our Lord Jesus Christ: by whom also we have access by faith into this grace wherein we stand, and rejoice in hope of the glory of God."

The open Bible sits on a plain wooden cross. Or at least it is meant to; the combination of Mondriaan father and son had not mastered spatial depth. In effect, the Bible floats in front of the object on which it allegedly rests. Scattered around the weightless book and mid-positioned cross, also unaffected by gravity, are a scythe, to represent death; an elaborate hourglass, to suggest the passage of time; an anchor, to embody hope; and palm branches, to symbolize victory. The emblem of sincerity, a white dove, is perched on the palm frond; if it, too, appears as if it might fly off, at least here that ability to defy gravity is appropriate.

A red curtain is drawn back with a theatrical flourish behind part of this conglomeration of objects. The rest of the background is the sky, blue on the top, with orange clouds below. Possibly they indicate a sunrise. But perhaps we are supposed to be looking at an enormous conflagration. Maybe these are the fires of hell.

After all, this painting was made to teach a lesson. A swallow, flying in from the upper right, symbolizes restless wandering, the uncertain search that will be fulfilled only with faith. Most of the people looking at *Thy Word Is Truth* were sufficiently well versed in biblical iconography to know that.

The young artist who was painting these images and texts ordained by his father got the message clearly. It would not do to go through life without direction. The only route worth taking in life was to spread the gospel of God's almighty power.

The minutes of the school board meeting held on January 31, 1894, include the statement that "Mr. Mondriaan explained his son's painting and recited a poem." Identifying the symbols, Pieter Mondriaan elucidated what he declared the great achievement of twenty-two-year-old Piet as a result of his professional training. Mondrian had worked hard on the father-son collaboration during his visits to Winterswijk. His willingness to join his father in expressing the idea of faith as salvation was more than an effort to please. Like so much else, it was at odds with the subsequent myth of their underlying conflict. Mondrian shared his father's determination for humankind to achieve spiritual grace.

The precise faith Mondrian would eventually endorse would not depend on Jesus as its spokesman. He would find his own voice. But the son held his father's complete conviction that there is a truth higher than the small issues of everyday life.

V

Following the summer when Mondrian returned home to paint *Thy Word Is Truth*, the stipend that paid his tuition was not renewed. He continued his studies by taking drawing classes in the evenings and doing his best to eke out a living during the days.

He needed to pay a fee of forty guilders to remain at school part-time, and set out to do whatever was required to garner an income. Knowing that the most lucrative form of painting was portraiture, he quickly landed some commissions to do paintings of fellow members of the Reformed Churches in the Netherlands. The images needed to be meticulous; when his clients were unavailable to pose for him, he used photographs to make the likeness as true as possible.

Mondrian's first portrait of a human being—he had, after all, done a puppy—was of Dorothy Gretchen Biersteker, a girl just shy of three years old. Adriaan Biersteker, the girl's father, commissioned it. Besides being a fellow sect member, Biersteker was Mondrian's dentist. We don't know whether Mondrian was paid in cash or did the portrait in exchange for dental work, but he accomplished his task with aplomb. The little girl's skin is soft, her eyes crystalline. The textures and density of the materials of her clothing are subtly differentiated. The child's dress has the sheen of silk; her ribbed stockings are palpably woolly. Both are white, their hues similar, but on the frock the white is cool and reflective, while on the stockings it is warm and refractive. The girl's shiny slip-on shoes, her glistening bobbed hair—freshly washed and brushed—and the Persian rug draped over the table on which she has placed a pudgy little hand, all read authentically. The impeccable rendering evokes the bourgeois comfort and respectability fundamental to domestic life in late nineteenth-century Amsterdam. Mondrian has captured the style of the new urban class, in all its materiality, with a novelist's detail as well as a highly developed skill at handling paint.

Removed from the drudgery of completing the overloaded religious allegory he had made in partnership with his father, Mondrian enjoyed the freedom to indulge his fondness for brightness and fine things. The little girl and her family's visible affluence brought a new sense of simple delight to his work. It was a far cry from the fire and brimstone demonstration of God's power he had painted according to Pieter Mondriaan's dictates.

Mondrian also started to paint tiles, which he sold to embellish the houses of the cosmopolites who were his new client base. Their smooth porcelain surfaces enhanced the lightness and grace of the lovely Dutch scenes he created on them. Traditional in style, they provide a sense of well-being. This was the opposite of the intimidation induced by *Thy Word Is Truth*.

Then Mondrian got his most significant commission to date. It was for Höveker and Son, the publishing company housed right below the apartment where he lived. He was given the task of illustrating Christian reading material being published for distribution in South Africa. It would be a full-time job for months to come, and meant that he could move out of the digs he shared with the Wormser brothers and the family's staff.

On April 9, 1895, when the academic year was nearly over and the drawing classes soon to end, Mondrian, for the first time in his life, started to live alone. He would do so for the rest of his life. He rented an attic for himself at Ruysdaelkade 75. He knew the building because his brother Willem had briefly lived in it the previous October after returning to the Netherlands following a stay in Suriname, on the north coast of South America. On another of Amsterdam's streets named for a great Dutch artist, it was behind the Rijksmuseum in a recently constructed, middle-class neighborhood. Although Willem had moved to Utrecht at the end of 1894, Mondrian had liked the place in the three months his brother lived there, and was content to find available space in its well-lit attic.

Once on his own, Mondrian began to meet new people who were less hidebound than the Reformed Churches in the Netherlands crowd. He befriended Catholics, Anarchists, Theosophists, and others outside the Protestant milieu. To be closer to these new cohorts, he moved from Ruysdaelkade to the Eerste Oosterparkstraat. While working on book illustrations that pulsed with Calvinist fury, Mondrian was starting to discover other approaches to how to live. He was meeting people who did not think that human pleasures, or private passions, were sins.

The images Mondrian had been commissioned to make were for *Christ's Heirs, History of the Persecution of the Christian Church*, by Pieter Daniël Rossouw, 1845–1896. A pastor in the Dutch Reformed Church of South Africa, he wrote the book to spread the gospel there. In Mondrian's twenty-eight illustrations for it, he demonstrated not just his great skill as a draftsman but also an astonishing imagination for human tortures. Mondrian invented and articulated a fantastic array of physical punishments inflicted upon their hapless victims with steely control and fiendish delight.

These gruesome pictures, which would be published as full-page plates in a handsomely bound volume that came out two years later, have been essentially overlooked, or edited out, in writing on Mondrian and in exhi-

bitions of his work. Yet the drawings of religious persecution are far more original than that large, heavy-handed mural Mondrian painted for the anniversary of his father's school, which is reproduced in numerous publications. This provocative early work reveals an astounding side of Mondrian.

The forms of persecution Mondrian showed in his twenty-nine lithographs were utterly sadistic. Whether in his early tame paintings of farm cottages and woodland scenes, his euphoric sunrises and pictures of lighthouses and windmills and church steeples in vibrant colors, or the pure abstractions that are the work with which he is most completely identified, Piet Mondrian's art generally evokes an easy frame of mind. His drawings that took Rossouw's descriptions and elaborated them with gruesome details of his own invention are so seemingly at odds with what appears to be Mondrian's mentality that most people simply avoid them. The canvas for his father depicted God's power, but not in the form of full-fledged physical torture. On the surface, the illustrations for *Christ's Heirs* are too inconsistent with everything else, which is why they get relegated to a minor position at best. If examined with the closeness they deserve, they throw us into troubling territory concerning the real Mondrian.

One astute observer has suggested the presence of "some sublimated gay erotic element" in these drawings, pointing out that "torture is a regular theme in pornography." Most of Mondrian's images are so excruciating that they are difficult to look at. One scene depicts a hooded man cutting out the tongue of a fellow tied to a post. A swashbuckling man in a helmet observes the excision attentively, brandishing a sword and savoring the moment while threatening to decapitate the victim. As in most of Mondrian's personalized narrative, you get not only the violent act but also confident and manly brutes delighting in it.

Part of their effectiveness comes from the style in which Mondrian renders these scenarios. Whereas the manner with which Pieter Mondriaan drew *his* biblical scenes imbued every detail of posture and facial expression with maximum drama, in a drawing technique that accentuated the emotionalism, his son takes the opposite approach. Mondrian's carefully regulated crosshatching, sure delineation of the subject matter, and subtle use of grays and whites, reminiscent of Rembrandt's etching technique, make the violent imagery especially chilling. They suggest that he can study and show torture without batting an eyelash.

One of Mondrian's illustrations, *The Strappado*, depicts a gallows-like structure from which a man, tied up as if in a bundle, is suspended while a young fellow in shorts pulls at a rope to hoist him in the air. Another scene is of a man being simultaneously strangled and burned. Death by fire is a preferred subject throughout the series, with hanging from the gallows tak-

ing a close second place. Mondrian presents all the tortures and killings with the matter-of-fact technique in which he had become so adept. In a scene of a man on the rack, one feels that what counts most of all is the way light falls on the victim's legs. Some officials—their robes and caps suggest that they are high court judges—view the gruesome pulling apart of a human being as if they are a theater audience watching a slightly boring drawing-room comedy, with one of them resting his weary head on his left hand. The eloquent artist seems to be a similarly impartial observer.

The restraint of Mondrian's artistic approach was patently the opposite of his father's hyperbolic style. It was effective by plan. Mondrian recognized that understatement is what gives satire its bite.

The control served another purpose beyond its impact on the viewer. The precisely weighted strokes and overriding sense of organization in these illustrations gave Mondrian his own stability. His careful, methodological approach and his will not to register a personal response enabled him, at age twenty-three, to maintain his equilibrium.

Mondrian's refined technique, and the consequent feeling of balance and order, would be fundamental to every phase of his future art. He would not allow himself to show emotional pain. Mondrian's restraint, and his overarching sense of measure and control, regulated whatever havoc lay within.

The Strappado from Christ's Heirs, 1894

VI

The illustrations for *Christ's Heirs* reveal the young artist's strength as a draftsman. In addition to that sadistically salacious book, he used his skill for more palatable subjects. In about 1896, Mondrian made a black crayon drawing, *Girl Writing*, which like *Woods with Stream* reveals him as a prodigy. In *Woods with Stream*, his vantage point is from within, as if he is under the canopy of the trees he is drawing; with *Girl Writing*, he has assumed the position of an observer at a physical distance from his subject. Regardless, Mondrian has the same consuming emotional engagement as in the drawing of the forest; there is a oneness between him and what is before his eyes. He *becomes* his subject.

This presentation of a farm girl bent over her schoolwork has the total connection between the artist and his art that would apply to everything Mondrian would do right through the Boogie Woogie paintings he made at the end of his life. The surprise is that from the start Mondrian eradicated the space most artists maintain between themselves and what they put on view. With Mondrian, there is no separation or distance. Other painters step back; Mondrian, with his vigorous crosshatching, again stylistically similar to Rembrandt's, is engaged as if he and the image are one and the same. The artwork is his haven, the place where he is allowed to be consumed with passion.

Even though Mondrian was just beginning to explore the process of making pictures, he maintained steely control while attaining an emotional pitch. The broad strokes which define the background, and the shorter dashes which establish the rough cotton of the girl's dress and sash as well as the folds of the tablecloth, are highly articulate. Mondrian's own vitality, concentration, and imagination assume physical form in this drawing. The intensity that predominates is of what we see, not of the person evoking it.

Mondrian, and the girl who is his subject, are fired up, but not frenzied. In about a decade, Mondrian would, for a while, paint as if in an altered state of mind, briefly producing work that is confused and confusing, as if he had lost his mastery of himself. But here, in this early drawing, he exercises restraint, and, while vehemently engaged, captures his subject impeccably. The abstract elements of the drawing—the flurry of lines that are more about the act of drawing than the process of representation—remain in balance, composed in precise relationship to one another to achieve overall pictorial harmony. That was Mondrian's intention, and whatever we may postulate about what he was setting aside concerning his inner self, his art takes us elsewhere.

Mondrian is already using, by instinct, white space and white accents, the

visual voids, to pump air into his art. The bare paper he leaves visible in this drawing of a schoolgirl evokes the omnipresent universe. It is oxygen and light, that dematerialized wonder which is essential to seeing. Its brightness seems to come from the sun that is the source of life. Even at this early stage of his artistic experimentation, Mondrian already had the perspective on earthly existence which would later underlie his more sophisticated abstract compositions, the vision whereby everything is revealed as taking place in the vast cosmos which is greater than any of us, and which is eternal while we are mortal. At age twenty-four, Mondrian was developing the scope and breadth that would lead him to his greatest work.

The interplay between the specific and the universal in a drawing he made at such a young age was presumably not the result of a conscious plan. It reveals, nonetheless, an intuitive tendency to make the background—in this case white paper, eventually white canvas—part of the foreground. This integration causes the setting of all life to assume greater importance than the details under observation.

The white in this breakthrough drawing is not just sunlight and air. What remains untouched by crayon on the sheet of paper is also like the radiance of the girl's thoughts as she closes her eyes to focus on what she is committing to paper. Additionally, that white serves an important technical purpose. It enables the artist to realize the modeling of form, to bring one of the girl's shoulders forward and wrap a kerchief round her head.

In his art of every period, Mondrian would use the void as a fundamental tool in the articulation of his visual subject and as the vessel in which he would locate forms in three-dimensional space. This would be even more the case when that subject was an entirely abstract configuration of horizontal and vertical straight black lines and rectangles of pure unmodulated color. The whiteness has the weightless flow of a reverie. It always breathes the spark of life into the inert object that an artwork actually is.

In order to survive, Mondrian made saleable copies at the Rijksmuseum and continued to give private art lessons and undertake portrait commissions. He also periodically sold a landscape painting. He managed this without the machinations of his competitors for the same sort of work. The other young painters—they were almost all men—providing art for the prosperous bourgeoisie who wanted it to decorate their homes, tended to be social gadflies. Mondrian was more reserved and less outgoing, but he still made a favorable impression as someone who was competent and trustworthy. Tall, broadshouldered, and trim, the young Calvinist exuded correctness. He was strikingly handsome. He stood erect, with the bearing and the well-organized appearance of a military officer. More pensive than gregarious, he captivated people with his deep enthusiasm for painting and quiet thoughtfulness as

well as his appearance. While his three brothers were all fair-haired like their mother, Piet had a shock of his father's smooth black hair, which he wore neatly trimmed with an impeccably straight part in the middle. There was never a lock out of place, which gave him a certain bravado. Unusual for the time period, he was clean-shaven. Image mattered a lot to him. It required good clothing for him to give the impression of a gentleman, and he always managed to scrape together the money to buy it. Perfection was essential in every domain of existence.

VII

A new model of bicycle had been developed in the 1880s. Unlike the old velocipede, it had two wheels of the same size and a chain that synchronized them. An efficient, inexpensive, enjoyable means of getting around, it promised to transform the way people lived. When the first automobile appeared in 1886, it was also a breakthrough—it went nearly sixteen miles per hour—but it was only for very rich people. The sole other form of transport in the city were horse trams; electric trams would not come into use until 1900.

Living in central Amsterdam in the lively neighborhood of Leidseplein, Mondrian wanted to make regular outings to the rural outskirts of the city

Mondrian bought a bicycle so he could take outings from Amsterdam into the countryside. His friend Simon Maris did these drawings of him in 1906.

where he could find subject matter closer to what he knew from Winterswijk and made the momentous decision that a bicycle was the answer. He found an old used one and bought it. He had never before spent that much money on anything, and the expense, even though he kept it as low as possible, was daunting. Mondrian used his new two-wheeled transport for daily excursions southeast, along the Amstel River, to the Gein, a quiet, narrow river that ran between the village of Abcoude and the small city of Weesp. It was a trek—bikes were still fairly primitive and hard to pedal—but he was content to hang his art supplies from the handlebars and head off to a bucolic setting.

There he painted a number of small canvases of the scenery alongside the river with its tall trees, occasional farmhouse, and mills. Enchanted by color and light, competent with brush and paint, and gifted at composition, he endowed these scenes with a quiet poetry. But Mondrian had not yet developed an original vision or found his inner flame, and the paintings he produced one after another lack bravura. They have their charm, though, for the young artist already had the instinct to celebrate the earth's bounty and to make the evocation of visible beauty his exclusive goal. Painting mundane subjects like irrigation ditches, Mondrian evoked the glory of sunlight in puddles of water. He feasted on the lush darkness along the banks of modest trenches, the growth of even the most humdrum species of trees, and the sky at any location whatsoever, and he rendered these everyday sights as splendors. Working and reworking the same themes, he strived to present the essence of everything he saw and organize it in compositions with a life of their own. He encapsulated the truth of each subject and, with a delicate touch, arranged the whole in small canvases where the individual elements interacted in a graceful dance.

Painting modest vignettes in the industrial neighborhoods he chose as his subjects on the rural outskirts of Amsterdam, Mondrian was focused on the timeless, universal forces that would be his lifelong obsession.

VIII

He was producing a lot of paintings but not selling them. He needed money, and he was restless. Having tried but failed to get to England the previous year, at the start of May 1898, he applied for a Prix de Rome. The award, funded by the Dutch government, gave its recipients four years of study abroad.

The admissions process was grueling. It began with a ten-hour-long exam in art history, for which Mondrian received a "satisfactory"; he was considered sufficiently well versed in architecture, painting, sculpture, and

perspective to qualify. The next step in the process was to do a figure draw-
ing of a naked male model. The results were disastrous.

The jurors rated Mondrian's knowledge of human anatomy as grossly
insufficient. On May 27, he received his official rejection letter. After all
the training with Braet von Überfeldt and at the Rijksakademie, Mondrian
simply could not sketch a nude man adequately. Given his training and com-
petence, it seems that the subject matter made him too uncomfortable.

The shaken twenty-seven-year-old had seen the Prix de Rome as his sal-
vation, a rescue from the financial nightmare where he saw no way to keep
supporting himself. He was too prudent to get into debt, but he was com-
pletely out of funds when the rejection came.

Frittering on every level, he had no personal life of consequence. Noth-
ing was constant or clear except for his wish to paint. He retreated to the
one place where he was sure he was welcome. Ready for the benefits of a
summer in Winterswijk and for the creature comforts of a household run
by his mother, he headed home, but he still had to make art that would sell.
His only option was to return to Amsterdam for short stints to do copies of
seventeenth-century paintings at the Rijksmuseum.

For each picture, Mondrian needed to make a formal request and receive
written permission. The documents remain. They tell us that in July and
August, he worked on a copy of *The Spinning Woman* by Nicolaes Maes, and
at the end of August he was accorded the rights to set up his easel in front of
The Parrot Cage by Jan Steen, which he painstakingly copied over the next
couple of months. While periodically escaping Amsterdam's summer heat
and painting outside in the country air of Winterswijk, he worked on his
slavish renditions of the masters to make himself solvent. Once he returned
to Amsterdam to stay, he completed the Steen copy. Years later, he would
write an essay praising Steen for "going beyond 'depiction' to 'determina-
tion.'" It was one of the rare occasions when Mondrian would comment
on the work of a dead artist. As a vision of Steen, whose playful scenes of
debauchery as well as family life revealed such different impressions from
his own, Mondrian's response is enticing. He gleaned in Steen the drive and
willpower to do one's very best. Making those facsimiles out of necessity,
Mondrian had already defined himself as someone who would take his paint-
ing just as far as he could.

Once he earned what he needed to live independently, he mainly wanted
to paint country scenes, and not just from memory. He began to make regu-
lar outings to Het Gooi, a pretty agricultural area not far from the city, at
the southern edge of the large inland sea that was then called Zuiderzee and
became IJsselmeer after it was closed by a dike in 1932.

The region had long been popular with painters and writers. To get there,

Mondrian would take a steam-powered tram from Weesperplein station to the town of Laren. Then he would wander on foot, or, on the days when he had carried his bicycle on the train, travel farther afield. He was captivated especially by a compound of farm buildings where the rooflines met in an intriguing way, and pedaled there frequently.

The sights of Het Gooi inspired him. The hefty cows and ancient trees of its farms, the bridges that crossed the canals and the barges that floated down them, and the windmills providing energy to the region made excellent subject matter. But in the residential part of Amsterdam called the Schinkelbuurt, Mondrian responded equally to themes that to a less appreciative viewer would have had no allure; he did not require the picturesque. Rather, he valued everything his eye took in. With animated brushwork and a light touch, Mondrian made humdrum sights like shipyards and irrigation ditches luminous and engaging. The Royal Wax Candle factory, a bleak industrial structure, became lyrical through his appreciative eyes and skillful hand. Mondrian recognized the miracle of daylight hitting every sort of surface. Reflections in water captivated him, and he made their magic come alive. The sky was his elixir. He put exactly the right weight and brightness into it to evoke its splendor.

He had a knack for construction. In his paintings of this period, Mondrian used color both to establish position and to embolden the strong forms he carefully worked against one another. His art was original and more authoritative than that of his confreres. Mondrian's canvases resembled a lot of what other people were doing in this culture where painting was both a respected profession and a proven source of commerce, but his style distinguished itself. Superficially, it belonged to the mainstream in its execution, but it exulted in the industriousness of human endeavor. Above all, Mondrian's art both captured, and created, light. The light that animates these small paintings of ordinary life was, as light itself is, magnificent; it also brought the know-how intrinsic to barges, windmills, smokestacks, and the flotsam of daily life into sharp focus. These everyday sights on the outskirts of Amsterdam, as rendered by Mondrian, are to earthly existence as blood is to human life. They embody a mystery that is everywhere.

IX

Not everything Mondrian did in these first years on his own in Amsterdam has the same force. He made several portraits of young girls that are sentimental to the point of being saccharine. They shilly-shally; when Mondrian was forced to take obligatory portrait commissions of Calvinist bourgeoisie,

the results seemed inauthentic. And his nudes, men and women alike, are listless and tepid. Yet on the rare occasions when he drew people he knew in the act of performing music, Mondrian summoned his inner force. The work and its subjects come to life. When inspired, Mondrian rose easily above the ranks of journeyman painters and let loose with the vigor and engagement he had when he did not have to make money—or when some unknown source of discomfort saddled him.

Then, in October 1898, his dentist, Adriaan Biersteker—father of the little girl who had been the subject of his first portrait—had an idea. Dr. Biersteker knew the Consistory of the English Reformed Church, in the Begijnhof of Amsterdam, in the city center. He proposed that they have Mondrian design, for the pulpit, wood panels in honor of the newly crowned queen. On September 6, 1898, Wilhelmina, having turned eighteen a week before, had ascended to her royal position in one of the most lavish coronations of all time. The Dutch people regarded royalty as a direct link to their Christian God, and it was vital to glorify the new queen wherever people worshipped.

The dentist's idea was welcomed enthusiastically. It became Mondrian's lifeline.

The church building dated to the end of the fourteenth century. Since 1607, it had served congregants from the Church of Scotland and the Nederlandse Hervormde Kerk, both bastions of Calvinist thinking. Some of the English Protestants who worshipped there would go to America in 1620 and be known as "the Pilgrims."

The culture of their large church in the Begijnhof was anchored in authority and power. The scenes Mondrian drew to be carved on the sides of its altar furthered that mission by representing the relationship of Dutch Calvinism to the House of Orange. The sculptor who executed them in oak was Lambertus F. Edema van der Tuuk, and although neither the preliminary sketches nor the final drawings have survived, the shallow wooden reliefs still grace the altar today.

Mondrian performed his assigned task with the necessary diligence, but also managed to put his own slant on matters of church and state. In the first panel, a rigid female figure represents the Netherlands. In her left hand, she holds a sword—the quintessential vehicle of military might. With her right hand, she shakes the right hand of a second woman, equally erect and stiff. This awkward character represents the church, which is symbolized by the Bible she holds in her left hand. The personification of the state shows her own hair, elaborately coiffed, while the stand-in for the church wears a head scarf that falls in pleats to the hem of the dress.

The contrast, and the intersection of opposites, are pure Mondrian. The

mundane hairdo makes the state almost ridiculous in its vanity; its brandishing of the sword denotes the confidence with which it controls. It is a mocking portrayal of those who rule with might. By contrast, the church's rejection of the flesh is announced in the concealment of all that is natural under layers of drapery, and its yearning for spiritual knowledge rather than for absolute power is manifest with the book. At age twenty-six, Mondrian was constantly weighing those differences. All around him, he saw the world of materialism and the glorification of the self. The milieu of religious fervor and personal denial in which he had been raised called for casting them aside. The financial well-being of his paternal grandparents and uncles came from wig-making and hairdressing, and while Pieter Mondriaan was their son and brother, the schoolmaster had eschewed such luxuries in his own life and that of his family. In spite of the large house in Winterswijk, Mondrian's father lived austerely and sought only to serve God and his demands. In his soul, Mondrian had not left the nest. Depicting Church and State, he patently confers greater worth on the purists than the pleasure-seekers.

The spiritual quest would dominate his life. Materialism would never attract him—the sole exception being that penchant for respectable clothes in limited quantity. He would not resist vanity, though. All his life, Mondrian would perpetually restyle his hair and his beard, mustache, or lack thereof. The main distinction, though, between the priorities Mondrian illustrated on that church pulpit and his own eventual preferences is that his form of the spiritual would be utterly joyous. The Calvinist concept of "goodness" had no more allure for him than did materialism. The ambassador of Christianity in young Mondrian's portrait of her looks grim and parochial; he would ultimately embrace and transmit a more universal, happier religiosity. Still, his preference for a certain dematerialized lightness was already clear.

On another panel, Mondrian showed an angel with enormous wings. Standing behind an ornate shield decorated with the Netherlands coat of arms, he clasps his hands in a position of prayer. The royal crest is replete with a very fancy crown, held by two lions. With their other front paws, the lions proudly display flags. One flag bears the queen's birth year—1880— the other, her year of coronation, 1898. You could not be more anchored to precise moments in time, the trappings of royalty, and the domination of the individual than this.

Mondrian would devote most of his life to showing, and desiring, the opposite. Theosophy and abstraction would be vehicles for achieving a sense of equality among all people, for values that are universal, and for timelessness. But at age twenty-six, making the drawings that enabled him to pay his bills, he was slavishly faithful to the tenets of his father's Neo-Calvinism.

Giving the wood-carver his task, in what look like scenes in an amateur religious pageant, Mondrian did what was expected of him.

Yet, as with his figure of Religion in the previous panel, he was already leaning toward the spiritual uplift of his most sophisticated abstract paintings. One of the oak panels Mondrian designed for the pulpit of the cavernous English church has a sun rising in the background. It represents the capacity of brilliance to render what is irrelevant invisible.

That luminous sun evokes an infinite and universal beauty. The elevation to a purer state, the chosen subservience of the mundane sides of existence to something more lasting and absolute, already existed in Piet Mondrian's mind. Only the form and intensity would change.

X

Mondrian started to give drawing lessons to several Amsterdam ladies. His new students could afford his tutelage and were bent on improving themselves through art and books and religion. Among them were Catharina and Elisabeth Hogerzeil, Eva Emmelina Seelig, and Hannah Crabb.

Mrs. Crabb was English. While Mondrian dutifully taught her to draw, she gave him lessons in her native language. As thanks, he made a bookplate. Mondrian etched it in the same illustrative style as his pulpit designs. A triumphant hard-shelled crab, risen on its many legs, honors his student's name. But there is something else here: for the first time in Mondrian's work, the symbols of Theosophy are present. They surround the crab. These representations of another domain of the soul are a startling contrast to the sinister crustacean.

Mondrian had encountered his new students at meetings of the Theosophical Society. He had become intrigued with this spiritual movement that had recently started to attract a small but intense group of devotees in the less conventional circles of Amsterdam society. The gatherings brought together believers in the faith that was growing in influence at the end of the nineteenth century. Mondrian had collaborated closely with Lambertus van der Tuuk when Van der Tuuk carved the church pulpit according to Mondrian's drawings, and by the end of 1898 Van der Tuuk had introduced Mondrian to the new form of religion. Mondrian had already drawn an emerging sun with spreading rays for the pulpit in the English Reformed Church. A rising sun, as well as stars, and a lotus blossom—all squeezed into the small bookplate for Mrs. Crabb—were essential symbols of Theosophy.

Theosophy had been codified in 1875 under the leadership of Helena Blavatsky. This intrepid Russian woman had traveled all over her native

country—and then worldwide—to study and preach her ideas of universal spiritualism before founding the Theosophical Society in New York. Now gaining traction in the Netherlands, the Theosophical Society brandished the slogan "There is no Religion higher than Truth."

It was a far cry from the *Thy Word Is Truth* Mondrian had painted in Winterswijk according to his father's design. But rather than making the teachings of Jesus Christ the source of all that mattered in life, Theosophy regarded truth itself as the basis of the peak of earthly existence. That non-sectarian, universal standard was associated with no single individual, place, or religious movement.

Madame Blavatsky defined Theosophy as "the archaic wisdom-religion, the esoteric doctrine once known in every ancient country having claims to civilization." In 1888, she had published a book she titled *The Secret Doctrine*. In it, she declared the principal goal of the Theosophical Society as being "to form a nucleus of the Universal Brotherhood of Humanity, without distinction of race, creed, sex, caste, or color."

The founder of Theosophy had died in 1891 in London, but she remained the guiding light and exemplar of her faith. Madame Blavatsky had lived as she preached. From a wealthy family, she had enjoyed great material luxury at an early age. She had moved from Odessa to Bucharest to Paris, always living in splendid accommodations and being wined and dined by her family's rich friends. Then, when she was about to embark on a ship to New York in her usual luxurious circumstances, she saw on the deck a poor woman who could not pay the fare for herself and her two children. Madame Blavatsky

Helena Blavatsky. The founder of Theosophy and author of *The Secret Doctrine*, Blavatsky was a celebrant of universal beauty and a foe of materialism. Mondrian hung this photograph of her on his studio wall; she was the only person other than Josephine Baker accorded that honor.

swapped her first-class ticket for four third-class tickets and made the two-week trip in steerage.

Mondrian readily took to the idea that one's beliefs matter more than personal comfort. Initially, he was only dipping into Theosophy, but Madame Blavatsky's faith and practices confirmed the new direction his life was already taking. The rules and regulations of Calvinism held no such sway for him. Pieter Mondriaan's faith focused on self-denial; Theosophy celebrated universal beauty. Mondrian was attracted to its positive energy, and its embrace of life's bounty, the opposite of the notion of noble suffering with which he had been raised, its apogee represented in *Christ's Heirs.*

Theosophy, however, shared with Orthodox Protestantism its reproach of materialism. If one had simply what it took to survive while enjoying a higher purpose, life could be inestimably rich. To feel that way in a world where what the poet Wordsworth called "getting and spending" dominated most people's existence was no small thing.

XI

In these years where he moved from place to place in Amsterdam, Mondrian returned to Winterswijk more frequently than simply in the heat of summer. Whether he actually enjoyed spending time with his mother or father, whether there was someone else in the town who beckoned him back, he undertook the long and complicated journey surprisingly often. Staying in the family home for substantial spells of time, he made further drawings of St. Jacob's Church, did paintings of the weavers' house on the Zonnebrink, and began to focus on the area of town called the Lappenbrink. The word, which means "field of cloth," demarcated the neighborhood where textiles were bleached by the sun. It was only a few minutes' walk from the family house, and the making and coloring of materials enthralled him.

Mondrian recomposed the world around him in an unprecedented way. Transforming actual scenes into pictures where something very different was going on, he made a stride forward in his concept of what art could be. Again it focused on human drama, but in a very different way from *Christ's Heirs* or the pulpit carvings. One of these paintings, *On the Lappenbrink*, is a large gouache of a farm girl. Mondrian's family must have thought that he had taken leave of his senses.

The odd young woman of whom it is a portrait has an enormous head, and no neck; her face sits on top of her chest. Her lips and eyes are not representations so much as signs for those features, drawn as a child might have rendered them. Her contorted mouth, higher on the right side than on the left, has the roughness of a jack-o'-lantern carving. Whether ecstatic,

deranged, or both, she resembles the inmate of a madhouse. Carrying a straw basket with eggs in it, she charges forward at an awkward gait, her shoulders hunched. Mondrian captures her at the last possible moment before she will have pushed past the spot which he makes his vantage point. The sense that she might knock into the viewer discomfits us.

A shimmering light on the tile roofs near the foreground adds to the woman's otherworldly, out-of-body aura. And, on a roof farther back, the blast of the sunlight is so strong that it obliterates the distinctions between the tiles. We are in a spectral state. The dramatic foreshortening of the street and the choppiness of the brushstrokes intensify the frightening feeling of a world out of control. The woman is painted either as if she is insane or as if something very strange was taking place in Mondrian's life.

His new awkwardness also became evident in unsettling renderings of farmyards and riverscapes, subject matter he had previously approached in the traditional Hague School style but now painted as blockier and bolder. In *Wood with Beech Trees*, c. 1899, a watercolor and gouache, the forest floor zooms into the background at vertiginous speed, and the trees are gargantuan. The earth reaches a pointed peak at the top of the painting. No matter how long we study this painting, it remains unclear if that triangle of soil on which dead leaves are strewn is a hill rising upward or a flat expanse that juts into a lake along a shoreline that appears to have been cut with oversized shears. A stand of bare tree trunks that we see close-up marches toward the

On the Lappenbrink, 1899,
Kunstmuseum Den Haag

ambiguous triangle like a group of gigantic soldiers of which we see only the boot-covered calves.

Something in Mondrian was out of control. That same year, he made another painting that is impossible to fathom fully. In *Two Girls in a Wood*, set in the same wooded area in front of the identical triangular horizon as *Wood with Beech Trees*, the girls are even more mysterious than the setting. They are nothing but flesh-colored brushwork with dashes of dark paint to constitute their mouths, noses, and eyes.

The haunting nature of this trio of very odd paintings—*On the Lappenbrink*, *Wood with Beech Trees*, and *Two Girls in a Wood*—has to do with Mondrian's internal issues and the other art he had recently seen. In both canvases of forest scenes, Mondrian has moved the horizon lines to make the setting hallucinatory; his own, inner horizon had become unstable. The simplified, cartoonish features of the young women reflect a regression to the security of childishness. Additionally, Mondrian may well have seen Edvard Munch's recent work in reproduction, with its similarly deranged characters. Whatever its source, this otherness, this transport into a vague ecstasy, distinguished Mondrian now more than ever.

XII

When he returned to Amsterdam after doing those puzzling paintings in Winterswijk, Mondrian switched worlds. He got himself full-time work decorating the entire large dining room ceiling of the fancy townhouse of a rich doctor, Abraham van de Velde. Van de Velde lived at 608 Keizersgracht, one of the city's most fashionable streets. Mondrian could hardly have moved further from the small canvases of crazed young women in the dazzling sunlight. The artist whose strange subjects had been in an incomprehensible trance now became a slavish craftsman executing a commission to show mythological figures with classical decoration. He presented them strictly according to the rule book.

The expanse for which Mondrian painted a canvas that was then inserted was an octagon that measured, at its widest and longest, 430 by 510 centimeters—nearly fourteen by seventeen feet. It was meant to entertain everyone who entered the luxurious house, and, above all, to wow people when they looked up from the table during fancy lunches and dinners. Mondrian's scenario was framed by elaborate molding, with an ornately paneled ceiling around it; a gold chain descended from its center point to hold a chandelier. The scheme the twenty-seven-year-old artist composed featured winged putti, garlands of fruit and flowers, and sheaves of grain, the coup de

grace being a cherub who was a portrait of the client's three-year-old son. To succeed at his assigned task, Mondrian painted in a style in which his own taste and instincts are absent. The putti with their oversized wings are in a puff of pink-tinged cumulus clouds. The intertwined chains of flowers arc excessively elaborate, as if the sheer quantity of blossoms increases their worth. The cherubs—wide-eyed, full-lipped, pug-nosed, and pouting—cloy. Looking at their pudgy arms and golden curls and feathery white wings, we ask: Mondrian? Is this possible?

The work, in fact, is signed and dated. And it can still be seen in the reception room overlooking the garden of this fine house. Here one understands the lifestyle of well-heeled Amsterdam residents in a period of new prosperity at a time when Mondrian was dependent on clients like the Van de Veldes. The ceiling has been restored, but one can envision Mondrian as he was in 1899, diligently forming one flower after another. He had managed to study the face of three-year-old Hendrik, too young and restless to sit still, quickly and astutely, succeeding in making the child recognizable as a cherub. This particular cherub has no wings—an important detail, for it signifies that he is alive and of this earth; when a cherub has wings, he is enjoying the afterlife.

Hendrik's head, which stares down at us, is positioned next to the center disk from which the chandelier is suspended. About the same size as the disk, the little boy looks like a soap advertisement. He embodies cleanliness and innocence as he rules this allegory of the four seasons. Spring is represented by flowers, summer by apples and grapes suspended from a garland, fall by a sheaf of wheat alongside a rake, and winter by some figures who are asleep and others who hold warm, insulating draperies; the child's purity reigns supreme over all of it.

The radiant Hendrik is the ceiling's focal point. The boy as cherub provides a spiritual aspect which is consistent with the rest of Mondrian's art. Like the woodland views, the paintings of dunes, and his purest abstractions, this portrait is true to his lifelong obsession. Even while making what appears to be a Baroque confection more than an artwork of its own time, Mondrian was driven by his passion for a state of being devoid of conflict and difficulty. Three-year-old Hendrik flourishes in that trouble-free sphere which was Mondrian's ideal mental world.

Unlike his father's concept of paradise, the territory Mondrian sought as an alternative to normal earthly existence did not depend on a notion of God in the Christian sense. Rather, it was like Mozart's chamber music or the sky: some glorious realm undisturbed by emotional pain or material desires. For all the iconographical complexity and traditional figuration, the ceiling in the center of Amsterdam offers the same idyllic state of being as the com-

positions Mondrian would make at the end of his life. The luminous white background that serves as the setting for rhythmic action in the dining room on Keizersgracht has that glorious otherness that makes Mondrian's mature work so uplifting. If one could hang *Broadway Boogie Woogie*, a late work in which vibrant small squares play against the white, in the Van de Veldes' dining room, the parallels with the ceiling would be evident.

XIII

The church bells that rang at midnight on December 31, 1899, announced the start of a new century. The timing was propitious; Mondrian was finding a more comfortable voice.

The twenty-seven-year-old artist was gaining the discipline to express his originality more cogently. He first succeeded with paintings of chrysanthemums. Previously, his flower paintings had been traditional bouquets in vases on highly varnished tables against backdrops of ornate draperies. Perfectly suitable to posh Amsterdam interiors, they mimicked the general manner of many other artists. Now Mondrian began to simplify the subject. The change was radical. He isolated the flowers by eliminating the setting.

Initially, Mondrian presented three blossoms and their long stems. Then he further reduced the elements to single buds emerging from plain glass tubes. Some times he cut off these compositions of individual or small numbers of flowers in unusual ways, zooming in on his chosen details. They could have been anywhere; they were timeless and belonged to the entire universe. The solitary flowers enabled him to enter his preferred realm: a haven of serenity and transformative visual beauty. They were a stepping stone to the solid rectangles of his later work. Mondrian was composing with new authority. Chrysanthemums, with their extraordinary forms, captivated him, and he invested each flower with a visual dynamism. Like underwater plants, more dramatic than pretty, they are mysterious and surprising.

Some of the flowers Mondrian portrays are at their peak; others are on their way out. The ones with wilting leaves and petals appear inhabited by spirits from another world; they are macabre and ghostlike. These flowers that Mondrian painted in 1900 and 1901 are totally different from the way he or anyone else had presented flowers before. By abandoning ornate vases and golden wallpaper, putting behind him all that was old-fashioned and quaint, Mondrian had liberated himself. Once he was painting these solitary chrysanthemums, his art acquired a new emotional pitch. Each individual flower appears as a persona. Some of them pose proudly and flaunt their charms; others shyly retreat from us, as if embarrassed to be seen naked. The flowers suggest something other than themselves—they are anthropomor-

Chrysanthemum in a Tube Vase, c. 1899,
Kunstmuseum Den Haag

phic creatures, with personalities—and their force, rather than being worn on the surface, comes from within. One bud is almost savage, the spidery petals like tentacles of a sea creature: a haggard comedienne, trying against the odds to show her beauty. Another, in full bloom, celebrates living at its peak. The human qualities come through more effectively than when Mondrian painted actual people.

A new friend, Albert van den Briel, sometimes accompanied Mondrian to the flower vendor's. Van den Briel and Mondrian had met for the first time in September 1900. The nineteen-year-old, just out of secondary school and about to enter medical school, was fascinated by the very particular habits of the twenty-eight-year-old artist. Van den Briel was especially intrigued watching Mondrian select the buds he would paint.

Van den Briel would describe Mondrian often reducing the salesperson to a state of "despair" while studying the blossoms he was considering for purchase. The vendors' normal clients were people selecting gifts to cheer up the sick or men buying their girlfriends pretty bouquets. The beleaguered flower sellers could not fathom the goal of their silent customer who carefully examined the petal structure and color of each individual flower. Mondrian would investigate a single blossom like a scientist in a laboratory, calibrating the precise width of the petals and the size of the gaps between them. He also studied the shapes of the leaves with mental calculations beyond anyone else's grasp. Mondrian—as Van den Briel knew, even if the flower sellers did not—was imagining the future progress of the blossoms as they withered

and died. He was not sure at which stage he would paint them, but he was considering what lay ahead for the possibilities.

After what felt to the vendor like an interminable period of contemplation, Mondrian would then buy a single stem. On rare occasions, he would acquire as many as three. But never had the vendor seen a client devote so much time to such a small purchase.

XIV

Mondrian was coming out of his shell socially. Another one of his new friends was Simon Maris, an amiable young painter who knew lots of people. Maris, one year Mondrian's junior, was the son of Willem Maris, a venerated master of the Hague School. Simon was a society painter who made his living mostly by doing portraits of rich people and government officials; unlike Mondrian, Maris lived a full-blown cosmopolitan existence. He had the funds, and the inclination, to take advantage of the city's offerings. Dressed stylishly, he dined in good restaurants and socialized happily. He persuaded Mondrian to come along to the occasional plays or concert. It was at a performance of *Hedda Gabler* at the Stadsschouwburg, one of Amsterdam's splendid theaters, that Mondrian first encountered Van den Briel. During intermission, Maris tried to introduce Mondrian to other painters, as well as collectors and gallerists. Mondrian, as usual, kept himself on the sidelines, and met the younger Van den Briel inadvertently when, strangers to one another, they simply struck up a conversation. Mondrian preferred the medical student to anyone in Maris's circle.

Albert van den Briel had been born in 1881 in the small village of Stratum, near the city of Eindhoven, in the southern part of the Netherlands. He was the oldest of three children, their father a manufacturer of linens. When he was thirteen years old, his family moved to Amsterdam for his father to start a new business. At the time that he met Mondrian by chance in the theater, Van den Briel, while doing his medical studies in Utrecht, was still living at home with his parents at the Weesperzijde, a prosperous residential neighborhood on the east side of the Amstel River.

Part of Van den Briel's appeal was that, from the start, Mondrian knew that the medical student considered him extraordinary. Van den Briel had never before encountered anyone with such "inner strength and stability." He attributed Mondrian's force to what he termed the "unity of man-painter." Deeming the "oneness of man and artist exceptional," Van den Briel was captivated by the way that everything in Mondrian's personality guided his painting, just as his making of art determined how he lived.

The impressionable Van den Briel was also fascinated with Mondrian's growing involvement with social and political movements. By the turn of the century, the artist had become surprisingly leftist. Van den Briel was excited by Mondrian's compassion and activism, far from the interests of most of the other people in the clique of fashionable young painters that had formed around Maris. Having grown up in a staunchly royalist household, it was an unexpected development for Mondrian. He had faithfully adhered to the family's views right through Queen Wilhelmina's coronation in 1898, and his foray into the world of anarchists and other radicals was a dramatic departure.

While for the first time Mondrian was enjoying the company of his fellow artists in Simon Maris's circle, he had befriended a number of factory workers. Both in the neighborhood where he lived and on his outings to paint at places like the Royal Wax Factory, Mondrian joined in their struggle against management for more equitable treatment and worked toward social reform that would require changes in the approach of the factory owners.

Mondrian's political engagement would be short-lived. By the end of 1903, he would be determinedly apolitical, and he would never refer back to his left-wing days. His radicalism had a personal element from which he would ultimately be determined to separate himself.

XV

Although he managed to buy theater tickets and occasionally meet his new friends in cafés, in the first couple of years of the twentieth century, Mondrian was nearly broke. He gave art lessons to the daughters of the Calvinist pastor Hendricus Vredenrijk Hogerzeil in exchange for the meals he would have after teaching the girls how to paint, but on other nights he ate in a church soup kitchen where dinner was served free to people in need.

When he lined up with homeless people and held out his plate to have modest grub ladled out, it was not, however, because he was completely destitute. Mondrian was sometimes so absorbed in painting that he forgot to get groceries and simply wanted a meal without having to think about it.

And even when he ate in soup kitchens, he dressed well. Mondrian did not yet have his own tailor, as he would in Paris, but he kept up with the latest fashions. When he attended a performance of Ibsen or showed up to work on a commissioned portrait at the home of one of his prosperous Calvinist clients, he wore dark suits that fit correctly, the spread of his shirt collar (invariably white) in perfect harmony with the lapels of the jacket. After all, angles count. So does one's façade.

Mondrian's overriding objective, meanwhile, was to be in his studio alone. Aside from the time he had to devote each week to working on por-

traits and giving art lessons, he used all the remaining hours of daylight to paint the landscapes and flower studies that were his personal exploration. He was delighted to sell them, but that was an incidental reward.

This was one of the rare periods of his life when, after nightfall, Mondrian needed human congress. In later years, he would go out once a week, but only that. In this period from about 1900 to 1903, the artist-companion with whom Mondrian was seen to spend the most time continued to be Simon Maris. It now seems, based on subsequent events in 1903 and 1904, that Mondrian also had clandestine relationships, but the only people to know about them besides Mondrian himself were his fellow members of the anarchist group with whom he shared a political agenda separate from his artistic one. One of them would publicly and boisterously claim that he and Mondrian had been homosexual lovers at that time. But this was a life apart from Maris's open houses in a fashionable location at the center of town.

Lizzy Ansingh, one of the regulars at Maris's, said these events were "where women painters poured tea and Piet Mondriaan gently murmuring tried to make clear his ideals." Mondrian was respected for the earnestness with which he delivered his incomprehensible monologues, but he remained the outsider. Still, in the aspects of his life that were not secret, he was opening up. He attended concerts and went to cafés, and even invited a selected few friends to visit him in his small studio. Except for Maris, the new people

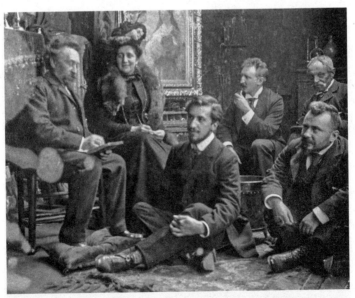

Seated in the center, Mondrian enjoyed the regular social gatherings at the home of his friend Simon Maris (back row, second from the right), a well-established and well-connected Dutch painter, c. 1900–1902.

were mostly younger than Mondrian. Besides Van der Briel, the one with whom he began to spend the most time was Rinus Ritsema van Eck, twenty years old to Mondrian's twenty-eight.

When they first met, Van Eck was a law student. Shortly thereafter, he shifted course and decided to train to be a pianist. This meant moving to Paris to study with Marie Jaëll, a renowned pianist and composer who was the first person to perform all of Beethoven's piano sonatas in the French capital. Marie Jaëll had studied with Franz Liszt and was an expert in the physiology of piano playing. Her views were akin to Mondrian's; she wrote, "The body and the spirit, the movement and the thought are the same force." But even if he subscribed to the same belief, he regretted Van Eck's move. He was sorry to see such an interesting young fellow leave just as they were getting to know one another.

Fortunately, Van Eck periodically returned to Amsterdam. When he did, he raved about the French capital and how wonderful it was to devote his life entirely to musical performance in a society that not only accepted but embraced and supported individuals who made artistic pursuit their full-time job. Mondrian thrilled to the intensity of Van Eck's engagement with piano. That excitement infuses a wonderful charcoal and crayon portrait he made of his young friend. Shown in an exhibition of the Kunstliefde in Utrecht in the spring of 1900, shortly after Mondrian drew it, this large sheet perfectly illustrates Marie Jaëll's assertion that "the energy of the movement is in connection with the intensity of the mental representation of this same move-

Rinus Ritsema van Eck at the Piano, 1900, private collection

ment." Mondrian depicts Van Eck in the fury of playing. Leaning forward forcefully, the pianist presses his fingers hard on the keys as he plays a chord. The hammering of the strings makes the sketch become audible.

Mondrian has dexterously drawn most of a grand piano with the top open. Rather than reproducing the piano with the exactness of traditional Dutch art, he has achieved a greater resemblance by using bold strokes. His technique emphasizes the physical act of applying the charcoal to the paper. Mondrian displays his own artistic medium as bluntly as his friend's. His energy is present in every swirl of the crayon. So is his discipline, which also parallels Van Eck's. For all their apparent frenzy, the pianist follows the notes and performs the melody—we are sure of it—and the artist encapsulates the form of the piano, the sheen of its black veneer, the glistening of light along the edge of the open top, the baroque form of the stand for the sheet music, and the interplay of white and black keys.

This drawing has the same total engagement that gives such force to the gouache of the crazed woman carrying eggs. The subject and the artist are fully ignited. The art of Mondrian's colleagues is laconic by comparison. Uncle Frits's canvases looked as if their artist might have been chatting while painting them. The animation of Van Eck's hands, the focus with which he surveys the keys, the intensity with which the pianist hunches his shoulders and sits as if ready to sprint, betray the hundred percent concentration and love for the act of creation that would become Mondrian's hallmark.

Figurative or abstract, young or old, Mondrian always had this instinctive ability to summon everything within himself. In the sketch of Van Eck, he has used the contrasting colors of the keyboard for subtle artistic effects of the sort that would, in the coming years, constitute his enchanted territory. The disparate elements of the drawing, each streamlined, relate to one another. The luminous band of the white keys, encapsulated with a bold diagonal, is echoed in that streak of light along the edge of the wood behind them. The black line of the sharps and flats is, similarly, paralleled above. No wonder that this drawing attracted a favorable review in one of Utrecht's daily papers. It was singled out as "stronger and more interesting" than other work in the show. The critic credits its "firm outlines" as being "powerfully established." It was just the encouragement Mondrian needed to go further in making art where the passion was salient.

XVI

With his thick black hair, twenty-eight-year-old Mondrian appeared Byronic. His large eyes, their pupils also black, the irises a dark gray, betrayed his intensity, but it was impossible to know his point of focus. He seemed mainly

to be looking into unknown territory, more than at the people to whom he was explaining spiritualism and the art with which to convey it. His bold nose and carefully trimmed mustache and beard were those of a Roman warrior.

One of the ladies for whom Mondrian was a guide to the cultured life, the English woman for whom he made the bookplate—Hannah Crabb— invited him to Cornwall, and he accepted and went, but their relationship is a mystery. All that we know for sure about his trip to the southwest coast of England is that he went swimming in the sea. Mondrian would claim that this was the cause of a serious bout of pneumonia that forced him to recuperate in Winterswijk later that summer and that periodically plagued him lifelong. But that is the sole certain fact. It was not easy to get to a remote region of England from Amsterdam in 1900, and this was Mondrian's first trip out of the Netherlands. No further information remains. We have no idea if he stopped in London. Nor can we say for how long he was abroad, or whether he and Hannah Crabb had a romance.

In 1900, Mondrian made a self-portrait. He appears to be in a trance. Mondrian artfully deployed bright highlights within the overall dark palette of the picture. The glistening white of his large, obfuscating eyes; the streak of light down the main line of cartilage in the strong nose; the brightness of a white shirt where it appears from behind a dark vest: all snap with life. They augment the sense that Mondrian is possessed by external forces.

A few years after Mondrian painted this image of himself in a trance, the youngest brother of Albert van den Briel, a cadet at a military academy,

Mondrian often changed apartments and moved studios. Here he is in one he briefly occupied on Albert Cuypstraat, c. 1901.

keen about modern automatic weapons, was doing some pistol shooting with Mondrian in the basement of the building where Mondrian lived in Amsterdam. They generally used Mondrian's discarded canvases, all of them failed portraits, as targets. The two men started firing. "Piet was a good shot; his hand was steady," Van den Briel tells us. "When all the portraits had been used, there was only that self-portrait left, and Piet wanted to shoot it too."

Mondrian was determined to obliterate the canvas by riddling it with pistol bullets. Van den Briel's brother objected, however. He told Mondrian that Van den Briel would be upset. "Besides, they were running out of ammunition." Mondrian then gave the painting to the brother to give to Van den Briel. The artist said "that it was an insignificant thing, made only to solve a technical problem—that of making the sitter's eyes always meet the spectator's."

There was more to the story. The painting is inscribed, very neatly, with India ink, in block letters, all uppercase, in two carefully ruled lines at the lower left. The Dutch translates as "Thus do I dare to bring myself before the world—and calmly stand in wait—for the eternally pursuing destiny forces my desire to a state of certainty." But it was not Mondrian himself who wrote the words.

Albert van den Briel would eventually confess that it was he who added the text some six years after acquiring the painting. It is a translation from a poem in Icelandic, possibly from one of the early sagas. Van den Briel explained: "The text is certainly dramatic and exaggerated. But Piet himself had not gone beyond that stage."

XVII

On June 1, 1901, Mondrian again passed the entrance exam for the Prix de Rome competition. He was one of four young artists to have done so, and was optimistic that this time he would win the award whereby the Dutch government would pay for him to study art in Italy for two years and provide him with a generous stipend to live and paint back in the Netherlands for a further two years afterward. This was his last chance. Thirty was the oldest permissible age for candidates for the award, which was given at three-year intervals, and Mondrian was twenty-nine. Determined to land this prize that would allow him to make art in a new setting—liberating him from the stifling need to seek and take commissions, give art lessons, and copy masterpieces to survive, while painting as he wanted only in the remaining hours of the day—he was optimistic that he would be heading to Italy.

The preliminary exam had required "thorough knowledge of art theory,

aesthetics, history of art, anatomy and perspective." Mondrian's grades in that first hurdle were a five (out of five) in aesthetics, a four in art history, another four in "objects within perspective." But yet again he had a problem with anatomy, nearly failing with a three.

Then, from June 17 to July 3, Mondrian and the three other candidates convened for the execution phase that followed the written part of the competition. They were given those two weeks to paint two religious scenes and a male nude. Of the four artists, Mondrian was the only one who failed. The judges, all academicians, observed of his rendering of a naked man from behind: "The study of a nude model does not respond to reasonable expectations, since in neither form nor color is a relationship maintained with nature." They specifically criticized the "compact but pithy forms" and the "shapeless clumsiness and obtuseness of line. The legs are much too thick and display very little pertinent anatomical understanding. . . . The dull gray color and for the most part insipid modeling make no favorable impression. Only the upper part of the trunk of the body suffers less from the above-mentioned ills." How could someone with the consummate skill to articulate the complex form of a chrysanthemum lack the wherewithal to paint a naked man? The reason for the rejection was startling. Was the man who had three brothers and had lived with two men his own age during his first three years in Amsterdam truly so unaware of the form of the male body? It seems that the subject made him highly uncomfortable.

His hopes for financial security dashed, Mondrian had to find a new means to support himself. What he earned from giving private instruction, his primary source of income, was not enough to make ends meet. He decided to try to emulate Uncle Frits's success at selling scenes of the countryside. In the aftermath of his Prix de Rome rejection, Mondrian rapidly produced a number of small landscapes. The newly affluent Dutch public had a perpetual demand for them.

These light and sketchy paintings from 1901 and 1902, intended to grace bourgeois interiors, are perfectly agreeable. But they are lackluster. A few years earlier, when he was first discovering the different ways of evoking sunlight on farmland or the canopies of trees in the forest, Mondrian had painted with flair. In this period of retrenchment, he was just doing his job.

XVIII

Then a major change occurred in Mondrian's life. On July 25, 1901, the twenty-nine-year-old bachelor went to the wedding of one of his Amsterdam friends, Lucas Barend Lindeboom, to Margaretha Petronella Harrenstein. Lindeboom, a dentist, had, over the past couple of years, become a

Mondrian collector. The parents of the bride were also among the Dutch bourgeoisie who bought Mondrian's small canvases almost as soon as he produced them. Such successful professionals had become the backbone of Mondrian's life; between them, Lindeboom and the senior Harrensteins owned half a dozen of his paintings.

During the celebration following the ceremony, Mondrian met the bride's younger sister. Twenty-three-year-old Diderieke Petronella Harrenstein, known as Nell, wanted to become a painter. She knew that the lean, bearded, brooding Mondrian was a gifted artist even before she actually met him, and she fell head over heels in love.

The relationship that began over beer and herring at the wedding reception continued. In the days that followed, Nell and Mondrian often met to take long walks together. Ambling through farmland near Amsterdam, they would discuss concepts of beauty, Plato's in particular. At least so it was reported over sixty years later; at the time the walks were secret. But in 1963, Nell's daughter, Mrs. W. H. Luyten, wrote Robert Welsh, a Canadian scholar working on Mondrian's catalogue raisonné, about her mother and Mondrian's romance, which is why it is known about today.

The young woman who wanted to be an artist and the young man who was already a successful one were so attracted to one another that they would have liked to marry. But Mondrian did not have a steady and reliable income. The Harrensteins admired Mondrian's work enough to acquire it, but he was an unacceptable match for their daughter.

Nell was unwilling to challenge them. She and Mondrian enjoyed "a deep friendship, based in part upon a common antipathy to the restrictions of conventional bourgeois society at the time," but Nell would not violate those restraints even if she shunned them. Mondrian's first serious romance came to a rapid halt.

The failed relationship with Nell deflated Mondrian's spirits. By the start of 1902, he had again sunk to a crisis point. The Prix de Rome jurors' judgment of his ineptitude had already stopped his painting and drawing of men; now he ceased making images of women and girls as well. He declined portrait commissions; he was off people. He felt he could survive solely on the sale of his scenes of riverbanks and farmyards.

Meanwhile, Mondrian had gotten into some sort of troublesome situation with at least one of the individuals within his new circle of the self-proclaimed anarchists willing to resort to violence to fight the powerful industries that had generated Amsterdam's recent rise in wealth. By July, he would decide that he had to get even farther away. The issues were extreme; he could no longer paint. The only solution would be to pack up and leave Amsterdam forever.

XIX

Albert van den Briel had left Amsterdam and gone to Brabant, a thinly popu-
lated region of farm country and small villages in the southern Netherlands.
In Amsterdam, Van den Briel had been studying medicine, but after taking
courses in biology, evolution, and "monkey science," he became convinced
that his eyes needed a rest from too much time looking through a micro-
scope. Emotionally shattered, he consulted a doctor who advised a career
shift to forestry, and Van den Briel complied by taking a position working
on a reclamation project for the Dutch Moorland Company. The requisite
move to the serene Brabant region suited him, and the local people took him
in enthusiastically.

Mondrian missed Van den Briel. He had come to depend on this respect-
ful nineteen-year-old who was engaged in neither art nor politics, but who
understood his passions. The young man sympathized with Mondrian's will
to make the world a better place, and his need for independence, and their
conversations were more probing and intimate than was Mondrian's usual
habit. Having grown up in a world where not only every human action but
every thought was judged, Mondrian had never had a comparable ally. Now
that Van den Briel had moved, Mondrian wrote him urgent letters saying
that his current situation had become so dire that he was no longer able to
paint. He subsequently sent Van den Briel a letter that was far more upsetting
than any to date and which Van den Briel destroyed. Whatever Mondrian
told him made Van den Briel urge Mondrian to escape Amsterdam imme-

Mondrian's close companion Albert
van den Briel with Beppie, the dog
he gave to Mondrian and which
Mondrian named for him. Van den
Briel's unpublished memoirs describe
the life he shared with Mondrian in an
isolated village in Brabant in 1904.

diately and head to Brabant. Van den Briel assured the anguished Mondrian that what would rescue him would also enable him to start painting again.

Mondrian agreed to the trip as an essential emergency measure. What the issues were is cloaked in mystery, but Mondrian was so plagued by them that he chose to uproot himself for a year. There was, the forester tells us in a text he wrote for Robert Welsh about Mondrian's personality, "a further issue troubling the painter. Mondrian was in those days also vulnerable because of other reasons, and the case will not be discussed here. He got out of balance thanks to a questionable matter, and wrote to one of his old friends who was in Brabant." The voice of Mondrian's letter discussing "the questionable matter" was alien; it lacked the "semi-ironic, mocking tone in which he normally wrote." The writer is being coy; the old friend was Van den Briel himself.

On another occasion, however, the forester wrote to J. M. Harthoorn, a mutual friend of his and Mondrian's: "Something was awry, although I didn't know what it was, of course." Why feign ignorance about a matter when on a previous occasion you knew the details but decided out of tact not to provide them? In any case, the mysterious issue plaguing the artist would be revealed over a year later, once Mondrian had settled in Brabant.

Brabant and Afterward

A ugust Allebé, a professor from the Rijksakademie who had been Mondrian's closest aide and mentor, had spent several weeks in the small Brabant village of Uden, seven kilometers east of Nistelrode. Allebé sang the praises of that specific town and its surroundings, emphasizing to Mondrian the piety and spirituality of the local population; most of Uden's residents were deeply religious Roman Catholics. On January 18, 1904, Mondrian arrived there having been very specific with Van den Briel that Uden was where he had to live.

Van den Briel lived in Gemert, fifteen kilometers away. Their proximity enabled the forester to devote himself to the artist's well-being as no one else had since Mondrian's mother when he was a child. Van den Briel knew little about art, but he regarded Mondrian as a messiah, and Mondrian could count on his young friend to deal with the practical issues of his life efficiently and dependably.

For Mondrian's accommodations in Uden, Van den Briel rented part of a house belonging to Louis van Zwanenbergh, a cattle merchant. Mondrian could walk to shops that sold paints, canvas, and paper. Once a week, the local farmers set up stalls selling their produce as well as meat and cheese and bread. In his new, deliberately simple existence, Mondrian never had to venture farther.

Van den Briel visited Mondrian almost every evening. Arriving by bicycle after stopping at farms to procure sausage, ham, and bacon that the farmers made from their own pigs, as well as freshly churned butter and eggs that had just been laid, he stocked the larder that enabled Mondrian to prepare their meals. Mondrian devoured the bread baked by the peasant women, telling Van den Briel that the experience was "eating and drinking at the same time." This dark-wheat country loaf with its hard crust was sacred as a source of health and as a celebration of earthly offerings. Each day, Mondrian felt himself freshly fortified; he was, he said, happy as he had never been before. He had escaped his private hell and arrived in paradise.

During their evenings in the flat, Mondrian and Van den Briel would sit

together facing a blazing fire and read and talk. Mondrian's book of choice was the Bible. He and Van den Briel often discussed religion. Mondrian focused on the theories of Theosophy, evaluating its principal tenets in comparison to other belief systems.

Mondrian was the cook. Preparing evening meals for himself and Van den Briel over the hot coals, he became adept at roasting and grilling. His greatest triumph was his leg of lamb, which he made whenever Van Zwanenbergh gave him one. He also used the open fireplace to prepare farmers' coffee, a powerful brew for which Mondrian put ground coffee into a copper pot and added furiously boiling water. He then placed the pot into the hot ashes of the fire until the coffee had the intensity he desired. Later in life, he adapted the method to urban living and astonished visitors with it.

II

The indigenous architecture of Brabant captivated Mondrian. The standard regional building design combines domestic and working spaces. The wall in front of the living quarters is lower than the walls of the adjacent threshing floors and stables. Three doors, one for each unit, line up in a row along the front, declaring that life and work exist in tandem. Riveted to these unusual structures in which human beings and their animals exist intertwined, Mondrian painted the farmhouses time and again.

In small canvases of these Brabant dwellings, Mondrian made the honest and functional forms flow in a melodic rhythm. The materials as well as the shapes were straightforward and reliable, their rigor and logic mirroring the qualities of the local people. Mondrian painted the structures with a reverence that had been absent in his religious and royal images. The paintings of Brabant farmhouses evoke his new well-being.

In the large watercolor *Farm Building at Nistelrode*, Mondrian has made a playful patchwork of these rectangular roof forms. While evoking the real world and depicting his subject with authenticity, he makes his artistic choices in the interest of visual music, achieving a strong beat with the support posts which hold up the overhanging front edge of the roof. The watercolor captures the house but presents shapes and surfaces as optical entertainment rather than the precise details of a farm building. The colors are impeccably calibrated. The green of the grass in the foreground is fringed in the vibrant yellow of the sunlight, which splashes the side of the wooden barn with a sequence of pink, mauve, and orange. Mondrian was reborn.

Another revolutionary element that animates *Farm Building at Nistelrode* is Mondrian's use of the edges of the sheet of paper to cut the imagery off at unexpected points. This surprising way that lines end and forms get severed

Farm Building at Nistelrode I, 1904, Kunstmuseum Den Haag

would, decades later, become a hallmark of Mondrian's geometric composi-
tions. The tiredness and academicism that had often been evident in Mon-
drian's commissioned work of the previous years, and in the landscapes he
had painted mainly to pay the rent and put food on the table, were gone; he
was back on his independent course.

III

There was no apparent reason for the idyll in Brabant to come to an end.
Van den Briel had located Mondrian in a well-suited workspace and home
in the center of Mondrian's chosen town. His landlords, Mr. and Mrs. Van
Zwanenbergh, were exceptional. Rather than treat Mondrian just as a lodger,
they provided services and hospitality that left him free to paint. Other peo-
ple might have resented the sole occupant of the left half of the small house
they shared with their seven children; the Van Zwanenberghs took the quiet
young artist from Amsterdam under their wing. Louis van Zwanenbergh
assisted Mondrian in the buying of everyday staples like coal and wood. A
butcher as well as a cattle dealer, he provided him with meat when he slaugh-
tered it as well as vegetables from his garden. Since he knew how much
Mondrian hated gardening as a result of his father forcing it on him when
he was a teenager, he also weeded and hoed the space allotted to Mondrian
himself, cultivating the plot so successfully that it provided a bounty of leeks,
parsnips, and potatoes.

Mondrian, however, responded to his landlord's kindheartedness with a mix of diffidence and hostility. Van den Briel explains that Mondrian "had done all he could to avoid his neighbor's efforts to make contact . . . which attitude arose from Mondrian's anti-Jewish sentiment." Van den Briel was so troubled by Mondrian's extreme prejudice that he commented on it at length.

Mondrian made a cruel caricature of his landlord to be printed on a postcard. Van Zwanenbergh's wife was so offended by the malignant image that she bought and destroyed all the cards she could get her hands on.

But one card escaped Mrs. Van Zwanenbergh's campaign, and it is dreadful. Mondrian gives his subject the stereotypical hooked nose and furrowed brow, and a bald spot on his head in the shape of a yarmulke. Adding insult to injury, Mondrian has written above his landlord's face "Lewieken." In the old Brabant lingo, this was the term for a man who purchases swine for slaughter. Given that kosher laws prohibit the eating of pork, the word vilified Van Zwanenbergh by putting him in the business of selling pig meat, willing to violate his religious tradition to make money.

Van den Briel discusses Mondrian's attitude to Van Zwanenbergh in a second unpublished text about the artist:

M had a slightly Jewish appearance, which was more pronounced at some times than others. There is no evidence of any Jewish elements in his family. But also the appearance of his mother and sister gave some suggestion of Jewish ancestry, although there are no traces of that to be found in the genealogy. What is remarkable is that M had a clear dislike of Jews. For instance, he never got friendly with his landlord and neighbor, who was a Jew, and also a cattle dealer. . . . The man was very forthcoming, but they never became friends, which was in sharp contrast to the social interaction among the farmers of Nistelrode.

Van den Briel steers us correctly in establishing the connection between Mondrian's anti-Semitism and an element of self-loathing. When he was living in New York at the end of his life, he talked about his father—not his mother—"looking Jewish."

Prejudice and resentment may have been tied up with dependency. In Paris he would be rescued by members of the Sanders family; his most important gallerist in Paris would be Léonce Rosenberg. In New York, Sidney Janis would be his art dealer and companion for evenings of ballroom dancing, and Harry Holtzman would be his ultimate savior. They were all Jewish.

Louis van Zwanenbergh, 1904

IV

In this account of Mondrian's idyll in Brabant, Van den Briel often repeats that Mondrian was "cured." When he arrived in the region, he had been plagued by a Calvinist sense of sin, a feeling of culpability—we are not told why—that he would carry to the grave, after which the fires of hell awaited him. But the Catholicism that prevailed in Brabant, and in which Mondrian was indoctrinated by some local farmers with whom he became close, absolved him of guilt. He was forgiven for what were deemed his sins.

Then calamity struck.

The summer of 1904 was scorchingly hot and dry. Amsterdam experienced the most arid conditions on record, with the water level of the Meuse exceptionally low. Anyone who could fled to the countryside to escape the city's stifling heat. The Tram Station, a small hotel in Uden which had a café on the ground floor and was next door to Mondrian's digs in the Van Zwanenberghs' house, was filled to capacity.

When some people Mondrian knew from the Theosophical Society booked into the hotel, Mondrian told Van den Briel he feared they would interrupt his painting. He was then relieved that they recognized the sanctity of his working time. But other visitors staying at the Tram Station did not. Like a bolt out of the blue, a man and a woman from his old anarchist group barged into his studio one afternoon when he was painting. A startled Mondrian hastily asked them not to interrupt him again, and they left, but the intrusion stymied him and he could not resume painting.

The following morning, they again came unannounced. They soon left, but Mondrian's peace was shattered. A few hours later, Van den Briel showed up for the weekend. Mondrian told him that he was so disturbed by the invasion that he had again lost his ability to paint. Visibly bothered, Mondrian spilled out the reason he was so upset. He told Van den Briel that, in Amsterdam the previous spring, this same anarchist who was now traveling with a woman had spread rumors that he and Mondrian were having a homosexual relationship.

This—the gossip, if not the fact itself—was apparently the reason Amsterdam had become so unbearable to Mondrian that he could no longer work there. Van den Briel wrote J. M. Harthoorn a detailed account of the event, saying that he had arrived ahead of schedule because of a premonition of trouble.

I arrived in Uden (on a Saturday?) much earlier than usual, I think it was already on the previous day, and found M. looking very downhearted. There were visitors (lodged in the tram-stop which also served as hotel or inn, as in Nistelrode, especially for cattle traders at that time): a young woman and a "gentleman." The girl was a brainless goose, and the "gentleman" a seedy-looking individual, although that may be an exaggeration—at any rate not an upstanding fellow, and surely a drinker—such things attract attention in an environment of heath and woods. The man was a homosexual, so M. told me later. I may add here that M. is capable of strong, warm friendships, which may last a lifetime, but that he never gave the least intimation of homosexual leanings. (I am not so sure about one of his brothers in this respect.) If, like me, one is chosen to strike up a true, healthy, heartfelt friendship with a worthwhile person, one senses the extent thereof very clearly. M. told me that the fellow had already bothered him in Amsterdam, and that he [the fellow] had been told where to find him by the young woman accompanying him. That was precisely the kind of thing that had upset M. in the past. M. was very nervous, (embarrassed about his friends!), but most of all he was dismayed about being kept from his work by those 2 visitors.

Mondrian was irked, he told Van den Briel, that the gossipmonger and his girlfriend had walked into his studio uninvited at a moment when he was concentrating on a canvas of a cow lying down in the stable and was making great progress on it. Mondrian maintained that it was the intrusion on his work, more than the issue of his rumored homosexuality, that upset him.

By Saturday afternoon, seeing how distraught Mondrian was, Van den Briel decided that the following day he would take action to put a stop to the

encounters that were causing the artist to plunge back into the darkness that had been devouring him a year earlier during that initial visit to Brabant. Van den Briel knew that in the late morning on Sunday most of the local people were at mass. This would be the perfect time to confront the man from Amsterdam in the café, since none of the people Mondrian knew in Uden, except for the bartender, would be there to witness it. Van den Briel was confident that, based on Mondrian's description, the man would already be drinking. He went to the café.

The twenty-three-year-old forester faced the visitor from Amsterdam. "Come with me, I need to talk to you," he instructed him.

Van den Briel had two objectives. He wanted Mondrian to paint undisturbed, and he was determined to prevent the man from gossiping in Uden. The farmers and shopkeepers would have ostracized Mondrian.

The man did not budge. Rather, sitting on his barstool, he began to shout obscenities at Mondrian's young friend. Van den Briel grabbed him by the collar and left arm and pulled him through the alleyway between the café and the house where Mondrian was staying. He forced the man into "the garden at the back of the house, and told him to get the hell out of Uden."

The man tried to kick Van den Briel. Van den Briel dodged his assailant's foot, punched him between the eyes, and knocked him out. Van Zwanenbergh heard the ruckus and ran to the scene.

While Mondrian looked on, Van den Briel and Van Zwanenbergh poured water on the man lying on the ground. "I told him, in front of Zwanenbergh, what was what: get out of here, Monday morning early, and don't come back, or else—. And stay indoors on Sunday, don't visit M., and keep out of my sight."

But Van den Briel had not yet saved the day.

The young woman came next. Treated her far more mildly, even amicably, although she looked daggers at me, and treated me with scorn. Told them both to go away and never come back. Warned them both. And that was that. I dare say they took me for a homosexual myself, but that was a risk I had to take. M. had got himself into a very awkward situation, and I was afraid all the good it had done him to be in Brabant would be undone. I believe I had no choice. And I was angry. Which is also an excuse. The man came from a good family, with an old surname, and money. A tragic case, no doubt about it. A wasted life, sadly. But I was there for M., and had to take action if he was unable to. M. resented this a bit at first, and referred to his "guests." But we talked it all over, including the situation of last year and his so-called "crisis," and in the end he said I was right. He actually smiled when he heard Zwanenbergh's account of it afterwards. When I

talked with Zwanenbergh again later, he said it was just as well that they had left, or M.'s reputation in Uden would have suffered.

Van Zwanenbergh told Van den Briel that the man and woman from Amsterdam had in fact already gossiped about Mondrian and managed to sully his name, but that once they were out of town the matter would no longer be discussed. Mondrian's loyal landlord thanked Van den Briel profusely for having sent the intruders packing.

V

As the end of 1904 approached, Mondrian had depleted the funds he had set aside for his first year in Brabant. He realized that he could no longer survive financially without the support of the collectors and patrons whom he knew through Calvinist circles in Amsterdam. He had also discovered that what he had fled was neither inescapable nor as significant as he feared. In mid-December, he told Van den Briel he "needed the tension and friction that were there in the big city." He was moving back to Amsterdam.

Too broke to make a rent deposit, Mondrian initially stayed in other people's flats. He first needed to earn some money by giving art lessons and taking on portrait commissions with partial payment up front. This became possible because he had quickly reconnected with Albert Hulshoff Pol, a painter eleven years his junior. Hulshoff Pol recruited his uncle, D. J. Hulshoff Pol, an Amsterdam health official, and his wife to study painting with Mondrian. The D. J. Hulshoff Pols subsequently commissioned Mondrian to make portraits of their sons and to copy Nicolaes Maes's *Het Gebed zonder Eind* at the Rijksmuseum. Granted permission to start the painting on February 15, Mondrian soon rented space in the attic of the building of the St. Lucas Society, an artists' organization which had been founded in Amsterdam in 1880.

The Hulshoff Pol brothers posed for Mondrian during several sittings, but Mondrian depended mainly on photographs of them to do the paintings. The results were lackluster at best. While technically adequate, these prosaic images could well serve as advertisements for a men's haberdashery; the Hulshoff Pols emerge as well-heeled young men in proper attire, totally without personality, too clean-cut and virtuous to be true.

For now, Mondrian was coasting artistically. Back in urban life, he had lost both the lightness of touch and the warmth that infused the canvases of cows and windmills he had been making in Brabant a few months earlier. Not an ounce of emotion comes through in the dry verisimilitude of these commissioned pictures. The anodyne style which may have helped Mon-

drian mask his anxiety over being back in the place he had fled, was, however, more suitable to his next project. Mondrian got himself hired to make bacteriological drawings for Professor Reinder Pieters van Calcar (1872–1957), who from 1905 to 1935 was a professor of bacteriology, health science, and forensic medicine at Leiden University. The purpose of these illustrations was to teach the use of the microscope. Mondrian was given the task of showing bacteria enlarged by the power of thirty, so that the person using the microscope would have an idea of what to expect to see in the lens.

Here the emotional distance was requisite. These pictures depended on mechanical accuracy only and would have been ill served by visible feeling. Performing his task while putting his emotions under wraps, Mondrian became increasingly precise and methodical. His execution was impeccable. Professor Van Calcar was sufficiently pleased to keep him on, and, at a later point, to take him into his household to continue these drawings.

Bacteria belong to all of life. The microscopic images might have felt inglorious, but their universality was significant. Unfortunately, none of these drawings remain, yet the professor's satisfaction with them testifies to their success.

Doing portraits in a clinical style and executing meticulous drawings of bacteria, Mondrian was in a safety zone. Then, about a year after his return to Amsterdam, he let loose. Painting scenes he remembered from the Uden region, he unleashed a force that he had repressed during his readjustment to Amsterdam. Mondrian dashed off a flurry of small canvases. They capture sunshine pouring through bare branches, moonlight bouncing off sloping barn roofs, golden sunsets penetrating the clouds over a pond in which they are reflected, and the pink-tinged sky brightening the blades of a windmill. Light—immaterial, essential to the act of seeing, exhilarating to the human psyche—was Mondrian's elixir. Regardless of the attempts of science to make it a comprehensible phenomenon, it is ultimately inexplicable, and Mondrian was in its thrall.

VI

After a year and a half back in the city, Mondrian once again decided that life in Amsterdam no longer suited him. Starting in the fall of 1906, he exiled himself to the countryside. For a second time, he relocated himself under the aegis of a younger male friend who was regularly in his company. Albert Hulshoff Pol organized Mondrian's travel and made his living arrangements in the small village of Saasveld, due east of Amsterdam and close to the German border. It was not far from Winterswijk, which lay directly to the south. Once Mondrian was there, his art took a fantastic leap forward.

Mondrian had known Albert Hulshoff Pol in the days when a group of artists would paint together on the Gein River. Albert's father, Willem Hulshoff Pol, a textile manufacturer, had a factory in Hengelo, not far from Saasveld, where he had a farmhouse called De Waarbeek, his pied-à-terre in the region. Since Willem hardly ever used De Waarbeek, Albert moved Mondrian into it in the fall of 1906. A new structure in an old farm complex, it was both functional and charming. Albert also organized a rudimentary studio for Mondrian in the home of the town's schoolteacher, not far from the farmhouse.

The move had a dramatic effect on Mondrian's work. Riveted to the woods in the region, he made breakthrough drawings and paintings of the oak trees, many of which were hundreds of years old, as well as the fields of heather. Working on a large format in a burst of freedom, Mondrian began to generalize details. He gave new sweep to his vistas, and intensified the power of light radiating from the background. *Pine Woods near Oele*, drawn in crayon with unabashed transport, evinces Mondrian's phenomenal capacity for celebration, and the ability to transmit his joy to others which would underlie his subsequent developments. This spectacular drawing took his exuberance to a new apogee. Mondrian used the point of the charcoal stick to establish the essential forms, and the side of the stick to create the canopy of pine needles and to give texture to the tree trunks. The two different forms of marking function in perfect synchrony. With his advanced technique, the thirty-four-year-old artist created a rhythmic event of taut against lax, tensile against sweeping, diamond-hard against cotton-soft.

Mondrian's best work over the previous few years had been odes to light and air. With a new technique, he now succeeded more than ever before at capturing these elusive subjects. *Pine Woods near Oele* makes salient the forces that enable the trees to flourish. Mondrian's later preoccupation with white to represent the entire universe as the setting for all existence is forecast in his use of blank paper in this early drawing. The background has equal value to the intense working of the crayon that evokes the woods. Just as the painted whites of his abstractions would be the birthplace of the rich rhythms, that untouched paper functions like the oxygen and sunlight essential to botanical life. The whiteness is the germinating force that allows nature to sing.

Mondrian's improved circumstances added to the confidence that soars in *Pine Woods near Oele*. Albert Hulshoff Pol made him financially secure. And a doctor five years Mondrian's junior, Johannes Fredericus Samuel Esser, who had recently moved from his native Leiden to Amsterdam, had begun to collect the artist's work. "Jan" Esser was Mondrian's first really steady client—not simply a collector who on occasion bought something but one

of the handful of individuals whose enthusiasm and regular purchases would make Mondrian's existence as an artist feasible.

Eventually, Esser, a plastic surgeon, coined the term "stent" after using a compound invented in 1856 by the English dentist Charles Stent for a form for facial reconstruction; Esser applied the dentist's name to the general concept of devices used to expand constricted tubes of body tissue. He was among Mondrian's collectors who were themselves exceptional; the distinguished doctor would also be the Dutch national chess champion. For much of his life, Mondrian would benefit from the largesse of bright and accomplished people. While living in Oele, Mondrian knew that Esser might purchase anything he produced. Prices for Mondrian's pictures were going up: when a recent painting of the Gein River, of which the whereabouts are now unknown, was in the St. Lucas twenty-fifth jubilee exhibition, it was listed at eight hundred guilders—about $12,000 today.

Mondrian had new gusto for everything he did. When his brother Willem got married in Pretoria, on March 7, as a wedding present he sent twelve plates on which he had painted Dutch landscapes. Mondrian now made light his main subject in a series of large-scale oil sketches: whether in the energized reflection on a full moon or the visible sliver of sky over a distant horizon that falls on territory beyond our field of vision. In one painting of a mill, the entire sky is aglow in pure yellow paint with occasional dabs of blue. Consumed by what had been burgeoning in Brabant, he engaged with paint and brushwork as independent forces. Representation and the illusion of a subject mattered less; the adventurous exploration of technique obsessed him. In that painting of a mill, we are not sure if two bands of purple—one is above the brown horizon, while the other is a reflection in an expanse of water alongside the imposing machine to harness the wind—denote distant land or more sky. Mondrian makes us feel that it does not matter; what counts is the act of painting.

VII

By the time he was painting those triumphant scenes in Oele, Mondrian had become far better known to the Dutch public. His paintings in group exhibitions attracted increased interest in the press, and collectors were increasingly eager to snap up his work. His direction was akin to that of other modernists in Paris and Munich as well as closer to home, but his style was unique. Mondrian's complete originality and his unprecedented vision infused the brazen brushwork and vibrant colors of the 1907 oil on cardboard *Red Cloud* (see colorplate I). *Red Cloud* belongs with Matisse's *Dance*,

painted the previous year, and with Picasso's contemporaneous *Demoiselles d'Avignon*, as one of the breakthrough paintings of the twentieth century. Radically simple in its few structural elements and condensed, bold palette, it conveys a peak moment of natural splendor. Mondrian's acrobatic capability, his sensitivity to the wonders of the universe, and his power to evoke them in this small painting are astounding. He uses the hay-colored bare cardboard background as the neutral setting for the ecstatic events on top. His sun-drenched greens make the grass grow before our eyes. The horizon line is positioned to enable the viewer to move into the picture space with a precise sense of the distance. Four dabs of black pigment evoke two cows. The brevity of line and distinct articulation give the animals the same immediacy and blunt reality as the horses and stags that anonymous painters made in the caves at Lascaux twenty millennia ago; art is an imperative. As for the luminous blue sky and the orange-red cloud: they define celestial energy and give color its miraculous capacity to gladden the human heart.

The barn that Albert Hulshoff Pol had transformed into a studio enabled Mondrian to paint on a larger scale than before. *Fen near Saasveld* is 102 by 180 centimeters; a number of other canvases averaged 75 by 120 centimeters. The larger dimensions affected his palette. The sky in *Riverscape with Row of Trees* consists of irregular bands of lime green tinged in a luminous deep yellow juxtaposed with striated, billowing expanses of dusty pink. A soft mauve appears at intervals in the pink. The green-yellow of the sky and the pink-purple of what must be rows of clouds establishes the time of day as sunset. The same hues, all brought down a key, appear as reflections in a vast pond. The generous height and width of the canvas enabled Mondrian to carry off these bold effects with an ease that would not have been possible on a smaller scale.

Hulshoff Pol served as Mondrian's amanuensis, organizing the transport of work for important exhibitions back in Amsterdam. The system was ideal. As soon as Mondrian was satisfied with a new painting that he named *Summer Night*, it went off to an exhibition of the artists' society Arti et Amicitiae held in April and May 1907. Mondrian gave this pastoral scene a full moon, which he composed as a brilliant circle of light yellow that has two wider circular bands surrounding it. The inner band is also bright yellow but slightly toned down; the outer is a subtler deep mauve. The moonlight is in turn reflected in what can be read as either a marsh or a shallow river that is a radiant silver, while the sky is a sea-mist green. The foreground is a mix of lush fertile green and the brown of rich soil. The impressive display of colors works to articulate the scene while giving it the balance of an "allegro" followed by an "andante." Mondrian's powers were at a new peak.

VIII

In 1908, Mondrian moved back to Amsterdam. He took an agreeable space for working and living in a building designed just for artists, at Sarphatipark 42, but the return to metropolitan life did not go as he hoped. Now that he was in the city again, the euphoria that fueled his work from Oele evaporated. He plummeted emotionally. Absent the serenity he had felt in Hulshoff Pol's barn, uncomfortable in his own skin, Mondrian sought to redefine himself. He assumed a dramatically different appearance. He let his beard grow long and full and stopped cutting his hair; he now resembled a mix of an Indian swami and Rasputin. Whenever the camera was on him, he had a wild look in his eyes.

His new style of self-presentation was part of a deliberate effort to become a mystic seer in the eyes of others in the Theosophic movement. This swing to a new identity had begun that March when Rudolf Steiner, secretary of the German branch of the Theosophical Society, gave lectures in Amsterdam. Steiner's thinking, even more than the writing of Madame Blavatsky and her followers, emphasized art, and it grabbed Mondrian totally. Among the few books he would save lifelong was a published summation of those talks.

Rudolf Joseph Lorenz Steiner, an Austrian cultural philosopher and literary critic born in 1861, was the doyen of "anthroposophy," a philosophically based spiritualism rooted in German idealism and Theosophy. Intelligent and charismatic, he was a figure of heroic proportion throughout the Western world as the founder of a widespread movement that promulgated his beliefs. Steiner had come a long way in life; his parents had been a count's gamekeeper and housemaid until the count declared their marriage illicit and they fled to the village of Pottschach in the foothills of the Austrian Alps. His father became a telegraph operator in a train station. They subsequently moved close enough to Vienna so that Rudolf could study at the Institute of Technology, where Steiner became a distinguished and rigorous scholar. While eschewing mysticism, he tried to synthesize spiritualism and science, with an emphasis on clear thinking.

Steiner was at heart splendidly optimistic, in a way that became seductive to the thousands of people who started to follow him. He believed that the possibilities of human knowledge are limitless, and that the mind absorbs knowledge the way the eye takes in colors and the ear sounds. Mondrian, during the years in Amsterdam when he had first become immersed in Theosophy, had admired Steiner for linking Madame Blavatsky's ideas and the arts. But in 1913, when Steiner broke from the Theosophical Society and formed the Anthroposophical Society, rejecting the more mystical tenets of Theosophy, Mondrian lost interest in him.

Steiner, meanwhile, became increasingly renowned. The same year that he codified Anthroposophy, the philosopher, who was also an architect, designed a building for his new organization in Dornach, Switzerland, and called it the Goetheanum. Following the First World War, he became involved with the Waldorf schools. He shared with Mondrian both a desire to connect with the spiritual in the universe and an ardent wish to see society move from individualism, and made that the priority of the universal over the personal essential to the Waldorf curriculum. But Steiner saw meditation, more than the arts, as the means of achieving his goals.

Mondrian welcomed Steiner's statement that "the human soul finds truth by other ways than discussion." This was consistent with his own belief that brushes and paint and canvas, rather than verbal language, would lead him to that higher truth, and consequently to the betterment of humankind. A decade later, when Mondrian was living in Paris, he would expound on Steiner's theories to Theo van Doesburg and say they were fundamental to his own beliefs in the transformative power of art.

Mondrian's 1908 *Evening: Haystacks in a Field* depicts the cosmic force at the root of Theosophical belief. For the first time, he gave supremacy to the three primary colors he would make central to his later work. A single stripe of red creates a sunset in a patch of blue against the white cloudy sky that constitutes almost the entire painting, while a band of vibrant yellow on top of an even more intense yellow line radiates above the horizon in the lower part of the canvas.

The penetrating hues set against the gray whiteness of the entire universe evoke earthly existence in its fullest dimensionality. Petty details become meaningless in comparison to the universality and timelessness of the solar system and beyond. The natural light of dusk intoxicated Mondrian as the neons of Times Square would thirty years later.

IX

Mondrian's interest in Theosophy was not just spiritual. In 1908, he met, in a concert audience, the violinist Aletta Jacoba de Iongh. Even though they never became lovers, they developed what for Mondrian was, in spite of his flirtation with Nell Harrenstein, a closer relationship than he had had with any woman to date. That September, when Mondrian went to Domburg, a beach resort in Zeeland which was the preferred haunt of painters, musicians, and writers who practiced Theosophy, it was she who was most likely his unnamed traveling companion.

Domburg resembled a New Age yoga retreat, with the Theosophists assuming meditation poses on the beach and aligning their chakras. It was

also the Dutch equivalent of Deauville in France and Newport in the United States. An old fishing village, in the nineteenth century it had become a luxurious beach resort for a fashionable clientele. It offered tennis, hiking, and croquet to the German and Dutch aristocrats who came not so much for ocean swimming—the water was cold and the currents strong—as for saltwater cures and other amenities that could be enjoyed at the large wooden hotels with wide verandas. On September 12 that year, the *Domburgsch Badnieuws* provided the information that "P. Mondriaan and family (two people)" had been at the Strand Hotel between September 3 and 10. His companion in the luxurious hotel might well have been Aletta de Iongh; they were spending a lot of time together, and she had sufficient family money to pay for it.

Michel Seuphor, meanwhile, provides completely different information about that first trip Mondrian took to Domburg. He reports that Mondrian went there with Cornelis Rudolf Hendrick Spoor, a fellow painter and active Theosophist who had become a member of the Theosophical Society in 1905 and, in 1909, would cosign Mondrian's application to that elite organization. Spoor, five years older than Mondrian, had become a close friend in spite of the total dissimilarity between his very traditional work and Mondrian's. Spoor would have been a far cry from De Iongh, but it's hard to know whether to trust Seuphor. For decades, Seuphor's Mondrian monograph, published in French in 1956 and in English in 1957, was the single significant source on the artist, the bible indispensable to painters, collectors,

Michel Seuphor, shown here in 1928. An abstract painter as well as a critic, playwright, and art historian, Seuphor would have unequaled influence on the way Mondrian was perceived as a personality. He had a highly specious vision of his subject.

and anyone else interested in Mondrian, but its "information" is sometimes questionable. Seuphor, who was born in Antwerp as Fernand Berckelaers, and had renamed himself with an anagram of Orpheus, was often more imaginative than factual.

Mondrian appears to have produced no art in Domburg that year, but he would later in life consider the overall impact of Domburg transformative. If, on that first short trip, all he did was to enjoy the companionship of whomever he registered at the hotel as "family," relish his new circle of friends, marvel at the scenery, and meditate on the principles of Theosophy, he would eventually attach great significance to the effect of the place on his art. "The first thing to change in my painting was the color," he would recall in 1941 in his only explicitly autobiographical essay. "I forsook natural color for pure color. I had come to feel that the colors of nature cannot be reproduced on canvas. Instinctively, I felt that painting had to find a new way to express the beauty of nature."

That shift to a palette based on the spirit of the hues more than their capacity to represent nature invigorates *Woods near Oele*—a tour de force he completed in the fall of 1908 after that first trip to Domburg (see colorplate II). Not only did Mondrian's attitude to color take wing; the brushstrokes in this sumptuous picture directly reflect the act of painting more than they simulate knowable surfaces.

Mondrian summed up his own progress and the factors that governed it: "After several years, my work began to deviate more and more from the natural aspects of reality . . . I knew little of the modern art movement . . . I admired it, but I had to seek my true way alone." More than ever before, Mondrian was focusing on the grand scheme of the universe. In *Woods near Oele*, the forest had intoxicated him.

Mondrian has, as usual, painted trees from the vantage point of being smack up against them. The trees don't merely grow; most of them shoot upward and reach toward the sun. But there are glaring exceptions to their robust health. The few trees that do not soar from the ground are not merely inert; they are tragic. Some are uprooted. One unfortunate specimen is bent and slumped over, appearing to be in a macabre dance, responding to another disabled tree with which it does a slow tango. These dead trees are as forlorn and destitute as his most wilted chrysanthemums.

In society, Mondrian was reserved, even timid; with a paintbrush, he allowed himself to be at the edge of total abandon. Though he was socially inhibited and reticent, when he used the tools of his trade he exercised unbridled force. In this remarkable canvas, the horizontal gashes of bloodlike red, the celestial blue radiating its otherworldly light, and the rusty oranges arrest us. These vibrant hues are just the opening salvo, following which the viewer

is pulled toward a pool of yellow dashes which represent sunlight itself. With pure paint, Mondrian had, in keeping with Rudolf Steiner's beliefs, evoked universal truths.

Mondrian had become his own master. The developments of the previous four years—Van den Briel's care, Catholic redemption, Hulshoff Pol's generosity—had converged to make him confident and fearless. Theosophy, via Rudolf Steiner, replaced the fear of God of his childhood with knowledge that the marvel of life could be expressed by the act of painting. Mondrian had mastered his craft and developed the technical skill to be able to paint on his own terms. In *Woods near Oele*, by allowing the unprimed canvas to appear in the background sporadically, he gives the colors their maximum impact. Now that he was making his own rules, he willingly let the drips show.

Mondrian's independence and originality become even more evident as you advance beyond the foreground. You get into the woods, and you feel Mondrian celebrate the sun as the source of life. You savor the smell of trees, even the feeling of your boots sinking into damp ground. That experience and the hues and the brushwork themselves invigorate you.

As far back as you can see, on the left, there are some diagonal dashes that move downward to the right. These broad strokes of mauve and blue, essentially the same width, run into a brilliant yellow—a small region of pure sunlight the shape of an archipelago—that emerges from behind the mop-like foliage of a couple of happy, flourishing trees. This region of lighter colors is a poignant vignette, a visual equivalent of heaven that is a spiritual heaven to look at. The quietest moment in this bold assemblage of strokes, this little area of delicate hues and deliberately measured dashes is the essence of Mondrian's art, the fulfillment of the same goal that determined his later abstract compositions: an expression of utmost grace, equilibrium, and joy.

X

Mondrian would return to Domburg in subsequent summers, and to the same spiritual territory in perpetuity. Inspired by the coastline, encouraged by his new camaraderie with fellow artists, he gained confidence. At the end of the year, Mondrian and two of his fellow artists, Cornelis Spoor and Jan Sluijters, wrote a letter to the mayor of Amsterdam requesting a three-person exhibition. They knew that C. W. H. Baard, the Stedelijk's curator, would be sympathetic, but the approach was audacious: "The undersigned painters take the liberty to contact you with the respectful request to provide them with the necessary space in the Stedelijk Museum during January 1909

to organize an exhibition of their works of art. The reason for the request is that every painter has a special, personal aspiration in his art, that at large scale exhibitions—because of the many different artworks displayed, and the few they are allowed to show—is never given adequate attention." The answer was yes, but there was little time to spare. The three-man show was scheduled to open at the start of the following year.

The exhibition would give Mondrian the chance to present the range of his work to an international public, but he had a lot to prepare. He and the other two artists put their collective vision together at breakneck pace and at their own cost. Mondrian asked everyone possible to lend the paintings he had been so happy to sell to them; in addition, he was painting and sketching new pictures for the exhibition up to the very last moment. He ended up with approximately two hundred and fifty works on view. Spoor had almost as many, and while Sluijters had slightly fewer, their combined production blanketed every available wall at the Stedelijk.

This hodgepodge was shown without labels and absent any sense of sequence. There was no budget for a catalogue or checklist; the artists felt lucky to have the funds for picture hooks. The result was both a calamity and a triumph. Mondrian had thrown a lot of his canvases into rough white wooden frames at the last moment; he was criticized for that and for including a number of paintings that he was still working on and others he had never finished. Nonetheless, when the exhibition opened its doors on January 6, 1909, the unedited selection suggested to some people that, even if Mondrian was inconsistent in style, he was consistently determined to paint fluidly and to present a vision of earthly bounty. If there was one element that every work—from the early portraits to the views of somber industrial buildings to the colorful sunsets in the countryside—had in common, it was the dominance of the two intangible miracles of light and air.

Yet life itself seemed precarious. Two days following the Stedelijk opening, Mondrian's mother died in Arnhem. Mondrian's parents had moved to this prosperous city near the German border with their children Johanna and Carel in 1901 because after his retirement in Winterswijk, Pieter Mondriaan needed income beyond his state pension, and in Arnhem there were students from families able to pay his fees.

Nothing is known about whether Johanna Christina Mondriaan died suddenly and unexpectedly, or whether she had suffered from a long illness. She was seventy years old, a decent age for the time. But while the details of her health remain unknown, what has been and continues to be reported is Mondrian's response. It is stated consistently in the Mondrian literature that the artist considered himself too busy with his exhibition in Amsterdam to bother to attend his own mother's funeral.

Robert Welsh, the scholars' scholar in Mondrian studies, writes: "January 8: death of the artist's mother, whose funeral Piet does not attend due to his involvement with the just-opened exhibition at the Stedelijk Museum." The catalogue of the 2011 Mondrian exhibition at the Centre Pompidou in Paris, a definitive recent source with a substantial chronology, says Mondrian was absent at the funeral because he was "retenu par l'ouverture de l'exposition du Stedelijk Museum." No one makes any editorial comment about the artist's failure to get there; they don't have to. For someone not to attend his mother's funeral—unless there are extraordinary circumstances preventing his being there—is the quintessential indecency.

Neither Welsh nor any of the other writers provide a source for this bombshell. Still, one assumes that such a serious scholar had a basis for the claim that the Pompidou repeated without question. That is why it was astonishing to find, in 2012, a letter Carel Mondriaan wrote a year following Mondrian's death. Carel, living in Breda, was reconstructing his brother's life for Sal Slijper, an art collector and dealer who had been a major patron of Mondrian's. Slijper was attempting to assemble biographical information while it was still possible to do so. Their correspondence is in the Harry Holtzman Papers at the Beinecke Library at Yale University. On November 15, 1945, trying to determine the date of Piet's move to Paris, Carel says, "So I think the first time he went to Paris was in 1910 or 1911. I remember him being present at Mother's funeral in 1909." Mondrian was dedicated above all to his art, but he was not the heartless careerist historians have decided to make him.

XI

Most of the press for the Stedelijk show was unfavorable. One critic jumped on the "crude, scarcely planed, white wood frame," which, he wrote disparagingly, suited Mondrian's "hallucinatory landscapes." In February, the psychiatrist, utopian, and moralist Frederik van Eeden wrote in an article, "Health and Decadence in Art," that "Mondrian's fall is tragic and terrifying. As his original gifts were of the very highest, so his fall is the hardest." *Woods near Oele* was the exemplar of the way the artist had plummeted.

Van Eeden commends the artist's "early period" for its "really magnificent subjects," color that is "marvelously beautiful," and a "grand and noble" vision of the natural world—in spite of the absence of "a single finished masterpiece." Then came what Van Eeden terms a "mad confusion" in Mondrian's art. "What is certain is that once he threw off all academic constraint, he has taken to daubing in the most abominable style." Van Eeden goes from there to characterizing the artist's "stupidity and insensibility."

Trained as a psychiatrist, Van Eeden wrote novels, plays, and poetry, as well as critical essays that delved into mysticism and social reform. His comments on Mondrian had considerable impact because, rather than coming from a die-hard conservative, they were pronounced by a serious and accomplished intellectual who had written a rhapsodic article in which he praised Van Gogh as a colorist and an artist of rare determination; Van Eeden's reputation as an enlightened and progressive thinker is what made his attack on Mondrian so damaging. He opens his article in the February 1909 *Op de Hoogte*, a monthly magazine published from 1903 to 1939, with the provocative remark that people claiming "not to believe in good and evil" were, nonetheless, always concerned with their own health; moreover, the distinction between beautiful and ugly, while falsely considered "just a matter of taste," paralleled the difference between healthy and sick. This is a lead-in to his characterizing Mondrian's state of mind as being like a contagious illness.

Van Eeden continues with a lengthy exegesis which resembles a psychiatric manual in its diagnosis of people who prefer what is ugly to what is beautiful as suffering from a major disorder. The doctor of mental health, writing of these vulgarians of whom Mondrian was a prime exemplar, characterizes their "decadence" and "decline of taste" as symptomatic of "degeneration." In the past, when such degeneration had permeated "an entire people for ages," it became "a chronic epidemic"; when it afflicts "a single individual for a short period of time," it is a case of "an acute sporadic decadence."

Van Eeden says that, having had his head turned by some outside influence, probably Van Gogh, Mondrian "lost balance totally." His deterioration is evident "in a painful orgy of the rawest, most barbaric and lurid colors he could put together." Van Eeden's pronouncement is that Mondrian has completely lost his "drawing, composition, and technique." The resultant art is "simply mindless, much like unsightly juvenilia. The work of a child indeed, a sick, rebellious child with a few pots of paint to hand." Both Mondrian and Sluijters, according to Van Eeden, had come to work in such an egregious way "because they think this is the most beautiful way to paint. What healthy people think is repulsive, disgusting and hideous, they see it as the true, real beauty." Yet they had the audacity to consider themselves healthy, and healthy people sick. Van Eeden had never met either one of them, but he was certain in his diagnosis of their severe malady, which was plainly manifest in their grotesque new paintings.

XII

In 1908, Mondrian and Aletta de Iongh had begun to see one another frequently, sometimes just the two of them, on other occasions with mutual

friends. By April of that year, Mondrian was writing warm letters in which he addressed De Iongh as "dear sweet Zus"—the Dutch term of affection for "sister"—and calling himself "your Piet." He would sign off with "much love."

De Iongh, the daughter of an attorney, had studied violin with the first violinist of the Amsterdam Concertgebouw. When Mondrian met her, she was at the conservatory training to become a professional musician. She would eventually become first violinist of the Resedentie Orchestra, using her married name of Aletta Rackwitsz. In 1920, she gained further renown as Princess Juliana's personal violin teacher.

Toward the end of her life, De Iongh would give her trove of letters from Mondrian to Mrs. G. E. van der Hucht–Van der Stok, the head nurse of the nursing home Tabitha, in The Hague, where De Iongh was ending her days. In February 1994, Mrs. Van der Hucht–Van der Stok donated the letters to the Kröller-Müller Museum. The director at the time, Evert van Straaten, noted that the head nurse had said that De Iongh told her that "Mondrian was also homosexual." The "also" was because De Iongh had discovered that her husband, the painter Piet Rackwitsz, was homosexual; they never consummated their marriage. Rackwitsz was part of the same social circle as Mondrian in Laren, the village he began to frequent in 1912, and where he lived for almost five years during and after the First World War. It is unclear whether De Iongh was suggesting that Mondrian and her husband were lovers—but she was certain about Mondrian's sexuality.

Piet Mondrian, *Drawing of Aletta de Iongh*, 1908–1910. Mondrian was exceptionally close to this gifted violinist. In a period when he was seeing lots of women, he spent more time with her than others. At the end of her life, she suggested that, like the man she eventually married, he was homosexual.

In this same period of his life following his return to Amsterdam, at age thirty-seven, Mondrian developed such a peculiar style of kissing that the women who were its recipients talked about it. His best-known kiss would be one he suddenly planted on Peggy Guggenheim's lips—depending on the version of the story you prefer, in her London gallery in 1939 or in the back of a New York taxicab in 1942. Written about in many texts about Mondrian and in books by and about Guggenheim, that kiss would become part of Mondrian's legacy—not just because Guggenheim talked about it but also because of its unusual nature. Mondrian took Guggenheim entirely by surprise, lunging at her out of the blue and forcefully putting his mouth on hers. Guggenheim would maintain that it seemed completely out of character for the man because of the apparent asexuality of his art.

That kiss when he was around seventy years old was somewhat in the style for which Mondrian first became known in 1909. Mondrian was then approaching his thirty-eighth birthday. It is unlikely that he had ever kissed a woman on the mouth before. His kisses were full force on the lips and intense. By all accounts, they were one-sided and awkward rather than mutual. Mondrian seemed like someone in a trance, focused on his own intense feeling, uninterested in the woman's experience.

This began when Mondrian met Eva de Beneditty at the end of January 1909, concurrent with his seeing a lot of Aletta de Iongh. De Beneditty, twenty years old, was tall, strong-willed, and determined, given to stylish silk jackets and fashionable hats, but she was by no definition pretty. Her large nose and exceptionally thick eyebrows were accentuated by her determined gaze; with her heavy hands and big fingers, and powerful physique, she made a mannish impression. This well-heeled heiress lived with her parents in their luxurious apartment near the Concertgebouw. Her father, Abraham Matthias de Beneditty, was a Portuguese Jew who had become prosperous as a securities trader; Eva's mother, Rosalie de Groot, was also from an affluent Jewish family. Shortly after Eva and Mondrian met, they began a romance of sorts, but the De Benedittys forbade their daughter to date the indigent artist. The parental prohibition only added spark to the romance.

By the start of February, Mondrian and De Beneditty had managed to organize several secret rendezvous. De Beneditty kept a diary that ran for forty pages about the cavorting that lasted from then through the end of June. She felt swept off her feet by the man she called "my painter." He gave her life an unprecedented value.

"He is good and honest and I trust him. I believe him and everything he says; to me he is a rock of truth in my life," De Beneditty writes in her journal. She was convinced that Mondrian was equally happy to be with her. He

Piet Mondrian, *Portrait of Eva de Beneditty*, 1908–1909. De Beneditty and Mondrian had an on-again, off-again romance. She timed Mondrian's kisses, reporting that while the average was twenty minutes, some lasted half an hour.

gave her a painting he had done of a chrysanthemum, which she considered a memento of his love. She kept the delicate watercolor of a single flower in her bedroom, and whenever she was feeling lonely, she would look at it and dream of the artist's presence.

De Beneditty's son, Paul Huf, would, shortly before he died in 2002, tell an interviewer that his mother never got over Mondrian's style of kissing. Huf, a photographer known for his publicity portraits of famous Dutch actors, actresses, athletes, writers, and politicians, was used to the ways of the world, but he had rarely encountered anyone as astonished by an encounter as his own mother when she described Mondrian's kisses to him.

From Mondrian's studio, the young woman had a view of the clock on the steeple of the Oranjekerk. This allowed her to calculate the time he spent with his lips on hers. An unbroken twenty minutes was the norm, but on occasion the kisses lasted half an hour. She made it sound like an endurance test. Her capacity to keep track of its duration came from her being in a different emotional state from the man who was kissing her.

Still, De Beneditty was totally smitten with Mondrian, and delighted emotionally if not physically by the extraordinary feat that she considered to be a mark of his love. As Abraham and Rosalie de Beneditty became increasingly adamant that their daughter stop seeing Mondrian, the lovers thrilled even more to their illicit liaisons. Eva's diary that March reveals frequent meetings with Mondrian, forbidden and wonderful. While her father and mother objected to the "painter with a beard, living in an attic and eating

rice out of poverty," she managed behind their backs to return happily and with increased frequency to the attic where she timed his kisses.

By April, however, it all began to change. Mondrian told De Beneditty that he had less time for her. The spring weather enabled him to resume his excursions by tram and bicycle to his favorite riverbanks and windmills on the city outskirts; he would paint until it was too dark to work anymore, and return to the city too tired to see his girlfriend. Eva records in her diary that on April 11 and 12 he went to Arnhem to spend Easter with his family; it was the first major holiday following his mother's death, and he considered the trip essential. He then became preoccupied with the upcoming exhibition of the St. Lucas Society at the Stedelijk, claiming not to have an hour to spare. If they saw one another at all, the infrequent encounters were too brief for Mondrian's style of kissing. On Tuesday, May 11, De Beneditty wrote that Mondrian had "no time for me at the moment."

De Beneditty was unabashedly disappointed not to see more of him, yet she bore "my painter" no resentment. She had always known that his work was his priority and accepted the fact. When Mondrian took the time to write her a short letter, she felt nothing but grateful.

And then the bloom of romance was on again. Either Mondrian's schedule had truly opened up, or his longing had become more than he could resist. On May 23, he took Eva de Beneditty to a Beethoven concert held in the garden of the Concertgebouw. The event, on a breezy spring evening, was utterly magical for the enamored young woman. To her, Mondrian had an alertness and sensitivity unlike anyone else's. Their hours under the stars together were spellbinding. De Beneditty would write of being "in the fairy-tale illuminated garden, with the glorious music of Beethoven, interspersed with strange rustlings of the wind in the trees, lovely sea-sounds, and the soft warbling of a few birds that were still awake, which did not disturb the music."

The sounds of nature that delighted De Beneditty destroyed Beethoven for Mondrian. The painter was troubled by the noise of the wind in the trees. At first, he concentrated on the music "with eyes cast down, in quiet delight," but then that wind interrupted his trancelike state. De Beneditty observed him "glancing up at me now and then, when the sound of the rustling leaves was momentarily heard over the music." While Mozart was his favorite composer, he adored Beethoven's music and found the disturbance intolerable. De Beneditty felt that Mondrian's refined auditory perception equaled his visual acuity. His annoyance at the intrusion of the natural world on the disciplined human performance showed a rare attunement to all stimuli.

On June 10, Eva de Beneditty visited Mondrian's studio with her renewed anticipation of record-breaking kisses. In the more than two weeks following the concert, she and Mondrian had again been seeing one another frequently, and she had dreams of what their relationship would become that summer. That evening, her hopes were dashed. Mondrian abruptly announced that by the end of the month he would be leaving for Domburg—and would be away for about eight weeks.

He then handed her a photograph of himself. It had been taken in the studio where they were standing. She knew that the gift symbolized the eventual end of their encounters there, for in the photo he was alone with his art.

Still, they had a fortnight prior to Mondrian's departure. Mondrian and De Beneditty met frequently during those two weeks. He was, she noted, "endlessly lovable." Then, after he left, on June 24, she wrote, "He will be able to work in nature to his heart's content, and have a wonderfully peaceful time! Still, he won't be too pleased about not seeing me for a long while, but he has his art, which takes up all his thoughts, and he will work hard there, and be utterly immersed in it."

Mondrian's yearning for Eva de Beneditty would never supersede his absorption in his art. It appears that, even after he returned to Amsterdam, she and Mondrian never saw one another again. For over a year, De Beneditty made no reference whatsoever to Mondrian in the diary with which she meticulously recorded her life's events.

Then, in October 1910, she wrote that she had received a letter from her "old friend the painter." A month later, a second letter came. In it, Mondrian was solicitous about her state of mind but added that she need not reply if she did not feel like it.

In the long run, Mondrian became the one who was unwilling to let go. That New Year's, Mondrian asked De Beneditty's nephew, Louis Saalborn, who was his painting student—and probably had introduced them initially—to tell her how eager he was to see her again. De Beneditty told Mondrian's intermediary that she refused. The pain had been too great; she could not bear a reunion. She would never again meet the artist whose work she prized and whose kisses were of such astounding duration.

Eva de Beneditty was, we assume, protecting herself because she was so in love with Mondrian and could not bear being hurt any further. After Mondrian left for Domburg at the end of June and she imagined him devoted to nothing but painting, she found out that on April 27, 1909—just after he told her that their clandestine meetings in his studio needed to end because he needed every possible moment to prepare for the St. Lucas Society exhibition—he and twenty-five-year-old Margaretha Louise Heijbroek

signed the guest book of her family's home in Laren together. By the fall of 1911, Heijbroek and Mondrian would be engaged to marry. When Eva de Beneditty saw Mondrian for the last time in her life in June 1909, she had not even known that Heijbroek existed.

XIII

On May 25, 1909, Piet Mondrian became member "N° 1,690" of the Dutch Theosophical Society. The small organization, created nearly thirty-four years earlier, was reserved only for the most dedicated adherents of the faith. This was about the time when a frequently reproduced photograph of Mondrian was taken, in which, with his long hair and arm gestures, he resembles a generic guru or Eastern prophet in a yoga posture. In 1941, Mondrian would tell Charmion von Wiegand, an American artist he befriended in New York, about this photograph. The way he was holding his arms and hands had to do with "special study of physiognomy" being undertaken by Alfred Waldenburg, a fellow Theosophist. Mondrian nicknamed Waldenburg, who was a phrenologist, the "skull measurer." Waldenburg believed that human traits and abilities depended on the size of various parts of the brain, and that the proportions of one's hands and fingers reflected the measurement of the cranium. According to Waldenburg, this image of the outer surface of Mondrian's skull, and its echoes in Mondrian's hands, indicated differ-

The phrenologist Alfred von Waldenburg, who took this photo in 1909, believed that one's hands and fingers reflected the size of various parts of the brain, which in turn impacted human characteristics. Mondrian's metaphysical spirit was thus visible.

ent faculties within the twenty-six organs of his brain. Characteristics like destructiveness, acquisitiveness, self-esteem, and even metaphysical spirit were plainly visible.

Von Wiegand would write of this photograph, "The man himself was so powerful and energetic and the curly black hair so wild and profuse, the hands so strong and tense, that it reminded me of Gruenewald's *John the Baptist*. It is very close to it. But it is strange that the slight, modern, clean-shaven, rather dour looking man that Mondrian is today could have been that other man." Ten years earlier, Mondrian had dressed in the correct suits and starched collars of the bourgeoisie who were his client base. Five years earlier, he had worn the same cut of jacket as his farmer friends in the Brabant countryside. Eventually, he would be the artist who only painted in a clean white smock and wore the impeccable clothes of a businessman when out in public, groomed meticulously; when he sported a mustache, it was an orderly rectangle. He always cloaked his inner self, but nowhere is he more enigmatic than in Von Waldenburg's photo.

XIV

The sea was Mondrian's elixir. It provided a sense of well-being. Now the expanses of water that dominate the earth's surface took him one step closer to the absence of all subject matter and the disappearance of quotidian reality that would constitute his ultimate paradise.

The second year that he went to Domburg, the outburst of creativity had begun the moment the weather made it easier to work outside. After a long spell of rain, the sun broke through. On the first bright and clear morning following his arrival, Mondrian set himself up to paint on Hoge Hill, an elevated promontory looking out over the Domburg dunes and the sea. He now positioned himself differently than he had in the woods. Rather than being encased within the sacred place and surrounded by trees, he gave himself a vantage point that was high and afar.

Mondrian returned to the spot each day, starting at daybreak and working until dark. He painted on cardboard, which meant that he could use oil paints without bothering to carry an easel. He applied the pigment quickly and lightly, the results looking deceptively like pastel. In this abbreviated, rapid style, Mondrian captured the panorama of shifting sands and the sea that was alternately rolling and calm.

Then, in August, he worked on canvas. *Sea After Sunset* would be a new "summa" in his capacity to use brush and paint to evoke the givens of the cosmos. With the ocean's edge in front of him, his painterly imagination took a lcap parallel to the personal awakening to which Theosophy had led

him. Madame Blavatsky's approach to earthly existence was the vehicle that enabled him to realize his desire to paint the all and everything of existence.

Mondrian captured the moment that only occurs once a month, when low tide coincides with the last moment of daylight. High tide, covering the complex seafloor with the pure and consistent surface of the water, would have presented a more uniform sight; low tide offered natural workings stripped of their cover. Rather than being cast in darkness or illuminated by midday brightness, as it is during the rest of the twenty-eight-day cycle, what is visible becomes a mysterious amalgam of seaweed and rocks as the edge of the sea recedes into itself. Evoking this, possessed by energy as he laid down pigment, Mondrian applied his boldest, simplest dashes of intense color to date. Mondrian's brushstrokes are vibrant bullets angled to soar.

In the aftermath of a tumultuous spring, the artist had developed both a new assuredness and the capacity to convey it with exquisite lightness. Some of these airy, weightless dashes evoke the purely natural: the sky, the distant sea, and the strip of shoreline exposed only just a moment ago. These dexterous staccato strokes also establish the distinctly man-made elements of the view. Mondrian displays, in its full effectiveness, the means with which human beings come to grips with the furies of nature. The predominant device is the pile of sand extending outward on the right side of the natural sandbar. Such constructions dotted the Zeeland coast to control flooding and stabilize the landmass at risk of being washed away.

Sea After Sunset has the hallmarks that would underlie the pure abstract compositions Mondrian would make fifteen years later. Transforming us, this oil on cardboard anticipates the work in which Mondrian would no longer represent a known sight. It overtly displays the processes of man-made art while presenting the cosmos as being greater than any of us. Its energy and perpetual motion invigorate the viewer; its colors penetrate us.

XV

In July 1909, Mondrian's submission was turned down by an exhibition of Works of Art by Living Artists in Arnhem, but one of his flower paintings was included in the annual Arti et Amicitiae show, and he also had recent paintings in the St. Lucas Society exhibition. The ones at St. Lucas were the last straw for his uncle Frits, who told critics that he no longer would have anything at all to do with his "depraved nephew." This was when Frits initially demanded the name change already mentioned in the discussion of Mondrian's early training.

Most sources err about the timing of the name change and the reason for it, claiming that Mondrian dropped the second "a" three years later, in

1912, when he moved to Paris, streamlining "Mondriaan" to go with his life in a more modern studio. The truth is that the alteration had been imposed on him. Frits Mondriaan also paid for a public statement in the newspaper declaring that he had nothing in common with the nephew on whose name change he had insisted. Piet's latest work, and Van Eeden's critique, had impelled Frits to disassociate himself from his radical relative.

It was a brutal move from Mondrian's closest mentor. Piet revered the person who had trained him to draw and paint. Piet's own early oil sketches of the Dutch countryside had resembled his uncle's so strongly that most people could not discern who had done which. Yet back then, Frits had no quibble with their having the identical last name even though people assumed that the work of one was by the other. For a beloved blood relative to force a member of the next generation to not just alter the spelling of the family name but also to make the reason public cannot have gone down easily. Piet was taciturn when referring to his uncle's public rage, but his true reaction to the sting was another side of life to hide. Piet consistently volunteered that Frits had taught him to paint. He never played the victim, but he had been disowned.

Mondrian completed several paintings of single trees in that same time period. While they were overtly essays in Pointillism derived from the method of Jan Toorop, one of his favorites of his contemporaries, they have a Herculean energy that is Mondrian's alone. In *Apple Tree, Pointillist Version*, intense short dashes radiate from the apple tree in all directions beyond the boundaries of the cardboard into the distant reaches of the universe.

This painting appears as a physical act. We are not given a mere picture of an apple tree. Mondrian starts his gymnastic feat where the trunk emerges from the ground. Having loaded his brush with black paint and worked his way upward, he proceeds in the direction and series of actions with which the tree grew. From the tapering trunk, he moves into the major branches. From there, as if creating all the branches simultaneously, he makes the younger ones sprout from the more major ones. This is not a re-creation so much as the development of a living organism in the here and now.

Mondrian has twisted one branch so that it contorts itself into a loop and then plunges downward. The struggles and defeat of that limb are a metaphoric fall from grace. The branch bows, beaten into resignation, as if its effort to reach high crushed it. Other branches declare their triumph. These limbs leave the trunk light of foot and leap in a happy dance.

To have this tree enact its epic performance, Mondrian initially approached his subject face on and then shifted positions to place himself under the bare branches at which he looks upward. The canopy the tree will acquire when spring comes resembles a large bracket, encompassing most of the outline of

the bare-branched tree while pointing above. On top of this umbrella form there are bright circles of color with substantial gaps between them; we feel that these have been added because we sense this painting having been constructed as a sequence of events, the act of painting an unfolding of time akin to the cycle of nature. These lush red circles, set against a sapphire-like ice blue, create an elegant color trio with the black of the tree. Pure and universal, they presage the palette that will constitute Mondrian's abstractions.

XVI

At the time that he started to paint single trees, each isolated on its own rather than as part of the forest, Mondrian again began to draw and paint individual flowers. Later in life, he would isolate rectangles of blue, yellow, or red, framing them in black and surrounding them in white, so that each could exert its independent force. These solo performances—of trees, flowers, or blocks of solid color—provide points of focus that eliminate the overload of everyday life. Concentrating their subject, they concentrate us.

To be solitary, to exist uninterrupted and independent, with everything extraneous stripped away, was essential to Mondrian. He still planned to have a wife and children—and theoretically was just looking for the right woman so that he could follow the norm and have a family—but he liked isolation in his subject matter as in his life.

Mondrian had not painted flowers since 1902, when he had done so to make money. Now he infused each single blossom with a significance consistent with the Christian association of flowers with the Virgin Mary and the other female saints and with Theosophical doctrine, which accords each blossom her own personality.

Mondrian anthropomorphized his flowers accordingly. Some stand upright like proud coloraturas. Others, wilted and dying, are hunched over; they resemble Toulouse-Lautrec's tragic and lonely chanteuses, faded beauties with the days of glory behind them.

Shortly after finishing a painting of a magnolia, he gave it to Greta Heijbroek. He had once given a flower painting to Eva de Beneditty, as a sort of consolation prize when he ended their relationship. The present to Heijbroek was a different sort of gesture, since by then he planned to ask her to marry him.

XVII

A story, published in 1994, has gained a fair bit of traction. It claims that, on one evening, a number of men, most of them painter friends of Mondrian's,

contracted syphilis, all from the same woman, "a prostitute or a model," in the back rooms of De Vink, the café they frequented when they painted on the River Gein. The essay also reports that Conrad Kickert, a painter who socialized with Mondrian, maintained that between 1906 and 1909 Mondrian "visited several times prostitutes. He was infected with syphilis three times, after which he according to tradition abstained fully from sexual intercourse." Kickert, whose syphilis was public, knew a lot about the subject.

The essay through which the claims of syphilis entered the canon of Mondrian scholarship focused on the painting *Passion Flower*, a portrait of a young woman which Mondrian painted in this period when Theosophy impacted him so deeply. The story told is that, in 1908, Mondrian was struck by the green coloring of the skin of a woman seated across from him in a train car and he was sure she had venereal disease. It has been deduced that "Mondrian connected this color with the symptoms of syphilis."

The subject of *Passion Flower* wears a low-cut, filmy white dress. It could be anything from a uniform for members of a religious order to a nightgown to a streetwalker's provocative getup. Her piles of hair reflect considerable effort, but now, facing upward with her eyes shut, she is in an otherworldly trance. Whether it is intense despair or ecstatic reverie that has captured her is as uncertain as the precise nature of her dress. Her pose also offers multiple readings. The painting stops at the woman's waist. The position of her arms, of which the skin tone is pale as a ghost's, suggests that she has her hands clasped; they could be over her genitals, but they could be slightly higher or lower. She could be holding them as Eve does fleeing the Garden of Eden, covering the source of her shame. But perhaps she is simply being modest or has interlocked her hands in penitent prayer. Or maybe the woman called "Passion Flower" is masturbating.

Is this a painting of a prostitute with syphilis or of a religious acolyte in a moment of piety? Do we agree with the viewers who consider this strong-jawed, thick-necked person exceedingly masculine? Is her garment meant for a spiritual rite, its white a mark of purity, or is she a hooker all gussied up?

Whatever its meaning, the deadly earnest *Passion Flower* gives the viewer the uncomfortable feeling that occurs when one faces someone absorbed by his or her own mysterious emotional state, flaunting an air of being overcome while keeping its origin secret. Most of Mondrian's art, before and since, celebrates visual splendor; whether it depicts dunes and the ocean or is purely abstract, it exemplifies certainty and the skill to communicate it. *Passion Flower* was the antithesis.

Madame Blavatsky deemed a celibate existence imperative to the receipt of occult knowledge. We do know that Mondrian stopped going to De Vink as he became increasingly allied with Theosophy. If *Passion Flower* was

painted in 1908—there are different theories concerning its date—and if Mondrian indeed had syphilis, and if he focused on venereal disease as his artistic subject, it was the most autobiographical painting he ever made. It was, in that case, the revelation of what he perceived as the dangers of sexuality and his choice of abstinence. If this is a portrait of a syphilitic whore, felled by the illness Mondrian feared in himself, *Passion Flower* announces his rejection of complication in life and the arrival of spiritual light, evident in the symbols around her. Was Mondrian revealing himself plagued by a sinner's guilt and extolling the otherworldliness and the transcendent state achievable through Theosophy? All of this would, in that case, be a stepping stone to abstraction.

Mondrian had already, on one occasion, escaped a source of torment and taken flight—to Brabant for a year. The time near Oele had been another period of self-imposed isolation. Both attempts to live in the countryside had been a deliberate effort to distance himself from emotional complexity. Does *Passion Flower* illustrate another form of renouncement? Does it add the element of shame to the idea of vice? If so, should we see those painful feelings as the catalyst to what would soon follow for Mondrian: a life devoted to ideas of universal perfection, when everyday existence consisted of extending a line by two inches on one day and reducing it the next, relocating a plane of color and then, a week later, fine-tuning its position? Was Mondrian in Paris like one of those characters in Tolstoy who ends up in a convent to cleanse herself of a previous life of sin, who focuses on goodness and godliness because the "self" has become intolerably frightening?

XVIII

In 1908—here the date is certain—Mondrian made a painting he called *Devotion*, which has many of the same elements as *Passion Flower*. It, too, is a portrait of a young woman with flower blossoms next to her. The following year, Mondrian would write a letter to a well-known critic, the writer Israël Querido, to explain what was on his mind when he painted it. While she is lost in her own state of mind with the same total absorption as the subject of *Passion Flower*, the girl in this painting is, rather than gloomy, rhapsodic. Knowing why Mondrian presented this ten-year-old girl in such an ecstatic state will tell us a lot.

Following the three-man show at the Stedelijk at the start of 1909, there was sufficient interest in Mondrian for Querido, who had been writing a series of articles about the artist in *De Controleur*, to print—"with the painter's permission"—the letter in its entirety. *Devotion* had been both attacked and admired during the exhibition. Mondrian's letter makes clear his wish to

Passion Flower, c. 1901 (later?),
Kunstmuseum Den Haag

advocate against materialism and to elevate some greater value better suited
to the modern era.

The girl in *Devotion* is giving thanks; her prayer is one of gratitude, not
of supplication. For Mondrian, the appreciation of life's miracles was vital.
He was determined to use art to convey his reverence—for seeing as for the
entire universe. He told Querido that the success of a painting depended
on its capacity to invoke its maker's convictions. "I believe that a painter's
conscious spiritual knowledge will have a much greater influence upon his
art, and that it is merely a weakness in him—or a lack of genius—should this
spiritual knowledge be harmful to his art."

An artist was at risk, even if he had had powerful spiritual experiences, of
not being able to provide them to his viewers.

Should a painter progress so far that he attains definite firsthand knowl-
edge of the finer regions through development of the finer senses, then
perhaps his art will become incomprehensible to mankind, which as yet
has not come to know these finer regions. . . . I do not know how I shall
develop, but for the present I am continuing to work within ordinary,
generally known terrain, different only because of a deep substratum,

which leads those who are receptive to sense the finer regions. There-
fore, my work still remains totally outside the occult realm, although I
try to attain occult knowledge for myself in order better to understand
the nature of things.

At age thirty-seven, Mondrian was devoted to being awake to what was
sacred and lasting. His life's task was to feel and convey the "finer regions"
clearly and effectively. "I observe my work attaining greater consciousness
and losing all that is vague."

In his painting he was trying to enter territory that had nothing to do
with the pulls of everyday existence. "Art can provide a transition to the
finer region, which I call the spiritual realm," he wrote the sympathetic
Querido. Mondrian was determined to follow "the path of ascension; away
from matter." At the same time, he felt he would only achieve his task of
comprehensibility if his painting avoided the occult and retained its straight-
forwardness. *Devotion* was an effort to express purity in a form that could be
readily grasped.

XIX

In the summer of 1910, Mondrian again took a job making bacteriological
drawings for Professor R. P. van Calcar. It now required him to live in Van
Calcar's home, near Leiden. While his friends with money were heading off
for summer travel or to the seaside, he packed his couple of suitcases and
took the train so that, in a small room tucked away in his employer's large
house, he would live almost like an indentured servant. He did not mind it
in the least.

Mondrian wrote Aletta de Iongh that it suited him to do the microscopic
work to bolster his income. He preferred it to making paintings designed
to please popular taste; the idea of churning out the sort of landscapes he
could easily sell, or doing portraits designed to flatter and please bourgeois
patrons, seemed a form of dissembling. The work for Van Calcar had greater
integrity.

Besides, it was a welcome part of his learning process. In taking on his task
load for the biologist, Mondrian was instinctively attracted to the emphasis
on precision and measure. The obsession over millimeters appealed to him.
Accepting the reality that, for now, his financial needs completely compro-
mised his life by necessitating the move into someone else's family home in
a city far from Amsterdam, he learned to work with the meticulousness, and
the awareness of the subtle difference the slightest variable can make, that
would become utterly essential to him. And the way of life suited him: He

wrote De Iongh, "And it is rather fun for someone with aristocratic leanings like me to spend some time in a villa with plenty of servants!" Besides, the biology professor's children were "very sweet," and he was pleased that his host did not eat meat, which meant that he was not expected to do so. For Mondrian now followed, at least to some extent, the rules of conduct at the core of Theosophy, vegetarianism among them.

In June 1910, the first issue of a Dutch magazine devoted to Theosophy—*Eenheid: Weekblad voor maatschappelijke en geestelijke stroomingen* (Unity: A weekly journal of social and spiritual trends)—was published in The Hague. Its articles focused not only on vegetarianism but on Buddhism and "sexual purity in body and spirit." Mondrian subscribed from the start, and gave a subscription to Spoor as well. He made the rare gift to Spoor of the relatively costly subscription to this new esoteric periodical because he saw Theosophy as a torch to a glorious path in life; he wanted the friend with whom he spent time in Domburg and who had shown with him at the Stedelijk to benefit from the same faith.

If Mondrian strictly adhered to the tenets of Theosophy promulgated in this publication, that decision would have required his giving up a sex life—if in fact he had one—regardless of what its nature was. The only situation in which conjugal relations were deemed acceptable was marriage between a woman and a man, with sex as a means of procreation. If Mondrian's own quips late in life, when he referred to "no longer" seeking the services of female prostitutes, were truthful, it meant halting visits to brothels. Given the prevailing standards of "morality" for women of the social class of Mondrian's fiancées, it is highly unlikely that he slept with any of the girlfriends whose visits he had juggled the previous spring; the only women available for sexual relations were the sort who sold their services at the De Vink café.

Mondrian would in the 1920s tell the Belgian Surrealist E. L. T. Mesens, who was urging him to join an outing to a brothel, that "every bit of semen expended is a masterpiece lost." He may have really believed that. Mondrian's drive to create artistic masterpieces superseded everything else in his life. What is unknowable is whether he considered sexual satisfaction an impediment to the highest caliber of artistic creation, and abstained sacrificially, or was finding a rationale for desires he unwittingly stifled.

XX

With Aletta de Iongh, meanwhile, Mondrian communicated at a deeper level than with other people. After De Iongh spent some time in a small rural town, he weighed in about his own relationship to rural life. "Just like

you, I wouldn't be able to lead that kind of quiet life all the time, and I like *living* in a big city. Like you, I believe that when you are alone in nature, you have the best chance of getting really close to it."

Mondrian also told De Iongh that he had no expectation that the larger public could discern artistic quality any more than they noticed the nuances of nature. As he had said to Querido, he accepted the insensitivity of the masses and had no dreams of converting them; his only hope was to proceed with his own work. "But most people aren't as sensitive in that respect, as I expect you have often noticed yourself." Mondrian's own sensitivity was intense. Having taken a break from work with Van Calcar to spend six weeks in Domburg, he wrote her:

> How lovely the flowers are in Zeeland, too, don't you think? Have you noticed? I think it is because they are so beautifully set off by the little white houses, and because they grow in drifts of the same type. Flowers are so exceptionally delightful, I find. There were such lovely ones last week on that square behind Brijman. The sky, too, has an extraordinary effect on me.

De Iongh wrote Mondrian that the last time they met she had found him greatly changed. He responded with remarkable self-awareness: "That is just superficial: I'm still the same, just a little more balanced, if I'm not mistaken. The study of Theosophy has been a great help. I find it very useful: it is truly an aid in the development of consciousness."

He was pleased that De Iongh had organized her own Theosophy instruction with a qualified expert, but he opposed her attending the seances that had become part of her pursuit of the occult. Mondrian was emphatic that she needed "regular study" to acquire a true knowledge of "spiritism—a means of demonstrating that there is a more refined kind of existence than that which we perceive in our wakeful consciousness, but for the layman it is playing with fire. . . . What I advise you if I may is: don't attend any more seances. Doesn't do the nerves any good either. Occultism is very different: there is preparation there, which allows for more spirituality."

In early October, winding up his sojourn at the seaside resort, he told De Iongh that, following a quick return to Amsterdam, he would go back to Leiden to work and make some money.

> It is quite beautiful here now: the woods are looking more attractive, too. But I have no time for all that, as I have to leave so soon. I spent most of my time studying dunes and churches. Unless you focus on a small number

of things, you risk failing to make anything of all the beauty there is, don't you think? Well now, my dear Letta, warm wishes as ever from Piet.

De Iongh had been correct in noting a change in him. His new concentration and spiritualism now defined him, and his art had undergone a transformation.

Since arriving on the edge of the dunes in the last week of August, Mondrian had worked almost exclusively on a single large blue-and-yellow painting of the sand and sea. *Summer, Dune in Zeeland* was one of the biggest canvases he had ever painted. It is possible that he had already started it the preceding autumn, following his time in Domburg that summer; at the latest, he had begun it early in the current year, because he had shown it in the St. Lucas Society spring exhibition. Presumably he had considered it finished when he put it in such an important show, but this had not stopped him from taking it to the actual spot so he could revise it further a few months later.

Mondrian was developing what would become a lifelong habit of perpetually adjusting his colors and the measures of his lines. This painting was a first foray into a new reduction of his palette, and it demanded unprecedented precision so that he could maximize the rhythm and achieve a certain balance. Mondrian did not want simple equilibrium; rather, he sought a rich interplay of disparate elements. He was working toward the perpetual movement that would underlie all of his work in the future. He calibrated his compositions to be as complete and resolved as an engine operating with maximum synchronization of the parts. Everything was cohesive, yet

In the early years, Mondrian often changed the style of his hair and the form of his beard and mustache. This photo was taken in 1910; a year later, he would be clean-shaven, with his hair brushed flat.

a straightforward mirroring of top and bottom, or left and right, or a neat display of concentric forms, would have been insufficient. Simple formulae could not apply.

Mondrian presented worlds as complex as the inner workings of the human body or the entire earth with its variables of life on and in sea and land. He evoked multiplicity, but with the different aspects carefully coordinated in relation to one another. In this large canvas on which he was still working away, every angle, and every variation in the light intensity of the single yellow and single blue, had to be just so.

Even during that longer stay in Domburg, Mondrian did not complete *Summer, Dune in Zeeland* to his satisfaction. He continued to work on it in his two-week interval in Amsterdam before returning to Leiden. He was about to reenter the world of infinitesimal detail, making microscopic drawings that required delicate handwork to achieve utmost accuracy. He knew how laborious the exercise would be, and how confined his life would be as a paid employee in the house of his boss's family. With the enormous canvas in front of him, he was immersed in an opposite universe. This was a broad and sweeping vision, generalized rather than meticulous, spectacularly loose. He was painting the essence of freedom.

Mondrian had reduced his vocabulary to large patches of blue—subtly gradated, some with a hint of yellow in them—on a white background. There was very little else. He had reworked the tonalities and dimensions so that the minimal elements have full force. The result of his intense and prolonged labor is sublime. *Summer, Dune in Zeeland* gives the deceptive impression of having been accomplished in a state of complete relaxation. Four feet four inches high and six feet four inches wide, the painting has a boldness that engulfs the viewer because of its overall size, the force of the brushstrokes, and its resolve.

When it was first shown, in its earlier incarnation, at the St. Lucas spring exhibition, this brave and unusual artwork had been attacked. The critic for *De Telegraaf*, C. L. Dake—who was Mondrian's former drawing professor at the Rijksakademie—wrote that, having seen *Summer, Dune in Zeeland* at a distance of between six and eight meters, he calculated that thirty-eight meters was the minimum required, for only then might it read as dune, sea, and sky. "There was no need for so much chemical-opting splashing about. . . . The piece could best be reduced to a sixteenth of its size." Nathan Wolf, in *De Kunst*, wrote this was "no longer the art of painting, even no longer art." Another reviewer declared, "The structure is unsound . . . too much subordinated to the effort to find expression for the spiritual semblance." At least Conrad Kickert defended the work in a minor Dutch newspaper, while admitting an initial struggle to understand it. This "simple dune . . . at first

twinkles before your eyes but in times becomes very satisfactory—the vibrating sun blazes upon whitened sand."

Today, when the human eye has become used to looking at large paintings that teeter between abstraction and representation, we quickly perceive the finished painting—which had progressed considerably between its showing in April 1910 and its completion that autumn—as a dune landscape. So long as we are not right up against it, the reflection of the blue sky on the white sand is easy to apprehend. The majestic scale and spareness of the brushwork soothe rather than intimidate us. The generous dimensions, and Mondrian's painterly élan, infuse this image of the land's end and the distant horizon with the physical and spiritual grandeur they warrant. The rich blues penetrate us. Mondrian had succeeded in elevating his art to the spiritual plane he was more and more eager to inhabit.

XXI

Once Mondrian returned to the Van Calcars' house in Leiden that October, he would remain there making his bacteriological drawings until the following spring. The alternative was penury, and the situation was agreeable. Mrs. Van Calcar took Mondrian to concerts. He had changed his taste in music, writing De Iongh that he considered Haydn and Mozart "too weak and tame and of course Saint-Saëns better." The "of course" was because Mondrian now deemed what was recent and modern superior to the old, and even if Saint-Saëns's symphonic poems seemed opposite Mondrian's taste, at least the composer was French. Mondrian was increasingly antipathetic to everything German or Austrian; his dislike of all he considered Germanic would eventually replace his anti-Semitism as his reigning prejudice.

Living with the Van Calcars, he was free to take off during work holidays. Mondrian spent Christmas 1910 in Arnhem with his widower father. However much the literature on Mondrian insists on his alienation from his natal family, he remained loyal and devoted to the downtrodden Calvinist now living in retirement. But he was hatching a plan to move from the Netherlands.

XXII

With his taste for Saint-Saëns and his membership in the Indépendants, the artists' society created in 1884 to exhibit work by individuals whose paintings were too experimental for the well-established Academie de Beaux Arts, Mondrian nodded toward France. In an exhibition in Nantes from January through March 1911, he showed two paintings for which he used French titles—*Soleil de Printemps* and *Matin d'été*. It seemed possible that, in the

country where modern painting was flourishing, he might actually survive as an artist. That spring, Mondrian's *Soleil* was admitted to the Société des Artistes Indépendants show in Paris. Paul Signac was its president, and Braque, Derain, Matisse, and Picasso were all active members. His first painting ever shown in the French capital, it had the spiritualism inherent to Theosophy. The canvas exulted in the force of the sun as a weightless star that provides light and warmth to the earth.

But the crosscurrents between Paris and Amsterdam were not all to Mondrian's taste. The spring St. Lucas exhibition featured twenty Fauve paintings by Kees van Dongen, a Dutch artist living in Paris. Van Dongen had gone further than most Dutch artists in breaking from Academism, and Mondrian appreciated his temerity, but this was not his sort of painting. He canceled his membership in the St. Lucas Society. He then resigned from Arti et Amicitiae; separating himself from the two most established organizations for young artists in the Netherlands, he decried all he deemed trendy rather than based on serious vision. While he never would have acknowledged it, Mondrian was echoing his father by breaking unceremoniously from former allies.

Mondrian no longer really belonged where he was. Sluijters and Kickert talked to him about Cubism as it was developing in France and showed him reproductions of still lifes and portraits that, while at first scarcely legible, had decomposed bottles and vases and men in hats and naked women and reassembled them to allow viewers to feel they were seeing these elusive subjects from multiple directions at once. On Saturday, May 13, 1911, Mondrian took a train to Paris. He wrote Aletta de Iongh that the trip "would be very instructive"; he was "gradually getting back to my work again" and was counting on Paris to help make that happen.

Like his first journey to Brabant, that maiden trip to Paris was a cautious investigation to enable him to evaluate another way of life. He explored the French capital, and at the latest Salon des Indépendants delighted in seeing one of his own paintings exhibited with the latest groundbreaking art. He sent a postcard of Notre Dame Cathedral to Simon Maris, writing, "I benefit a lot from being here. Everything is great and grandiose."

But even if life in the French capital beckoned, a few months later Mondrian would declare his plan to live as a married man in the Netherlands.

XXIII

When the Moderne Kunstkring opened its International Exhibition of Modern Art at the Stedelijk Museum in 1911, Mondrian's *Evolution*—a large altarpiece-like assemblage of three oils on canvas—brought viewers to a halt.

Gaudy in color, devoid of subtlety, emotionally wrought, the behemoth is a deliberate representation of inner vision. It shouts "I have a message." Its aura of profundity made people afraid to ignore it, which would have been like not listening to a church sermon. In this exhibition of which the centerpiece was twenty-eight paintings by Cézanne—who had died five years earlier—*Evolution* was an anomaly that begged for, and succeeded in attracting, attention.

This unappealing trio of images is a biographical gold mine. Mondrian had, with relentless earnestness, taken it upon himself to depict the stages of human existence as he now perceived them. He presented the soul on a journey from materialism to spiritual freedom. It can be seen to represent his vision of his own inner life as he approached his fortieth birthday.

The concept was attractive even if the voice was devoid of the subtlety requisite for Mondrian's art to succeed. The soul in each of its three stages appears in the form of a bizarre naked woman. She changes in character, but she consistently has thin and flaccid arms, broad shoulders, and small breasts. Although the lower edges of the canvases slice her mid-thigh, she appears very tall. On the left and right, large geometrical flowers sit atop her flat shoulders—as in *Passion Flower*—giving the impression that she is carrying the weight of the world. She is relieved of that burden in the middle image, where a fiery yellow-and-white octagon suggesting angels' wings frees her of the heaviness.

Van den Briel identifies the woman as "Liesbeth," from Laren. Still, even if Mondrian used a particular individual as his model, she has been abstracted beyond recognizability. In all three of her renditions, the woman is essentially incorporeal. Geometry, rather than flesh and blood, rules. Her head is a compendium of straight lines and sharp angles; with its razor-sharp chin and jawline, it resembles a steel helmet.

The woman's body could make one wonder if Mondrian had ever actually seen a naked woman. The vagina resembles a little boy's drawing of one. Prepubescent boys commonly envision the female genitalia as the absence rather than the presence of something. In the triangular vertical slit extending between the separation of this woman's legs toward her navel, Mondrian, nearing age forty, has rendered it as a child would.

All three images of this naked woman are desexualized, and quintessentially uninviting. In the versions left and right, everything is closed tight: her eyes, her mouth—and, of course, her sexual organs. The only openings are within the symbolic flowers.

On the left, the woman symbolizes an attachment to what is material. She has her eyelids sealed and clenches her teeth, regretting the wastefulness of her ways. The right-hand image symbolizes the next stage of the progres-

sion toward a better life: although the woman still has her eyes shut, she now looks serene for she is perceiving the divine and the holy light.

The middle canvas is the summa, an allegory of the ascent to purity. She is less fleshy—her breasts and hips are not as pronounced as in the other renditions—which is what enables her to rise higher than they. Her disklike eyes fathom the truth. Those oversized orbs indicate vision on its highest level.

Mondrian wrote a friend, Arnold Saalborn, brother of his former student Louis Saalborn:

> I think the ordinary human being seeks beauty in material life, but I believe the artist should not do this. He should wish for nothing from the material world: he must be alone and stand alone. He must create on a level that is immaterial: that of the intellect.

Mondrian was stating the goals which would guide his life. "Being alone means (to the great) turning to the inner self, to self-knowledge, knowledge of humanity, of the man-god and the divine." His primary purpose, he was convinced, was to reach that "divine." In order to achieve that, the seekers must search their souls, and meditate, in solitude. They must escape life's normal distractions. That was the elevated state he presented in the largest,

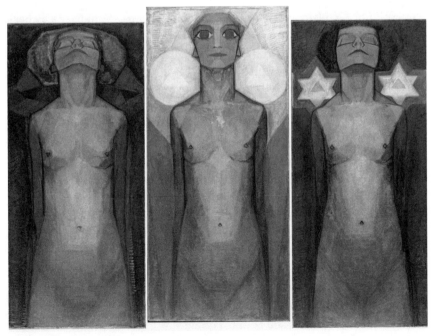

Evolution, c. 1911, Kunstmuseum Den Haag

victorious creature in the middle of *Evolution*. He wanted to create paradise. That triumphant, ascendant character encapsulates the attitude toward human conduct which was hardening in him. Her weightlessness and vision endow her with a state of serenity. The other two grimace, and have their necks tilted backward in pain, while she is in balance. She represents Mondrian's own ideals of being free of erotic desire and removed from materialism. The triptych depicts asexuality as the highest state of being.

XXIV

On October 9, 1911, a review in *De Telegraaf* singled out the triptych, commending its quality of tone and color but declaring the subject "tedious" and in need of a text if one was to understand it. A popular painter wrote a widely read criticism lamenting Mondrian's "astral manifestations." Mondrian's fellow painter Lodewijk Schelfhout "collapsed against the sofa laughing" when he saw it in the exhibition. Mondrian wrote to Schelfhout that the guffaws had been reported to him. An article in *De Controleur* on October 14 identifying the artist of *Evolution* as Frits Mondriaan—confirming Mondrian's uncle's worst fears—described the "three gigantic blue human figures, all with square eyeballs, in such relief that they bulge through the eyelids." The critic for *Het Nieuws van den Dag* on October 25 said, in reference to *Evolution*, that other work by Mondrian "led us to expect more from this painter." On October 30, in the *Arnhemsche Courant*—Mondrian's father's local paper—there was a reference to "bluish green misses with reddish blue eyes, a representation of 'evolution,' of which no one knows what to make, the painter probably included."

Some pundits, however, were more sympathetic. A review in the *Nieuwe Rotterdamsche Courant* on October 12 commended the modeling of the figures and the "penetrating expression in their features devoid of all earthliness." On the fifteenth, Willem Steenhoff, an art critic who was deputy director of the Rijksmuseum, offered stinting praise: "However immature this work may be—and certainly not strong in its basic idea—there is nonetheless a bearing which impresses."

Mondrian did not seek out all the reviews or read the papers every day, but it was painful to have his work called "immature." He was grateful when Saalborn, writing about *Evolution* in *De Kunst*, saw the three canvases as he intended. Saalborn discerned Mondrian's essence. In this article, which appeared on November 4, he describes *Evolution* in depth, saying that on the left and right the woman is "desiring happiness," while in the middle "she possesses happiness, and is able to grant it without ceasing as long as she

lives." Saalborn commends "the delicate beauty and elevated, noble purity of lines and tints . . . the intensity and the sincerity of this dream of sensations, the sacred more than the human ecstasy of happiness." The wide eyes of the central figure indicate, according to Saalborn, a degree of happiness beyond any joy the viewer could possibly know personally. The critic goes on: "Through all of this Piet Mondriaan seems to me a person of genius."

Saalborn observes that Mondrian "carries the fatality of his subtle geniality." He explains: Mondrian does not construct "toward the outside, toward the beyond, as did the Sphinx builders and Michelangelo, as did Dante," but "constructs toward the inside, toward the unfathomable depths and tenderness of the soul, as does the bee, forming its cells and filling them with golden honey." It took rare prescience to recognize the drive for universal beauty that was part of Mondrian's own evolution, and that was soon to take a new form in his art.

XXV

The same fall that Mondrian completed and showed his altar-like exegesis on the three stages of human emotional and spiritual development, he became engaged to marry.

Greta Heijbroek was from a solid bourgeois family. Her father was an Amsterdam merchant, her brother, Marius, a banker who collected Mondrian's paintings. In the spring of 1909, the widow Heijbroek and her son, intent on cultivating Greta's artistic gifts, had hired Mondrian to be her private art teacher.

It was a courageous choice. Mondrian, well known in the aftermath of the Stedelijk show, was a painter people either loved or hated, and while the Heijbroeks' son had the vision and independence to buy his work, many people considered his art a mark of madness. The Heijbroeks did not consider that the thirty-seven-year-old artist to whose studio their twenty-five-year-old daughter was going for those painting lessons would pursue her romantically. In any case, he was juggling the visits of other female visitors; this was when Eva de Beneditty imagined Mondrian becoming her husband, and Aletta de Iongh and Marie Simon—secretary of the Theosophical Society—were seeing a lot of him as well. Still, the connection with Heijbroek was personal enough for her and Mondrian to visit her brother's country house in Laren that April. What happened over the next year and a half is unknown, but in October 1911 there was an engagement party for Mondrian and Heijbroek in that same lovely villa in Laren.

Kickert and Schelfhout attended that celebration. They looked forward

In 1911, Mondrian became engaged to marry Greta Heijbroek. She was from a prosperous family, and they appeared to be a perfect upper-middle-class couple. Shortly after this photo was taken, he broke off their relationship precipitously.

to seeing their friend at the altar, and thought it was high time he married. Later that month, at the opening of the Moderne Kunstkring exhibition, Mondrian presented Heijbroek to Jan Toorop as his fiancée; the upcoming marriage seemed a sure thing. Mondrian's friends approved his taste and were anticipating the wedding as a luxurious event where there would be great reason for merriment. In Mondrian's artistic circles, few people other than Kickert and Simon Maris could afford anything other than cheap wine; now there would be champagne in crystal flutes and joyous toasts to start people drinking it. Planning his life with a woman from a family with means, Mondrian was heading toward bourgeois stability and secure domesticity. His days with anarchists were a thing of the past.

We know nothing of what happened next except that by the start of 1912 their engagement had ended, and Mondrian had moved to Paris. Greta Heijbroek was as surprised as everyone else was. Yet again, an artistically inclined woman from a wealthy background had thought she was having a serious romance with Mondrian, only to have him retreat abruptly. And Mondrian had again felt impelled to escape a way of life which, even if it had been the dream of a moment, no longer suited him in the least.

Paris, 1912-1914

I

On Wednesday, December 20, 1911, Mondrian filed documents at the registrar's office in Amsterdam to establish his legal residency outside the Netherlands. He wrote to Kickert, who was back in Paris, to see if he could find him a place to live, and tried to sell off the small remaining stock of his older pictures. His friends who had more money helped him out; Simon Maris paid one hundred thirty guilders, the equivalent of $1,600 today, for a substantial group of paintings and drawings, and Schelfhout bought him his train ticket.

Mondrian left his remaining unsold paintings with Van den Briel and another of his friends, Anna Bruin. Bruin, a pharmacist, who had been living in Amsterdam and recently moved to The Hague, was among those loyal enthusiasts who occasionally sold work on his behalf.

Shortly after having adhered to Dutch law by establishing that he was no longer a resident of the Netherlands and therefore could live abroad, Mondrian boarded the southbound train for the capital of France. Unattached and with few possessions, he intended never again to live in the country where his ancestry went back for as long as anyone knew.

Mondrian had delivered his surprising information to Greta Heijbroek that their wedding was off only a few days before filing the paperwork to leave the Netherlands. He would later say that he had thought he could live a fantasy until realizing that he was incapable of it. A side of him still idealized marriage and the emotional and financial security he would have had in the Netherlands, but having recently conceived and executed his oversized allegorical triptych *Evolution*, Mondrian now had his own epiphany. He acknowledged to himself that he was inherently different from the self he had imagined.

Mondrian wrote to Aletta de Iongh the following January about his almost having become a husband. He does not refer to Greta Heijbroek by name; it is almost as if she was a concept more than an individual. He tells his confidante that he had stepped with one foot into a lovely, alluring domain, and then withdrawn it when he woke up to the recognition that he in no

way belonged in the territory he had imagined entering. The deal-breaker was his realization of who he really was. Mondrian understood what had attracted him, and also why he had to retreat.

The episode had been exquisite, he informed De Iongh, but its termination had been essential.

> I expect you heard that I nearly got married last autumn, but fortunately I realized just in time that it was nothing but an illusion, all that sweetness and light. Although I have always lived for my art, the good life also attracts me, which is why I sometimes do things that seem out of character.

He describes his new existence in Paris, where he was living on the avenue du Maine, a busy thoroughfare not far from the gare du Montparnasse:

> To start with it was all a bit nerve-racking, as you can imagine, what with all the unfamiliarity and new insights and so on. But now I feel just about the same as I did at Sarphatipark in Amsterdam, only my room here is tiny, although the studio is the same size. And it's no more expensive for me here than in Amsterdam, and much more instructive, obviously. It's wonderful, the way you can just be yourself in a big world city like this. I bet you envy me for being here!

In the metropolis, he could construct an existence in which he could live with his new self-knowledge. His private desires and needs were his to manage in his own way. He could stop playing a role and could give up what he now saw as theater. He was possessed of a joy and exhilaration that would infuse the paintings he would soon start to make. His vision was now so clear, pure, and celebrative that those qualities would, through his art, penetrate viewers. Mondrian was married to life itself.

Cubism became the means through which Mondrian could launch himself. In his new and streamlined existence, he would push his art toward the same candor that underlay his human relationships. Cubism offered toughness and integrity. It made the impact of the surface a secondary issue to the raw essence of his subjects. The intricate compositions of Braque, Picasso, and Juan Gris beguiled Mondrian for revealing the underpinning of things. The way that objects and people occupy space and displace air was the crux of the matter. What Mondrian gleaned from the new painting that had riveted him on his first short trip to Paris, and now became his focal point, was a new way of seeing, a totality of perception that revealed the impact of every element on every other.

Mondrian's willing acceptance of an artistic approach not of his own invention permitted him to grow. He had the confidence to be a follower and acknowledge it. His exploration of Cubism would lead him on his own way, even if he lapsed into a degree of imitation that was unusual for him and inspired a rare level of mediocrity in his painting.

The Cubist geometrizing of form became a guide to Mondrian. That rhythmic movement of small units, energized by their juxtaposition to one another at carefully calculated intervals, would underline his work from this point forward. So would the relationship of their colors conceived with utmost attention to every nuance of hue and light intensity; the animation of the picture surface would be echoed in his own work. Reverently studying Braque's and Picasso's careful orchestration of multiple elements, he marveled at the flow that was both harmonizing and replete with ceaseless surprises. It was vital to all of his future painting.

Mondrian's own version of Cubism was impressively rigorous, yet it lacks the charm and poetry of the best work by his Parisian confreres or of his own subsequent art. The lessons of Cubism, once he applied them in a more original way, would serve him beautifully, but he did not paint masterpieces in the new idiom. The switch in the artist's style when he arrived in the French capital was a detour, even though it had great benefits. Eager to learn and advance, trying new techniques in order to develop his own voice, he initially produced some rather murky paintings that, if we came upon them out of context, without knowing in advance who the artist was, we could take to be by a number of second-tier practitioners of Cubism. They had value as stepping stones in Mondrian's search for order and control in the expression of infinity, but they were more like student exercises than giant steps.

Still, they were a stride forward. Via Cubism, Mondrian changed his art almost as radically as he had altered his life plan. Experimenting with this breakthrough approach to painting, he was coming closer to the language that would most effectively enable him to express the universal. With the move to Paris, Mondrian was reformulating both his own existence and his style. Inside, he was the same person and the same artist he had always been, ruled by the same passions, but the presentation would be different, and presentation was everything.

II

When the 28th Salon des Indépendants opened on March 19, 1912, Piet Mondrian joined, for the second time, the list of distinguished artists shown

by the rebel organization. He had been in the Indépendants exhibition the previous year, with his painting *Soleil*, for which reason he had made his short trip to Paris that April; now he was in the important show as a Paris resident.

Mondrian had not yet been in Paris for a full three months, but his entries in the 1912 Salon instantly made him a major figure in the world of the city's avant-garde. Guillaume Apollinaire wrote in the newspaper *L'Intransigeant* that Gallery XX, which had three of Mondrian's latest oil paintings in it, was "perhaps the most important gallery of the salon." Mondrian's paintings were in the company of major work by Gleizes, Le Fauconnier, Léger, and Metzinger; Mondrian and Léger were the stars of the group, and Apollinaire's declaration had incalculable weight.

The exhibition catalogue states the artist's name as "Pierre Mondrian." He used classic French titles for his pictures: *Dans le Jardin*, *Dans la Forêt*, and *La Fruitière*. This last one—of a woman selling fruit—is the same canvas which later became *The Large Nude*. This is not because Mondrian in any way altered the painting as he had many others. The reason it could eventually be given a new title so different from its original one is that its representation of its subject is deliberately so nonspecific that what could be read as a fruit seller's white apron could just as easily be seen as bare flesh. The central

The Large Nude, 1912,
Kunstmuseum Den Haag

figure is vaporous, as if emerging like smoke from the stone-colored solid structure that has more reality than she does. To be human is to be temporal, more spiritual than physical.

The metamorphosis of Mondrian's representation of the human figure was analogous to his personal development. While a few months earlier he had publicly announced his intention to live as a married man, now he had become, at least emotionally, celibate. Rather than turning into a family man with all its responsibilities, he had opted for an ascetic way of life with minimal everyday needs. Without personal distractions or obligations, he had become able to purify seeing and distill art. *The Fruit Seller/Large Nude* reflects Mondrian's deliberate renouncing of earthbound physicality. Like the central figure of *Evolution*, he had moved toward what was universal and spiritual in both his life and his art.

To achieve his objectives, Mondrian had adhered rigorously to the principles of Cubism. The carefully constructed composition approaches the subject from multiple positions simultaneously, and minimizes color. It lacks, however, the animation of a Braque or the panache of a Picasso. The geometric division of the face seems more arbitrary than organic. While Braque's and Picasso's female sitters of the same time period have, for all their Cubist disjointedness, a persuasive grace and sensuousness, Mondrian's rendition of the woman on view—whether we see her as wearing an apron or as naked—is stilted. She could be a soldier standing at attention, or a ghost. And the painting, overall, is limp. The important French critic André Salmon was not being entirely unfair when he wrote in *Paris Journal*, after describing Gallery XX as the "royaume des Cubistes," "Mondrian does his Cubism as a blind person would, in his complete ignorance of the laws of volumes. His inspiration comes from Van Dongen!" Salmon saw Mondrian and some of the other recent converts to Cubism as setting back a worthy cause: "Such newcomers, alas! will drive public opinion to distraction, and will lead it astray for a long time."

Yet for all its limitation, *Fruit Seller/Large Nude* was an earnest attempt to go further toward generalized, nonspecific subject matter. And when Mondrian avoided the human figure—a subject with which he had never been at ease—his forays into Cubism had greater life. During his first spring in Paris, he made several still lifes and paintings of trees. More relaxed with leaves and branches and fruit and serving objects than with women, whether naked or clothed, he became warm and lyrical. Once he was away from the human figure, Mondrian enlivened the surface and infused the pictures with a delightful range of soft colors. His level of ease enabled him to imbue ceramic bowls and apples and nature as he glimpsed it from his studio window with charm and grace.

III

Having been asked to be on the selection committee of the Moderne Kunst-kring exhibition, Mondrian went to the Netherlands that summer. Scheduled to open at the Stedelijk on October 6, it was a show of vital importance in the furtherance of modern art. Conrad Kickert had asked him onto the committee, knowing that Mondrian would agree that Gauguin should not be the central figure as planned.

Kickert and Mondrian were more interested in the recent art they had discovered in Paris. They had their way: the exhibition ended up featuring six Braques, seven Derains, four Herbins, fourteen Légers, thirty-three Le Fauconniers, and twelve major Picassos.

Thanks to that show, Picasso became, at that crucial moment in his history, better known and appreciated in the Netherlands than anywhere in the world. Neither in France, where Picasso was now living, nor in Spain, where he was born, was the public as attentive to him. The Picassos in the 1912 Amsterdam exhibition included paintings that are now considered his Cubist masterpieces: *La Violiste, Verre et tasse, Verre et pipe, Homme à la pipe*, and *Mandoliniste*. Most of the other committee members had initially opposed the prominence given to Picasso, but Mondrian had persuaded them.

Mondrian himself had seven works in the Kunstkring show. Among them was *The Sea*, which he had begun in Domburg and completed in Paris. The waves that roll dramatically appear as if through the zoom lens of a camera. It is not unlike the images of cellular life greatly enlarged that Mondrian had drawn when recording what Dr. Van Calcar saw through a microscope; the focus and framing have a mysterious effect. The detail of the ocean recedes into the distance, but, because of the startling absence of surrounding space, the canvas presents something that is totally *other*. The surface of the rolling sea is an impenetrable plane, like a solid wall. At the same time, the water, moving nonstop, with all the mysterious qualities innate to that mixture of hydrogen and oxygen, suggests infinity.

Mondrian knew that he had little chance of selling this unusual painting. Nothing would make him stop pushing his art in new directions, but he had a keen awareness of the realities of the marketplace. He disparaged most collectors for their lack of courage and their inability to discern the best. He believed that, if given the chance, they could be counted on to choose what was prosaic over something more original and profound. A client, Miss Bine de Sitter, had been deliberating between his painting of a tree and the one of the sea. After having "the good news" that she had bought the tree, he quipped to Conrad Kickert and his wife, Mary, "That argues for the sea—n'est-ce pas?" With his essential contempt for bourgeois taste, Mondrian

accorded *The Sea* its superior position because it was too challenging for the ordinary collector. *The Tree* was second-rate because it found a client. "For just a little more money they could have had a thing of good quality. The tree isn't bad, but it's much weaker."

Mondrian's understanding of human conduct barred expectations of things being other than the way they were. He had no doubt that his art was getting stronger, but he knew with equal certainty that public taste could not possibly advance at the same rate as his painting style. "Ah well—perhaps I will sell the sea in ten years' time, because right now I'm selling the tree done in last year's way, and as sales are proportionately slower, I reckon ten years for the just-made sea. Buyers (nearly) always lag behind in their appreciation." Still, he was encouraged that three of his paintings were sold from the Kunstkring show. Even if he no longer wanted to live in the Netherlands, his native country was proving hospitable not just to the Parisian modernism he and Kickert had imported but to his own personal form of Cubism. It was as if his move to the hotbed of modernism made him go up in the esteem of his countrymen. The Dutch public, now more than before, admired his work and paid attention to his theories. Not only did his new way of painting enjoy an esteem among artists who were happy to lap up French sophistication but it was paying off financially with the collectors. Mondrian had never questioned the direction of his art, but now he could be confident that it would sell.

IV

By the time of the Kunstkring opening, Mondrian was treated as an important personage in avant-garde circles in Amsterdam. When he was invited to someone's house for dinner, he was invariably the guest of honor.

A lady named Catharina Hannaert, known mainly as "To" but sometimes with the nickname "Katinka," three years Mondrian's senior, had met Mondrian during one of his visits to Laren. She too had a country house in this small village. At the time of the Kunstkring show, she had recently returned to the Netherlands from Berlin, where she had gone to study voice and recuperate from the recent failure of a long marriage.

Hannaert was a woman of means, but she had chosen to live in a modest pension during her stint in the German capital; her lavish life with her husband had felt like imprisonment. She wanted to broaden her horizons, and simple living quarters full of young and creative people provided a better chance of freedom than did the upmarket hostelries in which she and her ex had stayed.

It was as she had hoped. In her inexpensive rooming house, Hannaert

met a young pianist and composer, Jakob van Domselaer. Hannaert and the musician from the Dutch city of Nijkerk became friends. They often went to concerts together, and when one of them decided to move back to Amsterdam so did the other.

Van Domselaer was as interested in exploring unprecedented ways of making music as Mondrian was in developing a new form of painting. When the composer told Hannaert that he would be visiting Paris that winter, she became adamant that he encounter Mondrian. Hannaert had met the painter whose name was on everyone's tongues at one of those dinners given by the committee during the Kunstkring show, and she felt that Mondrian would be excited by the gusto with which Van Domselaer discussed the artistic breakthroughs being made in Paris. Hannaert was eager to help the sympathetic and creative young man meet the artist who, eighteen years Van Domselaer's senior, would be sure to give him a leg up in the French capital. Mondrian had extended his time back in Amsterdam, and Hannaert hastened to organize a dinner before Mondrian returned to Paris.

The woman Jakob van Domselaer later married would recount pertinent details about Mondrian's idiosyncratic conduct that night in 1912. In 1959, following Van Domselaer's death, his widow, Maaike, would write some reminiscences about how, after Mondrian and the composer arrived at the house of their kind intermediary, the conversation started awkwardly. Van Domselaer, unassuming and modest by nature, asked a few respectful questions about Mondrian's work and life in Paris, but Mondrian either just stared at him blankly or gave staccato responses that left the younger man feeling as if he had hit a wall.

The dialogue was stilted and the silences painfully long. Since Mondrian was both eminent and a generation older, Van Domselaer was careful not to presume that Mondrian considered him anything but a waste of time, so he stayed reticent while Mondrian only made matters worse by registering no reaction. Hannaert could bear it no longer. Older and worldly, she tried to steer the discussion in a way that would engage the painter. Her gambit backfired; once Hannaert interjected a couple of innocuous remarks meant to break the ice, Mondrian went from uncommunicative to petulant.

The hostess persisted. Despite the antipathy Mondrian projected to the younger man, she remained convinced that the painter and the musician with such similar interests might potentially have a great friendship. She considered Van Domselaer intellectually brilliant and his easygoing manner a rare attribute in one so gifted. She was determined to get the taciturn Mondrian to relent.

Hannaert needed to go see someone on the Keizersgracht—the street

of fine townhouses where Mondrian had painted a ceiling decoration years earlier. She coerced Mondrian and Van Domselaer to accompany her. This, she knew, would force them to wait outside alongside the lovely canal while she visited her acquaintance. Hannaert assumed that, standing there, the two would have no choice but to begin speaking with one another.

The scheme failed. "And so Mondrian and J. continued to walk back and forth along a quiet dark canal, neither of them saying anything. The visit lasted quite a long time . . . not a word was spoken." Mondrian's indifference to usual social conduct, and his conspicuous lack of effort to put a younger and agreeable person at ease, was of a level neither Van Domselaer nor Hannaert had ever imagined.

Afterward, Van Domselaer made a simple decision. He would abandon his plan to write Mondrian a note about his intention to be in Paris. The notion that Hannaert had planted in the young musician that the artist might help him once he was in France needed to be dropped.

But once Mondrian was back in Paris following the Kunstkring opening, Van Domselaer was persuaded by Hannaert that nothing would be lost if he gave it a go anyway. At Hannaert's insistence, Van Domselaer wrote the artist with precise details concerning his scheduled arrival there. A few weeks later, toward the end of the given day, the young composer got off the train at the Gare du Nord and walked to the end of the platform. There was Mondrian.

Van Domselaer was astonished. He had not expected him to be there. More shocking still, Mondrian greeted him warmly, as if they were old and dear friends, and immediately told Van Domselaer that he had rented a room for him on the rue Jacob. Mondrian accompanied Van Domselaer to that quiet street in the Latin Quarter, near the church of Saint-Germain-des-Prés. After showing Van Domselaer the place where he would end up living throughout the winter, Mondrian proposed that they go off for dinner. All evening long, Mondrian was convivial to a fault. Knowing that Van Domselaer had never been in Paris before, he led him home after the last café closed. They reached the rue Jacob at 2 a.m. The autobuses had stopped running well before; by the time Mondrian had gone back to the boulevard Saint-Germain and then walked the length of the rue de Rennes to get on the other side of the boulevard du Montparnasse and continue to the rue du Départ, where he had moved from the avenue du Maine, it was probably close to three.

For the next several years, Mondrian and this man nearly twenty years his junior saw a great deal of one another. It was different from Mondrian's friendship with Van den Briel. Van den Briel had been like the most ded-

icated aide-de-camp, worshipfully devoted to the physical and emotional well-being of the man he treated like a god. Van Domselaer was not just an intellectual protégé but a rare younger person whose innate creative gift and passion for new approaches to music excited the painter.

Mondrian and Van Domselaer had a daily program. Once daylight had fallen at the end of his long workday, the artist would close up shop, cleaning his brushes meticulously and capping his paint tubes. He would then head off from the studio on the rue du Départ, walking alone until he met Van Domselaer at the *bouillon* on which they had previously agreed. The visual clutter of these traditional brasseries with ornate Art Nouveau wainscoting and marble mosaics, full of colorful stained glass reflected in shimmering mirrors, was the opposite of Mondrian's lean studio. Amid the optical cacophony, the middle-aged artist who had emerged from his white retreat and the young composer who had been working in his simple room quaffed Belgian beer and ate the staples of bistro cooking that suited their personal diets. As with Van den Briel, on weekends Mondrian saw Van Domselaer not just in the evenings but during the day as well. The friends whose first meeting less than a year earlier had been so awkward developed a Sunday ritual of long walks. Van Domselaer was accorded more speaking time than most people who had the chance to be alone with Mondrian. On Sunday evenings, Mondrian and Van Domselaer would visit the artists Peter Alma or Otto van Rees. But Monday mornings, it was back to work. In daylight on weekdays, there was no interruption. The routine was invariable.

V

Except for the rare occasions when he was with the few individuals whom he trusted totally, Mondrian existed in his own space. Paradoxically, he could sometimes go out of his way for other people. An acquaintance in Amsterdam, a man Mondrian hardly knew, sent him a letter saying that his son had taken a job as a waiter in Nice. The son was going to be taking the train to Paris, arriving at the Gare du Nord, and then switching to the Gare de Lyon in order to head south. Initially, Mondrian complained to Van Domselaer that he was miffed because the Amsterdam acquaintance had not frankly stated what he wanted, and was annoyed by the implicit request to extend himself for someone he had not even met. The future waiter was traveling from the Netherlands on a night train which would arrive in Paris at about 5 a.m. On his way to dinner with Van Domselaer the night before, Mondrian was livid that he would have to rush home right after the meal because he needed to get up at an ungodly hour to go to the Gare du Nord. Yet Mondrian had decided he had no choice; they had to make it an early evening so

that he could get to the station before dawn. "Well, you see, it was something I promised to do, but I am so afraid that I will oversleep."

Van Domselaer expected a hasty, unpleasant dinner. Yet the food and wine were unusually good that evening, and Mondrian's mood changed completely. By the end of the meal, Van Domselaer suggested that they simply forget the idea of going to sleep. Mondrian embraced the new plan as if it was the most original idea he had ever heard.

Mondrian and Van Domselaer lingered in the restaurant until it closed. They next went to a night café where they were allowed to stay until 3 a.m., after which they simply stood on the quiet sidewalk in front. Then they walked through empty streets toward the Gare du Nord.

As they made their way through the seedy neighborhood between the Gare de l'Est and the Gare du Nord, passing dark shop fronts and the occasional beggar, Mondrian and Van Domselaer were too exhausted to speak. Yet even in his silence, Mondrian was in wonderful spirits. By the time that Mondrian and Van Domselaer reached the Gare du Nord, it was raining steadily, but Mondrian made clear that, whatever Van Domselaer might have anticipated, he did not mind in the least.

Mondrian and Van Domselaer stood outside, positioning themselves against a wall to keep as dry as possible until the station doors opened when the train from Amsterdam—the first of the morning—arrived.

Then, as the train pulled in, Van Domselaer went home at Mondrian's request. The young man arrived. Mondrian, holding a sign with the name of this person he had never met, welcomed him warmly at the gate. He took the aspiring waiter to the Gare de Lyon, gave him a good breakfast, and saw him off on his journey to Nice. This was the story, start to finish.

VI

Between 1912 and 1914, Mondrian filled two pocket-sized sketchbooks, each about 4 by 6 inches, with rapid sketches. He drew the various stages of buildings being demolished. In some, the building façades remained largely intact; other sketches showed rubble. Alongside the sketches, he wrote down the essential ideas that would guide him and his art for the rest of his life. He reflected on life, time, matter, and forces beyond our control.

In the texts as in the drawings, a greater force matters more than the demolition of those buildings. What counts is that things can be *seen*—which is more significant than what they are. Matter exists. Air is in all the voids. Light is like a godly force revealing the vast scenario of life.

In these drawings which he made after arriving in Paris, as in the abstractions he would develop there, Mondrian evokes the ongoing processes tak-

ing place in any given moment: past, present, and future. Certain elements, consistent in all these drawings, cause us to feel in our hearts and our guts the sheer thrill of looking at something, the magnificence of that act of beholding what is visible and of having the extraordinary mechanisms within our brain that make it appear before us. Mondrian works the charcoal with great animation in the foreground. The viewer, absorbing the force and liveliness of the strokes, intuitively has a sensation of excitement. The specifics of what the vigorous black dashes represent are a secondary matter. What is pertinent is the process of making marks (as in cave painting), and then the events that occur as we look at those marks.

It has taken nothing more than the dexterous application of his charcoal pencil on paper to conjure what was an entire neighborhood. Human residences no longer habitable, the sense of what shelter means to people, the air and light that remain even when what was once carefully constructed has now been shattered: all come to life. We also bear witness, in raw and fundamental form, to the will to make art, the urge to communicate in a way that has nothing to do with words.

With his animated style, Mondrian opens us to a new awareness of the material of paper, the structure and chemical components of a stick of charcoal, the ability of the human hand to move that stick, the power of light to facilitate vision, and the miracle of eyes.

We proceed past the rubble of the foreground. Further into the drawings, the windows that belong to structures that have been condemned and abandoned appear as their essential selves: as opportunities created to allow illumination into interiors and also to permit people inside to look outside. Mondrian has evoked windows in a generic, timeless way. Now that they no longer have their functions, as remnants in walls of empty buildings, the purpose they once served comes into sharper focus. Mondrian's skill is in part his rare capacity to get to the universal essence of his subject. We feel windows as the brilliant, inventive devices they are at their core, and also as a source of the pleasures of geometry, their crisp right angles and horizontal/vertical interplay charged with rhythmic energy.

In these representational drawings he made in the same period when he was progressively eliminating subject matter from his large oil paintings, Mondrian establishes the essential elements of construction at its most fundamental. Walls are screens against the elements and vehicles for privacy. Courtyards are providers of essential open space. The presence of light and air—which Mondrian evokes like a magician with a wand—makes these drawings celebrations of the invisible as well.

In these settings where gravity exerts itself and invisible forces (centrifugal, magnetic) play in perpetuity, the verticals soar. They signify the human

ability to build, the intelligence and willpower that have enabled our species to go further than any other in housing itself. And the horizontals provide the solid footing without which such construction could not exist. These drawings are vignettes of Paris in 1912, but their essential components apply to all places on earth, in all time periods. This eternal beauty was becoming the core of Mondrian's life's work—and therefore of his life in its totality, with personal specifics and needs reduced to the bare necessities enabling him to present the collective and everlasting.

Mondrian had long been assured and confident in his artistry, but now he was on his game more than ever. He did not flaunt the sharpness of his draftsmanship—he had no instinct to show off—but used it to recapitulate and enhance his wider vision. Paris delighted him with its urban landscape, presenting, as if he had never recognized them before, the acts of construction and enclosure. He was responding full throttle. His stimuli had always been competent engineering and mechanical systematization. In his earlier work, he evoked them as they appeared in nature: trees growing in a glen, farmland changing in the seasons, waves rolling on and off sand dunes. Now, in his sketchbooks, he captured them in everyday urban scenery. In the studio, he was celebrating the same forces in still life. Regardless, nothing was ever static. Yet even when its notion was frenzied, it was coordinated. Mondrian worked in a way akin to the natural world—with invisible methodology and sturdy scaffolding allowing the magnificence of the everyday to exist and to be seen.

Mondrian could easily have walked, in fifteen minutes' time, to the Luxembourg Gardens. There he might have made his subject a row of perfectly manicured flowering trees or the ornate façades of the palace that once housed the kings and queens of France. Instead, in tough black charcoal, on plain white paper, he drew the harsh horizontals and verticals of rooflines and drainpipes.

Eschewing the historical, picturesque, or personal, and illustrating an inelegant everyday subject in a straightforward way, he presented existence in its raw, fundamental form. In that high-ceilinged garret on the rue du Départ, Mondrian had found his bearings.

VII

The Erster Deutscher Herbstsalon opened on September 20, 1913, in Berlin. Mondrian had two paintings in it. Their titles—*Tableau N°1* and *Tableau N°2*; in German *Gemälde I* and *Gemälde II*—were statements in themselves, since the word simply means "Painting," so as to suggest that no subject matter is needed. Mondrian painted them at the same time that he was copy-

ing an early-nineteenth-century portrait at the Louvre. Those long days of demanding labor had enabled him, in the short bits of daylight remaining after he made his daily trek across the Seine, to develop these paintings that were entirely abstract, liberated of all representation of physical matter.

Mondrian made two further paintings with the same nondescript titles and put them into that year's Moderne Kunstkring show at the Stedelijk which opened on November 7. Hendricus Petrus Bremmer, a connoisseur and art critic who was one year older than Mondrian, and who was the advisor to the art collector Helene Kröller-Müller, bought *Tableau N°1* (exactly the same name as one of the paintings in Berlin) for her out of the exhibition. He acquired an even more recent work from the astonishing series—*Tableau N°3*—for himself.

Today Bremmer's name is largely unknown. He stayed behind the scenes, but in this crucial period of Mondrian's life, he was the artist's lifeline. Bremmer taught connoisseurship and led his students to buy paintings. Helene Kröller-Müller became one of his pupils. Combined, they would be a formidable force in the art world of the era, and a godsend to Piet Mondrian, whose life they changed forever.

Born Helene Emma Laura Juliane Müller in 1869, Kröller-Müller was wealthy by birth and wealthier by marriage. The daughter of a rich industrialist in Essen, she had been brought up to expect the best in life. At age nineteen, Helene married the Dutch shipping tycoon Anton Kröller, who had a fortune to which he gave his young wife unlimited access. He did so with the

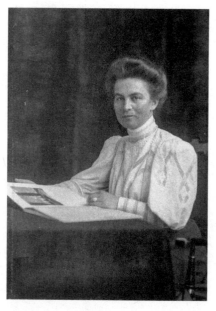

Helene Kröller-Müller. An intrepid art collector who owned nearly a hundred paintings by Van Gogh, wealthy by birth and even more by marriage, Kröller-Müller became one of Mondrian's greatest patrons. She opened her large house in The Hague in 1913 as a museum, believing that others should enjoy what she was lucky enough to be able to afford.

sure knowledge that she was one of the rare rich people for whom having a lot of money was an opportunity to exercise great taste and imagination and do the world some good.

In 1913, Kröller-Müller made the decision to turn her house in The Hague into a museum. Modest in demeanor, this affable, unpretentious, handsome woman believed that since she could afford great art, others should enjoy it too.

Among the first people ever to collect the work of Vincent van Gogh, she eventually owned over ninety paintings and a hundred and eighty-five drawings by him; she also bought important works by Picasso, Léger, Gris, and Seurat. When she considered acquiring Georges Seurat's *A Sunday Afternoon on the Island of La Grande Jatte*, she unwisely accepted Bremmer's advice not to, but generally both she, and he, made excellent choices.

Kröller-Müller resolutely avoided work by the German Expressionists and other artists currently at work in her homeland. She had the interesting, and independent, view that they were "insufficiently authoritative." Dutch modernism, on the other hand, appealed to her immensely, which is why she had Bremmer purchase, on her behalf, Mondrian's *Tableau N°1* when it was barely dry in 1913. Kröller-Müller and Bremmer in tandem bought five of the twelve paintings Mondrian made that year. Having risked such a brave new approach in his art, Mondrian could hardly have imagined having two such enlightened patrons appear on the scene so quickly. The cash enabled him to keep paying the rent, and the collectors' foresight in buying these unusual abstract compositions in 1913 gave him the knowledge that there were sophisticated aficionados who believed in him.

His pencil sketches were one thing, his oil paintings another. Even if there are elements that can be seen as deriving from known objects, Mondrian had now moved decisively into territory absent all association beyond the purely visual. With an intellectual zeal akin to Picasso's, Braque's, and Wassily Kandinsky's—all in the same time period—he had entered a new world. Choosing the unknowable over the recognizable, he had dared confront the whole notion of "art." To do so was the height of sophistication; it was also a move back to the preverbal innocence of life inside the womb—and following birth, babyhood and toddlerhood. It was both a scientific advance and a retreat.

Tableau N°1 presents a realm with no moral judgment, no scruples, no demands, no expectations, no names. Mondrian has made a sanctuary. The surface is, first and foremost, a flat plane, even if the forms and color organization make it rippled like a choppy sea, with skips and starts. The animation is under complete control, like a well-executed jitterbug, its high-octane energy tempered with a pervading equanimity.

Mondrian had developed the means to facilitate nonstop movement in a state of overall balance in purely abstract art. He animates the painting in part by interweaving warm and cool hues; his meticulous deployment of almost golden tans, ambers, and bluish grays with the feel of steel or glass creates combustion. The soft white accents make linkages that lend harmony to the perpetual flow.

This dynamic composition is infallibly graceful. To contain the action—that containment being as essential as all the active coming and going—Mondrian has constructed an overall scaffolding out of black lines that are predominantly vertical and horizontal. Yet he avoids being formulaic. He has also allowed himself a number of gentle curves, as well as a few diagonals, to keep the viewer's eye moving upward. That sense of ascension, and the way the painting appears to grow organically upward from its base, give it a buoyant optimism. Immersed in these forms, we rise into the higher orbit of spirituality.

This painting is the realization of the ideal state of existence that is symbolized by the middle figure in *Evolution*. Since moving to Paris, he had realized the goal that previously he could only represent symbolically; he had invented a new means of embodying the qualities he previously could only narrate with the woman with her abstract jaw. The viewer takes the journey with Mondrian. The state of dematerialized spiritualism—the dominance of soul, which previously we observed in a rather grating illustration of it in the form of a theatrical figure meant to possess those qualities—is now ours to enter. With abstraction, we, too, are elevated above the earthly sphere.

Shortly after selling Bremmer and his client those two paintings, Mondrian wrote the critic a letter in which he cited the objective behind his predominantly gray-brown palette and the cubistic breakup of forms.

> Because my purpose in constructing the lines and color combinations on a flat plane is to visualize beauty per se in the most conscious way. Nature (or that which I observe) inspires me; it affects me, as it does all artists, with the emotion that incites creation, but I want to get as close to the truth as possible, which is why I try to reduce everything to its essence (but ever a visual essence) by means of abstraction. To my mind it is self-evident that by not trying to say something *specific*, one may succeed in making the most specific and (all-embracingly) *truthful* of statements.

To Bremmer, Mondrian readily acknowledged Picasso's importance to him. "I am not ashamed of mentioning this influence, because I think it is better to be receptive to improvement than to content oneself with a level of imperfection once it has been attained, in the estimation that it enhances

one's originality, as so many artists seem to think. Besides, I am certainly completely different than Picasso, as indeed is generally said."

Originality, or what he thought of himself, was not what counted. The issue for Mondrian was to engage with color and light and visual rhythm to evoke universal forces, and if aspects of Picasso's technique guided him better to achieve his goal, he willingly absorbed it. What mattered above all to Mondrian in his perpetual quest was something higher than any of us. He delighted in finding, in Picasso's work, the means to evoke it.

There was the hint of obsession. In spite of what he gleaned from Picasso's work, Mondrian needed to tell Bremmer not only that he was "completely different" from this artist whose painting had so singularly affected his own work but he had to add that this was "generally said." Mondrian either knew about or imagined an entire circle of people who compared his and Picasso's work and came to the same conclusion about how apart they were.

Picasso loomed so large for him, after all, that Mondrian made sure never to encounter him, not once. One does not feel that staying clear of Mondrian mattered similarly to Picasso. And there are no records of Picasso's ever opining on Mondrian's work. It was a bit like Mondrian's growing avoidance of trees. In his new life, now more than ever, Mondrian protected himself from an excess of emotion beyond his control. He insulated himself thoroughly against the challenges he could not face.

VIII

In 1973, the seventy-nine-year-old New York–based psychoanalyst Phyllis Greenacre published, in *Psychoanalytic Quarterly*, a paper called "The Primal Scene and the Sense of Reality," which includes "reflections on the life and work of the painter, P. Mondrian." It illuminates what happened to Mondrian and consequently to his art as he redefined himself following his arrival in Paris.

Greenacre is modest in tone, using the term "some reflections" for her commentary. She does not purport that her theories are facts. But the text specifically about Mondrian with which she concludes her general study of "the influence of the primal scene on the development and functioning of the sense of reality" makes a strong case for the idea that the reason he began to paint walls and then continued to do so stems from his witnessing, "through seeing or hearing," his parents having sexual intercourse, as well as, in all likelihood, the births of his younger brothers. In Amersfoort, he slept in the room with his parents, who produced Willem two years following his own birth, and Louis three years later. His brother Carel was born in Winterswijk, shortly after the family moved there when Mondrian was eight,

but he, too, was conceived in Amersfoort, where Piet and his young brothers remained in their mother and father's bedroom. Only their older sister slept apart from them.

Even though the psychoanalyst's postulates depend only on suppositions, Greenacre is probably correct that Mondrian experienced those primal scenes. Mondrian's essential isolation, in how he lived as well as what he painted, starting with the move to Paris following the abrupt cancellation of his wedding plans, and forever after, may well have been a consequence of such exposures. His splendid walls were blockades. He wanted something forgotten, or at least hidden from his thoughts. His painted backdrops created areas of safety that were in part a means of dealing with his inability to integrate sex and emotional connectedness into his life.

By making his barriers so beautiful, not only did Mondrian screen out what could never be resolved but he substituted pain and self-questioning with pleasure and certainty.

Referring to Mondrian's early childhood and its aftermath, Phyllis Greenacre writes that the reaction to the experience of a primary scene is denial. "Denial as a defensive maneuver" causes a person who has had exposure to his parents' lovemaking to "eliminate the external world by turning his head and eyes away." This is a perfect account of Mondrian in almost all group photos, looking to the side. Denial furthers repression and can prompt "isolation, rationalism, and displacement." It can cause someone to eschew "conflict . . . body feelings . . . superego-determined anxieties, etc." Greenacre specifies that with Mondrian, "There is a special form of denial which, with such accessory defensive paraphernalia as repression, isolation, and displacement, becomes so strengthened that it forms a wall, illusory, yet built as though for permanence."

Phyllis Greenacre pinpoints *Tableau N°1* and *Tableau N°2* and other works of 1913 and 1914 as seminal to all his subsequent painting, and as the means with which he found his way to a new state of personal balance and happiness.

He began to paint walls themselves, first of rather warm reddish brick in patches, perhaps the indistinct walls of a house in the half light in which the right angle of the joinings of the bricks stood out like small right-angled crosses, sometimes embraced by incomplete ovals. Later, the texture of the brick faded and the ovals disappeared while the little crosses became prominent in irregular patterns as though scattered in space, still suggesting motion and emotion. Next, the crosses extended their linear arms to join each other to create rectangles of varying sizes and distribution, each enclosing its own primary color. He is said to have spent

hours arranging and rearranging these to form a pattern which would have absolute balance, in which nothing would be loose or open-ended. This search for perfection in both expression and strong containment of the primordial forces progressed through various stages until it reached the compositions of infinitely precise rectangular forms, for which the painter became famous in his later years.

What began in 1913 with *Tableau N°1* and *Tableau N°2* would be the basis of all his future art. The safe positioning and then artful containment of primordial forces allowed them to be abundant and full of vitality. Energy, connection, and lively rhythm are all present. Having escaped the confines of pictorial representation, Mondrian painted sheer combustion. He had developed a means to organize fire.

IX

In the winter of 1913–14, Mondrian threw himself into an essay he was writing on art and Theosophy for *Theosophia*, the journal of the Theosophical Society. The text was a chance to elaborate on the ideas about which he had written H. P. Bremmer. He worked on it every night after the daylight was gone, stopping only for a plate of lentils. Mondrian became so possessed that eventually the writing took precedence over his painting, and by March 1914, when the days in any event were growing longer with the start of springtime, it occupied some of his daylight hours as well as the evenings.

The article was scheduled to appear at the end of April. Once Mondrian delivered it, he began to suspect that the editors would consider it "too anarchistic." Still, he could hardly wait for its publication, even if it was sure to engender controversy. To Schelfhout, he said he was proud that his writing might be too far-fetched even for people who purported to be open-minded: "That may speak well for it."

But while Mondrian expected opprobrium, he had not anticipated rejection. When, at the last minute, he was informed that it would not be published, he was devastated. The rejection felt like a repeat of his failure to secure the Prix de Rome. Mondrian was not often thrown by a sense of defeat, but on the rare occasions when he let down his guard and imagined his life changing before his eyes only to have a door slammed in his face, he was shattered.

Mondrian was probably offering himself false comfort with the idea that the text was turned down for being too radical; it is more likely that it was never published because it was badly written and too long. He wrote the way he spoke when he was with other people; he did not so much converse

as hold forth, and he failed to give adequate consideration to his audience's response. Still, negative feedback soon became a positive stimulus to him. His art was based on oppositions, and so was his life; he ultimately relished being at odds with the mainstream. Six years after his essay was turned down by his fellow Theosophists, Mondrian would write his new colleague Theo van Doesburg, "I am glad criticism is completely against us. Otherwise we would have nothing left to do."

And fortunately, he had Bremmer as his ally. After buying *Tableau N°1* and *N°3* at the Moderne Kunstkring exhibition, in the spring of 1914 the independent connoisseur declared his wish to publish them in an article in *Visual Arts—Beeldende Kunst*, a monthly magazine he owned. Mondrian told his sympathetic patron that people generally considered his "work to be rather vague: at best it is said to remind them of music," and justified it in a letter that encapsulated the essence of the unpublished essay. The work was "outside the domain of visual art. Because my purpose in constructing lines and color combinations on a flat plane is to visualize *beauty per se* as consciously as possible. . . . It is my belief that it is possible, by means of horizontal and vertical lines that are constructed *consciously* but without *calculation* in a highly intuitive way, and brought to harmony and rhythm—it is my belief, then, that it is possible, with these basic forms of beauty (supplemented if necessary with lines of different orientation or even curved lines) to arrive at a work of art that is as forceful as it is true."

Mondrian followed this with a statement of unequaled importance if we are to dispel the errors so often repeated about him:

> Nature (or the visible) inspires me, arousing in me the emotion that stimulates creation, no less than for any other painter, but I want to approach truth as closely as possible: I therefore abstract everything until I attain the essential of things (though still their outward essential!). I am convinced that, precisely by *not trying to express anything determinate*, one expresses what is most determinate: truth (the all-embracing).

While Mondrian ceased representing nature in his work, it remained his constant inspiration. So were the qualities of Greek temples. He wrote Bremmer, "For me the architecture of the Ancients is the greatest art of all." In a new and original voice, Mondrian would maintain the clarity and rightness of the Parthenon and Delphi, the pairing of spontaneity and order that, even in buildings he would know only from book illustrations, epitomized human achievement.

The Netherlands Again

On Saturday, July 25, 1914, Mondrian left Paris to go visit his father in Arnhem and then see an exhibition of his work at the gallery of Willem Walrecht in The Hague. Walrecht had opened the gallery the previous year on Smidsplein, a large square that was home to several embassies in the center of town. It was Mondrian's first solo show anywhere. He was curious to see how his work looked in this small bastion of modernism that the intrepid Walrecht had created in the Netherlands' elegant capital city, and he hoped desperately to sell at least one picture from it. Following The Hague, Mondrian intended to go to Amsterdam to catch up with friends. Then he would proceed to Domburg. He would no longer paint the dunes and sea in recognizable form, but he longed for their inspiration; the appearance of his art had been transformed, but its essence was the same.

Mondrian was in good spirits. By the time he reached The Hague, the show at Walrecht's had already done better than he had dared to imagine. Six of the pioneering compositions he had painted in Paris over the preceding few months had sold at the opening, and in the following days, Helene Kröller-Müller had bought *Composition No. II*, and Bremmer had bought *Composition No. X* and *Composition No. XII* (see colorplate IV). A man previously unknown to him, the Remonstrant minister Hendrik van Assendelft, who lived in Gouda, had purchased three paintings.

Van Assendelft collected art most people failed to understand. He had already bought an important Kandinsky composition of 1913 when the paint was barely dry, and his purchase of three new Mondrian canvases— *Compositions V, VII,* and *XIV*—was even braver. Walrecht's show had been bitterly attacked in *De Amsterdammer*, a major weekly paper. The well-known art critic Albert Plasschaert had written, "The content has no virtue. . . . The work presented here is restless without being arousing. It is not coarse; that is the only positive thing that one can say about it. Mondrian has never really been a strong painter." But Van Assendelft had no problem bucking the tide. As a Remonstrant, he opposed strict Calvinism and disparaged the idea that

sinfulness was beyond the control of the individual and, equally, beyond absolution. He believed, rather, in the Five Articles of Remonstrance, which emphasized the responsibility of human beings for their own actions. The gallery arranged for the forward-thinking minister and Mondrian to meet, and the encounter went well.

Yet even as he was enjoying himself in the Netherlands, Mondrian intended to be back at home in Paris some three weeks after leaving. Having started life anew and settled in happily, he had no idea that it would be five years before he could return to France.

Michel Seuphor gives a dramatic twist to the reason. Seuphor describes Pieter Mondriaan as gravely ill. Mondrian, working away as usual in Paris, is suddenly summoned to his father's bedside in a retirement home in Arnhem. He dutifully rushes there. Mondrian, in Seuphor's narrative, quickly closes up the studio he was renting from Kickert, packs only a few essentials as one does on an emergency trip, and heads off, unprepared for anything but devotion to an ill parent. Seuphor makes his account even more touching by depicting the younger Mondrian as nobly putting his struggles with his father behind him.

Ever since Seuphor put his account in print in 1956, one source after another has the loyal Mondrian hurrying to his ailing father's bedside following the urgent summons, being devoted despite the old man's cantankerousness, expecting to return to Paris right after. He has no other stops planned in the Netherlands. But he is stuck in the wrong place because of the unanticipated outbreak of war.

This is all invention. What Seuphor would turn into the emergency that has become a major element in Mondrian's incorrect life story was in fact a carefully organized journey that the artist had anticipated and planned well in advance. Mondrian's letters of 1914 prove the fallacy of the version of history that has been accepted as fact for half a century. On June 7, he had written Schelfhout that he would deliver an early sketch to him in August "because I will be in Holland." Planning the details of the trip over two months before embarking on it, five days later Mondrian again wrote Schelfhout to inform his friend that, when he made that anticipated visit in August, he would not be able to spend the night because he had too much else already scheduled, even that far in advance. Moreover, when he did get to the Netherlands, he went to The Hague first. Additionally, his father was not in the retirement home where Seuphor places him but still in the house to which he and Mondrian's mother had moved prior to her death, and where their daughter cared for him. There is no indication that he was ill. The war caught Mondrian by surprise, but it had not been because of an urgent summons that he was stuck in the wrong place.

Of course, there is more drama in making Mondrian the victim of his father's needs. Seuphor's portrait of the artist forgiving the tyrant and hastening to comfort him adds a sympathetic slant to his tale. But Mondrian had simply made an amicable visit to his father that he had organized well in advance, and war only stopped him later in the trip.

II

The German invasion of Belgium began on August 4. Suddenly it was impossible to travel back to France. The only route was now a war zone.

Belgian neutrality had been guaranteed ever since the Treaty of London was signed by Prussia in 1839. More recently, it had been confirmed by the German Empire at The Hague Conference of 1907. Mondrian was not alone in believing that Germany would keep its promise. When the chancellor, Theobald von Bethmann Hollweg, announced, without advance warning, that the treaty of 1839 was nothing but a worthless scrap of paper, the only people who were not taken by surprise were the chancellor's colleagues in the German High Command.

To put themselves in an optimal position to outflank the French army and push their way toward Paris, the German troops not only entered Belgium but did so suddenly and with astonishing force. They immediately killed some six thousand Belgian citizens, destroyed over twenty-five thousand homes, and forced one and a half million Belgians—a fifth of the people in a country that considered itself neutral—to flee. Train travel through Belgium came to a halt. Technically, Mondrian might have traveled through Germany, as long as the Netherlands remained neutral—which it did throughout the war—but there, too, all normal service was disrupted.

Eager to return to work on several canvases that he considered his most advanced compositions to date and that were still in process in his Paris studio, Mondrian decided to journey by sea. He hatched a plan to sail to England first, and from there to take a second boat to Le Havre. Many years later, he would tell the art historian James Johnson Sweeney that he only scotched the plan once his family convinced him that the trip was too dangerous.

Mondrian had in fact landed in a pocket of relative order in a discombobulated world. His unintended relocation allowed him, over the next five years, at a time when most Europeans were struggling just to stay alive, to continue to make art and push himself in new directions.

Absent a home base, feeling like an outsider among his former colleagues, uncertain of what he would do next or when he might return to Paris, Mondrian had simply resumed what he was best at. In the late summer and early

Pier and Ocean 1, 1914, private collection

autumn of 1914, he produced some of his most breathtaking art to date. He made a series of large drawings of the ocean at Scheveningen. They exude a force and a sense of what would endure no matter what was shattered by the horrors of the war that was wreaking havoc inland. Thrust into unusual circumstances, Mondrian focused on the sea, which was unaffected by the vagaries of current events. The aspect of the ocean Mondrian depicted was now neither stormy nor threatening as it had been in some of his paintings four and five years earlier. Rather, it was a world all its own: calm and soothing. His life had turned dramatically opposite his intentions for it; he found ballast and conveyed it in a voice of deep appreciation.

III

Mies Elout-Drabbe offered Mondrian a spare room in her large family house in Domburg. Elout-Drabbe was a figurative painter who was one of the leading forces in the village's artistic community. In September 1914, she made a portrait of Mondrian. Using only pencil, Elout-Drabbe exactingly renders his hollow cheeks and high forehead, as well as his habitual pulling of his mouth ever so slightly to the left. She portrays him as pensive and distant. Mondrian's eyes seem glazed; he is either communicating with a higher force or entirely immersed in his own thoughts. Along with his odd way of holding his mouth, his gaze makes him not quite of this earth.

Elout-Drabbe described Mondrian as he was in Domburg when she made this drawing and war was engulfing Western Europe:

He was so engrossed in his work that he was completely unaware of the Belgian refugees who flooded the isle of Walcheren and caused a short-age of relief workers in the towns and villages where they were being accommodated. In the deserted house, Mondrian was standing bolt upright, though with a kink in his back, working at a white sheet of paper at which he was drawing lines. He was standing there giving everything he'd got, even more than the committee members who did their utmost looking after the Belgian refugees. When he went for a walk he seemed to become one with nature, although at first he could overcome his greater love for the city only with difficulty.

Elout-Drabbe would accompany her houseguest on his evening walks, during which he would pull a small sketchbook out of his pocket and write or draw in it. Mondrian drew ceaselessly, and allowed her to take a close look at his daily output. Elout-Drabbe observed, "Day after day he kept working at that suggestive scribble, each day a step further from reality and a step nearer to its spiritualization."

We invariably feel, in these small impromptu drawings as in the larger compositions, the presence of a man in direct contact with the big questions of existence. Mondrian wants nothing less than to reveal the meaning of earthly life, by capturing what has been there for many millennia and, one hopes, will always exist. In a flurry of soft pencil strokes, he establishes, in the

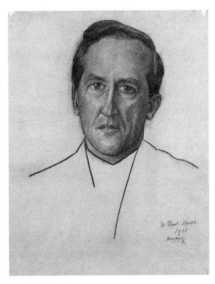

Mondrian's friend Mies Elout-Drabbe drew this portrait of him in 1914, though she signed and dated it the following year.

foregrounds of these sketches, the form of the pier jutting into the distant ocean, foreshortening it dramatically. It zooms from its wide entrance to its narrow opening to the water. With its charged angularity, it becomes the route of a dramatic journey from solid ground to the infinite sea. The pier is the by-product of human rationalism; the ocean, in its depths and movement, its ancient history as well as its ongoing processes, is unknowable.

On some of the sketchbook pages, Mondrian surrounds the pier and ocean, and then the sea alone, in an oval that orders them. That elegant, encompassing form reminds us that this is art. Design and regularization are necessary if we are to survive in the face of the infinite, just as the pier is requisite for the commerce of the sea, essential for human survival.

Mondrian had developed a completely original voice, a method that no longer bore traces of anyone else's influence. The technique he had invented had its origins in Cubism, but he did something new in order to render the sweep of ocean before him in constant, eternal motion. He composed the sea out of strong horizontal dashes interspersed with shorter, lighter vertical ones. These irregular dashes are palpably hand-drawn, sometimes on their own, otherwise comprising two thin elements roughly parallel to one another. Mondrian's only tool was his eye—he has used neither straight-edged devices nor rulers—yet his sense of measure was so meticulous and precise that the dashes, all remarkably similar, cover the paper in a way that has been precisely organized but that concedes to no pattern. Sometimes the verticals, which play second fiddle to the horizontals, cross through the horizontals; a few cross near the center point of the horizontal, while some are to one or another side. On other occasions, the verticals rise—or plunge—in the interstices between the horizontals. With a minimal vocabulary, Mondrian creates great variety.

Those of the compositions that include the pier read very differently from those that represent the surface of the water in generalized form—as it could be anywhere offshore. By adding the navigable wooden expanse extending into the greatness of the sea, Mondrian changes the viewer's perspective, adding depth and drama to the whole. He sometimes drew these works on paper only in charcoal, sometimes in ink combined with gouache, sometimes in all three. In all of them, he furthered the success of his new means of articulation by surrounding the delicate flurry of short straight lines with that oval that appears to caress it but that also leaves it floating in the air. The pure whiteness that remains outside the oval form while encompassing the composition, and extends into the corners, adds an ineffable grace to the whole. The use of the oval form, which Picasso and Braque had made a major element of Cubism and which was based on centuries-old tradition in French painting, exemplifies Mondrian's ability to employ

the most appropriate elements of the tried and true while applying them adventurously.

He was not in Domburg for long, but in the little time he was there he made eight oversized drawings. The tumult of his life had caused him to latch on to something of rich serenity, and he adhered himself to it as if to eliminate all intrusion. While Western civilization was being ripped to shreds, Mondrian homed in on a world that was eternal.

IV

In between the drawings in the first Domburg sketchbook, Mondrian worked a soft pencil rapidly across the page in sprawling handwriting with large letters, freely expressing his innermost thoughts. Afterward, he drew vertical lines through some of what he had written, as if to cross it out, but it all remains legible; he valued what he had replaced and altered, because otherwise he would have concealed it completely.

This first small sketchbook is unequaled as a guide to Mondrian's mind. Waiting out worldly events, staying with his various friends, making art at the edge of the sea in Domburg as the German army forged into the country just south of him, Mondrian was sorting himself out. He writes in his sketchbook: "Two paths to the spiritual: the path of doctrinal instruction or of direct exercise (meditation, etc.); and the slow and sure path of evolution." The first path—"doctrinal instruction"—leads "to degeneration." He had grown up with the "right and wrong" dictum of his father's sermonizing and with the doctrinaire rules of art laid down at the Rijksakademie; the following of such absolute guidelines was not the route to knowledge. Rather, one had to reach enlightenment from within. "When the artist finds himself on that plane of evolution where conscious and direct spiritual activity becomes possible, we are in the presence of ideal art. . . . An old soul (or an old stage of spiritual evolution) must dwell in a new body and slowly become conscious." The large drawings Mondrian was to make of the sea later in 1914, and the pulsating abstractions which were to follow, would carry forward Mondrian's "old soul" in a new form that would encompass his ideals. "Each man, each thing, everything in this world has its reason for being. Everything is beautiful, everything is good, everything is necessary; the existence of each thing and each being has its relative value."

The essential issue Mondrian addresses concerns men and women. At age forty-two, elaborating on the profound differences he believes exist between men and women, he is strident about the opposing nature of the sexes. He is unflinchingly candid about his sharply defined views of gender difference, which impacted both his personal conduct and his art.

Female: static,
Preserving, obstructing,
Element.
Male: kinetic
Creative, expressive,
Progressing element.
Woman: matter-element
Man: spirit-element
Woman: horizontal line
Man: vertical line
Male artist: spiritual joy
Female artist: material joy.

He treated his opinions as inarguable facts. On the next seven pages of
the pocket-sized sketchbook, Mondrian enumerates the essential differences
between men and women that prevent their successful union. He knew—
facing the sea, ruminating about his artistic breakthroughs in France—that
solitude was a vital element of his being able to transmit his own essence
into his art. Women were too different from men, he realized, for an intense
one-to-one relationship with a female to be possible if he was to achieve his
goal of being, as a person, inseparable from his work.

The vertical and the horizontal would be the basis of all of Mondrian's
subsequent art. And not only did he identify the vertical and the horizontal
as embodying the male and female, but he acknowledged that belief unre-
pentantly. The paintings that would be Mondrian's true flowering, his gift to
the world, his equivalent of Mozart's quartets and Shakespeare's last plays,
have no angular components whatsoever. Being devoted above all else to the
interplay of horizontal and vertical, to right angles as events, Mondrian's art
would reflect more than anything else his views of maleness and femaleness
and their impact on one another.

"The spiritual"—the very thing Mondrian has declared to be the objec-
tive of his art, the goal of the Theosophy that enchanted him, the realm
in which he was determined to reside in every element of his existence—
was, for him, incompatible with all that is female. That view was probably a
long time developing. Mondrian began to acquire his ideas of maleness and
femaleness in early childhood; Pieter Mondriaan devoted his life to religion,
while Johanna stayed home and made soup and cleaned the house.

In the sketchbook, Mondrian writes:

Because the female element is matter, as a basic type, woman is hostile
to the spirit. Simultaneously she is a friend. Matter and spirit oppose and

desire each other. Being a unity, they attract each other. Positively and negatively. A woman desires spirit and to be spirit, but in primal essence she remains matter. Man desires matter and nonetheless remains spirit. He continually yearns for matter and his spirit grows thereby. Woman continually yearns for spirit, and her spirit thereby also grows. Woman is the real, man the unreal. Woman is against art, against abstraction—in her innermost being. However she desires art and abstraction, but is not abstraction. Man does not desire it, but is it in his innermost being.

A man always will be disappointed if he loves a woman in her spiritual substance, because this is of lesser quality in a woman than in himself.

Should this spiritual quality in a woman be very high, then (in most cases) she is physically less radiant and falls short of the demands made by a man as a lover of matter.

He goes from there to discuss "an artist." The one he has in mind is most certainly himself:

An artist can not truly love a woman, because he loves abstraction alone and woman is the real. A man can love a woman only physically, and not spiritually, because a man (spirit) loves matter.

A woman, in contrast, can love a man spiritually, because it is a man (spirit) whom she loves.

Sitting on the dunes, cut off from his home base, uncertain about where he would put his few possessions and sleep the next week, Mondrian had worked out his own internal issues in a way that worked for him.

He writes:

The positive and negative states of being bring about action. They bring about the loss of balance and of happiness. . . . Being positive or negative is the cause of the rupture of unity, cause of all unhappiness. The oneness of positive and negative is happiness.

He believed that as long as one separates what one perceives as the positive and negative of the soul and regards them as irreconcilable elements, a feeling of disunity and unhappiness ensues. If one can enable the opposing aspects of the psyche to coexist harmoniously, happiness is possible.

Whatever the conflicting elements are—the realities of one's sexual desires in contrast to the behavior one considers acceptable; ambivalent feelings about one's mother and father; fantasies of evil versus a notion of the

good—is beside the point. What counts is the word Mondrian underlines: their oneness. Mondrian not only achieved it within himself but made the unity of seemingly opposite forces the essence of his art. No wonder his constructions of black lines on white, with blues and yellows and reds sparkling within their strictly horizontal and vertical nexus, would bring such consummate well-being to so many people.

V

Mondrian spent the rest of 1914, up until the holidays, in Domburg, and then went to Arnhem to celebrate Christmas and New Year's with his father. At the start of 1915, he accepted the reality that the situation in Belgium and Germany was not going to change for a long time and that he needed a place to live in the Netherlands for the long term.

As would be the case throughout his life, Mondrian had unbidden guardian angels. He had a survival instinct that made him let his friends know when he was in dire straits, and people respected him enough to come to his aid. This time, his savior was To Hannaert.

Hannaert invited Mondrian to take a room in De Linden, her capacious and slightly old-fashioned country house in Laren. He could, she told him, remain there until the summer season, when she ran it as a pension for holiday-makers. He would not have to pay her—an immense relief since he still had to come up with rent money every month for his Paris studio. At the start of January, he moved into these free new digs, devoid of possessions except the clothes he had traveled with six months earlier, a couple of warm jackets friends had given him to help him brave the winter months, and his art supplies and latest canvases.

Twenty-eight kilometers to the southeast of Amsterdam, with just over three thousand inhabitants, Laren was different from other Dutch towns. In the 1880s, the prominent Hague School painter Jozef Israëls had discovered the village and transformed it into a summer community for his friends. Most were anarchists, Theosophists, and artists; a few belonged to all those groups. When Mondrian moved there, Laren remained a refuge for these individuals who did not fit in with the bourgeoisie.

Living in Hannaert's house, Mondrian had all that he needed except a place to work. He took a series of studios he could get at little or no cost, and moved from one space to another as required. He kept himself going thanks to a few clients who, even in wartime, commissioned portraits and copies. Mondrian wrote Bremmer, who had returned to Amsterdam for the winter, that he was like someone with three jobs: painting abstractly, doing those pictures for hire, and writing.

The war intensified in the spring of 1915. Being in limbo, struggling to pay for the Parisian home and workplace he could not get to, toughing it out in the free room for which he was grateful and any studio space that was cheap or free, Mondrian took it all in stride, and worked away on more large drawings based on the studies he had done the previous autumn in Domburg. Hannaert's house was a godsend. Most evenings, he sat bent over a desk laboring on a book in which he elaborated the ideas he had written in his sketchbook; he had reached a point of equanimity.

And he had good companionship. Maaike Middelkoop was also rooming at no cost in Hannaert's house. In her early twenties, she was a bright and outgoing woman who commuted to Amsterdam for work but preferred to live in Laren with its colony of artists and writers and musicians breaking the boundaries of human creativity. Mondrian and Middelkoop stuck together when they had to move out of De Linden before Hannaert's summer guests started to arrive. Giving up free lodging, needing to find the cheapest possible places, they learned that two small rooms were available in a Laren boardinghouse where Jakob van Domselaer was living. Mondrian and Van Domselaer had kept up the friendship which had had such a rocky start, and Mondrian had become fascinated by Van Domselaer's experimental approach to music, which was directly related to what he was trying to do in painting, while Middelkoop had her eye on the composer romantically.

Once he had taken a room in the pleasant wooden house, Mondrian managed to find a small studio in the nearby town of Blaricum. It had been built by Jacob van Rees. In 1899, Van Rees, a pacifist and anarchist, had started a communist-based farming colony—the Kolonie van de Internationale Broederschap—in Blaricum; the studio was on the colony grounds. Initially, it was intended to be used by his son, the painter Otto van Rees, but the younger Van Rees had moved away.

Mondrian relished the legacy of his new workspace. It was not just a place to paint but a structure built by someone whose ardent goal was the betterment of all humankind. Jacob van Rees was convinced that education was the key to improvement for civilization in general. Besides the farming colony in Blaricum, in 1903, Van Rees had created the Humanitarian School in Laren. This was a center for idealists who tried to make their social conscience determine every aspect of their existence. Believing that art should reflect and serve universal drives and needs, with what was personal and private playing no role, Mondrian felt that he had ended up in the right place.

Van Rees's compound also brought Mondrian close to his brother Louis. Louis is the member of Mondrian's immediate family about whom the least is known—there are no traces of him and Piet encountering one another in

later years—but from 1915 to 1918 he taught geography, math, and drawing in accord with the educational philosophy of Jacob van Rees at the Laren Humanitarian School. As a person, Louis cut quite an image for himself. Considered a weirdo by his students, he had a long beard and mustache and almost always wore a brown Manchester coat of the type used by farmers; double-breasted and oversized, it was practical for milking cows in heavy rain. This was well before the era of today's rustic chic, and everyone noticed it. Louis had a reputation for sleeping during class; he also smoked conspicuously, although it was strictly banned. His true passion was farming; he got up every morning at 4 a.m. to harvest vegetables from the school garden and pile them into his horse cart. While Piet despised gardening and never got over his resentment of the enforced hoeing and weeding of their childhoods, Louis had an insatiable fondness for the tasks their father had made them do.

Yet these two unusual sons of the same parents had in common that, whether advancing the art of painting toward pure abstraction or harvesting vegetables, they were performing a service for the world. Each was convinced that this is what we are put on earth for.

VI

Middelkoop and Van Domselaer quickly paired up as both had hoped. The devoted lovers became a source of equilibrium in Mondrian's life. While Mondrian's income was unpredictable, they both had steady jobs; Van Domselaer gave music lessons locally, while Middelkoop continued to work in a shop in Amsterdam. They were happy to ensure that their older housemate, whom they considered a genius, had the wherewithal to live and make his art, and occasionally advanced him cash.

Mondrian was determined not to take unfair advantage of their generosity. When he was paid for one of his copies, he put every single guilder into the coat closet of the boardinghouse where the three of them had rooms. He told his friends that he would not touch any of the money until they had taken out the total amount they had lent him as well as whatever they had spent for his share of the groceries.

Broke as they all were, the three housemates, as well as the painter Peter Alma and his wife, who had also moved from Paris, and the mathematician and philosopher M. H. J. Schoenmaekers—who lived nearby—pooled their resources to hire a local woman, Heintje Smit-Boog, to prepare their evening meals. Everyone shared the cost, and they dined together. After decades of living alone, Mondrian flourished with this unintended change to his way of life. Middelkoop provides an account of those evenings shared by people

Jakob van Domselaer, eighteen years Mondrian's junior, was one of the number of men young enough to be his son who worshipped Mondrian and who became devoted acolytes. Van Domselaer and his wife, Maaike Middelkoop, were keen observers of Mondrian's eccentricities.

trying to make art and music on shoestring budgets during a world war. Mondrian took a while to switch from his daytime quietude into a more sociable mood, but once he got going, he loved to talk and monopolized the conversation. When Middelkoop went to bed ahead of the others in order to be ready to take a 7 a.m. train the following morning for work in Amsterdam, she knew that Mondrian would keep the rest of them as late as he wanted. Confident that the others would stay, he gave his discourses for hours on end.

His subject was invariably the liberation of art from representation. A generation older than the others, he enjoyed his elder statesman status, and no one interrupted him. But his eccentricities baffled people. There was an incident that Middelkoop would never forget that occurred on a Saturday, Mondrian's day for going to Amsterdam to work on his copies at the Rijksmuseum. Middelkoop describes him coming in late after one of those weekly outings. As he rushed by the others to go upstairs and wash and change for the evening meal, he turned his head and reported that he had procured an eel, and would be downstairs quickly.

Everyone stayed up so late savoring this rare delicacy that they were all still in bed at noon the following day. They were then awakened by an unexpected visitor. It was, according to Middelkoop, someone who came periodically but whom she and Van Domselaer "didn't know very well." When the person knocked at the door of their boardinghouse, Mondrian was the first to wake and head to the entrance. On his way, he called from the stairs that he would let the person in.

Middelkoop and Van Domselaer heard Mondrian and the visitor go to the back of the house. After a gap of time, Mondrian peered around Van Domselaer's door—Mondrian is often described with these sideway glances—and, thinking Van Domselaer "was alone in his room," said, "Don't worry—he went first to peepee." Then Mondrian saw Middelkoop in Van Domselaer's bed. At that point, he simply burst out laughing and entered.

We are told nothing more. Who the visitor was, why Van Domselaer might worry, is never explained. Yet, Middelkoop thought that these events merited recording fifty years after the fact. A portrait emerges. It is the same as in other incidents described by the perspicacious Middelkoop.

Mondrian lived in his own universe. With friends but no intimates, he was amused by odd things, and rarely showed signs of being bothered by anything. But what amused him and what he wanted in human relationships was incomprehensible. In how he dressed and groomed himself, he cared deeply about his appearance in the eyes of others; as for the effects of his behavior, he seemed indifferent and unaware.

Even though Mondrian, Middelkoop, and Van Domselaer had had to give up their lodging at Hannaert's to make space for the paying summer guests, Hannaert often invited them for dinner with her clients. One evening, when their hostess was present, Mondrian and Van Domselaer left dinner ahead of Middelkoop. They had not even excused themselves politely. Middelkoop was furious. Once everyone else had said goodnight and she caught up to the two bolters, she told them they had been unconsciously rude to Hannaert. Mondrian simply said that one of the people at the table had been speaking so cockily about art without knowing what he was talking about that he could not tolerate it for a minute more.

Middelkoop defended the man Mondrian found so offensive. He could be immensely funny, she told Mondrian. Getting up and flouncing out was much worse than anything Hannaert's other guests had said or done.

Mondrian would not acquiesce. He continued to attack the visitor and defend his action in a nasty and dismissive voice. Mondrian rarely sneered, but when he did so, Middelkoop found it chilling.

The following day they were again invited to Hannaert's. In his most withering manner, Mondrian instructed Middelkoop to remain longer than usual after dinner. He told her that he and Jakob would leave early as usual, but she should stay. "After all," Mondrian remarked, the offensive guest would still be there, and Middelkoop liked the self-anointed art expert so much that she should stay to the bitter end. Mondrian was relentless. He normally avoided contretemps, but there were moments when his sense of moral superiority possessed him.

VII

Middelkoop recalled an evening when Lodewijk Schelfhout's wife came for dinner. Mrs. Schelfhout invited Van Domselaer to play some of his "Proeven van Stijlkunst" at a soirée they would all be attending at the home of affluent Laren "society" people. These suites for solo piano—their title translates as "Experiments in Artistic Style"—represented the first attempt to apply to music the principles of what would soon be known as "Neo-Plasticism."

The seven austere, mathematically based pieces were all inspired by Mondrian's painting and writing. The static elements in opposition to the "peaceful and flowing" musical movement were equivalents to the juxtaposition of the vertical and the horizontal in visual art; Van Domselaer had "tried to translate into music [his] impression of Mondrian, both the man and his works."

The others at the dinner table expected Mondrian to be enthusiastic about Mrs. Schelfhout's proposal. He was nothing but snarky. He loathed the social pretentiousness of Laren's "smart set," and could not stop belittling the feints at culture of the wealthy denizens of the summer colony who robbed Laren of the authenticity it had during the rest of the year. Still, Mondrian reluctantly agreed to attend out of respect for Van Domselaer.

The evening began with a speech from the hostess. With the haughty voice of a teacher informing uninitiated students, she stood in her lavish evening gown illuminating her guests about the upcoming performance and the latest developments in modern art. Radiating with what she considered her intellectual sophistication to her handpicked audience in her opulent living room, she expostulated on recent advances in painting and musical composition. In a patronizing tone, she explained how she identified with the artists and musicians who had come in from their simpler digs.

Middelkoop "didn't dare to look at Piet." If initially she had expected the evening to go well, she now dreaded what Mondrian might do or say. And the success of the performance was vital to Van Domselaer.

Mondrian "sat with a sullen face in the half dark conservatory."

Middelkoop was relieved when, determined to shut out what would only irritate him, he let his eyelids drop and fell asleep.

Then the host took the floor from his wife. This scion of upper-class Dutch society read a story "about a giant spider." The man's voice woke Mondrian. Startled out of his nap by the description of the grotesque insect, Mondrian shouted, loud and clear, "Oh, God! How creepy!" Everyone in the room heard his cry, turned, and stared.

The speaker continued as if nothing had happened, diplomatically seem-

ing impervious to the disruption. Mondrian again turned silent. He was now fully awake but was uninterested in his own outburst or its impact on everyone in the room. Van Domselaer's piano preludes were then performed. The audience sat rapt as the musician evoked both the artistic constructs and the contradictory nature of the man who had just imploded upon hearing about a large spider. They acclaimed the preludes rapturously. The evening ended without further incident, a resounding success for the young composer, and therefore for Middelkoop.

She reflected afterward that Piet Mondrian was the most unpredictable individual she had ever met. Mondrian seemed okay about being stranded hundreds of miles from his new home, but he struggled mightily when the light changed suddenly in the evening sky as unforeseen clouds rolled in, or when he imagined a spider crawling.

One perfect springtime evening, Middelkoop and Mondrian were walking across the heath talking about the way appearances change in the moonlight. Suddenly Mondrian blurted out, "Nature's a damn lousy affair, when you think of it. It's almost unbearable to me." He had to avoid what he could not control; sexual or emotional intimacy topped the list.

VIII

During that difficult summer of 1915, the thirty-one-year-old Salomon B. Slijper, a successful real estate agent, was on holiday in Laren. Slijper booked into To Hannaert's pension. He could not take his eyes off the painting Hannaert had hanging on the dining room wall. Mondrian had given his hostess one of his recent compositions to thank her for her hospitality. Slijper was amazed to be moved by such an abstract image. Hannaert told her guest that the man who painted it had been staying in the pension when it was closed in the winter, but could not afford it in the summer when paying guests like Slijper were there and was now staying in a boardinghouse nearby. Slijper said he wanted to meet the artist and buy some of his work.

Slijper's father was a successful diamond broker who had brought up his children in a lavish house in Amsterdam, while never allowing his wealth to distract him from his piety. When one of his daughters was born on the Sabbath, neither he nor any of the other witnesses signed the birth certificate, such an act being forbidden on the day of rest. Salomon went to a state business school—in keeping with the family's politics, partial to the labor movement and ruling out private learning institutions—and learned bookkeeping and accounting. When Slijper's father died in 1903, Salomon inherited eighty-five hundred guilders—which had the purchasing power of about $300,000 today. He was working for a bank, his career advancing, but

Sal Slijper, c. 1926. An avid collector of Mondrian's early work, as well as a dealer in it, Slijper would leave his vast holdings of landscapes, windmills, and other subjects to the Dutch public, impacting forever the understanding of Mondrian's artistic beginnings. In Laren, Slijper sometimes provided Mondrian with the clothing that the artist considered requisite for ballroom dancing.

by 1906 he had become so restless that he gave up the position. For a while, he enjoyed the life of a rich young man—although, with his soft chin, elongated nose, and low rounded shoulders, he was by no standards a handsome one. He spent most of the year in Amsterdam, but for his summer holidays he liked the bucolic charms of Laren.

Hannaert arranged the encounter between Mondrian and Slijper. In spite of having been drawn into Mondrian's work by a recent abstraction, the only thing he was interested in buying was the earlier work Mondrian had done before going to Paris. Mondrian was disappointed but had no choice in the matter; he needed to sell whatever anyone wanted to buy.

In little time, Slijper decided to form a collection of these figurative paintings with the intention of keeping them together under one roof. Mondrian had misgivings about both Slijper's taste and his motives, but he embraced the project. He sent Slijper to Anna Bruin, who was storing work in The Hague. Slijper bought five paintings, paying five hundred fifty guilders—around $10,000 today—for the group, frames included. Mondrian also asked Simon Maris to be on the lookout for other early paintings that Slijper might buy, and by the end of 1916, the devoted collector had acquired *Evolution*. In that difficult period during the war when money was tight for most people, Slijper also functioned as an intermediary for Mondrian, seeking out collectors whose finances allowed them to buy other paintings Mondrian was storing. But Mondrian knew from the start that Slijper was a bargain hunter determined not to pay full freight, and warned everyone—often with an anti-Semitic barb about his patron's money grubbing. Salomon Slijper, who eventually would donate his fantastic holdings of Mondrian's work to the Kunstmuseum in The Hague, would be the individual most responsible

for preserving Mondrian's art for all time, but to Mondrian he was above all a Jewish financial speculator.

When Slijper bought his farmhouse in Blaricum in 1917, he registered as being without profession. He was, however, in the real estate business—buying, selling, and leasing it—and did not disguise that his art collection was a business venture. He was assisted in his work by Johanna Hamdorff and his live-in housekeeper. Hamdorff was the niece of the owner of the grand local hotel that bore her uncle's name.

Slijper shared Mondrian's taste for dancing there, which is one of the reasons that, in spite of Mondrian's antipathy, they were friends of sorts. They were an unlikely pair of pals—the short, squat Orthodox Jewish son of a diamond merchant and the tall, lean artist brought up by his fire-and-brimstone Calvinist father—but they had in common a will to break free of the strictures of their upbringings and to enjoy life with pleasures denied by their parents. They loved to dance with pretty women, sport fine clothes, listen to jazz, and play billiards. And when they were not diverting themselves by aiming a cue or whirling a lady around the dance floor, they engaged in serious intellectual debate with Peter Alma, Jakob van Domselaer, and Maaike Middelkoop. Sunday afternoons became a sort of salon in Slijper's farmhouse, with discussions about Freemasonry and Theosophy rambling on into the evenings. Mondrian realized that, whatever his misgivings, in Sal Slijper he had an individual to whom he would be able to entrust all his work when the time came at last for him to leave the Netherlands.

IX

Once a week, Mondrian would go to the dance hall at the Hotel Hamdorff. This was one of Laren's grand hotels, a luxurious, rambling structure built when the untouched rural village was discovered as a perfect holiday getaway easily reached from Amsterdam. The ballroom was open to all, and two orchestras played. One was led by "the well-known maestro Janos Joacksycoros . . . and his black gagged band of musicantos." The other was the house orchestra, conducted by a Hungarian violinist whose name, Zunky Joska, evoked the pace and playfulness of the music. To Gypsy music and ragtime, the assemblage of artists, anarchists, and Amsterdam cosmopolites danced waltzes, tangos, and two-steps.

The dancers' abilities and training varied greatly, but most everyone on the dance floor moved in the prescribed style—except for Mondrian. He stood out conspicuously, and lots of people were flabbergasted by his dancing technique, although most did their best not to stare. Even when some gazed at him in palpable astonishment, he seemed not to notice their regard.

Mondrian's style of dancing was "geometric." A young Dutch journalist and literary critic, Jan Greshoff, was the person who used that term to describe the artist's peculiar way of moving and not moving at the same time. Greshoff claimed that Mondrian was as unusual and original a sight doing two-steps at the Hamdorff as his art was in the houses of its collectors.

Greshoff had become a connoisseur of Mondrian's individualism. He was amazed by "the similarity between his way of life, his body movements, and his work." His particularities were unlike anyone else's. When he took to the dance floor, his motions were "stately": he moved only his feet and held the rest of his body rigid, with his head tilted upward. Even during what was supposed to be a fast dance, Mondrian went "very slowly." Sal Slijper was another person who could not get over the way Mondrian moved around the ballroom. Slijper said that Mondrian was "so stiff on the dance floor . . . you had the feeling he was wearing a corset."

One evening, Mondrian went to a costume party at the Hamdorff with the daughter of the painter Manus van der Pot. He was dressed as Pierrot and she as Pierrette. Clad entirely in white, with a monkish austerity and his unnatural, robotic posture, Mondrian stuck out as he tried to turn himself into a straight vertical line. Helma Wolf-Catz, who grew up in nearby Blaricum and was a teenager in Mondrian's dancing days at the Hamdorff, would later remember hiding from him in the large ballroom. "He was no matador," she quipped. He tried without success to attract her onto the dance floor. She felt he was completely unaware that she was nearly thirty years younger than he was, and that he believed that his artistic renown would make him desirable. "We laughed about Mondrian . . . I thought he was so unattractive that his brilliance could not seduce me," Wolf-Catz remembered decades later. She bore him no resentment, though; he was peculiar, not malevolent, and she had only fond memories of the awkward oddball who amused her and her friends.

Other women were more open-minded than Wolf-Catz; several allowed him to take them in his arms and lead them across the floor, however stilted his gait. When someone consented to be his partner, Mondrian was beside himself with pleasure. Herman Hana, an artist living in the region, described an evening at the Hamdorff when he and Mondrian and Sal Slijper drank the local gin while Mondrian enthused about a twenty-year-old woman with whom he had just been dancing. Mondrian was ecstatic to have had "such a naive, honest, cheerfully amenable child" in his arms as they moved around the floor.

Hana and Slijper, who had witnessed Mondrian with the woman less than half his age, were less comfortable. When he raved about her and how much fun he had had, they tried to switch the subject to art. Mondrian, mean-

while, could not be distracted from the only thing that interested him. When Slijper prodded him about his painting, he would discuss only his partner's "pretty dancing shoes."

Middelkoop often accompanied Mondrian to the Hamdorff. She noticed he was in good spirits when he had a young date. "When I asked him, joking, how old the girl was this time, he smiled shyly, blinking his eyes: 'I don't know, the younger the better; but she's very sweet.'" Still, Mondrian did not relax on the dance floor. Even with one of his "sweet girls" in his arms, he was unfailingly serious. His back was, as ever, ramrod straight, his head inevitably cocked at the usual angle. He also never stopped gazing upward—rather than making eye contact with his partner. And he always made stylized steps. His nickname was "the Dancing Madonna." He probably had no idea that this was what people called him. But if he had, he would neither have understood why nor cared.

X

On August 19, 1915, Mondrian wrote Simon Maris that the work on his book was taking up all his evening time in Laren. But that was not all he was doing when he lacked the daylight to paint. Mondrian went on to grouse to Maris that, even though it was the peak of Laren's social season, he had none of his preferred lithe young ladies to dance with him. At the "little Paris at Hamdorff," he had not "found a suitable dancing partner: all the girls I had access to are rather fat!"

Still, even when Mondrian did not have his favorite companions for waltzes and foxtrots, the Hamdorff suited his sense of style. He liked the white-painted wooden chairs and tables that were standard furniture for a country resort; a few years later, he would coat the furniture in his Paris studio that same matte white, conjuring memories of the decorum and lightness he relished on those summer evenings.

The Hamdorff was the only place where Mondrian engaged in the same greetings and social pleasantries as everyone else. When the men and women rose from those white seats, they all behaved quite formally, bowing as they greeted each other. Everyone was cordial with everyone else, their good manners of a piece with the tacit understanding that they were all on the prowl. Mondrian, like most of the men, would gaze toward the buffet where the bright lighting enabled him to study potential partners, and whisper to his companions about the conquests he hoped to make.

The dancing itself had an uncanny bearing on his art. Those moments when Mondrian moved his feet in measured steps forward and backward, his limbs and torso rigid, helped establish the rhythm and angles of the new

world he was creating on canvas. He was directly influenced by dance steps in the forms and angles and measures of his painting.

Whatever the sources of stress were as Mondrian remained in Laren while the world war droned on, as each summer approached, the Hamdorff was foremost in his thoughts. That pleasure he felt when holding a woman in his arms and moving his feet as the music played was a reprieve from some of the exigencies of life, but so was his painting, and they were interconnected. Rhythm and motion, and the relationship of the horizontal and the vertical—the female and male—in compositions within his control made up Mondrian's happiest territory. Pleasure—safe, measured, yet, for all the restraint, euphoric—was invariably his goal.

XI

On May 24, 1916, Mondrian wrote Slijper, "On June 10 Hamdorff opens and then I want to be ready with my clothes!" He asked if he could hold on to a jacket he had borrowed from the collector. There would be outdoor dancing, requiring a layer of clothing that would keep him warm. He often felt cold and did not want to risk chills and illness, but he was not about to show up looking shabby.

It was an obsession. He wrote Slijper one letter after another about suits and jackets. He considered going to Slijper's tailor, but the cost was prohibitive; instead, he wore an old suit of Slijper's. This was the subject of negotiation; it was not a gift, but part of an exchange of art for his client's discarded clothing. Later that year, Mondrian would swap a self-portrait for yet another suit. He and Slijper also exchanged jackets, writing back and forth about the price difference, with Mondrian having to pay Slijper fifty guilders. This was the same amount of money Mondrian was then receiving as a monthly retainer from H. P. Bremmer so that he had a guarantee of regular income regardless of actual sales of his artwork; he needed it if he was to look decent.

When Slijper gave Mondrian a jacket, not as an element in a deal but simply as a present, Mondrian liked it so much that his response was to ask Slijper if he also had a vest that went with it. When Mondrian needed evening clothes to attend a dinner at an artists' conference, Slijper lent him his own, free of charge, and they served their purpose in spite of the height difference between the two men. Then, months before the 1917 season opened at the Hamdorff, as aerial bombardment was overtaking much of Europe, Mondrian began to negotiate with Slijper so that he could acquire the new suit he considered essential. Slijper was in many ways Mondrian's nemesis, but without his dealer/collector/dancing partner, not only would Mondrian

have been desperate to sell more art but he would have risked the ignominy of being badly dressed.

XII

The art critic Augustine de Meester-Obreen, who was writing an article about Mondrian for a Rotterdam newspaper, posed some questions to him in a letter. Mondrian jumped at the chance to answer them, writing her twice in response.

There was little that the forty-three-year-old artist liked more than explaining his artistic intentions to sympathetic ears. In this period when he felt as if he were living in seven different places, and had to copy a seventeenth-century painting just to survive, Mondrian relished the chance to articulate his philosophy:

> Emotion is more superficial than the mind. The mind constructs and combines, whereas emotion expresses mood etc. The mind constructs the simplest line in the purest manner, and uses only the most primitive color. The most primitive color is the most deep-seated: the purest. . . .
>
> It is in portraying the outward appearance of things (in their normal guise) that opportunities arise for the human element, the individual, to reveal itself, whereas when one portrays the interior of things, notably by means of abstraction from the external shape, one comes closer to revealing the spiritual, i.e. the divine, the universal.
>
> To us as individuals this universal or general aspect appears colder and less sensitive than the particular, which is more in line with our humanity. The same goes for what you say about observing a flower. . . .
>
> I portrayed it by emotion, and that emotion was human, possibly even common to all humans. Later on, I thought there was too much emotion in it, and I did a blue flower in a different way. This one retained its staring, stark quality, and already came a bit closer to immutableness. But to me the colors, although already pure, were still too expressive of individual emotion. I then had a phase of sober colors such as gray and yellow, and tried to be bolder in my use of line. Gradually I arrived at the use of almost exclusively vertical and horizontal lines.

Rarely did Mondrian provide such clear access to his conscious flight from individualism to larger universal truths.

Augustine de Meester-Obreen concludes her piece with some vital information about Mondrian: "He would have loved to become a vicar, later also music conductor." If we imagine Mondrian preaching from the pulpit, or

waving a baton with his hand, we picture him as he saw himself. He wielded a brush instead, but the drive to induce a spiritual state in other people was the same.

XIII

There was another major development in Mondrian's life. In the course of a five-artist exhibition at the Stedelijk, a character emerged who shared many of his beliefs and desires. He had never imagined there would be someone who would provide such intellectual camaraderie.

Theo van Doesburg, eleven years Mondrian's junior, was a painter, poet, and writer, who, for an important if relatively short period of time, helped transform the regard in which Piet Mondrian was held internationally. Van Doesburg considered himself more of a colleague than an acolyte, but he accorded Mondrian the position of the reigning genius of the artistic movement they would found together.

Van Doesburg lived in Utrecht. After seeing the Stedelijk show, he wrote Mondrian asking the older artist to send him some works. He did not make the purpose clear; he seemed simply to want them for his own observation. Mondrian replied that he had nothing available.

Mondrian could think of no other response to an outrageous request from someone he had not even met. But he was polite and tactful. He sent Van Doesburg a photo of a drawing of a church façade he had contributed that August to an album which had been put together for Queen Elisabeth of Belgium to thank her for working to defend the Belgian people. Mondrian wrote Van Doesburg, "As you see, it is a composition of vertical and horizontal lines which (in an abstract way) is meant to express the idea of rising, of greatness. The same idea which was behind the building of cathedrals." He goes on to explain that it is the style of the rendering, not the representation of the subject, that reveals his intentions. This is why he kept the drawing untitled. It would, Mondrian added, appeal to "an *abstract* human mind. I always concentrate on expressing the universal, i.e. the inner self (which is closest to the soul), and do this in the most simple external form in order to express the inner self in the least veiled way."

Van Doesburg was not fazed by the receipt of a photographic reproduction in lieu of original artworks. He wrote a poem, "Cathedral I," and dedicated it to Mondrian. Mondrian believed he had found a soulmate. Without having yet met Van Doesburg in person, he wrote him, "Your verse has the same will as my work does . . . [it] expresses the abstract just as I do."

Van Doesburg reviewed the Stedelijk show that October in the weekly journal *Eenheid*. He singled out Mondrian's work, saying of it, "To limit his

means to so little, using only white paint on a white canvas with some horizontal and perpendicular lines, yet end up giving us such a pure artistic expression, that is extraordinary."

Convinced that he had found "the way" and that his mission in life was to impart it to others, Van Doesburg gave lectures on the new approach to painting, poetry, and architecture, and was planning a periodical devoted to the cause. He asked Mondrian to join him in starting a magazine named *De Stijl*. One of the most important artistic movements of the era was being born—with the hope that its vision would become widely diffused and begin to change painting, building, and design at every level and in all places.

XIV

On February 6, 1916, Van Doesburg and Lena Milius, his female companion of the moment, went to Laren to meet Mondrian. Until then, Mondrian and Van Doesburg knew each other only through their letters.

The thirty-three-year-old Theo van Doesburg was a bit of a self-invention, with a more deliberately artistic persona than Mondrian's. Legally registered as the son of Wilhelm Küpper and Henrietta Catharina Margadant—she was a relatively old mother for the era, having been aged thirty-eight when she bore him—he had been named Emil Küpper. Born in 1883 in Utrecht, he was the seventh and last of their children, three of whom had died in infancy. Wilhelm Küpper was a German photographer; Henrietta Margadant had no profession. Küpper was a Catholic and would not divorce even though, in 1884, Margadant moved to Amsterdam with her baby and several of the other children. There she began an on-again, off-again relationship with Theodorus Doesburg, a Dutch watchmaker nineteen years her junior; following Küpper's death in 1892, she married him. It is uncertain whether Theodorus Doesburg or Wilhelm Küpper was the actual father of the child named Emil Küpper at birth; in a letter he eventually wrote to his wife, Agnita Feis, Emil referred to Doesburg alternatively as his stepfather and his father.

The only certainty is that Emil Küpper scrapped his name for the snappier, sexier Theo Doesburg, and quickly added the aristocratic "van," the way Ludwig Mies threw in "van der" when he added his mother's maiden name of "Rohe" to soften the sting of "Mies."

Van Doesburg had initially been a traditional figurative painter. His pictures of dogs were like old-fashioned sporting paintings, but in his self-portraits, he made himself diabolical. With a strong jaw and chiseled cheeks, he stares with threatening eyes. In one image of himself as an old faun, he appears capable of major mischief. In actual life, he dressed as if to accentu-

ate the deviltry, sometimes in bright red trousers and tall black boots. Mondrian in his white smock at work and his businessman's suits in public and Van Doesburg in his attention-seeking costumes were opposite in persona, but they shared a commitment to expressing what was abstract and universal in the human mind.

Van Doesburg had the intuitive grasp of human foibles that made him both a gifted caricaturist and an effective manipulator of other people. By coincidence, in 1910 he had made a series of pencil drawings that successfully parodied the features of two people who had made life difficult for Mondrian: Abraham Kuyper and Frederik van Eeden. Van Doesburg also did cynical drawings of farmers, burghers, aldermen, and a "Don Juan" as bizarre stereotypes. Soon enough, though, this sharp-witted draftsman went off on another artistic tangent, and then another. First, he made some atmospheric paintings of dunes—while pleasant, they were not nearly as strong as Mondrian's earlier paintings of the same subject—and from there he shifted, in 1914, to distinctly Cubist work, resembling above all that of Metzinger. The following year, he painted colorful representations of sound. Here, he was working in the manner of Kandinsky, who had used the visual to represent the auditory. Van Doesburg also made a portrait of Lena Milius, the woman who accompanied him to meet Mondrian in Laren, which bears a strong resemblance to the portraits Henri Matisse had painted a decade earlier. Now, in 1916, Van Doesburg was painting compositions that looked like Robert Delaunay's.

When Van Doesburg came to call on Mondrian for that initial meeting, they had, among their many differences, Mondrian's conspicuous solitude and Van Doesburg's perpetual need for female companionship. At the time she and Van Doesburg arrived in Laren to meet Mondrian, Hermina Frederika Helena Milius was twenty-seven years old. An accountant, she had first encountered Van Doesburg two years earlier just after he had been mobilized into the Dutch army and been encamped near Tilburg, where she lived. She and Van Doesburg had become lovers, although he was married to Agnita Feis. Van Doesburg declared Milius his muse, saying she had inspired his latest compositions, and his love poems to her had recently been published.

Walking into Hannaert's house, Van Doesburg, with his inevitable cigarette parked in the corner of his mouth, and Milius, with her wide eyes, cupid lips, and black chignon, were a commanding pair. After meeting them happily, Mondrian introduced his visitors to the Van Domselaers, Peter Alma, and M. H. J. Schoenmaekers. The following day, Van Doesburg wrote his friend Antony Kok about the event. Kok, born in 1882, was a telegraph clerk in the railway station in Tilburg but also a pianist and poet, a sympathetic

and unusual person. He was simultaneously esoteric and grounded in reality, a good person in whom to confide. Van Doesburg was excited about encountering Mondrian, but had no qualms about being disloyal from the start; and Kok was sufficiently discreet for Van Doesburg to fire away with abandon. "I have the general impression that v. Domselaer and Mondriaan are in the grip of Dr. Schoenmaekers's ideas," Van Doesburg wrote Kok. That condescending observation suggested an inherent malleability in Mondrian that would have made him the ideally subordinate colleague for Van Doesburg, but its inaccuracy was the reason their relationship would ultimately collapse.

The people who met in Laren had the usual ins and outs of most bands of idealists. No wonder Mondrian saw art as the sole means of achieving balance and equilibrium. The hero of one month was the culprit of the next; strong personalities butted heads; people took sides and then switched them. From the start, Van Doesburg was a troublemaker, and it would not be long before Schoenmaekers joined the ranks of people causing dissent.

Schoenmaekers was a mix of genius and Svengali, Van Doesburg someone with more ambition than genius. Van Doesburg misrepresented both Schoenmaekers's ideas and Mondrian's response to them by oversimplifying them. "He regards mathematics as the only purity; the only pure measurement of our emotions. . . . Mondrian applies this by using the two purest forms, the horizontal and vertical line, in order to express his emotions." Those summations of two brilliant men were based on truth, but Van Doesburg, assuming a superior position, distorted complex precepts in order to mock them. He also characterized Mondrian as a misanthrope. In that same letter written the day after their first meeting, Van Doesburg writes, "Mondriaan is not really the convivial type. He prefers to be alone and does not make new acquaintances willingly."

Van Doesburg was not inaccurate in picking up on Mondrian's social awkwardness, but what he failed to recognize was that it was *his* company, not necessarily everyone else's, that Mondrian was resisting. The person who was regarded as an extraordinary artist, his giftedness and intensity justifying the special treatment he was given, was not so simple to read. Maaike Middelkoop observed of Mondrian, "When he was no longer fascinated, he became distant from all that was happening around him, and no longer paid attention. But then he would hear a single word, and make a comment that pertained only to that word—a funny quip irrelevant to the gist of what was being said." That lack of social grace enabled Van Doesburg and other outsiders to belittle and feel superior to him. But Mondrian knew what he was doing. When he kept his distance, it was not by accident; it was because he chose his moments to engage.

XV

For a man in his mid-forties, Mondrian had the advantage of being in good physical form. Tall and trim, he had remained sturdy. Except when he had one of his periodic stomach ailments or bad colds, he was robust. His main form of exercise was walking; there was no place to dance during the winter where he was, and he had not yet taken up the habit of foxtrotting and waltzing alone in his studio, accompanied only by the sound of his gramophone. He marched at a strong gait when he went into the small village or the surrounding countryside. As always, he saw to his grooming. This was one of his periods of being clean-shaven, with his hair neatly trimmed. He dressed fastidiously and unflamboyantly, his clothing fitting his lanky body impeccably, his looks designed to please and never to startle.

When he returned to Laren in January 1916, Mondrian hoped to work with minimal interruption on his new paintings. He had received sufficient payment for a Beeldemaker copy to be tided over for the foreseeable future. Even if he was not leading the life he wanted in Paris, to which he perpetually imagined he might head back, he was in gear. While Mondrian would only complete one canvas in this season, he made another significant leap in his painting. For he now began *Composition in Line*. On July 15, 1916, thinking he had arrived at a point when he was ready to photograph it, he would write Bremmer that he was trying to achieve "the greatest possible general expression . . . of the natural in the deepest possible manifestation." The man who only four years earlier had painted the overloaded, garish *Evolution* was developing a new form of beauty that was as ethereal, lithe, graceful, and timeless as great music—and universal in its radiant spirituality.

Still, he was not satisfied with the results; he was working continuously on *Composition in Line* without being able either to achieve his goal or to work on anything else. This tentativeness was only increasing with time.

The painting is a large square canvas—42½ by 42½ inches. Mondrian's ambition for the roughly circular composition he created within the rigid form was that its short lines engage with a lively irregularity. As assiduously as he calculated the individual elements, he could not get it right. The simple components in their intermeshed totality needed to have a pulse, to move inward and outward. He never achieved his ambitions sufficiently to consider the painting completed; the result of what was Mondrian's entire output after a year of work exists today only in a photograph, because he completely revised the painting in the course of the following year.

In *Composition in Line (first state)*—the version known only through the picture of it—Mondrian took what he had done in *Composition 10 in Black and*

White a step further. He eradicated the distinction between the background tone behind the design scheme and the hue surrounding it, unifying what we read as the background of the canvas. The bits and pieces of space visible behind the lines appear darker than the empty space surrounding them, but this is optical, not factual. It was a fascinating development, and while moving from studio to studio and shuttling between Laren and Amsterdam because of his obligation to take commissions, Mondrian refined and altered the abstraction repeatedly. On May 3, 1916, he wrote Sal Slijper that when he was finished redoing *Composition in Line* he would show it to him, but he allowed that Slijper might be better off waiting until he had made further progress; in theory, he hoped that Slijper would buy it, but he was realistic about both Slijper and abstraction and, in any case, about the work still not being ready. He wrote that he wanted Slijper only to buy "something which is completely to your liking." Yet Mondrian was already discussing price. He alerted his collector that this large new work would cost at least two hundred guilders—added reason that the buyer needed to be "completely happy with it."

Mondrian had a better chance of prevailing in a negotiation with Slijper about a suit or jacket, but it was a maneuver. Knowing Slijper's preference for the early work, he was trying to bait the collector into thinking that if something was expensive enough it warranted being acquired.

Four days later, Mondrian wrote a very similar letter to Van Assendelft about the high price the painting would have when finished. With the pastor, who had already shown a taste for abstraction, he had a far better chance of a sale than with Slijper. Mondrian had made it his routine practice to let collectors know what he was currently working on in order to lay the groundwork for an actual purchase by interesting them in advance. With what he considered his most important painting to date, he worked hard on the presale, notifying Bremmer as well.

In mid-July, Mondrian informed Bremmer that he had finally achieved what he wanted with *Composition in Line*, or, at least, come closer. He was sending the art advisor two photographs of it; he was pleased, because it was "more advanced, more universal in its expression" than anything to date. As usual, Mondrian denigrated his earlier work. He felt that his church façades of the previous year suffered from "a certain 'loftiness.'" He was now happy, however, because, in what he called his "humble opinion," he was now approaching "the greatest possible expression of the natural in the deepest possible manifestation."

Mondrian sent a photo of the work to Van Doesburg as well, although there the reason was just to provide an update, not to grease the wheels of a sale. This is the image that shows the work Mondrian eventually buried for

all time underneath a new construction. He used a little cross on the back of the photo to show which side was the top, because otherwise it would not be apparent.

On August 1, Mondrian wrote Bremmer, allowing that because he had a commission to do two portraits, he could wait to sell the abstraction until he was again free to work in the way he wanted. The portrait income gained him essential time; he was delighted that he could make further refinements to *Composition in Line* rather than being obliged to sell it as it was. To labor over copies was a price he was willing to pay for the liberty to push his new work further.

When Mondrian completely overpainted *Composition in Line* the following year, obliterating the painting that had preoccupied him for most of 1916, he voiced no sadness or grief. What mattered was the quality of what he achieved, not the energies he had deployed. Time spent was knowledge gained. He knew better than to foist on the world something that did not fully realize his intentions.

XVI

One evening, when he knew Jakob van Domselaer was out performing in a concert, Mondrian asked Maaike Middelkoop to have dinner at his place. After dinner, she decided it was her obligation to clear the table, since Mondrian had done all the cooking. Mondrian argued that, since both of them had eaten, both should clear, and he insisted on helping her.

Mondrian explained to Middelkoop that he had a ritual concerning dirty dishes. He stacked the used plates and glasses and utensils in neat, orderly piles next to the sink and only washed the accumulation every three days. He showed her how many cups and plates he had in total. He knew the exact count of each size of plate and knife and fork and had carefully calculated the number of days he could go without washing up; there were enough so that his system worked even if he had a single guest on one of the three nights.

After he and Middelkoop had put the dirty dishes and utensils in their impeccable piles, Mondrian developed a strange affect. They had agreed that, at an appointed time, they would walk to Hilversum to meet Van Domselaer, but they had finished eating and cleaning much earlier than expected. Forty years later, Middelkoop would describe what happened next. She sat down in Mondrian's room to read, while "Piet sat at his table with his back turned and started to write. We didn't say a word anymore; each of us forgot that the other one was even there. Then, suddenly, Piet turned around and said, 'Uh . . . listen . . . it looks as if we are married, don't you think?'"

Middelkoop lost her composure. At age twenty-five, the attractive young woman, recently married to a man her own age, could not agree with the man who was twenty years her senior and who was her husband's alleged best friend. She "looked at him flabbergasted."

Mondrian's sole reaction was "a guttural 'ha ha'" and then more laughter—to which his dinner guest did not respond.

Mondrian and Middelkoop soon left to walk to the place where their rendezvous with Van Domselaer was scheduled. Neither said a word about Mondrian's remark. Then, when they heard "footsteps in the distance, Mondrian said, 'Here comes Jakob. Let's go to the other side of the road so that he doesn't know where we are coming from.'" Middelkoop, too flummoxed to argue, silently followed Mondrian. They both positioned themselves behind some trees. When Van Domselaer reached their meeting point, thinking that his wife and Mondrian had not arrived, they snuck up on him from behind while Mondrian shouted out, "Hey there Lamberg!" Of the three, the only one who was really amused by the prank or charmed by the nickname was Mondrian himself.

Following that event, whenever Mondrian came for dinner at the Van Domselaers', Middelkoop was slightly uneasy. One evening, Mondrian and Van Domselaer had already begun drinking at a tavern before the meal. On the way home, they purchased a bottle of wine which they quickly consumed while eating Middlekoop's concoction of kidney beans, potatoes, and chopped lemon zest. Mondrian, "in a delicious hazy mood," kept saying how tasty the mixture was. Middelkoop was pleased to have scored a culinary victory with her discriminating guest. Then Mondrian made a remark she would remember verbatim forty years later. "When you nibble on a bit of the peel the sensation is quite overpowering." She was convinced that the reference was sexual.

After dinner, Mondrian rolled and smoked a cigarette, apologized for having eaten too much, and nodded off. "At such times his expression could be remarkably warm and friendly. These ordinary things have stayed with me because of Piet's personality, which, quite unintentionally, put everything in a certain perspective," Maaike Middelkoop recalled. Shortly thereafter, in October, Jakob van Domselaer and Maaike Middelkoop moved to Amsterdam, seeing far less of Mondrian but always considering their time with him to have been a highlight of their lives.

XVII

As World War I further engulfed much of Europe, most people could think of little else beyond the question of human survival itself. Mondrian gave

his particular slant on the subject in a lecture at the Theosophical Lodge in Laren. Standing before his audience, he offered a unique solution to the current turmoil.

He did not risk spontaneity. The tall, lean, neatly dressed forty-four-year-old artist, without any form of chat or personal asides, simply started reading aloud from the introduction to his new book. Looking down at the page through the black-rimmed eyeglasses that gave him a slightly owlish look, he recited this text on which he had labored tirelessly day after day, perpetually revising the words and punctuation. His goal was to articulate his theory that the right art could replace everyday reality with something purer. He spoke with absolute certitude as he voiced his faith in art freed from all representation—whether of seen reality or emotional narrative.

While Mondrian invoked his ideal of a heightened spiritual state with palpable triumph, his audience was not enthusiastic. Whether the problem was his ideas or his delivery, the complex language and cumbersome manner in which he stated and restated his points did not sway his listeners.

Mondrian was not blind to the negative response. It was entirely clear to him that he had inspired disdain rather than the enthusiasm he had naïvely anticipated. He found specious reasons for his failure. Without recognizing the problems of his delivery, and of his indifference to his listeners' needs, he believed that the only issue was human reluctance to engage with new ideas—the same reason he always gave for hostile opinions. After the public address, he wrote Van Assendelft, "I stood firm, but I was under the distinct impression that these folks were not quite ready for 'absoluteness.'"

Mondrian had no doubt that the artistic purity he was pursuing would benefit the masses even if they did not realize it. He wrote Van Assendelft that he was "completely convinced" his ideas had a "justness," and that "those people"—the audience in Laren—would recognize their wisdom eventually; it was just too early. As when his piece was rejected by the Theosophical Society, Mondrian never considered that his text itself might be the problem.

Still, he was determined to increase his effectiveness by sharpening his language. Mondrian tried to improve his verbal articulation with the same frenzied ardor with which he chronically repainted the short straight lines on his latest canvas. Revising the introduction to his book, he went to the same pains in choosing his words as in determining the thickness of his lines or the exact tone of the white paint. He sent his revised introduction to Van Assendelft, asking "if it was any better." He had also begun to consult with the artist Bart van der Leck on the text that followed the introduction. Van der Leck had recently moved to Laren and lived five minutes away from Mondrian. They saw each other almost every day and played a lot of billiards; Mondrian admired him as a colorist. Concerning the details within

his paintings, Mondrian was always his own judge; with his writing, he occasionally turned to others.

Meanwhile, his finances were again getting the better of him. Mondrian was behind on his Paris rent and now had to send it urgently. He was forced to ask Mr. Van Aalst, a client for commissioned portraits, for an advance. It would still be a couple more weeks before he could deliver the finished paintings, but, although the monthly payment from Bremmer helped, he would not have enough without the partial payment or money from another source. He felt forced to ask Van Assendelft for assistance.

> So I will have to improvise, as I'd rather not ask for another advance, and Bremmer's money isn't enough at the moment. So you know where you can put it, if you happen to have some extra. But that won't be for a while, I suppose, because you sent some recently. In any case—now you know.

When the heroic vicar took up on Mondrian's disingenuous hint and sent money, Mondrian quickly acknowledged this "great service," as if the funds were for a shared cause, beyond their meaning for the individuals giving or receiving them. After all, both Hendrik van Assendelft and Piet Mondrian viewed the development of Mondrian's art not as one man's work but as a service for humankind.

XVIII

On February 22, 1917, Mondrian wrote Van Assendelft from his rented room in Laren about his own battles in that dire moment of the war. He felt an ease and comfort with the vicar that allowed him to open his heart. After thanking Van Assendelft both for sending important material and for his "participation"—meaning the vicar's defense of Mondrian's recent work as well as his help with Mondrian's finances—he writes of his own technique for dealing with his ongoing struggles. "Be assured that I will go ahead regardless, with resignation as to 'the long run'—it is also a war, less elementary, but still a matter of strenuous perseverance, to do what has to be done."

Mondrian goes on to tell Van Assendelft, "I am now reading a wonderful book by a young French painter who became a soldier and wrote letters to his mother, with an interesting foreword by a certain André Chevrillon." He explains to the vicar that the book was simply called *Letters from a Soldier.* At the moment, no one knew whether the man was dead or alive, only that he was missing. On the chance that he was still alive, it could put him at risk by providing his name as its author.

Having grown up surrounded by preachers who expected fealty to their

reactionary views, Mondrian relished the chance to address such a liberal man of the cloth. Mondrian allowed to the vicar that the unknown soldier was the model for his own comportment. Calm rather than self-pitying, resolved about how to proceed through the various difficulties he encountered, possessed of a sensible perspective on his relative significance in the world, he was quietly heroic. The way the soldier coped with difficulty, in tandem with the depth with which he felt the wonder of life, was an inspiration. The soldier writes his mother:

> The essential thing now is to appreciate fully the present moment and to get out of it all the good and beautiful and edifying that are in it. . . . Do you not find that life has showered on us many pleasures and that one of the latest and greatest is our being able at last to communicate with one another and feel how united we are?

That embrace of life without fear or fretting, and the means to express universality, were Mondrian's raison d'être.

Later the soldier writes:

> Dear Mother, less than ever should we despair, for never before have we been so convinced that all these agitations and human deliriums are as nothing in comparison with the eternal spark which each of us bears in his breast, and that all these monstrosities will end in a better future. . . . Have you not remarked that in the midst of all this destruction not a particle of the soul is lost and the belief in the existence of a superior law has never been lessened an iota?

Mondrian had found his perfect soulmate in this anonymous soldier believing so strongly in a "superior law." To see the eternal and prize it above all that is particular and individual—and to rejoice rather than feel victimized—was the only way to live.

XIX

The world war was intensifying. The Germans began to bomb Paris regularly. Whether this was a notion of sound military strategy or a hysterical act of retaliation, the citizens of the French capital regularly had their nights disrupted by sirens summoning them to rush into the makeshift shelters that had been created in cellars all over the city. The few who refused to seek cover watched enemy aircraft strafe the city, exploding key buildings and bridges.

Having no idea when he might go back to Paris, Mondrian continued to rework *Composition in Line*. In his studio near Laren, he now made the ground of the entire composition a uniform bright white as he tried to finish the canvas for the Stedelijk show opening on March 10. Still, the painting was not succeeding. On March 7, Mondrian wrote Bremmer to apologize for not having sent his patron a single work in the past year, despite receiving his monthly allowance. He explains, "The main reason is: this year I worked and searched a lot, much of the old had to be changed. I searched for a purer expression: that is why nothing yet satisfied me."

Mondrian now thought he had made a mistake in completely covering up the early incarnation of this large painting. He lamented what he had destroyed. He felt he would have been better off leaving the canvas as it was, and starting a new painting rather than revising one that probably was not so bad after all. "But with searching one never knows *how* in advance." Frustrated, for a while, Mondrian then set it aside completely, but on April 18 he wrote Slijper that he was back at work on the elusive composition and was "beginning to like it." His mood shifted, and he became convinced it would be ready by May, when he would include it in a different show at the Stedelijk.

Then Mondrian ran into unanticipated technical problems. His studio was so cold that the surface that had been pristine began to disintegrate before his eyes. On May 4, Mondrian wrote Bremmer, "The white ground has cracked in places, owing to all the searching but also because the white would not dry in the cold and the place could not be heated enough." To stabilize the ground in time for the exhibition, he switched to zinc white from his usual cream white.

The results succeeded. *Composition in Line* was done, and went into the show. Bremmer bought the revolutionary painting immediately; it was like nothing he had ever seen before, and ravishingly beautiful. Mondrian quickly wrote to Van Doesburg to tell him the good news.

The result of more than a year of revisions is like a view into the universe. *Composition in Line* has a perpetual movement, a constant graceful flow in a myriad of directions simultaneously. The remarkable sequence of lines, varied in width and length, some crossing one another while others stand alone, interacts in the way that parts of the human body do. In *Composition in Line*, named with such apt simplicity, everything is totally refined, yet nothing has been premeditated. Absent a mathematical system, it has an absolute rightness.

This painting appears both spectral and organic, while it does not represent anything known to us. While solid and nearly palpable, it is floating, immaterial, and spiritual. It inhales and exhales as we look at it; certain

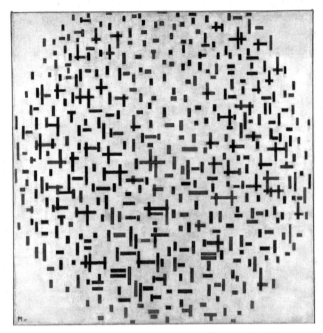

Composition in Line (second state), 1917, Kröller-Müller Museum

areas appear inflated, while others are dense and taut. Sparkling, as rich as it is subtle, inciting multiple rhythms in all directions, this assemblage, composed of nothing whatsoever but short, unmodulated black horizontal and vertical lines on an equally unmodulated white surface, is its own world.

XX

Mondrian never allowed himself to be content for long, but *Composition in Color A* and *Composition in Color B*—the small canvases that followed *Composition in Line*—were certainly reasons to be pleased. Each brings the viewer to a halt. They are jewels: color and light emerging from minimal vibrant components in perpetual interaction.

These two works, which Mondrian completed in 1917, read as variations on a theme, "A" in a minor tone and "B" in a major tone. Fortunately they still live together—at the Kröller-Müller Museum near the Netherlands' eastern border, not far from Winterswijk in a wooded landscape like the one that had initially inspired Mondrian to make art.

To see either of these canvases, each measuring about 20 by 17 inches, is to find oneself in a new universe.

It is possible that Mondrian was more influenced than he realized by his work on portraits and the copies he made of the Old Masters, because there

is three-dimensionality in the way that some forms abut one another while others overlap, blocking out part of what they are covering. Mondrian would soon take such illusion out of his art, but it is one of the reasons these two canvases are a transition to his less physically realistic compositions, where spatial depth will be replaced by its absence.

"A" and "B" induce a meditative state in which our spirits rise. This previously unknown territory is established by blocky dashes of the type Mondrian developed in *Composition in Line*, now in a delightful trio of rusty orange, celestial blue, and dusty rose on a gray-tinged white background. If we knew nothing about Mondrian's beliefs or intentions, and just came upon these paintings without having any idea what they were, we would feel physical and emotional elation from the encounter. No personal experience, no history, no narrative, no biography—either Mondrian's or our own—has any bearing here.

Each *Composition* avoids a pattern or any repetition within the design. And there is deliberate asymmetry. To be centered or full of equations would imply a rational ordering; these paintings, on the contrary, exalt the randomness of confetti thrown into the air and of smoke floating upward.

Physically dematerialized, emotionally unburdened, these canvases are removed from the tribulations of everyday life. By making art which did not show the slightest trace of the vicissitudes of his own existence, not only did Mondrian create something exceptional for others but he rescued himself. At age forty-five, Mondrian was coping with pressures few people could have survived with such equanimity; the calm and serenity of these images provided a safe harbor.

XXI

On May 16, while "A" and "B" were being exhibited at the Stedelijk, Mondrian wrote Van Doesburg:

> As to the blue, you are right too, although the light at the Stedelijk seems to change the colors. In my—too small—studio the effect was different. It is merely a technical question, anyway; my feeling is that my work had to be made on the scene and in connection with the scene itself. I also regard my work as the new decorative art, in which the pictorial merges with the decorative.

It required rare confidence to declare his search for the absolute as entirely consistent with making "the new decorative art." Decoration, after all, had the power to transform the setting of one's everyday existence. Mon-

drian had no wish to follow the example of church art that instructed on religion or of his father's lithographs intended to teach history and lay down the rules of human conduct. Rather, he was simply providing people with a positive experience. His own surroundings were the décor of a boarding-house and of a small studio which belonged to someone else, but in his mind he envisioned a completely new milieu in which what was on display would become integral to the wall.

Mondrian hung *Composition in Color A*, *Composition in Color B*, and *Composition in Line (second state)* as precisely at the Hollandsche Kunstenaarskring show at the Stedelijk as he had positioned the colors and forms within the paintings themselves. In July, he sent Van Doesburg a photo of the Stedelijk installation, emphasizing how pleased he was with the overall effect. The work "shows the religious etc. etc. so well, and the placing together of the three is quite expressive."

The wall was matte black. *Composition in Line (second state)* was hung high, well above eye level. *Composition in Color B* hung to the left of it, low down. *Composition in Color A* hung to the right of it, equally low down. The intervals between the paintings are eighteen inches—the same measurement, exactly, as the width of the smaller paintings themselves. The bottom corners of *Composition in Line* line up with the exact middles of *B* and *A*. This placement of the two colored works in relation to the large black-and-white canvas creates an overall effect which far exceeds the impact of any of the paintings individually. Mondrian's new recessed frames, of the simplest white-painted strips, furthered the homogeneity.

Hendrik Bremmer bought *Composition in Line* directly out of the Stedelijk exhibition.

The two smaller *Compositions* in color went to Bremmer as well, as part of their contract arrangement whereby Mondrian owed him four paintings for the stipend he had now been receiving for over a year, and he was happy to see the three works remain as a unit.

The cracking in the background of *Composition in Line* would have prompted someone of a different temperament to redo, or even destroy, the canvas. Mondrian, however, was willing to let the crumbling painting go into the world as it was. The purely material aspect of his work did not concern him all that much. His task had been to locate the forms and adjust the colors, to create the living being. From then on, his approach was practically Zen. What happened, happened. Today, when we look at Mondrian's paintings with their white surfaces cracking, so that they resemble shattered egg-shells that have retained their form but become covered with fissures, their condition should not necessarily be read as a disturbance but, alternatively, as a state of affairs consistent with Mondrian's vision. Paintings, like all living

beings, change in time. Mondrian not only accepted the instability of life but honored it. Perpetually moving colored panels up and down his studio walls, he exulted in the change inherent in the universe. What was sacred to him was life itself, with all its ebb and flow, and not just his own life, or that of one of his paintings, but the endless time and space of the cosmos.

XXII

In November 1917, the first issue of the magazine *De Stijl* appeared. Five years later, in its fifth anniversary issue, Theo van Doesburg, in his capacity as founder, would credit Mondrian for having invented the approach to painting and design for which the magazine was named.

The artist Bart van der Leck would ultimately claim—to Michel Seuphor, in the 1950s—that *he* was the father. He insisted that, after Mondrian brought him to Van Doesburg's studio and introduced the two, Van Doesburg had almost immediately begun to copy him, and that was how the new style really got going—not with Mondrian. The matter would become a rat's nest—it still is—for art historians trying to tackle the question of whether a single individual started De Stijl. Michel Seuphor maintained that Van Doesburg gave Mondrian credit as its founder only to make sure that no one thought that Van der Leck was too important. Seuphor quotes Van der Leck saying, "That's the sort of person Van Doesburg was. No ideas of his own. And a cheat into the bargain."

The only person who was above all this jockeying for preeminence was Mondrian himself. The issues of "credit" or fame—and ego—had no role for him. Hans L. C. Jaffé, a definitive De Stijl scholar, considers Mondrian as the singular source for De Stijl's "shared point of departure: the principle of absolute abstraction—that is to say, the complete elimination of any reference to objects in nature." The editorial statement of the first issue of *De Stijl* in 1917 established its purpose as "a new aesthetic awareness" that would counter "the prevailing archaic muddle" with "the logical principles of a new style"; it was Mondrian who developed those priorities. The artists whose work and writing would appear in the magazine were uniformly devoted to "the emergence of plastic consciousness": the heightened awareness of the essence of structure and form that, more than any reproduction of the natural, was the essence of Mondrian's goal.

The devotees of Mondrian's artistic credo would be united in their wish "to awaken aesthetic sensibility among laymen." Color was one of the vehicles of this awakening, and the majority of the evangelists would be painters rather than architects—who, the editors felt, naturally avoided "meddling with color, which should be the business of a painter." But the plastic con-

sciousness could be inspired in white as well as through color, and the architect J. J. P. Oud was included in that first issue along with Mondrian, Van der Leck, and Van Doesburg.

Some of the ideas elegantly put forth in the Dutch magazine would be echoed two years later when the Bauhaus was formed in Weimar in Germany. Both movements rose from the determination to counteract academic approaches to painting and to avoid design dependent on historical styles. The Bauhaus, however, would give equal space to a range of arts and crafts, whereas *De Stijl*, regardless of Oud's inclusion, focused on abstract art "and first of all painting." *De Stijl* advocated the rise of the "authentically modern artist" with "a double mission. First, to produce the plastically pure work of art: then to make the public capable of experiencing this pure art."

In theory, the magazine *De Stijl* was the tool of an entire movement which was to be a collective enterprise. The underlying principle was that when artists recognized "their basic equality" and banded together in developing "a universal plastic language, they will no longer remain timorously attached to their individualism. They will go beyond this individualism and seek to serve the universal principle." The objective was "a spiritual community." Artists were expected to renounce personal ambition if this were to thrive and produce a new style. It sounded great, but as Van der Leck's later swipes made clear, the suspension of the human ego was not a reality.

Mondrian, meanwhile, not only shrugged off the issue of who had what role but seemed impervious to his being in a totally different class than the others as a painter. He happily accepted the group agenda, and when he did learn something from his fellow artists—at one moment Picasso, at another Van der Leck—he gladly acknowledged it. He was as distinguished from the other De Stijl painters in his level of sheer talent as he had been from his fellow students at the Rijksakademie—and then, people like Toorop in Domburg—yet he never revealed any sense of superiority or rivalry. He respected everyone's efforts and did not compete. His battles were bruising, but they were only with himself. All that mattered to Mondrian was that he achieve his elusive goal to maximum effect. He rarely felt he succeeded, but, unlike most other people who make art or write, he hardly ever disparaged anyone else. His own toughest judge, he imposed his demanding standards on himself alone.

XXIII

That first issue of *De Stijl* enabled Mondrian to publish his introduction to *Neo-Plasticism in Painting*. The essay linked the new art to overall changes occurring for all of humanity. Mondrian believed that a general transforma-

tion was taking place, and that civilization was in a forward momentum. He opens the essay declaring "The life of modern cultured man is gradually turning away from the natural: life is becoming more and more *abstract.*"

This individual Mondrian was depicting was, more than anyone else, himself, yet he believed he was describing a trend that, soon enough, would be global. Out of naïveté or blindness, he failed to recognize that the impact of the current war engulfing much of Europe prevented people from focusing on abstraction. While Mondrian saw people as moving into the world of vision disconnected from nature, most were concerned only with the need to rush into cellars during aerial bombardments and cope with food shortages. Mondrian was simply unaware of the distinction between his own rare persona and that of the majority of human beings in Western Europe at a time when bombs were raining down from aircraft.

The "modern cultured man"—Mondrian himself—was a rarity. Few other people could fill the bill when he wrote "The life of *truly modern* man is directed neither toward the material for its own sake nor toward the predominantly emotional: rather, it takes the form of the autonomous life of the human spirit becoming conscious." When he published those words in 1917, it was exceptional to have the luxury of such autonomy. The daily destruction of lives, neighborhoods, and even parkland preoccupied most people more than the luxury of Mondrian's fixations. But in the naïve idealism of this essay that had obsessed him for over a year, and that at last found its way into ink printed on paper, Piet Mondrian was showing, unfiltered, the same extraordinary connection with essential, pure beauty that is the lifeblood of his painting.

If the forty-five-year-old Mondrian was disingenuous, it was certainly not because his own circumstances were especially privileged. Rather, he could decry human greed and extol abstract beauty because external conditions mattered so little to him.

XXIV

In October 1917, Sal Slijper, having recently moved to live full-time in Blaricum, recognized that Paul Sanders, a twenty-six-year-old composer and music critic who was one of his new neighbors, was someone to introduce to Mondrian. Through Van Domselaer, Mondrian had already come to connect his writing and painting to music; Sanders was sure to interest him.

Sanders came from a successful banking family, and had been supposed to join the same business where all the men in his family had worked for generations. Instead, he opted for the far less lucrative profession of journalism,

with his specialty being music. His dream had been to be a composer, but he feared he would have earned no money whatsoever if he had tried, and writing about music was an agreeable alternative. Sanders was also intensely committed to leftist politics and had become a leading voice of the Dutch Social Democratic Labor Party. Mondrian had officially disassociated himself from the labor movement, but its views remained dear to his heart. Slijper was sure that a young man who shared Mondrian's politics and had the courage to go his own way by devoting himself to music rather than banking would intrigue Mondrian.

Besides, Sanders had the sort of worldly charm and kind, agreeable manner Mondrian liked. Clean-shaven, impeccably groomed with his thick wavy hair brushed back off his high forehead, elegant in his wide-lapeled double-breasted pinstripe suits, the young musicologist was one of those people whose company appealed to Mondrian, and made his everyday life more pleasant. This was one of the rare friendships that would endure. Eventually, as a music critic for a Dutch socialist newspaper, Sanders would spend a lot of time in Paris, and he would become a loyal and helpful devotee of the struggling artist twenty years his senior, whose work he adored.

One evening, shortly after Mondrian and Paul Sanders had met for the first time, and they were "chatting over a cup of coffee"—the memories are in Sanders's words—"Piet suggested that we take a little walk. Slijper preferred to stay home, and a little walk turned into an expedition of several hours."

Mondrian and Sanders headed off on the Torenlaan, the road that linked Blaricum and Laren. The tram rails ran alongside it, and the former dirt road had been paved seven years earlier, but it was devoid of traffic, entirely quiet, bordered by trees. Occasionally they passed a farmhouse with light coming through a couple of windows; otherwise the landscape was pitch-dark. Although Mondrian had proposed the outing, he said nothing whatsoever. The two walked about a quarter of a mile in silence. Then Mondrian indicated that they should turn back toward Blaricum, while still remaining wordless. Sanders, being nineteen years younger than Mondrian, felt it was not his place to break the silence and disturb the painter's thought process. Sanders longed to ask this man for whom he had such ardent respect what he thought of some of the pioneering modern painting he had seen in Berlin before the outbreak of the war, but he restrained himself.

Then Mondrian suddenly started to talk. He turned to Sanders and asked what he thought of the music of Jakob van Domselaer. Without preamble, he simply asked the question, in as few words as possible.

Sanders knew that Van Domselaer's work was popular with painters, but

he personally considered it "rather monotonous and bogged down in only partially successful experiments." He wanted, however, to be tactful. Rather than say this flat out, he told Mondrian he greatly preferred Schoenberg.

Having struggled to handle his response with delicacy, Sanders then realized that it had made no difference. Mondrian had not been paying any attention whatsoever to the question he had just asked. Instead of discussing music, "he started talking about the influences that had affected his technique and style" and about his belief that abstraction was more meaningful than naturalism. "He went deeper into the analogies and the differences between the application of that concept on the visual arts and music." The question had only been a conversational gambit; Sanders's views on Van Domselaer did not concern him in the least. Mondrian was off and running on the subject of his passion. Again he shifted direction on the country road, now in the direction of Laren. By the time they got back to Blaricum three hours later, they had shifted course more times than Sanders could count, Mondrian holding forth without stop, and with an intensity of a sort Sanders had never encountered in any other human being.

XXV

Willemina Agatha Wentholt was from a wealthy, distinguished family. Her father was Minister of the Dutch Marine; her mother did volunteer work in a prison. Mondrian met Wentholt, who was fourteen years younger than him, when she was living in the same luxurious pension in Amsterdam as Sal Slijper. She taught French at the lycée; from the time she met Mondrian in late 1917, thanks to Slijper, they spoke French together. "Willy" Wentholt is another of the women in Mondrian's life where we ask if they were lovers physically.

For some writers on Mondrian, it has been essential to believe that he was a womanizer who bedded both girlfriends and prostitutes. To others, who delved more deeply, it is possible that Mondrian never had sex with a woman. We know little with certainty. In the case of Willy Wentholt as with Nell Harrenstein, it is likely that, given the mores of Calvinism and the social behavior of young bourgeois women in the Netherlands in the early twentieth century, neither of the two went to bed with Mondrian, but we cannot be sure. Charmion von Wiegand would make it clear that, in the relationship she had with Mondrian when he was seventy, they were never lovers.

Still, it is probable that with Willy Wentholt, whose dalliance with Mondrian has only recently come to light, it was the same as with a string of other young women between about 1907 and 1920. Mondrian liked to dance; he

liked to plant kisses. Beyond that, almost all that can be ascertained about their relationship is what we infer from the letters Mondrian wrote to her. Mondrian saved none from her to him, but fortunately she saved his side of the correspondence. Music was a favorite topic, and Mondrian opined as only he could. In response to some reviews that Wentholt sent Mondrian on February 20, 1918, Mondrian answered, "I read those with approval, yet I find that Debussy still expresses 'stijl in the natural manner': that's okay too, yet it brings too much dominance of natural feeling." He must have already felt considerable rapport with his new friend, since clearly he expected her to understand that his aversion to "the natural" in painting now applied to music.

He began to write Wentholt regularly concerning plans for possible dancing with her and also for dinner, but already by March 6 he was in effect pushing her away just as he had Aletta de Iongh. In different languages with different women in different periods of his life it was always the same story: Mondrian avoiding intimate encounters with women more interested in him than he was in them. His stalling tactics were hardly subtle. Clearly there had been some romantic intensity between them, and he now wanted to back off, attributing the peaking of emotions to a sort of fever delirium. On March 6, without mentioning that the following day was his birthday, he wrote her:

Willy, of course I would enjoy it if you come here tomorrow, yet all kinds of people come here in the afternoon and at night my brother. All that aside, I am so incredibly busy that I will continue painting at night and if there is some time left, writing for de Stijl. So let us wait until more quiet times, after the 16th; then the exhibition opens. Slijper will probably not be better completely on Sunday, but I assume he will let you know. In any case, I will have dinner at his place and, if you do not come, I will write to you after dinner, like I did last Sunday.

I will hear from you if it suits you to come by soon after the 16th. Maybe that Sunday, first at my place and then at SL.

It might be true what you write, but don't you agree that it is better if we get back to the same condition to each other as before I got ill: I think that when I got ill I could not see clear. Think about it, do not write about it. We will talk about it once.

It all becomes clearer when he wrote her ten days later:

Saturday afternoon.

Willy, thank you for your letter; I agree we are more likely better off this way. I am not disappointed in you, but first I had the illusion of a very

great love. I am not sure if this very great love, which I mean, would come up to you later, and therefore it's better this way.

So we will not talk about it anymore, as you suggested. If you remain the same towards me, I will never be closed to you. Goodbye Willy, I see you on Sunday.

Very best from Piet.

I didn't have any other paper.

Yet, not for the first time in his life, after enough time had lapsed, Mondrian was feeling amorous again:

Willy, here is the answer about the eating: more expensive than I thought. I need to say again how much I love you!

Goodbye Willy, see you Wednesday. Your Piet.

There is no knowing what happened in the ensuing two weeks, but reading between the lines, things needed to cool down again having briefly gotten hotter:

Sunday afternoon.

Dear Willy, I need to write you to tell you that I am feeling happy again. We have made a pure relation of a very beautiful friendship. Let us keep it this way and we will have a nice time when you are here. I hope you don't mind me staying a bit more on my own than it was common lately: I know that you can also be on your own. Well bye, see you Wednesday. Your Piet.

From there forward, Mondrian would have the sort of communication with Willy Wentholt that he had with most people to whom he felt close. This consisted of a detailed account of his own health. On October 1, Mondrian wrote Wentholt:

I have prepared a lot of canvases for new work. For my health it is much better here that it was in my previous studio: I already notice that. My ear has not gotten worse: rather better, yet I also notice something in my molars and although those are treated well, I wanted to go to my dentist yet his house was demolished and now I lost track of him. But I will write to him.

Once Mondrian moved to Paris, he would remain in touch with Willy Wentholt at least until 1923. The content of the letters was extraordinarily

pedantic. Mondrian could carry on and on about the problem of Wentholt having used the incorrect postage stamp on a letter to him. The most interesting detail to emerge from pages of communication is that the shimmy, danced to "fast fox-trot" music, was "the best dance that I know."

What appears to have been the last letter Mondrian sent to Willy Wentholt is a perfect summation of what the relationship had become:

> I also struggled with my nose and throat as you know, but gargling with salt water, and nose pomade etc. I keep it going. I wrote to Dr. Leonard about it and he says it isn't anything serious and sent me some kind of snuff that helped a lot. I write you this because I do not think surgery will help a lot. Shouldn't you wait a bit longer and consult Dr. Leonard? He must be really clever. I sleep with open mouth most of the time and that isn't good for your disease, that's true. But I heard from a lot of people that surgery didn't help a lot. Bye Willy, lots of good, I am going out for fresh air, it is so hot in here.

XXVI

By the start of 1918, Mondrian had begun encasing the rectangular planes of color that he had developed in the compositions of the previous year. Having floated untended, the various hues were now contained by bold black lines of equal width. That grid gave the paintings a new syncopation.

With no sign of world peace or of the possibility of his return to Paris that spring, he also put new energy into mastering further dance steps at the Hamdorff. He requested the orchestra to play music for the "one-step"—a fast ballroom dance that had been growing in popularity over the last decade. It was a precise and demanding series of movements. The one-step had to be executed to music in exact 2/4 or 6/8 time, with about sixty bars a minute. Mondrian was equally eager to hone his skill in the two-step, a modern derivative of the polka. For this, one of the dancing partners moves forward, the other backward, each taking a step in the same direction on the same foot, and then making a closing step with the other foot, either perpendicularly—at ninety degrees—or at an oblique angle. Those movements are followed by another step with the first foot in the same direction as the initial move, after which the dancing partners can do either a right or a left two-step, in tandem, ending the sequence back in the positions in which they started.

Mondrian met his objectives in the Hamdorff ballroom. In the season, he repaired there faithfully once a week. But now he also began to dance on his

own at home. He became competent at both the one-step and the two-step, and then decided to try moves that were even more complicated and learn the Boston and the tango.

In his painting as in his dancing, Mondrian adhered to a new set of rules and imposed a specific discipline on himself. He developed the means to lend new grace to his art. While he was mastering these new dance steps, he introduced a grid of gray lines into his work. In painting, the guidelines were every bit as strict as the requisites of the tango, but in this case they were invented by him alone.

The pallor of the gray posed particular issues to be resolved. Moreover, Mondrian knew that, hard as it was to interest clients in the paintings with black lines, the lighter tone would make the paintings nearly impossible to sell. But this did not prevent him from going with the gray, which became his aesthetic preference.

Besides, he was pushed toward the gray for practical reasons. As supplies dwindled because of the war, primary colors were becoming less available and prohibitively expensive. Mondrian had to mix these rare commodities with white or use pigments that were more muted at the start in order to cover the areas where he wanted color. Now the tones were too muted to withstand the impact of jet-black lines adjacent to them; the contrast was daunting. What developed in part out of economic necessity proved fortuitous; after completing *Composition with Color Planes and Gray Lines 1, 2,* and *3,* Mondrian felt they were the best work he had done to date. He reveled in the by-product of the more restrained tone of the lines and the self-imposed restriction of the entirely regular grid.

Neither Van Doesburg nor most of his other colleagues agreed. Their opinions did not bother Mondrian, but he recognized the consequences of the lack of appeal of these more subtle new paintings. The only chance of selling them was to Bremmer. If Bremmer did not see their merits, Mondrian would somehow have to find another way to have enough money.

He wrote Van Doesburg defensively:

> It is true, with a regular division there is a risk of repeating oneself, but that can be countered by contrasting. Everything can become a system, both the regular and the irregular division. It only depends on how it is solved.

Mondrian refused to be flapped by the antipathy to the more regular format of this new work. Whenever other people, even the so-called cognoscenti, questioned his latest independent step forward, or openly disparaged it, Mondrian inevitably responded by justifying what he was doing and con-

tinuing as he wanted. He could never allow himself merely to keep doing what had already succeeded, even if he had the choice. It was as if hard circumstances and negative critique were an impetus to push ahead undiscouraged. Art was always a progression, and the new had to be better than the old.

XXVII

Then, Mondrian made a further leap when he developed a series of paintings he titled *Compositions with Grid*. Each has as regular and meticulous a grid as graph paper or a checkerboard, except that each is slightly wider than it is high. They have sixteen modules across and sixteen up and down, these cell-like units having in microcosm the precise shape and proportions as the canvas itself, which is also subtly rectangular. The unwavering structure is the basis for continuous movement and playfulness. Working at a fever pitch, Mondrian became determined to complete a dozen related compositions of this type so that they would be ready for the Hollandsche Kunstenaarskring's fifth annual exhibition, which was scheduled to open in February 1919. Then Mondrian accepted the reality of his inability to complete paintings quickly enough to fulfill that goal for a year's work. To assure that each could be a total success, he reestablished his objective as being eight paintings in all. He thought in easily divisible numbers; he wanted the number of finished artworks to be exactly half the number of cells that each had per side.

Mondrian credited a conversation with the artist Vilmos Huszár for the use of "a regular subdivision" for his new formats. Vilmos Huszár was born in Budapest, Hungary, in 1884. In 1906, he had moved to The Hague, and in 1916, he had met Van Doesburg. He designed the covers of the first issues of *De Stijl* magazine. He was a new player in the movement that helped realize many of Mondrian's most sacred ideas, and although he would break with Van Doesburg in 1924, he would remain faithful to the principles of De Stijl long after. Nonetheless, Huszár, like Van der Leck, retained elements of traditional subject matter in his work, always a shortcoming in Mondrian's eyes, but even as Mondrian reworked the mathematically regular grid in a more radical way, as the basis of abstractions that referred to nothing but themselves, he would not forget Huszár's gift.

Discussing his response to outside influence, Mondrian wrote Van Assendelft, "I am constantly changing—without wanting to." The compositions themselves had some of that same restless motion that governed the man who had made them. Like him, the paintings never stop going this way and that within a neat framework. None of the new works have either repeats or

simple formulas. There is inevitably another step to take, a different unexpected move.

Finally, Mondrian would complete only two of these paintings with perfect grids, and that would not be until he was back in Paris after the end of the war. Nonetheless, he was preoccupied with their creation during this period at the end of 1918. Mondrian instructed Van Doesburg, who he assumed would see them in Amsterdam, on what to consider when viewing them.

> You must keep in mind that my things should be seen as paintings, that is to say, they are an expression in and by themselves, not part of a building. And that they were made in a small room. And that I use subdued colors temporarily, adjusting myself to the present environment and world: it does not prevent me from preferring a pure color. Otherwise you might think I contradicted myself in my work.

No wonder that the letters from an anonymous, life-loving, stoic soldier on the front lines meant so much to him. Since the pigments he would have preferred were either unavailable or unaffordable, he had started to use those lighter hues out of necessity to be consistent with the soft tonality about which he had no choice. Lifelong, Mondrian's way of dealing with limitations—material, physical, personal—was to acknowledge their reality and find solutions. Like that soldier at the front, he would always discover the means to celebrate the beauty that nothing can violate.

But finally the scarcity of available paints made him put the elongated checkerboard compositions to the side. Mondrian decided to try something completely different. He tilted a large square canvas forty-five degrees, with two of the corners top and bottom, two right and left, and made it simpler than anything he had previously painted. He reduced his palette to nothing but two unmodulated dark grays and a single white. The composition is simply a few straight lines. With his minimal means, gyrating like an acrobat standing only on a single toe, he achieved startling results. Miraculously, color and motion occur in profusion when all that Mondrian had painted was in fact colorless and still.

With its austere vocabulary of both form and hue, *Composition with Grid 3: Lozenge Composition*, which he succeeded in completing in 1918, radiates light. Everything is at even intervals; the distances between the lines that cross the canvas are always of exactly the same measure. In a departure, Mondrian has used diagonal lines—meticulously making them all the iden-

tical width. The only variation he allows himself is with the widths of the horizontals and verticals that bifurcate the large canvas, of which each side measures nearly three feet. Those two different thicknesses and the clusters formed by the intersections of the lines going in three different directions create the shimmer and sparkle of a diamond that has been carefully cut by a jeweler to achieve maximum brilliance. The luminosity of the white adds to the state of perpetual movement. The result is as forceful and timeless as a star-filled sky on a clear night.

How Mondrian achieved the exactitude of his widths remains a mystery. No one witnessed him in full work mode even if he could be seen compulsively making minor adjustments here and there. Whether he used an engineer's tools, or achieved his precision only with eye and hand, is unknown. But what is certain is that he had astonishing technical prowess. Dr. Van Calcar had had good reason to hire him a second time to do microscopic drawings.

Mondrian had searched and experimented for many weeks to find the precise white paint for the field of *Composition with Grid 3*. He then applied the dark gray grid. Once he finished his work, he became ill. When he revived and rose from his sickbed a couple of weeks after succumbing to one of his nasty bouts of flu, he studied this most important of his new creations. The white no longer looked right to him. He felt he had to change it completely, and did so, demanding as the task was never to perturb any of the gray edges. The new results pleased him, and he believed that his forced time away because of his illness, and the subsequent change he felt impelled to make when he saw the canvas in a fresh way, were a gift of the gods.

The only issue was that the paint was drying slowly. Mondrian needed to have *Composition with Grid 3* ready for an upcoming exhibition, and was concerned that it would still be tacky. In order to have it completely dry by the delivery date, he put it near his wood-burning stove.

When he looked on the following day, the white areas had begun to blister, with the flat paint developing a series of fissures. In the course of a single day, the cracks widened. Mondrian could accept imperfections, and had had his previous experience with blistering, but this was too much. He had to remove all the whites and repaint them entirely.

He would, lifelong, be secretive about his technical processes and keep them unknown even to his fellow painters. With modern technology, however, it has recently been deduced that he started with a layer of lead white, and then applied zinc white or permanent white on top of it, each layer thinner than the one beneath, utilizing the technique he had developed with *Composition in Line*. Those were his materials until about 1930; in the '30s and '40s, he would use titanium for the top layer. Those choices of materials

were vital, as was the method of application. The exact tone of the white was fundamental to the snowy purity of the work, its luminescence and glow.

To have to do the canvas a third time would have been too daunting a task for almost anyone else. But Mondrian not only undertook the effort; he did so, as always, in such a way that no one could see or imagine what went into the result. Only the end product mattered.

One night in August 1918, the painters Co Breman and Evert Pieters and the architect Herman Walenkamp had transformed the Hamdorff into a Pompeian court. Those who attended walked around in Roman sandals. They dressed in tunics and pallas with wreaths of flowers in their hair, and did "faun-like dances." Standing tiptoe on one foot, shimmering white, moving nonstop, elegant and playful, *Composition with Grid 3* had the same festive spirit as that evening, when Mondrian danced until dawn.

The vibration of *Composition with Grid 3*, the way it bursts like a flower, the up-down, left-right, inward-outward movement at the tempo of one of those two-steps Mondrian was mastering at the Hamdorff, is astonishing. Without tape or straightedge, using only his hand, yet initially giving the impression of machined precision, Mondrian has breathed life onto the canvas. The junctions all sparkle. The interaction is exuberant.

Eventually the viewer deduces that, as with the warp and weft of weaving, some of the lines are on top of, or beneath, others. Generally the thicker ones appear nearer to us, covering the thinner ones. But there is no formula.

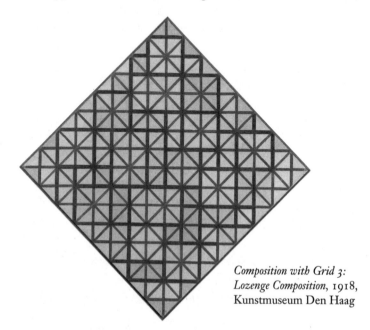

Composition with Grid 3:
Lozenge Composition, 1918,
Kunstmuseum Den Haag

Rather, this is like life itself: with a pulse, with ongoing motion, with systems and reasons but also with anomalies and full of unpredictable events.

Mondrian was on one of his upswings. The taciturn painter, phlegmatic in affect, now age forty-six, was moving forward in his art with audacity. Presenting himself not just to the world but to himself as if he were, perhaps, an educated shipping clerk, he had unequaled courage and originality in his art. His lengthy letters, full of details about which painting was going where, how to frame them, and issues like the amount of money required for a sec- ondhand jacket, have none of the élan with which he painted. He lived with this reticence so that he could better break new ground in his art. His bold, completely unprecedented way of painting was not a matter of defiance or a rejection of anyone else's rules. If he was a rebel, rebellion was not his goal. He was possessed of a powerful rationalism which facilitated the complete lack of inhibition.

Of the grid of lines he balanced on a corner point, he had, when working on it, written Van Doesburg that he was testing to see if this method was possible. "It has something to say for it, because the standing and the lying occur everywhere in nature; I would neutralize it by diagonals." He was, of course, contradicting the stance he had taken so firmly against diagonals. But his wish to honor nature and also enhance it required flexibility and an open mind. Guided above all by his eye, making his overall goal his priority over any rules that could impede it, Mondrian had made a canvas which gave the world something that had never existed before.

XXIX

While at last the war was coming to an end, the internecine battles of the De Stijl group were intensifying. Mondrian did his best to stay on the side- lines, but he opposed the inclusion of architects as members with the same stature as painters, and it was a bone of contention with other members of the organization. Mondrian insisted on the primacy of painting and had consciously avoided writing about architecture in his text that was being published serially in each issue of De Stijl's eponymous magazine. When, in November 1918, he was one of the seven cosignatories of the "De Stijl Manifesto," he antagonized a lot of architects by making sure that none of them were included.

By the end of the year, Mondrian was again nearly out of money, and he had to do what he called "pot boilers" by undertaking commissions for por- traits and copies. His energies had been further depleted by repeated bouts of Spanish flu that autumn; every time he was convinced he had shaken it,

he became ill again. Theoretically, Mondrian could finally have returned to France, but Europe was in shambles, and there was no certainty about when train routes would reopen.

Still, the paintings Mondrian managed to produce when he could eke out some time and wasn't feeling too sick manifest ambient joy. The horizontal/vertical divisions provide order and resolution. Each canvas had its own integrity, with its parts interrelated in a complex balance. The totality and completeness of the composition were part of what made the work beneficent; so was its lack of utility. The geometric subdivisions of new building façades were appealing, but they had a practical function; this was creativity with no other purpose than the rich experience provided for the onlooker. On February 13, 1919, Mondrian wrote Van Doesburg, "You must keep in mind that my things should still be seen as paintings, that is to say, they are an expression in and by themselves, not part of a building." He had made them in a small room, independent from their architectural setting. In that year when the Bauhaus was being born, when all the visual arts were being treated as part of an overall scheme, the primacy of painting was increasingly essential to him. It was one of the reasons he was so eager to return to Paris, for centuries the home base of traditional picture makers.

Paris

I

By the start of 1919, people were mourning for the lives lost, but hope was in the air, and Mondrian knew he could move back to Paris.

He gave notice to the proprietor of both his living quarters and his studio in Laren, promising to have his possessions out by June 1. It was not hard to empty both spaces of what belonged to him; Mondrian's personal property and the few paintings that remained unsold fit into two boxes, which Slijper would ship once Mondrian was settled in back on the rue du Départ.

Slijper also agreed to buy the earlier paintings that were now accessible in Paris. And Peter Alma purchased one of Mondrian's new paintings even before it was finished. These sales, along with Bremmer's monthly allowance, gave Mondrian a fresh start. But the trip back to France was rougher than he anticipated. On June 21, a Saturday, when Mondrian left Amsterdam on the Paris-bound train, he expected a speedy journey. At the Belgian border, however, the authorities who boarded the train were not satisfied with his passport. They made him disembark in Roosendaal and instructed him to go back to Rotterdam. It being a Saturday, most government offices were closed, but Mondrian, resolute and taciturn, managed the bureaucratic hurdles and got the missing official stamp on his documents. By the time he was done, it was nightfall and he had missed the last train; carrying his few clothes and recent paintings, he found a place to stay. The following morning he resumed his trip. Around ten o'clock in the evening of Sunday, June 22, 1919, almost five years since he had left the rue du Départ—Mondrian was back in Paris.

II

"What will you do after the war?" Jakob van Domselaer had asked Mondrian one day in Laren two years earlier. Mondrian answered his friend "that he had done what he had to do." With the artwork he had made since returning to the Netherlands in 1914, he had achieved his goals as a painter and had no

reason to go further. He told Van Domselaer, "I'll return to France just the same. Even if I can't sell any paintings. I'll go south and work for a peasant, picking olives."

There were dozens of occasions when he declared that he should pack up and go to southern France and work as a farm laborer. But it was never long before Mondrian was back at the easel pushing himself further. All it took to rekindle his need to paint was the feeling that one black line had the wrong dimensions or needed its position shifted half a centimeter, or that a small red square had to descend ever so slightly, and he had his work cut out for him. He invariably got past his low points with new purpose at his easel. When Mondrian, at age forty-seven, returned to Paris, he felt himself renewed.

He was a different artist from the one he had been when he left. Managing in whatever studio he could in Laren, never having one that was his own, Mondrian had made vast leaps in his painting, and during the evenings in the different boardinghouses where he could live cheaply, he had put his new artistic beliefs into words. At the start of 1919, he had begun his most intense effort as a writer, the *Trialogue*, a three-person conversation in the form of a play in ten scenes. Its main character, an abstract artist, was autobiographical. The play was a labor of love, and even though it was unlikely that it would ever be performed in a theater, one of his ambitions when he returned to Paris was to complete it.

He also hoped that back in France he could go further in mastering the two-step. The previous summer, at the Hamdorff, he had struggled to perfect the movements and their timing with any young female partner who would join him on the dance floor. He knew that once he was back at 26, rue du Départ, he would have the privacy to try it alone. But mainly he wanted to start painting again as soon as he could; in spite of having said he had achieved his goals and was prepared to stop painting, he was brimming with ideas for new compositions.

The return to his old digs did not go according to plan, however. When he opened the door, his studio "was very dirty, much worse than I had expected." The state of disrepair was so daunting that he stood motionless for fifteen minutes. The studio appeared larger than he remembered, which he attributed to the small scale of the places he had had in the Netherlands, and he looked forward to settling in, but it was uninhabitable. Once he decided it was too filthy to sleep in, Mondrian stayed instead with "a French friend of mine." While we do not know who the friend was, we do know that Mondrian took all his meals in a cheap restaurant because the friend could not afford to feed him.

For two weeks, Mondrian cleaned his flat and packed things belonging to Peter Alma, who had left them stored there. He was not about to abandon his plans; on June 27, five days after arriving back in Paris, Pieter Cornelis Mondriaan, identified as being of "nationalité Hollandaise," acquired his French residency card from the Préfecture de Police. He was in Paris to stay; he intended never to return to the Netherlands except for short visits where there was no chance of again being trapped.

When he could finally move back into 26, rue du Départ, Mondrian had another surprise. He went to a small local food store to buy a few staples. Milk, butter, and eggs all cost twice what they had before the war. It was no worse than the inflation in the Netherlands, but he was not prepared for it. If he was going to survive in Paris, Mondrian recognized that he would have to both scrimp and sell more art quickly. Since a single egg cost sixty centimes, Mondrian wrote Slijper that he did not need to eat eggs, and at least bread was still reasonable; he was determined to manage it all, but it would require more sacrifice. Fortunately he had the money Slijper had paid for the paintings he had done just before leaving the Netherlands; as long as he managed it correctly, this gave him what he required for a fresh start.

Mondrian had definite ideas of what was essential and what was not. He could not imagine living without a cleaning lady. He was relieved that the pay for a "femme de ménage" was no higher than it had been in Laren, and calculated that the forty cents an hour he had had to give the woman who cleaned for him there was almost the same as the franc an hour in Paris. He contemplated getting a job—a friend was getting twenty francs a day selling movie tickets—yet he was determined to paint full-time. If he could only finish some paintings, he might get a contract with an art gallery the way some of the Cubists did. He anticipated that this would take him about a year, and he wanted to use every possible minute to produce saleable pictures.

He wrote about all these concerns to Slijper, pointing out that he was fortunate to be one of the few people whose rent had not gone up. "Still I am happy to be here. I am a lucky guy, notwithstanding all my poverty." He could not for the time being make any improvements to the studio or buy anything for it, and he had to reacclimate himself to the noise of the nearby train station—"it is as if it is constantly thundering"—but with the windows closed, the studio was quiet.

Yet for all that resolution and determination to make the most of difficult circumstances, Mondrian was still subject to certain fears, and anxious even if he did not know the reasons. He had repeated dreams that he was hearing a person screaming loudly. Then he would waken, and realize that in fact he had thought that because of a train whistle. It was only with the conscious-

ness that comes with daytime and the alertness he could prompt with his usual pots of strong coffee each morning that Mondrian could shed these disturbances.

And then he began to construct his Neo-Plastic haven.

Despite the mess, Mondrian wrote Sal Slijper that he was delighted to have found all of the art he had left in his studio in perfect condition. And there were even more early paintings than he remembered. He was happy to discover among his trove of unscratched pictures *The Red Mill*, seven canvases of lighthouses, some of the most sublime scenes of dunes, a Cubist nude, a group of large and fully realized drawings, and numerous sketches. On June 21, he offered Slijper the lot of them, naming a price for the entire collection of seven hundred guilders "+ 150 for the drawings and 150 for the studies." They negotiated for four months, finally agreeing on terms and stipulating that Slijper was allowed to sell the work so long as he used the proceeds to buy Mondrian's recent abstractions.

That never happened. Slijper simply acquired early Mondrian in bulk, amassing a substantial collection of it. He began to buy what he could in the Netherlands, first by lapping up, at auction and in private sales, a dozen drawings from the collection of Johannes Fredericus Samuel Esser, the plastic surgeon who had been an avid Mondrian collector in the early years. Mondrian may have felt let down that Slijper never directly supported his move to abstraction, but at least it was good for his market that Slijper drove up the prices of his figurative art. And not that Mondrian lived to know it, but even if Sal Slijper failed to finance Mondrian's new direction as promised when he sold the odd piece, he would have a tremendous impact on Mondrian's legacy when he eventually bequeathed a hundred and twenty-four paintings and seventy-five drawings to the Kunstmuseum in The Hague.

Finally, Mondrian finished two paintings from the series he had begun in the Netherlands which were the only compositions he ever painted with a grid of units resembling floor tiling or a checkerboard. He had first intended to paint sixteen paintings of this type, and then eight; it was only when he was back in Paris that he finally completed two of them. It had not been easy to work in this unvaried plan in which the placement of the solid colors is the sole driving element to generate movement and rhythm.

Checkerboard Composition with Light Colors and *Checkerboard Composition with Dark Colors* are triumphs (see colorplates VII and VIII).

Nonetheless, these two paintings made Van Doesburg write to Oud saying that he hoped Mondrian would start something different in Paris. Van

Doesburg condemned the regularity of the format. But the restrained visual vocabulary had served Mondrian well. It enabled him to keep himself emotionally stable in a time period rife with hazard. Moreover, Mondrian was joining a continuum of artists going back almost to the start of visual art who incorporated a checkerboard pattern in their work.

Subdividing the canvas in this way, it was one time in his life when Mondrian used a device which he knew was not his own. But he had made his own variation by elongating the individual cells imperceptibly rather than keeping them square. And with his highly original color choices he combined understatement and playfulness in a way that rendered the ordinary extraordinary.

Mondrian must have loved painting *Checkerboard Composition with Dark Colors* and *Checkerboard Composition with Light Colors*. Even though the process required tough decision-making, which is why he completed only two paintings of this typology, he performed his dance of colors with vibrant, pitch-perfect movement.

These two grids of rectangles instantly move their viewers away from anything that is personally troublesome and provide a sense of ease. In color reproduction, and even more so when seen firsthand, they function like a quick-acting "happiness pill."

The *Light* checkerboard manages, with the simplest of formats, to be in perpetual motion. The yellows and whites sparkle against the grays and blues and reds. The scale of the canvas—it measures 34 by 42 inches—makes it comfortable to look at, large enough to be robustly present, but not so big that it looms or imposes itself. Everything about the painting provides contentment. Like one of those magical carpets in a fairy tale, it is about nothing and everything. It can be compared to a tap dance or to flashing lights, but the associations are secondary; what counts is the feeling that life's difficulties are momentarily solved. Savor the reassurance that what we see with our eyes can energize and nourish us.

Checkerboard Composition with Dark Colors defines elegance. When we see it and *Light Colors* side by side, whereas *Light* is festive and playful, *Dark* is worldly and urbane. While the design of these two paintings is absolutely identical, the only variance whatsoever between them being in the colors, they become physically as well as emotionally different. The individual units in *Dark* appear to be ever so slightly squarer, not quite as elongated as the rectangles in *Light*; that distinction is an illusory by-product of color and color alone. The different palettes generate opposite movements; *Dark* stretches itself languidly leftward and rightward, while *Light* jumps up and down.

Mondrian let the colors guide him; he did not guide the colors. He al-

lowed the darker oranges and blues, and the brick reds and dusty roses, of *Dark* to tell him where they should be placed so that the motion that they set into place is continuous, just as he let the brighter hues of *Light* dictate their positions.

While *Dark* has a slower motion, it is by no means sad or lugubrious. Rather, it is stately—regal and dignified, yet sweet and without pomp. *Light* is the one of these two compositions that immediately cheers one up, while *Dark* provides a sense of the sublime.

Van Doesburg faulted the format. But Mondrian's deliberate reductionism had served a purpose. Psychologically, it made sense when he was moving from one place to another and did not even know for how long he would be allowed to stay at the place to pare down and simplify. The singularity of form was a source of comfort. Mondrian conceded to Van Doesburg: "But it could very well be that the rectangle dominates too much notwithstanding that. And also, as you write, it depends so much on the thing!" Mondrian's chronic self-doubt functioned in tandem with his belief in his chosen course.

Nonetheless, these exceptional paintings provided Mondrian with ballast that countered the vagaries of life. In the two checkerboards, Mondrian demonstrated how the will to find and relish what is right in the world can overpower quotidian reality.

There was also an unconscious reason that the checkerboard pattern beckoned Mondrian. In this time period of homecoming, of his returning to the city where he felt most centered and comfortable and where he had initially moved to spend the rest of his life, as he now again intended to do, Mondrian had reiterated the patterns of the windows in his parents' house at Winterswijk. It is unlikely that he was aware that he had returned to the even grid of vertical and horizontal black lines and the pattern of identically sized openings through which he had observed the world in his formative years. But Mondrian had enjoyed the stable structure of life in that capacious house when his father was headmaster just across the courtyard; after all, when he might have taught anywhere in the Netherlands, he had chosen to remain there. Now, unconsciously, faced again with an even grid, he had the security of being back there.

IV

By the time he had settled back in Paris and completed these grid paintings, Mondrian became more comfortable with himself. Confident that he could remain in France, painting abstractions which enabled him to retreat from external reality, he acquired a new serenity and resolve.

He ceased making other people ill at ease and developed a personal grace

he had previously lacked. There were no more incidents of his remaining rudely mute with other people. It was known that he did not like being surprised by visitors, but if anyone showed up uninvited and unexpected, even in his optimal painting hours, he was gracious and solicitous, offering food and drink. Having a place that was truly his own, he now invited friends to stay with him. And when they did so, sometimes for as long as a week, he concerned himself with needs of more importance to them than him, like their having blankets that were not too scratchy. He was transformed by his return to the place where he felt at home.

The art dealer Sidney Janis, who would meet Mondrian in the 1930s and spend a lot of time with him in New York up until Mondrian's death in 1944, considered him as unpretentious and relaxed as he was brilliant. They would go to dance halls together, and Janis invariably recalled those outings with a warm smile. When he spoke of other artists he knew well—among them Picasso, with whom Sidney and his wife, Harriet, lived one summer in France, as well as Alberto Giacometti, Jean Arp, and Josef Albers—he conveyed none of the same simple likability. Considering none of them to be Mondrian's equal as an artist, Janis equated Mondrian's supreme personal grace with the charmed atmosphere achieved by his paintings. It was at the time of his return to Paris that Mondrian and his life developed this oneness. There was a coherence; the art and the human being were mirrored in one another.

Mondrian's appearance now became carefully studied and managed; he would never again look like an Indian mystic or a wild-haired, bearded Theosophist. He occasionally sported a mustache—1919 was one of those periods—but it was neatly trimmed and he was always meticulous. The mustache looks to have above all a matter of geometry and proportion; this time, the black horizontal with which he was experimenting was on his face.

The clean white smock in which Mondrian painted made him resemble a lab technician, but in public, he looked like a highly fit Dutch businessman. He was fastidious without being a dandy, and elegant without being foppish—just as he was self-assured without being arrogant. His persona had the grace of his art.

Magazine and newspaper articles devoted to Mondrian were now appearing, and even if he only made two or three paintings a year, he was gaining renown. Modernists all over the world—from Frank Lloyd Wright in his Chicago buildings to makers of political posters in newly Communist Russia, from printers of beer labels in Ireland to architects in Sydney—would, in the next decade, make Piet Mondrian's unique geometry and his solid primary colors the core of their own work.

At the Bauhaus, which was in its second year, Mondrian was a guiding light to both students and faculty in the myriad workshops. Gropius and all

the masters in the various fields knew his latest work; his contemporaries like Klee and Kandinsky accorded him great respect, and the designers in wood, metal, and textiles made his straight lines and solid colors their essential vocabulary. They made their first "Bauhausbuch" a monograph about him. That book, which was well distributed, was fundamental to the dissemination of Mondrian's vision.

But the art world was developing into opposing camps. In the summer just after he returned to Paris, Picasso, for whom he previously had such respect, became a target of Mondrian's outrage. His disdain peaked with the Picasso show that opened in July. Mondrian had been bothered before by the evidence of subject matter in Picasso's work; now he became utterly disgusted. What he saw in Picasso's wish to be "versatile" was for him treason.

The exhibition was at the Galerie L'Effort Moderne, an establishment of great importance to Mondrian. The name suggested the leanness and total newness he expected of what was presented there. The lack of a preposition, where one would expect *de* or *pour*, gives it punch and concision. For a commercial art gallery to identify itself as part of an "effort" had the sort of purposefulness that Mondrian liked.

The Galerie L'Effort Moderne was the brainchild of Léonce Rosenberg, who was seven years younger than Mondrian. His father, Alexandre Rosenberg, had been a prominent antiques dealer, and, in 1906, Léonce and his brother Paul had inherited their father's shop on the avenue de l'Opéra. It was a well-established enterprise that sold old-fashioned paintings and objects to rich Parisians and clients from abroad. The foreign customers prided themselves on returning to New York or London or Moscow with crates full of new possessions that brought French taste and sophistication into their homes in places that seemed like backwaters compared to Paris. Four years later, after taking over his father's business with Paul, whose taste ran to whatever was the "blue chip" of its era, Léonce opened a gallery which he called Haute Époque, at 19, rue de la Baume. He showed, and bought for himself, work by those painters who were pushing Cubism to a new extreme. Picasso, Metzinger, Gleizes, French painter Auguste Herbin, and Gris constituted his staple; he presented their latest work, however hard it was to convince clients of its merits. Paul, meanwhile, started a gallery which focused more on nineteenth- and early-twentieth-century art that had already gained greater acceptance and was therefore more readily saleable.

Léonce Rosenberg had discovered avant-garde art at the Salon des Indépendants in 1911, which was when he saw his first Mondrian. In 1912, he had begun to frequent the gallery of Daniel-Henry Kahnweiler. When Kahnweiler, as a German national, was forced to leave France and had his property seized by the French government at the outbreak of the war, Rosen-

berg bought twenty of Kahnweiler's Picassos and ten Braques. In 1915, he had volunteered for military service. He worked as an interpreter in the field headquarters of the Allied forces on the Somme front, and even from that outpost managed to buy art and help artists emotionally as well as financially. He supported Léger, Metzinger, Gleizes, Henri Laurens, and others; the poet Max Jacob wrote that "without him, a number of painters would be drivers or factory workers." In 1917, Rosenberg had reopened his gallery on the rue de la Baume, and given it its new name; Paris was still being bombed, but he managed to sell a small bit of art. Ever since the armistice, he had been going full throttle to make Picasso, Braque, and Léger prominent. Picasso was Rosenberg's star above all the others.

Once Mondrian had moved back to Paris, he made it a habit to visit Rosenberg's gallery regularly. If the weather was fine, he took the hour-and-a-quarter-long walk across the Seine to the neighborhood of small streets in the affluent 8th arrondissement, where the art galleries were. On cold or rainy days he used the Nord-Sud underground railway line to go from Gare Montparnasse to the stop at La Madeleine, a fifteen-minute walk from there to the rue de la Baume. Wearing a well-tailored, English-style dark suit, square-shouldered, with wide notched lapels, the jacket suppressed at the waist, he generally sported a bright bow tie of dotted silk and a broadbrimmed hat. He relished not only the idea of going to Rosenberg's gal-

Léonce Rosenberg. This prominent Paris gallerist had discovered Mondrian in 1911 at the Salon des Indépendants. When Mondrian was back in Paris after the end of the war, Rosenberg occasionally exhibited one or two paintings by Mondrian in a way that was life-altering.

lery but the rarity of visiting the Right Bank, which he hardly ever did. His bearing erect, he walked purposefully with a strong gait. He observed the latest fashions, the few cars that were beginning to replace horse-drawn carriages, and the shop windows displaying new products for everyday living. The world was bursting with innovation.

On his very first visit to the new gallery, Mondrian had seen a Léger which he admired greatly as a sign of how pure abstraction was becoming the vocabulary of some of the greatest artists of the day. And the setting suited the art. The rooms in Rosenberg's townhouse were decorated with motifs from Cubist painting. Mondrian immediately developed a strong desire to have his work shown at L'Effort Moderne; throughout that summer and autumn, he wanted nothing else as badly. He knew it would be the best possible venue not just for himself but also for Van Doesburg.

Mondrian was so determined to have his paintings on those walls on the rue de la Baume, and to have Rosenberg promote him, that he was willing to set aside his ingrained anti-Semitism to pursue it. After all, sometimes it was necessary to work with Jews, as he had with Slijper. On August 1, 1919, he wrote to Van Doesburg about Picasso:

> Like most of the Cubists he is under contract with Rosenberch [*sic*],
> that art dealer, while showing other work—serious portraits and so on,
> apparently—with Rosenberch's brother. Those Rosenberchs are Jews but
> the galleries in the Rue de la Baume are very good, and exclusively Cubist.
> I would like to exhibit there later on, if possible. I'm not doing anything
> about it until I have a sufficient number of finished works. The canvases I
> was working on back in Laren are still there, and it costs f 25 per 100 kilos
> to get them here, but I'm considering it anyway. Once things get back to
> normal you might have an exhibition there yourself.

But to get "things back to normal" would not be easy. In that first summer back in Paris, on Thursday, August 21, Mondrian wrote Van Doesburg and Lena Milius that he was struggling

> with my nose and throat. It's a recurrent problem: my throat plays up easily
> and one of my nostrils is a bit tight. I had a sort of infection (I think) in
> my nose and also felt something in my throat. Polyps came to mind, and
> because it didn't go away I went (a bit late, perhaps) to a clinic, where they
> gave me a load of medicines, mouthwash to gargle with, ointment for my
> nostrils, etc. My nose is more or less all right again, but I can still feel
> something in my throat.

He blamed the doctors for not taking better care of him; they were as morally corrupt as so many people in the art world.

> Yesterday I went back to the clinic (after ten days), where they cauterized the inside of my throat with a sort of poker, and told me to continue taking my medicines. You never know what to make of such treatments—the man didn't even realize that this was my second visit. I suppose it didn't matter much in this case, but it could be very disadvantageous, it seems to me. And all just because of the lack of seriousness, and the desire for more money. How wonderful everything could be if only people were different. The same goes for art.

Everyone gets sore throats and stuffed noses; few people describe them in vivid detail when writing letters to friends. Lacking a spouse or partner or parent to whom he could report his symptoms, Mondrian regularly updated Van Doesburg and Milius. The friendship was of a type he had never had before.

> So here I am, all on my own, which is rather tiresome. But that is only to be expected, and fortunately I have my work to get on with. So your letter was doubly welcome in that it made me realize that I'm not a complete loner after all, I'm in good company.

In spite of Van Doesburg's antipathy to the grids, he was enthusiastic about Mondrian's most recent direction, and Mondrian depended on Van Doesburg for a unique understanding of his artistic intentions as well as for friendship. Mondrian at last had a soulmate, someone with the same mission as he and subject to the same criticisms; he wrote Van Doesburg, "Let them sputter and call us Calvinistic, I am convinced that we advocate the one and only pure art." Nothing else mattered as much.

V

"The season"—the time of year, following the summer holidays, when galleries reopen and preparations for the larger salon shows gather steam—began that autumn with more than the usual gusto following the hiatus of action in the art world during the war. Mondrian observed the networking and careerism of his fellow artists with a pithy, novelistic eye. He could not stand the maneuvering of people jockeying to become insiders, just as he could not tolerate artistic imitation as opposed to true creativity and origi-

nality. At the start of October, he reported to Van Doesburg, who remained removed from it all in the Netherlands:

> I haven't seen Archipenko lately. I did call on Tour Donas again, who is working a bit less à la Archip. nowadays, although a bit more like Picasso. But please keep this to yourself. Last week Kickert was sitting in a cafe when he was spotted by Archip., who promptly came over to badger him about an exhibition in Holland. Don't let on to Archip. that you know about this, but it shows that I was right about him using you to get connections.

Alexander Archipenko, a painter/sculptor born in Kiev in 1887, was Mondrian's nemesis. Following his move to Paris in 1908, Archipenko had quickly enjoyed success for his Cubist work in plaster and stone, which was accepted in the salons and museums showing modernism. Mondrian disliked him personally, and the human figure that Archipenko persisted in making central to his art, in lieu of the pure abstraction that was all that Mondrian now valued, helped make the creator of these sculptures the enemy.

After grousing about Archipenko to Van Doesburg, Mondrian reports on the situation concerning his home-workplace. Kickert had just written to him that he was desperate to rent the little room adjacent to the studio, where Mondrian slept. Kickert and his wife were unable to find a place for themselves, and all of the other studios at 26, rue du Départ were currently occupied. Mondrian felt he could not refuse, since it was Kickert who had helped him get his first studio in Paris, and his current studio had been Kickert's previously.

The Kickerts had moved in by the start of October, and Mondrian was pleasantly surprised.

> So he lives next door to me with his wife; it's a small space, but they manage. But he has changed a lot, and for the better: he is his own man again, and has broken with Le Fauconnier and Schelfhout etc., and is now (relatively) sympathetic. We don't discuss work, though, which is fine by me. He's not a bad sort, I think, only weak, in having allowed himself to be influenced by others. It's convenient for me financially, of course. I sleep in the studio now.

These were Mondrian's attitudes through and through. He was resilient and uncomplaining; the thing that really mattered to him most was the fidelity to pure abstraction. His only requisites were a roof over his head, simple

nourishment, and adequate health to persist so long as he could paint and write to advance his cause.

But Mondrian then had another of his debilitating "flu"s, a combination of respiratory and digestive problems that made it just about impossible for him to paint. Fortunately, he did not feel totally alone with it. Mondrian was cognizant of his good fortune in having friends who cared about not just his living situation and his finances, but also his health. "Thank you, and Lena too, for your kind concern for my health. I am feeling better at last. Just one more visit to the clinic and that will be the end of it. It has been going on for two months!"

De Stijl, meanwhile, was falling apart. The painters and architects and designers who, two years previously, had believed they could work in unison to advance a mutual cause were now riven into factions. At best, they were divided by honest intellectual disputes; at worst, by vituperative power plays. Mondrian knew, of course, that all such artistic movements—in which individuals of differing levels of talent try to band together—fail sooner or later. He had kept outside the fray as best he could. But the tenets of De Stijl incarnated the principles of Neo-Plasticism which were vital to him. He was by nature an optimist, and he was disappointed by the number of artists who abandoned the faith, causing conflicts that echoed the internecine battles Mondrian had witnessed as a child when his father was odd man out as the different Calvinist groups splintered. He knew it was human nature that group efforts almost always prove futile, but De Stijl had intrigued him. Nonetheless, he had to separate himself and avoid wasting time on group politics. Mondrian had come to see that the best way to achieve his goal for the elevation of pure abstraction to a position of supremacy was simply with his own artwork. More than any movement or credo, he made the completion of his new paintings, entirely devoid of reference to nature, his priority. Mondrian plunged into work on new abstract compositions that, whatever the vicissitudes of his life, were as forceful, and as happy, as anything he had ever painted.

VI

In November, Mondrian wrote Van Doesburg and Milius that he had moved to 5, rue de Coulmiers, near the Porte d'Orléans. It was a thirty-minute walk from his former residence, but the new location permitted greater possibilities for refurbishment than the old one had, and it would not be long before Mondrian was making his first Neo-Plastic home there.

I am—I believe—happy with the change; the old studio was a gloomy place, for all my attempts to improve it. Kickert has filled it with antique furniture (Kickert! the man of the Modern Art Circle!), which goes well with the gloom. Those people have no seriousness of their own, which is probably why they prefer a (seemingly) serious environment! Here I also have light from above, and everything looks nice and bright, although the paintwork is not the way I like it of course. I also have a small spare room here which you can use if you come and visit.

Mondrian continued to rail against the lower ranks of artists. Their machinations appalled him. He wrote that Archipenko

wants to exhibit his work in Holland and is using De Stijl to achieve this. He and the others are probably against Rosenberg, whereas I believe that Rosenberg may well be a good place for us to exhibit at some point. Whatever the case may be, I think it is best for us not to get involved. . . . The good Cubists are staying with Rosenberg. No point in going for the second-rate, don't you think?

Mondrian lived on the sidelines, but from his remote new headquarters on the rue de Coulmiers, he was like a hawk as he watched the manipulations of the art world with an eye on his own goals.

VII

Even while postwar Paris was still suffering from shortages of materials, Mondrian wrote Van Doesburg and Milius, "I am quite content: my new abode suits me very well. One's surroundings make a big difference." And on November 15, he wrote Sal Slijper:

I'm quite pleased with my new abode, and am feeling more at home. I seem to need my surroundings to be a bit more comfortable for me to be content! There hasn't been much opportunity for dancing yet. I am still staying away from the danseuses—don't get me wrong! Still, thanks to Van Eck I've learned the tango well. I think I already wrote you about that yesterday. Bye Sal, warm regards from your friend Piet.

After moving into his new studio on the rue de Coulmiers, Mondrian had decided to transform it into the three-dimensional equivalent of one of his abstract compositions. The idea had been brewing for a while. In one of his many studios in Laren, he had hung colored planes on the wall. Now he

intended to paint rectangles of solid color all over the white walls. Rather than adhere to a pattern, he would position them as his eye dictated, choosing the colors and determining the sizes spontaneously. When his landlord prohibited it, Mondrian came up with the solution of painting pieces of cardboard in the same blue, red, yellow, grays, and whites he had intended to apply directly to the plaster surface and affixing them to the walls in a way that left no marks underneath. He painted the furniture, which he owned and could therefore transform as he wanted, in the same array of colors as the panels. But with the walls what he had to do out of necessity ended up suiting him so well that it determined the method to which he would always adhere: the detachable panels made it possible to move the colors around more easily than if he had to repaint them each time he wanted to try something new.

The transformation of his nest changed his existence. He had built himself a world to live in that made no reference to the past, to the known, or to nature. It consisted only of pure color in honestly artificial and rational geometric forms. Human invention ruled. With precise mechanics and spontaneous action, Mondrian let go of all preconceptions to create an environment that he considered sublime. He had found the means to be perpetually encased by intelligence, energy, and balance, and to avoid anything troubling. Now he had full control.

From whatever vantage point he had in the studio, he could look at the whiteness and his latest arrangement of neat rectangles of unmodulated yellow, blue, and red. He might leave them in their current position or change them at whim; not only did any alterations require no reason or justification, but they belonged to a realm that was spectacular for its glorious illogic, its folly and therefore its joy. The walls with which Mondrian surrounded himself became weightless.

This environment had nothing to do with anyone else, or with his own past; it made no reference to anything but the absolutes of unmixed color, straight lines, and perfect right angles. Mondrian was, for the first time in his life, in a place where everything was right and uplifting, where no memories were conjured, where existence was pure music.

On December 4, 1919, he wrote Van Doesburg in soaring spirits. He had begun some new paintings that he considered superior to everything he had done to date—to the extent that his past efforts seemed ready for the garbage heap. This time he associated his leap with the new studio setting.

My new article deals with decoration, among other things. This is due to my studio here, where I have been doing a bit of experimenting. I couldn't work directly on the walls, so I had to make do with sheets of painted

cardboard. But I have now seen quite clearly that it is possible to integrate N.B. [Nieuwe Beelder = Neo-Plasticism] into a living space. Obviously, I had to paint the furniture as well. I don't regret the time spent doing that, as it is conducive to my work. I have now made a thing that pleases me more than all the previous ones.

His new group of compositions was vastly different from the grids he had painted in Laren that had reached their ultimate form in the *Checkerboards*. Now Mondrian divided his canvases into areas of solid color, square or rectangular. The dimensions of the units varied, and the colors were as precise and decisive as the forms. Mondrian's new palette consisted almost entirely of bright blues, yellows, reds, and grays; in tone as in format, what he painted as he reestablished himself after five years of exile had a new boldness and authority. By the end of 1920, Mondrian would complete eight of these triumphant paintings to which he would attach the simplest of names, like *Composition N°II* or *Composition A*.

In the first of these paintings, Mondrian kept the definitive, richly black lines quite thin, like taut steel wire. In the following six, they are slightly wider; in the last, they are thicker still, proportionately like the window mullions in Winterswijk. Right angles and a precise grid of black lines evoked for Mondrian a sense of dependability and of a pattern to life.

But there was a pivotal difference from Mondrian's previous work. The straight black lines rarely reach the edges of the canvas, either top or bottom, left or right. The way these components stop short adds to the magic of what the artist has created. It gives the paintings the élan of dancers suspended in air. That lack of contact feels like a poignant hesitation; the absence of physical support for the scaffolding, making it weightless, adds something ineffably poetic.

In these new compositions he made following his return to Paris, the airy lightness of the white, the flash of the yellows, the heartbeat of the reds, the celestial ethereality of the blues penetrate us. As a person, Mondrian remained reserved; in his art everything was *possible*.

In *Composition with Yellow, Red, Black, Blue, and Gray*, now at the Stedelijk, the rectangles of yellow, black, blue, and red move and relate to one another around squares and rectangles of white and gray in a way that provides sheer delight (see colorplate X). Any rational explanation as to why such pleasure occurs misses the point; it would be like identifying the phenomenon whereby Dizzy Gillespie's trumpet, or orgasms, or some favorite food, makes us happy. What is utterly clear as we behold this jewel—it measures a mere 20 by 24 inches—is the victory of Mondrian's answers for himself at the start of his new, postwar Parisian life.

All eight canvases from this series he started in 1919 and finished in 1920 are evidence of his success at the management of his physical and psychological needs, and of his felicitous mix of freedom and structure. In his solitude, in his bare-bones lifestyle, in his choice of city and management of his relationships with other people, in his reduction of his personal and material needs and his almost monastic abnegation of even modest embellishments to daily life, he had put himself in a situation which allowed him to give the world an unprecedented gift. Even as people struggled to recover from the losses and privations of the previous five years, and mourned the dead—this war, after all, had taken more human lives than any in history—their optimism was returning. Mondrian's art mirrored that hopefulness, both reflecting it and intensifying it.

VIII

In June 1919, the same month that he returned to Paris, the first installment of the *Trialogue*, Mondrian's play for three voices, appeared in *De Stijl*. Over the course of the next year, eleven more installments were published in the magazine, one per month. This text that Mondrian had started on quiet evenings in a series of small rooms rented or lent to him in Laren pointedly makes that case for the dismissal of the past—one's personal experiences as well as the events of world history—and presents the man Mondrian became on the rue de Coulmiers, where he was living by the time he finished writing it.

The *Trialogue* has three characters. X is "a naturalistic painter," Y is "an art-lover," and Z is "an abstract-realist painter." In seven scenes, they take a walk "which begins in the country and ends in the city at the studio of the abstract-realist painter." At the start, these three individuals united by their passion for art but at odds in their perspectives are surveying the "vast horizon" with the moon visible high above the flat countryside. X and Y extol the beautiful colors spread before them, only to have Z exclaim, "What repose!" The others voice surprise that nature has an emotional impact on Z, to which Z replies, "If it didn't, I wouldn't be a painter . . . Nature moves me deeply. I do depict nature, but in a different way."

Z is Mondrian himself. That respect for nature is Mondrian's essence. Even if he no longer went to the dunes or the woods, he was totally attuned to natural occurrences in their broader sense. He now deemed it futile to confine himself to specifics, and to represent trees or human beings, but that was out of deference to the larger, nonstop life of the entire universe, which concerned him more than any precise manifestations.

Throughout the *Trialogue*, the two painters discuss the distinction be-

tween naturalistic and abstract painting, and the relation of music to both. The art-lover, who says little, functions mainly as a mediator; Z speaks the most, holding forth at length with his theories. The first five scenes are set in the rural Netherlands. Each setting describes an important painting Mondrian had done in the previous decade, evoking the time of day as well as the place he illustrated. The first scene is "Late evening—flat landscape—broad horizon—the moon high overhead"; this is *Summer Night*, from 1907. The second is "Scattered clusters of trees silhouetted against the bright moonlit sky." The painting Mondrian had in mind must be *Fen near Saasveld (Large Version)*, also from 1907. The third is "Night—the stars, now in a bright sky, above a broad expanse of sandy beach"; here we cannot be absolutely certain, but that description seems to evoke *Composition with Grid 5: Lozenge Composition with Colors*, painted by Mondrian the previous year. This is the longest scene in *Trialogue*. It concludes with Z declaring—and Mondrian underlined the words—"Pure plastic vision must construct a new society, just as it has constructed a new plastic in art—a society where equivalent duality prevails between the material and the spiritual, a society of equilibrated relationship."

This was Mondrian's goal for both his painting and his life. The material—where he lived, how he supported himself, even what he ate—had to be in balance with the higher truths that were his life's goals.

IX

In 1920, Mondrian told the writer W. F. A. Röell that one of his new compositions was titled *Foxtrot*. He had this idea because of the dance step invented six years earlier, its name suggesting a trim and speedy animal moving quickly at a regular rhythm. In 1914, the husband and wife duo Vernon and Irene Castle popularized the step after seeing it performed at a "Negro nightclub." The Castles first danced it to "The Memphis Blues" and called it the "Bunny Hug"—until they realized that that was not the best name for such an elegant and sophisticated dance. Performing the new step to music played by a big band accompanied by a vocalist, they decided "Fox Trot" was more suitable. What the Castles made part of modern culture was silky smooth, with long movements that flow into one another. A well-executed foxtrot is marked by its continuity; and for all the precision of the steps it never has abrupt halts.

The painting which Mondrian called *Foxtrot* is perfectly contained in its nearly square shape, yet it breathes with a deep inhalation and full exhalation. We feel the oxygen filling our lungs, then slowly moving out as the composition moves down and left and right and in and out.

The three rectangles of yellow—perhaps we should count them as four, since one is bifurcated—dance in front of us. Positioned perfectly, they give the painting its exuberance. The reds suggest the energy of healthy blood within a beautifully functioning body. The deep, almost indigo, blues, six panels of them, are an inviting and elegant hue that combine sea and sky. While factually these colors are nothing but well-worked oil pigment on a flat white canvas, rather than being opaque, each of the colors is translucent. The areas of light gray and a subtle blue gray, while cool compared to the other colors, have the amorphous quality of sea mist.

The perpetual dance of the black and gray lines with these colors makes it all a visual banquet which, indeed, has the precision and movement and grace of a well-executed foxtrot. But it is so much more as well: a form of endless, timeless, ecstatic life.

X

In the course of 1920, money again became a desperate issue for Mondrian. As Western civilization tried to pull itself up by its bootstraps after the war, the arts were considered a luxury more than an imperative, and few people were buying paintings.

At the end of January 1920, Mondrian had a misunderstanding with Hendrik Bremmer. Wondering why he had not received his monthly allowance as usual, he wrote to his patron. Bremmer replied that they had terminated their agreement at the end of 1919. The information came as a shock; their accord, at least in Mondrian's eyes, had no end date. It left him financially stranded.

What Mondrian considered a betrayal came during one of his health crises. On February 9, 1920, Mondrian wrote Milius and Van Doesburg saying he had not written sooner to thank them for some valuable editing they had done on an article by him because he had been incapacitated by the combination of stomach problems and his nervousness waiting for an answer from Bremmer. He had noticed a difference in Bremmer's character the previous summer. Bremmer told him at the time that he could support Mondrian for no longer than another year; Mondrian had assumed that this meant another year ending on March 31, 1920, since their annual arrangement, which had begun on April 1, 1915, was always renewed at the start of each April.

Once he had arrived in Paris, Mondrian received only a hundred and fifty francs, which was significantly less than he expected. In the Netherlands, his stipend had started at fifty guilders—a little over two hundred francs—

which Bremmer had subsequently increased to seventy-five guilders, the equivalent of three hundred francs. Mondrian assumed that a change in the exchange rate was the reason he received half of what he used to get when he was still in the Netherlands. But he had thought it would be ungracious to complain.

Now, receiving nothing whatsoever since the start of 1920, Mondrian wrote Bremmer desperately. Bremmer informed him that the agreement had been terminated at the end of the calendar year—meaning December 1919—rather than the end of another year of their agreement. Nonetheless, Bremmer wanted four paintings. Mondrian told his friends, "That he wants to be rid of me I can understand, but now it appears that he did it for profit, at least if he can't sell them anymore." Mondrian suspected that Bremmer was encouraging Mrs. Kröller-Müller to buy paintings by other artists, Sluijters among them, instead of his own.

On February 9, Mondrian wrote Sal Slijper, "Besides this being a moral disappointment, it is also throwing my calculations into disarray."

He proposed a new financial arrangement with Slijper that would solve the problem, but if that didn't work out, he envisioned another solution. A friend owned some land near Nice, and Mondrian would be able to live there and "do agriculture." How much simpler his life would be than in this rat's nest of art dealers and competitive painters!

XI

In February 1920, Mondrian met Gesina Antonia Milgens and Willem Marie Emile Stieltjes. Even in the sophisticated milieu of the Parisian avant-garde, they were considered an unusual couple. In 1914, Milgens—known as Tonia by friends—had divorced Jan de Meijere, a photographer to whom she had been married for six years. She had then started to live with Stieltjes, a moderately successful businessman six years her junior. Like Mondrian, they had moved from Amsterdam to Paris in 1919, and in January 1920 they moved to 26, rue du Départ. As always, Mondrian kept a certain distance, but he liked the couple and spent a fair bit of time with them. Milgens and Stieltjes were devoted adherents to the principles of De Stijl, and Mondrian got a boost from their encouraging opinions about his painting and writing.

Stieltjes's modest success as an engineer and inventor enabled him and Tonia to announce their intention to buy one of Mondrian's new paintings, *Composition with Large Yellow Plane*, from him at this moment when it made a pivotal difference. Mondrian needed the money as well as the emotional support, and was pleased to sell one of his most experimental works to people

so different from the fashionable collectors and art investors for whom his paintings were just a few of the many they were acquiring. Moreover, Tonia showed a vivid interest in Mondrian's writing, with an attention he found irresistible.

Tonia was the daughter of a Dutch mother and a Surinamese father. This striking mixed-race woman would develop a close bond with Mondrian. Albert van den Briel would, on Christmas Day 1967, write Robert Welsh that Mondrian often talked about this "half-blood Negress." Van den Briel wrote that Mondrian had a distinct attraction to "Negroes," whom he characterized as "soft, meaning sensitive to impressions from outside."

Michel Seuphor, in a 1966 essay called "Le commerce de l'Art," provides a moving description of Mondrian's relationship to Willem and "To" Stieltjes, and in this instance one has the impression that Seuphor's account was entirely accurate. Tonia in particular made Mondrian feel supported and understood. The Stieltjeses, who would marry in February 1922, lived modestly at 26, rue du Départ, and in their simple way received Mondrian with great respect and admiration, while Mondrian hung on to every word Tonia said. On several occasions later in the 1920s, the young Seuphor was also invited for dinner. In the apartment graced by Mondrian's painting, the couple did everything they could to be gracious and hospitable, giving Mondrian his favorite foods.

> He appreciated them in every detail, and played the role of spoiled boy with grace and charm. To was jubilant. The conversation was cordial and tranquil, not the least bit intellectual because everyone assumed that the great ideas were already known.

Seuphor goes on to say, "Mondrian spoke to me very seriously about To. He said that everything she said was worthy of attention, that she understood his art as no one else did."

In 1988, Seuphor's memories intensified: "There was a black woman who loved Mondrian a lot. And Mondrian loved her very much." When "To" said one of Mondrian's paintings was okay, Mondrian considered her view the seal of approval. Now Seuphor, over forty years after Mondrian's death and sixty after the time period in question, recalled that "To and Mondrian often had dinner together at a small table, and everything was done very neatly for Piet. Everything for Piet."

Tonia Stieltjes played a role in Mondrian's life unlike any other woman's. When she died in 1932, Mondrian was bereft. Tonia had given Mondrian unique confidence, and he had felt unparalleled ease with her. Seuphor felt

that Mondrian got from her a selfless, intelligent love unlike anything else he had ever experienced—or would again. This was the one relationship with a woman where Mondrian was not the one who had decided to end it.

XII

Theo van Doesburg wrote to J. J. P. Oud, "One could cross the Place de l'Opéra with the greatest caution, but Mondrian did it as calmly as if he were in his atelier." All day long, people walk across that intersection of Paris's Right Bank in front of Garnier's grand and historic opera house. It is one of those places in Haussmann's Paris where so many streets come together at angles from very acute to very obtuse that it is necessary to be on high alert; while in 1920 there was not as much traffic as there is today, the hansom cabs and omnibuses still came at rapid speed. Mondrian, however, was blind to danger. With his ramrod posture, he went at his own pace, without any sense of risk, mentally in his own very particular and exciting territory.

On March 21, Mondrian completed an essay that appeared a week later in *De Nieuwe Amsterdammer* with the title "Les Grands Boulevards." The piece "gave the editor bad dreams," but Van Doesburg, the newspaper's art editor, pushed it through.

The text begins:

Ru-h ru-h-h-h-h. Poeoeoe. Tik-tik-tik-tik. Pre. R-r-r-r-uh-h. Huh! Pang. Su-su-su-su-ur. Boe-a-ah. R-r-r. Foeh . . . a multiplicity of sounds, interpenetrating. Automobiles, buses, carts, cabs, people, lamp-posts, trees . . . all mixed; against cafes, shops, offices, posters, display windows: a multiplicity of things. Movement and stand-still: diverse motions. Movement in space and movement in time. Manifold images and manifold thoughts.

Images are veiled truths. Manifold truths make truth. Particularity cannot describe everything in a single image. Parisiennes: refined sensuality. Internalized outwardness. Tensed naturalness.

Mondrian exults in the complexity of the scene.

Time and space move: the relative moves and what moves is relative. Parisian: fashion transforms the boulevard from year to year. Every age has its expression. Although a man is still a man and art is still art—I see the expression of art changing. What is temporal moves; what moves is temporal. Separation is painful.

This is within a long paragraph that rambles on and on until it concludes with "To annihilate the particular is to achieve unity, say the philosophers."

Not for the first time, Mondrian amplifies on his decision to abandon the specific in life. His embrace of pure abstraction is his only means of coping with the myriad manifestations of humanness that coincide unrelated to one another. He writes:

> Negro head, widow's veil, Parisienne's shoes, soldier's legs, cartwheel, Parisienne's ankles, piece of pavement, part of a fat man, walking-stick nob, piece of newspaper, lamp post, red feather . . . I see only *fragments* of the particular.

From there the writing reaches a crescendo of references to beggars and shop owners and policemen and turning wheels and motors and black patent leather shoes.

Then, suddenly, at the end, everything changes. "The sidewalk under the awning is a refuge." And so is painting. "What is brought to rest aesthetically is art. Rest is necessity, art is necessity." The boulevards—which are where we have been throughout the cacophonous ramble—are the scene of "artifice"; what is needed is "art."

XIII

The editor who had nightmares over "Les Grands Boulevards" printed it despite his forebodings. But Mondrian's second Paris sketch would not be published during his lifetime. This was to the loss of the contemporary public. In its deliberate disjointedness, imagination, and soaring spirits, it is even more amusing than "Les Grands Boulevards."

With the title "Little Restaurant—Palm Sunday," the festive atmosphere of this portrait of urban life is established. The essay reveals, more than does Mondrian's didactic writing, how open he was to the richness and variety of everyday existence. He could make written language sparkle with color much as his paintings do.

"Little Restaurant" invokes Mondrian's perpetual affinity for contrasts and his attraction to the unexpected. Life is like a dance step in which we go this way and that.

> A man is sometimes a woman and a woman sometimes no woman.
> *"Un boeuf gros sel." "Une pomme dessert."* The coarse and the fine. Both are necessary. . . . An automobile. A Sunday hat blows off. I feel the wind

on the glass screen behind me. The sun is shining and the wind is cold. The good and the bad together. The sun is shining on the flower carts, on the oranges, on the avenue. A poster across the way: Fabrique de sommiers. The factory is necessary like the restaurant.

Mondrian has stepped boldly outside his Neo-Plastic cocoon. He is open to everything he sees, and relishes the rhythm between things. He does not judge; what counts is not what something is but that it is part of the larger cosmos. A hearty slab of beef and coarse salt and an ethereal confection of refined ingredients all belong to life's treasure chest. Everything flows into everything else. Riches pour out nonstop throughout the entire essay, six pages of text in a single paragraph without a break.

The essay has a jaunty end:

The flower seller doesn't water her wine but her flowers in the sun. Her flowers come from outside Paris and so does she. So does the little woman with the *coeurs à la crème*: a heart of buttermilk in milk. White in white and yet not the same. Buttermilk in Paris! We find the same thing everywhere in different forms. Many *coeurs à la crème* take the place of liqueurs and medicines. The liqueurs and medicine in turn replace many "hearts." *"Je vous donne mon Coeur"*—she has many of them, *la bonne femme. Ma fille!* . . . At one time she had just one heart. The couple over there are sharing one *coeur à la crème*. This *petit trottin* [messenger boy] has two *coeurs à la crème*. The foreigner over there is eating his *coeur à la crème* alone. A soldier. Has he a *coeur à la crème*? A *coeur à la crème* is not only soft but also white. *"Vous avez terminé, monsieur?"*

It's no wonder that Mondrian retreated to the world of pure abstraction. The vagaries of life, the possibility of a glass of wine being knocked over, the need of a waiter to be obsequious, the loss of the innocence represented by that soothing white heart-shaped dessert made with buttermilk, the vulnerability and fragility intrinsic to a deeply felt life: these were so potentially overwhelming to Mondrian that he had to find a way to express the wonder of existence in a form that he could control.

XIV

For all the times that Mondrian declared he would have to give up painting and move out of Paris, it generally took nothing more than the sale of a work or the prospect of sales for him to regain faith that he would survive, even flourish, as an artist. In early March, a visit from Léonce Rosenberg turned

his gloom to optimism, and he became ebullient about Van Doesburg's presence. On March 10, he wrote Lena Milius:

> We had a wonderful time, such a pity you weren't there. Does has been writing to you as faithfully as you to him, so you must have heard all about it already. I expect you have also heard that Rosenberg has been to see me, and that it all turned out so much better than expected. A while ago I was in despair about my financial situation, but my courage is back now and I will press on.

He urged Milius to come to France and settle there, so that Van Doesburg would stay on and they could publish *De Stijl* in French.

It was a remarkable shift of mood. For five years in the Netherlands Mondrian had been resigned to his fate, looking for opportunities to get back to his old life but taciturn about where he lived or who his companions were. He mainly painted, and danced with whatever women were willing to be his partners at the Hamdorff. Now he was on an emotional roller coaster. Four months earlier, he had delighted in transforming his new living and working space into a private haven unlike anything that had ever existed. Two months ago he had decided to give it all up—painting and Paris, all of it—and move to the hinterlands and be a farm laborer. Now, with Van Doesburg staying with him and Rosenberg suggesting he might get at least a painting or two into the gallery he most wanted, he was soaring. Mondrian had never before been so openly happy about another person's company as he was about Van Doesburg's. He urged Lena Milius to give up her job and home so that Van Doesburg would remain in Paris and together they could advance their bible of Neo-Plasticism in the French language, which would assure its having a far greater impact.

Mondrian and Van Doesburg went together to the Salon des Indépendants. Afterward, Van Doesburg wrote Oud that the show was "nothing more than the bungling of dilettantes." Still, Van Doesburg was gregarious, and circulated in that world of people he criticized, with Mondrian happily going along. Van Doesburg took Mondrian to visit Fernand Léger, the Norwegian painter Thorvald Hellesen, and Léopold Survage, a Finnish-born painter who worked in the spirit of the Russian avant-garde. Van Doesburg's access to the reclusive painter who realized their mutual theories with artistic masterpieces was a feather in his cap, and the other artists were excited to have Mondrian visit.

Léger, the only one of the group who came close to equaling Mondrian in skill and originality, would remain in Mondrian's orbit from then on. They would never be close friends, but they would maintain enough of a

Fernand Léger. Van Doesburg
introduced Mondrian to Léger
in 1920. They were very different
types of artists but always enjoyed a
certain rapport.

connection so that, twenty-four years later, Léger would be among the small
group of people to file into the church for Mondrian's funeral in New York.
In spite of Léger's adherence to the figure, Mondrian liked the Frenchman's
independence and boldness. Mondrian's use of black lines and primary col-
ors had such an impact on Léger that to this day their work gets paired in
museum installations.

Mondrian, however, was looking for another type of companionship.
His resource was classified ads. In a subsequent letter to Van Doesburg and
Milius, he continued, "I saw an advertisement in Paris-dance from 'une jeune
fille' looking for a 'partenaire pour la danse.' I wrote to her, but perhaps a bit
late. I'm not very good at that kind of thing."

This is as much as can be discerned about his personal life now that he
was really settled in Paris, except for the pleasure he took with the tête-à-tête
dinners with To Stieltjes. What we do know is that Mondrian was preoccupied
with the April issue of *De Stijl*, which featured a second manifesto. This one
was dedicated to literature. And he was pushing forward with his painting.

He wrote Van Doesburg and Milius that he had at last completed a major
new composition:

I have finished that big thing at last. The lines kept me busy for a long time.
Last Sunday the Stieltjeses saw it, and they were pleased. I think it's quite
good myself, but now the other, smaller ones don't look nearly as good in
comparison, so I'll have to do a lot of work on them to achieve the same
effect.

The Stieltjeses' intended purchase of *Composition with Large Yellow Plane* gave him some economic security, but Léonce Rosenberg had informed him he would only give him a solo show if he could put up twenty-five hundred francs in advance, which Mondrian could not possibly do. Again, he was living on a shoestring.

XV

Three of Mondrian's latest paintings were to be in the exhibition *Paris, Kubisten en Neo-Kubisten*, which was to open in Rotterdam on June 20 and then travel to The Hague before a final venue at the Stedelijk. He gave instructions to Van Doesburg, who was handling the details:

> I forgot to tell you that I prefer my pictures without wooden strips framing them; once they hang there won't be a problem with the nails, otherwise you might paint over them with a shade of grayish white, no? I am so afraid of damage to my stuff during packing and unpacking, with those fellows putting their paws on the paint, can't you do something about it? I did leave a note in the crate saying take care.

By having the work unframed, he would blow away the confines that separated paintings from their environment, and move toward his idea of eradicating the notion of "art" in favor of a totally new environment:

> I expect you are very busy, but once you have hung my work (because only then can you see it), would you or Lena please write and tell me briefly what you think. . . . It has always been my conviction that, in the end, plasticity is always tied to the *plane* in our minds, the way we do it. After what you wrote me all I want to say is: please bear in mind that (in my view) the *center must not be moved, but annihilated, cancelled out.* Don't you agree, or am I rambling? If you simply move the centre outside the canvas, it will still be *one* canvas; it's just that your canvas then becomes merely part of a larger canvas, right? . . . As for van d. Leck, I totally agree with you: he's small, narrow minded and underhanded. I suppose you have no dealings with him anymore. Nor do I. I have not heard a word from the whole gang since. Miss Steijling wrote me that van't Hoff is building a house in Laren or Blaricum, and is very busy with Beekman. Let them do whatever they like! As far as I am concerned they no longer exist.

Mondrian's way of dealing with people or aspects of life he did not like was to eradicate them. He could cut out an artist he felt was no longer on

In almost all group photos, Mondrian stood to the side, slightly
apart from everyone else. In this picture of him taken in 1922
during a visit with friends in a suburb near Paris, everyone else
is relaxed and smiling; he is in a characteristically serious pose.
The man on the left is Marinus Ritsema van Eck.

the right track, drop friends who began to get under his skin, or, as in the case
of his marriage engagement, run away fast. In that same letter of June 12, he
also wrote Van Doesburg about Jo Steijling, an acquaintance who worked as
a nanny and who had been a housemate in Laren, one of those women with
whom his relationship was ambiguous but who was somehow involved with
helping him to sell his work:

> That Miss Steijling is quite special and has a good eye for what we want,
> that is true, but despite all her good intentions, she is *very arrogant* and not
> *sincere* either. She wanted to find a job in Paris, whereas she kept making
> me believe that she agreed about the contact with me being *temporary*. I
> have now written her in plain terms that I don't want to see her any more.
> It's one's own goodness causing trouble, that's what!

It would happen with Van Doesburg as well, but for now he depended
completely on Van Doesburg as a sympathetic ear to share his anxieties.
Mondrian generally had a single person in whom he placed his trust, and, for
now, his fellow apostle of De Stijl was the one. He counted on Van Doesburg
to care not just about his human relationships but also about his financial
plight—as the ally who understood the purpose of his life and the reasons he
was willing to endure hardship.

Stieltjes will be paying off 100fr. each month, he says.

Fortunately Slijper still owes me some money, perhaps I can ask him when he has seen some more of my work in Rotterdam. But he won't want to pay the full price. At this rate I might as well stop, if I have to live the way you found me. It's a constant sacrifice, on the one hand, isn't it? Bye, Does.

The repeating of his friend's name in that final salutation has a touch of despair. Still the needy child who craved someone else's caring, Mondrian again felt that he was on the verge of ceasing to paint forever, but at least he had a confidante.

XVI

Male/female—the pairing he equated with vertical/horizontal—was perpetually on Mondrian's mind in the summer of 1920. He had now been back in Paris for a full year, and even if he had his usual struggle to come up with the next month's rent payment for his space on the rue de Coulmiers, he had time not only to paint but also to reflect and write, now with reflections on George Bernard Shaw. On July 5, he wrote Van Doesburg:

> Dr. Schoenmaekers had given a lecture in which he said that Shaw has written a play in which he portrays the *psychological* effect of opposites, in man and woman. I think Schoenmaekers was harking back to a conversation he had with me and Van Domselaer, but whatever the case, in my article I will give Schoenmaekers credit for pointing it out—for the sake of purity, I mean. I am so pleased that it is dealt with by Shaw (I am very taken with him).

It would be surprising if Mondrian read Shaw's plays; it's even less likely that he saw any of them. But his declaration of being "very taken with" the Irish playwright is rare evidence of an aspect of Mondrian's life about which little is known. He never owned more than a handful of books. Whether or not he frequented a lending library is unknown. All that is certain is that what he read mattered to him intensely. Shaw, like the unnamed soldier writing letters from the front, impacted his approach to life.

In spite of their mutual animosity, Mondrian acknowledges Schoenmaekers as the source of his discovery of Shaw's wisdom.

> In classical and romantic literature we also find the action of contraries expressed . . . but without verbal plastic and veiled by description. Dr. H.

Schoenmaekers sought to show that in *Candida* Bernard Shaw opposes psychological contraries. Similarly, in the literature of ancient India we often see two things that seemingly destroy each other.

This idea would nourish Mondrian's essay on literature, "Neo-Plasticism: The General Principle of Plastic Equivalence." In the evenings on the rue de Coulmiers, he was writing this text with which he intended to simplify the ideas of the *Trialogue*. He knew that Léonce Rosenberg's Galerie L'Effort Moderne would publish it. Initially, it would appear in Dutch, but Mondrian would translate it into French that summer so that it could be excerpted in *De Stijl*.

Although art is the plastic expression of *our* aesthetic emotion, we cannot therefore conclude that art is only "the aesthetic expression of our subjective sensations." Logic demands that art be the *plastic expression of our whole being*: therefore, it must be equally the plastic appearance of the *nonindividual*, the absolute and annihilating opposition of subjective sensations. That is, it must also be the *direct expression of the universal in us*—which is the exact appearance of the universal outside us.

Some key sentences in the essay lead us to Mondrian's essential notion of self and to the mental functioning he succeeded in making his own: "This action contains all the misery and all the happiness of life: misery is caused by *continual separation*, happiness by perpetual rebirth of the *changeable*. The immutable is beyond all misery and all happiness: it is *equilibrium*." Here we have the three different stages of Mondrian's own existence, comparable to the progression he illustrated in *Evolution*. In that triptych, the first step in the process toward a state of spiritual well-being—expressed by the words "misery" and "continual separation"—is illustrated by the anguished woman on the left-hand panel of the triptych, with her clenched jaw and dramatically shut eyes and her sharp chin thrust into the air. The "separation" evident in that stage for Mondrian could refer to everything from birth itself to all of the experiences of his youth. Next had come his many years of development—as a painter, but also as a participant in various progressive movements, ranging from Theosophy to his support of factory workers. Now, in 1920, he had arrived at the second stage—"happiness"—which was evident in his home and art with his immersion in the "perpetual rebirth *of the changeable*." Those words are a perfect description of Mondrian's new living environment, with his capacity to alter the positions of his panels of color on the wall.

His goal now was to get to the glorious stage of equilibrium, based on the immutable, which he describes in the next paragraph:

> Through the immutable in us, we are united with all things; the mutable destroys our equilibrium, limits us, and separates us from all that is other than us. It is from this equilibrium, from *the unconscious*, from *the immutable* that art comes. It attains its *plastic expression* through *the conscious*. In this way, *the appearance of art* is plastic expression *of the unconscious and of the conscious*. It shows *the relationship* of each to the other: its appearance changes, but *art* remains immutable.

Mondrian was already in fact in that ideal state of being.

Abstraction offers salvation. "*In the vital reality of the abstract*, the new man has transcended the feelings of nostalgia, joy, delight, sorrow, horror, etc.; in the '*constant' emotion of beauty*, these feelings are purified and deepened. He attains a much more profound vision of perceptible reality." The italics, which were used in the publication of Mondrian's text to represent the words he had underlined in the manuscript, are telling. Abstraction will offer the constancy lacking in the natural world and in the private emotional world. He believed this, and he would make it true in his art.

Mondrian goes on: "It is generally not realized that *disequilibrium* is a malediction for humanity, and one continues to cultivate ardently the feeling of the tragic." In one of his most revelatory—and horrific—soliloquies, Mondrian reveals the means of existing in a pure abstract state:

> Up to the present, the most exterior has dominated in everything. The feminine and the material rule life and society and shackle spiritual expression as a function of the masculine. A Futurist manifesto proclaiming hatred of *woman* (the feminine) is entirely justified. The *woman* in *man* is the direct cause of the domination of the tragic in art.

Mondrian is declaring his plan. By abolishing women from one side of his life, and not attempting a kind of unity he felt did not and could not really exist, he found a larger unity, a stronger one. With women out of his life in one way, he could accommodate them in another way; he could accept the female and male within himself. Yellow against red against blue—the highly charged interplay, achieved through the artificial colors of paint, juxtaposed through the constructed artifice of art—could establish a unity and a form of super-harmony that were simply impossible in traditional ways: in representation, in the family, in men living with women.

Later, he writes, "In our time, which is everywhere characterized by the striving for unity, it is most important to distinguish real unity from apparent unity, universal from individual. Thus we distinguish aesthetic harmony from natural harmony." These oppositions can be read directly in relationship to his own life. He was aware of the marriages of people he knew; he had grown up in a traditionally structured family. He had tried to participate in one or another political or religious or artistic movement. In all he observed of human relationships—the Van Domselaers' marriage, Van Doesburg's and Milius's coming together and subsequently growing apart, his brothers' and sister's changing dynamics as they grew in different directions, his father's subjugation of his mother, the disputes within the Dutch Reform movements culminating in his father's rift from Kuyper, the turning against him within the anarchist groups with which he had tried to work so optimistically in Amsterdam at the start of the new century, the disagreements within the Theosophical Society, the politics and battles within the artists' groups in Amsterdam and now within the De Stijl movement—he had observed the same thing. There may have been, briefly, an apparent unity, but it did not endure.

The last paragraph of "Neo-Plasticism," however, is suffused with his optimism, the sense of wonder which soars through his art:

> Thus, through the new spirit, man himself creates a new beauty, whereas in the past he only painted and described the beauty of nature. This new beauty has become indispensable to the new man, for in it he expresses his own image in equivalent opposition with nature. THE NEW ART IS BORN.

XVII

Mondrian was magnetically attracted to anyone he thought might join him in the belief that pure abstraction must be an artist's primary goal. His latest presumed soulmate was the architect J. J. P. Oud.

Born in 1890, Jacobus Johannes Pieter Oud was almost a generation younger than Mondrian and Van Doesburg. The son of a successful merchant who sold wine and tobacco, he was affable and pleasant looking. Always clean-shaven, with his boyish countenance and profusion of curly brown hair, he resembled a well-brought-up and gentlemanly, if not quite handsome, university student.

In his style of building, Oud had been a modernist from the start. His first influence had been Hendrik Petrus Berlage, the Dutch architect and phi-

losopher who had designed the mansion where Anton and Hélène Kröller-Müller housed their Mondrians. Berlage's respect for the truth of materials and "practical aesthetics" devoid of ornament had had international influence. Oud had met Van Doesburg and became a passionate adherent of De Stijl. In 1918, he had been appointed Municipal Housing Architect for Rotterdam, where he had developed socially progressive residential projects for the heterogeneous group of laborers who had infused the city as its industries came back to life following the war. Even before they met, Mondrian had heard a lot about the idealistic young man with high aesthetic standards. Admiring Oud in advance, he was predisposed to like him in person.

Oud had initiated their connection by writing Mondrian that January. They met in person about half a year later when Oud visited Paris, and the two hit it off so splendidly that they saw each other frequently throughout the summer, until Oud needed to return to Rotterdam toward the end of August. On August 25, shortly after Oud's departure, Mondrian wrote him from the rue de Coulmiers, with his starting point being that the name "Oud" in Dutch means "old."

> Dear Bob, as I would rather call you, because Oud doesn't really suit you as a name, unless you treat it as its *opposite*!
> I am glad to have met another New Man, especially *as a friend*.
> If you weren't a Neo-Plasticist we couldn't be so close, I think. Yes, we had a good time, and you can see that the only reason why I am a bit strange sometimes is that I am unable to live in my atmosphere among my equals. I am certain that our relationship will remain as it is now.

Mondrian recognized himself as a social misfit and appreciated that Oud could accept his quirks. It meant a lot to him that Oud, after spending a fair number of summer evenings in his Neo-Plastic domicile on the rue de Coulmiers, grasped the total revolution in human living that was Mondrian's raison d'être. Mondrian continued excitedly:

> Yes you were right: what it comes down to here is that all is immaterial, or seems so—even though everything revolves around material things. Perhaps through the maturation of the material: all extremes revert to the good. The point is to persevere to the end: that is what is so good about Neo-Plasticism.

The friendship blossomed at the same time that Mondrian's relationships failed with those of his colleagues who did not adhere to the new gospel.

On September 5, 1920, he wrote Van Doesburg about how upset he was with their former ally the painter and sculptor Georges Vantongerloo. In so doing, he delved into the inner workings of his own mind.

Well now, here we are again with our Stijl movement facing a new threat with our friend Vantongerloo. His Belgian intellect is currently busy setting up a whole framework, which, in my opinion, is based *on nature*. He has not the faintest idea about the difference between *in the manner of nature* and *in the manner of art*. I can now see how clearly I made the distinction between the unconscious and the conscious: he is doing all the calculations with his ordinary consciousness. He wrote me about having negotiated with Rosenberg (I don't know what about) but that it had fallen through. He's a smooth operator, so take care. You see, I intuitively gauged him right. Big difference with Oud, who is a Neo Plastic, whereas T. is not. He goes about things like an (ordinary) Theosophist. I already know that you will agree with me.

Mondrian next wrote Van Doesburg about Auguste Herbin, whose success with an exhibition at Rosenberg's, where he wanted such a show, irritated him: "But he just doesn't get it. You can ask Oud (he will have told you already, probably) about how Herbin ended up with Rosenberg. Even Survage and Archip think it's bad."

Meanwhile, the expense of printing his brochure about the Neo-Plastic had been higher than anticipated, and he had to cover the difference. Inflation was rampant all over Europe, and prices were skyrocketing especially in the Netherlands, where the brochure had been produced. Mondrian took comfort in knowing that food in Paris was cheaper than in Amsterdam or The Hague, but he still had to finish paying off the printer's bill. Léonce Rosenberg agreed to underwrite the cost for a thousand copies of its French translation, but Mondrian was still so strapped for cash that he decided not to participate in an exhibition in Geneva into which he had been invited because he could not cover the shipping cost.

In October 1920, Mondrian had come so close to reaching the bottom of his savings, with no income in sight, that he tried to get a job as a part-time bank clerk. He wrote Van Doesburg that he had heard "third hand that a musician who needed money to survive was working being employed by a Dutch banker named Wybrands, earning eight hundred francs a month for four hours of work a day." Hoping to secure a comparable position, he had written Wybrands repeatedly. Mondrian felt no embarrassment about his persistence. Finally the banker answered. He apologized for having kept Mondrian waiting, explaining that he had been out of town. Respectful of

Mondrian's importance, Wybrands was solicitous. Mondrian read the gracious apology with bated breath, praying that the next sentence would be an offer of employment. His hopes were dashed when Wybrands continued by telling him that, while he was indeed looking for a clerk, it was a job beneath Mondrian. The artist wrote back immediately. He assured Wybrands that if the salary was eight hundred francs, he would be thrilled to apply. This time, the banker did not respond. Mondrian was at his wits' end, telling Van Doesburg: "Yes, fortunately I do make progress with the work, but the finances!"

The situation became even bleaker toward the end of the year. Winter was always a struggle for Mondrian because his fragile health made it impossible for him to scrimp on heating fuel. In the first week of December he developed influenza, and wrote Van Doesburg that he was "in bed for 3 1/2 days, the first day without anyone and anything." Fortunately his old friend the pianist Van Eck, who was now a doctor, came to see him.

> I could have got some help from the Stieltjeses, e.g., but I preferred not to. The second day I had a visit from Van Eck, who ran some errands for me. The concierge came as well, he even brought me a hot soup—for a tip, obviously. Money can get you anything here, like everywhere else—if only we had some more of it! Anyway, I recovered gradually and then the Stieltjeses came by with some eggs. I am painting again, only I still get tired easily.

He would soldier on, but Mondrian's spirits descended further as the year drew to an end. The strain of his finances, the feeling that he had no one else who truly adhered to the aesthetic philosophy he considered the salvation of humankind, and the melancholy that can be a symptom of influenza, converged.

Toward the end of December, Mondrian wrote Van Doesburg:

> My news is that Rosenberg says he won't do any more solo exhibitions, meaning that he will be showing me in April along with Léger and the others. Only six works. I would rather show them all, between 20 and 30 of them. He says it's too much for people to take in—he's a salesman first and foremost. Maybe he's right, and what is encouraging is that he wants to show me every three months, which would give people a chance to learn how to look. Let's hope I can last that long, eh?

With the onset of fear, Mondrian again flirted with the idea of changing professions. He charted his course if Rosenberg failed.

Otherwise I'll look for some other job. Out on v. Eck's farm, for instance. But perhaps I'll start selling after all. Thank you for any efforts to find buyers for those two things. Slijper will come round to pick something out. He sent me an advance of 500 fr.

The start of a new year was, however, like a shot of adrenaline. With the arrival of 1921, he felt his work was getting better than it had ever been and settled on the higher goal of thirty for the number of new paintings he would have ready for the spring. He was in a flush of returned optimism when he wrote Van Doesburg on February 10:

I could let the small one go for 500 fr., if need be. Because my current work is much stronger again. I am glad your work is going well: as long as we have enough to eat, so to speak, we have nothing to fear, my friend!

Keeping himself supplied with lentils, coffee, and his other staples was still a battle. A painting had been damaged en route to an exhibition organized in the Netherlands by La Section d'Or, an alliance of artists connected to Cubism. He had yet to get a refund from the transporter. Instead, he had to pay twenty-five francs to Survage for expenses of the show's tour.

Mondrian's letter provides Van Doesburg with a detailed accounting statement—money in, money out—and related anecdotes concerning the reasons, the timing, and the people involved in each transaction. He then names everyone who has received the latest copy of *De Stijl*, followed by a list of the names and addresses of various people Van Doesburg should contact to pique their interest in the magazine. Then comes a one-line paragraph:

My old man has died, but that means nothing to me, as you know.

What immediately follows is business as usual.

So I haven't written to Kok after all. May I leave that to you? Bye.

The aside about his father dying brings us up short. Later in life, Mondrian would denigrate his father in several interviews, but less than seven years earlier, he had gone to visit Pieter Mondriaan for a week. Some enormous rift between them must have occurred in the years when Mondrian was back in the Netherlands. Clearly he had discussed his father with Van Doesburg, and cared enough to mention his death while acting as if it had no significance, but his unabashed gruffness represented a change of heart about the parent who had had him put the colors into *Thy Word Is Truth*

and had engineered his admission to the Rijksakademie. One wonders if his father's lack of interest in Neo-Plasticism was what rendered him insignificant to his namesake. Whatever the reason was, whereas Mondrian had indeed attended his mother's funeral, he certainly did not go back to the Netherlands for his father's.

Continuity

I

The twelve closely related compositions Mondrian painted in the first four months of 1921 weren't as many as he intended, but it was more than he had ever completed in such a short period of time since turning to abstraction. The dozen canvases have a lot in common with one another. They all have straight black lines, vertical and horizontal, of consistent width. Some of these interior dividers stop shy of the edges; others reach them and seem to extend beyond. Rectangles of vivid solid colors are atop white and gray backgrounds. For all they share, however, they are very different from one another.

The variance of the outer dimensions and internal arrangements is what individualizes these vibrant compositions. Mondrian avoided repetition; he exulted in different elements to create combustion, for which the absence of pattern was an essential ingredient. In some of these paintings, the bold colors take up a high percentage of the surface space, while in others, the colors occupy only a few square centimeters. Not only do we feel the lack of formula but we sense each decision as being from the gut.

In May, Léonce Rosenberg borrowed five of the finished gems to include in a group exhibition in his gallery. Mondrian himself became actively involved in trying to sell each of the others, writing a flurry of letters to anyone who might be or know a buyer. He did not hesitate to admit to potential collectors that he was "quite hard up." When one of the new compositions actually sold, the five hundred francs was a lifeline.

Mondrian never showed regret at a painting leaving him, even if it was an integral part of a series. Once he finished a canvas, he did not care about it as a possession. All he wanted was the wherewithal to keep working and materializing his vision in new ways. But that capacity was again in question; he believed in the spring of 1921 that he was even more at the brink of financial destitution than he had ever been before.

Mondrian always thought that each spate of poverty was worse than any he had known previously. Yet, although his financial straits were real, they

were also his choice. He had a savings account which had a small bit of money in it, and somehow he always had enough cash to live on. He could have sold some of his earlier work that was kicking around the studio. But he needed the rigor, the slight discomfort, that comes when one has no cushion. There are people who feel more energetic when slightly hungry; it was as if the sense of being broke kept Mondrian on his toes. Mondrian needed to live lean and on the edge rather than to feel puffed up. To have had spare cash would have been like letting his paintings please him for more than a brief period of time; he flourished on a sense of urgency.

II

The five compositions Mondrian had consigned to Rosenberg's gallery were presented at the very back of the space. Mondrian was not upset the way most people would have been to be treated like an afterthought, with the placement giving collectors the impression that his work was not in the same league as what was shown up front; even in the worst possible position, at least they were being shown in the leading gallery for modernism and were installed with taste.

Those five canvases grouped in Rosenberg's gallery were lighter in feeling, the dance quicker, than in anything previous. The black lines move. While the verticals jump, the horizontals glide along like skaters on ice. *Composition I*, the first on the left of this new group of small canvases aligned on the gallery's back wall, envelops us in a world of pure shapes and precisely circumscribed emptiness. The solitary red form—a nearly square horizontal rectangle—emerges ecstatic. Below it, positioned with a deliberate visual dissonance, smaller vertical rectangles of blue and yellow frolic like carefree children. In *Composition with Yellow, Blue, Red, Black, and Gray*, the two red rectangles (one a wide vertical, like a door, one a narrow and long horizontal band), three yellows (two of them broad verticals, one a horizontal band even more elongated and thin than the blue one), and two small blues (different dimensions from what we have seen in the other colors, but the same yin and yang) invoke sheer laughter. In a third painting from this group, the single yellow vertical pressed into the lower right-hand corner is in a dance with the short horizontal red in the upper left and the longer, thinner horizontal red sliver in the upper right. They engage not just with one another but also with the large blue panel that looms slightly below and to the left of the center. We first perceive that blue form as square, but then realize that it is slightly wider than it is high. Its difference from what we first assumed it to be provides a

sort of kick start, like something that sharpens our taste buds; the sense that we cannot count on our quick responses or subsequent expectations awakens us.

The motion of this painting becomes, in little time, brisk. The combination of colored panels gyrates in ever-changing formations with the black lines and gray areas of the painting. All of this activity occurs not just in front of the whites but also colliding with them on the same plane. The animation and force is like the movement of the solar system: nonstop, high speed, everlasting.

While *Composition with Large Blue Plane, Red, Black, Yellow, and Gray,* another in the series, is only 24 inches high and 20 inches wide, it feels oceanic. The dominant blue square, bifurcated by an incomplete broad T, is a window to infinity. It is both the window at Winterswijk, with those black lead mullions, and the future that awaits in the world beyond the schoolmaster's house: life without boundaries for the adolescent boy looking out the window.

Mondrian has stopped one black line about a centimeter before the left-hand border of the canvas, leaving a smidgen of red showing as if from behind. He has left a full three centimeters between the bottom of the same red form and the bottom of the painting. The sense of measure has the finesse of Rudolf Serkin at the piano or Benny Goodman on the clarinet: we are in the realm of artists with impeccable judgment and nuanced timing. Two of the black lines reach the edges (top and right); others do not. The perfection of every decision is the source of ravishing results.

Mondrian in 1921 was, at last, for all the abnegations, the hardships and sacrifices, the self-denial, the artist he wanted to be.

III

Mondrian rarely went out in the evening for more than a drink at a café or dinner in a modest bistro, and hardly ever attended events like concerts or theater performances. But he made an exception just before the start of the summer of 1921. The reason to don one of his impeccably tailored suits and head across the Seine was a performance of music by the "bruiteurs futuristes italiens." He did not go at his own initiative. He later wrote Oud simply saying that it was "someone here" who had proposed the outing and took him, implying that it was either a neighbor whom he considered of no consequence or someone best unnamed.

The concerts were given at the Théâtre des Champs-Elysées, which had been constructed eight years earlier. The building itself was too modern for the taste of many Parisians, but not modern enough for Mondrian. Its bold

white marble façade was simplified compared to the ornate front of the Palais Garnier, the Comédie Française, and the other large theaters in town, but Mondrian approved only of complete flatness for a wall. Besides, he would have preferred painted plaster to marble. The natural grain of that quarried stone produced subtle irregularity and conveyed a sense of history, all best avoided. Nonetheless, the geometry of this theater just off the avenue des Champs-Elysées, its revolutionary clarity and sense of lightness, had prompted Le Corbusier, recently arrived in Paris, to declare it the best modern building he had ever seen, and it impressed him so much that he went to work for its main architect, Auguste Perret.

The theater interior was a collaboration between Perret and the Belgian Henry van de Velde. It had sculptural bas-reliefs of allegorical figure scenes by Antoine Bourdelle and frescoes by Maurice Denis, also lamentably representational as far as Mondrian was concerned. There were elaborate lighting fixtures by the crystal artist René Lalique. But even if it had the flaws of naturalism and historicism, inside and out, the Théâtre des Champs-Elysées was possessed of a quality of newness and real bravura, and for Mondrian, it was a step in the right direction.

Besides, the institution had won his admiration for its performances. The Théâtre des Champs-Elysées hosted events whose creators willfully abandoned all tradition in order to celebrate forcefully the eternal givens of life. No amount of opprobrium discouraged its management. Shortly after the theater opened, Stravinsky's ballet *Le Sacre du printemps*, choreographed by Vaslav Nijinsky, had had its premiere there. The events of that evening in May 1913 had prompted Carl Van Vechten to report in the *New York Sun* that "the unruly audience became as much a part of the performance as the dancers and musicians." Their shouts were so loud that the management felt obliged to turn all the lights on so they could control the mob, whose noise dominated the performance even after the loudest protesters had been forced outside. More recently, Josephine Baker had appeared on the stage here, naked except for a pink flamingo feather as she performed splits while being carried upside down on the shoulders of a large Black man.

The concert Mondrian went there to attend in 1921 was performed by twenty-seven mechanical noisemakers under the direction of the composer Luigi Russolo. Born in 1885, Russolo had been engineering such events for eight years. Mondrian was fascinated; like him, Russolo deliberately got away from "reproductive imitation"; Russolo's complete disassociation from anything in the natural world was Mondrian's ideal. Because noisemakers are able to produce sounds that cannot be recognized or identified, they were the perfect vehicle.

Filippo Marinetti, then forty-five years old to Mondrian's forty-nine,

Luigi Russolo, 1915. The composer used mechanical noisemakers along with traditional instruments. Mondrian admired the absence of melody in his music and considered his "amalgamation of the most dissonant, strange, and strident sounds" a vital step toward "pure expression of the new spirit," even if it was only in painting that it would be fully realized.

introduced the performers. He and his work had considerable significance for Mondrian, and gave him the charge of real camaraderie. In 1909 Marinetti had published, in French, the *Manifeste de fondation du Futurisme*. It was one of those sweeping declarations, in principle like Marx and Engels's *Communist Manifesto* of 1848, and the "De Stijl Manifesto" Van Doesburg and Mondrian had signed in November 1918, which stated its arguments as if they were the sole answer to everything in life. Marinetti's paean to danger, aggression, speed, and battle celebrated the latest technology, and urged a revolution which called for the destruction of museums and the art academies. The following year, Marinetti was the main author of *Dei Pittori Futuristi*, which elaborated on those ideas. This time, his language was Italian. Translated as *The Futurist Manifesto*, its radical text, signed also by Giacomo Balla, Umberto Boccioni, Carlo Carrà, Luigi Russolo, and Gino Severini, would have a powerful impact on adventurous artists all over the map. Sitting in the audience at the Théâtre des Champs-Elysées, Mondrian thrilled to Marinetti's devotion to breaking old molds. Both of these middle-aged artists believed that their unprecedented means of communication would benefit all of humankind. They were convinced that what they were doing in their own painting and insisting on for music and writing would have widespread effects in every realm, from medicine to economics to issues of political justice. Seeing and hearing differently would lead to a complete metamorphosis in human civilization.

The forty performers on the stage that evening were organized like a traditional orchestra. A large and ornate harp was positioned in the foreground on the side of the stage that was to the right, as seen from the audience. At

first, it resembled any other event in a concert hall. The male musicians were in evening clothes, their black bow ties impeccably tied, their white shirts glistening, while the female harpist was in a crushed velvet gown. But when the curtain rose at 9 p.m., Mondrian and the rest of the audience saw, with the violins and other familiar instruments, a machine that looked like an organ grinder, and two enormous ship's foghorns. Some of the musicians were reading music, but some had no stands in front of them. The other anomaly was that, in the back rows, the performers wore outrageous hats— white boaters, brown derbies, and fantastical caps.

While there were two violins, one viola, one cello, one double bass, one flute, one oboe, one clarinet, one bassoon, one trumpet, one harp, one kettledrum, one xylophone, and a chime, there were also twenty-seven "intonarumori" in that orchestra. The thirty-six-year-old Russolo had invented the word. In 1913, he had written a manifesto called *The Art of Noises*, and subsequently he had engineered the sort of sounds and combinations that constituted this concert. This was why Mondrian had decided to chuck his usual habits and go out that evening. As far as we know, it was the only time in the nearly twenty years of his living in Paris that he crossed the river to attend a performance. But he had heard about Russolo's noise machines and could not resist them.

The printed program listed the six compositions by Luigi Russolo's brother, Antonio Russolo, with which the concert would open:

Roars, Thunderings, Explosions, Hissing roars, Bangs, Booms
Whistling, Hissing, Puffing
Whispers, Murmurs, Mumbling, Muttering, Gurgling
Noises obtained by beating on metals, woods, skins, stones, pottery, etc.
Voices of animals and people, Shouts, Screams, Shrieks, Wails, Hoots,
 Howls, Death rattles, Sobs
Screeching, Creaking, Rustling, Buzzing, Crackling, Scraping

Following Marinetti's speech and the playing of this work by Antonio Russolo were two pieces by Nuccio Fiorda, with the wonderful names of *Processione sotto la pioggia* (Procession in the Rain) and *Cocktail*. Luigi Russolo operated one of his own machines; Antonio conducted. While some of the noises sounded like steamships, others were unlike anything anyone had heard before. They are, however, more familiar to us today than they were to anyone back then because of their resemblance to film scores accompanying extraterrestrial voyages.

Mondrian was impressed that the Bruiteurs had gone beyond the "veiled naturalism and individualism of the old music," and admired the avoidance

of all melody and the advance over the imagery or emotions conjured by the Romantic composers.

Still, revolutionary as the Bruiteurs' performance was, it fell short of Mondrian's ideals. What came out of the sound-effects boxes was lacking in the abstraction he deemed vital to a truly new music. He wrote about this for *De Stijl*, in two articles that appeared in the August and September issues. In his "Manifestation of Neo-Plasticism in Music and Italian Futurists' Bruiteurs," the connection of Mondrian's notion of "the new spirit," whether manifest in music or in painting, and his definition of his own existence is remarkable.

> The *pure manifestation of the new spirit* remains unchanging and identical in life as in art. It is an *exact and conscious plastic equivalence of equilibrium* and therefore of *equivalence between the individual and the universal, between the natural and the spiritual*. In both respects, the man of the past is an *"unbalanced whole."* Continually maturing and growing, man achieves understanding of the *"equilibrated whole"* and becomes capable of revealing the new spirit.

Piet Mondrian himself was the prime example of his evolved human being. In his Neo-Plastic cocoon, he had made his life and his art of a piece. Believing himself to have been emotionally unbalanced until recently, now he had found equilibrium by getting away to the furthest extent possible from the "individual" and focusing on the universal. There was no denying the inevitable needs of the body and certain realities of life, but the role of the natural had been greatly reduced in deference to the spiritual.

Mondrian considered Russolo's "amalgamation of the most dissonant, strange, and strident sounds" a step toward his ideal. It had not entirely achieved *"pure expression of the new spirit,"* but this "completing sound with noise" was a "first step." Nonetheless, it was only the art of painting that had achieved Mondrian's requisite "pure plastic expression of the universal."

In writing about that ideal conveyance of what is everywhere, Mondrian was referring to the achievement of his own work. *Diamond Composition with Yellow, Black, Blue, Red, and Gray*—the one of his 1921 series where he turned the canvas forty-five degrees to make a diamond shape, which he in turn bifurcates with verticals and horizontals—is an exemplar. We enter a completely new world with it, and to follow its details is to experience palpable joy. Each triangle of vibrant color—the three-sided forms we perceive as having been cut out of rectangles by the diagonal edges of the painting—is suspended at a titillating distance from the others, in front of a radiant whiteness. The large-sized yellow one, a smaller blue one, and a tiny

black one catapult us into a celestial state. Pure black lines establish the one non-interrupted form, nearly square but ever so slightly vertical, small but intense. The horizontal dividing line that is just above center reaches, as if to extend over it, the diagonal edge on the right, but falls just short of arriving at the mirrored edge on the left and instead comes to its own neat ending. The way that line has an end on one side but not the other is spectacular. All the other black lines have neatly cut ends on both sides; this is the only one that keeps going, as if to wrap itself around the package.

At the same time that our eyes take in these few lean elements and succumb to their slowly yielding richness, the vibrant colors and lustrous whites penetrate us, injecting energy. This minimalist composition causes a lot of events to occur simultaneously and with such force because it lacks simple harmony. Each of the three primary colors has a different impact because of its hue, with those particularities attenuated by the sharply varied sizes. There is no balance in the composition; this is not simply nonrepresentational art adhering to the traditions of picture-making. Rather, with its deliberate asymmetry and intentionally jarring tempo, this form of vision is without precedent.

If the painting resembles anything familiar to us, that likeness is to the life which the artist had created for himself. Based, to the greatest extent possible, on paint and form, Mondrian's new abode, and the way he lived in it, was removed, completely, from "reality," emotional or physical, and the limitations that come with most people's concept of existence. It, too, was without a model or precedent.

IV

Oud, Mondrian's latest close friend, was suddenly out of favor. The person to whom Mondrian complained was Van Doesburg. A few months earlier, Mondrian had been grousing about Van Doesburg to Oud. Within a year, he would become utterly furious with Van Doesburg, but for now Oud was the one disappointing him.

Mondrian wrote Van Doesburg and his new partner, the twenty-one-year-old avant-garde musician and dancer Nelly van Moorsel, a letter about Oud's attitudes on abstraction ("N.P." stands for Neo-Plasticism):

Dear Does and Nelly, I have just replied to a letter from Oud which I received 10 days ago. That letter made my blood boil and I fear that the break has come for me too. Oud said he had also written to you but that you hadn't replied; well, I can see why. But I gather from your letter that he made you angry about something else, too, whereas he was always good to

me, e.g., by finding me buyers. I must not forget that. The old friendship between me and him remained constant, and so it is doubly painful for me to see that friendship being eroded now that he is writing me things that are diametrically opposed to my principles. He blames me for having *fixed ideas*, and that sounds very dangerous to me. You don't need advice from me because you already know, but otherwise I would want to warn you about being influenced by his idea of "adjustment," his fear of a "form," as he sometimes calls N.P. So what does he want? What can any mortal ever create with assurance if he isn't sure about his idea? Rather than quoting from his letter here, I prefer to quote part of my reply. . . . Among other things, I wrote: "And since your last letter in particular I am beginning to think there is even a fundamental difference in insight. If you do not wish to 'restrict' yourself to the N.P., it is because you don't realise what it stands for or because it does not appeal to you."

Mondrian was despondent. Not only was Oud, his great source of hope a few months earlier, letting down him and Van Doesburg, but the entire tide of opinion was turning against them. In another letter, he wrote Van Doesburg and Nelly:

Everything is dead here, at least for our art, at the moment. I don't hear anything: will it ever change? Or rather, will we live to see it? Oh well . . . as long as we are alive and can eat!

With support for the Neo-Plastic having eroded, Mondrian had no choice but to start painting flowers again. He had a commission from the Netherlands to do a flower painting for three hundred francs.

I am now making flowers until I have some in stock. You know that I do it as a *profession*, as if I were an artisan. I want to try and stay in Paris. It has nothing to do with my art—you don't need me to tell you that. P. Mondri*aa*n and P. Mondri*a*n are *two separate* beings.

When, between 1907 and 1909, he had made drawings and watercolors of amaryllis, arum lilies, chrysanthemums, dahlias, gladioli, and marigolds, Mondrian signed them mostly with the double "a" of "P. Mondriaan." But starting as early as 1907, a few bore the single "a": "P. Mondrian." This was precisely the period in which he was starting to drop the second "a" at the request of Uncle Frits to avoid any possible confusion of authorship. Now, in the early 1920s, when he again had some of these same flowers serve as his

subject, but mainly made pictures of roses, singly or bunches, he consciously signed them with the double "a": "Piet Mondriaan."

His idea that the return to the signature of his youth made him "two separable beings" shows how strongly Mondrian identified his evolved self with pure nonrepresentational abstraction that prohibited recognizable subject matter. Insistent that the flower paintings be regarded only as mercenary work, he denied their beautiful abstract qualities.

It was one of those periods when he felt that everything was going wrong. Mondrian had just suffered from a bout of bronchitis which lasted for more than two weeks, probably the catalyst for his slump. Then, as soon as his health improved, he had one of his bursts of optimism. Van Eck had told him there was no permanent damage from the illness. He ended his letter to Van Doesburg with renewed faith that art provided hope; their shared faith made problems disappear, and Van Doesburg was the truest of allies. "I just received De Stijl, which shows that there is still some (spiritual) life. Congratulations on your hard work. Bye."

When the pendulum swung upward, it went high. Mondrian again believed in Van Doesburg's efforts with heart and soul. He was upset that they were not having the impact they deserved.

He was now convinced that Oud was the main reason the gospel of pure geometric abstraction was not gaining greater ground. He treated the matter not as disagreement but as treason. On a Monday in August 1921, Mondrian wrote Van Doesburg and Nelly:

> My dear friends, your letter did me good. Fine contrast with Oud and so many others. I think I have now reached the same point as you vis à vis Oud. He has not replied; I wrote him at the same time as you. He has struck me, too, in my holiest aim, but so carefully and indirectly that you could barely pin it down. But in the end it has all come out clearly in his letters. He thought it *old-fashioned* of me not being able to separate friendship from insight . . . ! That illustrates his kind of (superficial) friendship. What you wrote me about those postcards to you is the last straw. "Rescue your little Stijl" . . . it's awful. Anyway, it's over now. I will remain *grateful* for what he did for me. The question remains whether it was on *his* initiative that a few people bought things from me.

Mondrian was more forgiving of Léonce Rosenberg. He did not expect an art dealer to have the intellectual rigor essential to artists and architects. And if Rosenberg endorsed a lot that Mondrian disdained, at least the dealer did not make withering remarks about De Stijl. Mondrian was over his earlier

annoyance at Rosenberg's proposing that he fund his own exhibition, and was grateful to have been included in the recent group show. Rosenberg had returned the unsold paintings from it so as to prevent their being harmed while the gallery was being renovated and was still supporting Mondrian's work.

> I have got my work back from Rosenberg. He sent a very friendly note saying he was afraid they might suffer damage in the coming renovation! I had a talk with him and he was very nice, as always. It was true, apparently: downstairs had been emptied out. He wants to start selling "classics" as well. Well, you can't blame a merchant for that. He says he will keep on with the new and wants to show me again later on.

What was less acceptable was Rosenberg's failure to read Mondrian's most recent article. The only periodical he had in his gallery was *L'Esprit Nouveau*; Mondrian was annoyed by this leg up for the competition, especially since *L'Esprit Nouveau* had assigned him to write an essay and then failed to print it. The battle for Neo-Plasticism needed every possibly ally.

V

Mondrian wrote Van Doesburg and Nelly on a hot summer day when Paris was largely emptied out by the French who had gone to the countryside. Life had returned to a certain norm; the city was again taken over by the tourists who had been unable to travel there during the war years. Mondrian's concerns, meanwhile, were his usual: dancing and Neo-Plasticism:

> Great news and fun about you two "stepping out." You must tell me what you think of the Shimmy (new foxtrot). It is *the* dance as far as I'm concerned. A bit complicated at first with that heel-toe. Nowadays they take liberties with that, but it's still the basis. It will have a good effect on you, and I am also glad that you are taking it up because it is an "expression." I can just see Oud doing a Shimmy!! The parties were not a success for me. The younger of the two Polish girls has gone to Belgium for a time and I have already broken up with the elder. So I had no one. And then I had some trouble with my nose and throat, but it has cleared up now. Am glad your hay fever is better.
>
> Well now, Does and Nel, best regards from Piet. Funny—you sending Stijls to the Stieltjeses, they are loyal to the cause and wrote me that they will have money for a subscription in the autumn. Good that you are translating my article into German.

There was a period when Mondrian considered Theo van Doesburg his complete soulmate, possessed by the same passion for pure abstraction. The relationship that Mondrian had with Van Doesburg and both his first and second wives was possibly the closest of Mondrian's lifetime. But their friendship was on-again, off-again, and ultimately ended in a complete schism between the two men.

Everything was connected and part of a coherent whole. Dance rhythm, adherence to abstraction, his own health, human loyalty or its lack, the will for freedom: all were essential to a lightness of being.

Then, toward the end of September, Mondrian's landlord at rue de Coulmiers informed him that he wanted to use Mondrian's space himself. Having at last created his personal paradise, Mondrian had to leave it.

Having taken his painting to a higher level than ever before, he was convinced that the setting was an inimitable part of the progress he had made. But while most people would have been flapped by landlord difficulties and the requirement to move, Mondrian accepted the need to move on. He wrote Van Doesburg:

> Dear Does, now I am told that I will have to leave my studio! My landlord wants to add it on to his apartment. Quite possible, then, that if I can't find anything cheaper I will have to take the Stieltjeses' studio for the time being.

He would return to 26 rue du Départ after all.

VI

Léonce Rosenberg went to see Mondrian on October 2, just before he would be moving from the rue de Coulmiers. It was a Sunday, which is when he made his studio visits, the gallery being closed. Mondrian was in crisis. He

had just learned definitively that he had to give up his space; he had no choice but to sublet the Stieltjeses' studio on the rue du Départ, which was expensive. Rosenberg arrived just as Mondrian was desperately trying to figure out how he would manage the increased rent. The timing could not have been better for the dealer to make a proposal that convinced Mondrian that everything was possible.

Absent his usual workday suit and tie, but dressed with dash in his more colorful casual attire, Rosenberg was possessed of the inherent confidence of the scion of a family of successful art and antiques dealers. The worldly young man respected Mondrian's independence and genius, and was delighted to provide hope to an artist who, nearly fifty years old, had not yet begun to sell as Rosenberg felt he warranted. At a time when very few collectors understood, or would dream of purchasing, Mondrian's new compositions, so totally divorced from all that was familiar, Rosenberg not only told Mondrian he wanted to put three works into an upcoming auction in which L'Effort Moderne was participating at the Mak Auction House in Amsterdam but he also picked nine paintings to exhibit in his Paris gallery in November. Telling Mondrian he would pay twenty-five hundred francs for them, the arrangement meant that Mondrian could take the sublet for at least a year.

On Saturday, October 22, Mondrian made the move to the two-story space with its small annex. In Laren, he had learned to change his work and living spaces often, as dictated by necessity, without being discombobulated. With few personal possessions, and no one else whose homelife he had to consider, Mondrian switched locations easily. On the rue du Départ, he quickly reestablished himself in a pure visual environment like the one he had created on the rue de Coulmiers and still managed to paint and write almost every day.

But, while refurbishing his new home, he became desperate for the rest of the money beyond the five-hundred-franc advance Rosenberg had given him. By the time two weeks had lapsed following the closing of the November exhibition, Mondrian's patience wore out. He tried to approach Rosenberg; the gallerist would not see him.

On December 1, Mondrian wrote Van Doesburg:

Then he went to Holland and sold a thing of mine there—300 was for me, which he would send. When I needed the money, I asked him for it. Then he said he had already given me 500 over the 300, so that I actually owed him 200! That he had no money, times were really bad and he would pay after closure. A fortnight after he closed I wrote asking for the money, got a letter back saying that due to bad times and no sales he can't pay cash, so

that the paintings are at my disposal again! It was a bad shock, as I had been counting on it.

Still, Mondrian had derived rare satisfaction from the exhibition, and admired Rosenberg's courage in defending his work.

Fortunately I have got over it now (physically)—I wasn't much affected morally—and wrote him asking if he could pay me later in installments, or in any case to go on trying to sell etc. That is best, because after all I had a very fine exhibition again with him.

Mondrian was grateful for Rosenberg's willingness to contend with the forces against him. "Valmier was the only one who liked it, Rosenberg said." Everyone else had jumped ship on abstraction.

I don't know what Herbin thought but he's gone back to being a naturalist! Léger is back again too. Utrillo has joined them: nature in full. I think it's the influence of this damned stupid society. It is simply not possible to exist as an artist. But the others haven't sold either.

Mondrian was practically paralyzed. At one moment, he thought he might "try to hold on for a while"; at the next, he again considered a complete career change. Counting on the money from Rosenberg, he had furnished and repainted the new space, but having lived on a false hope, his inability to pay the bills made him too uneasy to paint or write. For months following the move, he did neither. Besides being in debt, he was bitter that no one had responded to the essays over which he had slaved, even though they were published in both French and Dutch. He became unable to write several overdue articles; it was hard to glorify the new with so few people attuned to it. "They just refuse to discuss anything, those dimwits and sleepyheads nowadays who want nothing but to stick with the old and easy."
Mondrian's own faith in Neo-Plasticism was intensifying almost in proportion to the opposition to it. It was intolerable to him that the more entrenched he became, pushing its agenda vehemently, the more so many other artists, even those who had initially been sympathetic, went in the reverse direction. Mondrian's loathing for the opponents of pure abstraction began to consume him. In the same letter to Van Doesburg, Mondrian added:

I also think Steiner and the Theosophist clique are cracked, just as all religion is a grotesque version of what it should be. *We* are the only ones

showing the content of what they make a mess of: N.P. has the ability to purify. But the dumbos won't listen. I sent Steiner my brochure with a letter, which may not have reached him personally, in any case there was *no* reply! I have been busy for a long time writing an article against all that, and hope to do some serious fulminating one of these days. . . . I felt melancholy at the sight of such fine Picassos and also Légers at the Kahnweiler sale. One wonders to what extent the whole lousy society is to blame for those folks taking a step back. Equally lousy is that prices are now being paid, too.

The high prices for representational Picassos were, as Mondrian wrote Oud, all the more upsetting because of his own "financial worries" since Rosenberg had committed an "about face" by suddenly saying he could not fulfill his promise to buy paintings.

So now he writes me that he can't pay. At that rate everybody can make a purchase! I couldn't believe my ears and it even affected me physically, but now I tell myself it's because times are bad. Nobody else had sold anything either. I don't want to go into detail about the whole affair, and how Rosenberg twists and turns. The thing is that I will have to manage without him again for the time being. I have decided to leave my things with him, and wait and see what he can still do. Best for me is to stay on good terms with him. . . . The studio here suits me fine and I can cook now, too, which also makes a difference. Lucky you to have a fixed salary! It's an odd business, being an artist!

Best wishes and regards also to the wife, from Piet.

His discouragement was no light matter. Five days later, Mondrian wrote Oud that he was resigned to stopping painting completely. This time he sounded entirely certain. The clincher was the cold weather. He could not afford the coal and wood he would need to stock the stove. Mondrian showed no recognition of the particular difficulty of heating an open space with a high ceiling—only an awareness that he could not stay warm. He explained to Oud that no artist was selling anymore, and that he would rather cease painting forever than compromise his standards in order to become one of the rare exceptions. Mondrian was back to the plan of doing vegetable farming, the task he had most hated as a child, for Van Eck, at Van Eck's farm in the south.

Art and the art world were not for him; he was through. For four days, in his new home, he imagined packing up.

Then, on December 10, Mondrian wrote Oud:

I expect you have received my previous letter. I kept fretting about my decision to accept my friend Van Eck's offer. I had already decided, as you saw, but changed my mind. I would rather lead an uncertain existence here than a presumably good life down south.

Once Mondrian had resolved to stay, he went back to Rosenberg's gallery. There he had the jolt of encouragement he needed. Rosenberg told him he was "his best artist"; he simply had to endure, as he had during the war. Rosenberg, having himself struggled to survive, could be counted on.

Rosenberg was not yet ready to promise Mondrian a solo exhibition, but allowed that it might be possible the next spring, and that he would nonetheless keep showing Mondrian's new compositions to the right people. The intrepid young dealer had one hanging in his private apartment above the gallery. Visitors who were invited up considered themselves privileged, and there was always the hope that one of them would have the vision, as well as the funds, to buy it. Rosenberg's clients had to pay far more if they wanted one of his Picassos or Légers, so the cost was not likely to be as major a concern as the absence of even the slightest hint of subject matter. To Mondrian, the encouragement of the man he had recently diabolized was a lifeline.

VII

Mondrian's prospects began to improve near the end of December. Jo Steijling visited Paris. In spite of having said that he would never again have anything to do with her, he was now delighted to have her take a painting on consignment. Van Domselaer, at last in a position to make a down payment for a painting, sent two hundred francs. It was a hand-to-mouth existence, and every bit of income helped. Mondrian hoped that the paintings of flowers he was making for Slijper to try to sell could fetch ten guilders each. He wrote Van Doesburg on December 28 that, finally, after a three-month hiatus, he had begun to paint again. It had taken that long since his move to the rue du Départ "because I hadn't yet arranged the furnishings properly here, and got everything 'clean.' Also because of the Rosenberg let-down. Now things are alright again."

Still, there were problems. The winter had started off with unbearably cold temperatures, and heating the studio was prohibitively expensive. To work in physical discomfort was not possible. "Just shows what a difference there is between an old-time painter and a Neo Plasticist. The former could make his illusion sitting on his foot-warmer out in the cold, whereas we must 'live': life is painting and vice versa."

Mondrian had precise theories on why Neo-Plastic artists could not work

in the cold, whereas figurative ones could. In the past, when he was paint-
ing recognizable subject matter, he had managed in freezing temperatures
so long as he could position his easel right near the stove. Now he needed
overall warmth to be able to move around his entire workspace in order to
navigate freely and gain various vantage points of the paintings themselves
and of the panels he periodically moved on the white walls; he had to be
warm everywhere, not just next to the easel and stove. He also could not be
chilly if his fingers were to have the dexterity necessary to paint the straight
lines and keep the solid rectangles of color precise in form and immaculately
flat. In addition, he was in fragile health, increasingly inclined to the debili-
tating viruses; he needed to be able to pay for coal.

VIII

Mondrian's precarious financial situation became even more of a factor in
February 1922, when he had the chance to take over the Stieltjeses studio as
its main tenant and stop subletting it from them. He would have to come up
with thirteen hundred francs for security and rent, fifty for water, and money
on top of that for window cleaning and a share of the concierge's salary. The
necessity of income put him in a conundrum at this moment when he was
more committed than ever to making purely abstract art exclusively. Léonce
Rosenberg, previously a source of hope that Mondrian could work only as he
wanted, was at risk of bankruptcy.

> Because he doesn't sell enough. Which explains why the poor fellow is
> drawing in more naturalists. Just as well they don't sell either.

Dutch collectors, meanwhile, were urging Mondrian to return to his
"old, beautiful, work." And he was succeeding in selling the flower pieces for
the anticipated ten guilders or a hundred francs each, while accepting orders
for more. He wrote Van Doesburg on February 7:

> Anyway, I don't mind scrabbling around a bit if it means I can carry on
> working. But you will understand that once I am truly convinced that
> working in N.P. will never be feasible financially, I will give up. Then it will
> be time to go olive picking down South. I can earn 12 fr. a day there, which
> is enough to live on. . . . And perhaps you folks will come too, we could
> have some good fun.

Mondrian went on to say that he had succeeded in scraping together
the funds to rent the studio on the rue du Départ directly. Moreover, after

being chronically hungry for the two years on the rue de Coulmiers, where he could only afford to eat in a restaurant with poor food, in the new space he had his own kitchen. This meant that he could "eat far more cheaply now, and better . . . I am already looking much healthier." Van Doesburg had proposed that he, Nelly, and Mondrian live together; Mondrian replied warmly but candidly about why it would not work: "You write about sharing a studio. That would be wonderful and much nicer for me too, but, as you said yourself, no longer a possibility, really, because I have lived all alone for too long."

Mondrian wrote Van Doesburg again on the cusp of his birthday. As usual, he considered his latest work his best to date. "Another *slight* adjustment in the composition. Better." But, liking his recent painting as he did, he was now irritated with Rosenberg.

> Got a card from Rosenberg (who was *supposed* to show me again in April!) with title: . . . et du cubisme vers une renaissance plastique. What does that mean? Surely not vers le Neo Plast., but rather vers une "return"—*a heap of rubbish*. Better still: *a heap of shit*. Your term non-sense is not quite the correct expression! Very nice that La Revue des Lettres is going to publish my article in April after all!

He had rarely been so volatile.

Turning Fifty

I

Well in advance of Mondrian's fiftieth birthday, Sal Slijper had told him that he wanted to organize an exhibition to celebrate the event. Mondrian declined, claiming that Rosenberg had all his good paintings and he did not have enough remaining work to make it worthwhile. Still, when the eighth annual exhibition of the Hollandsche Kunstenaarskring opened at the Stedelijk on Saturday, March 6, it included a small retrospective of Mondrian's work organized by Slijper.

Mondrian was not at the opening; nor did he see the show. He no longer traveled—or so he thought—and would never return to the Netherlands. Yet he was so pleased by what he knew of the installation by Peter Alma that he gave Alma *Composition with Yellow, Red, Black, Blue, and Gray*. Mondrian wrote to Van Doesburg that while "nobody came" to the Stedelijk show, Alma had defended the latest work as "really beautiful." Mondrian made a present of the painting both because Alma "liked it so much" and because Alma had paid "far too much" a few years earlier when he bought a different painting. And he recognized that Alma would never again have money to spend on art because he had married—"for the second time," Mondrian added disparagingly.

The fiftieth birthday had also prompted Alma, Sal Slijper, Willem Steenhoff, Jo Steijling, Simon Maris, and the Stieltjeses to band together to provide Mondrian with his annual rent of fifteen hundred francs. Mondrian, who to date knew nothing of the plan, would receive the sum in four quarterly installments; in return, he would provide a painting that would go into a public museum collection. The self-appointed committee then decided to purchase a painting immediately so that Mondrian could pay his entire rent for the upcoming year in advance. Steijling wrote Oud asking to join them, but there was no point in suggesting the same to Van Doesburg. He would not have made the minimum initial contribution of 2.50 guilders, while most everybody gave more.

They were adamant that Mondrian himself not find out about the intended purchase until it was a sure thing, and their task was even more dif-

ficult because, as Steijling wrote, "We can only ask kindred spirits. He would *certainly* not accept it from others." Peter Alma wrote an almost identical letter to Bremmer. The wheels were turning, but they did not want to give Mondrian false hope, and they were afraid he might refuse to accept their largesse. This meant that he would know nothing of their scheme, if it succeeded, until at least a month after his birthday, but the important thing was not the celebration of the date but his new, secure financial situation.

On April 20, Peter Alma addressed a letter to F. Schmidt-Degener, the new director of the Rijksmuseum. Steenhoff, the deputy director, who was one of Mondrian's support group, had expanded the museum's collections to include a substantial amount of recent art. Alma proposed having the group buy and donate the large 1914 *Tableau III: Composition in Oval*, one of the most beautiful and serene of Mondrian's paintings (see colorplate V). Mondrian desperately needed to sell something of that value, and its going to the Rijksmuseum would have been an honor. Besides, this large canvas, currently with Slijper, had remained unsold in spite of having been considered by several collectors of Mondrian's work.

Alma wrote the museum director, "It is one of his best works and therefore most appropriate for the department of the Rijksmuseum." He explained that it could easily be viewed firsthand, since Slijper lived nearby, in Blaricum. The large painting, imbued with an air of nobility and calm, is painted in subtle colors, mostly pale earth tones and dusty pink, and composed with a completely inventive vocabulary of abstract forms. Most of them are short horizontal and vertical dashes, but a few are curved. A viewer could happily be lost for hours in this graceful painting.

Schmidt-Degener replied to Alma's offer by return mail only to say that the painting would be better suited to the Stedelijk. Alma and his group followed this advice and bought it for the Stedelijk, whose administration received it graciously.

On May 3, Mondrian wrote Slijper that the payment for his canvas from 1914 would enable him "to hold out for another year" at least. The purchase, made so that Mondrian did not spend his fifty-first year destitute, presaged an upturn in his life. In mid-April, Kok visited him and bought two splendid new paintings. One of them, *Composition with Large Red Plane, Bluish Gray, Yellow, Black, and Blue*, while measuring only 21 by 21 inches, is, when we see it in reproduction, an entire world: fiery, but in the way that a happy, high-spirited child is fiery, with boundless energy and playfulness.

Today this glorious composition can be known to most of us only in reproduction. It was sold in a Christie's auction in 1992, and all we now know is that it is in a "private collection" in Monte Carlo, which probably means that it is squirreled away in an art warehouse.

Part of what makes this canvas so exceptional is that it has more bright red dominating it than does anything else Mondrian ever painted. This bold square, which covers half the surface area, seems even larger because of its luminous hue. Suspended in space, it defies the notion of "meaning." *Composition with Large Red Plane* realizes the objectives that drove Mondrian to want to remove melody from music, to reconsider all verbal language, to be unable to tolerate anyone who did not share his strident belief in Neo-Plasticism. Every millimeter of the painting matters only as itself. Mondrian was more strident in his severance from the past than were any of his modernist contemporaries; determined to create and arrive at an entirely different place, and approach to life, than had ever existed before—total newness, a new start rather than a modernized continuation of the old—he had made a vessel of energy that goes beyond signification.

Each black line of this marvelous small painting either ends shy of the edge of the canvas or, by reaching it, does not end at all but appears to go beyond the edge, heading actively into the unknown. That is the beauty of those lines that seem wrapped around the canvas; they are released from knowledge. Mondrian has eradicated the specific and the individual; the idea of a particular place, a previous event, or a single person seminal to art as it had been made for centuries was gone at last.

Mondrian has calibrated and differentiated the widths of each line, giving them their own identities and positions. There is a short horizontal black bar about two-thirds of the way up the left-hand margin of this canvas. An even shorter one is about three-eighths of the way up the narrower right-hand margin. Both are, by only a few millimeters, thicker in their girth than are the verticals with which they intersect. One cannot pinpoint a reason or the precise effect of that minuscule variation in width, yet the measurement was utterly conscious, and is as vital as the fraction of a second that differentiates a gold medal winner from a bronze medal winner in a ski race at the Winter Olympics, or as the variation in timing between notes and intensity of pressure on each key when Glenn Gould played Bach's Goldberg Variations early in his life compared to when he played the same music many years later. This meticulousness based on aesthetic feeling and artistic instinct offers profound pleasure. The yellow in the upper right-hand corner is a tiny but brilliant moment. The blue vertical rectangle in the lower right is equally vital to both the perpetual movement—that nondirectional action that was so essential to Mondrian—and to the work's spirit. What looks like an ebony piano key on the bottom toward the left also has an impact. Yet this composition is about nothing we know; it is itself. This is what Mondrian meant art to be, what he lived for at every moment: the other. The compositions Mondrian was making as he was turning fifty transport us outside of time.

II

Mondrian began to sport a most unnatural mustache. He shaved meticulously except for this perfectly squared thick black dash above his upper lip. There was not a strand out of place in his slicked-back hair. Even the human head could submit to his control and be a vehicle for ruler-straight lines.

The mustache represented a midlife identity shift. The tangled full beard of his hard-core Theosophy days was a thing of the past; rationalism and order now reigned. And he was suddenly prosperous. The purchase by his band of supporters of the large painting for the Stedelijk was followed by further sales. In May, Helene Kröller-Müller bought *Composition with Blue, Red, Yellow, and Black* when the paint was scarcely dry. Slijper had advised her to do so, but the collector needed some persuading. Jet Blommers, the daughter of B. J. Blommers, a well-known painter of the previous generation, had made it her task to convince the collector to go through with the purchase. Blommers was another new devotee of Mondrian's work, and a friend of Kröller-Müller's. Living in Blaricum, she was one of those people who, once converted to his recent abstractions, were eager to see Mondrian encouraged to continue in the same vein. Cognizant that he needed, emotionally as well as financially, to sell this new painting, she had successfully coaxed the collector.

Nothing had ever existed before like this recent canvas purchased by Kröller-Müller. It relates to Mondrian's work of the previous months, but its composition is unprecedented. We are drawn first to a slim and jaunty vertical yellow rectangle that tries to hug the right edge but is separated from it by a narrow black border. This black framework to the right of the yellow

Shown here c. 1922,
Mondrian periodically tried
a mustache that was like a
short straight line.

rectangle is slimmer than the line to the left, and while the yellow is firmly held, like a windowpane supported by lead mullions, the blue on the upper left runs off the canvas on top and to the left, and the narrow red band at the upper right, really just a slight sliver of color, also floats heavenward and into the void on the right. One white is ever so slightly yellowish, another grayer. If we are able to let go of previous knowledge and conceptions just as Mondrian let go, we see no resemblances; and we become weightless like the elements of the painting. Physicality is absent, and there is no emotional representation. All knowledge, all information, all theory is secondary to the sheer marvel of this painting.

The thirteen compositions that Mondrian made and completed in this fertile period following his fiftieth birthday have in common that they all have one dominant white form which is square or almost square, with the other elements all tucked into narrow bands on the sides. The jump in scale between the single large unit which reads as a void and the many smaller pieces of solid, bright color is courageous. Mondrian's spirits were clearly revived.

He turned his manic energy entirely to writing. The essay he was doing for *De Stijl* obsessed him to the extent that he stopped painting and did nothing but work on it.

> I have been working on it all week, evenings also, I couldn't stop. I have put it before our idea about letting "Art" come "to an end"!! and making the future and what went before become part of the realization around us. That must now be prepared and initiated in Architecture.

He wrote this to Van Doesburg, the one person he counted on to understand his fanaticism. Mondrian was going full tilt, funneling all his emotions into the aesthetic and moving beyond all of the traditional impositions of "art." The new art was to shatter all notions of balance and proportion and pictorial order going back to ancient Greece. He wrote that his essay "fits in beautifully with Futurists and Dadas (destroyers of art). It's a lot of work, I still have to correct it and polish it." He assured Van Doesburg it would be ready "in a few weeks time."

III

In order to paint and write well, Mondrian needed to breathe easily and think clearly. His requirements in life were few, but control of his sinus infections was among them. Whatever else was going on that spring, with an article at

last published in French and some of his work at Rosenberg's gallery, he still had to unclog his nasal passages.

On a Tuesday evening he wrote "Dear Does and 'Petro'"—a nickname he sometimes used for Nelly, both being derivatives of her given name, Petronella:

> Recently I was just thinking about your susceptibility to hay fever, I do hope that you will get through it better than last year. Isn't it something specific for Holland? I guess not, just like the love for the old and the natural. Fortunately this can not affect you! I also think it is a pity that you're not here for the movement as you might have been possible to do more now. Also in other countries I don't see much coming of "the" new, but in any case you now have been able to do everything you could. I believe that at least at the moment, there is not much to do.

In a single paragraph, Mondrian had directly connected the nuances of hay fever with the horrors of antiquated representational art, and concluded with the need to promulgate the new movement of pure abstraction. In Mondrian's mind, the natural world brought discomfort and suffering. Only through abstraction could one find health. It was all combined in his mind: issues of his solitary existence, his sense of abstraction as his cause in life, his belief that anyone who was not a proponent of that cause was the enemy.

On May 25, Mondrian wrote the Doesburgs:

> It is Ascension Day—nice warm weather (life seems even more intense in warm weather). Just as well I have that small room: it's cool there, the studio gets unbearably hot in the afternoon. Last night I could only sleep with the window wide open; between 11 and 1 the noise of the trains is simply hellish. But with the window closed I had nightmares! So you can see that sharing this space is practically impossible, as you already mentioned. If all three had to share this small room it would also get too hot. But I am very alone here now. I still have *nobody* here.

The women he had met as dancing partners did not make up for his feeling of solitude.

> I got to know two Russian Jewish girls, raised in Holland. One aged 21 and one 16. So the age is alright, but Jews always have something off-putting. They are good dancers so I dance with them from time to time. They pay for themselves—if they were French I would have to pay

their expenses. For the rest I am stuck at home. It's a bore not having friends here. It's all due to my work—i.e. that I am *this way* and not like other people.

Of the acquisition by his circle of supporters of that painting for the Stedelijk, he reported on "the purchase for 1500 of a canvas of '14. It was offered to the Rijksmuseum but refused! Damned nincompoops!" But it was not only the traditionalists who were his foes; most other modernists did not satisfy him. Mondrian believed that his views were too extreme even for Le Corbusier and the other founders of *L'Esprit Nouveau;* similarly, the artists and designers at the Bauhaus, while admirable, were in essence too hidebound. "I also think what those folks maintain is very interesting but don't forget that the whole gang including Kandinsky haven't found a solution: that they are, in reality, also hostile to us and to—our solution."

The year 1922 was an extraordinary one in human history, yet Mondrian considered his and Van Doesburg's approach to art a more radical rupture from the past than the other revolutions. This was when the USSR was formed in the aftermath of the Russian Revolution, and a civil war broke out in Ireland over the issue of its rule by the United Kingdom. In India, Gandhi was imprisoned; in the United States, nearly half a million railway workers walked off their jobs in a strike. The life-changing diabetes drug, insulin, was successfully used for the first time; the tomb of Tutankhamen was discovered in Egypt. In Italy, Benito Mussolini came to power; in London, a new concrete tennis stadium opened at Wimbledon. Nearer by, in France, Louis Pasteur and Pierre and Marie Curie and Henri Poincaré and Jean-Martin Charcot were making exciting breakthroughs in medicine, physics, mathematics, and psychopathology. Paul Verlaine and Stéphane Mallarmé were expanding the nature of poetry; the latest music of Jules Massenet, Georges Bizet, Camille Saint-Saëns, Claude Debussy, and Maurice Ravel was delighting large audiences with its Neo-Romanticism for the first three and brave experimentation of the last two. Marcel Proust died following the publication of *Sodom and Gomorrah,* the last volume of *Remembrance of Things Past* to appear during his lifetime. André Gide and Colette were publishing great novels. Surrealism was transforming the nature of painting. Mondrian considered himself remote from all such revolutionary forms of progress except for Dada and recent breakthroughs in American jazz music. He made a point of being unaffected by anything that did not relate directly to Neo-Plasticism, which was the only thing that mattered to him.

On a Monday evening later that August, Mondrian wrote Oud a letter that he considered his final communication with a former ally who had not taken Neo-Plasticism far enough. Using only the initials "NP" for Neo-

Plasticism, he focused on Oud's text for a small-circulation Dutch architecture magazine, *Bouwkunst*, as the decisive blow to what had been a close friendship.

This difference would not have caused estrangement if you, as you now write, had not found it necessary to oppose N.P. in Bouwkunst, which I do not understand given that everything you advocate as innovation is N.P. Now you even write that you have no expectations of N.P. aiming itself at space, so then all collaboration is out of the question, which I deeply regret, and I did my best to make it clear to you that what I mean is possible in future: for the present there is little to be done, also due to the divergences in attitudes, and so on. . . . I am very sorry, because, as a threesome, you, Van Doesburg, and I might have been able to achieve something. Now that you openly accuse Van Doesburg of being a provincial Cubist (as you wrote me) I am obliged to take that seriously, even if you say you make a distinction between him and me and are not against my work.* I do not doubt that you appreciate my work but you must understand that my work encompasses more than just *making things*: there is far more involved, and Van Doesburg's action is part of it, too. No need for me to go into this at more length, because you as a former Stijl contributor already know. Due to your altered stance on my ideas you yourself have broken the bond we had of views ostensibly shared or temporarily parallel, and hence our friendship, because pure (the deepest) friendship does not exist separately as a loose thing. If you keep missing the point and can't see my relationship with Does in terms of collaborating towards a shared goal and so on, I am not so sure that it is as truthful and sincere on your part as you seem to believe.

So each of us will go our separate ways —

Best regards also to Annie from Piet.

Better not write about this, time will tell to what degree you were my friend.

I don't understand how you arrive at the traditional idea of separating architecture from painting! Or of separating the person from the idea.

Would you please send the small damaged canvas by Cabos as a postal parcel to Miss Steijling in Laren, then I will get it in due course.

*Even if you do not consider his work beautiful, you should still respect what he advocates.

The break with Oud was the culmination of his mental discombobulation after his fiftieth birthday. It was as if he had vanquished his enemies and, having defined himself in relation to all that he was not, achieved some sort

of reprieve that allowed him to simmer down. By the end of the summer of 1922, Mondrian entered one of his periods when he was liberated from his demons. Enjoying the strength that can come when one feels one's own resilience, he was now making abstract constructions as nimble and sure-footed as he was.

IV

Nonetheless, in the entire year of 1923, Mondrian completed only two abstract compositions, and one of them has been lost.

The one he painted first—*Tableau with Yellow, Black, Blue, Red, and Gray*, a 21-inch-square canvas, which remains—is superb. But it is more the conclusion of the 1922 series than anything else. The painting has fantastic rhythm and motion; its forms and colors jump up and down with even greater élan than in the previous work. This little dynamo makes a brilliant ending to the series.

The single abstract painting which Mondrian took the rest of the year to complete is known only from photographs. It was a large vertical composition, apparently about three feet high, more unbalanced and arrhythmic than anything Mondrian had ever done before. That scale, unprecedented in Mondrian's abstract work, is easy to calculate from a photo in which Mondrian, looking like an orchestra conductor posing awkwardly for the camera, turning away from the canvas and staring at the camera suspiciously, stands in front of it, while Nelly van Doesburg, with bobbed hair, looks at him, tenderly, from the other side of the room.

The work was a radical departure in being so deliberately unharmonious and large. Mondrian was on an inventive upswing. A positive vertical line, to the right of center, almost but not quite as tall as the sides, nearly but not quite touching the top and bottom, dominates, with all the smaller elements to the left and right of it formed and positioned in relation to it. A little light vertical slit in one of the dark horizontal bands is one of the many beguiling small notes in this offbeat and fascinating painting.

We will, however, probably never know the colors of this breakthrough composition. Having been sold to a private collector in Germany, and then periodically exhibited in the Kabinett der Abstrakten in Hannover, the painting was in 1937 seized as degenerate by the National Socialists. One can only hope that it was not destroyed and will somehow resurface. But with the passage of time, the chances of its reappearing in the plundered collection of a Nazi with a rare connoisseurship for illicit modernism are slim.

In this photo from 1923, Mondrian and Nelly van Doesburg fit perfectly within the geometry of the setting. The painting on the easel is the 1923 *Composition with Yellow, Cinnabar, Black, Blue, and Various Gray and White Tones*, which was seized in 1937 for being "degenerate."

Meanwhile, Mondrian needed to survive. By the start of 1923, he was again in the business of painting flowers, and Sal Slijper was brokering their sales. Slijper had no trouble finding buyers for them back in the Netherlands. Mondrian wrote Slijper on January 25 that he had raised the price of the small watercolors of individual blossoms to twenty-five guilders "because the flowers are getting better than I dared hope." He was "putting a lot more work into them" than he had with his earlier flowers, and considered the results to be more fully realized artworks.

He now painted over twenty highly articulate, graceful watercolors of single dahlias, amaryllis, chrysanthemums, marigolds, and roses. The small watercolors—usually about 9 inches high and 7 to 8 inches wide—from this period are more refined, more elegant, and more ethereal than the flowers he had been making in 1907–8. In a marigold in a glass, Mondrian plays subtly with the geometry of the petals. When he angles one out to the right and curls another, which is next to it, downward, it gives the blossom a rhythmic motion. He juxtaposes a bright white to a slightly grayer one for further gyration. An actual flower, or one of the sort painted in traditional still lifes, like those of Henri de Fantin-Latour, has none of this whirlwind energy. Mondrian gives it full-speed motion that he freezes in place.

Almost all his flowers from this period are just a few hours beyond the moment of perfect full blooming. The blossoms are in their final robustness. Yet while they are on their way out, they have none of the melancholy of

the flowers Mondrian had painted previously. The theatrical weeping of the tragic lilies Mondrian had painted in Amsterdam belongs to the past. Now the blossoms perch on straight stems centered in front of their stage sets of healthy leaves. These flowers are approaching the end of their lives, but they will remain at this stage, dying forever.

Mondrian painted *Blue Chrysanthemum* during that brief but necessary return to flower painting in the early 1920s. Because it is now owned by the Guggenheim Museum in New York, this glorious painting is among the artist's masterpieces accessible to many of us. Seemingly retrograde, it has surprising similarities to the nonrepresentational compositions which it was painted to fund. Mondrian has orchestrated its matte whites and pale, almost icy blues in the same fashion that he subtly differentiates the grayish whites in the backgrounds of his pure abstractions. The single flower, which Mondrian presents with the microscopic exactitude of the biological drawings he made for Dr. Van Calcar, is animated with extraordinary power. Mondrian gave it the plenitude, the motion, the precision, and the assuredness of his nonrepresentational art.

Mondrian painted flowers in a way that renders them eternal. These are all flowers in all of time. When he accentuates "the tragic" of certain roses and marigolds with the wilting petals that indicate their impeding deaths, it is not a private, individual "tragic" of the sort he eschewed, but the universal cycle of life that he was resolutely committed to evoke.

V

An exhibition of De Stijl architecture opened at Léonce Rosenberg's Galerie L'Effort Moderne on October 15. It showed maquettes and elevation drawings by, among others, Huszár, Oud, Gerrit Rietveld, Mies van der Rohe, and Van Doesburg himself.

It was clear to Van Doesburg that the exhibition was the impetus that "spurred Mondrian to start working again." For one thing, Mondrian began to design an entire Neo-Plastic room. The floors, walls, and even the ceiling were to be composed mainly of vertical and horizontal lines and rectangles of vibrant color. The occupant of such a room would be encased in pure abstraction. There would be no furniture; existence would consist of nothing but the person in the room, the air surrounding him or her, and this entire world—visually alive, rhythmic, colorful, and clear—that referred to no actual subject. Concurrent with his starting to create this space in all its totality, Mondrian began to compose a large *Lozenge*. He would only complete it the following year, and repaint it a year later, but the moment

he got going, he was reborn. Additionally, he started "writing again with zeal."

Just after seeing the exhibition that presented pure geometry as it was manifest in painting, architecture, and other areas of design, Mondrian wrote an essay which he called "Setting One's Sail According to the Wind." In it, he asked how an abstract artist could survive in a world where people clung to tradition although it was impossible to manage economically while eschewing representation. Mondrian was convinced that the choice was either to adapt to the norm, mired in the old way of doing things and giving up one's preferred direction, or to satisfy popular taste on one hand (for example by doing flower paintings) while simultaneously being true to pure abstraction as time and money allowed.

When the article appeared in *De Stijl* at the start of 1924, Van Doesburg annotated it as being "Beyond the responsibility of the editor. TH.V.D." It was the last time that anything written by Mondrian would appear in the magazine or that any of his art be reproduced in its pages. But at least by then Mondrian was on an upswing. Having recently considered abandoning painting completely, the exhibition in Rosenberg's gallery in October changed his mood. Mondrian had again become convinced that he might manage to do nothing but abstraction, and that there were people in the world who would support it. In November, Count Wilhelm Kielmansegg, a

László Moholy-Nagy, who took these photographs of the view from the rue du Départ in 1927, was one of the many people at the Bauhaus who admired Mondrian and his art.

twenty-seven-year-old German nobleman who lived in Weimar, where the Bauhaus had been formed four years earlier, bought two works Mondrian had painted during his latest burst of creativity preceding the slump that had now lasted for nearly two years. One of them—*Tableau N°1 with Black, Red, Yellow, Blue, and Light Blue*—was to be reproduced as a lithograph by the Bauhaus print workshop.

With its judicious deployment of only a few forms, and its rigorous adherence to strict verticality and horizontality and flat coloring, that work attracted not only painters but weavers, glass artists, and craftspeople of every sort at the Bauhaus. El Lissitzky and László Moholy-Nagy, two of the leading avant-garde artists at the school in Weimar, the former Russian and the latter Hungarian, both of them highly adventurous and experimental in their work, saw more of Mondrian's paintings in the Grosse Berliner Kunstausstellung that fall. They were enthusiastic. Lissitzky and Moholy-Nagy had a very different sensibility from Mondrian's and were less refined and more visually complex in their own work, but for those very reasons, as well as their high position in modernist circles internationally, their fervent interest pleased Mondrian enormously. The friend who generously told Mondrian about this was Oud, the person who had been totally on the outs a year earlier but who now, with Mondrian's characteristic seesaw swing, was an insider again.

VI

In May 1924, Van Doesburg wrote a letter to Moholy-Nagy specifically to distance himself from accusations people were making against the Bauhaus. The school's detractors wrote a document called the "Yellow Brochure" which accused the Bauhaus of being pro-Bolshevist and anti-German. Walter Gropius wrote Mondrian asking him to issue a similar statement in defense of the school. Gropius's request reflected Mondrian's international standing and his position as an authoritative spokesman for what was important in modernism. Mondrian's reputation was enhanced by a recent article, "Piet Mondrian, the Pioneer," which appeared in two parts in *Wil en Weg*. This important Dutch magazine, which came out in May, had a laudatory text by Herman Hana. Hana allowed that Mondrian's latest work was difficult to understand, but that was often the case with great artists who are ahead of their time, and that Mondrian was "a pioneer worth paying attention to."

When Mondrian wrote in defense of the Bauhaus, he did so in German. The letter was a rarity in his life. He did not usually rally for a cause that was not specifically his own. But Mondrian was aghast at the contents of the

"Yellow Brochure." And whatever his differences were from Van Doesburg, he wanted to be supportive in decrying the attack on the Bauhaus.

Paris, 20 May '24. Rue du Départ 26. The directors of Bauhaus Weimar.
Dear Gentlemen, It is important to me to share with you that the disputes against the Bauhaus are near and dear to my heart, and I would like to give my opinion by saying that I completely agree with what Mister Th. Van Doesburg has already written to you. Yours sincerely, P. Mondrian.

But soon enough, the animosity between Van Doesburg and Mondrian was on again. That summer of 1924, Van Doesburg began to work with slanted lines. He declared himself liberated; he was no longer dominated by the oppression of the grid with its imposition of exclusive verticality and horizontality. To Mondrian, this was treason.

In August, Mondrian decided that it was no longer sufficient to avoid Van Doesburg and denigrate him to others; it was time to declare to Van Doesburg directly that the breakup was irrevocable. Not long ago, Van Doesburg had been the closest colleague and soulmate Mondrian had ever had. Mondrian had considered the mastermind of the De Stijl movement his partner in their messianic mission to transform all art and architecture. For five years following the end of World War I, they had shared the goals of providing humankind with unprecedented equanimity through the visible. Now Mondrian informed Van Doesburg and Nelly that if by chance they were in the same place at the same time, neither of them should expect so much as a "hello" from him.

VII

At the end of 1924, Mondrian believed he had completed a single painting, a diamond-shaped one which he called *Lozenge Composition*. We have a black-and-white photo of this painting taken when he considered it finished. But in the first five months of 1925, he continued to change the thickness of the lines and the deployment of color in various positions. Then he deemed it satisfactory for a second time.

The canvas, which hangs today in Washington, D.C., at the National Gallery of Art, radiates optimism. A red triangle on the upper left relishes a jaunty face-off with a blue one of nearly the same size on the lower right, whereas a smaller, more intense yellow, sparkling and vibrant, chimes in from the lower left. That three-sided red form at the top is like a neon arrow pointing heavenward, while its small blue and yellow counterparts near the

bottom are audible, like birdsongs. The black lines of different thickness move like a piston, and the brilliant white square interacting with its paler white neighbors creates nonstop rhythm. With the esprit and confidence and playfulness of Fred Astaire executing a tap dance, *Lozenge Composition* performs impeccably.

The interior subdivision has us thinking that the left-hand corner of the canvas is higher than the right, even though we know this is not true, and that the top and bottom points of the square mounted as a diamond align perfectly. It is an impossible fiction.

A closely related diamond painting, *Lozenge Composition with Red, Black, Blue, and Yellow*, also completed in 1925, is in a private collection. It has an unusual history. As soon as the canvas was dry, Mondrian sent it to a show in Amsterdam. On June 2, however, Mondrian wrote Oud that he hoped the architect had not bothered to go see it there. "I heard they dropped a box on it." It was not fit to be exhibited. "It's a long time since something upset and annoyed me so much. . . . Fatal, wasn't it? My best work, of all things."

To Slijper he called it "my latest and best canvas" and complained, "Those workmen are worthless. . . . You will understand, Sal, that I was very miserable about it, my best canvas gone to the dogs."

Mondrian was all the more miserable because initially he believed that the insurance for the transport company would provide compensation for the lost value of a painting too damaged to sell. Mondrian considered it unrepairable. All that the insurer would pay was a hundred francs for restoration that the artist was sure would be futile. Still, the money was sufficient to pay for relining, which Mondrian organized. After that, he was able to retouch it himself effectively. A year later, Mondrian "painted it again, so that it is now still better." Mondrian vacillated as usual. Despondent over the sloppy transporters' destruction of his masterpiece in June, he ended up seeing the physical damage to this treasure as a catalyst for improvement. What had been initially great, then lost "forever," would eventually be elevated into something even more transcendent than it had been at the start.

VIII

Paul Sanders was another of Mondrian's male friends who was significantly younger than him. Mondrian was forty-five, Sanders twenty-five, when they had first met during Mondrian's time back in the Netherlands during the war. They were in Laren, and Slijper introduced them. Paul Sanders would recall:

Paul F. Sanders, c. 1929.
A music critic and composer, twenty
years younger than Mondrian, Sanders
urged his brother to buy a painting at
a time when Mondrian needed a sale
to survive. Mondrian was ultimately
so grateful that he gave the collector
a second painting as well.

We had sat together for a while over coffee, chatting about this and that, when Piet suggested taking a stroll. Slijper preferred to stay behind, and the stroll turned into a walk lasting several hours, back and forth between Blaricum and Laren along the Torenlaan, at that time still a country road with few buildings and hardly any traffic aside from the old steam tram linking the various towns and villages of the Gooi region.

It was almost the identical scenario to what had happened when Jakob van Domselaer took a long walk with Mondrian on the road between Laren and Blaricum, and Mondrian talked nonstop about abstraction, while Van Domselaer did nothing but listen. This time with Sanders, Mondrian elicited information, ironically about Van Domselaer.

Sanders continues:

Once we were on our way I didn't know how to begin. So we walked side by side without speaking, until Piet broke the silence with a question I found surprising: what did I think of Jacob van Domselaer, a solitary figure among the emerging Dutch composers at that time, who was better known among visual artists and architects than among musicians. I got to know his work at one of the performances he used to give for small audiences at the studio of one of his artist friends. I was not much impressed, found it monotonous and mired in a kind of experi-

mentation that was only partly successful, and in my opinion lagging far behind the new music of Busoni and Schoenberg that I had heard in Berlin.

It took a while to dawn on me that it wasn't so much Van Domse-laer that Piet was interested in, but that he was trying to get me to talk. Once I realized that, I poured my heart out about everything that had moved me in Berlin. He listened to my flood of words without trying to stop me. Now and then a smile passed over his face, but I had the impression that I had roused his sympathy and interest, also and espe-cially because of my eagerness to find out about the whys and where-fores of the many art movements coming to the fore in that momentous period between the end of the last century and the beginning of this one.

Mondrian and Paul Sanders had stayed in touch ever since that first encounter in 1917. Now, in 1925, Sanders, who had become the music critic for *Het Volk*, moved to Paris for a year. His family funded his doing this so that he could work on his own composing without pay. Sanders took a room in a small hotel at the corner of the avenue de l'Observatoire and boulevard du Montparnasse. He would see Mondrian regularly, either in Mondrian's studio on the rue du Départ or at the Café du Dôme. The meetings were always to suit Mondrian's schedule, but Sanders, two decades younger than the painter he admired, did not mind.

One March afternoon, Sanders, visiting the rue du Départ and expecting to find Mondrian working on multiple paintings, discovered that the artist had a high fever and had been lying in bed too ill to go anywhere for several days. No one else knew about it.

Sanders started to visit him every day, bringing food and medicine, until Mondrian sweated out the fever and regained his strength.

Once Mondrian recovered, for the next week he and Sanders went to the park every day and found a spot where they could sit in the warm sun. Sanders's descriptions of these outings to the Jardin du Luxembourg echo Mondrian's conversations with Albert van den Briel just after he arrived in Brabant in 1903. The two men spoke intensely while basking in the sunshine.

We were talking about the fact that the radio stations were broadcasting more and more music. Mostly they used gramophone records for this, but had also started transmitting music directly from the concert hall into the living room. "Do you realize what this means for music?" Piet said,

with a degree of excitement in his voice that I was not used to hearing. "It means a whole new era for music, which you musicians will have to find some way of adjusting to as soon as possible."

He had read about the ether-waves instrument demonstrated by Theremin. It was quite possible, he argued, that this was only the early beginning of something new, or even that the starting-point was wrong, but that it proved nonetheless that it would not be long before a different type of instrument would be developed to cater to the microphone technology, and not the other way round.

"What a blessing for the composer," he said, "to be able to liberate himself at last from the intermediaries he has always depended on for the transposition of his notations into living sounds. For the composer it is now time to explore the field of electronic acoustics. What could be more fascinating than to perform your own compositions on an instrument of your own making?"

The young Soviet physicist Lev Sergeyevich Termen—in the West he would be known as Leon Theremin—had developed his "ether-waves instrument" as a proximity sensor for the Soviets. With the same technology that detected nearness of other people, the device also created unprecedented sounds. Mondrian was fascinated.

The theremin looked very much like a modern modem with two antennas, and functioned without its operator needing to touch it. In colorful theatrical performances that had already enchanted audiences all over Europe, the operator controlled volume by moving his left hand nearer to or farther from the antenna on the left, which was vertical and straight, and his right hand above and below the antenna on the right, which extended horizontally and was bent into an ovoid form. The performer—initially Theremin himself—resembled a mad magician, vibrating his open hands while making larger, more sweeping moves with them. The sound produced was a bit like a chorus of soprano voices humming.

Mondrian approved wholeheartedly. The theremin was entirely of its own time, without ancestry. It established a sense of impersonality and distance. Mondrian was not in favor of the use of the Theramin to play well-known melodies, melodramatically, introducing the very "tragic" that he so assiduously eschewed in his own work, but when it was employed to produce sounds independent of tune and absent emotional impact, he considered it a marvelous leap toward audible art that would achieve his dreams for Neo-Plasticism. He extolled this manifestation of human progress.

IX

Mondrian wanted to invite Sanders for dinner, but said that he needed to wait until he could afford a pan for frying potatoes. Sanders offered to buy him one, but Mondrian refused, finally consenting on the condition that it was not too expensive. They went to the BHV department store. Mondrian thrilled to the quality of the stainless-steel knives, and Sanders treated him to a couple of those as well. On his two-burner stove in the alcove that served as a modest kitchen on the rue du Départ, Mondrian prepared a meal that Sanders deemed "fit for the gods." But Sanders was aware that Mondrian's desperate financial straits had worsened because of his inability to work during his long illness and recovery. The situation prompted Paul Sanders to write to his brother Martijn, a successful businessman, and ask him if he would buy a painting by the indigent artist.

His reply was that I could buy a Mondrian for him, seeing as I was so full of admiration for the work. I could spend three or four thousand guilders on his behalf.

I will never forget Piet's face when I showed him that letter. He read it again and again, held his chin and tilted his head, which he often did

In the company of his great supporters Paul Sanders (left), Jacques and Frieda Tas, and, on the right, Georges Vantongerloo and his wife, Tine, Mondrian appears to be the least relaxed of the group, 1925.

when pensive, meanwhile staring at me over his spectacles in disbelief. . . . Suddenly he said—and I have never forgotten those words: "But Paul, you can't expect me to sell a canvas for that price! I have never done that before. Your friend's offer is far too high. I will have to give him two canvases for it."

Mondrian prevailed, happily sending two new compositions to his savior.

All the World's a Stage

In the fall of 1925, when he refurbished his studio for a second time, Mondrian had the idea of designing interiors for other people. Painting the large studio and its ancillary spaces a flawless white, hanging the panels and making a few simple pieces of furniture in addition to the sofa and tables whose colors had to be redone, Mondrian had no time to get near his compositions on canvas. This was not a frustration; it suited his goal of making everything of a piece, of eliminating the need for "art" in the old sense of the word. He was not interested in seeing his paintings go off to private collections where they would hang on paneled walls over marquetry tables; he wanted coherence in the visual surroundings. His paintings were simply part of the environment, not precious objects. There was no hierarchy.

His ideal for living and working places ruled out the function of architects. The environment needs to be pure abstract art inside, made by a painter, with its exterior appearance of no importance. The overall structure could be constructed by a building contractor who understood function; nothing else mattered. Mondrian felt that people should abolish the old-fashioned ideas of home. Public and commercial spaces could be made without the usual preconceptions; expectations of how human beings should conduct their lives had to be abandoned entirely.

Modernist design, like Le Corbusier's and Mies van der Rohe's, was at heart too traditional for Mondrian. The organization of the interior should depend solely on aesthetic feeling, the same force that motivates a jazz trumpeter when he simply lets himself go. "If we start from technical, utilitarian demands, etc., we compromise every chance of success, for intellect then clouds intuition." Mondrian wrote this in his essay "The Neo-Plastic Architecture of the Future" for the magazine *L'Architecture Vivante*. "The new beauty is created by *equilibrated relationships* of perpendicular lines and planes . . . something entirely different from the equilibrium of traditional aesthetic. Neo-Plastic harmony arises from *constant opposition*." That standoff is not just between lines; it is also between colors. Color, Mondrian adds, will not be "merely 'accessory.' Color will be integral to the architecture

itself." The result of all of these oppositions is "not traditional harmony, but *universal* harmony, which to the eyes of the past appears rather as discord."

Mondrian was determined to go beyond "the perspective vision of the past." He writes, *"The new (abstract) vision does not start from a single given point, but takes its viewpoint everywhere, from no fixed place. It assumes independence of time and place* [emphasis added]."

Mondrian took life to a new sphere, without any of the habits of any established form of human culture. No Victorianism! No puritanism! No Calvinism! Life should be spared their weighty intrusions. Mondrian replaced the appearance of life with unprecedented sights and, in so doing, liberated all human beings. His new universe required color: "without which the plane cannot be *living reality.*" Color was equally necessary to annihilate the natural appearance of materials. With "pure, planar, determined, primary, and basic (red, yellow, blue) . . . in opposition with 'noncolors' (white, black, gray)," the plane becomes *"living reality."* We are rewarded with a new form of life. The much cherished "equilibrated relationship" will be achieved by minimal amounts of those three primary hues in conjunction with greater amounts of noncolors. Now "there is no need to fear confusion from an excess of color."

This was what Mondrian craved: to stop fear, to eradicate confusion, to obliterate dogma, and end the trauma of emotion. Their absence was essential to personal liberation. In his own way of life, and in the art he made, Mondrian achieved all of that to an extraordinary degree. His dream was for other people to undo their shackles and enjoy the same freedom he had found for himself.

II

On December 3, 1925, two days after the show provocatively called the *Art d'Aujourd'hui* had opened, Le Vicomte de Noailles, then thirty-five years old, walked in and bought on the spot Mondrian's *Tableau N°2 with Black and Gray.*

Charles de Noailles was the quintessential gentleman. The epitome of quiet class, he was one of those people who bowed to no else's taste but was modest and unassuming in demeanor. Personally graceful in his every gesture, he had manners that made everyone who met him comfortable. His wife, Marie-Laure, heiress to an American fortune, was the one with the money, as well as a passion for being outrageous. She had portraits done of her by Salvador Dalí and Picasso, in addition to a large canvas for which the painter Balthus got her to leave her lavish mansion on the place des États-Unis to go to his simple walk-up studio on the Cour de Rohan, wearing

a dark suit that makes her look like a prison matron instead of one of her usual ball gowns. The viscount was less conspicuous. But, in his quiet way, his acquiring that Mondrian monochromatic abstraction two days after the *Art d'Aujourd'hui* exhibition opened was as audacious as his having bought a Paul Klee the year before. Charles de Noailles would be the first French collector ever to purchase a Mondrian during the artist's lifetime. No French museums did so.

The viscount bought his Mondrian as easily as he selected a fedora at his hatmaker's. He had perfect taste and did not question his own choices. But to others in his social set, the abstract canvas by Mondrian marked the edge of insanity. Their outrage made no difference whatsoever to him. A few years later, he would, similarly, fund the creation of *L'Âge d'Or*, a radically experimental film made by Salvador Dalí and Luis Buñuel, with its "few blasphemy scenes" made "with the utmost fanaticism to achieve the grandeur of a true and authentic sacrilege." For that, Charles de Noailles would be threatened with excommunication from the Catholic Church and would be thrown out of the Jockey Club. He withstood public disapproval with the same insouciance that enabled him to buy his Mondrian.

In their town house in Paris, the De Noailles had masterpieces by Delacroix, Watteau, and Goya. But they had just finished building a modernist villa in Hyères, designed by Robert Mallet-Stevens. The austere and minimalistic *Tableau N°2 with Black and Gray* was the second work to go into the new house, the first having been the Klee. Within the next decade, the collection in which the Mondrian was one of the seed works would come to include sculptures by Brancusi and Giacometti and paintings by Miró, Picasso, and Braque.

The only "colors" of this elegant small canvas—not quite 20 by 20 inches—are a jet black, a cool pale gray, and a single white. Mondrian used the black for the sole vertical line and the two horizontals, all three of equal width. He also employed that rich black for a long and thin expanse that repeats the width of the lines, at the bottom of the canvas, underneath the lower horizontal, and for the horizontal rectangle in the upper right-hand corner. The pale gray rises and descends—alternately or simultaneously, depending on the individual viewer's perception—as a vertical rectangle on the right-hand side of the composition. It also appears separated from that gray expanse by the lower horizontal line, in a peekaboo form directly underneath the gray.

"Joie de vivre"—the term Mondrian uses in his writing—pervades. The canvas never catches its breath, but it is never out of breath. Excitement persists because of the impeccable sense of measure which puts the painting in perpetual movement. Beyond that, this was a case of the artwork and the

space merging, with the painting an element in a unified space rather than a masterpiece on the wall. Even though Mondrian did not actually go to Hyères, he knew that his ideal was feasible.

III

In January 1926, Friedrich Bienert, son of the Dresden art collector Ida Bienert, purchased *Tableau N°1*, another painting by Mondrian that had been in the *Art d'Aujourd'hui* exhibition. After it had failed to sell during the show, Mondrian had sent it to Dresden, where Bienert acquired it to install it in the dance studio of his wife, Gret Palucca.

Margarethe Palucca was one of the many modernists who shortened her name so as to replace what was flowery and old-fashioned with something snappier. A twenty-four-year-old German/Hungarian Jewish dancer, she had studied with Mary Wigman—whose real name was Karoline Sofie Marie Wiegmann—one of the inventors of expressionist dance. Wigman, immensely influential both as a teacher and a dancer in the modern movement, performed either without any music whatsoever or with percussion alone. She and her disciples danced barefoot, the absence of the usual pointe shoes adding to the existential force of this breakthrough style of movement.

Following their marriage in 1924, Friedrich Bienert bought his bride a large building for her to convert into a dance school that she intended to rival Mary Wigman's. Palucca, with her animated dance technique, was at the forefront of modernism; she had performed for Kandinsky at the Bauhaus and been painted by Ernst Ludwig Kirchner. To have a recent painting by Mondrian to inspire her dancers in their workspace was a further coup.

The composition of the painting that hung in a rehearsal studio is even simpler in layout than the canvas the viscount de Noailles had recently bought. A thirty-one-inch square, it is divided solely with two vertical lines and one horizontal, a single open white space dominating. But here the square is turned forty-five degrees from the traditional orientation so that it rests on a pointed corner as a diamond.

And whereas the canvas that went into a new Mallet-Stevens villa overlooking the sea was monochrome, albeit with strongly contrasting white, light gray, and pure lead black, in the Bienert painting the white and gray are more akin to one another and a different form of life is created by two triangular forms, one a vibrant yellow that sparkles at the lower right edge of the canvas, the other a rich dark blue at the top.

Mondrian had calibrated every measurement for maximum impact. In the painting that hung in a dance studio, the shorter, truncated vertical, way to the left, is thicker than the lithe and tall one on the right which is nearer

to the center, its position within the ascending and descending boundaries of the diamond putting its base and ceiling at greater distance from one another. The horizontal is the perfect counterpart of that longer vertical. That female horizontal line has the same width and length as the male line to which it is perpendicular, and the same distance from the corners. Mondrian has left a tiny gap between the place where the shorter vertical touches down and the horizontal begins, on the lower left of the composition, so the painting is as much about interval, the spaces between things, as the things themselves.

Having created this beguiling space, Mondrian deploys color like a magician. Some of us see the yellow first, some the blue. Then the gray appears. While in quantity it is significantly larger than the two primaries, that gray is so quiet that it takes a while to come into our consciousness. The white is simply there all the time, like light itself.

It was the perfect painting for Palucca's dancers to look at. It has rhythm and repose, leaps of energy and then a calm balance and equanimity. It was installed on the side of the practice room where, as if in a little chapel, Palucca's students could absorb its qualities between their leaps and pirouettes. The combined impact of the painting and the setting was getting more and more real.

IV

To marry Gret Palucca had been an unusual choice for a businessman of Friedrich Bienert's staid milieu. But the taste for the avant-garde was in the family. Friedrich's mother, Ida Bienert, was a cultural adventuress. In 1925, the year after Friedrich married and bought his wife the Mondrian for her studio, Ida commissioned Mondrian to design a new library in her house in Dresden. Mondrian was to take charge of every visible detail—floor, walls, ceiling, furniture—along the lines of his own living space on the rue du Départ.

No one else had even considered such an idea. Most people who visited Mondrian's studio had enough trouble imagining how the artist himself could live there. But, having seen Mondrian's atelier, Ida Bienert thrilled at the idea of a Neo-Plastic space for her and her family. And her husband, Erwin Bienert, eleven years her senior and the son of a successful Dresden entrepreneur, was happy to provide generous financial support for Ida's various projects.

The year he married her, Erwin Bienert had built Ida a splendid mansion at Würzburg 46, not far from the Belvedere and Dresden's other magnificent buildings. She was not, however, satisfied to stay at home and devote her energies to her social life and instructing their staff. In 1906, Ida, at age

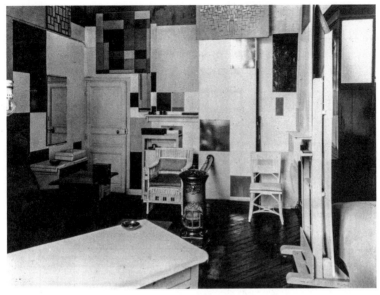

Photographers were fascinated by Mondrian's studio. This image, from 1926, is by Pierre Delbo.

thirty-six, began teaching in the first public library of Saxony. It was a pioneering idea to let people of limited financial means borrow books and learn about the world free of charge, and she wanted to be part of the venture.

By the 1920s, she had made her and her husband's palatial house a home base for the avant-garde artists associated with the Dresden Secession group, which had formed in 1919. Oskar Kokoschka, Paul Klee, Walter Gropius, Otto Dix, Emil Nolde, and Mary Wigman all felt at home there. Meanwhile, Friedrich's sister, Ise, went to study at the Bauhaus.

In the calm of Sunday evening, on January 10, 1926, Mondrian wrote the Ouds first about the sale to Friedrich Bienert and then about the library scheme:

> The larger canvas I had here at the abstract exhibition was sent by me to Germany on request, and only yesterday I received news that it has been sold; 400 marks for me, so that is a good price, as the middle man required 33%. It was bought by a danseuse who apparently has a white dance studio, and now my canvas hangs there as a restful moment for when the danseuse takes a break, so I was told in a letter. Which is rather nice, eh?*

The asterisk led to an important footnote at the end of the letter: "The payment is in 4 instalments, but that doesn't matter." That detail meant more than the client's name, which is left out. Mondrian was not interested in the

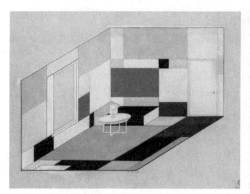 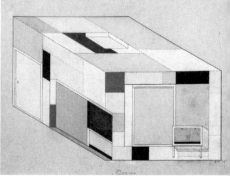

Mondrian designed the library of the Dresden house of the adventurous art collector Ida Bienert. Had it been constructed, it would have been the realization of his dream of an environment that encased one in pure abstraction.

Bienerts as individuals so much as patrons. "For some time now I have been busy with a projected chamber-library in Dresden; it only pays 150 marks, but it is good work though very difficult. Without the experience I've had with my own interior I wouldn't have been able to do it."

In pencil and gouache, Mondrian did elaborate drawings for the Dresden library. The first drawing, referred to as an "exploded box plan," resembled an image of a cardboard room model, a sort of child's toy, opened up with the walls pushed down and the ceiling unfolded adjacent to one of them. The floor, the four walls, and the ceiling painting are all presented in detail. Mondrian also made a detailed view of the floor and two of the walls, with a daybed carefully positioned against one wall and a table against the other. In a third gouache, he showed the ceiling and the remaining two walls, one with a bookcase in place, the other with a cabinet.

In its general appearance, the Bienert library was closely related to what he had done in his own studio, which was photographed that February and March by Pierre Delbo. To have an entire environment surround people other than himself with the Neo-Plastic would have been a major step. The fungibility of Mondrian's ideal abstraction was vital to it; the idea that it could nourish lives other than his own would have been further proof of its far-reaching applicability. The Bienerts' library was never built, but even as an unrealized concept it was one of Mondrian's most significant works.

V

One afternoon in the spring of 1926 when Michel Seuphor was at the rue du Départ, he read Mondrian a play he had recently written on a trip to Rome and that was going to be produced in Lyon in November. A few days later,

Seuphor returned to the studio and was astonished to see "a pretty multicolored structure, a sort of miniature theater." Mondrian had been so intrigued by the language and the imaginative nature of the time sequences that he had designed a stage set for it with changing backdrops.

Mondrian's design for *The Ephemeral and the Eternal* was a gigantic rectangular container of which one side had been removed. The first backdrop curtain was to be raised to reveal a second; the second raised to present a third. Since all three acts of the play occurred "not on earth, but in eternity," Mondrian deliberately kept the space shallow; greater depth would have been too naturalistic, too close to the world where there is life and death, while the compression suggested the everlasting and infinite. He had made the small model, 35 by 40 centimeters, using a cardboard box which he painted in gouache.

Seuphor was enthusiastic, and they agreed that the artist should get to work on making a more detailed model. Mondrian completed the project in September. The three nonrepresentational compositions that were the backdrops to the narrow stage closely resemble his paintings of the period, except that the active elements—the brightly colored forms—are proportionately more dominant, with less white space than in the paintings.

This image of Mondrian from 1926, a composite of a portrait of him and a separate photo of his studio, appeared with the article by W. F. A. Röell in *De Telegraaf*. Mondrian's studio was an object of fascination to the public.

When Mondrian was asked by W. F. A. Röell—in the 1926 interview with which this book opens—about how the actors would function in this compressed and unusual situation, the artist replied:

> They are not my concern. They will be dressed in a modern American way. For all I care, they may as well stay at home. If it were up to me, I would put my actresses behind little screens so that you wouldn't have to see them and could only hear the text.

This was the quintessential Mondrian: with all women blocked from view.

Mondrian's design was never used. Mondrian's attitude toward the cast may have had something to do with it, but by his account, it was because the theater in Lyon lacked funding. Mondrian destroyed the model about ten years later, and although Seuphor would have it reconstructed in wood in 1964, the handsome theater with its dehumanized characters was never built at full size.

The Bare Minimum

In 1926, Mondrian painted *Lozenge with Two Lines and Blue*, his sparest work to date (see colorplate XI). It is just what its title says, and nothing more. A square canvas, 33 by 33 inches, it is turned forty-five degrees to become a diamond, in which a vertical line and a horizontal line cross very near to the lower left-hand border. The starting and ending points of the two lines are off-center on the three borders of the canvas that they reach.

The elements are out of balance; the clash generates a confrontation. One side of the painting has the charge of two elements hitting it, like electrodes, while the fourth side is untouched. The pure state of that virgin edge gives it the feeling of being sacred, open to the entire cosmos. This combination of contact and its lack is enticing. The peekaboo bit of solid blue contained by the triangle formed by the intersection is a powerful note on top of it.

After Mondrian sent *Lozenge* to an exhibition in Amsterdam, he wrote Oud about the reduction of color, "It seems an evolution to me." It was as if he was observing himself in his function as the propagator of a development in which he was the agent of something more significant than himself.

Consigned to Sophie Küppers in Hannover, this refined marvel was bought by the Landesmuseum there. In 1937, it would be confiscated from that excellent public institution by the National Socialist authorities. They would declare it "degenerate" and stored it in Schönhausen Palace. Today, that Baroque "Schloss" on the outskirts of Berlin is a tourist attraction, its opulence and the lovely park surrounding it relished as an ideal example of the luxuries that wealth and status provided for the Prussian nobility. None of the official information for visitors mentions that when the Third Reich was in power, there was a special room, administered by Joseph Goebbels, Adolf Hitler's propaganda minister, for the storage of modern pictures deemed unfit for public viewing. Mondrian was in good company, even though he probably would not have liked the figurative canvases by Picasso, Van Gogh, and Gauguin also in the heap.

This masterpiece by Mondrian, a sublime expression of timeless beauty, was incarcerated as "Number 7035" in the Nazis' stronghold for the art they

banned. The canvas went from there to Karl Buchholz, a Berlin art dealer who, at Goebbels's behest, sold confiscated artworks to raise funds for the Third Reich. It next made its way to Buchholz's New York gallery, run by the great modernist dealer Curt Valentin, who, on behalf of the Nazis, sold art in the United States and sent the foreign currency back to Germany. The collector A. E. Gallatin, who would acquire a lot of work by Mondrian, bought it from Valentin. Mondrian knew at least some of this, because on December 6, 1938, he reported Gallatin's ownership of it, as well as its having been "rejected by Hitler," to the British artist Ben Nicholson.

Some of the other three-line paintings Mondrian made the same year survive only in photos. *Komposition III* went to an exhibition in Dresden, was seized, and has never been seen since. Unlike *Lozenge*, it hung straight up and down, but because the only reproduction of it was in black and white, we do not know what, if any, primary colors it contained. It was, or is—if by any miracle it has survived—one of Mondrian's most powerful uses of reduced means to create a complex drumbeat rhythm.

Schilderij N°2, mit Blau, Gelb, Schwarz und verschiedenen hellgrauen und weissen Tonen was also never photographed in color. Based on the title and the black-and-white image at the Photo Archiv Entartete Kunst, it seems that the small rectangle in the upper right was yellow, with the thin horizontal strip at the bottom right blue. It, too, was consigned to Sophie Küppers in Hannover and confiscated for storage in Niederschönhausen, where it was Number 7034, and it has never been seen since.

Another of these canvases from 1926—also with three lines, distinctly off-center, and a small rectangle of a single color—has disappeared into oblivion because of a different fate. It appears on Mondrian's easel in photos taken by André Kertész and Katherine Dreier, a great advocate for modern painting in the United States, but that is all we know. *Tableau N°2*, which measured (or measures, if it has not been destroyed) 20 by 20 inches—was consigned to Dreier, who would sell it for $300 to an unknown buyer.

But there are no further traces of it. Two more paintings only exist in photographs found in Mondrian's estate, so we know even less about them— not their sizes or colors, or the slightest detail about their fate.

Fortunately, Katherine Dreier actually bought the boldest of these breakthrough canvases. Another work hung as a diamond, it consists of nothing but four black lines of different thicknesses. Mondrian varied those widths, gave these bands their different lengths, and positioned them in a way that creates simultaneously consonance and dissonance. There is no color whatsoever. Dreier died in 1952, and the following year the monochrome work went by bequest to the Museum of Modern Art in New York. It exerts its magic freely.

II

That July, Michel Seuphor arranged for André Kertész to visit Mondrian's studio. Mondrian was gracious and accommodating to the thirty-two-year-old Hungarian Jewish photographer, who had only arrived in Paris the previous September. In Budapest, Andor Kertész, known as Bandi, had been a stockbroker, but he also took photographs of soldiers in the trenches during the world war. He had become well known above all for a picture of an underwater swim with optically rich distortions caused by the water. After going to Paris to establish himself as a full-time photographer, he changed his name to André and worked for various European magazines. To meet and photograph Mondrian in that first year in Paris was a breakthrough opportunity.

It is thanks to Kertész's photographs that we have records of some of those paintings from the mid-1920s that disappeared. Additionally, in one of Kertész's images, the cardboard box model of the stage set Mondrian made for Seuphor's play stands perfectly balanced on a straight-legged pedestal, the top of which is precisely the size of the bottom of the model. It reflects the perfect order of the studio; so does the famous shot Kertész took of Mondrian's straw boater hat and a white plaster flower and vase. That iconic image is a trenchant commentary on Mondrian's existence—the boater representing the costume Mondrian wore to present himself as a worldly and dapper character and the man-made flower encapsulating his perpetual desire for forms that never succumb to the ravages of time. Light falls in

André Kertész's photographs of
Mondrian and his studio helped fix
his image for the world, 1926.

André Kertész was fascinated by
the way Mondrian arranged the few
accoutrements of his life.

differing intensities on the shiny floor. The overall impression is of steely
control juxtaposed to the inevitable complexity of life itself. Kertész evokes
Mondrian's understated lifestyle and the restraint and discipline intrinsic to
his existence.

Sometimes, though, Mondrian was not able to maintain his personal
balance. In the July edition of *De Stijl*, Van Doesburg attacked "Neo-
Plasticism." After explaining why he had invented the term, he wrote that
he now preferred "Elementarism." This new movement, and the term for it,
ostensibly rejected the dogmatic nature of all Neo-Plasticism. But the cri-
tique was code for an all-out denigration of Mondrian. Van Doesburg wrote,
"Nature as nature, culture as culture, art as art, and architecture as an instru-
mental, practical method of construction. All previous systems . . . believed
they could neutralize the enmity between organic nature and human intel-
ligence. ELEMENTARISM rejects these systems."

Elementarism was Van Doesburg's way of identifying and then attacking
all that Piet Mondrian extolled in writing and achieved in painting. They
were not simply contrary to Van Doesburg's beliefs; they were fundamen-
tally wrong.

The paintings and philosophy that Van Doesburg now disdained evoked
the same derision from the public at large; Mondrian had his proponents,
but he was not mainstream. Now, with Van Doesburg's dismissal of Neo-
Plasticism, Mondrian had to absorb not just a lack of popularity but beyond
that the disdain of his former soulmate.

On the other hand, Mondrian had a handful of loyalists. César Domela—a twenty-six-year-old Dutch painter, sculptor, photographer, and typographer still faithful to De Stijl's principles—had become a great devotee of his work. Domela had convinced Christian Zervos, a Greek who had recently moved to Paris and founded the elegant art review *Cahiers d'Art*, to ask Mondrian to write an article which appeared in the July issue, fortuitous timing in relation to Van Doesburg's onslaught. Called "The Neo Plastic Expression in Painting," this piece in an important French magazine gave Mondrian a chance to restate his usual position, but with new twists and more punch. It was in part a response to Zervos's review of the *Art d'Aujourd'hui* exhibition which had appeared in the premiere issue of the magazine in January. Mondrian was too tactful to call Zervos directly to task for his arrogant insistence that "the Neo-Plasticists undoubtedly start from Léger," that "Neo-Plasticism makes architecture the central art, and painting its humble servant," and that "the movement can be faulted for operating through abstraction and for being dominated by its own system," but his cudgels were up.

Above all, Mondrian challenges the way that Zervos makes Neo-Plasticism emphatically Dutch. He begins his essay with the provocative statement that although his movement "was born in the north, its character is not completely 'Nordic'; Latin influence predominates. . . . Besides, it shows the influence of Paris, the gathering of all races."

Mondrian retains a calm voice in response to Zervos's vehement attack. Zervos had said that Mondrian's sort of approach "tends to suppress all sensuous and imaginative appeal." In reply, Mondrian moves from the point that "the new art shows the reflectiveness of the north and the clear spirit of the south" to the declaration that with his art "the universal expressive means was born: the rectangular plane of primary color."

Mondrian states his overarching goal that art serves all people in all time periods. For this, art has to be purely spiritual, which is why he painted as he did. "The plane suppresses the predominance of the material, whose absolute expression is three dimensional."

In this major essay for the highly popular *Cahiers d'Art*, Mondrian adds that the new art also shows "the influence of Paris as a city" and "the spirit of the new age." It is "concerned with literature, theater, and music" as well as art and architecture. He then works his way in a verbless sentence to his usual refrain, underlined as always: "The equilibrium of pure relationships, springing from pure intuition through the union of deepened sensibility and heightened intellect." Mondrian refutes the view of Zervos and of everyone else who sees his art and that of his confreres as more rational than celebrative. "Precisely through its relationships and pure plastic means, it can express life more intensely." And he concludes with his ultimate dream, that

"the New Plastic . . . will create in the future, a more equilibrated society where matter and spirit will be in equivalence."

III

In the fall of 1926, for the first time ever, two Mondrian compositions were shipped overseas. Mondrian's art had never before been seen outside continental Europe. Now consigned to Katherine Dreier, they were presented in the International Exhibition of Modern Art, which she organized at the Brooklyn Museum. The show was meant to introduce modern art to a larger audience. Mondrian's paintings were in the company of recent work by Léger, Giorgio de Chirico, Kazimir Malevich, and others.

In her book *Modern Art*, published concurrently with the exhibition, Dreier writes, "Holland has produced three great painters who, though a logical expression of their own country, rose above it through the vigor of their personality—the first was Rembrandt, the second was Van Gogh and the third is Mondrian. . . . Nowhere has such clarification been reached as in the paintings of Mondrian." Alfred Barr, a teacher at Wellesley College, who a few years later would become the founding director of the Museum of Modern Art, was among the influential people who saw those Mondrian compositions in Brooklyn. The United States would rapidly become the place where Mondrian's art enjoyed its greatest popularity.

At the same time that he had his new audience in America, Mondrian was enjoying increased support from the Netherlands. The homeland to which he intended never to return embraced him as a native son who had achieved international renown, and his inclusion in museum shows with consequent press attention fostered the occasional sale. He also had collectors in Germany. Sequestered on the rue du Départ, Mondrian was happy to benefit from his popularity abroad even if he had no wish to go to the places where people were buying, exhibiting, and praising his art.

Then, in January 1927, a former student of his—the sixty-year-old Cornelis Bergman, a successful coffee merchant—paid fifteen hundred francs, the largest sum to date, for a painting by Mondrian. He had not even seen the painting for which he paid in advance.

For the first time, Mondrian could luxuriate in the knowledge that the paintings on which he was currently working were likely to find buyers as soon as he considered them finished. His health problems that winter, however, prevented him from keeping up with the demand. Oud was waiting for some paintings on consignment, which Mondrian had said he would send at the end of January, but on February 3, Mondrian wrote him saying he

anticipated that March was a more likely delivery date. He was, he allowed, working on twenty pieces simultaneously. Not only was this requiring more effort than he anticipated but he had been ill since before Christmas.

In early January, he had finally gone to a doctor. The doctor, Mondrian told Oud, said he had

> a touch of arteriosclerosis, and was arthritic, also poor circulation etc. Which explains those thread-like strands in front of my eyes which I've had for more than two years, and which I told you about back then. I thought it was anaemia, and did the wrong thing entirely by taking rather a lot of meat and steel pills etc. Oh well, I'm getting better now, and was able to work all the time, though not as much as usual.

Mondrian did complete a group of twenty paintings by early March, with the plan of exhibiting the entire series a few weeks later in a new bookstore/gallery called L'Esthétique on the boulevard du Montparnasse, around the corner from where he lived. A recently formed organization of Dutch artists, De Klomp, asked him to give them a sneak preview on Saturday evening, February 26. Mondrian agreed, and decided to help his reverential compatriots by delivering and picking up the paintings personally. With his chronic need to report on his life's events, particularly setbacks, Mondrian described what happened and his reaction to it, to both Van den Briel and Oud, in accounts that are nearly but not entirely identical. As always, while Mondrian had calibrated his life so that he rarely had to hear about anything that happened to other people, he had an urgent need to feel that other people cared about events in his life and to receive sympathy. Wanting his stoicism and resilience recognized, he described upsetting events so that people would commiserate.

When he arrived at 10 a.m. on the Monday following his one-night showing for De Klomp, with the people he had hired to help him take the work back home, Mondrian was surprised to find no one from the Dutch organization there to meet him. He was told that the hall where the exhibition had taken place had been rented only for that one evening, after which the local French people running the place had cleaned up, throwing all his paintings in a heap in a laundry closet. Every one of them was damaged. By Mondrian's account, the nails going into the stretchers had dented all the canvases. In his usual way, Mondrian had been working on the compositions up until the last moment, repainting them chronically, which meant that none of them were entirely hardened; the wet paint was now smudged. And one of the works was ripped to an extent that seemed irreparable.

To Van den Briel, Mondrian wrote, "You may imagine that I was shocked." Night after night, he stayed up until three in the morning repairing the paintings, one after the other, in order to have them ready for L'Esthétique as soon as possible. He told Van den Briel that if he kept up that pace, he would have all the canvases, except for the one that had been torn, restored within a week of his writing. "The positive side is that the canvases are looking better, and that is the main thing. But instead of being able to rest, I have had to work twice as hard again."

He wrote Oud, "And now I find consolation in that the canvases have gained maturity as a result." Yet with Oud he allowed how upsetting their Dutch colleagues' shoddiness had been to him, and what he considered to be a nasty consequence:

> But the first shock didn't help to get my health back. And then, soon afterwards, I had a bad fall by tripping over a crack in the pavement when I was rushing to the doctor's to avoid having to spend time in the waiting room. I didn't break anything, but it was very painful, and I wasn't able to work for two days.

Still, Mondrian salvaged the situation. He sent three of the repaired paintings to the Salon des Tuileries on April 11, and sixteen to the bookstore for the exhibition that opened there on April 15. As he predicted, the only painting from the damaged lot which was still unfit to be shown was the one that had been torn. The restored paintings were triumphs, their presentation a high point of Mondrian's Paris years, and Mondrian was on his way to unparalleled success.

IV

L'Esthétique was an institution that is the stuff of fantasies. The bookstore/art gallery was the brainchild of a Siberian-born Jewish painter, Evsa Model, who designed and opened it shortly after he arrived in Paris in 1922 at age twenty-one. Model, who for a while was a seminal figure in Mondrian's life, was born in 1901 in the enchantingly named Nikolaïevsk-sur-l'Amour in southeastern Siberia. It is opposite the island of Sakhalin, which had been inhabited since the megalithic stone age and is just north of Japan, of which it is a fifth the size. Nikolaïevsk-sur-l'Amour is the last stopping point in eastern Russia for travelers going to Sakhalin; at the time of Model's birth, the town was prospering from a combination of gold mining and salmon fishing. Evsei—his name originally—was the fifth and last child of Constantin Model, who, while not officially a rabbi, functioned as if he were one, and

Sarah Feitzer, who imbued the children with her love for literature, painting, and music. The family was flourishing until the Russian Revolution. Then, following the coup d'état in 1917, Model took off on foot across China in order to avoid conscription into the tsar's army. His goal was to end up in Paris to become a painter.

After traveling halfway across the world, mostly on foot, Model reached Rome in July 1920. He was granted a temporary visa by the consulate of the provisional Russian government. A year later, he was in the French capital, where he registered under the name of Eusèbe Model and stayed with an aunt. He soon met Mondrian through André Kertész, who was Model's neighbor at 75, boulevard du Montparnasse, and he also came to know Michel Seuphor. In 1926, Model opened L'Esthétique.

Model was an intense, sexy-looking young man, sallow-skinned, with long vertical creases in his cheeks, handsome features, and large brown eyes. Clean-shaven, in photographs he seems to concentrate on the viewer, his thick dark eyebrows and full head of black hair giving him the look of the classic Russian intellectual. André Kertész photographed Model in evening clothes the same year that he gave Mondrian his exhibition, and with his shock of unkempt hair he resembles the young Johannes Brahms.

Model's own paintings were lean and powerful abstractions, often simply a red vertical and black horizontal intersecting on a white background, in the style of the Russian Suprematists. Their aesthetics—brilliant, cheerful, upbeat, and without precedent—characterized L'Esthétique. Its façade and plan were shown in *L'Architecture Vivante* in the winter of 1927. Its location at 90, boulevard du Montparnasse put it in the middle of what was becoming the artists' neighborhood, with buildings of studios like 26, rue du Départ and new art academies like La Grande Chaumière nearby. Model utilized an existing storefront but updated it. The renovated entrance brandished stencil lettering for the street number, which appeared in duplicate, a jaunty "90" floating upward from both of the two top corners. Between them, there is a jazzy design with the name written in bold sans serif lettering.

Whatever Model put on display in the shop window, he did with élan. The newest magazines, *Vouloir* among them, were stacked to create tall slim forms resembling ladders. Reproductions of work by artists ranging from Picasso to the Russian modernists were mounted in positions independent of a grid or any readily apprehensible ordering system. Yet they were by no means haphazard; one felt an underlying feeling for composition, a discerning eye beneath the exuberant playfulness.

Inside, where Mondrian's exhibition was, Model designed the presentation that was unlike any that had been created before or since. High above four rows of bookshelves, packed with volumes of relatively equal size, an

accordion arrangement of the canvases angled on panels resembled a pleated fan or a folding screen partially opened. The paintings were squeezed in, so as to make them integral to the environment and completely without the importance traditionally accorded artwork. Cantilevered at an angle to the wall, the pictures have one vertical side attached with hinges to the wall behind them and the other vertical side suspended in open space, so that, rather than being flat against the wall, each canvas had a triangular void behind it.

Mondrian's paintings were hung in two tiers on each panel: there was one abstract composition up high, another below it. Half the paintings were angled to the left, the other half to the right, leaving half of them facing one another and half with their backs to one another. Unusual cubic lighting boxes illuminated the work from above, while a very large circular light fixture like an oversized hatband, bearing the same lettering for L'Esthétique as on the façade, hung down over a central table for a book display that looked like a Cubist sculpture. The impression was of a lot happening at once, yet at the same time, of logic, precision, and impeccable engineering.

Mondrian wanted his paintings to be part of everyday existence, not something special and isolated. He disdained the aura of specialness accorded pictures in museums. The largest exhibition Mondrian ever had in Paris during his lifetime, this one which took place in a commercial shop on the boulevard du Montparnasse, was, with its unusual installation, the realization of his dreams.

Astonishing as it is that no museum or gallery gave Mondrian an equivalent show during the quarter-century span when he lived in the French capital, the bookstore was in many ways better suited to the artist's ideas. Perusing books at eye level, looking upward at the abstract paintings, one took them in as part of the same cohesive activity. The paintings functioned within daily experience, enabling their artistic qualities to be as central as blood and bones to the whole of life, rather than peripheral. The confluence of books with Neo-Plastic art, of the literary with the nonrepresentative, obliterated the usual categorization and distinctions imposed by habit on the human mind.

Because of what it was and the publications it offered for sale, the bookstore gallery became a stopping point for Le Corbusier, Michel Seuphor, Pablo Picasso, Jean Badovici, Jean Gorin, Sonia Delaunay, those Russian Suprematists who had found their way to Paris, and the various artists of Cercle et Carré (Circle and Square), the abstract artists' group that was founded in 1929 by Michel Seuphor and painter Joaquin Torres-Garcia. Mondrian's latest work had one of its most engaged audiences ever. The six-

teen canvases that, in 1927, hung in alternating directions at oblique angles above the bookshelves in L'Esthétique were all very similar in their reduced vocabulary and principal elements. Most of them have at least one vertical line that touches, and therefore seems to go beyond, the top and bottom of the canvas. Many have two horizontals that span the width, or come close to doing so. They are all predominantly white or white/gray, with vibrant, far smaller, units of red, yellow, or blue, or all three of them. Yet they are entirely different in rhythm, internal structure, and color play.

These compositions, each with its own particularities and refinement, never stop moving. Their motion consists of leaps and jumps, but, at the same time that the tempo of each is very fast, there is stillness in the solid areas. Each is a world of oppositions: color and noncolor, line and void, spatial depth and flatness, rapid motion and stillness. They juxtapose whimsy and intellect. And they radiate the qualities Erasmus describes in *Praise of Folly*: "The chief element of happiness is this: to want to be what you are. . . . For anyone who loves intensely lives not in himself but in the object of his love, and the further he can move out of himself into his love, the happier he is."

V

The show at L'Esthétique was a significant event for anyone who went into the small bookshop gallery on the boulevard du Montparnasse, but the visitors were not the sort of people who spent money on paintings. Again short of funds, Mondrian made an arrangement for Oud to take four paintings on consignment. "An acquaintance from Amsterdam" lent him some money; otherwise, at least according to his own conservative calculations, he would have been in dire trouble.

His critical success was on the rise, though, and it was all the sweeter because Van Doesburg was not getting the same attention. Mondrian wrote Oud about the new esteem being accorded him in America, adding that he was immensely pleased that Van Doesburg's work was completely unknown there.

Oud asked him to write an article for *i10*, an avant-garde magazine which the author and translator Arthur Lehning founded in 1927 and which flourished briefly, with Mondrian contributing to it three times before it ceased publication in 1929. Normally, Mondrian would have jumped at the chance to have more of his views published, but his doctor had told him he needed to walk rather than write in the evenings. And he had used all of his daytime hours finishing the paintings he hoped Oud might sell.

Mondrian had become so fearful after the damage to nineteen of his paintings earlier in the year that he wrote Oud with detailed instructions on how to open the box. Jumping from one subject to the next, he summarized his current and upcoming exhibitions and sales.

Friday.

Dear Bob, the crate went off this morning. I think I wrapped everything properly. The canvases can be taken out easily with the two planks they're screwed onto. The screws can then be removed (preferably with two men holding the canvases). In one case I had to undo two sides of the frame, but these two strips are nailed to the bottom of the crate, so they can be replaced around the canvas. Should there be any finger marks left by Customs, they can be wiped off using a cloth moistened with essence of pétrol (which they sell in paint shops). I hope they all survive the journey in good condition. The "Esthétique" exhibition on boulevard Montparnasse was rather good. At the Tuileries salon my work hangs next to Léger. I have sold a small canvas in Germany at last, thank goodness. Pity so much of the price stayed with them, but I still got a good 900 fr. My other canvases remain for sale in Germany. So that's not bad. I sent the crate without postage, labeled "peinture décorative," valued at 1200 fr (for Customs).

Mondrian wrote Oud a follow-up letter a few days later, after the shipment had been received in good form. He was now taking medicines for "rheumatism or arthritis" to good effect. Since he only had enough money left "for a few days," it was "of course okay" if Oud sent full payment for the painting he had bought; then, once the person to whom Oud had sold a second painting paid him for it, Mondrian would be able "to give back a part to that acquaintance of mine who lent me 2000 fr. last Winter."

Yes, life is still a struggle for me though in general it's not been too bad these last years. I will soon revise a French piece for 110 and send it to you, Bob. At the moment we have futurist theater here; the music is not at all futuristic, nor is the rest. They even did a thing to music by Debussy. But there was one very good thing, Cocktail by Marinetti and Prampolini, which was excellent. So there is still progress, fortunately.

Only one subject made Mondrian petty and vituperative. After signing his letter, he added a postscript: "I spotted Mrs. Van Doesburg at the futurist theater evening, but pretended not to see her. It seems he is still in Strasbourg, I expect you've heard that he's making a dance-hall there, but he is

already falling out with those people too, so I'm told." Van Doesburg's failures were inevitable solace.

VI

In July 1927, an article appeared about Mondrian in the Dutch magazine *Maandblad voor beeldende kunsten*. Its author, Henry van Loon, who had first written about the artist in the *Rotterdam Courant* in 1922, was more circumspect than the usual pundits for whom Mondrian's art and his way of life were simply amusing novelties. He describes Mondrian living "in the natural contentment of a solitude that is by no means an exile." He characterizes the fifty-five-year-old artist as having an "ordinary, bright, and somewhat clumsy manner." While living "in a light and frank reclusion," the clumsiness did not stand in the way of other Dutch and Belgian artists revering Mondrian "as a precursor and innovator."

In Van Loon's portrait, Mondrian is shown to avoid any airs of being a prophet. Although the radicalism and simplicity of his art might otherwise have caused people to suspect his abilities and honesty, that lack of self-importance is why "no one takes him for a charlatan . . . Indeed, the atmosphere around him is so pure, and his ability to paint in the conventional way so well known, that such an accusation would be untenable in the face of this overriding clarity."

Van Loon uses vivid, entertaining imagery en route to a remarkable summation of Mondrian's unique character. "Mondriaan lives the life of an unassuming, busy citizen, to whom restraint on the material level comes easily, as his needs are modest, while the creation of a new composition takes the same dedication as for instance learning a new style of dance. This life, in other words, is singularly homogeneous, as it is crystallized from the core of his consciousness, while all actions and thoughts, feelings and perceptions continue to be related with each other and with that core."

Van Loon observes that Mondrian "has grown into it, the way the material environment he described in the journal *Vouloir* takes shape like an animal's shell." This relationship of the space around us developing with us, of the individual and his surroundings being a unit, redefined the notion of home. Mondrian's self—his intellect and his spirituality—had now become the equal of the environment which he had initially created upon moving in years previously, and nurtured since. The house and the man had developed a symbiotic relationship. Mondrian's essence was, in part, those panels of color he applied around himself, the furniture he constructed and painted white, the large spaces and the interstices as well as the walls.

VII

At the start of December, the tide shifted yet again. Mondrian's funds were running dry. He wrote the Ouds thanking them for soliciting the architect Gerrit Rietveld to purchase a work or commission something for one of his houses, but Rietveld had failed to respond. This was surprising given that Rietveld was an active member of De Stijl. Even though the Ouds, now back in favor, did their utmost to help, Mondrian decided he was going to have to start to paint flowers again.

He grasped at straws. Some new friends, the Hoyacks, provided fresh hope, though. The former Ella Cramerus, an amateur painter, was the third wife of Louis Hoyack, the son of a wealthy grain trader who had left him a sufficient inheritance so that he never had to work. Like most of Mondrian's friends, they were younger than him; Louis would turn forty that March, two days before Mondrian's fifty-fifth birthday, while Ella was two years older than her husband. The Hoyacks lived fashionably, with a villa on the avenue du Maréchal Foch in Saint-Cloud and houses on the Côte d'Azur and the North Sea, but they were people of great intellect and probity. Louis, writing in French, had authored over thirty books, all philosophical; he had published monographs on Spinoza and Schopenhauer. Mondrian delighted in how atypical they were for the Dutch bourgeoisie.

Ella Hoyack was a radiant woman who liked to be photographed in bathing suits. Her father had died before she was born, and her mother and stepfather brought her up in luxury in Het Gooi, where she learned to teach French before studying sculpture. Shortly after the war, she became a governess in Cannes while setting up a studio there.

Louis Hoyack was greatly influenced by the mystic Hazrat Inayat Khan, the founder of the International Sufi Movement, who was another of his biographical subjects. Hoyack regularly attended Inayat Khan's summer school in Suresnes, not far from Paris. There the heir to a mercantile fortune became a member of the Sufi movement and developed a philosophy advocating a return to preindustrial values where contemplation and asceticism reveal the cosmic laws and sense of the eternal to which humankind has become blind. In theory, Mondrian shared a lot of Louis Hoyack's ideas, but he would often be irritated by the many publications that Hoyack sent him, especially his *"ideas about art and beauty"* in which Hoyack maintained that an artist had to express himself in natural forms with a spiritual content. Hoyack disdained abstraction; it was surprising that he and Mondrian even got along. Nonetheless, at the end of 1927, the Hoyacks had taken a painting from him to The Hague, convinced they would sell it. The next summer, they would introduce him to Ali Khan, a nephew of Hazrat Inayat Khan, known for his

Once a week, Mondrian would dine with people he knew. Kertész took this photo in 1926 at Leo Faust, a restaurant at 36, rue Pigalle in Montmartre.

unusual medical treatments. Ali Khan became Mondrian's great hope for improved health.

Ella would leave behind pocket diaries indicating that she often visited Paris from Saint-Cloud. Arriving at the Gare Montparnasse, the elegant and playful bon vivant married to a younger and more "spiritual" husband would head straight to Mondrian's studio. They would dance with the gramophone playing, and then go to the cinema or else to the cafés La Rotonde, La Coupole, or Le Dôme. Later in the evening, they went dancing at Le Bal Nègre, the Jungle Bar, or Le Petit Teddy. On occasion, it became too late for Ella to go home, and she spent the night at Mondrian's. There is no knowing whether Mondrian and his beguiling visitor ended up together in his curtained-off bed on the lower floor or whether she was on the sofa used by guests upstairs in the studio.

The Hoyacks tried to sell the painting they had taken with them to the Netherlands to a new museum for modernism in The Hague. Today that institution, the Kunstmuseum Den Haag, has the largest collection of Mondrian's work anywhere in the world, but at a crucial moment in his life where he desperately needed a sale, there was not yet any interest. Charley Toorop, a gifted painter who was the daughter of Jan Toorop, asked him to be in a group show at the Stedelijk, but he replied that the only thing that interested him was selling, and he could not waste the time or effort to be in an

exhibition otherwise. Although Toorop was the only person from his time in Domburg who remained a friend, Mondrian could not bother with anything that did not help replenish his bank account. He was frustrated not to have sold at the most recent show of the Indépendants. The lack of sales, and his new fear of his work getting damaged after the disaster in Paris, had him completely discouraged.

Mondrian wallowed in his own cantankerousness toward the traitors to his faith in the Neo-Plastic. On December 4, he wrote the Ouds:

> Dear Bob and Annie, now I have received a request from "De Stijl"!! to submit a photo of me and other photos, as well as an article for the coming anniversary issue! This is what I replied: due to your self-styled improvement? of Neo-Plasticism it is now impossible for me to collaborate in any way. I regret not being able to prevent reproduction (in the present Stijl) of articles and photos of mine. No hard feelings, though . . . I suppose you got an invitation too, and won't be doing it either, eh?

His health was

> all right again now, although I had a mild bout of jaundice and have to stick to a diet for another month, and take medicines. Have you read my article in 110 yet? I am eager to hear what you make of it. I believe it has some cultural importance, as you already mentioned in a lecture you gave about my work.

Mondrian had a chronic need for reassurance. He could not drop the matter by simply saying he was curious for the Ouds' response. He pleaded, "If you can find the time, please let me know your opinion of the article!" Planning an entire series of essays on the Neo-Plastic, Mondrian needed encouragement to push ahead.

VIII

In 1926, in his interview for *De Telegraaf,* Mondrian blasted out on the subject of a proposed ban of the Charleston, a lively new dance step, in the Netherlands.

> Yes, danced nervously, as it is by Europeans, it often appears hysterical. But with the Negroes, a Josephine Baker, for instance, it is an innate, brilliantly controlled style. All modern dance appears limp beside this powerfully sustained concentration of speed. How can they think of pro-

hibiting this spirited dance in Holland? The dancers are always so far from each other, and have to work so strenuously, there is no time for amorous thought. If the ban on the Charleston is enforced, it will be a reason for me never to return.

When the Dutch public read its most widely circulated daily newspaper on a Monday shortly after their summer holidays, many were shocked. These hardworking Calvinists getting back to their jobs were dismayed by a well-known artist expounding on matters they considered unfit for public discussion. But Mondrian had no qualms about making clear how much he relished the idea of strenuous effort with no possibility of human pairing, with individuals kept separate, with the act of love replaced by a thrill that, from Mondrian's point of view, rendered it unnecessary.

Mondrian was discussing the ban on the Charleston hypothetically. Certain Calvinist sects would have prohibited it on the Sabbath, but the legal interdiction never went through. The Amsterdam mayor, Willem de Vlugt—a devoted member of Kuyper's Anti-Revolutionary Party, the handmaiden of the Reformed Church—did try to forbid the Charleston, and two of the most stylish Amsterdam nightclubs, the Trianon and the Krasnapolsky, kept it off their dance floors, but no one succeeded in effecting the prohibition on a large scale. Still, the very concept outraged Mondrian, and to declare the heinousness of the idea was more important to him than speaking out on any other public issue. The Charleston was an exemplar of human capability. It provided the capacity to go beyond "the tragic."

For Mondrian, the Charleston was a mark of human progress rather than regression. It embodied his sense of freedom to abandon old taboos and to celebrate life with élan. Deriving from African American dance steps, it belonged to a tradition called the Juba and that included the popular Black Bottom. But it only acquired its name when it was performed to a song by the composer and pianist James P. Johnson in the Broadway musical *Runnin' Wild*, which opened at the end of October 1923 and ran until the end of June the following year. Johnson titled the song for the charming coastal city of Charleston, South Carolina, where he had first heard its clave rhythm from the workmen on the docks. Claves are two wooden sticks hit together, and the beat, which developed in both sub-Saharan Africa and Cuba, is based on a dotted eighth note followed by a dotted sixteenth note. The dance step demonstrated in *Runnin' Wild* was a new variation, in a form that gave it its appeal to the larger public and caused it to take off as a national and then an international craze.

The Charleston epitomizes enthusiasm and disinhibition; this dance with its African roots could be danced solo, by two people of the same sex,

or by a woman and man together. It was, however, most famously danced by flappers. This new breed of women bobbed their hair and wore dresses with hemlines well above their knees. Both styles—the short, straight coifs and the skirts revealing thighs in sheer stockings—were revolutionary. Flappers sipped champagne and martinis with conspicuous pleasure, and the sweeping, loose motion of the Charleston suited their sense of pleasure and abandon.

The Charleston movement begins with a seemingly lazy, almost desultory, twisting of the feet. The basic step resembles the act of walking in place, the right arm coming forward with the left leg and then moving back as the left arm and right leg swing forward, with the ankle turned so that the feet are at a right angle to the legs. This is one of the many right angles in the dance step that resemble aspects of Mondrian's compositions. The arms, like the feet, extend with the rigidity and straightness of his lines, with further right angles formed both at the elbows and again at the wrists.

It is a dance of contrasts. The initial slow, dragging steps are followed by ones danced to a vertiginously fast tempo—up to 350 beats per minute. The rapid-fire motion requires full concentration and a bolt of energy. When performed by two people, the partners face one another, the leader extending his right arm so that his hand holds the follower's back between the shoulder blades, the follower's left hand on the leader's right shoulder or biceps. The leader's left arm and the follower's right are stretched straight, at shoulder height or higher up, so that their palms are flat against each other.

On counts one and two, the leader places his left foot behind him without shifting weight, with the follower mirroring the movement with his right foot in front, also without a weight shift. On counts three and four, they bring their feet back to standing position and shift their weight to the feet they have just moved. On counts five through eight, they echo what they have just done. The leader brings his right foot forward, the follower brings his left foot backward, and then they bring them back to standing position and shift their weights.

When Mondrian wrote about the Charleston, he kept the dancers physically separate—inaccurately and unconsciously—to maintain the distances intrinsic to his art. Eliminating direct contact, the dance he described and the paintings to which it was analogous, perfectly reflected his human relationships now that he had moved to Paris. Despite Mondrian's claims to the contrary in his writing on the dance step, the torsos could, in fact, touch, but they did not have to. His distinct satisfaction in the idea that there was limited physical contact between the two people was very much his own view

of the step. There was a lot of touching and could be more. But Mondrian needed, for his own reasons, painterly as well as psychologically, to keep the dancers apart. He had, in his checkerboard works of a few years earlier, had reds and blues dance cheek to cheek. There were no dividing lines. But then he developed a new style dependent on the black lines that separated colors. He would soon go further in isolating each color element by making sure that there was always white space in the intervals.

IX

Two years after this pivotal moment in his life when he mastered the Charleston, Mondrian would write in his essay "Jazz and the Neo-Plastic" that this American dance step was the essence of the same "new life" in which Neo-Plasticism belongs. In his text, he conjures a dream setting—which is much like his own studio at 26, rue du Départ. It is a bar where jazz is played.

> No link with the old remains, for in the bar only the Charleston is seen and heard. The structure, the lighting, the advertisements—even in their disequilibrium—serve to complete the jazz rhythm. All ugliness is transcended by jazz and light. Even sensuality is transcended.

Here is Mondrian again: utterly in love with pleasure and convinced that the absence of the sensual is fundamental to that exalted state.

The first jazz recording had only been made in 1917. But it was based on older music from the American South, with African roots. Mondrian noted that, because of phonograph records, jazz gave ancient melodies, in their revised forms, a new popularity; it had already assumed a greater role for civilization than had Neo-Plasticism. Liberated and liberating music was ahead of its visual equivalent in becoming an everyday event. He was not envious; rather, he delighted in the kinship of these "revolutionary phenomena in the extreme: they are destructive-constructive."

Mondrian specified that the body of music on his mind was "Syncopated American, or Negro." While Neo-Plasticism was "realized only approximately, here and there," this music was starting to take over in bars and nightclubs. Mondrian was adamant that one of its greatest aspects was its absence of any element of psychology. "Man no longer lives in a private world and for himself alone but *within* the world: he is truly part of it, separate yet active." Again, Mondrian has declared the advantage of getting away from one's personal psychology—not to escape, but to get inside the larger sphere that encompasses all of humanity.

At the same time that Mondrian insisted on diminishing individuality and getting beyond the self, he was equally absolute that the human being must be at the helm. In his own life, he exemplified the idea that burned within him for others. A person is the catalyst for everything that occurs in his or her own life. The individual takes full responsibility for the obliteration of the restraints of his own individuality.

Mondrian declares that "the sublimated physical in man is indispensable to the new culture." How determined he was to get away from desire, the needs of the body, all that comes with nature! That sublimation was for Mondrian not part of a regression or a repression; rather, it was an advance, achieved with fullest consciousness and knowledge. It was the result of "a deepening process." He writes, "We have become thoroughly natural: we must become thoroughly human." He saw these as opposites.

Jazz provided the greatest evidence to Mondrian that the new culture was flourishing. "Jazz does not know the oppression of work," Mondrian writes. There was reason for celebration.

> In the bar we see what the new culture may bring in another, more sublimated way. . . . In the bar we find the childlike experience that eludes the people of modern society with their grim seriousness. . . . In the bar happiness and seriousness are one. Equilibrium is there, for everything is subsumed by rhythm. . . . No link with the old remains, for in the bar only the Charleston is seen and heard. . . . All ugliness is transcended by jazz and light. Even sensuality is transcended.

Here is Mondrian at his essence. His wish for human life is a form of joy he may never have had himself—the pleasure of being "childlike" for those who felt that way without trauma. Believing most of the people around him were oppressed, he favored a complete and total break from the old, and wanted others to relish happiness as he did now even if he had not been as lucky back then. He knew that it requires intelligence and work to attain the sense of pleasure life warrants, and he disdained "grim seriousness" as a violation of the gift of being human.

For Mondrian, jazz and the Charleston, like Neo-Plastic painting, were forms of personal ecstasy that exist in some space beyond the sexual world that preoccupies most people. Music and art take one to another territory, a sphere of happiness that does not exist anywhere else, and that requires, for full success, moving beyond other needs and longings. Mondrian writes:

> Jazz above all creates the bar's open rhythm. It annihilates. Everything that opens has *an annihilating action*. This frees rhythm from form and

from so much that is form without every being recognized as such. Thus a haven is created for those who would be free of form. . . .

Everything in the bar moves and at the same time is at rest. Continuous action holds passion in check. The bottles and the glasses on the shelves stand still, and yet they move in color and sound and light. Are they less beautiful than candles on the altar? They both have the same abstract form: height dominant over breadth. The dancers with made-up faces move and come to rest. No room for particular emotion. . . . In the bar, the bias to individuality ceases, only men and women. All dance well: all are part of one rhythm.

Here is the product of strict Calvinist culture extolling ordinary jars as the equals of altar candles.

Then comes—and Mondrian almost invariably has to do this—Mondrian telling us what it is we have to overcome to reach the glorious state that is the reward for transformation. At his idealized bar, "the bias to individuality ceases" and "all dance well; all are part of one rhythm." Aspects of the old life have to be eliminated.

Dance is not for the sake of woman. There is no room for business, politics, money. For these have another rhythm, a closed one; their rhythm . . . is expressed by a multiplicity of oblique lines: tense, but disequilibrated, restless, accidental.

That prohibition of the oblique is essential. Van Doesburg's crime violated all chance of the bliss that awaits if one succeeds in eradicating "particular emotion." Commerce, politics, man's desire for women, diagonal lines: these are prohibited if we are to reach the Sacred Kingdom.

X

The essay on jazz "took up an incredible amount of my time," Mondrian told Oud. But now that the article was done and published, he had time to write letters. The same day he wrote his young architect friend, he wrote Van Doesburg a response to Van Doesburg's request that everyone who had ever worked for *De Stijl* contribute to the tenth anniversary issue:

Dear Van Doesburg. Following your high-handed improvement? of Neo-Plasticism, cooperation of any kind from me is impossible. I regret that I cannot prevent my articles and photographs from being printed in *De Stijl*. Other than that, likewise: *sans rancune.*

The insincere "sans rancune" was a mockery of something Van Doesburg had written *him*. Ten days later he sent Oud a postcard on which he wrote:

> Perhaps it's not such a bad thing if you write something for that Stijl issue. Yes, you could tell V.D. that I have said just about everything in that 110 article and in previous "Vouloirs," and that he can quote from there. But then he may not pick the bits that people need to hear! Anyway, who still reads "De Stijl"?

Having sent that postcard on December 15, he wrote another on the nineteenth, reiterating the point.

> I haven't got time to write an article for De Stijl anyway, nor is it necessary as I have written all about my own ideas of N.P. in other journals. He can quote from my article in No. 1 of 110, for instance. But he won't do that!

Van Doesburg made his and Mondrian's quarrel public, doing his best to humiliate Mondrian in print. He was unremittingly nasty. He wrote in the anniversary issue, "Under the pretext of not wanting to contribute anything to this issue, Mondrian wrote with the lament that he cannot prevent the printing of his articles in the current Stijl," while at the same time he had an intermediary (meaning Oud) suggest that he quote from the recent article in *110*. On the subject of this essay, which Van Doesburg did not name but which was "Jazz and Neo-Plasticism," Van Doesburg snipped, "With regard to borrowing, which is hardly our style at *De Stijl*, we certainly do not need *110* (which consists almost entirely of the contents of my wastebasket)."

Van Doesburg nonetheless quoted liberally from some of Mondrian's earlier writing in *De Stijl* and *Vouloir*, and, in the same issue of *De Stijl* reproduced *Lozenge with Three Lines and Blue, Gray, and Yellow*—probably because its borders, at least, are diagonal.

Rupture

I

Toward the end of 1927, the relationship between Mondrian and Slijper began to get testy. On November 14, a Monday, Mondrian wrote the collector/dealer who had become the main agent for his work in the Netherlands. He feigns humor, but one feels him seething with impatience beneath it.

> Dear Sal, you have caused me a bit of bother by forgetting to send back the money. I suppose you thought I had lots of money! I still have some in the savings account but would prefer to leave it there. I also had taxes to pay. I didn't know that before, though. So please send it to me by return of post. I have put the title of the book below. Was glad to see you here. Well, au revoir, very best wishes, in haste Piet.

About a month later, Mondrian again addressed the subject of his recent sales. He jumps to the issue of a couple of family friends but it is essentially a ploy before he returns to financial matters, about which he couches his increased irritation in nice language.

> Things are fine here: except that sales are too far apart! I hope you are well. I haven't heard from Miss W.W. I wrote once, in reply to that card of hers in late summer.
>
> My very best wishes for '28 also to Miss Hamdorff and warm regards from Piet.
>
> You told me back then that you could have sold the triptych. I do appreciate your keeping things together but later I thought it would have been better if you had accepted and given me half. Then we would both have had an advantage and the painting would still be seen by people.
>
> Bye!
>
> There is an article of mine in the latest issue of i10. I only get sent one copy.

Mondrian had become newly concerned about his own early work that Slijper had bought in bulk nearly a decade earlier. The financial arrangement whereby Mondrian had sold everything to Slijper was both an attempt at solvency and a way of eliminating all signs of himself as a figurative artist. Mondrian had done so with the ardor of a convert needing to eradicate the old. Suddenly he developed intense interest in the paintings he had previously come to disdain. He had a mental checklist of the landscapes, portraits, and allegorical work he had made before leaving the Netherlands: not only the canvases and works on paper Slijper had bought from the rue du Départ in 1919 but also everything that Slijper had acquired from various collectors in the Netherlands. It becomes clear in a letter that Mondrian wrote Slijper at the start of 1928 that the idea had developed to amass a lot of the pictures in one public place.

On January 6, 1928, Mondrian wrote Slijper:

Dear Sal,

Thank you very much for your good wishes and the gift, very kind of you. As regards your idea, yes, selling directly to a museum would be wonderful, but that is not normal practice with museums! The other idea, selling them cheaply to private individuals on condition that they stay together and are bequeathed to a museum, this is feasible, I think. In that case you would have to have one trustworthy person, like Bremmer e.g. He wanted to buy a few things at the time, but your price was too high. I spoke to you about this during the war, remember?

A pity Kröller's finances aren't or weren't looking good, so I have heard, but how about writing to Bremmer about this, since you know him personally? You could explain what's going on and say that there is a risk of mould etc. in that farmhouse—which is true after all. He doesn't need to hang them all, half would be enough, if he prefers. He won't be able to pay a large sum so you needn't take me into account on that score—besides, the paintings are yours. I only wrote that in my last letter because you had mentioned helping me out. Then this sale of the triptych would have been better than your idea of the head of Christ. With Bremmer would be good, because Kröller has a museum, or at any rate a large collection. If you can find someone else you can trust that would be alright too. Anyway, do as you see fit, it's just that I keep worrying that they will suffer from damp at your place. Other than that I set great store by you keeping them together.

Well, my friend, now you know what I think. Do what you want: it's your property, you paid me what you could spare, and, while it wasn't a big sum, there wasn't anybody else wanting to buy back then.

Meanwhile, Mondrian lived very much in the present. He was more and more certain of his views on the key players. On January 25, 1928, he sent Van Doesburg a postcard, to save the difference in postage between it and a letter in an envelope. The frugality was in keeping with part of the message. Appearing polite, he was witheringly direct:

> Dear Van Doesburg, thank you for sending me the anniversary issue of De Stijl. I have appreciated receiving De Stijl up to now, but as I no longer am a contributor I feel I deserve it no longer (in view of the expense) so please discontinue; also because De Stijl is, at present, outside my direct field of interest. My regards to you both. Piet Mondrian.

His signing with his full name rather than "Piet," which in the old days would have followed a warm closing, gave the ring of a legal document more than a friendly request.

II

In the next issue of *De Stijl*, Van Doesburg printed Mondrian's letter declaring his break from the movement. Van Doesburg had not asked permission to do so, and was surely aware that Mondrian wanted neither his harsh opinions nor their feud made public.

On February 21, nearly a month later, Mondrian wrote the Ouds about the whole mess. Mondrian's subtle mastery of the art of damnation nearly equals his skills as a painter:

> Dear Bob and Annie, after reading or rather skimming the "Doesburg issue" of De Stijl, I kept wanting to write you but there is always so much to say. I am now doubly pleased that I didn't comply with v. D.'s request and he has been stupid enough to quote my reply etc. in it.

Mondrian goes on to observe to the Ouds that Van Doesburg's maneuvers meant that now everybody would realize that there was a schism between them. But Mondrian was confident that Van Doesburg's way of handling it all would fly back in his face. "People aren't so stupid," Mondrian writes, as to fail to recognize that Van Doesburg had presented only one side of an argument. He tells Oud, also subject to Van Doesburg's "mean attacks against you and the others," that he assumes Oud was not taking this personally, any more than Mondrian himself, subject to the worst vitriol of anyone, was.

Yet Mondrian could not prevent himself from being enraged by Van Doesburg's out-and-out lies.

> But one thing did irritate me, that he says articles that were turned down by de Stijl have been published in i10. How dare he! I hope you will have a word with Lehning about this, because I think it's slander.

The rest of the letter is one of his usual reports on sales—at the moment mainly their paucity—and the comings and goings of other friends. At age fifty-five, Mondrian was painting masterpieces of unblemished joy, creating euphoric art that would in time raise the spirits of people all over the world. Yet he was still struggling to have the bare minimum of personal support and financial security essential simply to keep going. His enemies were out to get him, and, popular as his vision was becoming with the general public, he was again unable to sell enough of his small output of abstract canvases to pay the rent and keep himself with enough coffee, lentils, and phonograph records—the few necessities for his survival.

III

Fortunately for Mondrian, even if mainstream taste was not yet in his favor and he was not able to sell enough of the new work, there were some remarkable experimental exhibitions in which his latest canvases were featured and applauded. In Hannover, at the start of 1928, El Lissitzky designed, at the request of Alexander Dorner, the very innovative and influential director of the Provinzial Museum, a "Kabinett der Abstrakten." These two foresighted individuals hung the 1923 composition by Mondrian which the museum owned and one from 1926 lent by Lissitzky's wife, the art historian and collector Sophie Küppers.

The museum itself was a lavish Neo-Renaissance palace, covered with an ornate compendium of pilasters, bas-reliefs, moldings on top of moldings, and dentils, with an imposing central dome looming over its entrance hall. It was hardly the sort of place where one expected to find anything newer than the most traditional art of the previous century, but Dorner was a courageous curator. The Abstract Room was only part of his redo of the formerly old-fashioned institution. Dorner presented the history of art up to the current moment with a series of "atmosphere rooms"—not simply showing the chronology but presenting it as evolution, with a radiant sense of progress—and this last space, where not an iota of naturalistic imagery remained, was the glorious culmination of all recent developments.

Lissitzky designed the room so that different parts of the walls moved, and the background colors for the artworks changed. He also used a mirror to add a deliberate complication to the experience of entering, so that, as one walked around the room, it looked different from every angle. The combination of Dorner's selection of paintings and Lissitzky's design attracted international attention. It would not be long before the German government deemed these feats of human imagination degenerate, symptomatic of a decadence and mental disorder so flagrant as to necessitate extrication of many modern paintings and their champions from society at large. Dorner would be forced into exile to the United States and Lissitzky back to Russia. For a brief period of time, however, this establishment in Hannover was the most advanced in the world, and recognized as such by the cognoscenti throughout Europe and America.

The wall of the gallery was made from thin vertical wooden ribs. The artworks were mounted on panels, of different sizes and dimensions but with frames of equal width, assembled in a lively abstract composition. One Mondrian painting hung low, in a vertical panel with its bottom just about touching the floor. The other was high, in a panel the top of which was above the ceiling molding. What appear in photos to be two Moholy-Nagys were between them.

That pair of paintings by Mondrian are among his glories. The lower one, *Composition with Yellow, Cinnabar, Black, Blue, and Various Gray and White Tones*, is as audacious as its title. This is one of the two paintings Mondrian had completed in 1923; the museum in Hannover had bought it the following year. One can see why Dorner picked it. As it was confiscated by the Nazis in 1937, we only know it from black-and-white photographs, but the varying grays and whites make it gyrate with a bold force, and at the same time it has rare delicacy and refinement. The other painting, no less extraordinary, is similarly named—*Composition with Blue, Yellow, Black, and Various Light Gray and White Tones*—but dates from 1926. Nearly square—19¾ by 20⅛ inches—it is totally different from the earlier one in impact. Startling in its lightness, it is subdivided in unexpected ways with its two small rectangles of color tucked against the right side, one at the top, one at the bottom, with fascinating asymmetry. Sophie Küppers had hoped to sell it from the show, and when she did not succeed left in on loan to the museum. It, too, would be confiscated by the Nazis in 1937.

Like the presentation in Model's bookstore, the installation in Hannover made Mondrian's work integral to the overall environment. This high-spirited setting was sure to strike most people who entered it as a radical statement. In its contrast to the aesthetics of the museum itself, it could be

considered harsh and strident. But the paintings, individually and in combination, used crisp vertical and horizontal lines, precise right angles, and the force of primary colors to make unpredictability a virtue and are absent of all moral judgment.

In keeping with the two Mondrian paintings that were its high points, El Lissitzky's design was based on the will to belong to the present and the future without any roots whatsoever in the past. It was contrary to ideas of "tastefulness," of "this goes with that"; rather, it made everything into a homogeneous whole in which dissonance reigned. Instead of the usual museum situation in which art is presented in a setting of unrelated style, here the paintings and their environment merge into a single, unified whole. Lissitzky's installation fulfilled Mondrian's highest goal of an integral relationship where neither the space nor the display assumes priority, but, rather, they dance like foxtrot partners in perfect sync.

Today we see Mondrian mostly on computer screens or in glossy reproductions printed on paper. If we have the chance to encounter them on museum walls, they are at eye level. Moreover, they are usually under glass, installed as "masterpieces." They often have wall texts at their sides, not only with gratuitous explanations of their historical significance but, worse still, notice of which wealthy person gave them to what institution. None of this has anything whatsoever to do with Mondrian's intentions. Lissitzky and Dorner's Abstract Room put the work in a setting much closer to what he deemed essential.

This modernist temple in Hannover was closed in 1936. Its interior was decimated. The Nazis were as unequivocal about what was all right in art as in people's genetic makeup. Mondrian's two paintings in it were soon destroyed, presumably by incineration.

IV

In February 1928, Mondrian sent a composition he had completed a few months earlier to Amsterdam for an exhibition at the Stedelijk organized by Charley Toorop; the show's purpose was to put together "all non-academic tendencies in art." The Stedelijk, barely twenty years old, was doing just what it had been created for by assembling examples of the myriad modernist movements of which their main shared characteristic was their rebelliousness against the tried-and-true style being taught nearby at the much larger and older Rijksakademie, where the art being produced was more to the taste of the great majority of Dutch citizens.

The architect Pierre Chareau bought a small gem of a Mondrian painting out of the exhibition. His acquiring it was a powerful endorsement from

the very sector of domestic architects and interior designers about whom Mondrian had cast strong doubt in his recent writing, and whom Van Doesburg would soon attack vociferously. Yet it makes sense that Chareau—who had exceptionally good taste, a superb eye for detail, and a will toward lightness—made this Mondrian part of his life. *Composition V, with Blue and Yellow* is simultaneously lean and abundant. Just three centimeters shy of being perfectly square, it consists, or so it appears, of two horizontal lines that span the canvas, one very near the bottom and the other toward the top although at some space from it, and a single vertical about as far from the right-hand edge as the uppermost horizontal is from the top, thus creating a neat white almost-square in the upper right-hand corner of the whole. A third, much shorter and slightly thicker, horizontal serves as a bottom border for a rich royal blue rectangle hugging the right of the canvas underneath the small white "square." At the bottom left of the canvas there is an elongated small sunny yellow rectangle, which Mondrian has accommodated by putting in a minuscule vertical line that is a companion to the one formed by the bottom of the floor-to-ceiling vertical on the right side. Both of these small vertical elements meet the lower of the two horizontals that span the composition, but the one on the left, bordering the yellow strip, halts at it, while the one on the right, bordering the blue, crosses authoritatively to the top of the composition. The little vertical on the left is perhaps twenty millimeters wider than the one on the right—this is one of Mondrian's utterly brilliant moves, giving necessary weight to the short one that is in effect a stump that seems to help support the lower horizontal.

In 1928, Mondrian was in one of his phases of looking as immaculate as his paintings.

There are no mixed paints, no unmeasurable forms, no elusive emotions. Precision was the vehicle to the infinite.

The exactitude was accentuated by the nuances. The whites of the panel—which is to say most of its surface—are not all the same white. They are divided into a very large primary form, nearly square but ever so slightly vertical; a small almost-square in the top right corner, ever so slightly horizontal; a large horizontal panel at the top, one of almost equal width but shorter in stature on the right; and two friendly, horizontal white bands at the bottom. Some of the smaller ones are slightly warmer and modestly grayer and browner than the large dominant one. And none of the black lines actually touch the edges they initially appear to touch—except for the two horizontals, which really and truly get to the left-hand side, although not the right, of which they are just a bit shy.

The by-product resembles jazz music: cheerful, universal, uplifting, and timeless. Measure is everything, but it is based on decisions made from feelings and impulses, not from forethought. Chareau had acquired a work of esprit and elegance. He was just beginning to design his House of Glass on the rue Saint-Guillaume; his small Mondrian was a perfect guide to the etherealness and grace of its architecture.

V

By now Mondrian was a household name in the Netherlands, and well known to partisans of modern art in the United States and Germany. This was less the case in France, even if he lived there. Although Chareau and the vicomte de Noailles bought his work, he did not hang out in the circles of people like Gertrude Stein or fit in with any of the trends that dominated Paris. Yet so long as he earned enough from sales of his small production of work, he had everything he wanted.

Another young acolyte entered Mondrian's life. The twenty-six-year-old Alfred Roth had started out admiring Mondrian's genius from afar, and then became one of the rare people who connected with him as an individual. Roth, a tall, lean, broad-shouldered Swiss architect, dashing in appearance and full of energy, was passionate for the modernism that was gaining momentum in Germany and France in the 1920s. He was born in German-speaking Switzerland, and in January 1927, shortly before turning twenty-four, he had gone to Paris to work for Le Corbusier in his office at 35, rue de Sèvres. By the end of the year, Roth had met Oud, who admired the young architect and invited him to Rotterdam to give a lecture. Roth visited a nearby seaside villa that Oud was finishing for a Dutch art collector, René Trousselot, who showed him a Mondrian painting from 1922 that required

some restoration work. Since Roth was on his way back to Paris for his new job, Trousselot asked him to take it with him and deliver it to Mondrian. Roth already knew the Mondrian text published in 1925 by the Bauhaus and was happy to do the errand.

On that first visit to 26, rue du Départ, Roth instantly knew that his life had changed. The luminous canvases, propped or hung, some finished and others in process, in tandem with the colorful panels on the walls, stirred him more than he could have possibly imagined.

Roth and Mondrian would remain in constant contact until Mondrian left Paris in 1938. Roth was modest and straightforward, and he adhered to Mondrian's artistic values. He was also amiable and persuasive. Roth organized a visit for Mondrian and the Dutch architect, furniture designer, and urban planner Mart Stam to Le Corbusier's Villa Stein in Garches, a rare outing during the hours of daylight when Mondrian might paint.

Oud and his wife had, meanwhile, replaced Van Doesburg and Lena or Nelly as the recipients of Mondrian's self-reporting. Mondrian wrote them regularly, providing details on the bout of flu he had in April, on an exhibition with his work in the garden of the Tuileries, and most especially the painting Alfred Roth had brought from Trousselot for repair. It was important to

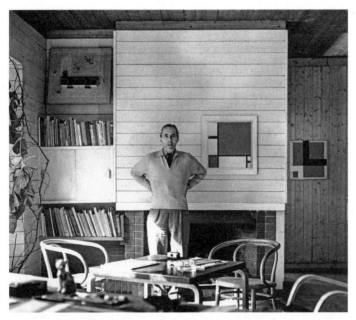

Alfred Roth, 1957. A handsome and dashing Swiss architect who worked for Le Corbusier, Roth, more than thirty years younger than Mondrian, felt that his life changed forever from the moment in 1928 when he entered the studio at 26, rue du Départ.

Mondrian that the Ouds know all the details: "Roth brought me Mr Trous-selot's canvas; it could easily have been repaired in Holland, just a small blemish along the edge and a few finger-marks which could have been wiped off with some essence of petrol. I will write Mr Trousselot when it has been repaired and ask how he wants it sent back." His need to have his friends engaged with the details of his life was urgent. In July, he wrote the Ouds:

> Dear Bob and Annie, I wanted to write you straight away when Mr and Mrs De Jonge van Ellemaat had been to see me. From them I heard that Bob is getting better. Mart Stam, who stayed here overnight, told me that you weren't properly recovered yet. But I was so busy putting my surroundings to rights; I've done the little side room and kitchen as well now. Just as I had almost finished I decided I could have a lie-in at last, the first in weeks, so I was late and in my work clothes when Mr and Mrs De Jonge van Ellemaat arrived.

Mondrian allowed that he knew he should have written as soon as Stam told him Oud still was not better, but he had been too busy renovating the lower level of his studio/apartment at 26, rue du Départ to do so. Altering every-thing at which he looked every day, he was impressed with the Van Ellemaats for admiring his unique style.

> They are very nice and liked my studio and told me a lot about you. I gave them the address of the Tuileries Salon to take a look at my latest work. I have now got a frame of aluminized wood, i.e. now I can attach the canvases with the old-style edging onto (not in) the aluminium frame, it works very well like that and avoids getting dirty when handled.

It was important to him that Oud understand how he had fine-tuned his framing technique in a way that was better both visually and practically. Mondrian was elated because of recent sales, Oud having brokered one of them:

> Charley Toorop also came to see me with her son, and she wants to buy a thing of mine for 200 guilders. So that's good. There's another buyer on the horizon, but nothing has "happened" yet, so I was extra pleased with your news. I really want to sell it, even if for only 100 guilders. Price is relative, and also depends on circumstances and individuals, after all. I am glad to hear that Mr Trousselot's canvas arrived safely; just as well I had already sent it when Roth offered to ask a lady travelling by car to Sweden via Holland to take it with her, because recently I heard from Roth that

she had a car accident on the way and got stuck in Belgium. I had written
Mr Trousselot that the expenses would amount to 30 francs, but if he buys
something else from me he needn't send me the money. If the other canvas
has got a bit dirty it is easy to wipe it clean with cold water and white soap,
without damage to the paint. The other canvas is still with Van Anrooy,
I suppose. I will ask him to send it back to your address if he hasn't done
so already. Thanks to Roth, Stam and I saw several interesting houses by
Corbusier. Last week I had a former pupil here, who I showed around the
neighborhood; as a result I was out and about and didn't need to do any
cooking. Still, it was very tiring. I may go to St. Cloud soon to spend a few
days with the Hoyacks, who are returning from the south later this week,
where they stayed with friends for three weeks. Now then Bob and Annie,
bye. Very best wishes from your friend Piet.

In subsequent letters, Mondrian voiced concern over Oud's health, but
the painting belonging to Trousselot was his priority. Nearly a month later,
on August 12, he began a postcard by expressing his concern that the can-
vas had not reached the collector. He then added that he hoped Oud had
recovered. Two weeks later, all that was on his mind was the slump in sales
inevitable in August.

A month after that, Mondrian's own health was his preoccupation. The
Hoyacks had led him to an Indian practitioner who made him

fully recovered . . . I am telling you this but for the rest I want to keep
quiet about it, because people always mock that kind of healing. He worked
wonders with me, as with many other people, and I am very grateful that
the Hoyacks told me about him. It is a sort of Sequa-treatment, stretching
the joints etc. You may have heard about him from Lohuizen, as that man is
temporarily housed by the Sufi movement.

Still, regardless of his physical condition, Mondrian was completely
upbeat. The loyal and tenacious Sophie Lissitzky-Küppers had come to his
aid. The museum in Hannover was probably going to buy one of his paint-
ings, and the museum in Essen had bought one

for the nice price of 500 Marks. All thanks to Mrs. Lissitzky's good care.
I have now sold a canvas to Giedion from Zurich; he can't pay much but
1500 fr. is still pretty good. And Charley Toorop has bought a huge thing
of mine which I had painted on cardboard because I had no money. So it
has got a bit warped, which an artist doesn't mind but other people do. So
I promised it to her for 150 guilders in February, if nobody buys it when I

send it to their exhibition. Now then, dear Bob and Annie, I look forward to hearing from you; and if Bob doesn't have time then Annie will send me a note, won't you? Very warm wishes from your friend Piet.

He added a postscript about a potential sale that had fallen through: "Van Anrooy has written me that he didn't sell the canvas after all and that he had returned it to you thanks to Otto van Rees's mediation." As usual, Mondrian calibrated people according to how they responded to him and whether they could help him. It was not, however, his personal self that mattered, it was the tenets of Neo-Plasticism, and his art as their embodiment.

VI

By the start of 1929, Mart Stam had become the newest fervent Mondrian loyalist. The twenty-nine-year-old architect arranged for nineteen of Mondrian's paintings, the largest assemblage to date of the artist's abstract work—even more than Evsa Model's exhibition at L'Esthétique—to be shown in the Kunstgewerbe Museum in Frankfurt. Again the presentation of Mondrian's work was completely different from the manner in which it has been shown since his lifetime. This museum devoted to handicraft installed Mondrian's paintings in the midst of an exhibition of chairs. Stam, a specialist in seating, had organized the grouping of about a hundred chairs chosen by Ferdinand Kramer, a young Frankfurt architect. Stam included paintings by Léger, Juan Gris, and Willi Baumeister along with the Mondrians.

A photograph taken at this exhibition shows a sequence of chairs placed in a row, all with their backs at a slight angle to the wall. The degree of the angle varies and the space between the chairs is irregular. The chairs appear nervous, as if they are waiting for something. They look like furniture brought out for a party and yet to be placed; in one instance, five identical chairs have been left stacked. A horizontal white panel behind the row of chairs starts at the floor and reaches eye level. Above it, against a black wall, hang six of the Mondrian canvases. Their positioning seems haphazard; they do not have either consistent bottom lines or top lines or center points, and there is a large gap in the middle of the group.

The lack of intentionality—of the arrangements of both paintings and chairs—is plain to see. It asks the questions "Why impose systems all the time? Is there nothing more beautiful than the random positioning of the stars as we see them in the night sky?" Stam's installation celebrates a new way of thinking—open-minded, relaxed, free of the strictures we have come to expect in our visual surroundings.

Mart Stam, c. 1928–1930. An architect and furniture designer, in 1929, at age twenty-nine, Stam organized the largest Mondrian presentation ever, in the midst of an exhibition of about a hundred chairs. At this show in Frankfurt, the arrangements of chairs and paintings appeared haphazard.

The Mondrian paintings in the photo, hung so that they dance around the void in their center, appear to be among his finest. They are abstract gems that now fully realize the goals he had developed and fine-tuned to their apogee. But some have disappeared, and, except for their inclusion in this photo, are not in the Mondrian catalogue raisonné, which means that there is no trace of them whatsoever.

One of the canvases that remains was the most recent painting in the show, which Stam bought for himself. Two belonged to Werner Moser, a Swiss architect with whom Stam worked, and who went to the exhibition at Stam's behest. Moser bought two sparkling abstractions, one that Mondrian had completed four years previously, the other *Composition with Red, Yellow, and Blue*, fresh off the easel. But the unidentified work that Ferdinand Kramer bought was subsequently lost when Kramer was forced to flee Germany.

One could develop an imaginary exhibition of all the Mondrians that disappeared in Germany in the 1930s. There are the paintings of which only faded black-and-white photographs remain, and others of which there is only a vague idea, as was the case with Kramer's.

These paintings delighted viewers in Hannover and Frankfurt. People found them so beautiful that they spent money to own them. Some may still exist, and might eventually surface, but where are those missing Mondrians?

With a hunt underway for missing paintings presumed to be in attics or closets in the suburbs of Frankfurt or the countryside near Hannover, fakes

have appeared. In September 2017, one such forgery—of a Mondrian painting said to have disappeared in the 1930s in Germany—was displayed as if authentic at the Stedelijk Museum. Outside expertise subsequently resulted in its being removed from view. But what if just one or two real Mondrian compositions could have the cobwebs cleaned off and reappear for the world to enjoy?

VII

Martinus Adrianus Stam had invented himself. His father was a tax collector, and he grew up in Purmerend, the town in the northwest of the Netherlands where Oud had been born a decade earlier. It is in the midst of an agricultural and livestock breeding region, and local people all were raised to anticipate that they would work in those fields or in commerce and professions that served the people who did this labor. But, like Oud, Stam developed other ambitions when he was still very young. By age seventeen, he got himself to Amsterdam to train as a draftsman. Two years later, he landed his first job, in an architectural firm. He quickly declared, "We have to change the world."

In 1920, because he refused to do his obligatory military service, Stam was sent to prison, where he remained for two years. On his release, he left the Netherlands, not wishing to live among people who had imprisoned him for his principles, and moved to Berlin. He again found work assisting in an architect's office. In the German capital, he met El Lissitzky, with whom he created the Wolkenbügel. The name, which translates to "cloud irons," was a new idea in skyscraper design that called for the use of three metal-framed columns, seventy meters high, each on a different street corner, supporting the three endpoints of a horizontal T-shaped structure, three stories high, above a busy intersection. These cloud irons were meant to be positioned above the network of roadways on the outskirts of Moscow. In theory, there were to be as many as eight of them at a given location.

Stam also founded a new architecture magazine and started to design furniture. He created a cantilevered chair that utilized run-of-the-mill fittings on gas pipes; it was handsome, functional, and inexpensive to make. It would quickly have great influence on the furniture designs of both Mies van der Rohe and Marcel Breuer.

By the end of the 1920s, Stam and Breuer would be battling each other in a patent lawsuit in the German courts, the issue being which of them had come up with the idea of chairs using tubular steel. Stam won the case. Breuer would become the better known of the two, and would eventually make far more money for his designs, but to people like Mondrian, Stam was the real inventor.

Stam had also garnered admiration for a remarkable house he made for the 1927 Weissenhoff Housing Estate in Stuttgart. To the modern eye, it resembles a temporary construction hut. Flat-roofed, it has, on the second floor, in a seemingly random up/down pattern, windows with cantilevered overhangs on top of them, and similarly grooved doors on the first floor. The third story has windows organized as a straight band of industrial-style openings. The success of this house resulted in Stam's being summoned to Frankfurt to work with other architects and urban planners on a major new scheme for that city, which is what he was doing there when he conceived that exhibition in 1929 with all the Mondrian paintings in the midst of a hundred chairs.

Among the paintings that disappeared after the exhibition is a 1927 *Composition*. We know it from a photograph that belonged to Theo van Doesburg, who had it tucked into the manuscript of "Panorama de la Peinture Contemporaine," an essay that went unpublished, and from the exhibition installation shot that appeared in the review of the "Stuhl-Ausstellung" in a Frankfurt newspaper. We can calculate that it measures about 35 by 38 centimeters—just a tiny bit wider than a square. Based on the tonalities of other black-and-white photographs of work where we know the colors, we assume that its single block of color, a hovering vertical rectangle on the left, is yellow.

Even in a faded old black-and-white photo, *Composition* moves gracefully. With its white void dominating the canvas, it became the prototype of a group of paintings Mondrian made in 1930, to which he gave the name *Fox Trot*, the same term he had used for a composition he showed W. F. A. Röell in 1920, although at that point he did not make it the official name of the painting. These compositions are appropriately light of foot; the areas above and left of the white box glide slowly, magisterially, while the narrow spaces around it, hardly wider than the black lines, are fast skips. The few forms in this simple composition are weightless and in perpetual motion. *Composition* possesses what Mondrian heard in the music for the dance. It has the shifting rhythms and the spontaneity with which the notes were played when the heart is full of joy. This is the freedom and sensual pleasure on which he elaborated in his essay on jazz. Energy and confidence soar.

VIII

While those nineteen paintings by Mondrian were on view in Frankfurt, Mondrian himself was confined to the studio with another of his frequent bouts of flu. He was in good spirits, though. Too weak to paint, he resumed work on a book he called "Old and New Cultures." He wrote Oud cheer-

fully on March 14, 1929, to describe recent visits from various architects, the interest in his writing, and his pleasure over "the kind services of Stam" in facilitating the Frankfurt show. Mondrian was delighted with photos he saw of the installation with chairs positioned at interesting angles, excited by the demystification of painting in this setting that made art and furniture work together. He was pleased enough that paintings by Léger, Gris, and Baumeister were also included; even if they were figurative and suffered from all the related limitations, he liked their integration with the array of modern seating. Mondrian was thrilled with Stam's way of doing things as well as the open spirit of the show. The only problem was that no one had bought anything, forcing him to accept an order for two flower paintings at forty guilders each.

A month or so later, Mondrian agreed to put work into an exhibition of contemporary art that Nelly van Doesburg was organizing. Even if he may have agreed to this project organized by Van Doesburg's wife only because he was desperate for sales, it signified a begrudging reconciliation. By chance, shortly after communicating with Nelly, Mondrian ran into Theo van Doesburg at the Dôme, the café on the boulevard du Montparnasse at the corner of boulevard Raspail that was like a clubhouse for artists.

Van Doesburg wrote a journal entry about that unanticipated meeting on a May evening.

The first encounter in five years with Piet Mondrian at the café du Dôme was completely unplanned and spontaneous. What astonished me above all was that Mondrian had not changed an iota in all that time. I attributed that to a sense of repose outside of time, and to the space in universality, or in the extinction of life.

In spite of our differences, it is now possible to maintain a more profound friendship in which each lives himself and therefore is profitable to our respective friends. Mondrian's oeuvre is far more relaxed than rigid. The constraints that he imposes on himself with his horizontal and vertical lines, his reds, blues, and yellows, may lead him to repeat himself with time.

This reconciliation is a rebuttal to the little opportunists who had succeeded in taking advantage of our separation.

A couple of months later, Mondrian wrote the Ouds:

I have also submitted work for that show in the Amsterdam Stedelijk Museum organized by Madame Van Doesburg. You may be surprised to hear that I am on "good" terms with the Van Doesburgs again, and that

we have been meeting from time to time. A while ago, in a café, they approached me in such a friendly way that I decided to let bygones be bygones. Also because he is closest to me on the level of painting. He is more like he used to be in the old days, perhaps thanks to his experience in Strasbourg. Anyway, I will tell you all the details when you come here.

It was generous of Mondrian to declare that Van Doesburg has a talent close to his own. Mondrian was the exceptional artist, the genius completely apart. In a photo taken by Henri Glarner in Mondrian's studio in August 1929, there are some other good artists present—Alexandra Exter, Henryk Staz-ewski, Fritz Glarner, and the ever-loyal Michel Seuphor among them—but Mondrian's position, at the center, with his rigid stance and his head actually larger than the other people's, shows him as he was: independent and quietly dominant. Just as he had been as a child when his brothers knew he was the one who would not play the way they would because he needed to protect his eyes, Mondrian was unlike the rest: a creative genius dedicated to goals beyond the usual human realm.

IX

Having sent his most recent compositions to New York at the start of August, Mondrian now began to develop nine new ones simultaneously. He had par-ticular exhibitions in mind and embraced the task with gusto. If he had had the means to keep on painting without needing things in the marketplace, he probably would never have finished a single canvas. But there were three shows scheduled for October—Nelly van Doesburg's in Amsterdam and exhibitions in Zurich and Barcelona, all promising commercially—and he was determined to put his best foot forward in all of them.

Alfred Roth wrote Mondrian at the start of September saying that at last he could afford to buy a work. Yet Mondrian deferred the sale, explaining that he had to send off everything still in the studio to the shows later in the fall. It was Mondrian's usual stalling tactic; he resisted letting go of paintings until he had no choice. He then would see a black line that could be extended ever so slightly, or a block of color needing its height reduced by half a cen-timeter; his work was never done.

Roth decided that the way to get Mondrian to complete and sell him a picture was by turning the intended purchase into a commission with unusual and specific demands. The architect wanted a painting small enough to travel with, like an icon. He specified to Mondrian that it should reveal "a bit of passion," even if that meant the loss of "a too serene subtlety." Mon-drian answered with a rare comment on the significance of certain colors.

He would make Roth a small work, good for travel, in "blue and yellow, white and gray, or, rather, red, a little blue, and yellow. These last ones—with red—are more 'real,' the others more spiritual."

Mondrian finished the painting as specified by Roth at the start of 1930. At 18 by 18 inches—one of Mondrian's few exact squares—it has the proportionally largest red area within it of anything Mondrian ever painted. Another in the series of what can be thought of as the box-step form, the rhythmic dance around two sides of the overarching red square contains smaller gemstones of blue and yellow. Roth, who eventually would give the painting to the Kunsthaus Zürich, got what he requested, but the result is among the least successful of Mondrian's compositions of that time. The red is too dominant, a stoplight rather than the beckoning into space proffered by the white that usually occupies most of the picture space and accentuates the small bits of red and blue that dance around it. When he made the color of overt passion the subject of a painting, Mondrian was ill at ease.

Once the other paintings in this splendid box-step series of 1929 were sufficiently complete to be shown, they went to some unexpected buyers. One, sold to Dr. R. J. Harrenstein, eventually found its way to Marguerite Arp-Hagenbach, wife and subsequently widow of Jean Arp, who in turn gave it to the Kunstmuseum in Basel. Another was bought and given to the Boijmans Museum in Rotterdam by the group of Mondrian's friends who

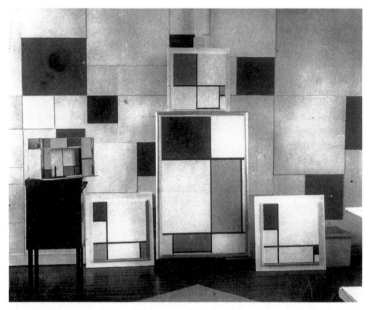

Mondrian's studio, shown here in 1929, had solid panels on the wall which he moved around.

had decided seven years earlier, when the artist turned fifty, to purchase a work a year and give it to a public institution in the Netherlands. At the Boijmans, Mondrian's composition with the blue and yellow deployed subtly was in the company of Hals and Rembrandt, the same artists whose work the Rijksmuseum had deemed Mondrian unfit to be seen with when they had abruptly declined a gift. Mondrian would, three years later, give one of the remaining unsold ones to Michel Seuphor. Another was purchased for the National Museum of Yugoslavia in Belgrade. Two were consigned to the American Katherine Dreier, who subsequently gave them to her Société Anonyme, an artists' organization she founded in 1920 with Man Ray and Marcel Duchamp, with much of its collection ultimately going to the Yale University Art Gallery. Mondrian made a gift of a third one to Dreier herself, whose estate would, in 1953, give it to the Guggenheim Museum in New York. One was bought by the rich young American architect Philip Johnson, who, a decade later, would give it to the Museum of Modern Art.

Four of these paintings had been in a selling exhibition of abstract art in Zurich at the Kunsthaus. Three of the Mondrians were at 1,300 Swiss francs, one at 1,400, putting them in the same price range as Arp reliefs and works by Moholy-Nagy, Man Ray, and Braque. The most expensive artist was Robert Delaunay, by whom an important painting cost 14,000, while a glass construction by Josef Albers could be had for as little as 250 Swiss francs, and recent oils by Max Ernst ranged from 800 to 500; works done by De Chirico, Léger, and Lipchitz were around 3,000. When we read the prices for the work back then, with the knowledge that the artists probably sent their very best work to a show of such distinction, and compare the amounts of money to what similar art fetches today, we become aware of one of the most dramatic transformations of human values and taste in the course of the past ninety years.

Lily Bles

In 1972, a Dutch woman gave an interview to the *Holland Herald*, an English-language magazine, in which she reported that, in 1929, Mondrian fell desperately in love with her. Following a brief, intense tryst in Paris, he proposed marriage. She was then twenty to his fifty-seven.

Lily Van Pareren-Bles was sixty-two years old when she made her story public. Although there was a flurry of newspaper coverage, including a piece in *The New York Times*, the revelations never gained a lot of traction. Either the public did not believe the story or preferred not to consider it. Even in the Netherlands, where he was a cultural icon, his alleged desire, as a seemingly confirmed bachelor, to take a wife young enough to be his granddaughter only briefly spurred attention.

If Van Pareren-Bles's account is accurate, Mondrian's ardor destabilized him. The dream of companionship, with the daughter of a friend, a girl he had initially encountered when she was barely out of diapers and he was forty-two years old, and his longing for their future together, readied him to reconfigure the existence he had constructed so carefully. The values Mondrian extolled and demonstrated to a fault were, apparently, up for grabs. The idea that the artist—who had renounced marriage and domesticity nearly thirty years previously, after precipitously breaking his wedding engagement and fleeing his homeland in 1912—was ready to overthrow his solitary existence suggests a side of him that was never evident before or since. For most of his life, Mondrian had conspicuously sublimated personal desire and individual emotions in deference to the quest for universal truths and for their expression through objective abstraction. He had been unwavering. Was he really so swayed by passion for a friend's young daughter that he was willing, at age fifty-seven, to upset the meticulous organization of his life and carry on differently from this point forward? Was he so naïve as to think that the young woman might agree to his plan?

If so, did it make him happy to succumb to this consuming and unexpected surge of emotion, or was he torn by the idea of love for another person taking precedence over everything to which he rigidly clung? Was

this possibly the ultimate extension of his willingness to be like a jazz musician, conforming to his goal of allowing preconceptions to be overruled by spontaneity? Or did the impact of desire discombobulate him?

Mondrian, after all, believed, at least in theory, that rigidity should be supplanted by instinct. As a painter, he counted on feeling taking over in his work, once rationalism had enabled him to lay the proper groundwork. Rapturous joy was the goal in art. Why should it not be his to enjoy completely in his own life? Why should he be forbidden it?

II

At the time that Lily Bles's alleged revelations appeared in newspapers, at least one Dutch journalist questioned their validity. This may well have been the familiar pattern of women claiming, many years after the death of a creative genius, to have been the man's girlfriend. We know of that scenario in the mythology of, among others, Le Corbusier and George Gershwin. In both instances, the "I was his lover" character had, indeed, met the famous man but was almost certainly not a sexual partner; now that he was no longer alive to contradict the story, it gave the woman luster to have the alleged connection believed. It would not be surprising for someone who knew and admired Mondrian to invent more of a liaison than actually existed.

Until 1972, Bles had never mentioned these events publicly in the forty-three years between the alleged romance and her interview. Assuming that her story of what happened with a man who had been dead for nearly three decades was true, it recounts events about which Mondrian confided to no one in writing—except, supposedly, in three letters Bles says he wrote to her directly but that she was unwilling to produce. On the other hand, Albert van den Briel wrote a letter to Robert Welsh describing what appears to be this relationship, while leaving the woman nameless, and Charmion von Wiegand said that Mondrian told her that in the late 1920s he was counting on having a baby with a woman and on their living as a family in the studio at 26, rue du Départ. Still, the very reliable Von Wiegand wrote that the young woman was a shopgirl, and from an entirely different background than Lily Bles.

Lily's father, Dop Bles, was a friend of Mondrian's. Dop, eleven years younger than Mondrian, born in Rotterdam, was a successful poet who wrote under his own name and a slew of imaginative pseudonyms, among them R. Brevier, Ronselaar Brevier, R. de Buci, A. Dolfers, J. Th. Ring, and Ida de Wilde. He published his first book, *Mijn dagboek* (My Diary), in 1905. He was working on his second, *Schrijven zoals* (Writing Like), when Mondrian,

according to Lily, first came to know her as a little girl. "I was four years old when we first met," she told the *Holland Herald* in January 1972. "Mondrian often came to visit my father in our home in Amsterdam. Mondrian used to perch me on his knee and I would sing Amsterdam street songs for him. It was my party-piece."

Lily's details are off. If she was four, the year was 1913. In 1913, Mondrian lived in Paris, as did Dop Bles, who was supporting himself in part by being a tour guide. Lily might have met Mondrian in Paris, but not in Amsterdam. If Mondrian regularly visited Bles's home in the Netherlands, it has to have been after June 1914, by which time Mondrian, counter to his initial plan, was living back in the country where he was born. We know, from letters that Mondrian wrote Dop Bles, that Bles had mailing addresses in The Hague and Rotterdam, but we have no evidence of an Amsterdam address, and, in any case, Lily, who was born in 1909, would have to have been at least five if she met Mondrian in the Netherlands rather than France, and, if so, it would have been in one of those other two cities. On November 4, 1916, by which time Lily would have been seven, Mondrian wrote Dop Bles proposing that they meet in Amsterdam, but at a café, the Americain, which suggests that Bles did not have a home in Amsterdam; in any case, there is nothing giving the impression of Mondrian meeting Bles at home.

There is added spice to a woman's claim that a much older man asked her to marry him if she has memories of having sat on his lap as a four-year-old. That detail gives the romance a Lolita twist. It is not impossible that this occurred, and that she simply got either the age or the location, or both of them, wrong, but something is off.

We know from a letter Mondrian wrote to Theo van Doesburg on June 6, 1917, that he was no longer in touch with Dop Bles, because he reports that he had no idea how the poet was doing. In 1918, Mondrian told Van Doesburg that he and Bles had lost all contact. The next trace of Dop Bles in Mondrian's known correspondence was when, in a letter to Van Assendelft on February 10, 1926, he asked the Remonstrant minister if he ever heard from Dop Bles and his wife; Mondrian asks for Bles's address, if Van Assendelft can provide it. Mondrian then learned that Bles's wife—Lily's mother, Jo Bles-Thuring—had died two years earlier, at age thirty-eight. We don't know, however, if Mondrian got in touch to offer belated condolences. Nor do we know from any source other than Lily Bles's account if Mondrian actually saw Dop Bles after 1917; there are no known references to encounters with the poet in the following years, although Mondrian's tone about Bles was always friendly.

By the 1920s, Bles had had a successful, if less than lucrative, career as

a writer. *Schrijven zoals* had come out in 1915, *Levensdrang* (Life Urge) was published the following year, *Narcose* (Narcosis) in 1921, and *Parijsche ver-zen* (Parisian Verses) in 1923, the same year that Bles translated *Cyrano de Bergerac* into Dutch. But what the connection between Mondrian and Bles was—except for Mondrian's making references to not having been in touch with Bles and not realizing that his wife had died—cannot be apprehended by any source other than Lily Bles's reminiscences. It is not implausible that in May 1929, Bles took Lily along to see Mondrian. Bles and his daughter lived together in the Netherlands, but occasionally visited Paris. We know for sure that Lily was in Paris then, because Gino Severini gave her a draw-ing of a harlequin that he inscribed to her with the date and location. But nothing other than Lily's own account corroborates that she and Mondrian saw one another, although they very well might have.

Lily paints a rich picture. Following her claim of having had those repeated encounters with Mondrian when she was four, she tells *The Herald*:

> Our next meeting was 16 years later in Paris when my father took me to visit Mondrian. The three of us went to operas, theaters, exhibitions and dined together with friends like Jean Cocteau. But whenever we could, Piet and I would spend time alone, away from my father's gaze. We were in love but my father disapproved because Piet was 56. I was 20. But not bad looking, I must say!

The detail about Cocteau—a uniquely witty and talented writer and art-ist associated with Dada and Surrealism—is puzzling. Lily said that she and her father and Mondrian went to La Coupole together, which is plausible—even if Mondrian's usual café was Le Dôme—but nothing the artist himself or anyone else has ever said suggests that he knew Cocteau. Cocteau could well have been a friend of Dop Bles; they may all have dined together; but, if so, neither Mondrian nor anyone else refers to his meeting Cocteau, whose work and lifestyle were antithetical to his own. It makes a nice scene—Mondrian, Cocteau, a lesser-known Dutch writer, and the writer's adoles-cent daughter—having dinner together, but the only record of it is in Lily Bles's recall over forty years later.

The impressions that Lily Bles reported in hindsight ring true, however. "I admired Mondrian for his quiet charm, his enigmatic personality and his clean paintings. His apartment and his studio were like his paintings—you felt that if you moved anything you might unbalance the total décor," she told her interviewer.

The New York Times picked up the story shortly after it appeared in the

Holland Herald. Whether because the *Times* journalist had direct contact with Lily Bles, or because the writer simply decided to embellish the *Herald* story, it became slightly more dramatic in this second account.

> "Then," she went on, "we fell in love. . . . As soon as my father suspected something, he hustled me back to Amsterdam. Mondrian was 56 and I was 20. We wrote each other for a while and at last in one letter he asked me to marry him. I could not say yes because in those days, parental consent really meant something, and that was the end of it. A mutual friend later told me that Mondrian after that last letter waited for two years before he gave up hope."

The *Times* also refers to "rumors," although it cites no source for them. Where the writer got his idea about what was being whispered forty-two years previously is hard to imagine, but he declares it nonetheless. "Around 1930, the Dutch painter worked in Paris. There were rumors at the time that one woman had played a more important part in his life than any other, but she had never been identified." Maybe it was so; maybe this was the relationship about which Mondrian told Charmion von Wiegand; maybe others heard of it as well. Nonetheless, there is no actual evidence other than hearsay and Lily Bles's amorous history.

An article by Ben van der Velden—"Late liefde in jaren 20: Mysterieus huwelijksaanzoek van Mondriaan" (Late love in the 1920s: Mysterious marriage proposal from Mondrian)—appeared in Dutch in the *NRC Handelsblad* on January 8, 1972, just after the *Herald* piece came out. Van der Velden wrote it quickly, wanting to be in the lead breaking the story. He did not have the scoop—*De Telegraaf,* which came out in the morning, had a short article about Mondrian and Lily Bles that day, and *NRC Handelsblad* was an evening paper—but Van der Velden was the first Dutch writer to go into the news of the marriage proposal in depth.

It is unclear whether Van der Velden spoke with Lily Bles directly or based his piece entirely on what had appeared in English in the *Herald.* He reports that Mondrian's scandalously young girlfriend recalled that, following that idyllic week together in Paris, "the love between Mondrian and her flourished." As soon as she returned to the Netherlands, Van der Velden writes, Bles received a letter in which Mondrian asked her to marry him. It was quickly followed by another letter repeating the proposal.

In the *Herald* her father knew about the romance and was appalled, while according to the *NRC Handelsblad,* Lily Bles said nothing about her and Mondrian to her father, who she knew would be horrified at the idea of her marrying this friend of his who was eleven years older than himself. In this

second account, apparently her father had failed to notice the romance. She recalled that she simply wrote back to Mondrian saying that she knew how much her father would have opposed the idea, and that she would not go against him. The scenario of her father even having to confront such a heinous possibility was, however, hypothetical; she would never have imposed it on her beloved parent. "Mondrian sent a third letter in which he wrote that he couldn't understand all of it." That was, she said, their last communication of any sort.

Van der Velden describes Lily Van Pareren-Bles as giving this account "without any reticence." The writer makes clear that he would not expect otherwise. Then Van der Velden—who gives the impression that he did, indeed, participate in the same firsthand audience as the writer for the *Herald*—writes:

> But that makes it all the more strange that she won't let anyone see those three letters she has of Mondrian's. Nobody else has ever set eyes on them, so she says. She doesn't keep them at home, they are hidden away somewhere. Not in a bank's deposit box, and not with friends, but she won't say where.
>
> Nor will she say what exactly Mondrian wrote in those letters. "I can't remember exactly myself," she says, "because I never re-read them. I didn't want to, because it was a closed chapter of my life, and I don't intend to read them again now either." But if that chapter of her life is so definitively closed, why does she so enjoy talking about her romance with Mondrian?

In asking the question, Van der Velden implicitly casts doubt on Lily Pareren-Bles's plausibility. On the other hand, he is not the most scrupulous of journalists. He spells both names incorrectly in reporting that "Mrs. Van Pareren-Bles's account is confirmed by her friend Ella Hojak, to whom Mondrian mentioned that he waited for two years before giving up hope of marriage."

None of the journalists covering the story, however, bothered to reach Ella Hoyack directly. We are left without much to hang our hats on, except for the melodrama that Van der Velden evokes in reporting that Lily van Pareren-Bles said that the week with Mondrian had affected her forever after, although she had never previously discussed it. Seeing her former suitor rise to worldwide fame after his death, and coming to realize that marriage with him might have left her with great financial wealth, she was glad to have had enough time with him to be grateful that she had not accepted his marriage proposal.

"Because, could we have been happy together? Mondrian was a tormented man. He was a masochist, really. Everything he considered beautiful caused him to suffer. He loved the sun, but wanted a window-less house to be built. I wouldn't be surprised if he actually wanted me to turn down his proposal," she says.

Ken Wilkie, the author of the piece for the *Herald*, writes:

> Over the years it was frequently rumored that in Paris there was a mystery woman in Mondrian's life about whom he would never talk. There was. And she is still in Amsterdam to tell the tale. Authoress, translator of countless cookery books and *The Life of Helena Rubenstein*, Lily van Pareren-Bles—still an eye-catching figure at 62—recalls how she fell for Mondrian's "quiet charm."

Yet, like Van der Velden, Wilkie also emphasizes that in her reflections on the proposal she declined at age twenty, a factor beyond her father's disapproval was that, however enamored she was, she considered Mondrian too neurotic and puzzling to be a suitable husband. Wilkie writes:

> Like others who knew him, Lily found Mondrian enigmatic. "He had some of the qualities of a monk—austere and detached. His apartment in Paris was small and simple. I couldn't have imagined a bouquet of flowers there. There wasn't a speck of dust anywhere. The walls were painted in geometrical patterns that reflected the precise way he thought. Like the impression given by his paintings, you felt that if you moved anything you would unbalance the total decor."

In Wilkie's account, Dop Bles, knowing what was going on, was not the happy third for a week of outings with Mondrian and his daughter, but a furious parent:

> The meetings between Lily and Mondrian were making her father so hot under the collar, she says, that he took his daughter back to Amsterdam. "Piet and I wrote to each other. In his last letter he asked me to marry him. But I couldn't. I was still under the influence of my father—as Mondrian himself had been at my age. I never saw Piet again. But a friend called Ella Hojak, who knew the painter well in Paris, told me he had waited for two years before giving up hope of marriage. I was told that during these two years Mondrian kept one little flowering plant in his

bedroom. I definitely would have married him had it not been for my father. Consents were all-important in those days, I'm afraid."

Van der Velden differs from Wilkie in saying that Mondrian proposed marriage in his first, not his last letter. But not only are there the discrepancies between the different articles; there are inconsistencies in what Bles said to Wilkie. Having made it sound as if she would never have married Mondrian, and was wise not to have done so, Bles then says that she certainly would have married the man who was nearly three times her age, and that the only reason she had not done so was knowing how much it would have upset her widowed father. And she changes her mind about being sure she was better off for not having married him:

"I may have been happy with Mondrian, maybe not," says Lily, who ultimately eloped at 27 and is now a widow. "But when I see his paintings today all my old feelings are rekindled. More than anything else it was the cleanliness of his whole work that I loved. It reminded me of a fire burning and leaving behind clean white ashes."

What is consistent is Lily Bles's love for the poetic.

III

Albert van den Briel wrote to Robert Welsh about a relationship in which he leaves the woman unnamed:

There was a forbidden relationship which caused M a lot of sadness. Someone he had known for a long time (and of whom he was very fond) was influenced by slander and gave in to pressure from her family to break with him. When M left for England he asked me to keep an eye on her, and to help her if necessary. Which I did. . . . The break of what might fairly be called the engagement happened around the same time that he was informed that he was not eligible for membership of the French Free Masons (because his work was too communistic). After M picked me up from the Gare du Nord we went to his studio, and those were the first things he told me.

If the unnamed woman whom Mondrian asked Van den Briel to keep an eye on was Lily Bles, it contradicts Bles's story. By Lily's account, she and Mondrian were never in touch after she wrote him declining his marriage

proposal; why would she have communicated with a friend of his she had probably never even met?

There is also the factor that Dop and Lily Bles were Jewish. Could someone as given to anti-Semitic generalizations as Mondrian, and who made that nasty anti-Semitic drawing of his landlord when he lived in Brabant, really have wanted to commit his life to a Jewish woman and have children with her?

Van den Briel also alluded to the near marriage in a letter to Michel Seuphor. There, too, Van den Briel associates the anguish of the personal blow with the pain of his rejection from the Freemasons.

> This failure to become a member [of the Freemasons] was a great disappointment. It was a difficult time for him for other reasons, too. His engagement was broken off by the girl, under pressure from her family. That period, around 1930 and shortly afterwards, was the period of his best work.

In this account, the two were actually engaged to marry, another discrepancy from Lily Bles's own story, and it seems possible that Van den Briel, writing in 1951, was conflating the true marriage engagement of 1912 with Mondrian's wish for marriage in 1929. Charmion von Wiegand's "shopgirl," about whom nothing more is known, is a more likely candidate.

IV

Maud van Loon, a writer and painter who was married to the *NRC Handelsblad* journalist Henry van Loon, was a close enough friend of Mondrian's that he gave her his collection of phonograph records when he moved to London in 1938. She wrote about Mondrian two years after he died. In these recollections, she gives a fascinating, romantic account of the effect of an episode in Mondrian's life for which she provides no year:

> One time when I visited his studio I noticed that something had changed, it was more luminous, more radiant, as if the sun had penetrated into the monastic cell. He seemed somewhat secretive, and didn't play his latest gramophone record straight away. His hair seemed darker and shinier, he was somewhat restless, and then he suddenly announced that he was planning to get married. So then I saw what had changed in the studio. All the black had gone—ousted by his new life-view. For weeks he was filled with youthful optimism. Afterwards he never mentioned those

plans again, he grew even more reticent towards strangers than before, but the black never returned to his studio.

This seems like another case of someone believing what she wants to believe, and sticking to it. At no point in those years did Mondrian stop using black lines in his painting, and since he had never used elements of black on the studio walls, it is hard to imagine how he removed it.

But Charmion von Wiegand's diary entry seems to confirm that, whether or not Lily Bles was the woman in question, there is some validity to the idea of a disarming passion that had Mondrian ready to overturn his life at just about the time that Lily Bles claims was when Mondrian wished to wed her. Von Wiegand and Mondrian themselves had an ambiguous relationship. She wrote about it and related issues at the start of January 1942, when they saw each other regularly in New York. "Carl" is probably the painter Carl Holty. "Mrs. Glerner" refers to Lucy Glarner, wife of the painter Fritz Glarner, who had first visited Mondrian in Paris in 1929 and had moved to the United States in 1935.

> The other night Carl told me a story that explains Mondrian's whole attitude to me now. He said that I think Mrs. Glerner [sic] told him that Mondrian ten years [ago] in Paris was planning to get married. He fixed over his studio, got a bigger bed, and built a cradle. All was ready and then it never happened. When I hear this a big lump came in my throat— and Carl said "You see he created a whole fantasy." But I knew it was no fantasy and that it had been a terrible blow to him.

Even if he had decided, after breaking off his engagement with Greta Heijbroek in 1912, that the idea of marriage and domesticity had no reality for him, and had determined that there was only one way in which he might live, Piet Mondrian had, it seems, on at least one occasion in his life, been overcome by love for another person. There is no certainty that she was the daughter of a friend and thirty-seven years his junior and therefore taboo, but passion had flourished, with enough force to quash all of his rationalism. At least in his imagination, he threw caution to the wind.

Foxtrots and Other Dances

I

In 1929, Mondrian painted *Fox Trot B, Composition N°III with Black, Red, Blue, and Yellow*. It has the taut lines and precise angles, the "equilibrated relationships" Mondrian favored in every aspect of his life. For all its exactitude, however, *Fox Trot B* is infused with great freedom. The colors dance around a white square that holds the center. In *Composition with Yellow, Blue, Black, and Light Blue*, painted at about the same time, a comparable white square floats on its own, on the upper right of the equally square canvas, but the gyrations are less energetic. In both works, the white form dominates the whole, yet "dominate" is too strong a word, because in Mondrian's world there are no power plays, no issue of one entity overtaking another, any more than there was in his life. Still, *Composition with Yellow, Blue, Black, and Light Blue* is a shade less balanced—its two whites overwhelming—and therefore less dynamic, while in *Fox Trot B*, the colors—here four rather than three—encased in black scaffolding integrated with the whites, provide a supercharge of energy.

As usual, the artist kept his personal self absent. His was not the distance of an emperor but, rather, the remove of a free person, one who believed that everyone else was entitled to the same liberties as he. The white square in this composition occupies far more of the canvas than does any other single form, being about 32 by 32 centimeters unimpeded in a canvas that is 45 by 45 centimeters in its totality, but there is no imbalance, only a sense of universal coherence, as with the relationship of sea to land on the surface of the earth.

Composition with Yellow, Blue, Black, and Light Blue makes a totally different impression than does *Fox Trot B*. It is a form of halt, a floating but stable form. *Fox Trot B*, by contrast, is on the ground, feet gliding, physicality, and peppiness. In both works, the leaner, more static composition and the allegretto one, are absent all rules or guidelines, paeans to liberty; it is just that *Fox Trot B* realizes its freedom with whirlwind force. Mondrian at his ultimate used leanness to celebrate endlessness and in so doing transport the viewer into paradise.

After it left his studio, this "summa" of Mondrian's work was shown in important exhibitions in Zurich and Munich, and then, in the United States, New York City; Buffalo, New York; Chicago; Black Mountain College in rural North Carolina; Springfield, Massachusetts; Hartford, Connecticut; and a number of smaller, unexpected cities, like Durham, North Carolina. This was because Mondrian consigned this gem to the spirited Katherine Dreier. She would eventually buy it, which means that, unlike the work by Mondrian that disappeared during the Nazi era, it is usually available for all to see at the Yale University Art Gallery.

II

The press alternately deified or vilified Mondrian. In March 1930, Carola Giedion-Welcker wrote an article on twentieth-century art for *Das Kunstblatt* in which she describes Mondrian's studio as "Experimentierzelle-Zeitseismograf" (an experimental cell-time seismograph) and uses a wonderful shot of it to bolster her point. That same month, Mondrian published his own text in the first edition of *Cercle et Carré*, where its inclusion was a point of pride to the editors of the new publication. But what thrilled some people as the epitome of experimentation and progress offended others.

Efstratios Eleftheriades, a publisher and critic who went by the name Tériade and who contributed regularly to *Cahiers d'Art*, was among the prominent critics who declared that Mondrian's work and thinking betrayed all standards for beauty. Tériade would eventually become well known for the

Efstratios "Tériade" Eleftheriades, photo by Gisèle Freund, 1953. A prominent critic and one of the most respected publishers of art periodicals, Tériade categorized Mondrian, because of his fealty to pure abstraction, as being alienated from "the warmth in life" and being "dead."

lavish art periodicals *Minotaure* and *Verve* and for his beautiful collaborative work with Matisse, but he did not yet have the vision to recognize Mondrian's qualities. In the January 1930 *Cahiers d'Art* he laced into Mondrian, whose work he labeled "la jeune peinture." For the thirty-three-year-old writer to call the mature work of a fifty-eight-year-old artist "jeune"—young—was a particularly snide way of denigrating it. He criticized Mondrian's work for having taken Cubism in the wrong direction. Then, for the important intellectual journal *L'Intransigeant*, Tériade wrote a different version of the same piece, timed to appear on March 11, with the knowledge that on March 15, the first *Cercle et Carré* would be published, a few weeks prior to that organization's inaugural exhibition. Called "Hygiène Artistique," Tériade's piece blames abstract art for destroying Cubism, and goes on to say that abstract art itself has died. Tériade takes Neo-Plasticism specifically to task. He describes it as "strictly decorative painting, reduced to a minimum" in service of "triumphant modern architecture" in the Netherlands. For Tériade, the connection to building design lessened the importance of painting, and art that did not fit into the French pictorial tradition was of secondary importance. He attacks Mondrian's idea of "perfecting" Cubism by simplifying it, as well as Mondrian's faith in a single aesthetic doctrine. "This is calculation, and nothing could be further removed from creation," the critic writes.

The Cubists, Tériade writes, had "a sure instinct [which] stopped them well short of the abyss." The pure abstractionists, on the other hand, had entered "an arid wilderness where they try to make something out of nothing." Then Tériade lets loose with possibly the most hostile statement ever uttered against Mondrian: "Those who march relentlessly forward, their gaze fixed on a remote chimerical goal—they alienate themselves from the gifts, the needs, the warmth of life. They do not sleep; they are dead."

Mondrian answered, although *L'Intransigeant* did not publish what he wrote. His dignified and temperate response did appear, however, at the start of the following year, in the January 1931 *Cahiers d'Art*. Mondrian attributed "M. Tériade's views that Neo-Plasticism itself is not true painting" to a failure of understanding. He also explained that his approach was "neither decorative painting nor geometric painting. It only has that appearance." Mondrian's text was, as usual, too long, and it rehashed his usual points, but within the ramble he made a strong case for the idea that looking more closely at his painting would lead to wonderful discoveries. "One must become thoroughly familiar with Neo-Plastic work to know that, like all other painting, it expresses *the rhythm of life*, but *in its most intense and eternal aspect*." Mondrian does not stoop to Tériade's ad hominem vitriol. Rather, he turns it around:

To "march relentlessly on, intent on some distant and chimerical goal"—
that is exactly what we must do. But this goal is not "chimerical," and
in this way we do not become "alienated from life with its gifts, its
needs, its warmth." On the contrary . . . Neo-Plastic work is deduced
from life, from which it is also produced: from continuous life, which is
"culture"—evolution.

Cahiers d'Art did not print Mondrian's text in its entirety, but we know
from the typescript that its intended closing sentence was "Finally, I would
like to thank M. Tériade for having defended Cubism—and therefore Neo-
Plasticism." It was a clever tactic for dispatching someone who has slapped
you in the face.

III

In any case, Mondrian had tougher battles to fight than with Tériade. In
March 1930, he again declared a complete break with Van Doesburg. This
time the schism would endure. Based on what Mondrian considered Van
Doesburg's heinous behavior toward others, it was different from their dis-
putes about the use of diagonals.

Van Doesburg had resumed his habitual troublemaking, creating the sort
of tangled web of human relationships Mondrian assiduously avoided. The
differences in artistic philosophy between the two men were again an issue,
but it was Van Doesburg's treatment of Mondrian's friends that Mondrian
could no longer tolerate.

On March 30, Mondrian wrote Van Doesburg:

I was sorry to learn that even though I told you about Seuphor's sympathetic
attitude towards you and have tried to defend Cercle et Carré, you have
made quite unfounded accusations against both in a letter to Garcia.

I can understand that you have an ideal of a highly homogeneous,
beautifully produced, journal. But the circumstances should be taken into
account, and as such I think C. et C. is very successful and I can't help
acknowledging Seuphor's effort therein. No other journal has done more
justice to Neo-Plasticism, and the other expressions are equally deserving
of notice. Seuphor's article is very good in my opinion, and since you have
stooped to personal accusations which I do not share and also because
Seuphor is my friend, I am sorry to say that relations between you and me
have become impossible again—a great pity, in view of our friendship and
our agreement on so many counts, and I also appreciate Pétro very much
and have enjoyed her company.

I very much regret having to let you know about this renewed break
between us. I console myself with the knowledge that contact cannot
be maintained, despite all the friendship, if one party refuses to take the
insights of the other into account.

Regards to you and to Pétro, from Piet.

Although Mondrian was calm but resolute, as with most breakups this
one did not go according to plan. Van Doesburg kept trying to reconnect.
Mondrian, unequivocal, was obliged to restate his case. Without being self-
righteous, he had his father's strong will about the movements with which he
would or would not align himself. Right and wrong were as clear to him as
his verticals and horizontals were straight. In midsummer, he needed to clar-
ify, albeit politely, his position with regard to Van Doesburg's "Art Concret,"
to get beyond the sort of ambiguity that was anathema to him. Mondrian
deliberately appeared to be responding to a recent letter Van Doesburg had
written *him*, but what really prompted him had been a diatribe Van Does-
burg had blasted at the young Michel Seuphor.

Dear Does, thank you for your letter. But there has been a mistake: I have
not joined your society. I knew that I would be exhibiting with the rest of
you, which is fine because we are all part of "abstract" (!) art—(or concrete
art, depending on how we see it). But I can't go along with some of your
ideas as put forward in the first issue of A.C.—about mathematic art,
among other things—so I can't contribute to your journal.

Mondrian then explains that he, Mondrian, has a perfect right to be
included in an exhibition in Stockholm, organized by his new colleagues,
Otto Gustaf Carlsund and Jean Hélion, for it is not directly affiliated with
the movement and its magazine, *L'Art Concret*, and its doctrinaire view, even
if it has artists who in some ways fit in with its aesthetics. He simply *had* to
differentiate his approach from one that constricted painting with a precise
system. Mondrian allows him: "So I am entitled to regard this exhibition as
separate from A.C. and to treat it as a general manifestation for A.C. and to
see it as a general manifestation for l'art abstrait-concrète [*sic*]."

That declaration was the last word between them.

IV

One of the paintings Mondrian exhibited in the Cercle et Carré show at Gal-
erie 23 at 23, rue de la Boétie was *Composition N°1: Lozenge with Four Lines*.
It is almost identical to his 1926 *Lozenge with Four Lines and Gray*. Mondrian

had returned to approximately the same conclusion as before, but with even greater boldness.

The ability to come back to his old truth in a new way puts him in the league of the small group of courageous, intelligent individuals—they range from philosophers to Supreme Court justices to scientists—who adhere to convictions that withstand all outside bombardment. No fad, no change in circumstance can alter the greater truths they have discovered and continue to pursue. They resist fashion and its relentless need for novelty.

The artist who devoted every day of the week to painting, taking time away from his primary pursuit only when illness forced him to, had certainly not forgotten, in 1930, the *Lozenge* he had painted in 1926. Almost as soon as its paint was dry, he had sent it to Brooklyn at the request of Katherine Dreier, but Mondrian kept photo albums of his own art, with a handwritten list of everything, and this pivotal artistic statement could not have escaped his memory. When in 1930 he again turned a square canvas by forty-five degrees, thus making it diamond-shaped, and then painted nothing but two horizontal and two vertical black lines on it, each cut off by the diagonal edges of the painting—or, if one prefers, each extending beyond those diagonal edges, as if wrapping itself around the sides and onto the back of the canvas—he knew he had come to a familiar idea in a new way.

What is uncertain, though, is whether Mondrian had in his mind the comparison and the difference between the works. The earlier one is larger—about 44 by 44 inches, as opposed to the approximate 30 by 30 inches of the 1930 painting. In the new, smaller version, the two verticals are visibly joined, on their inside boundaries, with the lower horizontal. This creates an interior white square, clearly articulated even though it is lopped off at its top two corners. However, as is always true with Mondrian, nothing is quite as it first appears. The left-hand bottom corner of the white square formed by the black lines just about touches the lower-left diagonal of the painting, because of the position in which Mondrian has placed and sliced two of the boundary lines. The lower right-hand corner is different. There he allows us to see a bit more of the meeting of the vertical and horizontal elements, although not the entire joint. In any case, while we never see any of the corners in full, we read the four lines as part of an invisible square.

It is so simple: a square white canvas, turned on its side, and four lines on it. But the more we look, the more we see. Initially, few people would have read the differences between the lower corners. And most would have accepted all four black lines as being of equal width, for the mind automatically wants to package things and requires coaxing to do otherwise. But then we discover that two of the black lines have the same width, while the left-hand vertical is slightly thicker and the top horizontal is a hair thicker still.

The whites are not identical. In addition, what appeared initially to be a perfect square is not quite a square; it is slightly elongated, horizontally. This almost-but-not-quite square is, also, not accorded the central position in the perfectly square turned canvas it occupies, but is floating upward and away to the left. Out of habit and expectation, viewers are surprised once they perceive this deliberate quality of being off-kilter, and then are amazed again because they had not anticipated this and the other rhythmic irregularities.

Most people see what they expect to see. In a painting of such implicit simplicity and concentric balance, viewers instinctively, in their minds, imagine the elements to be parallel, and everything to be in "two plus two equal four" sort of order. The painting then beckons us, if we allow it, to take time. We engage in a purely visual process that empties us of other concerns and calms us. It replaces our usual personal mental gyrations—a hodgepodge of moods and emotions, of shifts between calculating our schedules and wondering about what we will have for lunch to rumination over an event that occurred years ago—with a very different experience. We go into the beautiful whiteness, and relish the crisp decisiveness of the lines. We flourish in the realm of subtle variations of measurement and the glorious new territory of beat and rhythm.

After a while, looking at the 1930 *Lozenge*, once we have noticed and accepted the surprising measures, we come to feel as if the lines have a life of their own. They take action; they move. They jump, or glide, and then they hold themselves. They have authority and power and clarity, yet they are without a hint of arrogance. While rigorously black and white, they are lighthearted in their irregularity, the way they accept being cut off, the way they demand nothing but to exist in a weightless state of freedom.

Almost as soon as it was returned to Mondrian's studio from the Cercle et Carré exhibition, *Lozenge* enjoyed a fate befitting its optimistic spirit. Initially, Mondrian learned that the show had been a commercial failure, with not a single work by any of the forty-six artists selling. Neither its lively opening, at which Seuphor recited phonetic poetry and Russolo performed his "bruitist music," nor the catalogue of work by, among others, Kandinsky, Arp, and Léger, engendered positive press. But Mondrian had no expectations of selling his simple canvas, which he recognized as being too spare even for the most intrepid of collectors (the sole possible exception being Katherine Dreier, who had already stuck her neck out by taking its mate on consignment). Nor had he imagined enthusiasm from the critics. Then, after *Lozenge* was returned from the exhibition, Moholy-Nagy arranged for Mondrian to meet the Baroness Hilla von Rebay, the thirty-year-old art advisor to Solomon Guggenheim, the American heir to a mining fortune who was forming a collection of "Nonobjective art." Rebay, herself a painter, was

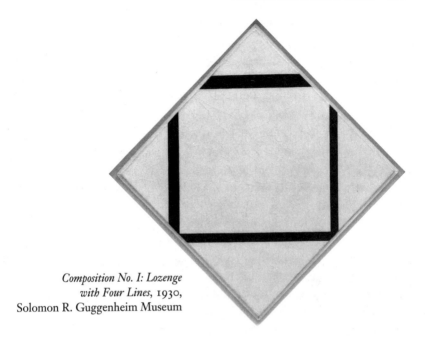

*Composition No. I: Lozenge
with Four Lines,* 1930,
Solomon R. Guggenheim Museum

known for her strong opinions and general arrogance. But everything about her encounter with Mondrian was exceptional. Rebay went to Mondrian's studio on June 3, with Félix Fénéon, at age sixty-nine a distinguished critic best known for his texts on Paul Signac and Georges Seurat. That evening, she wrote her lover, the painter Rudolf Bauer, to tell him she had been taken

> to see Mondrian, the Dutch painter—do you know him? He partly paints, he constructs 2 or 4 lines or squares, but he is a wonderful man, very cultivated and impressive. He lives like a monk, everything is white and empty but for red, blue, and yellow painted squares all over the room of his studio and bedroom. He also has a small record player with Negro music. He is very poor and already 58 years old, resembles Kandinsky but is even better and more alone. Moholy loves him and venerates him in his quiet, intense way.

The Baroness von Rebay goes on to tell Bauer that she bought one of his paintings for herself:

> (for nobody will like it), a white oil painting with four irregular lines. I love it, but it was mainly to keep the wolf from the door of a great, lovable man . . . I feel that Mondrian's painting emanates something sacred, which is why I will gladly keep it.

Two days later, Mondrian wrote Rebay to describe a visit he made to Fénéon's house the day after she and the critic had visited his studio. Mondrian emphasizes that Fénéon's wife was as hospitable and pleasant as he was. The couple graciously showed him their collection; Mondrian very much liked the Seurats. Life was full of positive pleasure for these people.

On June 6, Moholy delivered Rebay's payment. Mondrian wrote her, "I thank you so much for it; I can better continue my work." The price was 6,000 francs. Within a week, Arp would write Giedion-Welcker about the sale and the price, and in the course of the summer Mondrian would write both Oud and Roth about it; this sort of information became public knowledge.

In October, Mondrian wrote Rebay that he had delivered the painting to Fénéon, and covered it with soft protective paper and sealed the corners because it was in a room with other artworks and he feared the nonchalance of the workers. As usual, he sent cleaning instructions. If the painting became dirty, all that was required was a little bit of water and white soap; the paint was thick enough to survive them. He also suggested that she be careful not to hang the work too low, and to avoid bright daylight.

Rebay died in 1967; the painting went to the Guggenheim Museum in 1971. Solomon Guggenheim was known to disdain Mondrian's work for most of his life, so it is a good thing that Rebay made the 1930 *Lozenge* part of the collection of the museum he founded. It remains among the Guggenheim's masterpieces, there to impart its radiant beauty and celebrative spirit to all of us.

V

In 1930, Mondrian met the rich, dilettantish, brilliant, unscrupulous American Philip Johnson. Oscar Wilde could not have crafted a more glib or more intelligent character.

With his taste and influence and wealth, Johnson would improve Mondrian's situation immensely.

Johnson was rich enough never to need a paying job, while the artist who was twice his age was nearly destitute. But Johnson, who had turned twenty-four in 1930, had no lack of temerity. To buy a Mondrian before the Museum of Modern Art had sway showed a rare eye and courage. It would be another five years before his friend A. Everett Austin Jr. bought one for the museum in Hartford. Johnson's acquisition of one of the latest canvases was pivotal to Mondrian's vision making further inroads into the consciousness of American designers and architects.

Philip Johnson, photograph by Carl Van Vechten, 1932. The rich young American architect bought a Mondrian painting in 1930, although he had Oud pick it out for him. He paved the way toward the discovery of Mondrian by important American museum directors.

Johnson, however, did not pick out the painting himself. Mondrian was in Paris and he was in Berlin when the purchase was made. Johnson had been in Paris that May, but now he was in Germany to look at the "international style" of architecture and write an exhibition catalogue about it. Johnson was absorbed in the new approach, with its abolition of ornament and exaltation of geometry in all its manifestations, and the book had to be ready in time for the exhibition, which was to take place at the new Museum of Modern Art two years later.

Johnson felt that the new architecture reflected the direct impact of Mondrian's paintings. With that in mind, he wrote asking Oud to select a work for him.

> Now that I have this book on my hands, I shall have no chance of going to Paris and buying the Mondrian. And yet it is important that I have one this year. Would it be too much trouble for you to pick out one and send it to me with the bill? I know one should buy one's own pictures, and I should if it costs too much money, but as I remember it, you said they were not so expensive. If you can get me a good one that is reasonable enough, I shall be delighted to take it unseen.

After Oud wrote to Mondrian that the young American wanted a painting but would have someone else choose it, Mondrian wrote Oud:

I was glad to hear from you that Mr. Johnson wants to have one of my canvases. However, I hesitate to send one right away, because of the differences in my work: I have canvases with much color, with little color, and in simple black and white.

I sent a couple of sketches with prices, from 200 to 400 guilders. It's true, my prices are now double what they were.

But money was not an issue, and the transaction began. Mondrian sent Johnson the sketches of the paintings on which he was currently working. It was, however, neither Johnson nor Oud who ultimately made the choice; it was Henry-Russell Hitchcock, Johnson's coresearcher. Johnson asked Hitchcock to return to Paris and go to Mondrian's studio. The heavyset architectural historian, a commanding presence, with his full red beard covering his face so that his features were almost invisible, made his way past the debris in the courtyard and up the two flights of dusty, half-broken, wooden stairs to Mondrian's sanctuary. He selected Johnson's acquisition with the authority that governed all his quality judgments, the only caveat being that he had to stay within the budget of the heir to aluminum company stock. Mondrian would eventually report to Oud that initially Hitchcock wanted a large canvas for Johnson, "But its price was too high, so he took the small one of 2000 francs." Hitchcock also said he would like to buy one for himself as soon as he had the funds.

The painting with which Hitchcock walked out of the studio and sent to Johnson in Berlin was the 16-by-12½-inch *Composition N°II, with Red and Blue*, which Mondrian had completed the previous year. Of all the works of that period, this is one of the very simplest. A single vertical line spans the canvas top to bottom, off-center; a full-width horizontal, a hair thicker than the vertical, crosses it at the exact point requisite for a perfect white square to be formed in the upper right. A brilliant red fills in the space that remains on the top left; large and bold, that red rectangle is assurance itself. A second square is created below the white one by an ever-so-slightly-wider short horizontal which lies between the vertical spine and the right-hand edge; it is painted a celestial blue. The remaining areas are the same white except for an off-white crossbar, a sort of tail, at the bottom left, hugging the lower boundary.

The result is incomparable.

VI

More and more denizens of the East Coast of the United States appeared at 26, rue du Départ.

The Red Cloud, c. 1907, Kunstmuseum Den Haag

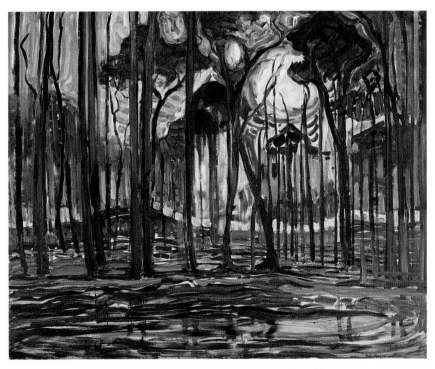

Woods near Oele, 1908, Kunstmuseum Den Haag

Dune Landscape, 1911, Kunstmuseum Den Haag

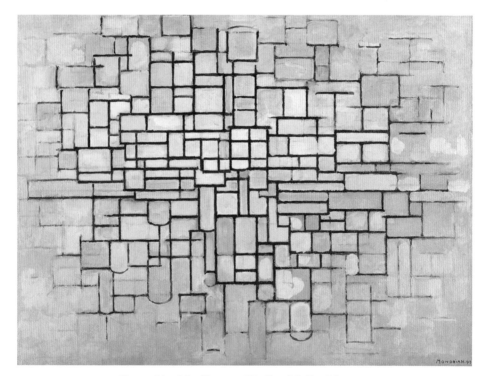

Composition No. II, 1913, Kröller-Müller Museum

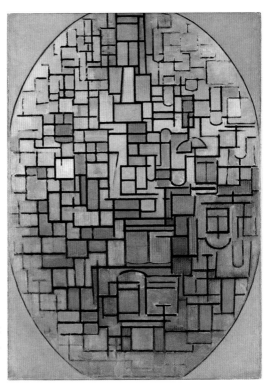

*Tableau III: Composition
in Oval*, 1914, Stedelijk
Museum Amsterdam

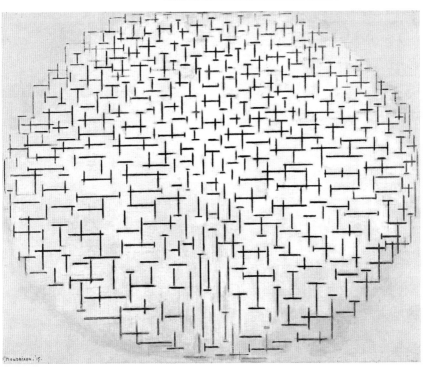

Composition 10 in Black and White, 1915, Kröller-Müller Museum

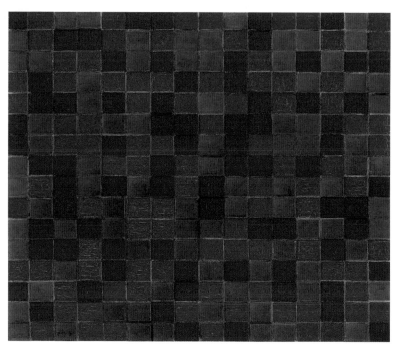

Composition with Grid 8: Checkerboard Composition with Dark Colors, 1919, Kunstmuseum Den Haag

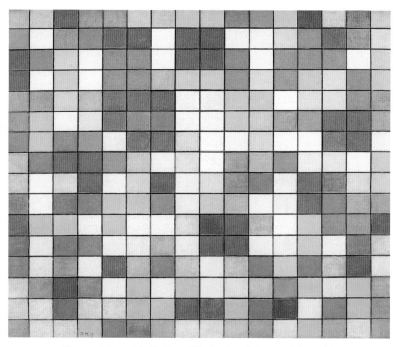

Composition with Grid 9: Checkerboard Composition with Light Colors, 1919, Kunstmuseum Den Haag

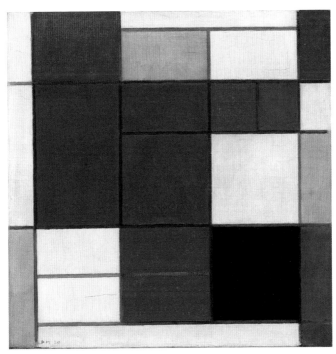

Composition C, 1920, Museum of Modern Art

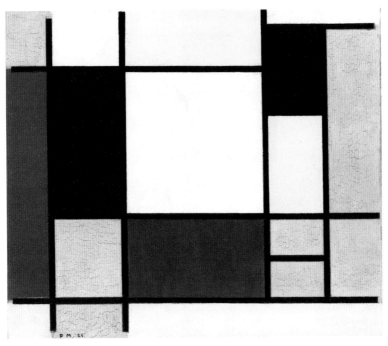

Composition with Yellow, Red, Black, Blue, and Gray, 1920,
Stedelijk Museum Amsterdam

Schilderij No. 1: Lozenge with Two Lines and Blue, 1926, Philadelphia Museum of Art

Composition with Red and Blue, 1933, Museum of Modern Art

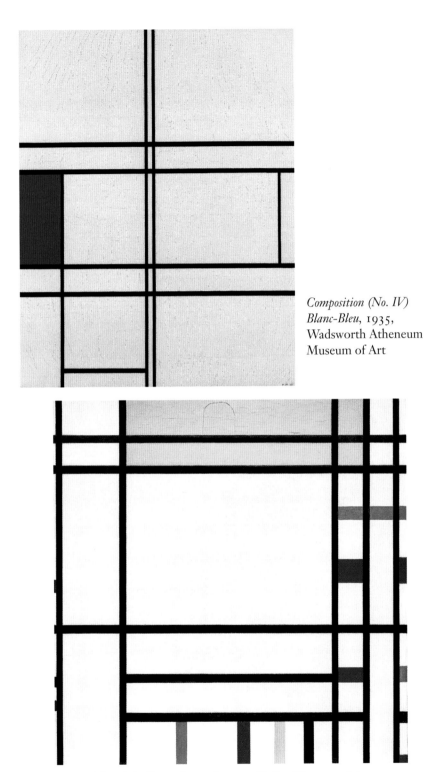

Composition (No. IV)
Blanc-Bleu, 1935,
Wadsworth Atheneum
Museum of Art

Place de la Concorde, 1938–1943, Dallas Museum of Art

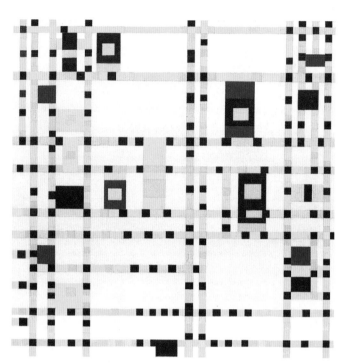

Broadway Boogie Woogie, 1942–1943,
Museum of Modern Art

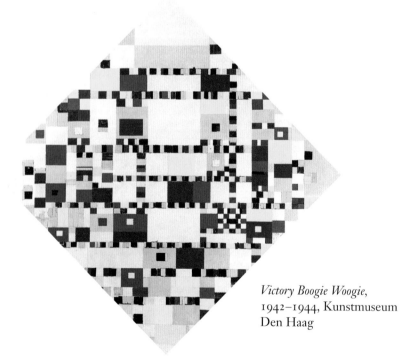

Victory Boogie Woogie,
1942–1944, Kunstmuseum
Den Haag

Alexander Calder had recently moved to Paris. The year before, his work had been a sensation at the Harvard Society for Contemporary Art, a modest exhibition space in Cambridge, Massachusetts, where three well-heeled and enterprising undergraduates—Lincoln Kirstein, Edward M. M. Warburg, and John Walker—organized art shows on a shoestring budget. They had arranged for him to perform his "circus" in Harvard Yard. The response was so positive that Calder, having taken the circus with him to Paris in 1930, decided to perform it there. The assemblages consisted of a lot of little circus figures—among them a sword swallower, a lion tamer, and assorted clowns—that could be moved in their dollhouse-sized tent. In the United States, Calder had handled the performance details himself. Now, in Paris, the young sculptor Isamu Noguchi would play music on a turntable during the performances Calder orchestrated in his apartment at 7, Villa Brune, not far from the rue du Départ.

Frederick Kiesler, a young architect/designer whom Calder described as "having a fling" with the circus, took charge of the event. For the presentation on Wednesday, September 10, Kiesler suggested that Calder invite the avant-garde artists and architects he considered most likely to take to it.

Alexander Calder in 1931. Mondrian went to see the first presentation in Paris of Calder's "circus." When the sculptor subsequently went to Mondrian's studio and suggested that it would be fun to make his solid panels of color oscillate, Mondrian dismissed the idea scornfully and said his painting was already "very fast."

Mondrian was among them. Kiesler had the vision to see the relationship of Calder's sheer inventiveness and his use of primary colors to what Mondrian was doing. Calder's art was deliberately comic, almost slapstick, while Mondrian's reflected years of intellectual probing, but both artists were irreverent, spontaneous, and devoted to human happiness. Even though one of them worked with representation and active physical movement while the other consistently confined himself to verticals and horizontals locked at right angles, Kiesler recognized the rejection of tradition and embrace of what was new and direct as a point in common.

Calder did as Kiesler advised. Besides Mondrian, he asked Léger, Le Corbusier, the critic Carl Einstein, and Van Doesburg to attend. The performance was to be at 5 p.m. precisely, and the guests were instructed to arrive with boxes on which to sit. Then, once he had invited everyone, Calder learned that he had made a faux pas, but here the story gets murky. He writes about this in his autobiography. Calder, new to the Parisian scene and not the sort of person either to align himself with one or another group or to make enemies with fellow artists, was told he should not have invited Van Doesburg. In writing about this, he explains that Mondrian and Van Doesburg were still a happy team, bosom buddies, and that the issue was that Van Doesburg and Carl Einstein were at war, and that possibly Léger was also uncomfortable around Van Doesburg. Calder also writes that Kiesler attacked him for putting incompatible people on the list—a claim that makes little sense since Kiesler was the one who came up with the names initially.

Calder published the memoir in 1966, thirty-six years after the fact, which may explain its various errors. The mistakes about who disliked whom, and who criticized Calder, are not that surprising; the world of these artists allegedly eager for equanimity in life as in their artworks was replete with schisms and controversy, and the winds often changed. The allies of one day were the enemies of the next. In any case, what is certain is that Calder subsequently visited Mondrian, and Mondrian made an unforgettable remark.

The day after the circus performance, a different Einstein from Carl—William Einstein, a young American painter from St. Louis who helped with the music for the circus—went to see Mondrian at the rue du Départ. He was so excited by what he saw there that he asked Mondrian if he might return with Calder. Kiesler had done well to arrange for Mondrian to see the circus, and Mondrian was sufficiently respectful of Calder to agree to Einstein's suggestion. It was Kiesler who took Calder, thirty-one years old, with him to 26, rue du Départ. Calder was deeply impressed by Mondrian's studio, and how much it was like Mondrian's paintings.

In 1937, Calder would publish an account of that visit to 26, rue du Départ. "I was very much moved by Mondrian's studio, large, beautiful, and irregular in shape as it was, with the walls painted white and divided by black lines and rectangles of bright colors, like his paintings." Calder was generous in his account of the event. "This one visit gave me a shock that started things." It is what made Calder go home and try to paint, although he found wire "an easier medium for me to think in."

Calder next recalled:

I suggested to Mondrian that perhaps it would be fun to make these rectangles oscillate. And he, with a very serious countenance, said, "No, it is not necessary, my painting is already very fast."

Almost thirty years later, Calder would again recall that visit to 26, rue du Départ. "It was very lovely, with a cross-light (there were windows on both sides), and I thought at the time how fine it would be if everything there moved; though Mondrian did not approve of this idea at all." Mondrian was adamant that while Calder had to cut out forms in metal and wood, join them with wire, and suspend them, he could achieve all the same motion, tension, and interplay by the judicious placement of shapes on a flat surface.

VII

In January 1931, a revolutionary educational adventure in New York took a leap forward when a new building opened for the New School for Social Research on West 12th Street. The New School had been founded in 1919 by a group of progressive American intellectuals. Many of them had been teaching uptown at Columbia University when they publicly opposed the United States entering into the world war, an act for which they were censured by the university's president. They resigned their positions in protest and created the New School as an alternative institution for higher education with the mission of fostering philosophical inquiry and an open exchange of ideas. It quickly attracted renowned intellectuals and exceptional students, among them Thorstein Veblen, John Dewey, Bertrand Russell, and Lewis Mumford.

The special exhibition organized for the opening of the New Building—with its deliberately anonymous name—included two paintings by Mondrian. A checklist titled *Who's Who* that accompanied the exhibition provided, as information about Mondrian and his art, "Precision and simplification based on a deep philosophy. Living and working in Paris." The two canvases bore

names which were different from any he had previously used: *Simplification* and *Simplification II*. In fact they were the same wonderful compositions that we know as *Fox Trot B*, from 1929, and *Fox Trot A: A Lozenge with Three Lines*, from 1930, both consigned to Katherine Dreier, who had them conveniently in Brooklyn. Exactly how the temporary name change came about is unknown, but it put Mondrian's work in the context of the New School philosophy.

That same month, on January 10, a raffle that had been put into motion the previous June by Carola Giedion-Welcker, Arp, Gropius, and Moholy-Nagy took place in Mondrian's studio. It was Arp who made the draw. The imaginative Swiss painter/poet who alternatively used the French "Jean" or the German "Hans" as his first name was one of the colleagues for whom Mondrian had the most respect, and even if his work utilized almost entirely curved lines as opposed to Mondrian's straight verticals and horizontals, it had in common with Mondrian's its purely abstract forms, undiluted colors, and abundance of joy.

The people who had bought tickets, who, besides the organizers, included Charley Toorop and Sophie Taeuber-Arp—as well as other painters, designers, and architects all determined to ensure Mondrian's ability to continue painting—eagerly awaited the announcement of the winner. Mondrian was watching as well, although the selection probably did not make much of a difference to him; these were all sympathetic people who had willingly paid a sufficient amount of money to participate so that he had been able to get through the year, which would have otherwise been impossible.

Arp called out the name of Jan Tschichold.

That happenstance had monumental impact. Tschichold was a graphic designer who gave new strength and clarity and a crisp elegance to the layout of printed matter all over the world. His acquisition of a small gem of a Mondrian—the 1930 *Composition in Yellow*—was a major event in the spread of the new aesthetic.

Jan Tschichold, like Philip Johnson, would wield great influence in forming a global approach to design. In the many years they both lived following their acquisitions of Mondrian's sparkling, groundbreaking abstractions as young men, Mondrian's rhythmic juxtapositions of color and line would become part of their lifeblood. Johnson altered the field of architecture, domestic and corporate. Aside from what he designed himself, he governed the taste of his influential friends and determined what would be seen by the larger public who visited the Museum of Modern Art, where, without pay, he ran the Department of Architecture and Design. Tschichold, with his development of new typefaces and the covers he created for some of the

most widely disseminated books ever, affected almost everyone in the world who reads the Western alphabet.

The acquisition of these pivotal artworks by Johnson and Tschichold was a catalyst to the chain of events which caused Mondrian's singular vision to spread worldwide. With the draw of a lottery ticket as with an acquisition selected by a friend, uniquely vibrant geometric design became seminal to building façades, shopping bags, newspaper layouts, computer websites, shoes, T-shirts, and whatever it is that people rich or poor now look at every day, as they will in the future.

Tschichold, born in Leipzig in 1902, was the son of a provincial sign painter. He was among those influential modern designers and artists who came from backgrounds with little intellectual sophistication and no family members having education past high school, but where technical skills and a sure knowledge of one's handicraft were considered essential. These individuals who would explode the boundaries of the appearance of everyday objects were raised to respect the discipline requisite of craftsmen and to prize practical capability as much as aesthetics and theoretical exploration. Trained by their fathers to develop manual dexterity and knowledge of tools and materials, they retained their down-to-earth approach and their respect for know-how and efficacy, while cultivating advanced artistic visions. Mies van der Rohe (the son of a bricklayer), Le Corbusier (the son of a painter of enamel watchcases), and Josef Albers (the son of a modest general contractor)—all older than Tschichold and figures of importance to him—had had similar trajectories.

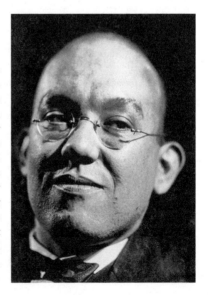

Jan Tschichold, c. 1930. This groundbreaking graphic designer, who would have vast influence through his 1935 book *Asymmetric Typography*, won a Mondrian abstraction in a lottery that had been organized to help the artist survive financially. When six SS storm troopers entered Tschichold's home in Munich in 1933 in a search for Bolshevik propaganda and his cleaning lady told them that they should take the Mondrian, they did not believe her that it could be worth a lot of money and instead looked for a wall safe behind it.

In 1923, when he was twenty-two, Tschichold attended the great Bau-
haus exhibition in Weimar. He was already sufficiently engaged in the new
art to get himself there to see the creative outpouring from the four-year-
old school. Visitors to this show of art and objects were greeted by striking
entrance graphics by the audacious young Herbert Bayer. Their bold design,
and the presentation of paintings by Klee and Kandinsky, glass constructions
by Josef Albers, furniture by Marcel Breuer, streamlined metalwork, and
textiles by Anni Albers (then still Annelise Fleischmann) and Gunta Stölzl
and other pioneering weavers, intoxicated him. In 1928, Tschichold wrote
The New Typography, in which he championed the use of sans serif type and
graphic layout schemes locked into a geometric grid. The book articulated
his philosophy eschewing traditional ornament and emphasizing functional-
ism, the values he first observed at the Bauhaus.

Tschichold would go on to write numerous books on graphic layout as
well as the design of letters, and would create four typefaces, the best known
being Sabon. He would be among the modernists to be disdained by the
Nazis. His bloodlines suited them, but his aesthetics did not. He would be
forced out of Germany in the late 1930s and, like Mondrian, would take
refuge in London. But whereas Mondrian would leave London, Tschichold
would remain. He would become the main designer for Penguin Books and
would have tremendous influence with the more than five hundred books
he created for them. By the time of his death in 1972, he was considered the
most influential graphic artist of the century. Today his name remains the
object of reverence for most everyone in the field, even if it is not familiar to
the larger world.

In *Asymmetric Typography*, published in 1935, Tschichold would declare—
and it is among his most famous statements, quoted ever since—"The works
of 'abstract' art are subtle creations of order out of simple contrasting ele-
ments." Those are the precise qualities he gleaned day and night from the
Mondrian canvas he had won in that raffle four years earlier. The painting
Tschichold acquired was nearly square. It measured 46 by 46.5 centimeters;
in another artist's work, the half-centimeter difference might have been
irrelevant, but Mondrian's sense of measure was so precise that the width
being a tiny bit greater than the height was significant. What most people
would read as black lines of equal width end up not being exactly the same;
what appears to be a single white is many. Similarly, what looks like a perfect
square is in fact not one. This was evidence of Mondrian playing with human
expectations—a line appearing to span a canvas doesn't reach its edges, and
what seems to be a square is not a true square. The lack of predictability
that makes reality different from what one anticipates is as fundamental to

real life as it is to Mondrian's art. Tschichold was another partisan of diversions from the so-called "perfect." Like Mondrian, he recognized precision and formulas as the stuff of artifice, and enriched his work with conscious asymmetry.

In the Mondrian painting that Tschichold won, most of the surface area is white. On our initial viewing of the painting, that ambient, exhilarating whiteness flows inside us like the overture of an opera. Pure and impeccable, it is a fresh start and establishes our upbeat mood. We put behind us everything that preceded it.

That sense of rebirth parallels Mondrian's own experience of creating it. When Mondrian made the painting, he was aware that it would ensure his own happy, new beginning. He knew it would be the reward for that lottery whereby his fellow artists, fiercely loyal to him and his life's purpose, had enabled him to survive. When Moholy-Nagy and Gropius and others devised this means of procuring those lifesaving funds for him, they had not known what painting would be the prize, only that it would be one of his recent works. The one he created epitomizes optimism and possibility, as well as the idea of a tabula rasa. *Composition with Yellow* has a feeling of commencement, and is celebrative to the point of being euphoric.

This is another of Mondrian's compositions that consists essentially of a single vertical and a single horizontal line, each spanning the entire canvas and crossing one another. The vertical is ever so slightly to the right of the center of the canvas. The horizontal, however, is significantly below the middle, nearly five-eighths of the way down from top to bottom. Wider than the vertical, it appears far shorter, while actually they are just about equal in length. The causes of that illusion are elusive, but Mondrian himself must have understood why it occurs. He made every dimension with a pervading sense of judgment to achieve his purpose of rhythm and movement.

The lower-right quadrant of the painting is where the action peaks. A horizontal band near the bottom of it, stemming to the right of the major vertical, and a vertical strip of the same width, dropping from the major horizontal, form a square—or at least what we assume is a square. A little yellow rectangle running along the right-hand border of the canvas, which convinces us that it belongs to a square that has been cut off by the edge, vibrates like the sound of a saxophone: queenly and radiant.

There is also a tiny bit of Mondrian's usual bright primary red in this painting. He has used it for the pencil-thin letters and numbers of the "P.M. 30," spaced out graciously, on the right side of the lower boundary of the small white square. Earlier in life, he had usually written his first initial and full last name when signing paintings—"P Mondriaan" first and then

"P. Mondrian"—but now he used initials. Surely Jan Tschichold appreciated the perfect simplicity and airiness of these two delicate, sans serif letters and two finely drawn numbers. They sing out like a little joyous thank-you, resembling in spirit the minuscule signatures of Jan Van Eyck which translate to "Jan Van Eyck was here." Once we know the story behind this painting, the red has the jubilance of the occasion when twenty-five intelligent and visionary artists came to the rescue of Piet Mondrian, who made this painting happily and appreciatively once he had enough money, thanks to them, to pay the rent and put food on his table.

There is a photograph of Jan Tschichold, taken after he won the lottery, with the painting propped at the back of a commode behind him. By not being hung on the wall or installed more definitively, Mondrian's canvas exists like a talisman, a part of the space, a merging of art and everyday life the way Mondrian wanted.

That central role of visual beauty did not, however, have the power to prevent human evil from rearing its ugly head. Two years after Jan Tschichold won this painting, shortly after Hitler rose to power, six storm troopers from the SS entered and raided the Tschicholds' apartment in Munich. The invaders were looking for pro-Communist and anti-fascist propaganda. They found such material and took it with them. The cleaning lady had informed the Third Reich's thugs in advance that they would also discover a painting, one that resembled nothing natural and was in her eyes without merit, but was worth a significant amount of money.

When they saw the Mondrian, the soldiers knew this was what she meant. But they decided she could not possibly be right about its financial value. They looked behind the canvas to see if it was being used to cover a wall safe, which struck them as the only logical reason for its existence. They did not bother to take the work itself.

The violation was intolerable to the Tschicholds. Later in 1933, they fled to Basel. There, Tschichold included the little masterpiece in the important exhibition *Konstruktivisme*, which he organized at the Basel Kunsthalle in 1938. Subsequently, after Mondrian died and the war ended, he sold it to Ernst Beyeler, the renowned Basel art dealer, for sixty thousand Swiss francs. This enabled the designer to buy a pension he deemed essential.

Within two days, Beyeler sold the 1930 Mondrian to the Kunstsammlung Nordrhein-Westfalen in Düsseldorf for twice the amount he had paid Tschichold. The winnings of a raffle ticket that had been bought to enable a genius to survive had become a financial commodity that made a rich man wealthier still. It also had survived Nazi violence because of the blessed imperviousness to its beauty that prevented looters from seeing its value. As an object, it had been exposed to what Mondrian deemed the tragic in life. But it also

surpassed the greed and ignorance that were part of its history. The small composition does what it has always done. Its white perpetually refreshes. Its clear and decisive lines exhilarate us; its yellow remains triumphant.

VIII

On March 7, 1931, Theo van Doesburg died at age forty-seven. At the end of February, he had traveled to Davos, where he had a severe episode of asthma which, a few days later, caused a fatal heart attack. The end was sudden, but his frailty was no surprise, for he had tuberculosis.

We will never know what Mondrian's private reaction was to the death at a young age of the man who had once meant so much to him, but to others he appeared unmoved. When Oud asked Mondrian to contribute to a last edition of *De Stijl* dedicated to Van Doesburg's memory, Mondrian consented, but grudgingly. Answering Oud's request, he acknowledged Van Doesburg's death only toward the end of a letter, concluding a sequence of other subjects in which he seemed to have prioritized a lot that mattered more to him. He avoided using Van Doesburg's name, referring only to "he" and "him."

> Dear Bob and Annie,
> Thank you for your letter. Good to hear you are well and that Bob has drafted a design. Wonderful that our work keeps going in spite of all the difficulties and downturn. I expect you have read my article in N.I. '31 Cahiers d'art. At least they let us defend abstract art, which is nice!
> I had a bad winter with two bouts of flu, which has now come back again in mild form. Sales are generally poor, but I can just manage. My expenses aren't high, thank goodness. From time to time I heard, from friends or acquaintances who had spoken with you, that you were doing well. You will be coming here some time in the summer, won't you? I will soon be sending you the little article for the Stijl: I hope it turns out all right. It's not easy to avoid mention of anything unpleasant. He was a strange mix of good and bad, so you can't judge him as one or the other. Well, bye now Bob and · Annie, as always warm wishes from your friend Piet.

In a subsequent letter which he wrote the Ouds on May 14, he addressed the issue of the article in *De Stijl* that was to mention Van Doesburg:

> Dear Bob and Annie,
> I will send the article for the new Stijl issue a bit late, but before or on the 15th. I've been down with the flu again, the third time this winter. The

weather is warm now, fortunately, so time to get better. I hope you are both alright. The article still needs correcting, but I assume you will take care of that. Do drop me a line some time.

Best regards from your friend Piet.

Please let me know what you think of my article—it was a difficult job!

His need to make a public statement on Van Doesburg plagued him. He wrote the Ouds a postcard with the usual updates on his health and art sales, but returned to the subject.

Dear Bob and Annie, I hope you are well. I sent you a little article for that Stijl issue, but haven't heard from you since. I am almost completely recovered again, after all that flu, and hope to get back to work soon.

Sold nothing in Brussels, yet again. Bye, best regards from Piet.

It is possible that the Ouds had not mentioned "the little article" because what Mondrian wrote about Van Doesburg was too anodyne to elicit a response. In any case, Mondrian was now busy writing the book he would call *The New Art—The New Life: The Culture of Pure Relationships.* There more than ever, he equates human conduct with the composition of paintings: best served when the elements only converge briefly, and at inviolable ninety-degree angles. The space he placed, or tried to place, between himself and the death of his onetime soulmate resembled the artistic layout he extolled.

Mondrian's "Homage to Van Doesburg," when it appeared the following January in the final issue of *De Stijl,* is mainly about himself and the evolution of modern art in general. Van Doesburg only appears more than halfway through the piece, after Mondrian has amplified his own "research toward an art free of naturalistic appearances" with "means of nothing but the straight line in rectangular opposition" and celebrated his discovery of Van der Leck and the significance of his "exact technique." Mondrian's arrival at the subject of the man being memorialized is unintentionally comic. The younger artist was "sincerely appreciative of my work," Mondrian reports, adding that Van Doesburg had asked him "to collaborate on a periodical he was planning to publish, named De Stijl. I was happy to publish the ideas on art that I was formulating; I saw the potentiality of contact with efforts consistent with my own."

Mondrian does, toward the end, refer to "the joy of meeting Van Doesburg," but qualifies the cause of the joy as being that Van Doesburg was "filled with vitality and zeal" for abstract art. When Mondrian extols "the ability and admirable courage of Van Doesburg," it is specifically for Van

Doesburg's championing of Mondrian's own work and Mondrian's own credo. Even then, Mondrian insists on reining in his words by adding "I speak only of the period of my collaboration," implying that at other times Van Doesburg was less worthy.

Mondrian concludes his "homily" describing "feelings of joy and friendship." But those emotions were brought on thanks to other De Stijl collaborators, whom he names individually. Van Doesburg is excluded from the list.

The Fashionable Self

An innovative Parisian fashion designer and furrier, Jacques Heim, thirty-two years old, had, early in 1931, started a periodical he called *Revue Heim*. Its editors asked a number of leading contemporary artists to write about the future of fashion. Mondrian was among them, and he accepted the assignment enthusiastically.

Mondrian wrote proudly to various friends that he was in the process of writing an essay on fashion; he planned to do far more than Heim had asked for. The editors simply wanted the various artists to answer two questions. The first was whether they believed that fashion reflected the current direction of fine art; the second was whether what was happening in their own art enabled them to predict upcoming fashion trends.

Mondrian apparently wrote a more substantial text than what appeared in the magazine. The editors apologized for their inability to print each text in its entirety, but they had been stymied by the length with which some of the great names of the Parisian art world had responded and could not accommodate all of the material that had come in. Besides Mondrian, Sonia Delaunay, Robert Delaunay, Raoul Dufy, Tsuguharu Foujita, Marie Laurencin, Albert Gleizes, André Lhote, Leopold Sauvage, Kees van Dongen, and Henri Clouzot, a distinguished art writer and director of the Musée Galliera, were among the people who took the questions and ran with them.

Jacques Heim produced a publication of rare panache. He was sufficiently engaged with aesthetic issues and what really matters about style and clothing, as well as perfume, to have elicited significant responses from Mondrian and several other artists.

The son of Polish Jews who had moved to Paris and opened a fur workshop in 1898, a year before Heim was born, as a young man he had gone to work for the family business when it was still modest. He was so innovative in his use of rabbit and other skins that clothing designers including Coco Chanel, Jeanne Lanvin, and Paul Poiret collaborated with him on fur pieces. Heim also designed clothes which used pure cotton in pioneering ways and developed what was considered the first two-piece woman's bathing suit.

Jacques Heim, 1950. A Parisian furrier and fashion designer, Heim commissioned Mondrian to write an article on fashion. Mondrian described the style of one's clothing as "one of the most direct expressions of human culture."

Its top had ruffles, and the bloomers puffed out. Whether because of those details or because women were still too modest to expose their midriffs in public, it was not a great success, but it was the forerunner of the bikini.

Heim was an unabashed celebrant of human desire and pleasure. He made perfumes to which he gave the names "Je veux" and "J'aime." He is credited as one of the people who made Paris the center of the fashion world after World War II when Mme. Charles de Gaulle appointed him her official designer. His outgoing manner and lack of preciousness were fundamental to his success; following his death in 1967, the *New York Times* obituary characterized him as "a great jovial man who looked more like a businessman or banker rather than a fashion designer!" Heim's persona was in accord with Mondrian's taste.

The edition of *La Revue Heim* which published Mondrian's exegesis on clothing has snappy graphics and the best sort of Art Deco lettering. Opposite the dashing title page, there is a beautiful full-page photograph of an Alpine winter scene taken by the architect and designer Charlotte Perriand. This is no mere fashion magazine. A poem by the nonconformist poet Joseph Delteil, whose most recent anthology was titled *The Androgynous Swan*, and who was a friend of André Breton and Max Jacob and Louis Aragon, covers a two-page spread that follows. Dedicated to Sonia Delaunay, the poem opens with "Fashion of the future is profound and mysterious" and has the lines "No, nudity, monotonous nudity is not the most marvelous of costumes." It concludes, "The universe exists to serve women. Women are the center of everything." Illustrated with lavish flourishes by Marianne Clouzot, that poem sets up the reader for the imaginative, amusing images and text that follow. There are superb photographs of classically elegant women, and

then a serious and sympathetic article about fur-covered animals in the wild in Russia and the United States. The article in which artists are queried begins with an intelligent text declaring that couturiers require more than scissors and pins, that they are linked to literature, and that the question of what fashion will be tomorrow requires asking, "What will our existence be tomorrow?" With a statement that "a dress is a form of physical poem" (this being the closest translation of "poème plastique"), the editors then provide the two questions they asked the various artists.

Mondrian used the inquiry as a pretext for publishing ideas that were of central importance in his life. He opens this little-known essay with, "Fashion is not only the faithful mirror of a period, it is one of the most direct plastic expressions of human culture." The clothing one wears provides a chance for a complete breakthrough from tradition, he explains, and he is as rigorous in his standards for apparel as for painting and architecture. Clothes must be devoid of any deliberate historical reference, and of floral patterns or any other reproduction of natural imagery. Designers' insignias and names are nothing but devices to flaunt material worth and bourgeois acceptability; Mondrian loathed the idea of their use to provide the wearer of a garment with a sense of self-worth.

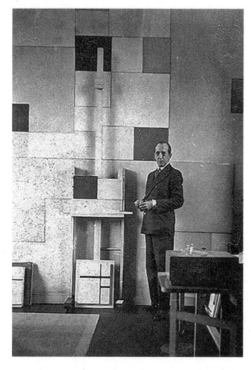

In this photo taken in August 1931 by Charles Karsten, Mondrian poses with his usual ramrod posture.

Mondrian states his values clearly and rigorously, while using the term "free art" in contrast to fashion design, in which functionality is a necessity:

> In fashion, however, just as in free art, we see a tendency to return to natural appearances. Nothing is more inhuman than regression. In order not to fall back merely into a new expression of the past, it is therefore most important for fashion to create an appearance expressing "man-nature" in equivalence . . . to oppose the undulating lines and soft forms of the body with tautened lines and unified planes so as to create more equilibrated relationships.

It is an audacious statement. Regression is, in fact, a human norm. By instinct, we all resort to old behaviors, respond to memory, and enter the world of our own pasts. It is natural to dress in ways that make one feel younger. Mondrian may not have liked this, but to call it "inhuman" betrays his inability to distinguish between his personal taste and reality for other people.

When Mondrian makes such declarations, it furthers the sense that, in his own case, memory, especially pertaining to natural instincts, belonged to territory he could not bear to enter. He was so troubled by the idea of looking at the past that he could not simply settle for his own avoidance of regression; rather, he had to go further, prohibit it for everyone, and declare it an aberration.

He quickly follows his assertion that regression is not human to insist that clothing should de-sensualize the body. That idea was completely at odds with what anyone else had to say. Mondrian states it so matter-of-factly, however, that few readers would have realized how unusual it was. For a middle-aged man to say that the objective of what one wears is "to oppose the undulating lines and soft form of the body with tautened lines and unified planes"—and to say so in the mouthpiece of Jacques Heim, the man who in that same time period was creating bathing suits meant to accentuate women's breasts and hips and to leave their bellies naked—was almost perverse. That he expressed the idea so coolly does not mitigate its peculiarity. To insist that women's skirts and tops encase their bodies in flat planes—drawing taut, straight lines around a woman's curves—or that men's trousers be cut like rectangular boxes, concealing the form of what lies underneath them, was a radical departure from the norm.

Mondrian himself did not dress according to his own dictates. His suit jackets were cut very much in the English style. There were straight lines in the jackets with their wide lapels notched at perfect right angles and squared

shoulders, and a precision in the way they were tapered at the waist, but they accentuated the form of his body. He was trim and fit, and very pleased to be that way and have it observed. His trousers had neat vertical creases, but he did not wear clothing that was primarily sculptural; rather, it was made to fit the man underneath. He also—inconsistent with his dictates in *La Revue Heim*—followed tradition, by wearing neckties, both bow ties and straight ones, not so dissimilar from what earlier generations of his family had sold in The Hague.

Nor was he so absolute that he would not occasionally wear perfectly round shirt collars, rather than the usual pointed ones. When he did so, he generally sported a collar bar. This meant that the horizontal line of the gold or silver accessory that pulled the two round collars closer to each other created a sort of launching platform for the vertical necktie; consciously or unconsciously, Mondrian was thereby making, more rigorously than with normal shirts and ties, a perfect horizontal-vertical juxtaposition with its concomitant right angles. But he was more human in his presentation of himself than in his dictates on fashion. And when he donned a patterned shirt or handsome combination of varying dark colors in the trio of jacket, shirt, and tie, he allowed himself to be photographed with a seductive wink in his eye.

As for what he wanted his dancing partners to wear: it is unlikely that Mondrian followed his creed of concealing sensuousness when he was out to have a good time.

II

Mondrian's sixtieth birthday inspired his admirers to rally to his support yet again. The De Stijl architect Cornelis van Eesteren wrote to him that fifteen people in Amsterdam were trying to collect the funds to buy one of his paintings to give to a museum in Amsterdam in honor of the milestone event. They wanted Charley Toorop to select it. Mondrian wrote to thank them on March 19, 1932, commenting, "All of you, shall we say, create new life and battle convention heading toward a dead end." Acknowledging how tough the financial situation was during the Depression, he said that he wanted them to have a painting for their purpose whether or not they actually raised any money for its purchase, although even a small amount would, he admitted, help him. He would be sure that the painting was one of his best. He was sorry that Charley Toorop, as well as Arthur Lehning, had not been able to get to Paris for his actual birthday, but he appreciated the honor they were giving him by helping pure abstraction become better known in his native Netherlands.

Having been so negative about Mondrian years earlier, Christian Zervos now changed his mind, again in print. Mondrian must have been surprised. Not only did the revered critic and editor praise his paintings in an exhibition organized by the Association "1940," but he said it was the opposite of Van Doesburg's work in the way it "simultaneously satisfied the eye and spirit." Zervos's main point in *Cahiers d'Art* was that many people were trying to paint in Mondrian's style, but that none of the others succeeded in producing work with such a positive impact on the viewer. Without acknowledging the way he had slammed Mondrian previously, Zervos argued that Mondrian's paintings were richer and better than those of his colleagues. "The dimensions of all the elements within each painting, the proportions of the forms, the rapports of the colors and their surfaces, are not the only qualities that reflect Mondrian's power. The sensibility, the mysterious gift that dictates the just and beautiful dimensions, plays a dominant role."

Alongside the article, Zervos reproduced a painting he had borrowed from Mondrian to show with work by Gorin and Arp in the Cahiers d'Art gallery on the rue du Dragon. In the neighborhood of Cahiers d'Art, Mon-

Mondrian is perched like a deity in the center of this group photo taken at the opening of the Gustave Buchet exhibition at Galerie Zak, Paris, November 22, 1929. Sitting, from left to right: Auguste Zawoyski, Michel Seuphor, Nadia Grabowska, unidentifed, Piet Mondrian, Florence Henri; standing: Henryk Stazewski, Stanislaw Grabowski, Pierre Choumoff, and unidentified.

drian was the person of the moment. Leaving the gallery, if you walked ten meters up the short and narrow street and turned right onto the boulevard Saint-Germain, you were greeted by a large red-and-white banner of one of his latest compositions. Suspended high above this great artery of Paris that begins and ends across from major crossings of the Seine, it advertised a show of modern Dutch art at the Galerie Zak. At the sidewalk cafés of the Deux Magots and the Flore, people sipped their coffees and ate their croque monsieurs with Mondrian's bold lines and lustrous colors in plain sight, free of charge, across the street from the wonderful Romanesque church for which the boulevard was named.

The show at Zak had four exceptional Mondrian paintings in it. No one bought anything, however. Mondrian was deeply disappointed. He needed to sell at least one work if he was going to succeed in having his new book see the light of day. Les Tendances Nouvelles, the publishing house where Seuphor worked, was prepared to produce it, if Mondrian would contribute to the costs. Without a sale at Zak, he could not afford to do so.

He tried the publisher Grasset, but they turned it down flat. Nothing mattered more to Mondrian than to get into print his ideas on the integrity of art and life, to disseminate the gospel that might awaken human civilization to unprecedented joy. He was convinced that his radical agenda for visual creation and everyday existence could pave the way to an end of human misery and a new well-being for all people.

Then, in June 1932, Les Tendances Nouvelles allowed that they could publish the book so long as Mondrian put up a thousand francs, which was less than the investment they had initially demanded. Mondrian agreed, and immediately set out to write a new introduction to the manuscript they had approved. He had to do so, he wrote Van Eesteren, "because people don't understand why a painter has to deal with questions of existence. They don't see that the laws of existence can perhaps most clearly be expressed in art." But Mondrian subsequently realized that the book was to have a small format and a typeface that was practically minuscule. It would be twice as expensive for him to have it printed as he wanted, and since he did not have the two thousand francs needed, he again had to put it on hold.

III

On June 16, 1932, the thirty-five-year-old art collector Sidney Janis, who had come to Paris to see the Picasso exhibition at Galeries Georges Petit, was taken to 26, rue du Départ. The encounter changed both their lives.

Janis—a short, dapper man with expressive eyes and long straight hair brushed straight back off his forehead like Mondrian's—usually sported bow

Sidney Janis, 1943. The art dealer, who had been a professional vaudeville
dancer, used some of the fortune he made manufacturing shirts to acquire
work by Matisse and Picasso before buying a Mondrian for $70. Later in life,
when asked who was the single greatest of all modern artists, he answered,
"Mondrian."

ties, and looked as if he might pick up a walking stick and start a song-and-
dance routine. Janis was confident and successful and Mondrian, while prob-
ably on guard because of his inveterate anti-Semitism, was happy to receive
the collector, who, even in these difficult economic times, was in Paris in part
to see Picasso in his studio and buy some of the Spaniard's work. In 1929,
he had bought Picasso's *The Painter and His Model*, having sold a Matisse
that had been an earlier purchase in order to do so. Even if that large canvas
illustrating a sexually charged exchange—between an artist who resembled
Picasso himself and his naked female model—represented a different world
from Mondrian's, its acquisition identified Sidney Janis as someone willing
to take risks.

Born in Buffalo, New York, as a teenager Janis had been a professional
vaudeville dancer, working on a circuit of small theaters. Janis's father had
made a name for himself as a cakewalk dancer and champion roller skater
while earning a living by selling clothing, and Janis was cut from the same
cloth. Like Mondrian, he knew the latest dance steps; he and his vaudeville
partner had publicly performed the one-step and the "hesitation waltz," with
its distinct stop and glide.

After the world war, during which Janis had been an airplane mechanic in the marines, he had returned to Buffalo to work for his older brother in the retail shoe business. This required his going to New York, where he would take breaks from calling on footwear wholesalers to visit art galleries. He relished this as "a nice, free diversion that you could enjoy in the daytime." He moved to the city in 1925 to open a shirt company, which he called M'Lord, and married Harriet Grossman, who became the bookkeeper of the new enterprise.

Janis had a scheme for selling shirts. Other manufacturers offered a range of sizes and colors; he made and sold only white shirts, a single model, with the unprecedented detail of two breast pockets. At trade conventions, where the competition had large display cases to show their range of shirts, he "would breeze in with a single brown envelope in hand. When asked 'Where's your line?' he would simply tap the envelope confidently." The orders poured in, especially in Florida, where Janis went to capitalize on its boom as a holiday destination. M'Lord thrived, and Janis began to buy rather than simply look at art on the gallery visits that had been part of his routine ever since the early days. First came a Whistler etching, in 1925, which he swapped a year later toward the Matisse oil, which, three years after that, he used as part of his payment for the large Picasso. In 1932, he and Harriet moved from the New York suburbs to an apartment in a building on Central Park West near Columbus Circle. Inside, it was as big as most American houses. Sidney and Harriet Janis had just begun to consider what they would like to have on the walls there when the collector first met Mondrian.

On that initial visit to Mondrian's studio, Janis bought *Composition with Red and Blue* for $70. It would not be until the following year that the artist shipped it to New York, by which time he had constructed and added a frame, its corners joined at right angles rather than mitered at forty-five degrees like all of Mondrian's frames to date. To get rid of the miters, Mondrian had developed a new carpentry technique to marry the strips with vertical and horizontal joints.

The composition that Janis acquired with a zeal and a decisiveness rare for art collectors was a new departure in Mondrian's work. A small vertical canvas, it has a bifurcated red rectangle in its upper left-hand corner, and a horizontal blue landing pad on the lower right. The impeccable proportions and positions of the two sole areas of color create a physical leap. This is a springboard which reverses all of our normal notions of how things should be. The tiny sliver at the bottom is, in its luminous, celestial blue, the sky: emotionally and physically weightless. The white that blankets most of the surface is also ethereal. On top of and above these dematerialized elements, the vibrant red rectangle and the vertical and horizontal black lines which

define the composition are embodiments of both maleness and femaleness, according to Mondrian's own theories. He has related his female and male elements with combustive passion.

The Janis painting is also a dance. On that first encounter, Mondrian and Sidney Janis might well have compared notes on the movements and rhythm requisite to the one-step and two-step. As the starting point of Mondrian and Janis's connection, *Composition with Red and Blue* reflected their shared passion. The composition simultaneously glides to the left and sashays to the right, while jumping upward and holding its arms out for balance.

This is not to say that the painting purports to be about a specific human act. Rather, it has the qualities of humanity in general, of all action throughout the whole universe. This is the point Zervos had perceived so aptly: Mondrian's mysterious powers which are beyond mathematics. Even when we elucidate the devices Mondrian used to make the magic occur— his deployment, for example, of a particularly bright white in the rectangle which is the field on the lower left, as opposed to the very slightly grayed whites to its right—the resulting energy and verve is beyond formulaic understanding.

Once he had finished the framing and any other revisions he might have snuck onto the canvas after Janis's purchase and at last shipped it off to New York, Mondrian wrote Sidney Janis that he was "sad to see it leave my hands; it is like a rose." In that simple, short statement, Mondrian shattered three of the fundaments of his mythic reputation. He was emotional; he was, on occasion, deeply attached to some of his paintings; he considered a living flower to be the epitome of beauty.

Unlike the Mondrian canvases soon to be confiscated in Germany, this painting would have a splendid fate. It introduced Mondrian's work, brilliantly, to a large American public in loan exhibitions at New York's Museum of Modern Art. Eventually, it would go on view with more of the artist's masterpieces in the gallery named for Sidney and Harriet Janis, who would be instrumental in making "Mondrian" a household name not just in the United States but internationally.

IV

In "The New Art—The New Life," an essay Mondrian wrote in 1931 but that was only published after his lifetime, he writes, with key phrases underscored for emphasis:

If we clearly see what underlies almost all the defects in our social and private life, we find that dependence is our downfall. It is not always the

weakness, frailty, or wickedness of man that leads him into dishonesty and disasters. On the contrary, <u>they generally arise from the need to protect his existence.</u>

<u>Above all, material or spiritual dependence produces the degradation of life, the degeneration of man, and retards human progress.</u>

This unpublished essay articulates the beliefs and decisions that not only governed every element of Piet Mondrian's life in Paris but that pertained equally to his attitude about the necessity he was soon to face of moving from Paris to London and then from London to New York because of the hazards of war. Disparaging "spiritual dependence," Mondrian was referring to organized religion. He had grown up in a milieu where everything revolved around religious practice and affiliation. He had seen his father allying himself first to this movement and then to that one, succumbing to the rules of arch-Protestantism at the expense of his own freedom. Material dependence, meanwhile, had bound most of Mondrian's other family members, the haberdashers and wigmakers, to their way of life. Had Mondrian gone through with his intended marriage, he, too, would have been dominated by material obligations.

He saw life as a minefield that had to be navigated if one were to escape the tyranny of everyday obligations to people other than one's self. "One of man's worst vices is mutual exploitation. Because we are too weak or powerless to secure our own existence, we seek the help of others." He loathed the way some people profited while others suffered in order for them to do so. "Mutual exploitation is practiced so cunningly in our society that it is not punished. . . . Yet it is as much a crime as those that are punished; it is really theft." He was confident, however, that this "detestable social situation" could change—once one had "a materially and spiritually independent life."

Mondrian followed with a description of the ideal existence that suggests that he had truly opted for sexual solitude, at least ever since that first move to Paris when he was forty years old, and perhaps earlier.

As so marvelously portrayed by Adam in the Paradise story, perfect man is entitled to live without care, even without working. In this state, he really breathes, he feels his rhythm at one with the vital rhythm everywhere and in everything. The constant, contrasting, cadenced opposition of this rhythm being equilibrated, he lives in perfect equilibrium.

Life is basically simple. It may grow more and more complex, but it need not lose this simplicity.

Complexity needs to be perfected: simplicity is man's perfect state.

Mondrian is speaking of Adam in the paradise he lost forever when Eve appeared and he became sexual. "Man's perfect state," when "he really breathes" and "lives in perfect equilibrium," depends on resisting the apple. Did Mondrian really expect his readers to agree?

But then Mondrian comes out in favor of sex after all. He writes, "To acquire experience and knowledge, man needs total opposition. As shown by the creation of Eve in the Paradise story, primitive man's nature requires not only outside opposition—contrary but homogeneous—but also the upsetting of his equilibrated state, which was originally particular equilibrium." What he calls "the equilibrated rhythm of contrary oppositions"—as realized in his own recent paintings—"is not only the culmination of human life but also the profound content of the life we all live."

Adam, before experiencing sexual desire, may have been in an ideal state as the "perfect primitive man" while "not conscious of life," but Adam's real life only began once he started to live with oppositions and became "conscious."

Equilibrium—the goal of human life—depends, Mondrian writes, on "equivalence of the two fundamental oppositions." He goes further: "This equivalence creates individual liberty, frees us from suffering, liberates us." After some more mental wandering, he underscores an entire sentence: "Only through equivalent relationships can the oppression of particular form be annihilated so that the tragic in life ceases to be reflected in our palpable environment." The opposition is horizontal/vertical, female/male, all within the single self. If we realize those forces in tandem, inside us as individuals, in the art we look at, in the design of our environment, we achieve not just mental health but also incalculable joy. The oppositions intrinsic to human existence must be celebrated and balanced, no element overpowering the other. Only then can an individual be totally fulfilled. Successful art echoes them through conscious manipulation of abstract form. Dependence on other people, like representational art, is fraught with elements of emotionalism and time passing and therefore the eventuality of death. Internal order, and the intentional rather than the haphazard, constitute the solution.

Mondrian advocates "purer mutual and individual relationships . . . disinterested love, genuine friendship, true goodness, etc.!" Describing those qualities, he evokes his paintings as their exemplar. "The mutual separation of particular forms is the beginning of the independent existence of line and color, because thus freed, they lead to the creation of neutral forms (and consequently of free lines) that are above limiting particularities. . . . Thus, art demonstrated that the mutual separation of individuals leads to individual and social liberty." The isolation of the color planes in his work is comparable to his own solitary existence on the rue du Départ.

We all have a tendency to lean on one another. This tendency produces false friendship. But man is born alone and dies alone; he is destined for independent existence. . . . Mutual separation is necessary for man's evolution in life as in art.

That mutual separation is fundamental to the composition of his paintings.

Mondrian wrote, "Whether we conceive life as joy or as suffering depends on which is most important to us: abolition or creation." Mondrian grew up in a world almost entirely lacking joy. Abolition—of pleasure in the form of dancing, of health protection in the form of vaccination, of charming clothing or festivity—ruled. Mondrian chose to devote his life to creation as an alternative to all that chronic forbidding, to be positive rather than negative, to accept rather than rule out.

Mondrian goes on in *Art and Life* to praise the human quest for perfection and the resultant improvement of artistic techniques along with the advances of science. He extols "the enormous influence of science and technology on internal relationships through progress in the use of steam and electricity." He was more conscious of the world around him than he appeared to be to people who knew him.

And, while he was critical of human foibles and greed and cruelty, he was convinced that society's ills were diminishing.

Every day we witness the marvelous discoveries and growing profundity of medicine. Here we see that knowledge truly creates happiness! Its progress has already done much to diminish the tragic in life, to reestablish the state of equilibrium, that man must lose as he gains other qualities.

The progress of medicine is therefore of utmost importance to mankind. Evidently this progress coincides with man's evolution; but this requires time!

Therefore, it is not the perfecting of science and technics that hampers truly human life but quite the reverse: the fact that they are not sufficiently perfected, and above all, that their organization or application is still imperfect and often terrible.

Life today is made disequilibrated by the wrong use of science and technology. Wonderful things like machinery, means of transportation, etc., employed by the mentality that favors private interests at the expense of others—this is what darkens life.

In order to free life—by destroying or displacing bad organization by just relationships—we cannot do better than create conditions worthy of man.

In all areas of life, social and economic, we must create new organizations—but as true socialism envisages, <u>self-governed organizations composed of producers and consumers in equivalent mutual relationships.</u>

The machine above all is a necessary means for human progress. It can replace man's primitive strength, which must be transformed in the course of human evolution.

The creation of the machine itself proves that man has already lost much of his animal force and has therefore sought to replace it. The machine can free man from his state of slavery.

This cannot happen in a single day. But in time the machine can restore man to himself. For man <u>does not live in order to work; he works in order to "live."</u>

The Certainty of Art

The temperatures in Paris turned unusually frigid at the start of 1933. Mondrian's bouts of illness were now more frequent, and brutal winter weather made them worse. His bad colds, rheumatism, and digestive problems caused him to struggle each morning to gain enough energy and well-being to paint. But his art was his ballast, and he summoned all of his force to work. When he was too weak to paint, he wrote. He would perpetually push forward with further texts championing pure abstraction, even if they repeated the ideas he had put on paper many times before.

Lozenge Composition with Four Yellow Lines, which he painted with the changes of seasons, was a breakthrough. By description, this new work, another diamond painting—a nearly square canvas turned forty-five degrees—was essentially the same as the 1930 *Composition with Four Lines*. As before, a square has been superimposed at a forty-five-degree angle to the tilted support so that the top and bottom of the square are perfect horizontals, parallel to the ground, and its sides are perfect verticals. But Mondrian had taken a major step. The square that has been painted in outline is the same dimension as the canvas, so that its corners are lopped off by the angled support and less of it is visible than was the case in 1930. Mondrian also now gave the lines that form the square differing widths. Most audaciously of all, he painted them a luminous yellow. They shimmer; they are ethereal, but forcefully present. We mentally imagine them extending into space, beyond the boundaries of the canvas; that magical conjuring, and the way it activates the viewer's mind, is part of Mondrian's genius. With minimal elements, he had achieved a new level of vivacity.

In January 1934, Nelly van Doesburg and the painter César Domela proposed that Mondrian be one of the four principal artists in an exhibition in the galleries of Association Abstraction-Création on the avenue de Wagram. The others were Domela, Theo van Doesburg, and Jean Gorin, a painter

whose work resembled Mondrian's. Mondrian declined. He wrote Gorin to explain. While congratulating Gorin on the way that his art and that of Domela "was separate from the art of the picture [tableau]," which in his eyes was "progress, because you know that I believe in the future end of 'art,'" he said that the problem was that Domela and Van Doesburg still treated their work as pictures.

Yet his arch stance created a dilemma. He needed his work to be exhibited in public, but by being unwilling to be in a group show and unable to finish his latest work to his own satisfaction, he made this nearly impossible. Later that January, Robert and Sonia Delaunay visited Mondrian and insisted that he send a large new painting, barely finished, to the Salon des Tuileries. Mondrian was annoyed. He complained to more than one person that he was so rushed that he had not even had the time to frame the barely dry canvas, yet he accepted the reality that he needed his paintings to be seen and to sell.

The Delaunays had traipsed up the three flights of decrepit stairs at 26, rue du Départ on a Sunday afternoon, having waited respectfully for Mondrian's calling hours to begin at 3 p.m. In their stylishly modern clothing, badgering the bedraggled Mondrian in unison, not only had they pried the large canvas from him while the paint was still sticky to the touch, but they had also managed to secure a smaller one for the show, which even though it was still called the "Salon des Tuileries"—the twelfth such exhibition—was held at 235, boulevard Raspail. There were over two thousand works in the show, most of them by unknown artists of no distinction. Sonia and Robert Delaunay each had two works in it, but neither Arp, Léger, Matisse, nor Picasso allowed his work to be part of this hodgepodge made by men and women from all over Paris and its suburbs. The Delaunays, eager to have another high-caliber artist in the mélange, had prevailed only because Mondrian felt he had no choice, and that it was better than being in the smaller exhibition with work of the late Van Doesburg.

Mondrian was given no special position in the large show, but the viewers who noticed his contribution had a great treat. *Composition Blanc et Bleu*, which is nearly four feet high and two feet wide, is visual bravura. The size and strident verticality of the canvas give it the authority of a great leader. It is commanding like a king or military general marching ahead of his admiring followers in a parade. This noble canvas is composed of spectacularly simple elements. Two black vertical lines span it from top to bottom; two short horizontals run between the right-hand vertical and the right edge of the canvas. These four linear elements are of equal thickness. A single, small rectangle of blue fills the void the artist created in the upper right-hand corner. Although the whites are different from each other, the canvas, so

grand in scale, could hardly be more minimalist. But its action is constant, the rhythm bold.

The "little one with red," as Mondrian described the other painting he sent, provided a nice counterpoint to the domineering, elongated *Composition Blanc et Bleu*. By Mondrian's standards, it is actually not so small. Almost square, it measures nearly twenty-three inches across and twenty-four in height. With those dimensions, it is approximately half the size of *Composition Blanc et Bleu*.

At the Tuileries show, this painting with a red form was hung with its top edge snugly against the bottom of *Blanc et Bleu*, which was almost the same width but twice the size. Large paintings by Robert Delaunay were positioned immediately to the left and right of the pair. An abstract sculpture by the young, Chicago-born Gwen Lux—a pioneering artist who often worked in polyester resin, and who was married to the architect Eugene Lux (they had collaborated on a recent skyscraper in Chicago, her lively relief sculptures gracing its facade)—was directly in front of the two Mondrians, surprisingly close. Many of us would rather see each of those fantastic Mondrians individually, at eye level, isolated. For the artist himself, however, this installation was exactly as it should be. He wanted his art presented without preciousness. He dismissed the notion of "pictures" in favor of the idea of a totality where art and its setting are one and the same. And it suited him to have his two paintings seen together as a vertical unit with the top part twice the size of the bottom—creating a new, third composition.

One might expect Mondrian to have been as precise about the installation as he was about his own paintings. Given his views on the essentials of art, how could he tolerate seeing his work with art that was pictorial, lyrical, picturesque, and on occasion expressionistic? Was this not totally inconsistent to be so finicky about his own painting and so absolute about his criteria, and then to be indifferent, even at ease, with these careless installations?

Yet the crowding of such disparate artworks in the big exhibition tickled him, as had the showing of his art on an angle among overpacked bookcases at "L'Esthétique," and its presentation in Mart Stam's exhibition of chairs. To have his paintings simply be there in this relaxed, unprogrammed way was part of Mondrian's revolutionary agenda.

III

In the spring of 1934, the editors of the third yearbook of Association Abstraction-Création asked member artists what they wished "to express" in their work. Mondrian deflected the question with a response that was deliberately contrary. In art, "to express" suggests voicing personal emotions.

"Expressionists" were artists often determined to convey their inner torment by using visual distortion. Mondrian reversed that notion of "express" into a quest for objective rather than subjective qualities. He described his own goal as "a blend of qualities both universal and impersonal," and his means as neutral, calm, and straightforward. Moreover, Mondrian stated that what was true for him was true for everyone.

> What do I want to express with my work? Nothing other than what every painter is looking for: to express harmony by the equivalence of the rapports of the lines, the colors, and the overall plan. But to do this in the clearest and strongest way.

Abstraction-Création had briefly given him the hope that the neutrality and purity of Neo-Plasticism would gain stature, with his means of expressing harmony being adapted by more people. But now, three years after its founding, the executive committee of the organization was so eager to increase the membership that they abandoned their initial artistic standards. They succeeded in expanding the roster to nearly four hundred artists, but Mondrian would have nothing more to do with them once they ceased to make pure abstraction their raison d'être. He could exhibit with almost anyone, but an artists' organization had to stand for something and never slacken its principles. Mondrian was not alone in resigning from Abstraction-Création; Arp, Calder, Sophie Taeuber-Arp, Robert Delaunay, Otto Freundlich, Naum Gabo, Barbara Hepworth, and Hélion also left.

Gabo, meanwhile, had become another of the stalwarts who were bent on Mondrian's survival. In this period when he was no longer sending paintings to Dresden, Hannover, and the other German cities where only a few years earlier he had been treated as a modern master, Mondrian was again struggling to make ends meet. Mondrian had first come to know Gabo, a Constructivist sculptor, born in Russia, after Gabo arrived in Paris in 1932; they were never more than passing acquaintances, but Mondrian had periodically encountered him and his brother, Antoine Pevsner, at exhibition openings and with mutual friends. Pevsner and Gabo were both devotees of pure abstraction, their intricate sculptures tidy formulations of lines and planes, their materials—wire and plastic—representative of nothing previously known. Under the rubric of "Constructivism," their work had complex structures and an active sense of assemblage very different from the simplicity and purity and refinement essential to Mondrian, but they respected Mondrian immensely. Gabo told him about the Caisse du Syndicat des Intellectuels en Chômage. This was the French equivalent of the Works Progress Administration in the United States, the American government's organiza-

tion that kept writers and artists from starving in this period of financial downturn. Mondrian went on the dole, receiving the equivalent of welfare payments of about eighty-five francs, around $63 today, every fifteen days.

Mondrian no longer spoke of giving up painting and taking a job working in a vineyard or on a farm in a region of France where it would be cheaper to live than in Paris. He had his government stipend, and his staunch supporters in America were trying to expand the market for his work. The newcomers, beyond Katherine Dreier, A. Everett Austin, Alfred Barr, and Gallatin, were Eugene and Gwen Lux and James Johnson Sweeney. Sweeney, a bright young art historian who would become a curator at the Museum of Modern Art—and, later in life, director of the new Guggenheim Museum—began writing about Mondrian, and got his work shown in Chicago for the first time.

Mondrian was not only on the receiving end. He recommended the work of Arp and Robert Delaunay to Sweeney. They were his favorites among his fellow artists. He also respected the Bauhauslers—Kandinsky, Moholy-Nagy, and Josef Albers in particular—and even if he did not champion them to the same extent, he helped put them on the radar for the forward-looking American collectors, museum directors, and gallerists who respected him as a guide to modernism at its best.

American culture offered Mondrian a lot. That November, he made a rare outing to an evening concert. The performer was the jazz vocalist and trumpeter Louis Armstrong. The thirty-two-year-old Black American from New Orleans was performing at the Salle Pleyel. This twenty-two-hundred-seat

This image of Mondrian in May 1934 with Gwen Lux shows the charming side with which he often beguiled his female friends.

Mondrian's collection of
phonograph records of recent
jazz music was among his few
material possessions. He loved
to dance, sometimes alone.
1934, 26, rue du Départ.

neoclassical concert hall on the fashionable rue du Faubourg Saint-Honoré, financed by the piano manufacturer Pleyel & Cie, had opened six years earlier. At its premiere performance, Igor Stravinsky and Maurice Ravel had both conducted their own music along with work by Wagner and Debussy. Mondrian had phonograph records of "Satchmo" playing and singing, and the chance to see and hear one of his favorite musicians in person in the prestigious theater on the other side of the Seine was not to be missed.

It was Armstrong's second European tour, and he was accompanied by an all-Black orchestra of Africans, American expatriates, and West Indians living in Paris. There were two other musicians on trumpet, two on alto saxophone, and one per instrument on the trombone, tenor saxophone, piano, guitar, bass, and drums. The abundance of woodwinds filled the hall with a lush and absorbing sound as they played recent hit songs like "On the Sunny Side of the Street," "Tiger Rag," "St. Louis Blues," and Armstrong's own "Song of the Vipers."

It was also the first time he performed "Will You, Won't You Be My Baby," a 1920s song made famous by McKinney's Cotton Pickers. That eminently danceable song was too melodic for Mondrian, the part where Armstrong sang too much of a cliché of a man pursuing a woman. Mondrian was disappointed. He wrote Gorin that Armstrong was already passé, except for the way he played the trumpet, which was in straight lines. "He's a true artist," he allowed, but it was only Armstrong's adventurous, free-floating trumpet solos that were unmelodic enough for Mondrian. Besides, he thought that the Pleyel was too old-style for jazz.

Still, Mondrian's spirits were high. As the new year approached, he was

in one of his high-energy stages. He was finally getting somewhere with his work; he would finish a dozen or so new paintings in the first few weeks of 1935. Victory was just around the corner. Whenever he had these bursts of optimism, the number of canvases he felt on the verge of completing was almost invariably twelve, although he rarely realized the dream. Unfortunately, there was no one else around to tell Mondrian that he occasionally had this same fantasy of completing a dozen pictures. He always believed that the paintings would reach their pinnacles simultaneously, as if with a drumroll. Mondrian was, indeed, working on a dozen paintings at once; it is just that he was unlikely to finish even a single one to his own satisfaction in the month ahead. He would inevitably see one more line to make leaner or a block of color to enlarge and then move a centimeter to the left.

IV

That December, a young American who had seen Mondrian's paintings at the house of the collector A. E. Gallatin in New York and felt he had to meet the artist knocked on the studio door at 26, rue du Départ, without an appointment. The American blurted out that his name was Harry Holtzman and he had come to Europe expressly to see Mondrian.

The sixty-two-year-old artist faced his twenty-two-year-old visitor and simply said, "This is very unusual." Holtzman waited to see if Mondrian would close the door on him or invite him in. Mondrian beckoned him to enter. Sitting in pitch blackness, unable to see one another, they talked for an hour and a half in a mix of French and English. Finally Mondrian turned on the gaslight.

The two would spend several evenings together over the next five months. Their conversations were harmonious and positive, the world outside increasingly troublesome. Hitler moved into the Rhineland, threatening France. Holtzman was annoyed that the English and Americans kept France from "calling his bluff." Holtzman would have liked to stay in Paris just to have those occasional visits with Mondrian, but he felt that the occupation of the Rhineland would lead to Germany's taking all of France. Nazi anti-Semitism was already clear to Holtzman; as a Jew, he anticipated what lay ahead and decided to set sail. Mondrian said that, if he were younger, he would join the amiable lad who was young enough to be his grandson. He had no idea how prescient he was.

The Support System

I

In 1935, another lady who was young enough to be Mondrian's daughter found him irresistible regardless of his awkwardness and diffidence. The English artist Winifred Nicholson, would, in the course of that year, become a significant ally and friend.

Nicholson would turn forty-two just before Mondrian's sixty-third birthday. Her marriage to the English artist Ben Nicholson was on the rocks, and she and her three young children had temporarily moved to Paris. She and Mondrian had met previously; now they came to know each other better. Their relationship was of such depth that Mondrian did the unthinkable: he warmly praised her naturalistic painting.

The former Winifred Roberts had been born in Oxford to a prominent family of Liberal politicians and activists. Her maternal grandfather, George Howard, was a painter who belonged to the group of artists called "The Etruscans" and was a patron of the Pre-Raphaelites. The ninth Earl of Carlyle, he owned a cluster of massive crenelated towers that formed Naworth Castle in Cumberland; the enormous, baroque Castle Howard in Yorkshire; and a more modern house in London, designed for him and his wife, Rosalind, by Philip Webb, at 1 Palace Green, Kensington. The family's private art collection at Castle Howard had one of Titian's masterpieces as well as pictures by Gainsborough and Reynolds, so when George Howard had Winifred, whom he addressed as "Darling Pluffit," start painting at age eleven, she had good material to study as she developed her skills. They were a talented family; Charles Roberts, Winifred's father, had written a book called *The Radical Countess*, about Rosalind, his mother-in-law, who championed temperance, women's suffrage, and other liberal causes.

Brought up by a nanny, Madge Sparrow, and a sequence of governesses, Winifred developed an early fondness for stories about fairies and for the worlds she imagined when walking in the woods. She adored animals, pretended she was a collie, and rode her pony at every possible moment. Her pets became her closest friends. In background and taste, she and Mondrian had nothing in common.

Then Winifred broke the mold of her upbringing by marrying an abstract artist. But even if Ben Nicholson was artistically avant-garde, he also came from a comfortable and distinguished family. Ben and Winifred were born to cultured luxury; belonging to the same milieu, they both enjoyed its benefits even though they rebelled against its expectations.

Ben's father, William Nicholson, the son of a Tory MP, was a successful traditional painter. Ben's mother and sister were painters, one of his two brothers was an architect, and his maternal grandmother was a niece of the Lauder brothers, a famous nineteenth-century artist duo. It was natural enough for Ben to become an artist, and he got his start at age ten after meeting the playwright J. M. Barrie in Sussex during a family holiday; he made a drawing that Barrie ended up using in a poster for a production of *Peter Pan* for which William Nicholson did the sets and costumes. After training at the Slade School of Art from 1910 to 1914, Ben began painting in a manner related to synthetic Cubism as well as to the primitive style of Henri Rousseau. Even before they actually met, Winifred had a premonition that she would marry him. She was in the country house, near Oxford, of a prosperous Howard aunt when, from the drawing room, she realized there was a man in the entrance hall speaking with her aunt. She had not yet laid her eyes on him, and could not discern what he was actually saying, yet she "knew in an instant this was the person I would be marrying."

During the summer of 1920, Winifred Roberts and Ben Nicholson were part of the same large group of people holidaying in Tippacott in Devon, and

Winifred Nicholson in her Paris studio, c. 1934. More than twenty years younger than Mondrian, she was a great admirer and supporter. It was with her guidance that Mondrian left Paris to move to England. While he usually disdained representational art, he made an exception for her lyrical landscapes.

they painted side by side. Winifred would never forget how, together, they "saw that wide cloud, floating away in whiteness." She would equally remember the two of them drawing in pencil, evoking "the swing of the moors, hard and black." She was destined to swoon for the art of Piet Mondrian.

When Ben Nicholson and Winifred Roberts were married that November 5, at the handsome church of St. Martin-in-the-Fields facing Trafalgar Square, they had a style all their own. The church, built between 1722 and 1724, was designed by James Gibbs in creamy white stone, with a perfect pediment and impeccably measured columns and Corinthian capitals that epitomized neoclassicism. But even if the forms and building materials were familiar, when it was erected as the reconstruction of its sixteenth-century predecessor commissioned by Henry VIII, a furious public had considered it outrageous and revolutionary. Both the understated elegance of the building and the historic opprobrium suited the couple being married. Winifred marched "up the isle . . . at a hand gallop." With that spelling mistake and description of herself, the bride who would compare herself to a horse was an unusual product of her social echelon. She wore a dark brown, utterly plain woolen dress. Ben had chosen it, and she felt she looked "like a monk." It was not a picture-book wedding. Ben had also specified the "dark red roses" bound tightly with a "dark blue ribbon," which she did not like, any more than she relished the snootiness of her aristocratic relatives during the wedding breakfast in her mother's house on Holland Park. But if the bride and groom did not fit in with the world of Winifred's upbringing, they were joined inextricably to one another by their independence and desire to make art.

The Nicholsons were an intrepid couple who had financial wealth and family encouragement that paved their way for a life together devoted to the purpose of creating visible beauty. Winifred's fortune enabled her and Ben to have a leisurely honeymoon meandering through Italy, painting the occasional watercolor and relishing the charms of Venice, Florence, Rome, Amalfi, Portofino, Genoa, and other fashionable watering spots and beautiful cities and fishing ports. Then they rented a house overlooking Lake Lugano, in Switzerland near the Italian border, until Winifred's father gave them the funds to turn the rental into an outright purchase. Winifred wrote her parents describing their idyllic life: "We do absolutely nothing, but paint all day, eat supper and tea at 6.30, wash brushes and prepare canvases, go to bed and dream painting. Sometimes we go for a walk to look for new painty things." To a friend from art school she described herself and Ben as "utter paint fiends. We have cobalt green with our coffee for breakfast, lunch at 4, and rose madder for supper, and all our clothes smell of turpentine." In the Alps, they both painted the scenery, with Ben abstracting it in lyrical yet

experimental compositions. Winifred was more traditionally figurative, and used more cheerful colors. She had a rare ability to render the landscapes of the Ticino in a naïve, childlike style achieved with a sure grasp of painting technique. She ably captured the way light falls—whether on snow in the dead of winter, grass on a bright summer day, or water inside a cast-iron pan sitting on glowing embers.

Henri "The Douanier" Rousseau was the Nicholsons' favorite painter. They traveled to Paris to look at as many paintings by him as they could find, and also immersed themselves in African sculpture and the latest work by Picasso, Derain, and Matisse. Ben was disappointed by what those painters, previously his preferred contemporary artists, were now doing; "Bar select few, they have all lost the pt of painting. . . . It is all froth."

The young couple settled back in London. Within a decade, they had a son and two daughters. Winifred's paintings focused on their domestic life. She made portraits of the children, either with Ben or on their own, and also painted still lifes of flowers, in profusion. Her art reflected what looks like a happy, comfortable existence.

But the Nicholsons' way of life fell apart in 1931 when Ben encountered the sculptor Barbara Hepworth at an exhibition where he was showing with Hepworth's husband, John Skeaping. Then they met again—it is not clear if this was plan or happenstance—at a cottage in Norfolk where Henry and Irina Moore were spending the summer. At the start of the following year, Ben left Winifred and their three children and moved into a studio near Hepworth's. In order to reconstruct her life, following the dissolution of a twelve-year-long marriage, the grief-stricken young mother moved to Paris in September 1932 and began to paint under the name Winifred Dacre. The separation from Ben was painful for her, but sufficiently amiable for him to come to Paris periodically, in order to see the family from which he was estranged.

II

Winifred Nicholson initially met Mondrian in 1934 thanks to someone who had recently become one of his most ardent devotees, the English modernist painter Marlow Moss. Strong-willed and eccentric, Moss made a mark with her personality and lifestyle as much as her art. Born in 1889 to a successful clothier and hosier, she had rebelled against her parents' plan for her to lead a calm bourgeois existence like theirs and had gone to the St. John's Wood School of Art and then the Slade. Then, at age thirty, she collapsed mentally and went to live in solitude in Cornwall. Four years later, she read a biography of Marie Curie which gave her the courage to move out of isolation,

return to London, plunge into sculpture at the British Museum and, in 1926, to set up a studio in London so that she could paint. She would maintain that if it were not for the book about Marie Curie and her breakthroughs as a woman scientist, she would not have revived.

With the move, she changed her name. From Marjorie Jewel Moss, she became simply Marlow Moss. She transformed her appearance so that she resembled a man by cutting her hair to a length slightly longer than a buzz cut and starting to dress as a jockey, always in jodhpurs and a cravat.

Moss had the money to live as she wanted, and in 1927, went to Paris. There she met the writer Antoinette Hendrika Nijhoff-Wind, thirty years old to her thirty-eight, wife of the Dutch poet and essayist Martinus Nijhoff. It quickly became apparent to both women that they would become lovers, as they would remain for the rest of Moss's life.

Nijhoff and Nijhoff-Wind had been friends of Mondrian's in Laren. The two writers had married when Nijhoff-Wind became pregnant at age eighteen, and Mondrian also knew their young son, Wouter Stefan, called "Faan." In 1920, mother and son, on their own, moved to Paris after deciding that the Netherlands was too stuffy, and Nijhoff-Wind kept up the friendship with Mondrian, who had returned to the rue du Départ the previous year.

After about a year, Nijhoff joined his wife and young son again. The family of three moved to Italy, where the Nijhoffs ran a guest house in Settignano. The relationship of the couple and an Italian woman named Maria Tesi who ran the guesthouse with them eventually became the basis of Nijhoff-Wind's novel *The Four Deaths*.

Martinus Nijhoff rejoined his wife and son, but with an understanding that Antoinette, who used the nom de plume A. H. Nijhoff and was called Netty by friends, also kept an apartment with Marlow Moss. A. H. Nijhoff published her debut novel, *Two Girls and I*, about the existence she and Marlow Moss shared. A. H. Nijhoff also translated André Gide's novel *La porte étroite* from French to Dutch.

Netty Nijhoff was not Marlow Moss's only reason for being in Paris. Shortly after she arrived in France, she had begun to study painting with both Léger and Amédée Ozenfant at the Académie Moderne. In 1929, Netty Nijhoff showed her Mondrian's work, and Moss was transformed.

Moss was a follower of Matila Ghyka. Ghyka, the great-grandson of the last reigning prince of Moldavia, was a Romanian naval officer married to a descendant of the kings of Connacht. In 1927, he had published *The Aesthetics of Proportions in Nature and Art*, in which he developed his theory of the Golden Ratio. A friend of Proust and a habitué of Natalie Clifford Barney's literary salon, he synthesized mathematics and poetry. To date, Moss had adhered to Ghyka's strict number systems in her painting and engineered

rectangles that could be subdivided into parts *a* and *b* so that the total was to *a* as *a* was to *b*. Mondrian's asymmetry, and the spontaneity of his choices about position and scale in lieu of a premeditated order, showed her an entirely different approach to geometric abstraction. She was swept off her feet by the freedom and courage of Mondrian's art. Whereas Ghyka emphasized formulaic proportions, Mondrian in effect threw caution to the wind and reveled in the absence of perfectly calibrated measurements conforming to a regulatory force. Sheer instinct was what counted.

Netty Nijhoff invited Mondrian to meet Moss in the flat that she and Moss kept together on the rue du Bac. It was out of character for Mondrian to leave 26, rue du Départ to be presented to a new person for the first time, but there was something about the invitation he could not resist.

The outing was easy enough—the short distance from his building down to the boulevard du Montparnasse, right onto that wide and busy avenue, right again on the narrow rue du Cherche-Midi, left onto the rue du Bac, and past the opulent new headquarters of the department store Le Bon Marché and on to Nijhoff and Moss's lair.

The encounter between Mondrian and Marlow Moss was not as warm as Nijhoff had hoped, however. "They were a pair of extraordinary lone wolves," Nijhoff would observe. Moss was obsessed with Mondrian, but he did not return the feeling. He would always emphasize their distance from one another by referring to her as "Miss Moss." Mondrian was most probably antagonized by the extent to which Moss's art imitated his own. Moss's paintings which he saw that day were almost copies of his recent work, without the panache. Among the founders of Abstraction-Création, friendly with Jean Gorin and Georges Vantongerloo, she was not simply a devotee of Mondrian's work; she imitated it so unabashedly that many people could not tell her paintings from those of her hero.

The architect Max Bill, who had been a student at the Bauhaus, had, following the closing of the school in Berlin, come to Paris. It was a safer place than Germany to pursue abstract art. On December 22, 1933, at the opening of an Abstraction-Création exhibition, which coincided with Bill's twenty-fifth birthday, he had been so struck by the sight of two conspicuously masculine women, one very fat and in a large dress, the other dressed as a jockey, both in hats with oversized flat brims, focused on the paintings in front of them, that he struck up a conversation with them by suggesting that it was a relief that Mondrian had put "such beautiful works" in the show. Marlow Moss replied, "Those are my paintings."

It was Moss who told Ben and Winifred Nicholson about Mondrian. Ben Nicholson was intrigued by the work of the Dutchman living alone in Paris, and when Nicholson and Moholy-Nagy were in a café one day, and

saw Mondrian, Nicholson was delighted to have Moholy-Nagy present him to the artist. Nicholson himself, twenty-two years younger than Mondrian, had, by the time of that happenstance meeting, developed a unique style of painting, unlike anyone else's. In the boldness of the sitters' heads and the way he drew pitchers and flowers, he showed something of the influence of neoclassical Picasso, but the combination of innocent and naïve, and gift for working pale colors and a particularly light-handed and deft drawing style, were Nicholson's own. He had a rare gift for making art that was both highly sophisticated and pleasant and agreeable.

After that first meeting with Moholy-Nagy, Ben wrote Mondrian asking if he could visit him at his studio during the Easter holiday, when he would be back in Paris to see his three children. Mondrian wrote back on Easter Sunday. He said that, although he was very busy, "I should be pleased to make your acquaintance." He proposed that Nicholson visit on the following Wednesday or Thursday, April 4 or 5, between 4 and 5 p.m., "if it is worth your coming all this way for the very short time I will be able to give you."

The humility and politeness were genuine, a propitious start to a relationship that would ultimately be Mondrian's salvation. Mondrian and Nicholson took to each other from the start. Ben Nicholson had all of the attributes of a well-brought-up Englishman with none of the bluster or hauteur that sometimes goes with the type. With his athletic build, strong nose, large dark eyes, and hollow cheeks, he made a good impression striding into the studio. Clean-shaven, his hair brushed back neatly from his receding hairline, he had the sort of Aryan appearance and military bearing Mondrian preferred to the bohemian artists who want to declare themselves through their unconventional personal style as much as their work. In addition to being highly intelligent, Nicholson was affable and had social grace; more important, he was deeply moved by the studio and got off to a good start by saying so to his host.

Fourteen years later, Nicholson would write the architecture historian John Summerson about the impressions that Mondrian's studio made on him that day. He evokes several important details that no one else mentioned and that are lost in photos. Mondrian's digs at 26, rue du Départ were, Nicholson writes, "very high & narrow L shaped (or rather 7 shaped) with a thin partition between it & a dancing school." Nicholson reports that from the window you looked

down into thousands of railway lines emerging from and converging into the Gare Montparnasse. He'd lived there for 25 years and during that time had not been outside Paris and he'd stuck up on the walls different

size squares painted with primary red, blue and yellow—& white & pale gray—they'd been built up during those 25 years. The paintings were entirely new to me and I did not understand them on the first visit. . . . They were merely, for me, part of a very lovely feeling generated in the room.

The "twenty-five years" without leaving Paris and always putting up those squares was inaccurate, but what comes through is the impression that Mondrian gave.

After he left, Nicholson found himself "sitting at a café table on the edge of a pavement almost touching all the traffic going into and out of the Gare Montparnasse, & sitting there for a very long time with an astonishing feeling of quiet & repose (!)—the thing I remembered most was the feeling of light in his room & the pauses & silences during & after he'd been talking. The feeling in his studio must have been very like the feeling in one of those hermits' caves where lions used to go to have thorns taken out of their paws."

Mondrian wrote Nicholson asking him to come back for his late-afternoon receiving hours. He apologized for not being able to offer him a ticket for the Salon des Tuileries and said that he had met Nicholson's wife with Jean Hélion and his wife and that he "would be pleased" if Nicholson brought her with him. Mondrian did not realize that Ben and Winifred Nicholson were no longer together, but what others might have considered a social gaff posed no problems for either man.

When he returned to London, Ben Nicholson told a lot of people about Mondrian. One of them was Mary Myfanwy Evans. This bright young woman had recently been graduated from Oxford, where she had won a scholarship to read literature. She had been given the use of a flat in Paris, on the rue Madame, in August 1934, when its owner, like most Parisians, was out of town. Ben Nicholson had given her a letter of introduction to Mondrian.

The twenty-three-year-old Englishwoman had a very different sense of the studio space than Ben Nicholson did. Thirty-one years later, Myfanwy Piper—who married the painter John Piper in 1936, and always went by "Myfanwy," without the "Mary," opting for what was Welsh and to most English-speakers oddly like "My fanny"—would recall her visit to 26, rue du Départ. It seems that each visitor perceived it differently. Myfanwy Evans noted that "Mondrian lived alone in his double cube studio, the window high up, the walls and steep staircase that led out of it divided with black lines and sparse rectangles of colour so that it was hard to tell which was wall and which was a painting hanging on it. The sense of scale was exact,

and the whole rather sober in intention, but capable of the sudden extraordinary experience of gaiety, like the pale, thin, shabby, conventionally dressed painter himself, who would throw off his melancholy and, putting jazz on the gramophone, dance frenziedly with whoever was there to dance with him."

Evans—an attractive, confident, and beguiling woman—was drawn as much to the man as to his dwelling, so much so that when Henry Moore visited Mondrian in the studio a few days after Myfanwy Evans, Moore asked Mondrian if he wanted to pursue Evans romantically. "'No,' Mondrian answered, flatly. 'She's too representational for me.'"

III

Mondrian first visited Winifred Nicholson on January 18, 1935. She and her young children lived at 48, quai d'Autheuil. It overlooked the Seine in the 16th arrondissement, and on the inside had the comfortable look of a modest English country house more than the appearance of a modern dwelling. There were rugs on rugs, an old-fashioned fireplace, and wooden poles suspended from the ceiling for drying wet clothing. The soft upholstered furniture was covered in wrinkled white slipcovers. Mondrian must certainly have noticed the way the horizontal double line of his *Composition 1932—Yellow Rectangle*, the only touch of the twentieth century in the room, was echoed by the similarly proportioned raised molding of the wainscoting on a wooden cupboard at a right angle to the painting. It was his sort of coherence.

When Winifred Nicholson bought the canvas, it was the only recent work he still had for sale. He told her that for other friends it would cost fifteen hundred francs, but that he considered this an enormous amount for an artist bringing up three children. She quickly made a down payment, and soon had the painting.

He was less flexible about the price when James Johnson Sweeney wrote him about wanting the closely related *Double Line A with Yellow*, which he had only just completed. Sweeney replied to Mondrian that the price was far higher than he thought, although the curator understood that it was hard to separate from such a beautiful painting. Mondrian answered that that was not the issue, but that what counted was that there was a lot of work to make a painting, and that he had to live at the same time—moreover, he had learned that Sweeney had bought a Picasso.

Winifred Nicholson was more feminine in appearance than Marlow Moss, but, by the standards of the era, far from frilly. She was one of those sensible-looking Englishwomen who look as if they would have no problem mucking out the stables, scrubbing up, and going about the next ten activi-

ties with dispatch. In photos, she appears quite manly, with relatively short, thick, dark hair parted to the side, strong eyebrows, and features no one would call delicate. She had a remarkable strength as a human being.

Winifred Nicholson's descriptions of her visits to 26, rue du Départ are the vivid accounts of a rare insider:

When one thought of visiting Mondrian one had to telephone before-hand—no free and easy knocking at his door—this was not because he might be working—he was always at work—but so that he could put on his patent leather shoes and his black-striped trousers. His studio was in a noisy street of Paris up many flights. There was no lift, no water, nor heating in it. What there was, was clarity and silence. The silence in which one could compose and create. The clarity did not come from windows but from the many canvases of which the studio was full, in all stages of their creation, for he worked at each one for long periods, considering each charcoal horizontal; each charcoal vertical, and moving them an inch or a millimetre one way or another. When at last the posi-tions were settled then there were many coats of white to be applied one after another, and only last of all after many months or even years, the rectangles of colour. Yellow, blue or red were painted, sometimes, but more rarely, a trio of three.

For if the studio was full of the silence of human voices, the voices of the pictures were all the more audible, and what they said, clear, funda-mental without frills or fancy—but sometimes did their speech become insistent to their creator, or was he lonely in his hermitage of purest art? Anyway he had a cheap square little squeaky gramophone painted vivid Dutch red, and on it he played the hottest blues jazz—only jazz, never that classical stuff. I don't remember any other objects in the studio except that gramophone—I doubt if there was any room for anything except all those canvases. Sometimes we had tisane made of cherry stones and stalks—that was if he had sold a picture in Switzerland and was in funds. He seldom sold a picture, and when he did he lived on the pro-ceeds for long periods.

He liked flowers, he told me that in his regenerate days he lived on the pictures that he had painted of them—but in Paris he had never had any. One would not have dared to bring any to him, too fancy. One took flowers when one visited Brancusi—he loved them and kept them for ever, dead and dry as beautiful, he said, as when they were in bloom.

Mondrian bought Cambridge colours, not because they were less expensive than others, but because he thought that Oxford, and so Cam-bridge, was the most reliable English commodity. I regret that in this

reliability we English let him down. He was just honest and Dutch and stern, friendly to those who were people of progress, harsh to those who were not—surrealists, fascists, reactionaries, people who tolerated green, purple, or orange—all impure.

"You are the first person who has ever painted yellow," I said to him once, "pure lemon yellow like the sun." He denied it, but next time I saw him, he took up the remark. "I have thought about it," he said, "and it is so, but it is merely because cadmium yellow has been invented."

The yellow to which Winifred Nicholson refers was probably Mondrian's *Composition with Double Lines and Yellow*. The title suggests it, but we only know the painting from a black-and-white photo taken in Mondrian's studio. He was thrilled to sell it to collectors from Zurich for five thousand francs, but, except for a presentation in the museum in Basel, it was never to be seen in public again; the catalogue raisonné says of its eventual fate "probably burnt in transportation by car during World War II." A similar fate befell *Composition N°II, White and Red* from the same year. It was shown at the Salon des Tuileries, and two years later was consigned to the adventurous New York dealer Valentine Dudensing. Subsequently it had a series of owners, until in 1958 Sidney Janis sold it to Paul Bittercourt in São Paulo. The catalogue raisonné simply reports "lost by fire."

IV

The rheumatism from which Mondrian was suffering in his feet and back had become increasingly intense. He had initially been stoic about the illness, writing Nicholson, "We all need opposition in life, at least once," but in March he wrote his brother Carel that he was getting old. He had been out of commission for an entire month and could hardly bear his physical discomfort and lack of energy.

Then a solution came. As Mondrian explained to Carel, William Howard Hay, an American doctor, "has demonstrated scientifically that people get ill because they have the wrong diet: for example, meat, eggs and fish do not go with potatoes and starchy foods." Mondrian believed that in diet as in art, the errors of the past had to be rectified by a radically modern approach. "It just goes to show that our dear ancestry, although acting in all good faith, has left us in a bad way." He had found an answer concerning what we eat that was equal to Neo-Plasticism.

William Hay, who was six years older than Mondrian, lived in America. At age thirty-nine, after practicing medicine for sixteen years, he had acute heart failure when rushing for a train and discovered he had a dilated heart,

primarily from hypertension. There was no known cure, and the prognosis was bad. Hay decided to treat himself by eating "fundamentally." This meant only eating unadulterated, unprocessed foods and never having proteins and starches at the same time. Hay knew from the research of Ivan Pavlov that dogs digest starches in two hours and proteins in four hours, while for people it can take over half a day to digest the mixture. Hay advocated three meals a day, starting with fruit at breakfast, a lunch of protein-rich foods with salad and vegetables, and an evening meal of starchy foods, also with salad and vegetables.

In 1932, Hay purchased a resort in the Poconos. People went there to practice his diet, which he had explained in depth in his 1927 *Medical Millennium*. At the start of 1935, Mondrian received a copy of it from Jean Hélion. Hélion inscribed the book, which was in English, "À mon très cher ami Mondrian. Avec l'espoir que le bouquin lui apporte la santé parfaite. Jean Hélion." Mondrian marked it up from start to finish while making six pages of notes. He began his new regime that February, when nothing else was working to assuage the excruciating symptoms of rheumatism. In March, when Sibyl and László Moholy-Nagy visited, having waited until he said he was well enough to receive them, he looked both sickly pale and flushed, but at least he was up and about, which was an improvement. He greeted them by saying that he had received a present the day before. "And you're just in time for the results," he added excitedly. He pointed to a pressure cooker in the small kitchen. He had wanted one for a long time, he told them, in order to make a pot-au-feu.

Mondrian took off the lid. The Moholy-Nagys could smell the delicious aroma of meat cooking with greens—clearly absent any potatoes. He gave the recipe, which Sibyl noted enthusiastically.

László had no interest in the food conversation, however. He only wanted to discuss art, in particular the half-finished composition tacked to the wall, and another unfinished canvas on the easel. Mondrian would not be swayed. He conspicuously put off any discussion of art while extolling the merits of Hay's separation of ingredients. Sibyl recalled that Mondrian "slowly closed the pressure cooker again and stacked the dishes and spoons in a basin," ignoring Moholy's request completely.

Then, finally, Mondrian got down on his knees next to a large piece of white paper on the floor. Kneeling, he began to move a long strip of black paper in tiny increments across the sheet. Moholy issued instructions: "'Stop! Go back again.'" Mondrian did as advised, and Moholy then told him to move it upward. Instead, Mondrian moved the strip to the left, while Moholy moved another long black strip to the right. They did this without speaking. Then Mondrian told Moholy it was "off balance."

At that point, Moholy took it upon himself to move the black strips again, quickly. He then got up on a chair, while Mondrian remained kneeling. In a victorious voice, he told Mondrian to get on a chair as well, and proudly explained, "From up here the tension is harmonized."

The only other chair available for Mondrian to stand on was the one where Sibyl was seated. She gave it up immediately. Mondrian jumped onto it and began issuing commands. Moholy now stepped down from his chair and became completely compliant. Mondrian, in a voice far calmer than Moholy's had been when Moholy was issuing instructions, had Moholy move one of the strips first to the left, and then simultaneously higher and to the right. But he had no use for the results of his directing. "'Non, non, non. . . . Too much, I say, much too much!'"

Moholy and Mondrian continued to work away. Moholy resumed his position on the chair, and again the two artists functioned in tandem, the one with the overview telling the one on his knees what to try next. Sibyl, who remained standing, felt the complete outsider. She would describe the scene:

> The room was chilly and my feet were ice-cold. I would have liked to leave. I was tired of standing. But I couldn't make my prosaic presence known. The two men on chairs were like seers, regulating the harmony of the universe with strips of black paper. The chaos of the finite world had been left far behind. They were living "a future life—more real, more pure; with needs more real, fulfilled more purely by the harmonious relations of plane, line, and color." Optimistic, and serenely confident, they created a macrocosmic order of the absolute rectangle, endowed with magic powers more potent than the pentagram of old.

Possibly when László and Sibyl Moholy-Nagy left after this rare collaboration, they thought that Mondrian was now content with the solution and would commit to paint the exact composition he had worked out with the strips of paper on the floor. If so, they did not really know Piet Mondrian.

V

At the start of April 1935, Mondrian became sicker still. It was a grave episode. Fortunately, one of his Dutch friends had the temerity to drop in without advance warning and quickly let others among Mondrian's acquaintances know about the dire situation. A support group formed with lots of people rallying in Mondrian's behalf, but then the artist's health got so bad that Arthur Lehning wrote to Ellen Boogaart, a friend of Charley Toorop's as well as Mondrian's, who was coincidentally in Paris at the time, "He can't do

a thing, lies slumped in a chair, and everything upsets him. I think the end is gradually approaching." Boogaart began to call in on Mondrian regularly like a visiting nurse.

Things got better by the time Boogaart had to return to the Netherlands. But then Mondrian became so unwell again that he described himself as "mortally ill," and Hélion wrote Gallatin that he thought that the artist was dying.

It was at that low point that, one afternoon, the doorbell rang. Mondrian managed to make it the short distance to the door. An old friend, Frieda Simon, was standing there. She had been working for the International Labor Union in Berlin but had moved to Paris at the end of 1934. She told Mondrian that, simply on a whim, she had decided to call on him unannounced. Simon started coming around every evening after work with food and medicines and to check on his condition, until he got better.

Mondrian would tell Maaike van Domselaer that he and Frieda Simon would "always go out for a meal together once a week." Mondrian felt that Simon had kept him from dying. To thank her, he gave her three flower studies as well as *Composition: N°III, with Red, Blue, and Yellow* which he had painted in 1927. This lovely small canvas, 15 by 14 inches, was a perfect way to reward the person who saved his life. The painting sings, with its simple design of a top-to-bottom vertical way at the right, and two left-to-right horizontals, almost as near to the top and bottom as the vertical is to the right, but with all of the measurements almost but not quite matching. While most of the canvas is white, the blue and yellow sparkle in the small squares that have been created in the top- and bottom-right corners, and the long vertical band of blue tucked against the left boundary of the painting, held in place with a vertical line between the two full horizontals, peers from behind and then moves forward and keeps going back and forth. Animated and vibrant, it is a visual "Ode to Joy."

On April 12, Mondrian wrote Winifred Nicholson. She was not yet "chère Winifred" but still Madame Nicholson. Nevertheless, however formal, his voice was warmer, his wish to please stronger, than when he wrote almost anyone else. He emphasized how sick he had been. He had been too tired to show his paintings to Winifred's sister-in-law, Anne Constance Davis Roberts, known as Nan, wife of Winifred's brother Wilfrid, when she wanted to see them. He also told Winifred that he had the good fortune of a Dutch lady friend, who worked in her office every day, making him dinner every night. "Women always spoil me," Mondrian told Winifred Nicholson.

On April 28, Mondrian wrote Eugene and Gwen Lux that this had been "the hardest time of my life." He describes rheumatism, swollen throbbing veins, and a general overall weakness. He had not gone out for a month, and

still had not returned to painting. To Ben Nicholson, he reported that he had been unable to paint for two and a half months, never went out, but was doing some writing.

His illness lingered that spring, but his spirits improved in May when James Johnson Sweeney decided to pay the asking price for *Composition A with Double Line and Yellow* and, at the end of the month, the new Gemeentemuseum in The Hague opened with eight Mondrians in it. In June, the recently formed Congrès Internationaux d'Architecture Moderne had a meeting in Amsterdam, and its thirty-nine members signed a letter written in French saying they were thinking of him and sent best wishes. Sidney Janis's *Composition with Red and Blue* was shown at the Museum of Modern Art. With all this good news, by June Mondrian was back on his feet. He resumed cooking, cleaning house, answering all letters, painting, and writing. Whatever the exact nature of his illness was, he suffered periodically from related symptoms and then, after gradual improvement, felt fully restored.

VI

At the start of summer, Alfred Barr, who had directed New York's Museum of Modern Art since its inception four years earlier, and his wife, Margaret Scolari Barr, visited. Sidney Janis and Philip Johnson had urged him to do so. Margaret Barr would write beautifully about the experience—describing the "emptiness verging on the monastic" of the studio. Mondrian talked to the Barrs about the way that the sight of a dock extending into the sea moved him toward abstract art. Margaret Barr writes, "The bare necessities of life, and his working materials, all in order, are in harmony with his uninflected tones." The astute wife of the museum director saw Mondrian's compartmentalizing of his food—meat with vegetables, starch with vegetables, never the three at the same time—as being consistent with his painting. The Hay Diet suited "his subdividing mind."

The diet seemed effective. Mondrian was mostly over his bout of rheumatism—except for a bad foot—and able to imagine picking up a paintbrush again. On July 8, he wrote a euphoric letter to Winifred Nicholson reporting that he was on the mend: "I am so happy that I can pick up again and finish my pictures and start new ones. This has been rather a hard time, but one learns always by life which is always good, despite the big difficulties which compromise happiness." Mondrian was again in one of his periods of positive spirits bordering on euphoria.

A new magazine, *Axis*, was published, featuring his work in the first issue. Myfanwy Evans opens the magazine with a provocative essay she titled

"Dead or Alive." She attacks Surrealism—"With all its apparent scope and new ground for exploration the subconscious mind is a more limited subject for painting than a blank wall"—and from there, progresses to Mondrian. She offers a particular slant on what he has achieved on his "blank wall."

> The abstract method has been attacked for being too simple. There would be more sense in attacking it for not being simple enough. A hair's-breadth between two positions of a shape on a background made the difference between one picture and another. This is exaggerated subtlety; an exaggeration that is an essential part of any stage. Mondrian's work is analysis perfected: not an end, but a *means* in itself: not to be imitated but isolated.

Wisely, since the magazine was printed with little color, the painting she reproduced was a new double-line composition exclusively in black and white. The 1934 *Composition in White and Black* made a handsome, jaunty introduction of Mondrian's art to the British audience. England had joined Germany, America, France, and the Netherlands in the growing territory where Neo-Plasticism had its voice.

VII

Harry Holtzman, Katherine Dreier, Sidney Janis, Philip Johnson, and the Barrs were not the only Americans to be more excited by Mondrian's brilliance than his fellow Dutch and Parisians were. The same month that the Barrs met Mondrian for the first time, A. Everett Austin Jr., director of Hartford's Wadsworth Atheneum, visited 26, rue du Départ, to discuss a show he was planning of abstraction. He also wanted to buy a painting. He wavered between two: *Composition N°II in Blue and Yellow*, of 1934, or *Composition of 1934*, which was evolving into *Composition N°IV White and Blue*.

Chick Austin—as everyone called him—had brought new life to the venerable Atheneum with the world premiere of Gertrude Stein and Virgil Thomson's opera *Four Saints in Three Acts*, the first large Picasso show in America, and a lavish costume party based on a Venetian masked ball. He had as his sounding board James Thrall Soby, a wealthy and courageous local collector. The artists who interested Soby the most were Balthus and De Chirico, but Austin found Soby sympathetic on all fronts, and also knew that Soby could help him diplomatically in Hartford. Soby was sufficiently rich and established so that the stuffy businessmen who ran the Atheneum's board would listen to him, and sufficiently open-minded and daring so that Austin could count on him to encourage adventurousness. From Paris he

wrote to Soby that before he got to Mondrian's studio, "Those arrangements of rectangular and square forms in primary colors . . . had always seemed limited in scope and meaning. But the longer I stayed, the more convinced I became that Mondrian was a true artist, intense, dedicated and on the track of enduring discoveries."

In the course of the visit, Austin settled on four paintings for the Abstraction show scheduled to open in Hartford that October, among them *Composition N°IV White and Blue*, its paint hardly dry, for $400 (see colorplate XIII). The Wadsworth Atheneum was the first American museum to acquire a Mondrian.

VIII

Interest was spreading: planning an international show of abstract art in England, and the accompanying issue of *Axis*, Myfanwy Evans intended to make Mondrian one of the stars of both. By the end of 1935, he was repainting old work and starting new pieces in one of his bursts of energy and optimism. He was undaunted that because the Gare Montparnasse was expanding and 26, rue du Départ faced the wreckers' ball, he would have to move. In a less fertile moment, it would have struck Mondrian as a disaster, but he took the urgent need to evacuate his paradise in surprising stride. Jean Hélion helped him find another studio space, on the boulevard Raspail near the busy Place de Denfert-Rochereau. While readying himself for the move, he sold a major work to the American artist George L. K. Morris, repainted a paint-

A. Everett Austin Jr., 1936, photograph by George Platt Lynes. In the early 1930s at the Wadsworth Atheneum in Hartford, Connecticut, Austin startled the establishment and much of the public with the production of a Gertrude Stein–Virgil Thomson opera and the first full-scale Picasso exhibition. In 1934, he made the Atheneum the first museum in America to buy a Mondrian when he acquired one of his paintings for $400.

ing Nan Roberts would be buying and that had just been returned from the Hartford Abstraction exhibition, and busied himself polishing compositions for Evans's exhibition, scheduled to open in Oxford on February 15, 1936.

The spirit of the reborn Mondrian is evident in those paintings he completed in 1935. Their creator's capacity to make life glorious no matter what the hardships are soars in this group of canvases. Besides the Hartford picture, which he had ostensibly done the year before but finished only now, there was another painting with only a single small rectangle of color—the same celestial blue—in a simple grid of black lines, nearly but not quite equal in width, on a canvas that is otherwise entirely white. Cheerful and upbeat, this elegant masterpiece, *Composition with Double Line and Blue*, the painting that was initially bought by George L. K. Morris, belongs today to the Beyeler collection in Basel, so, like the one at the Wadsworth Atheneum, it can be viewed by the larger public. *Composition (N° II) Bleu-Jaune*, acquired by Winifred Nicholson, is now at the Hirshhorn Museum in Washington, so it, too, is often available for the larger audience. Another remarkable painting from 1935, *Composition A, with Double Line and Yellow*, bought by James Johnson Sweeney, is the only one of this group of gems from 1935 that is in a private collection. Leaner still, it consists only of a single vertical line, extending from top to bottom off center, crossed by two full horizontals near to one another at the top, with the sole color being a horizontal rectangle of yellow in the space which remains in the upper left, even in reproduction it maintains its charm.

Another painting Mondrian completed in 1935, *Composition in Gray and Red*, was among those he sent to the Hartford Abstraction show and which went from there to the Chicago Arts Club. Mrs. Charles Goodspeed, the determined American lady who managed to have the Atheneum exhibition go to Chicago, bought this extraordinary canvas. Katherine Dreier thought that she had become its owner when it was in Hartford, but her acquisition of it had not been noted when the exhibition went to Chicago; Dreier agreed to let Elizabeth Goodspeed keep the masterpiece once it was delivered to Mrs. Goodspeed's house.

Years later, in 1977, when she was Mrs. Gilbert Chapman, the former Mrs. Goodspeed would write Robert Welsh:

> Mondrian was very fussy about letting his things be shown, because he used to keep them in his studio and put a little white paper over certain of his lines and over part of the picture until he sometimes kept them six months this way, watching them every day until he was completely satisfied with them. So you can imagine how long it took me to persuade him

to let me have the show. It really took me about three years before he
would let me have his things.

When she was Mrs. Goodspeed, Mrs. Chapman had indeed had Mondri-
an's paintings in Chicago, but the show she took was Austin's. It was not the
De Stijl exhibition she claimed, late in her life, to have mounted indepen-
dently. The story of the white paper over the paintings is another confection.
It seems a combination of Mondrian's normal working methods, the Sibyl
Moholy-Nagy story, and sheer invention. The three-year negotiation is also
a figment of Mrs. Chapman's imagination.

This mythologizing exemplifies the errors of fact, the fault of memory,
and the desire to aggrandize the narrative that Mondrian deliberately coun-
tered in his work. The painting itself belongs to a completely other realm.
Mondrian painted as he did to provide an alternative to the incertitude of
life. He had made the inviolable decision that art needed to go beyond sub-
jectivity, personal experience, the intervention of emotion. It had to present
a greater truth, an absolute, something infallible. He understood that the
achievement of those qualities depended not on mechanical perfection and
precise balance but on irregularity and unpredictability, the givens of life
itself, now presented in impersonal form.

The first painting of Mondrian's to reach the American Midwest marches
forward nobly. To face *Composition in Gray and Red* is like seeing close-up a
fast, well-structured dance. The soft, muted gray square and gray vertical
rectangles are sublime—the ethereal made geometric. The supine red rect-
angle stretched out at the bottom right provides the spark of combustion.
This painting cannot stop moving. There are lively kicks and, at the same
time, a stasis that results from the crossed double lines—two pairs of them—
that span the painting, the vertical ones a hair thinner than the horizontals,
and the gaps in each pair proportioned accordingly.

This painting is the triumph of Mondrian's resurrection. The gray
against the white is intoxicating. Where did Mondrian acquire this genius?
Who else could convey the essence of joy, of the assurance that human exis-
tence is beautiful in spite of illness and all the other struggles? Like the latest
architecture in glass and steel, *Composition in Gray and Red* celebrates right
angles, and merges discipline and high spirits, but it also does move.

For all of her subsequent admixture of truth and fantasy, Mrs. Good-
speed was one of those courageous women in Mondrian's orbit who had
the will to present what others could not understand. To buy a Mondrian
in Chicago in 1935 was brave. But Elizabeth Goodspeed had the necessary
temerity. The previous year, she had hosted Gertrude Stein when Stein gave

a lecture at the same arts club where the Mondrian would be shown, and Alice Toklas wrote Carl Van Vechten about how gracious and helpful "Bobsie" Goodspeed was: "Bobsie Goodspeed has been so very kind—considerate and sweet." Stein herself reported to Van Vechten that the attendees of her talk were "a hard-boiled audience with several university people who came anti and went away convinced."

A photograph shows Mrs. Goodspeed seated on the floor at Stein's lecture. She wears a lacy and frilly white dress at odds with her masculine features and sharply cut hair parted in the middle. Her handsome, dashing husband stares at her with total devotion, but she looks straight ahead as if impervious to his admiration. Behind her, on the sofa, are Gertrude Stein smiling warmly and Alice B. Toklas looking incredibly irritable. Thornton Wilder is seated on the arm of the sofa. Mondrian may have lived in modest isolation in Paris, but some of the most worldly and adventurous people of the era were in the circle that enabled him not just to survive but now, at last, to flourish.

IX

Another painting that traveled to Hartford and Chicago, *Composition in Blue and Yellow*, went next to the Museum of Modern Art in New York. There it hung in a show Alfred Barr organized of abstract art. This is the painting that ended up at the Hirshhorn Museum.

The collectors and museum directors who were stirred by Mondrian's art—to whom Philip Johnson had now introduced one after another—were enlarging its American audience in leaps and bounds. *Composition in Blue and Yellow* was a vivacious composition, a dynamo whose single and double lines and gemstones of color entertained.

Winifred Nicholson had agreed to buy the canvas once it returned to Paris. Mondrian wrote her in June that it was back in his studio. He was just putting a last bit of paint on it before it would be ready for her. He was doing the same with a painting for her sister-in-law. Both would be ready in six weeks; he just had to make and paint frames for them.

Winifred Nicholson had already paid six hundred francs; the total would be fifteen hundred. But she had run out of money. Mondrian was happy to reduce the price for his affable friend and admirer. When she paid the agreed amount, she in fact sent him a hundred francs too much. Mondrian promptly returned it to her; he was as meticulous about money as about linear measurements.

The transaction was almost complete—the payment resolved, the final adjustments made to the picture. But then, in September, Mondrian wrote

Winifred that the frame, almost as soon as he finished it, had somehow been damaged and he had to touch it up. The restoration of *Composition in Blue and Yellow* had a worthy purpose, meanwhile. It would "make it more pure."

Winifred well understood what that meant to Mondrian. He was writing a text in French for *Axis*, and Winifred Nicholson was translating it into English. Called "The True Value of Oppositions in Life and Art," it exalted his notion of purity. Mondrian felt that people did not see the necessity of oppositions, that the norm was to "search for false ease and static equilibrium, which is inevitably opposite to the dynamic equilibrium of true life. . . . When he creates apparent unities, man is trying to go too fast." Mondrian believed "that only by discerning and experiencing oppositions do we achieve unity." Those qualities—unity and purity—were part of the same goal of an art that reflected the energy and the inherent tensions of the whole universe.

Most of the text restated the credo Mondrian extolled at every opportunity. "Let us rejoice to live in the age when plastic art has freed itself from the domination of particular forms. Particular forms prevent full enjoyment of the unity that only neutral form, pure line and color can establish clearly when these 'means' lose themselves in composition."

As usual, Mondrian gets away from the particular to the universal. Any element of deliberate representation in art—not just of the world visible before our eyes but of personal emotions—was to be eschewed.

We are all part of life—the life not concerned with time and space, but, like art, always basically the same. Life had only to develop in us. Even despite ourselves, we are part of the great perfect composition of life, which when clearly seen established itself in accord with the development of art. Let us not forget that the present is a unity of the past and of the future.

X

Mondrian's latest work was reaching new audiences in profusion. *Abstract and Concrete*, the 1936 exhibition that featured three of his paintings and had spawned the exceptional issue of *Axis* with its odes to abstraction, opened in Oxford in February. From there it would go to Liverpool and Cambridge. Almost concurrently, *Cubism and Abstract Art* opened in New York at the Museum of Modern Art. Organized by Alfred Barr, it had six of Mondrian's paintings that belonged to Helene Kröller-Müller and additional work from the collections of James Johnson Sweeney and Katherine Dreier. In the exhibition catalogue, Barr names Mondrian and Oud as "two of the finest artists

of our time." It would have pleased Mondrian more if Barr had not also extolled the impact of Van Doesburg, "a man as versatile as any figure of the Renaissance," but, if he was to function in the world, Mondrian had to heed his own advice and set aside the inevitable torment of human relationships.

On March 20, Mondrian moved to his new living and working space at 278, boulevard Raspail. Arp and Kurt Schwitters both visited shortly after he started to get settled. A photo by Schwitters taken that day shows Mondrian suddenly aged. His face has deep creases; he looks almost forlorn. He could escape "the tragic" in his art, but the realities of age and illness were taking their toll.

Shortly after Mondrian moved, the young and audacious American art dealer F. Valentine Dudensing became determined to have Mondrian join his roster of gallery artists. Dudensing did not feel he had the powers of persuasion to do this on his own. He asked Jean Hélion to serve as an intermediary. Hélion was both a talented artist and someone whose personality got him far. He had lots of friends, both fellow painters and leaders in the art world. Dudensing counted on him to land both Arp and Mondrian, and in both instances he succeeded. Mondrian agreed to a one-year contract with the Valentine Gallery.

Francis Valentine Dudensing had graduated from Dartmouth College in 1913, at age twenty-one, and gone to work with his father, a dealer in nineteenth-century pictures. He quickly led the gallery into the modern era. Dudensing worked with Pierre Matisse, who was living in Paris, on a groundbreaking show of the School of Paris, in 1925. Among other things, both men had problems with their fathers. Pierre's father, Henri Matisse, had been generally aloof, a tough taskmaster in Pierre's piano studies. The senior Dudensing disapproved of the School of Paris show as too radical to guide the future. So often, this will to break away from hidebound parents was a point in common among the pioneers of modernism.

Valentine opened his own gallery at 69 East 57th Street in February 1926. In Paris, Pierre Matisse arranged to have work by his father and by Pablo Picasso sent to the gallery, where many Americans bought work by these artists. The younger Dudensing changed the name of his establishment to the Valentine Gallery, so it would in no way be confused with his father's.

This revolutionary art gallery quickly gave some leading modern painters their first solo exhibitions in America. In 1928, it was Giorgio de Chirico; in 1930, Joan Miró; in 1932, Kandinsky. The younger Dudensing had the charm and moxie to introduce a number of the most important collectors in America to modernism, and after Mondrian sent two paintings to Dudensing, the dealer sold one of them immediately to Walter Percy Chrysler Jr., the most artistically inclined of America's automobile heirs.

Mondrian's wealthy collectors often had in common that their fortunes were made because an earlier generation had gone out on a limb in life and taken substantial risks. Walter Percy Chrysler Sr., father of the collector, the son of a locomotive engineer, had apprenticed as a machinist and railroad mechanic before developing a reputation as a skillful roundhouse mechanic with an exceptional talent for valve-setting jobs. In 1911, when he was thirty-six years old, he was summoned by a General Motors executive who made him a production manager at Buick, in Flint, Michigan. His starting salary was $6,000, but he was so audacious that he worked his way up the corporate ladder and by 1919 he was able to sell the GM stock he had received in bonuses for $10 million. He then got himself a job trying to turn around Willys-Overland for a million dollars annually. In 1925, he started the Chrysler Corporation in Detroit. The company created the cars named Plymouth and DeSoto, purchased Dodge, and financed the Chrysler Building in New York, which was finished in 1930.

Walter Jr., born in 1909, had started collecting art after his father gave him $350 for his fourteenth birthday. The boy who had been born in Oelwein, Iowa, to a mechanic and the quintessential midwestern housewife, Della Viola Forker Chrysler, had, thanks to his father's rising fortune, become a sophisticated teenager by the time he was a student at the Hotchkiss School, a tony boys' preparatory school in Connecticut. His family by then had a large estate on the north shore of Long Island. He used his birthday money to buy a Renoir watercolor. It was essentially a landscape, but there was an inch-high nude female figure in it. His dorm master deemed the subject matter unacceptable and confiscated and destroyed the painting.

From Hotchkiss, Chrysler went to Dartmouth College, where he and another rich young man who liked art, Nelson Rockefeller, started a magazine called *Five Arts*. In 1931, at age twenty-two, Chrysler went to Paris and met Picasso, Braque, Gris, Matisse, and Léger, buying works from all of them. But Mondrian was not on his radar; it would take Dudensing to get Chrysler to consider the sort of abstract art that left Chrysler's cohorts cold.

By the time that Dudensing sold him his Mondrian, Chrysler had created a company he called Airtemp, which made the first air-conditioning system for cars, and became president of the Chrysler Building. His friend Nelson Rockefeller had involved him in the new Museum of Modern Art, where he was the first chairman of the Library Committee and a major donor. There he was content to be in the company of other men who were, as he was, homosexual but married to women. Chrysler was not timid. While other privileged Americans acquired small Mondrians, Chrysler bought a monumental one.

It was the same large *Composition Blanc et Bleu* that Mondrian had put in

the Tuileries exhibition at the insistence of the Delaunays in 1934. Mondrian had complained at the time about the pressure he felt to send the painting when it was barely finished and still unframed. That July, he had been asked to have his work in a show at Christian Zervos's gallery, where the other artists were Arp, Sophie Taeuber-Arp, and Hélion, but he did not have a single work ready to his own satisfaction. By September 1934, he had reworked the large vertical composition, and he wrote Lux that it would be interesting to compare the way it now looked compared to its previous "primitive and imperfect" state when it was "full of faults." Then, in mid-November, he had again reached a satisfactory result, apparently unconcerned that two months earlier he had said the same thing.

In his usual way, Mondrian had claimed that he was about to finish a dozen, maybe even twenty, paintings any day now. Then, by February 1935, he allowed that there was more work than he thought to do on everything he had hoped to complete. In fact, all that he was able to send to a show in Lucerne, where the other artists were Picasso, Léger, Arp, and Hélion, was this large *Composition Blanc et Bleu* and two others. In January 1936, he wrote Alfred Barr that he knew that Barr wanted that same tall composition for a show opening at the Museum of Modern Art on March 15. There had been a problem with the shipper, though, and it was still in Mondrian's studio. Mondrian said he had just now, at last, finished it to his satisfaction and he was so pleased with the result that he would pay the crating and shipping himself so that he could be shown at "the Modern." "It has improved a lot," he wrote Barr.

But it did not make it to the Modern. Rather, as Mondrian wrote his old pal Van den Briel, he had agreed to exclusivity with a New York gallery, and so off it went. He knew the gallerist would need to make money, but he would still get his usual net price. When Walter Chrysler Jr. walked into the Valentine Gallery at 69 East 57th Street, the price was not an issue for him.

This painting, which today belongs to the Kunstsammlung Nordrhein-Westfalen in Düsseldorf, is 59 centimeters wide and 121.3 centimeters high. The temptation, particularly because of the size, would have been to impose a system of rigid order; irregularity at a large scale is tougher to manage, for both viewer and artist, than in something small. It takes great inner control to allow for imbalance on the surface. Van Gogh, at the end of his life, painted horizontal landscapes that were precisely the dimensions of two squares positioned side by side; it was essential that the measurements be precisely doubled. Van Gogh suffered from such instability and disorder within that he craved it in an external structure. But Mondrian felt such con-

trol of himself that he deliberately ventured into disharmony and irregular-
ity: the height, rather than being exactly twice the width, is a small bit more
than double it, and then there is all the playfulness of the composition.

In its size and verticality and sense of triumph, *Composition Blanc et Bleu*
is the next generation of the central, spiritually elevated figure in *Evolu-
tion*. For all its monumentality, it exudes an otherworldly force. Like Giaco-
metti's most noble walking figures, this purely abstract canvas has physical
bravura although it is dematerialized and ethereal. The two vertical lines,
which are the main compositional elements, are both elastic and rigid. As in
the 1934 version, one is so near to the left edge of the canvas that it verges
on a leap into the stratosphere; the other, slightly to the right of center,
is more of this earth. But now, in the revised composition, the vertical on
the right is infinitesimally wider than the one on the left. These lines rise,
descend, strut, and stand still, all at the same time. Sometimes they move
together, in unison; sometimes they alternate. At moments, one of them
leans forward and the other backward. In 1934, there were two small hori-
zontal lines on the upper left which went from the long vertical to the left
edge of the canvas. Now they are gone. If they were still in place, none of
this action would occur.

The two horizontals between the vertical on the right and the right edge
of the canvas remain, however. So does the small blue horizontal rectangle
created in the upper-right corner.

Everything else is white, albeit a cool gray white on the left, a brighter
white in the center, and a slightly yellower one toward the right. Mondrian,
in his various revisions, had reworked those whites as well as the widths of
the black lines he left in. Using so few elements, he needed each to have its
maximum effect. By 1936, the painting had become an entire world. It sug-
gests birth and creation; it has the life of the whole cosmos in it.

Mondrian's decisions are based not on anticipatory knowledge of their
results, or any form of calculation and planning, but on a courageous open-
ness to change, a will to try not just a few subtle variations of an idea but
hundreds, even thousands, of permutations of lines and rectangles of color
and voids and intervals. The first decision concerned the dimensions of the
painting—the single element that, once determined, could not change. With
his characteristic need to tickle, to create a deliberate edginess more than a
bland resolution, Mondrian, as we know, made the canvas just a slight bit
off-square, with the height about 2 percent bigger than twice the width. The
floor-to-ceiling verticals are like struts, the short horizontals more in the
role of supporting elements. If we apply Mondrian's notion of the vertical as
male and the horizontal as female, the painting has a higher level of testos-

terone. *Composition Blanc et Bleu* does indeed have a very particular forceful-ness. Its quality, of course, requires no analysis.

Walter Chrysler probably did not dissect the elements that make his unusual Mondrian so invigorating to look at; nor is it necessary to do so. As with all of Mondrian's compositions, there is no need to calculate the mea-surements of forms, or to consider the issues of proportion and direction. Rather, one should simply succumb, as more and more people were doing. By the mid-1930s, the audience for the sort of compositions that Mondrian did not have a chance of selling a decade earlier was continuing to grow.

XI

Ben Nicholson became one of those people for whom Mondrian's work was life-changing. He quickly informed those of his friends whom he expected to feel the same way. Among them was one of those patrons of modernism who, behind the scenes, courageously introduced splendid new art to an initially skeptical public, only to make a tremendous impact. Nicolete Gray, born in 1911, put on an extraordinary exhibition that opened in Oxford and spawned the special issue of *Axis*.

In her exhibition, *Abstract and Concrete*, which she organized for the Oxford Arts Club, and which would subsequently go to the Lefebvre Gal-lery in London, Gray rejected the artistic taste then prevailing in Britain. The presentation was conceived to pave the way for the public to see art of a sort that had never before been shown in their country.

This international show would present art by, among others, Arp, Calder, Giacometti, Hélion, Hepworth, Kandinsky, Miró, Mondrian, Moore, and Piper. There would be three works per painter, and one or two per sculptor.

The prominent artist Paul Nash set the stage: "Whether it is possible to 'go modern' and still 'be British' is a question vexing quite a few people today. The battle lines are being drawn up: internationalism versus an indigenous culture; renovation versus conservatism; the industrial versus the pastoral."

Kenneth Clark, who in 1934 had become, at age thirty, the director of the National Gallery in London, was among the people who thought abstrac-tion "looked too easy to do, as if people could get away with anything . . . It's almost the emperor's clothes." Clark, however, made an exception for Mon-drian. In spite of his old-fashioned ideas about the masterpieces of world art, he had the sensitivity to be intoxicated by sheer beauty wherever he found it. A specialist in Piero della Francesca, Clark was open to grace and subtlety and artistic genius in a way that superseded all dogma. In *Another Part of the Wood*, the autobiography he wrote in 1974, he describes a trip he made in

1925 to the Kröller-Müller collection, which at the time was in The Hague, with Bobby Longden, who would become master of Wellington College, and Leigh Ashton, who would become director of the Victoria and Albert Museum. Clark was twenty-one years old at the time.

> There were a number of abstract pictures by an artist none of us had heard of named Piet Mondrian. Bobby thought them idiotic, and Leigh burbled, but I fell completely under their spell. That a totally abstract picture could give me such pleasure as a representational picture was a revelation to me, and I looked forward to enjoying this extension to my facilities.

Then, in these memoirs, Clark comes to the arrogant conclusion that "unfortunately, I have not got much further; nor, perhaps, has abstract painting." As a sophisticated art historian writing in 1974, Clark might have reconsidered dismissing, with a sweep of his hand, Jackson Pollock, Willem de Kooning, Albers, Kandinsky, Miró, and many other modern masters. Still, the swipe at most abstractionists makes it all the more impressive that only Mondrian, among all the abstractionists, suited Kenneth Clark.

Myfanwy Evans would single out Mondrian in her text about the exhibition:

> Mondrian's work is most penetrated by the analytic spirit and is the most nearly theoretical. The final reduction of the most simple object must be a vertical opposed to the horizontal, a primary colour opposed to black or white, a block opposed to no block. In this Mondrian finds a working proposition which also answers the complexity of the world around him, that oppositions have a value in themselves. He takes the most simple oppositions and perfects the approach to them by delicate adjustments. The intellectual conception of two lines crossing with a block of colour at the junction is given its greatest possible emotional content because it is made to exhibit a theory of life and painting at once. Even this simplest and most formal abstract art cannot be made to illustrate a theory of pure form.

Nicolete Gray embraced Evans's beliefs, and her reverence for Mondrian, with gusto. The exhibition she organized to present the new art to the British public in 1936 opened at 41 St. Giles' in Oxford on February 15. In April, it went to the Alex Reid & Lefevre Gallery on St. James's Square in London. There, Mondrian's "A," "B," and "C" hung close to one another,

their hanging wires visible. *"A"* was tucked against a corner to its left, next to *"B"* and *"C,"* which were stacked to its right. On the wall that made a right angle to the one on which the Mondrians were hung, there was a large Ben Nicholson white relief. The montage is sublime even in old photographs.

XII

Today, when we look at an installation shot of the corner of the gallery where the Nicholson and Mondrian walls met, with a white Barbara Hepworth sculpture, *Two Segments and Sphere*, on a stand in front of the Nicholson, we recognize this as a grouping of some of the great masterpieces of the twentieth century, each work of a caliber that would now throw auction houses and art investors into a frenzy. At the time, when Nicolete Gray asked Christie's to evaluate the work for insurance purposes, they declared it worthless. LEP Transport and Depository Ltd., the mover who brought the three Mondrians from Paris, put a total value on them of eighty pounds. Regardless, the twenty-four-year-old curator could not manage all the expenses. Fortunately, she found sponsors, among them John Maynard Keynes, Lady Violet Bonham Carter, Roland Algernon Penrose, and Sir Michael Sadler. Still, Gray had had to pay seven pounds six pence out of her own pocket for the insurance, which was one of the reasons that Evans wrote in her afterword for the exhibition catalogue that uncovered expenses remained and that "further contributions will be welcome."

Mondrian's London premiere prompted a critical response that was snarky in a particularly British way. The art pundits attempted the sort of witty put-downs mastered by George Bernard Shaw and Noël Coward. They may have had the same self-assurance, but they lacked the intelligence of those brilliant playwrights; the butt of their sneering sarcasm was a glorious new art of the highest caliber, not the silly efforts at fashionableness that Shaw and Coward targeted. *The Observer* labeled Mondrian as "pure Czerny." The remark alludes to the exercises practiced ad nauseam by beginning piano students. Czerny had developed a five-finger rote drill to help new pianists develop sheer technical capability, with a form of training in which personal feeling was to be suspended. Yet since Czerny had also composed some beautiful music, *The Observer*'s critic had, in a single sentence, made himself or herself a boor on two counts by mocking the gifted Austrian musician and composer as well as Mondrian. London's popular journalists outdid one another in what they considered to be humor. *The Daily Mail* deemed the exhibition "a jolly leg-pull" well timed in regard to April Fools' Day. The critic for the *Daily Express* wrote, "Nobody who has worked in collaboration with a good house-painter will think it is a slight upon the kind

to say that the execution of such works as Mondrian's is definitely a house-painter's job."

Regardless of his encounter with English conservatism at its worst, Mondrian did well to be in the *Abstract and Concrete* show. Nicolete Gray's friend Helen Sutherland bought a painting. Nicholson had beseeched anyone with the money and inclination to acquire a painting by Mondrian. The reason had nothing to do with financial investment, a nonissue in art collecting back then. Nicholson simply wanted Mondrian to have enough money to keep painting. Sutherland complained to Nicholson that she had spent "a great deal" for it—seventy-six pounds.

In 1936, when the pound was at an all-time high against the dollar, that was the equivalent of $380, which is today about $8,500. For Mondrian, it was a lifeline. Winifred Nicholson wrote Ben that she was

> very glad that Mondrian has sold a thing. He looks old and is I think suffering from lack of money with his move to the new studio (this is private). He is delighted to have sold and I am sure Helen will like the picture, which one was it?

The painting Helen Sutherland bought and that helped fund his relocation to the boulevard Raspail is one of Mondrian's leanest, and most deliberately unbalanced, ones. The lines form what is essentially a tic-tac-toe board, with the middle column of openings compressed into vertical rectangles and the right-hand side not quite as wide as the left. To prevent the composition from being too calm, Mondrian has introduced a vertical running between the two horizontals near the left edge. The large horizontal rectangular window at the upper left of the composition is a vibrant red—the sole color.

The painting is jarring. Its intentional lack of regular proportions, the violation of its own pattern, and the color imbalance provoke the viewer. In giving us a jolt, and energizing us, it is a masterpiece.

Mondrian was delighted by its sale. He learned of it from Ben Nicholson, to whom he wrote on May 4 that both Hélion and Winifred had already told him that the show in London was a great success. He was pleased "infinitely for all true abstract art," and by his own financial rescue. "The question of survival is preponderant for us, isn't it?, and for that reason what I have just learned from you gives me such pleasure. Also, my paintings have not been damaged."

Nicolete Gray wrote of the abstract work in the exhibition:

> From out of its grave under our great humanistic edifice the abstract work that we thought, and hoped, was dead seems to have risen again. It

is perhaps an ominous resurrection. In the West abstract art is Germanic, and to us Germanic culture seems a darkness from which we have tried to escape to the light of humanism.

In this context, the London show was a form of safe harbor from what Gray terms the "darkness" of "Germanic culture" that was beginning to impact much of the world, and a continuation of a logic and restrained elegance of ancient origins.

Boulevard Raspail

I

By June 1936, Mondrian had painted the walls of his new studio on the boulevard Raspail the white that was essential to his well-being. He then started to put up the requisite panels of color. He wrote to Winifred Nicholson, "My studio is another part of my painting." He was, at last, "calm." He had not yet redone the bedroom above his workspace, but this could wait. He was again so broke that he could not afford to put up some shelves he needed. Everything from lemons and dinner plates to paintbrushes was on the floor, covered in clean newspaper. Winifred Nicholson reported this to Ben. She could not stand Mondrian's penury for another moment and bought a second painting; she wanted it anyway, but her main reason was to give Mondrian some money.

Then Mondrian said something astonishing to Winifred. He commented on how much he had enjoyed an evening at her house, and volunteered, "I saw with pleasure your work; also your 'naturalistic' painting is very pure and true."

So he was not so doctrinaire after all! Winifred Nicholson brought him great joy as a person; so he told her repeatedly. Her paintings—flowers, portraits, landscapes—are charming, lyrical in tone, almost naïve, somewhat abstract, the imagery treated in an original and very happy manner. It is easy to understand that anyone who cares about what is pure and full of heart would like them. But it is extraordinary that the man who perpetually insisted that geometric art without an iota of naturalism was the only way to paint violated his own gospel.

That August, Carel Mondriaan and his fiancée Marie van den Berg visited Mondrian's studio on the boulevard Raspail. Mondrian never went to see any of his siblings or other relatives back in the Netherlands, and it was rare for any of them to visit him.

The occasion prompted an especially dour family photograph. No one offers even a hint of a smile. And no individual looks at another. Carel's fiancée appears to be very much a modern woman, in a new style of dress and

jazzy sandals, but her demeanor is forbidding. Everyone faces the camera grimly, with Mondrian seeming especially miserable.

This is our first look at the new studio. The squares of color on the wall echo the faces of the people standing in front of it. But they have more pulse, and Mondrian was forever organizing them according to his own whim. Whenever Mondrian was the one steering the action—and that was most of the time—he could determine the intervals, choose what color went where, and create the animation that was his quarry.

He needed control. In September, Ben Nicholson asked Mondrian to write an article to be included in the book *Circle: An International Survey of Constructive Art.* Mondrian agreed happily. Then, on October 5, he wrote Nicholson in a snit. He had been at the Pevsners'. There he learned that Nicholson had asked Joan Miró to send photos for the book. Mondrian was shocked. He told Nicholson he thought he was writing for a magazine devoted to "constructivism, or, in any case, purely abstract art." Why did Nicholson feel that Miró belonged there? And how could he put in the Spaniard's work when he had excluded Hélion and Arp?

It is not that Mondrian disparaged Miró; he went on to say that he considered Miró "a true artist." The issue was figuration expressed through curves that formed any part of an implicit circle.

Once he sent in the rest of what he had written for the book, Nicholson would understand that Mondrian's stance was "rightly against all the sentimental tendencies of the art of Miró, Kandinsky, etc." He asked Nicholson how he could possibly have included this work, and demanded an explanation.

Still, Mondrian could not resist the chance to be heard, whatever he felt about the vehicle that would publish him. Even if *Circle* disrespected the canon, Mondrian wanted to be in it. Besides, Ben Nicholson was enthusiastic about the essay.

He was again scraping the bottom financially, and he was again saved by a devotee. Nicolete Gray had spent more than she intended on her breakthrough show, but by October she was in good enough financial shape to ask Winifred Nicholson to tell Mondrian that she wanted to buy *Composition C (N°III), with Red, Yellow, and Blue,* one of the three paintings he had sent to England for the show.

This was the painting that hung below a larger composition of the same width in both the Oxford and London venues. In Oxford, it was squeezed into a corner of the room, with a large Hélion abstraction alongside it on the right. The top two-thirds or so of the Mondrian are in front of a dark brown wall. In museums and galleries in that time period, this was the color often used as background for displaying paintings; it was neutral and lent a cer-

tain gravity to the art. The bottom third is above wooden wainscoting that pushes the painting slightly outward, so that its bottom is angled toward us. The corner of the gallery was crowded with artwork. Another large Hélion, a big Nicholson relief covered with glass in which both these Mondrians are reflected, a Calder mobile hanging in front of the Mondrians and casting shadows on them, and sculptures by Hepworth and Moore are packed close to one another. The congestion only accentuates the force of the two Mondrians. Like the second Mondrian composition directly above it, the painting that Nicolete Gray bought held its own power. Exuding a quiet grace and confidence, it was self-assured without being in any way brazen or arrogant. Its form was noble.

Gray could not pay the asking price, but on October 14, Mondrian wrote to Winifred that she should tell Gray how much he appreciated her interest, and that he wanted to sell her "the painting with the three colors" for the same price as the one he had sold to Winifred, fifteen hundred francs, and that she could pay in installments. He realized that even this might be beyond her capability, but he hoped it would help.

On November 30, he wrote Gray again after she responded gratefully. "I thank you greatly for your appreciation of my work, and accept your offer with pleasure if it is not too difficult for you. I believe that a price of 1500 francs is enough for you; you could pay a thousand on the date you indicated, and I will be content: send the rest at a time when it suits you." At the time, fifteen hundred francs was worth about a hundred U.S. dollars, which, calculated on the basis of an inflation rate of 5 percent annually, would be about $2,200 today.

On December 5, Mondrian sent cleaning instructions to the owner of this treasure:

> One can wash it lightly with a chiffon and a little bit of white soap and warm water. It is possible that the red and yellow will give up a little color, but you can continue to clean, because the paint layer is sufficiently thick. The blue stays fixed better, the black and white as well. Ben Nicholson would always be happy to help you if necessary.

Whether or not she ever washed it accordingly, Nicolete Gray would eventually give this painting to her daughter Camilla Gray-Prokofiev, a gifted art historian who specialized in Russian avant-garde art and married Oleg Prokofiev, an artist as well as author of the book *The Scent of Absence*. He was the son of the composer Sergei Prokofiev, and the couple lived in Moscow. Camilla's deep understanding of experimental painting made her the perfect person to have it.

In 1971, Camilla Prokofiev-Gray died, tragically young, in the Caucasus. Ever since then, the painting has been on extended loan to Tate Britain. Nicolete died in 1985, but the family members who inherited the Mondrian have always kept it at the Tate, which is why so many of us get to see it firsthand today. It warrants prolonged viewing. At first, with its careful deployment of red, blue, and yellow, separated from one another at gracious intervals over the nearly square canvas, the composition appears to be slightly more balanced and resolved than many. But then we realize that the apparent point/counterpoint is illusory; this is another of Mondrian's paintings that tickle the viewer by putting into motion a sequence of surprises.

Nothing is quite as it seems. The natural ordering system of the human mind wants to read it as square, but the height, 22⅛ inches, exceeds the width of 21¾ inches by three-eighths of an inch. The black lines at first seem of equal width, but in fact the verticals are mostly narrower than the horizontals. Yet that, too, is not as it initially seems. While the two principal horizontals, which span the canvas, are thicker than the verticals, the one other horizontal, a short one underneath the blue square, has the same width as the verticals.

These sparks of irregularity and unpredictability ignite the painting. Its colors further enliven the plastic action. The red unit appears to be not only the one that is closest to us, but, from its position in an aerie, it actively moves toward us. The longer we look, the more it gallops full charge ahead. The blue is distant, and, for all of Mondrian's avowed lack of naturalism, it is a sky viewed through an open window.

The vertical slit of yellow is glorious. While one arrogant English critic compared its substance to a dash of housepainter's paint as applied to building siding by an ordinary craftsman, what Mondrian conceived so impeccably in its rich oil pigment is a geometrical embodiment of optimism. Its location, next to the open space of the larger world to its left and below it, is scintillating. Mondrian causes the yellow to hover—forever—in space, weightless, singing, and radiant. It creates light the way the sun does.

II

Mondrian had only relocated to the boulevard Raspail because he had no choice, but once he had transformed the studio space and, thanks to the sale to Nicolete Gray, could afford to put up shelves, he was oxygenated. The paintings following the move get physically and emotionally bigger. The 1936 *Composition en Blanc, Noir et Rouge*, about 40 by 40 inches, is like a simple sequence of notes constituting a musical fanfare. The red band at

the bottom of the Mondrian canvas is a euphoric conclusion to the sequence which begins with three horizontal bars above it. At the upper left, a light, ethereal form offers delicious contrast to the boldly triumphant voice of the rest.

It is astonishing that almost all of this canvas is white. The few lines and color are so powerful that we see them first and foremost, and they appear to have far more real estate than does the background. With his refined language, Mondrian chose a few physically unsubstantial elements for a powerful impact. They are like monosyllabic words achieving a crescendo of feeling.

Mondrian was energized to do more in Paris because of what he heard about the success he had had in England. Concurrent with the presentation of *Abstraction and Concrete* at the Lefevre Gallery in London, the architect S. John Woods organized, at a furniture store called Duncan Miller Ltd., an exhibition called *Modern Pictures for Modern Rooms*.

Mondrian had happily consented to have his work be seen as an integral part of a new environment, as if it were no more important than a decorative object. In the shop on Lower Grosvenor Place, one of his canvases hung with a coarsely textured raw silk wallpaper behind it. Right in front of the painting there is a round glass-topped table, with a sculpture by Eileen Holding, an ashtray, and a silver fruit bowl on it. A modernist lounge chair next to the table evokes physical comfort and ease, a luxurious sense of repose.

This was the same sort of new design for everyday life that was sprouting up in small pockets of modernism almost all over the world. Austin in Hartford had a dashing modern office space; the Modern in New York was displaying advanced design with the latest painting; Alvar Aalto's Villa Marea in Finland was a showplace of adventurous, intelligent modernism. These neutral, international environments were to some degree the realization of Mondrian's ideas for how human beings could live with clean geometry and a rich rhythm of universal allure.

At the start of September, Mondrian wrote to Winifred Nicholson: "There is so much confusion in the modern movement, I would like to try and clarify a little the content of art." His battle cry was more urgent than ever before. He had an agenda well beyond the scope of his own work, and he considered anyone who did not adhere to his beliefs to be a heathen. He counted on Nicholson to understand. He continued, "I too think that I have brought some order to the chaos of the tendencies! Everywhere one seeks and seeks in darkness. Yet it is so simple if only one understands a little the great laws that are more or less hidden in natural appearance." That was the saving caveat. Mondrian could afford to like Winifred's landscapes and

portraits and flower paintings so long as, in their innocence, their lack of imposition of a style, they revealed, underlying the subject, "the great laws."

Mondrian was a man on fire when he wrote Winifred Nicholson. He opened with unusual exuberance, underlying a declaration of the joy her last letter had brought him. That continuous straight line underneath his words was usually a way of emphasizing a didactic statement about abstraction, not an expression of personal emotions. From there, he focuses, in a way equally rare, on *her* well-being, not on his own.

Here is the whole letter. It needs to be read as a continuum, from the start to the finish. The erratic jumps of Mondrian's mind are like some of the scattered elements of his paintings; structure begets freedom. Mondrian's mix of awkwardness and confidence, and his ability to move from the intensely personal to the practical (especially when the issue is tubes of paint, his essential means for realizing the eternal), is unlike anyone else's.

> Chère Winifred,
>
> *Votre lettre me fait une grande joie.* I am happy that you are content with the pictures and that they have arrived all right. Also that you are in good health and that you work so much. I should like to see what you have done and see you in that beautiful country with the mountains. But I shall be as content to see you again in Paris and *chez moi*. The studio is now good enough; when I have finished a work that is pressing, I shall put in one or two days to better arrange my living surroundings; it is necessary, is it not? . . .
>
> I did not know that Gabo was marrying, I do not know him so well as his brother Pevsner whom I like a lot . . . I have not properly understood why you do not see Ben any more in the situation you speak of, but we will speak of it when you are here. Or does Ben want to marry and not Gabo? But in that case I do not understand why you withdraw. But I am not a woman, me, so I can say nothing. Excuse me that I touch this delicate question but I sense your difficulties.
>
> I will not speak to anyone of the marriage of Gabo because perhaps I have misunderstood you. I write you a little in haste because I am tired.
>
> The blue is magnificent and I should very much like it if you would buy a big tube for me and bring it. About the abstract exhibition in London, I should like you to show your picture of mine, but I cannot advise you because I am always afraid that they will dirty it. I should like it better if you kept it at home! *au revoir!*
>
> The colours interest me a lot: that is to say the red, yellow and blue. I am still not altogether happy with those of Foinet and Cambridge. Can you

find for me also a red and a yellow? I prefer it if you bring them because otherwise perhaps I have to go to the customs!
Je vous envoie mes meilleurs pensées et amitiés, votre Mondrian

In the essay for Ben Nicholson, Mondrian rambled similarly. Regardless, the two-part exegesis on abstraction that appeared in *Circle*, when it came out in 1937, was left untouched. Edited by Naum Gabo and the International Style architect Leslie Martin as well as Ben Nicholson, Mondrian's text was the longest, although the other contributions to the publication were by many of the major leaders of the modernist movement. Barbara Hepworth, Henry Moore, and László Moholy-Nagy were among the practicing artists; Sigfried Giedion, Herbert Read, and Lewis Mumford among the art and architecture critics; and Walter Gropius, Marcel Breuer, and Richard Neutra among the architects. The mandate was to write about "the constructive trend in the art of our day" and its "relationship to the social order." *Circle* had great success, particularly in the United States, and became a sort of bible to a generation of abstract artists.

Mondrian made his essential premise clearer than ever before, and "Plastic Art and Pure Plastic Art" became his best-known and most influential text. The opening three sentences, which contain the basis of Mondrian's belief system, are as valid today as they were then. This will be the case for as long as human beings express themselves visually, as they have ever since they lived in caves.

> Although art is fundamentally everywhere and always the same, nevertheless two main human inclinations, diametrically opposed to each other, appear in its many and varied expressions. One aims at the <u>direct creation of universal beauty, the other at the aesthetic expression of oneself,</u> in other words, of that which one thinks and experiences. The first aims at representing reality objectively, the second subjectively.

There was no question, of course, as to where Mondrian stood.

In his text, the recent convert to the Hay Diet does not mention its proscriptions, yet it is only with a knowledge of the specifics of Dr. Hay's regime that we can really understand Mondrian's "Plastic Art." Hay's emphasis on relationships, of the impact of one ingredient on another, on the need for separation but also combination, sheds light on what Mondrian writes about the effect of one form on another, and of one color on another. And Hay's fidelity to pure ingredients, so familiar to everyone today with the interdictions against processed and modified foods, increases the grasp of Mon-

drian's insistence on primary colors and on straight lines confined to the horizontal or vertical:

> We will gradually realize that we have not hitherto paid sufficient attention to constructive physical elements in their relation to the human body, nor to the constructive plastic elements in their relation to art. That which we eat has deteriorated through a refinement of natural produce. To say this appears to evoke a return to the primitive natural state and to be in opposition to the exigencies of pure plastic art, which degenerates precisely through figurative trappings. But a return to pure natural nourishment does not mean a return to the state of primitive man; it means on the contrary that cultured man obeys the laws of nature discovered and applied by science.

Mondrian at Whole Foods!

III

At the start of 1937, eighteen works by Mondrian were shown in a large show at the Basler Kunstverein. Just over the border, in Germany, they would have been considered unacceptable, but in neutral Switzerland, they were welcome, and of the three canvases the artist himself sent, which were hung alongside the fifteen from private collections, for the most part Swiss, two sold.

The sales kept him financially afloat, but barely. Still, he was now regarded as a living master. In February, the Museum of Modern Art in New York showed one of his compositions in an exhibition of recent abstractions that were gifts from the Advisory Committee. The press release from the Modern said that Mondrian was "generally considered the foremost living master of Abstract geometrical design in painting."

Ben Nicholson wanted to organize a solo show in London; Valentine Dudensing implored Mondrian to send as much work as possible to New York. Slijper was impatient to see recent work, to which Mondrian responded that although he was spending more time than ever painting, he wasn't finishing things. In any case, even if he did complete the work in time, he wrote the organizers of a show in London that summer called *Constructive Art* that he would not participate—not because he didn't have work to send but because Arp, Taeuber-Arp, Gorin, Vantongerloo, Hélion, and Moss were all excluded. He went out of his way to inform people that he and Vantongerloo were no longer friends, but he still did not think the artist's absence was right. And he was fiercely loyal to Arp, who had bought one of his works.

By spring he was feeling that pressure was coming from every direction for him to finish new canvases, yet he could not bring any of them to a point where he was completely satisfied, and he was glad when a large show planned in New York was postponed, giving him more time to develop his latest paintings.

On June 1, Mondrian wrote his brother Carel something completely out of character. He would, he said, "take some time to enjoy the beautiful summer weather which has been upon us for a few days now. When I looked over the terrace roof today I saw a real Winterswijk sky!" He had always loved nature, and still did, even if he had stopped reproducing it in his work. And even if his friends and the general public did not know it, Mondrian allowed himself both nostalgia and memories of his childhood. In private, to his brother, he could drop his doctrine. He forbade himself backward glances in either his art or his writing, but the attraction to the infinite and cosmic which had always been there was connected to memory. What Mondrian evoked with straight vertical and horizontal lines and unblemished colors was an abstracted version of those skies at which he had marveled from a very young age.

In London, New York, and Paris, Mondrian was increasingly coveted by collectors eager for him to finish paintings. But in Germany he was now officially demonized. That summer, two of his paintings were featured in the Degenerate Art show in Munich. One had been seized from the museum in Hannover, the other yanked from the Folkwang in Essen. They would never be seen again.

France was yet to fall to fascism, although it would do so in less time than anyone imagined. On July 30, a show opened at the Jeu de Paume called *Origins and Development of International Independent Art*. Mondrian wrote Carel that his painting on view in it stood "completely apart and is more something for the future; it doesn't belong in such an old French building," but he was still pleased. After all, this was "recognition. At the moment, it is only of moral use because nothing has been sold. But I'm still living from what I sold in the spring."

Mondrian's writing, as well as the commentary about it, was appearing more and more in English. Following the publication of "Pure Art and Pure Plastic Art" in *Circle* that June, the American painter George L. K. Morris wrote about Mondrian's work in *Partisan Review*. Morris, having bought an important Mondrian composition two years previously, knew the subject well.

George Lovett Kingsland Morris, thirty-two years old, was a privileged American blueblood—a direct descendant of a signer of the Declaration of Independence—who had attended the Groton School, the most elite of the

New England prep schools, and then Yale College. In 1929, he had gone to Paris with A. E. Gallatin, a Philadelphian from a similar aristocratic American milieu, and there he studied with Léger and Ozenfant. *Partisan Review*, a left-wing magazine which published a lot of Marxist writers, founded by William Phillips and Philip Rahv in February 1934, offered an alternative to the more strident *New Masses*, published by the American Communist Party. Morris's two-page review of *Circle* appeared in one of the issues of the so-called literary monthly published that year, with essays, articles, and poems by Delmore Schwartz, Wallace Stevens, Edmund Wilson, James Agee, Dwight Macdonald, Mary McCarthy, F. W. Dupee, and Lionel Trilling. The anti-fascist text and drawings of Picasso's *Dreams and Lies of France* were in this compendium of work by many of the most brilliant individuals of the era. Morris's text, which was about the overall content of the magazine, was for the most part stinting in praise—he wrote of the "lapses in the editors' discrimination" and groused about the art reproduced and essays by "painters who write abominably"—but Mondrian's essay fell into the category of "essays by creative artists of the first rank who can also express themselves verbally—a feat that is rarely accomplished. The long essay by Piet Mondrian on 'Plastic and Pure Plastic Art' is the most lucid key to a painter's intentions that this reviewer has ever encountered."

Appreciation of this sort for Mondrian was on the rise among Americans more than with people from anywhere else. In July, James Johnson Sweeney translated three statements by Mondrian in issue 26 of *Transition*, a lively avant-garde American periodical published in Paris, and the *Composition in White, Black, and Red* owned by the Museum of Modern Art was reproduced. But interest was still substantial in the Netherlands. Late that summer, in the August 28 *Hollandsche Weekblad*, Henry van Loon, who had, for over a decade, been providing readers in Mondrian's native land with lively portraits of its most unusual and influential native son, regaled readers with a charming portrait of the sixty-five-year-old artist.

To convince the good Dutch bourgeoisie that someone who painted as outrageously as Mondrian was not a swindler, Van Loon resorted to the tactic that many generalists use to spoon-feed modernism to the masses: he makes the case that Mondrian is really a legitimate painter who knew his trade. "He started out as an ordinary painter," Van Loon writes, before explaining that Mondrian wanted to paint because his uncle did, had received academic training and teaching certificates,

> followed the path of impressionism, and if he had kept it up he would have gone far, because he not only had talent but also developed his tal-

ent. And after the great evolution towards abstract art, he still sought relaxation now and then in making drawings and watercolours of flowers. Things of sheer fragility.

Van Loon defends his subject as being a decent and honest person in spite of turning to abstraction. "He veered more and more towards the subject-less painting, and those who doubt the good faith of this development demonstrate an utter lack of understanding of this man. If there is anyone free from attention-seeking, vanity and pretention, it is Mondriaan."

Then Van Loon, possibly because at last he was confident that he had won over his readership to someone they would have considered a madman without some sugarcoating, stops the apologies. At that point, he focuses on the man he has known for many years, and provides a portrait that is as accurate and insightful as almost any contemporaneous account of Mondrian at this moment in his life when he was at last being regarded as a living master.

But he abhors anything that resembles social ambition, or, in other words, snobbism. He lives alone and has restricted his needs. . . . He rejects those who claim to see tragedy in the art of this or that artist. Falsity in colour and attitude to life fills him with physical revulsion.

Van Loon is trenchant and captures Mondrian's essence:

The philosophy of Mondriaan is that he sees unity in everything. Thus it can come to pass that he considers dissimilar things as being on the same line. There is no other example of such a self-contained life. The man and the artist are truly one and the same. Whether you listen to him, read him, watch him painting, share a meal with him, witness him in convivial company, he is always true to himself.

Van Loon's Mondrian carries that consistency into his love for American jazz, his masterful writing about the modern city, everything he does.

IV

By the start of 1938, the Third Reich had succeeded in nearly wiping out unemployment in Germany. Loyalty to Hitler was soaring. The Wehrmacht—the German army—had, in the previous year, increased its ranks to many millions of soldiers. They were openly preparing for the annexation of Austria.

Italy, meanwhile, had pulled out of the League of Nations. Under the leadership of Benito Mussolini, they were laying the groundwork for racial laws like Germany's. In Spain, General Francisco Franco, whose fascist party's bid for legitimate power in 1936 had failed, had been behind a coup that July, and a violent civil war was raging. The fascists were edging their way toward ultimate victory.

Life in Paris, however, had changed little despite the developments in its neighboring countries. Elaborate preparations were underway for the FIFA World Cup, which the city would host that June, and for the Tour de France in July. Samuel Beckett, André Gide, Eugène Jolas, and Djuna Barnes were writing masterpieces; Django Reinhardt was recording his exuberant music. In the midst of this, Mondrian wrote Winifred Nicholson in January to ask her to come to his studio to see four canvases he was about to send Dudensing in the United States. He was forging links with America; he had developed the idea that it could be his haven. After all, it was the birthplace of the African-based music he knew through jazz. He had no plans on how to get there, but by sending these paintings, he was like someone shipping his personal effects in advance.

At age sixty-five, Mondrian had renewed energy. But most of his work from 1937, the last full year he would remain in Paris, is gone, buried beneath the artist's own later revisions.

The large paintings that Mondrian had finished by the end of the year would, for a while, remain as they were—since four had been shipped to New York, there was nothing more he could do to them—but Mondrian would, after he found refuge in the United States in 1942, repaint them. Three were to be exhibited at the Museum of Modern Art that year, and he would alter these and two other compositions with changes to their layout and to the choices of what primary color to have where. Thanks to period photographs, we can see what these paintings looked like in their first state. The major paintings begun in 1937 that we can see today—at the Tate, the National Gallery of Canada in Ottawa, the Museum of Modern Art, the Kunstsammlung Nordrhein-Westfalen in Düsseldorf, and the Munson-Williams-Proctor Institute's Museum of Art in Utica, New York—were realized in their current form in 1942.

Most artists simplify and reduce the elements of their art with age. Mondrian did the opposite. The paintings he made in 1937, subsequently repainted but known in that earlier form from period photographs, were leaner than what he eventually turned them into. It would be as if Mondrian used the earlier versions as scaffolding to which he added elements in their second phases in the United States. While one of the earlier ones had a large

horizontal yellow rectangle in the upper left, and a small red one in the lower left as the only elements of color, and was nothing but black and white except for a single small slightly vertical blue panel toward the lower right-hand corner, it and the other New York reincarnations have more going on.

When the paintings had fewer elements in 1937, they were less balanced. A pronounced disequilibrium, like an atonality, prevails in the few 1937 paintings that remained as they were then and in the photographs of the canvases taken prior to their 1942 reworking. We will never see firsthand the painting which Mondrian, in 1937, called *Blanc et Rouge*, because he would repaint it in 1942, when he renamed it *Composition with Red, Blue, and Yellow*. But we do know the way it looked initially, as much as we can discern from a black-and-white photograph taken in Mondrian's studio on the boulevard Raspail and from the information afforded by the original title. The main difference is the addition of blue and yellow to the palette that included, besides the usual white background and black lines, only red. Originally, that red was confined to a single slim vertical element running along the top five-eighths or so of the left-hand boundary of the painting, and touching the top. All of that changed with the New York revision, which, although it adheres to the essential format on top of which it was painted, has many small sparks of the red as well as the two new colors, some new linear elements, and changes in the widths of the lines. With those visual alterations came a different feeling.

It is not a reach to conclude that these paintings which Mondrian was so eager for Winifred Nicholson to see in January 1938, his production of the year just ended, had less equilibrium and resolution than his redos of them in New York in 1942 because, in 1937, he, too, was less resolved and balanced than he would be five years later. Rather than being in the midst of strife-torn Europe, Mondrian would, once he got to the United States, feel at a safe remove. And he would be surrounded by more enthusiastic supporters of his work than ever before.

The dissonance that reflected his inner emotional state during that difficult time in Paris was intentional. In these periods when he was unsettled, Mondrian wanted his art to irritate. This was not in the sense of emotional irritation which borders on anger, but the sort of irritation a trout feels when excited by a fly on the surface of a river, or the human eye feels when facing bright light that causes it to blink. He sought a deliberately discomfiting quality in the work he did on the boulevard Raspail, both because of what was going on inside him and because it increased its power of diversion. The distraction from other concerns, like the stimulus of atonal music, was essential. Mondrian's art in this difficult time period was restless in part because he was restless.

V

That February, Mondrian wrote Ben Nicholson with one of his usual refrains that he was not yet achieving everything he wanted in his work but was getting close. Several months later, he wrote him again about an entirely different matter. Mondrian told Nicholson that, until now, he had believed without question that there would be "a peaceful political solution" to what was happening in Europe. Now he had lost his confidence that this was so.

He needed to leave Paris soon. But the very thought of returning to the Netherlands "disgusted" him. He dreamed of going to America, but it was too far away and too expensive. Moholy-Nagy had said he would like to have him at a school he was forming and would call "the Chicago Bauhaus," but that institution was not yet underway. By early September 1938, Mondrian had decided that he wanted to go to London. He was sure that bombs would fall there as well, but from London he hoped eventually to make it to New York, and for now it was urgent to make that first step.

Just as Mondrian was becoming determined to get out of Paris, Antoine Pevsner told him that his brother, Naum Gabo, who had moved from Paris to London in 1936, would be visiting him in Paris and might have some ideas on how Mondrian could make the move.

Having failed to recognize what lay ahead when he left Paris in June 1914 for what he thought would be a two-week holiday and ended up as five years of exile, Mondrian in 1938 did not want to repeat his mistake of not anticipating imminent war, and he could no longer wait. He hoped that Nicholson would give him some advice quickly. Certain that a studio would be too expensive, he expected Nicholson to tell him at what price he might have a room in London where he could cook. Mondrian was in a frenzy with his wish to move.

Mondrian desperately instructed Nicholson to send him an invitation to go to London. Even before he knew where he would stay; this was essential in order for him to get a visa. "Send it to me if you counsel me to come; tell me also if I should come quickly with only a few necessities with me, or in several weeks. In the latter case, I will have time to arrange to move with a few kitchen utensils, canvases, paintings, etc."

That same day, Mondrian wrote letters to Harry Holtzman, Kiesler, and Jean Xceron. Xceron, a Greek-born abstract painter a generation younger than Mondrian, was a geometric abstractionist who periodically visited Paris and lived in New York. Mondrian beseeched these three people in America also to send the invitation essential for a visa, this time for the United States. Whichever visa he could get first—for America or England—Mondrian would simply board the next ship. What the world situation meant to oth-

ers was beside the point. "I am so deeply saddened that I must interrupt my work here in this way, brutally forced by necessity. I have only just found the solution to two paintings that are each a meter square, and three others."

Nicholson was the first to respond. It took less time for letters to get to and from England than the United States, and he answered by return mail. He assured Mondrian he would be able to find a room where he could work and cook, and told him what the rent would be. On September 11, a Sunday evening, Mondrian wrote thanking him but lamenting the expense; his London refuge was going to cost more than the Paris studio, where he also had his own bath.

Regardless, first thing the following morning, Mondrian made arrangements with the shipping company of Lefebvre-Foinet to send all of his paintings to London. There were far fewer than most artists have in their studios. He had little more than the dozen or so canvases in progress; Mondrian had managed to sell, or in a few cases give away, all of his earlier work. Within three days, they were en route to England.

He had given the incomplete paintings a priority. The shippers could send blank canvases and Mondrian's clothing later. Because Mondrian had little need for variety in the well-cut suits he wore in public and never held on to anything once it lost its shape or was threadbare, and invariably painted in clean white smocks, his entire wardrobe fit into a couple of suitcases. He also sent a trunk of manuscripts, and a second trunk with magazines and books, his phonograph, a few of his jazz records, the room screen, a single folding chair, and a handful of other personal effects. He would write Carel from England, "The rest which I'm leaving behind is really just ballast. I already have the standing work lamp; your teapot too. I sold an easel to acquaintances in Paris. I had to leave the other one on the ship."

On Wednesday, September 14, 1938, just as Mondrian was packing up the last boxes and suitcases for his move, French radio broadcast the news from London that Neville Chamberlain had decided to pay a visit to the German chancellor. The larger public was overjoyed that the British prime minister would go to Munich to strike an accord with Adolf Hitler. The Princess of Wagram wrote: "We ought to raise statues to Mr. Neville Chamberlain in every town in France." The hero worship on the part of an esteemed noblewoman with one of the finest houses in Paris was echoed throughout the land.

Millions of mothers of young men who might be recruited into the army publicly blessed the British leader. Sophisticated political observers in *Le Figaro* and other leading newspapers applauded Chamberlain's gesture as well, and soon the enthusiasm became nearly unanimous. When the French prime minister Daladier met with Chamberlain in London to signal

his country's approval, he was praised even before he arrived back in Paris. The consensus was that violence had been avoided through diplomacy more effective than any military response to German aggression.

Mondrian did not share the public opinion about the pending pact between England and Germany. Unlike many of his fellow Parisians, he saw Chamberlain's plan and the wholesale support of it as the kiss of death to any hope for peace. On September 15, the day after Chamberlain's intention to meet Hitler was announced, he wrote Ben Nicholson to report that he had shipped his large paintings to an address in London provided by his shipping company and that he was ready to follow them as soon as he could.

Mondrian thanked Nicholson profusely for all his help in arranging the move he would now hasten to make. Nicholson had had Winifred's brother, his former brother-in-law, the Liberal MP Wilfrid Roberts, issue the invitation to England that had enabled Mondrian to get his visa quickly and easily. The room about which Nicholson had already written to Mondrian was one he had rented in 1931 when he left Winifred for Barbara Hepworth; despite Mondrian's grousing about the cost, the moment it became available, Nicholson had booked it, assuming that Mondrian would take it soon enough. It did not have a bath, and Mondrian would have to buy or borrow furniture, but Nicholson planned to help him out.

Knowing that he had a place he would be able to make his new home, different though it would be from his Paris studios, Mondrian was immensely reassured. He now decided to leave France so rapidly that he would arrive even before he could take the new place; he could stay in a cheap hotel until it was ready. He was calm and matter-of-fact, and grateful for the help of friends. Naum and Miriam Gabo had written him to say that they had organized the hotel room which he could use for a few days until his own place was ready.

In 1936, Gabo and his wife, the former Miriam Israels, had moved to London, possibly because, being Jewish, they had felt the perils of remaining in Paris earlier than other people did. Mondrian was supremely grateful for their help in organizing his London life both in advance and once he got there; he kept his anti-Semitism at bay in anything he wrote about them. He was unequivocally appreciative of everyone making his move possible, writing Carel and Winifred Nicholson and Gorin and others about the Gabos' kindness.

Mondrian was giving himself three more days before leaving Paris on a day when he would be able to travel with Winifred Nicholson. Nicholson had made her decision to leave her lovely flat overlooking the Seine when a friend in England had advised her to buy bicycles so that she and her son and two daughters, one of whom was still a toddler, could pedal to the coast once

the Germans entered Paris. She was sorry to leave behind a period of her life that had been "chaotic, revolutionary, inspiring, intense, enlightening," but she also knew that the reality of an escape from Paris by bicycle with enemy troops all around was not a risk worth taking. By the time she and Mondrian were heading to London, she had already sent the three children. Mondrian made a point of telling Ben how glad he was that they were safely out of France and that Barbara Hepworth could help take care of them until their mother arrived from Paris.

Mondrian calculated that, once he covered his moving expenses, he would have, at most, six thousand francs remaining. He wrote Ben Nicholson for advice on whether he should take an easel and mattress and pots and pans with him, or buy new ones in London. Cost was not the only factor. He was worried about how the customs officials would look at him if he traveled with so many household items that they realized that he was not just going to England for a visit, which was what his formal invitation indicated. If the authorities thought he wanted to become a permanent resident, they might deny him entry.

He decided to sell one of his two easels and take the other. Henry and Maud van Loon bought it. Mondrian gave the Van Loons those of his phonograph records he was not shipping, as well as his record rack. He had constructed this piece of furniture out of wood and painted it white. Nearly seventy-nine centimeters high, thirty and a half across, and about twenty-eight deep, it was simply a three-sided box, open on the fourth side. Closed at the top, it had five shelves at even intervals, with a space of some five centimeters between the bottom plank and the ground. Looking like an ordinary, functional object, almost like a straightforward packing crate, to modern eyes it is a sculptural piece of furniture—resembling to a remarkable extent work by Donald Judd. Maybe it is only because we know it was Mondrian's that this record rack seems almost noble, but its candor and the straightforwardness of its unadorned elements are exceptional. The proportions are perfect, the intervals just right, the balance of lightness with adequate strength sublime. Fortunately, the Van Loons treated it as the rare gem it is, and left it to the Gemeentemuseum in The Hague.

On September 20, Mondrian and Winifred Nicholson boarded the train for Calais at noon.

On the first leg of journey, Mondrian was happily transfixed. Winifred Nicholson's account of him on that clear and balmy September afternoon is, although idiosyncratic in its sentence structure, breathtaking:

Mondrian on the other side of the carriage was gazing rapt on to the Somme country as we sped past it on our way to Calais. . . . The grass

was lush and green, the poplars were green and soft. The sky was evening yellow, sunlight, a green peace lay over the marshy lands. "How beautiful and peaceful it is," I thought, "and you see Mondrian does not hate green, or the country, his eyes are full of its marvel." "Isn't it wonderful," he murmured. "Yes, isn't it," I said.

"Look," he continued, "how they pass, they pass, they pass, cutting the horizon here, and here, and here." My hand moved as if to touch them, as they passed by out of the window of the flying train, and I realized that what delighted him were the telephone poles—the verticals that cut the horizontal of the horizon. The fundamental of his art of space, its perception, its comprehension. No superficial pleasure of lush flowering green countryside, no light of materially visible sunlight. The enlightenment of the harmony of opposites—the great two opposites horizontal and vertical—expressed in the two fundamental opposites of white and black—white space by black line. But duality, duality leads to madness, they must resolve with a trinity—so above the two paths of opposites, white versus black, horizontal versus vertical, sings the trio of blue, pure blue, yellow, purest yellow and red, vividest red—and if only one of these in the picture, why then it sings and calls for its complement like a lonely artist hermit in a sparse upper studio, a spirit searching for a new realism like a scientist in outer untrodden space. How lonely those on the frontiers of outward bound thought.

Once they reached Calais, the travelers switched to the ship to Dover. It was either at the dock or on the ferry that Mondrian had to abandon the easel he managed to take that far. He would write Carel that he left it on "the ship," but other sources say that he was not allowed to take it on the ferry because of its dimensions. Regardless, he managed to keep his standing work lamp and the teapot Carel had given him. Winifred Nicholson had already sent her furniture, of which she had a lot, so she was able to lend a hand.

The weather was fine on the ferry crossing from Calais to Dover, the English Channel calm. The pair continued from Dover on a second train that got them to London that Tuesday evening at about 7 p.m. It seems likely that the reason Winifred Nicholson had stayed behind after dismantling her household and dispatching her children was to accompany Mondrian. Thirty years later, when she reminisced about this, while allowing that her memory was hazy—"those were confused days"—she wrote that it was possible that friends had suggested that she and Mondrian travel together since he had not left Paris for so many years, and the journey would be too much for him alone.

Ben Nicholson had told Mondrian that, upon arriving in London, he could have a bed in the house Nicholson shared with Barbara Hepworth. Possibly because it was Nicholson's ex-wife who had accompanied him on the trip—but more likely because he could not imagine ever living with other people, even for a few days—he opted instead for the hotel the Gabos had suggested, the Ormonde at 12 Belsize Grove, in Hampstead, not far from where the Gabos themselves lived.

London

Naum Gabo was determined to help Mondrian settle in London as easily as possible. Gabo well recognized the importance of the right living space for the man who had been so entrenched in the life he had designed for himself in Paris. Gabo had visited the studio at 26, rue du Départ, and considered it

> a Mondrian in space. White, with geometric shapes of color on the wall. The furniture was just straight up and down: he made it himself. We used to have tea in exquisite white cups: they too went straight up and down.

Aware of how difficult the change might be for someone used to such a pristine environment, Naum and Miriam Gabo started by organizing Mondrian's hotel room as best they could. They knew it would not be easy, at age sixty-six, suddenly to be a refugee.

It was a long time since Mondrian had been in a hotel room of any sort. For nineteen years, he had not spent a single night in a bedroom other than his own. He was not used to other people's spaces. The Ormonde was in fact more boardinghouse than hotel. Its sixty rooms, created in two ornate Italian-style villas which had been joined, were antiquated and modest spaces brimming with refugees from Nazi Germany and elderly people for whom it was a retirement home. Mondrian was grateful to be there. But while he was neither neurotic nor demanding when circumstances gave him no choice, he believed that one's surroundings should correspond to the values of Neo-Plasticism, and therefore have no trace of historicism with its intrinsic sadness. Still, having to be in an old-fashioned, shabby hotel room with clashing flower patterns competing for space, he adjusted.

Then, after six nights, Mondrian moved to 60 Parkhill Road, into the ground-floor room that had been Ben Nicholson's a few years earlier. It ran along the back of a three-story brick house, built in the Victorian era but in a simple and straightforward architectural style. Three steps up from street level, the large dwelling had a basement flat below where the custodian and

her husband, a policeman, lived. The front room, which was on the same level as Mondrian's, was the home of an elderly lady he scarcely encountered. He found it all more than suitable. Many people considered London as risky a place to be as Paris, but for the time being Mondrian was content.

II

On September 28, Ben Nicholson wrote Leslie Martin that Mondrian "oughtn't to be in London." They feared a German invasion of some sort. Winifred Nicholson urged him to come stay with her at her house in the country, at Branford, or at her parents' place, Boothby. Even though their marriage was ending, the Nicholsons were united in wanting Mondrian on safer ground.

Mondrian, however, was resolute that he would go no farther; he had found a place that made him happy. Almost as soon as he moved in, everyone in the neighborhood was given a gas mask at town hall, but while Mondrian reported to Ben Nicholson that being provided with this protection against poisoning following an enemy attack was "not very encouraging," he was unflapped. Rather, Mondrian made a point of emphasizing the kindness with which the mask had been handed to him and his happiness over his new space.

From two oversized windows in the back wall, which faced east, Mondrian looked down at the roof of Nicholson's studio. When he lived in the room now inhabited by Mondrian, Nicholson had made the studio from a small outbuilding in the garden, and he still used it. A gate in the wooden fence in the garden opened to a short path which led to the Mall Studios. This was a compound of artists' dwellings where Nicholson and Hepworth lived, as did the art critic Herbert Read and other lesser-known figures who made or supported modern art and who would become Mondrian's friends in the treacherous period when the London that was his refuge became more and more dangerous.

Mondrian's living space at 60 Parkhill Road measured seven by four and a half meters, and was three and a quarter meters high. He would write Carel that it was better than his Paris studio, because the position of the windows along the long wall made it possible to stand farther from his work. Unlike the studios in Paris and New York, it was never photographed, but one can picture it. A built-in cupboard provided storage to the right of the door. There was an oversized white marble fireplace on the wall to the left. Folding X-shaped trestles supported a large board, making an ideal worktable; it had been brought, Mondrian wrote Carel, by the "squirrels."

Of the twelve phonograph records he had sent himself from Paris, one

was of the music for the recent Walt Disney film *Snow White and the Seven Dwarfs*. That was the source of the reference to "the squirrels." The Disney movie was much on Mondrian's mind. On October 2, shortly after he got his new landlord at Parkhill Road to paint the room white, Mondrian wrote Carel, "The landlord has had the room cleaned by blanché-neige [Snow-white] and has got the squirrel to whitewash the walls with his tail." It was rapidly becoming an obsession.

Having often listened to the songs from *Snow White and the Seven Dwarfs* in Paris, soon after arriving in London, he went to see the actual animated film at the Haverstock Hill cinema. The movie theater itself was a grand and exciting structure that, when it was being constructed in 1934, had been taken over by Oscar Deutsch's Odeon Theatres Ltd.

Deutsch was the British-born Hungarian Jewish son of a businessman who had made a fortune in scrap metal. His theaters, started in 1928, would between 1933 and 1938 grow from twenty-six to two hundred and fifty. The Haverstock Hill Odeon was the flagship of this chain of large cinema halls. It was designed like a sports stadium, or one of the amphitheaters of ancient Greece that were the original "Odeons" and the source of the name. These extremely comfortable theaters epitomized middle-class well-being in England. The Haverstock, as the jewel of the crown, had 652 seats in the stalls and a raised rear balcony section with 892 seats in which people could smoke. Mondrian, rarely without a cigarette in hand, was at home.

Walt Disney Productions had released its version of the Brothers Grimm's 1812 fairy tale in 1937. Initially considered "Disney's Folly," with his business partners trying to talk him out of it, it was the first full-length animated film in motion picture history. It had cost nearly $1.5 million, six times its initial budget, to make, forcing Disney to mortgage his house. But by the time Mondrian saw this blockbuster feature film in 1938, it was earning $8 million a year and becoming the highest-grossing musical film in history. Sergei Eisenstein would call it "the greatest film ever made."

And the overall mentality of the movie was Mondrian's work ethic. "Heigh-ho, heigh-ho, it's off to work we go" and "Whistle while you work" were perfect paeans to the joy of one's labors. Snow White herself was Mondrian's alter ego: innocent, pure of spirit, and able to bring enormous joy to others. And the association with whiteness was irrefutable.

On October 10, Mondrian sent Carel a brightly colored postcard of Snow White telling the dwarves a fairy story. He wrote, "The dwarves don't have time themselves to help me but send squirrels and birds." For Mondrian, the seven dwarves, the squirrels, and the birds were the Gabos, Nicholson, and Hepworth.

The people whom Mondrian identified as the birds in *Snow White*—the

Gabos—provided him with a cot, as well as a quilt to keep him warm at night as winter approached. We know only that it was blue, but what the precise hue was, whether it was solid or patterned, falls in the category of information we would love to have but have to accept as unknowable. Given Mondrian's propensity toward bronchial problems and frequent colds, that bed covering figured large in his life, as did the "pair of warm carpet slippers which he treasured," also provided by the Gabos.

Mondrian went shopping for furniture with the Gabos and bought what by some accounts was a bookcase and by others a cupboard, as well as a folding table and some cylindrical stools on which he could prop his paintings leaning against the wall.

Barbara Hepworth said that it took less than a week for Mondrian successfully to transform this "bed sit" in a Victorian house on the outskirts of London "into his Montparnasse studio." He had painted the bits of cheap furniture he had bought in Camden Town a bright matte white. As he had done on the rue de Coulmiers and the rue du Départ and the boulevard Raspail, he cut panels which he painted in primary colors and positioned them so that they "climbed up the walls." The writer Herbert Read also marveled at the replication of Mondrian's requisite sanctuary: "I myself had once penetrated to the immaculate white cell in which he worked (in Paris), and it was interesting to observe how quickly he reduplicated his favorite environment in London."

III

By the second week of October, his large unfinished canvases had been delivered to 60 Parkhill Road. With his habitual need to quote praise, Mondrian wrote Winifred Nicholson that "Ben and Barbara like them very much."

It did not occur to Mondrian that Winifred might not want to hear what her ex-husband—and the woman for whom he had left her and their three children—thought. Winifred was in fact especially sensitive to hearing anything whatsoever about Ben and Hepworth. Her and Ben's divorce was finally coming through, enabling him and Hepworth to marry. Hepworth already had, in 1934, given birth to triplets, shortly after Ben moved out from the family home that he and Winifred and their three children lived in. That was when Nicholson moved into the space where Mondrian was now living.

Winifred, meanwhile, after traveling back to London from Paris with Mondrian, had joined her children in Surrey, and then relocated them all to her house in Bankshead, near Boothby, in Cumberland. The location enabled the children to attend a new progressive school at Fresham Heights,

Barbara Hepworth, 1930. The sculptor, married to Ben Nicholson after he divorced Winifred, was one of Mondrian's secret angels. Having dug an air-raid shelter in the garden which her studio shared with Mondrian's, she exempted him from paying a percentage of the cost the way all the other local residents did.

her "official" purpose for being there, but being away from Ben's new family must have been essential to her. Now that he was in London, Mondrian was seeing more of Ben's second wife than his first as Hepworth and Nicholson and the triplets lived just across the garden. But as was always the case, no one expected him to take a side, let alone enter a personal conflict.

Still, those first weeks on Parkhill Road were challenging. There was fear of air raids and poison gas attacks, which is why the government handed out gas masks to those who remained in London. And almost everyone Mondrian knew had chosen to leave just as Mondrian was settling in. The Nicholsons and Gabos considered the situation an emergency and headed for the countryside. Winifred Nicholson did not dare come into town to visit as she had hoped to do; London was too risky for a mother of young children. Everyone urged Mondrian to get out of the city and join them; he flatly refused. It cheered him up to remove the dark wallpaper of his flat to achieve "the whiting"—a word he invented after crossing out "wighting." Reading the newspaper every day, he was worried about the very real threats to peace, but then "the news of the *meeting of the four statesmen*" relaxed him.

That conference in Munich where Edouard Daladier of France and Neville Chamberlain of England met with Benito Mussolini of Italy and

Hitler sat less well with others. It allowed Germany, following its successful invasion of Austria, to invade the Sudetenland in Czechoslovakia. This permission from Britain and France for Germany to go unchallenged in its conquest of millions of people prompted Winston Churchill to declare, "You were given the choice between war and dishonor. You chose dishonor and you will have war." But the Munich agreement relaxed Mondrian, who also took comfort in Barbara Hepworth's advice that he could seek shelter in a tunnel near the Mall Studios if need be. The sense of danger made it hard to paint, but still, once the flat was done to his liking, he returned to the easel.

Following his arrival in the British capital, Mondrian was bursting with energy. Having shipped the compositions he had begun in Paris ahead of everything else so that they would be there the moment he was ready to resume painting, he worked his way from one to the next and back again, adding and subtracting elements, moving lines up and down and left and right and narrowing or widening them. He simultaneously revised the large unfinished paintings he had brought along and sketched a third: *Trafalgar Square*, nearly a meter and a half in height. In the upcoming year, he would work intensely on this painting he named for the great crossing point in the center of this city he considered his haven as Paris was moving toward enemy occupation. He would eventually complete it in New York.

But success eluded him. He could not complete a single canvas to his satisfaction. The large canvases Mondrian reworked that fall would eventually go into further incarnations, so what they became in 1938 is lost beneath subsequent revisions.

Composition of Red and White: Nom 1., as he called it in 1938, would only develop into its ultimate self after Mondrian moved to New York. *Composition N°4 1938–42 with Red and Blue* would require another three years of tinkering before he gave it its name, which included the time span it took him to get it right. Mondrian would not be satisfied until he could get his viewer off guard. For starters, he deliberately tickles us by using a shape which appears to be perfect but is a hair imperfect. The difference between the height and the width is 120 millimeters, or about half an inch; the canvas is 100.3 cm (39½ inches) high, and 99.1 cm (39 inches) wide. That nuance contributes inexorably to the continuous rhythm and the visual pitch he would refine within the slightly offbeat whole. Mondrian could not change the world around him, but he could control the one he made.

Mondrian was as millimeter-subtle in the placement of colors as in the overall scale. There is a blue that was not yet present in London but that would appear in America as a tiny horizontal rectangle at the bottom right, tucked so snugly against the lower edge of the canvas that we do not even notice it at first in the final painting. We will never know how many such

color accents appeared on the stage and then went behind the scenes again in the history of this composition, but even if this blue ingot was the only element that Mondrian added in those four years, it changes everything.

We can only hazard a guess as to how many incarnations this painting had. It was formulated in Paris, then had two years' worth of changes in London, and then had further lives over the three years in New York—before Mondrian finally wrote "42" as the year of completion. We only know that this telltale blue, which is present in the finished painting, was absent in any of the photographs taken in the studio at 60 Parkhill Road and when the work was on exhibition in Paris in 1939 in an installation photograph of the exhibition *Réalités Nouvelles: Oeuvres des artistes étrangers.*

That blue that showed up at last in the composition's New York life, and remains, gives the final painting the three colors of the flag of the country where he became supremely happy and felt both safe and patriotic. Mondrian would enjoy that fealty to the United States that is particular to refugees who consider themselves saved there, but if he was referencing the American flag, it was probably not intended as such. But, still, in the country whose national flag gets called "the red, white, and blue," it is just possible that the blue appeared as an unconscious voice of patriotism. The artist who had, as a young man, officially honored Queen Wilhelmina in his *Shipworks* painting was not beyond such things.

The blue horizontal is not all that Mondrian would add during the painting's travels from Paris to London to New York. Mondrian would also put in two minuscule red blocks against the left-hand edge and at the bottom, and would add a second thick horizontal crossbar. But, even in its pre-revision form in London—which is where Mondrian did most of the work on it—this painting was like a glorious celebration. It resembles the fullest voice of a powerful operatic tenor expressing joy from the depths of his being. The three edge-to-edge horizontals, close together, and the four edge-to-edge verticals, positioned without calculation or preparation but by sheer instinct, make a scaffolding that suggests just how spectacular human endeavor can be. This canvas that is about a meter square is—like Egyptian pyramids, Greek temples, and Gothic cathedrals—a miniature metropolis. Mondrian's own world was in flux—London with the threat of bombs dropping did not feel more safe than Paris—but Mondrian wanted not just security but triumph in his art.

The coup de grâce is the red. It was already there in 1938, in a generous, large, victorious horizontal rectangle, bifurcated toward its bottom boundary by one of the three horizontals that spans the whole canvas. And that canvas was already the whole heavenly city. A second of those horizontals, at the lower boundary of the red, is very possibly at the center point of the

canvas. Or so it seems. Knowing Mondrian, however, it was and is a few millimeters off center. To make that calculation was not just how Mondrian survived the harsh realities of London in this fraught period; it was how he flourished in the face of adversity.

IV

The other large, nearly square canvas Mondrian reworked as soon as he had brought his London flat to life was first known as *Composition N°1, with Gray and Red*. When he revised it during the following year, it became, quite simply, *Composition with Red*. It was among the few paintings Mondrian would complete in London and never subsequently reconfigure. On his new large scale—a hair higher than wide, it measures about 41½ inches by 40¼, although the strength of its horizontal elements makes it seem the opposite—it is audacious, infused with an energy of atomic scale, and optimistic. If only a single painting would remain unaltered for Mondrian's two-year stint in London, it is a blessing that it is this one.

This was the painting that Mondrian said was of interest to Peggy Guggenheim. Fortunately, she bought it after he had made what would be the final changes in the spring of 1939. When they met again in New York, Mondrian might have happily taken the canvas off the living room wall in

Composition with Red, 1939, Peggy Guggenheim Collection

Guggenheim's large house on Sutton Place while Max Ernst and Marcel Duchamp and other lunch guests looked on, so that he could carry it the short distance to his studio and add some blues and yellows, and work on it more, but Guggenheim did not allow it. We get this painting exactly as it was from the time of its completion in London.

It had already gone through sufficient revisions in London. In 1943, the painter Max Bill would write about this composition and refer to a small gray square on the upper left. That explains the title it had in 1938. By the time Mondrian lent the work to an exhibition at the start of 1939, the gray was gone. The main differences between the painting as it was photographed in the show in London called *Living Art in England*, held from mid-January until the end of February in 1939, and its ultimate rendition, completed at the end of the year, were graphic. Mondrian slightly reduced the width of certain horizontal lines and made an even smaller increase in the width of certain verticals.

When we look at the image of an early version compared to the final one, we feel, as did Mondrian, that these changes were completely essential. The stage to which he took this canvas just after arriving in London had resulted in a splendid painting, but one that failed to take off a hundred percent. It did not gyrate the way Mondrian's masterpieces do. Then, with the few alterations of dimension, he turned it into a summa. This was when negotiations were underway for its sale to Peggy Guggenheim, who was then starting a museum in New York. While the acquisition was being considered, he continued to tinker.

At the start of December, when, thanks to the intervention of Herbert Read, Mondrian received an initial fifty-pound payment as a deposit from Guggenheim, he had, so he claimed, only a few technical changes left to make. Then, on the day before Christmas, he wrote Winifred Nicholson that he had "got it at last." Guggenheim took possession of it shortly thereafter.

V

Mondrian was thriving with the support and encouragement of his English friends. He pretty much confined himself to his Hampstead neighborhood, rarely leaving north London, but he had everything he needed in order to work. Still, he was excited by what was happening, now even more than before, on the other side of the Atlantic in the United States. Mrs. Charles Goodspeed's wonderful canvas was shown for the second time at the Arts Club of Chicago that November. And Harry Holtzman had become a greater devotee than ever. In 1936, following his return to America, Holtzman had married a woman from a rich family; his change of fortune would, in time,

directly impact Mondrian. Previously, Holtzman had been living on $26 a week from the Federal Arts Project. Now he had an annual income of $10,000. Once Mondrian was in England, Holtzman sent him a check and a letter saying he would send one every month from then on, adding, "When it's enough to buy a painting, let me know."

Mondrian began sending Holtzman photos of the canvas he planned to send. It was *Composition N°1, with Gray and Red.* The following year, however, he wrote Holtzman that Peggy Guggenheim wanted it. Holtzman assured him it made no difference and Mondrian should sell it to her, since his current house was too small for it anyway. He would be happy to have a different painting later.

That single room in Hampstead gave Mondrian what he considered the best physical conditions in which he had ever worked. The space was infused with ample daylight even in gray and rainy weather, and the kitchen and living areas were efficient and pleasing. The situation in Germany was deteriorating in the aftermath of Kristallnacht, and civilization as he had known it, even during the previous war, was threatened to the core. In this fragile world, Mondrian painted with new zeal.

Mondrian had developed a force that took him, and the viewers of his art, beyond the vicissitudes of human existence. Nothing could mitigate the tragedies of European life that were growing more horrendous by the day, but his art had luster and a spirit of hope that was indestructible.

Rather than bemoan the difficulties of exile, Mondrian entered another of his periods of intense rumination, and, while he found it difficult to paint a lot, he began, again, to write prolifically. As always, what obsessed him was the fundamental role of art in all of human existence. He wrote another essay, to which he gave one of his most doctrinaire titles to date: "The Necessity for a New Teaching in Art, Architecture, and Industry." Never published during his lifetime, the document remains a provocative treatise in its rigorous standards for designers. It addresses the creators "of everything that forms part of our material environment," saying they "must abandon the idea of making sculpture or painting," avoid "anything decorative whatsoever," abandon tradition, and be "bound only by aesthetic laws and the demands of utility." "Pure structure" and the supremacy "of form and color and of the relationships they have or produce" are imperative.

Mondrian writes, "The problem is not to 'say something,' to express a feeling, to depict an emotion, but to create something real that is useful and at the same time beautiful." He advises designers to begin with "an exercise," illustrating "on canvas or paper . . . something real: a house, a chair, and jar," paying attention to the plastic qualities not just of "the picture or the object itself," but to the essential element of "what surrounds it: space."

The form of the object is produced by line, but "color characterizes, alters, or animates the object or aesthetically annihilates it." The objective is always "an aesthetic whole corresponding to the practical demands of the time." To obtain the forms and relationships essential to that totality, "there are laws, inescapable limitations, but there is also freedom." Mondrian acknowledges the differences among designers as individuals, while making the main point that "there is universality, because basically all is one. Differences and similarities, but always the same laws."

The rest of Mondrian's text is very specific about the teaching of art at all levels, ranging from the classes given in early childhood education to the academies. He could not be clearer: "The academy is fatal to the creation of 'art.'" The problem is the pursuit of "form perfection. . . . The academy has to cease teaching the establishment of limited form, and its concomitant, natural color." Mondrian offers, instead, a "New Teaching Program" which emphasizes expression through "plane forms, plane spaces, and their determinations: lines, colors, and noncolors," with an emphasis on "proportions and mutual relationships (relationship of position and of dimension)." He follows this with pages of diagrams, some of which resemble the layouts of his own paintings. Everything comes back to "*the plane.*" While some of the diagrams have curved lines in them, finally it is "only through the straight line" that "the reciprocal and mutual action of planes" can be achieved, resulting in "*pure relations and forms.*"

This was not only his objective for all designers all over the world, and the fundamental goal of his own paintings. Now more than ever, in his new life in London, the approach governed his own life. He had pared down the number of his human relationships, and the ones he maintained had neither the conflict of the intellectual collaboration with Van Doesburg nor the demands of the intense personal link he had maintained with Van den Briel and the women with whom marriage had seemed a possibility. The friendships with Ben Nicholson, Barbara Hepworth, and Winifred Nicholson gave him ballast at the same time that physical distance posed no problem even when all the others were far from London. The lack of further human contact and intimacy suited Mondrian well as long as he still had these relationships. They fulfilled his imperatives and were devoid of the jealousies, power plays, anger, and frustration that Mondrian had known to undermine human closeness, whether in the religious sects of his childhood or among the Neo-Plasticists.

Or at least Mondrian chose not to focus on life's difficulties. Surely Ben Nicholson's leaving one woman, and their children, for another had caused distress. But for Mondrian, form was essential, in human comportment as in

art, and everyone maintained it. This anodyne approach to personal experience underlays the principal beliefs of "The Necessity for a New Teaching in Art, Architecture, and Industry."

VI

Peggy Guggenheim, then forty-one years old, first met Mondrian when he walked into her gallery one day. At least in the way she tells the story, one has the impression that his visit was unexpected. The occasion was neither an exhibition opening nor a scheduled appointment; it was simply a case of the most revered abstract artist in the world strolling in because he had a whim to see a show which had one of his works in it.

The heiress to a copper fortune then had a second surprise. Claiming to be one of the poorest members of her wealthy family, and known to have had many lovers, mostly writers and artists, she was not timid, but she expected

Peggy Guggenheim, in front of one of her paintings by Mondrian in Venice, 1957. An American heiress and ardent collector and impresario of contemporary art, Guggenheim knew Mondrian first in London and subsequently in New York. She bought a major composition and ultimately was led by him to her appreciation of Jackson Pollock. She would often tell the story of a surprising kiss from him.

Mondrian to be a cool Dutch intellectual. On that visit to her Cork Street gallery, "instead of talking about art," Mondrian asked her if she could suggest a good nightclub to him.

Guggenheim would later write that she understood his question better after dancing with him. "I realized how he could still enjoy himself so much. He was a very fine dancer, with his military bearing, and was full of life and spirits, although it was impossible to talk to him in any language." Finding Mondrian's French and English "very odd," she posited that he might have been more articulate in Dutch, only to conclude "but somehow I doubted that he even spoke his own native tongue."

Peggy Guggenheim had determined that the rent she was paying for her gallery on Cork Street was too much. Or at least the cost was a good excuse; she jumped from project to project as readily as from lover to lover. She decided to open a museum in London and hired Herbert Read to direct it. It was Read who had selected *Composition with Red* for Guggenheim to buy and to present at that museum.

In his studio, Mondrian was painting the five foot by four foot *Trafalgar Square*. With that title conjuring one of the city's greatest open spaces, named for a British naval victory in 1805 during the Napoleonic Wars, Mondrian violated his own mandate about subject matter in arts. But Trafalgar Square was, as it still is today, a metropolitan hub where people of every station in life pass one another, and as such it represented the possibilities of life on this earth in the nonspecific way vital to him.

Mondrian did not go to cafés and exhibition openings as he had in Paris—but he was almost in a family in Belsize Park when Hepworth and Nicholson and their children were there rather than in the countryside. In spite of feeling at risk at those times when they implored Mondrian to join them at a safe distance from the city, they periodically came back to town. At Mondrian's bidding, Hepworth and Nicholson regularly crossed the garden to come into his studio. Talking freely with him about the latest stages of the paintings on which he was working, Hepworth was "struck by his most extraordinary grace and strength." She also said that, when he showed his work, he did so "with the utmost grace of thought and movement." Her repetition of the word "grace" reflects the quality Mondrian now emitted, quite the opposite of his social awkwardness in the years before he became an abstract artist. Mondrian's circle of friends was smaller than it had been in Paris, but the relationships were more harmonious.

Hepworth was "a bit nervous about Piet coming over to my studio." It was "full of stone dust," and of the tools with which she cut that stone. She "knew he preferred a less violent atmosphere for his own thoughts." For the brilliant and original sculptor who had recently married a painter

of abstractions as sublime as her stone carvings were bold, Mondrian was "a pillar of strength" in a tumultuous time. Hepworth and Nicholson lived with their three five-year-old children while trying to juggle the demands of child-rearing with making art while coping with the privations of wartime. Although the family was chronically on edge, Mondrian, "with utter equanimity, had tea with the triplets in the nursery studio. Three pairs of eyes stared at him and he treated them as grown-ups which filled them with surprise and wonder."

Barbara Hepworth brought out sides of Mondrian that eluded almost everyone else who knew him. She had been one of the many people who previously believed the myth of Mondrian's dislike for nature. He had, after all, lived up to his reputation when, shortly after moving to Parkhill Road, he complained that there were too many trees in the garden outside his window. The problem with the foliage in the back garden was, however, only that it blocked the daylight Mondrian needed for painting. Barbara Hepworth discovered that Mondrian's reputation for hating to look out a window at nature was false. When he first came to her studio, she had diligently, in advance of his arriving, pulled the curtains to prevent his seeing the flowering shrubs outside. And she anticipated his disdaining her organic art with its clear reference to living forms. Mondrian immediately surprised her. Only minutes after entering her studio for the first time, he said how much he liked her naturalistic carvings and "patted them as though they were children or cats or dogs—which of course they were!" This inspired her to open the curtains, "exposing the flowering shrubs and the plebeian plants." Mondrian was delighted, as he was with everything in her household. "Mondrian seemed to love this family life and would relax and talk. . . . His intellect was superb."

Margaret Gardiner, a friend of Hepworth's, was less charitable about the refugee from Paris. "He seemed to me incongruous in Barbara's studio," Gardiner sniffed in recollection.

> [Mondrian] was dressed in dark, conventional clothes and seemed to have none of the panache and vivacity of [Nicholson and Gabo]. He stood very stiffly, with straight arms pressed close to his sides as though defending himself against some dangerous intrusion. And when Barbara introduced him to me, he was courteous but didn't smile. A Puritan, I thought, a Dutch Puritan, akin to the stern Arnolfini.

That reference to the seemingly wooden character in Jan van Eyck's famous wedding portrait in London's National Gallery managed, meanwhile, to summon an artwork of vibrant crystalline forms in a composition of

remarkable rhythm and balance, which may explain Gardiner's unconscious reasons for the association of Van Eyck with Mondrian.

Ben Nicholson saw to it that Mondrian "had his baked potatoes and tomatoes and his paints." It was Nicholson himself who listed the artist's necessities in that order. He knew his customer; this was the same Mondrian who felt emotionally restored in Brabant when farmers gave him country ham from their own pigs and crusty bread just out of the oven.

Ben Nicholson marveled at the way Mondrian had instantly transformed his living space. When Nicholson had lived there, it had been, if not bleak, ordinary. Now its former inhabitant felt ambient joy every time he entered it. Mondrian had turned the usual dull, rented room into a small sunlit corner of paradise. He did so not only with the presence of his work but also with orange boxes and that simple, cheap furniture bought in Camden Town painted an immaculate, glowing white. Nicholson, who often made white reliefs, believed that no one could make a white more white than Mondrian. The effect of entering Mondrian's room on a foggy Hampstead night made such a strong impression on Nicholson that he would remember it for the rest of his life.

VII

Miriam Gabo was proud that, because she had such a true understanding of the Hay Diet, Mondrian often came to her house for lunch knowing in advance that he would be able to eat everything. Miriam Gabo "used to tease Mondrian, insisting that he lived on carrots alone," but she always followed the rules and cooked with the purest ingredients. She used undiluted and unprocessed foods, as true to their essence as the primary colors and whites and blacks with which Mondrian composed his paintings, and kept the meats, vegetables, and carbs at the requisite intervals.

The rigorous scheduling necessary for all the separations gave Mondrian ample opportunity to look at Naum Gabo's constructions and Miriam's realistic portraits and landscape paintings. Mondrian's response was similar to when he saw Winifred Nicholson's naturalistic art. Maybe it was only when the artist was a sympathetic female who saw to his personal well-being, but again the high priest of pure abstraction became supportive of figurative art that in theory he outlawed completely. Mondrian encouraged Miriam to believe in her own skills, assuring her that a real talent was clearly apparent in her painting.

Still he proselytized. Mondrian insisted that she needed to become an abstract painter. A first step, her lunch guest advised her, would be to paint landscapes or portraits all in a single color. Her approach should be similar

to the Hay Diet of which she had such mastery: one thing at a time. But Miriam did not follow suit. She catered to Mondrian's taste, but only insofar as it impacted his life and work, not her own art.

Miriam Gabo relished taking Mondrian shopping as he acquired what he needed for his new life. He was grateful to have her lead him to the right emporia in London. Honoring Mondrian's various demands, she was the perfect guide. Initially, his main quarry was a painting smock. The likely places for finding one were the art supply stores on Hampstead Road. But what Mondrian was offered were the cloth coats worn by shopkeepers, not "a real smock with gathers at the yoke." The moment they found one, "he bought that and two or three big tubes of oil colour with a happy smile." As when he painted, he sought perfection and brooked no compromise, but the victories were sublime.

VIII

His workday done, it was often just about teatime when Mondrian sometimes walked over to the flat where Nicholson and Hepworth were living with their triplets. The two little girls and their brother were riveted when their sixty-seven-year-old visitor ate globs of red jam off the tip of his knife. Mondrian licked it clean until the blade glistened, without a drop of jam left. All that mattered about the method was its efficiency in rendering the surfaces spotless. If he noticed the effect on the children of seeing his tongue move precariously close to the sharp edge of the blade, he was as unconcerned as a cat licking its private parts.

Following tea, Nicholson accompanied Mondrian as they walked out of the flat. Nicholson would recall that, just after they stepped outside, "he remarked that all small children are barbarians. I must say that during tea this particular bunch were so angelic as to be unbelievable: if only he could have seen them when they were at their barbaric best or heard their remarks on his barbaric knife."

In 1966, an issue of *Studio International* would be devoted to Mondrian's time in London. Naum Gabo would write that Mondrian was "a man so concentrating on himself, very calm, not a man of words. He was intrinsically warm, but outwardly cold, but he was not a man with whom you could have personal relationships." Gabo allows that he did not know if Mondrian had any "close friends" and depicts him as having been quite pathetic by the time he got to London:

He had been totally neglected in Paris. . . . He couldn't look after himself properly. He was terribly thin and seemed to live mostly on currants and

vegetable stew. . . . He rarely touched meat. Once I called on him in the morning early, and he was wearing an old coat. I found that he didn't have any warm pyjamas. So I took him a pair of my own, and a woolen dressing gown. When I took them in I saw a smile on his face for the first time.

Mondrian's habit on Saturday nights was to walk down the hill from Parkhill Road to Camden Town, dressed in a dark suit and tie, and go to one of two dance halls, the Camden Palace or the Bedford. While Peggy Guggenheim considered him a good dancer, Miriam Gabo thought he was "terrible." Miriam said that she and her sister-in-law felt forced to dance with him, alternating with one another, each dreading her time with Mondrian's hands on her back and shoulders as he awkwardly guided his partner around, his bearing rigid, his movements awkward. For all his practicing at home, he seems not to have improved since girls avoided him at the Hamdorff. He had no fluidity and failed to relax. But he always loved to dance.

IX

Life in London became more hazardous. At the start of 1939, Nazi Germany had violated the terms of the Munich agreement by occupying Czechoslovakia. When, on August 23, Russia and Germany signed the Molotov-Ribbentrop Pact, Britain could no longer doubt the real danger of German expansionism. With his new sense of strength, Hitler directed German troops to invade Poland. On September 2, the British, adhering to the obligations of the Anglo-Polish military alliance, issued an ultimatum to Germany to withdraw every last soldier or face the consequences. In the eyes of Britain and France, Germany's conquest of Poland jeopardized the future of all of Europe. On September 3, they declared war on Germany. Having failed in 1914 to anticipate the speed with which the global map could change, Mondrian watched each development with bated breath.

Mondrian's London friends were apprehensive that in little time the war would reach British soil—if not the entire nation, then at least London. The Nicholsons wrote from the countryside on October 1 that they wanted Mondrian to take a room near them. He answered that he could not afford it while paying rent for his flat on Parkhill Road. And he was unwilling to give up this idyllic London studio where he was being so productive.

Mondrian still had the dream he had when he left Paris that he would end up in America. For the moment, however, it was impossible. He would need to take a boat to the Netherlands to obtain the necessary visa, and the boats that were scheduled were all filled up. Then, as the war intensified, the

subsequent crossings were canceled. In any case, it was required to have a certain amount of money in the bank for a visa to be granted, and Mondrian wasn't close to having enough. Jean Hélion, who had moved to New York himself, wrote warning him not to come because, even if he could manage the trip, once he got there the costs would be prohibitive.

Harry Holtzman, who had begun sending Mondrian a monthly stipend, was more optimistic than Hélion. He cabled to say he would help out, and that Mondrian could use his apartment once he got to New York. But Mondrian still felt he did not have enough money to give the journey further consideration.

Then, after his bursts of creativity that summer, Mondrian became too worried about what he would do in an emergency to be able to work. He wrote the Nicholsons that there was "too much to do, and the impressions too heavy," for him to paint, even though he was optimistic overall: "About the world situation, I am convinced that Germany will lose. And no Soviet Europe."

But he could not get out of his head that he would prefer to be in New York. In November, A. E. Gallatin showed seven paintings by Mondrian at his Gallery of Living Art, a sophisticated exhibition space that the wealthy collector had created in 1927 inside a large building belonging to New York University overlooking Washington Square. From a prominent Philadelphia banking family, Gallatin had, in the course of the 1930s, helped raise Mondrian's stature in America by acquiring some of the artist's most buoyant compositions. Gallatin's collection already included Picasso's *Three Musicians*, Léger's *City*, and Miró's *Dog Barking at the Moon*; he had stupendous taste as well as lots of money and the courage to acquire art that his social set failed to take seriously. Four of the seven Mondrian canvases in the exhibition belonged to Gallatin personally, and the other three were borrowed from private collections.

Mondrian wrote Nicholson that he had "no advantage in it." Because it was a loan show, the paintings had already been bought, and the main issue for Mondrian was that he could make no money from their sale. "But it is nice to hear that in this time there is to be a pure expression of pure relations, that only can make an equilibrium. He also has bought one of my Hannover museum pictures, rejected by Hitler."

Hitler's army was gaining force. But for Mondrian that was not the only hurdle at the end of 1939. He wrote to Winifred on December 24:

I have difficulty with an ear and the nose. Dr. Coburg took wax out of one of them but there remains a noise in the other. And then the nose began to

be wrong. One nose hole is too narrow and already 20 years ago I suffered with it.

Then, of course, there was the English weather. "Haven't you suffered of the cold?" he asked his friend in conclusion. Coal was in short supply in London, making the temperature outside another issue. By the start of 1940, with Britain having entered the war, everyone in Mondrian's circle who had not already moved out of London prepared to do so. He did not, but dreams of New York lurked in his imagination.

X

In London, Mondrian wrote "The New Religion," his first essay in English. He subsequently developed it further as "Liberation from Oppression in Art and Life," which George L. K. Morris asked him to submit to the *Partisan Review* the following year, when he moved to the United States. But its editors insisted on such substantial cuts that Mondrian refused to have it published, and it never appeared in print during his lifetime, which is unfortunate since, as a direct response to world events, it was unique in his life's work.

Mondrian starts by asking whether humanity needs "a new religion in this era when people see traditional religion annihilated by Nazism and Sovietism and replaced by a religion of state, work, and daily life" and, "seen superficially, it might seem that the Nazi-Soviet new religion can create a better life, better men." Mondrian uses the ploy effectively by going beyond the superficial to the profound. First, he establishes his ideal for Life with a capital "L." "Life is All in All," whereas "actual life," at least until now, "is not a pure expression of life." He states his goal: "We have to transform incomplete daily life into the pure Expression of Life, which is complete in itself." He dismisses traditional religion as old history and is adamant about the fallacy of beliefs based on visual images of God. Such faith removes "the Essence of Life" from daily life. That sort of belief system was the core of his own childhood, the harsh teaching and preaching of his father and the rule-bound Christianity that dominated, and severely limited, human aliveness.

Mondrian explains in this essay he wrote in north London that the Nazi and Soviet philosophies have, by being doctrinaire and closed to opposition, been as repressive as Calvinism, although he leaves the latter unnamed. "Life expresses itself in daily life to the extent that it is free of all oppression. The new Nazi and Soviet religion is oppressive, just like the traditional old

religion." Determined to liberate humanity, he jumps to the future. What is imperative is to get beyond the "oppressive veiling" of "the old morality," to accept and celebrate "*living reality, . . . to follow Life's pure expression.*"

In this text which Mondrian wrote as the war was altering the fabric of existence in London, Mondrian concludes:

> The new religion is faith in life.
>
> The new religion is for those capable of abstraction. For Realists like to have a concrete idea of God.
>
> New life—is actual life so bad? Yes and no. It is a mixture. Real human life is there, but it is oppressed by all sorts of things. . . .
>
> The certainty that the beauty of Life is to be enjoyed and found in this present life is our great joy. It gives us the strength to seek our happiness in this life despite all, to struggle—always to create "better."

Optimistic about victory for the Allies, and the progress of humankind, in spite of the recent military victories of the Axis powers, Mondrian maintained an unparalleled faith, on which he elaborated in "Liberation from Oppression in Art and Life": "The first thing to understand is that art is not mere entertainment, an enjoyment amid daily life, or a simple expression of that life, but an aesthetic establishment of complete life, unity—free from all oppression in general. . . . Plastic art can help to clarify this evil . . .

"The culture of art is the continual search for freedom," for which it was essential to choose "between past and present." Mondrian was optimistic: "Because of the inequality of men, simultaneous, equal progress is impossible. But progress continues—it does not wait." He believed that "fortunately everything is moving in a more accelerated tempo." Mondrian extolled the "progressive reduction of forms and colors and a growing determination of space. . . . The reduction of form and color—a freeing of form and color from their particular appearance in nature—is necessary to free rhythm, and consequently art. Clearer rhythm produces clearer equilibrium." What was necessary in painting was necessary in architecture as well. It would, if realized according to Mondrian's stipulations, require the recognition "that real freedom is not mutual equality but mutual equivalence." A new visual environment built from pure abstraction and simplified, vibrant colors would be "the substitute that compensates for lack of beauty in life." Mondrian had no doubt whatsoever that the freedom obtained through truly nonobjective geometric form was of a magnitude and value that made it, even at this dark moment in the history of civilization, the sole source of salvation for humanity.

XI

Winifred Nicholson hoped that Mondrian would join the exodus from London by going to her in the countryside. His response to the idea of moving to Cumberland was simple enough: "It is too green."

Ben Nicholson and Barbara Hepworth had now settled in St. Ives for the long term. To do so, they bought an old rattletrap of a car for seventeen pounds, and loaded their children and whatever art supplies they could fit into it. Hepworth would recall, over two decades later, that as they were leaving London,

> the last person we saw was Piet Mondrian in the street. We begged him to come too, or to follow us. We said we would find a studio for him. How could we look after him if we could not get back?
>
> He said *No.* He kept on writing to us until the bombing started and he left for the U.S.A.

Hepworth was devastated. Not only did she feel that she would never again see her own studio or Ben's and Mondrian's, but she rightly sensed that this would be the last moment she would have with the man she considered

> a saint in Hampstead. A much loved friend—a great artist. . . . What he created was the beginning of something—an opening of the door to all of us. . . . I shall always remember his eyes and elegant figure in the street in Hampstead.

The Gabos would follow the Nicholsons to Cornwall and Henry and Irina Moore would move out to Much Hadham in Hertfordshire. Herbert Read, who had also gone to Hertfordshire, proposed to Mondrian that the artist come stay with him there. Mondrian, however, continued to stick it out in London, even as the number of his remaining acquaintances dwindled.

XII

Robert H. M. Ody, who was Ben Nicholson's lawyer, was staying in Nicholson and Hepworth's house. He and Mondrian saw quite a bit of one another. At this moment when few people were even looking at art, Ody bought *Composition N°2 1938 / Composition of Red, Blue, Yellow and White: Nom III.* It had been in a slew of recent exhibitions—*Living Art in England* at the start of 1939, *Réalités Nouvelles* in Paris following that, and, most recently, *Abstract and Concrete Art* in London. But now that it had been returned,

Mr. Oddie—as Mondrian spelled his name—acquired it in installments. This small (17⁹⁄₁₆ by 15¹⁄₁₆ inches), jaunty canvas, spirited and energetic, is one of the few London pictures that Mondrian never got to redo. The payments for it on top of the monthly stipend from Holtzman, and fifty pounds from Peggy Guggenheim toward the price of the large canvas she was buying, made Mondrian sanguine in spite of the world situation.

As long as he could paint, little daunted him. There was a burglary in Mondrian's building—the Russians who were living there had left the door to their flat open and had some small silver statues stolen—but at least he had been left alone. He had sufficient money in the bank and a roof over his head.

Soon, however, conditions became too precarious to risk. Deciding that the hazards of remaining in his studio were untenable, Mondrian decided that he would probably be safer back in the Ormonde hotel. He wrote Winifred Nicholson that he was going to America—not to protect himself so much as his art. Even though he was sure that the British would ultimately achieve victory over Germany, he had an obligation to keep his work intact.

Mondrian believed in divine providence. The ultimate force of goodness would prevail. "England will win the war in the end however hard it may be—for we are fundamentally right," he wrote Winifred. But he had to face current reality.

XIII

At the start of 1940, as the threat of German bombs seemed more real, Mondrian continued to try "to get the old pictures better." He was again suffering from a noise in one of his ears. The duress of tinnitus, its incurability as well as its ceaselessness, added to the difficulties of the winter. Yet his spirits were high. "But on the whole I am much better than last year," he wrote the Nicholsons. He had started a new small composition "and was working on 'Art Shows the Evil of Totalitarian Tendencies.'" It was one of those times when he was more dedicated to his writing than to making pictures, telling Hepworth that the work on this text was "refreshing for my painting." He asked Hepworth to edit it and improve his use of the new language in which he presented the antidote to human evil. Mondrian believed that Hepworth would help him convince the world that visual art was the ultimate weapon needed to defeat Nazi and Soviet totalitarianism.

On May 10, at 4 a.m., German bombers attacked a region near Rotterdam with a vengeance. Within six days, the Netherlands surrendered to the Reich and became an occupied country. While moving into the Netherlands, the Germans had also started their invasion of France. The Belgians surren-

dered, the Maginot Line collapsed, and the German army surrounded Allied troops at Dunkirk. Prime Minister Winston Churchill called these events, in a speech he gave in the House of Commons, "a colossal military disaster." On June 14, the soldiers of the Third Reich entered Paris and marched victoriously through the Arc de Triomphe. With the German occupation of the capital, the French prime minister resigned. Mondrian had pursued the Neo-Plastic because he believed it could counter all the tragic forces of human existence, but when he learned of the conquest of Paris, he became unable to paint. He now realized that he had to go even farther than England in his search for safety.

Too stymied to work on his art, realistic about the impositions of war, on July 4, referring to the expansion of the Third Reich, he wrote Barbara Hepworth, "I am very pessimist." But that very same day he assured Winifred, "I did not lose my confidence in Human's future and Progress." The capitalized "H" in human and "P" in progress were not simply hangovers from the Dutch form for nouns; they signified that Human Progress was the point of life.

At that moment, however, human conduct was at a low. Mondrian could not escape the terrifying realities of the present situation. "Might the Nazis come in, what then?" he asked Winifred. He was terrified that his paintings might be destroyed.

Hepworth and Nicholson had dug an air-raid shelter in the garden of 3 Mall Studios. But they could scarcely cover its expenses, and required their neighbors to pay a fee in advance to use it. To one neighbor, John Cecil Stephenson, Hepworth itemized the expenses (in pounds, shillings, and pence):

£12.0.0—trench
 1.15.6—waterpump
 16.8—extra wood
 8.4—tools lights etc
£14.19.10

Even if those costs forced the Nicholsons to have everyone else pay a share, Hepworth made an exception for Mondrian. "The one thing I do want is that if Mondrian can be induced to use the trench that he should have a free place in it. . . . I wonder if you could find out if [he] is OK for money?" As usual, unseen angels were at Mondrian's side. Hepworth knew that Mondrian was again on the brink of being broke—the only chance of getting him into the shelter was if it was free for him—but he was more concerned about his art than himself. Protecting the contents of his studio was as vital as assuring his own life, and the situation was dicey at best.

XIV

Having hoped to get to New York ever since he left Paris, Mondrian now became more eager than ever. Money was the first obstacle, but not the only one. Mondrian had to procure an entry visa to the United States. Border controls had tightened to the extent that a shipload of people fleeing Germany had to turn back. It was harder and harder to get the right visa.

There were stages to obtaining the requisite documents. First, Mondrian needed his Dutch passport stamped with permission to leave England. On June 26, his new friend Robert Ody obtained the requisite seal of approval from the British authorities allowing Mondrian to leave. But he still needed America to agree to let him in.

He had a savior. Harry Holtzman had taken charge of Mondrian's making it to New York. Besides sending money, Holtzman helped process the visa Mondrian still needed in addition to the passport stamp. It arrived in August. Mondrian quickly signed himself up for steamship tickets. They were hard to procure, but Holtzman had paved the way.

In September, there was a false alarm for a German air raid. Mondrian now availed himself of the shelter Nicholson and Hepworth had created. On September 7, the Germans began to bomb London indiscriminately. Near midnight on the eighth, a high-explosive bomb fell on Parkhill Road, a couple of houses down from Mondrian's studio on the opposite side. Smaller bombs showered nearby into the early morning hours of September 9.

On September 12, Mondrian moved back to the Ormonde. It had an air-raid shelter in the basement, meaning that when the next bomb dropped, he would not have to go outside to get underground. On September 13, he reported to Ben Nicholson and Barbara Hepworth about the events that had begun five days earlier.

My windows were blown in (fortunately I had my blackout but shutters were blown half open all the same! By a bomb a little farther in Parkhill rd. I was in bed but had only dust in a eye. Lucky!) Then there is still quite near a time-bomb. Fortunately I had arranged all and yesterday I took my valises out up here in Ormonde-Hôtel (in the basement of my house I caught a cold!!) where I stay until I go. If all goes well in a few days. Here there is a good shelter under the hotel. Then a new danger comes.

He was still thinking in Dutch—he was referring to his blackout curtains—but he had been clear enough in using the word "fortunately" twice. He considered himself miraculously lucky.

444 MONDRIAN

Nonetheless, huddled in cellars with bombs coming down all around him, his capacity to help humankind save itself through visual art seemed tenuous.

Mondrian bemoaned his cold, using not just one but two exclamation points to emphasize it. His health and his writing were his two current obsessions. Not only was he suffering from congestion but he had now become skeptical about the value of "Liberation from Oppression in Art and Life," regardless of the issue of the requested cuts. The faith Mondrian had in the possible effectiveness of the piece was weakening, and the strengthening of Nazi and Soviet power in Poland had frightened him about the wisdom of publishing it. Mondrian had written Hepworth in July, "My article won't do me much good, neither. But I am glad I made it and could say what I had to say." In his current state of gloom, however, he was no longer certain that anything whatsoever mattered.

XV

For two weeks after moving back into the Ormonde, Mondrian spent his nights fully dressed and sleeping in an armchair. He wanted to be ready to travel on short notice.

Needing only a single berth, his visa ready and his passport stamped as required, he was a likely candidate if a space suddenly became available. In the third week of September, it happened, and on September 21, Robert Ody drove Mondrian to Liverpool to board the Cunard–White Star Line ship RMS *Samaria*. The U.S. immigration restrictions that had been put into effect in the late twenties required that travelers have both adequate money and correct visas, and Holtzman had seen to it that Mondrian had both.

Mondrian had even fewer possessions than he had had two years earlier when he left France, and this time he was alone on the journey. He was sixty-eight years old, leaving Europe for the first time, on his own. All he could hope for was that his paintings would be waiting for him on the other side of the ocean in a studio organized for him by the young man who had helped pave the way and pay for his ticket.

For two days, the boat just sat alongside the dock, its engines idle. The Germans were dropping bombs all over Liverpool, and if the *Samaria* pulled out, it would make an easy target. Finally, on September 23, it set sail.

The crossing from Liverpool to New York took ten days. The *Samaria* had first crossed the Atlantic in 1922, and was a model of fuel economy, cruising at eighteen miles an hour. But that was slow. Built mainly to transport

immigrants, most of the accommodations were steerage, and the Cunard Line was in this case more interested in cheap transit than in speed.

By the time Mondrian boarded the ship, it had been refitted so that the former steerage was acceptable as "tourist class." Mondrian benefited from the refurbishment and had a decent berth at a low price. But this was a functional boat more than a luxury liner; a month earlier, the *Samaria* had served to evacuate children from the United Kingdom to the United States, and the accommodations still bore traces of having been used by young boys and girls; there were scribbles on the wall and general disarray. In little time, the *Samaria* would become a troopship for the Royal Navy. Still, it suited Mondrian perfectly; the ship did its miraculous job without frills. All that the artist wanted was to travel those three thousand miles safely.

Months earlier, Mondrian had removed his own early work as well as a number of unfinished paintings and sketches for new compositions from Parkhill Road. Terrified that another bomb might destroy them, he had consigned them to a shipping company even before he had a U.S. address where they could be received. The Odys had agreed to pack and send his phonograph records and books. Mondrian was traveling light.

On board ship, he wrote to Ben Nicholson and Barbara Hepworth and Winifred Nicholson and other friends that he believed victory would occur. He anticipated ultimate success for Britain and France, and for the forces of freedom—and the ascendancy of pure abstract art. But he and his work had been at more of a risk than he realized. Shortly after he landed in New York at the start of October, the house adjacent to his on Parkhill Road, and the one next to it on the corner of Tasker Road, the place where he always turned to get to the Nicholsons' and Ody's and Herbert Read's in the Mall Studios, were bombed to smithereens.

New York

The haste and drama of the departure had caught up to Mondrian. By the time that the *Samaria* docked at the pier allotted to the Cunard–White Star Line, he had become wan and frail. The sixty-eight-year-old artist, exhausted by the journey, could not have made it off the boat without a helping hand. Fortunately, Harry Holtzman was there.

It was early afternoon, and Holtzman had planned to give Mondrian a quick tour of New York as they proceeded from the docks on the Hudson River to the Beekman Tower Hotel, right near the East River, where Holtzman had booked him a room. Holtzman had envisioned a first meal at the Automat, and he had a mental picture of all that would excite the visitor in midtown Manhattan. But seeing how weak and exhausted Mondrian was, Holtzman took him to the hotel right away so that he could lie down.

The hotel on First Avenue at 49th Street was an Art Deco skyscraper. Constructed just before the stock market crash a decade earlier, it was unlike anything Mondrian had ever seen in Amsterdam, Paris, or London. Instantly enthralled, he revived as soon as he walked in. Holtzman had gotten him a high-up room, from which he looked west toward the Hudson River and beyond. The vast expanse of Manhattan with its brick and concrete towers, the wide river, and the flatlands of New Jersey in the distance were Mondrian's introduction to the energy and spirit of the city to which he had long dreamed of moving. At the moment, what he most needed to do was to fall in bed and get some sleep, but he was excited to be in New York.

Before leaving Mondrian's room, Holtzman told him that when he woke up he should simply lift the phone and ask the operator to connect him. Mondrian replied that he had no idea how to use a phone except to receive calls, as he had done on the rue du Départ; while there was a telephone in the hallway outside the flat on Parkhill Road, he never once used it. But when Mondrian woke up in the early evening on that first day in New York, he followed Holtzman's instructions and was put through, which astonished him. Holtzman came to pick him up, and they walked the eight blocks up First Avenue to Holtzman's apartment at 350 East 57th Street.

At dinner, Mondrian heard, for the first time, boogie-woogie. This form of jazz had been developed by African Americans some fifty years earlier, but had only recently become popular in piano music and songs. Whereas the blues directly reflected human emotions, boogie-woogie was purer, meant mainly for dancing, based on eight-note or twelve-note progressions. It was more about rhythm than melody. Holtzman put the latest discs on his fancy hi-fi. "Mondrian's response was immediate, he clapped his hands together with obvious pleasure. He sat in complete absorption to the music, saying, 'Enormous! Enormous!'"

Mondrian's elixir in the apartment on East 57th Street was music played on three pianos at once by Albert Ammons, Pete Johnson, and Meade Lux Lewis. Ammons had formed the trio. At an early age, he had learned the components of chords by putting a roll on his mother's player piano, slowing the mechanism down, placing his fingers on the keys as they depressed, and marking the imprints with a pencil. He then formed a duet with Lewis, a childhood friend with whom he had grown up on Chicago's South Side. They both worked as taxicab drivers while playing and practicing after their long hours driving. They had their professional debut in 1938 at Carnegie Hall accompanied by another boogie-woogie artist, Pete Johnson, in John Hammond's *Spirituals to Swing* concert. It was a good start for musicians who had to keep driving cabs to make some money.

When the trio performed, it was as if the piano keys were smiling. The energy was infectious, and no one was riper for the lightness and sense of freedom than the bachelor artist who had arrived as an exhausted refugee only a few hours earlier. Any suggestion of a familiar melody—one of the trio's numbers was a riff on the song "Swanee"—was secondary to the play-

It was thanks to the help of Harry Holtzman and other American friends that Mondrian gained entry to the United States at a time when many refugees were turned away.

fulness and sheer abandon. The trills and hopping and leaps up and down spoke to Mondrian's deepest needs and desires. This was perfect music to stimulate a weary traveler. Boogie-woogie had the freshness, the spark, the irreverence, and the light-handed technical mastery that were everything Piet Mondrian believed in. Enraptured by Ammons, Johnson, and Lewis, revitalized by their high spirits, he was at home.

II

Holtzman had invited Carl Holty to be there that evening. Holty had first met Mondrian in Paris on a summer day in 1931 when he was taken to 26, rue du Départ by the photographer Brassaï. Holty would always remember that, following the visit, they were walking down the stairs and through the courtyard when Brassaï said, "Just think of it. The man makes botanical and scientific drawings just to keep alive. And for what? To make pictures of straight lines!"

Now, almost a decade later, they met at Harry Holtzman's apartment the evening Mondrian arrived. Mondrian was sixty-eight years old, Holty forty-one. From the day that Mondrian's boat docked in New York, Holty would devote himself to Mondrian's well-being, joining the string of aspiring artists who undertook the task of allowing the real master to function, even flourish, without minding in the least that it was an unequal friendship.

Holty was born in Germany, in Freiburg, but had come to the United States as a young child when his parents moved to Milwaukee, Wisconsin, where they lived in the German neighborhood. His father was a doctor and encouraged him to study medicine, but he had started art lessons as a teenager and was hooked. He left medical school for art school. In 1923, Holty opened a portrait-painting workshop in Milwaukee. Two years later, he married, and he and his bride moved to Munich. Holty's young wife soon developed tuberculosis; they moved to Switzerland for a cure, but after they had been married for five years she died. Holty's only solace was painting, and he moved to Paris. Holty had already progressed from his early figurative work to abstraction, to which he had been introduced when he studied with Hans Hofmann in Munich. Robert Delaunay liked his work and made him part of the Abstraction-Création group. This was when Brassaï took him to Mondrian's studio, the timing fortuitous as Holty's abstraction had become increasingly geometric. By the time that he was heading back to the United States in 1935, Holty had become one of many painters working in a style clearly derived from Mondrian's.

Following the return to America, Holty again studied with Hans Hofmann, remarried, and joined the recently formed group of painters called the American Abstract Artists, of which he would become chairman. He

started to use tape in his work, although it is hard to determine if he or Mondrian did so first.

Holty was a friend of Stuart Davis's: the colors of his work and its geometric animation have a Davis-like quality. As an abstract artist, he was a decent tradesman, but, while charming, his work has none of the authority of Davis's, or the magnitude and purity of Mondrian's. But, like Holtzman, he would be content to serve the genius who was his guiding light.

III

Besides arranging and funding Mondrian's travel, Harry Holtzman had prepared his hero's new life in New York. The day following Mondrian's arrival, the jaunty acolyte took Mondrian to see two places where he might live. One, a pleasant studio with a skylight, was at West 56th Street and Sixth Avenue. The other, on the fourth floor of 353 East 56th Street, in a row of brownstones with staircases in front, was only a block from Holtzman's. "He said he'd rather be near me (I could see his rear window from mine). That made it easier for me to take care of him."

It was not the first time Mondrian had let himself be taken care of by a younger man. When he had gone into exile in Brabant in 1903, at age thirty-one, he had similarly allowed the nineteen-year-old Albert van den Briel to choose the place where he would live, with Van den Briel nearby. In Paris, Conrad Kickert had helped him find housing; in London, Ben Nicholson did so. Mondrian relished being cared for by men who might have been his

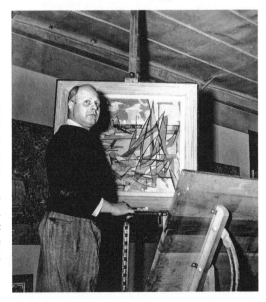

Carl Holty, c. 1950. Mondrian arrived in New York at age sixty-eight. A forty-one-year-old artist, Holty had met Mondrian in Paris when Brassaï had taken him to the rue du Départ and now acted as an unpaid assistant. Holty, a student of Hans Hofmann's, helped Mondrian with everything from buying art supplies to going through the procedures to become a legal American resident.

sons. Now, on the far side of the Atlantic for the first time in his life, he was again grateful to have someone look after him.

When Mondrian had arrived in London two years earlier, he had had no funds, and it had been a scramble to find even a simple cot to sleep in, with the Gabos and Nicholsons in turn lending him an old bed and providing whatever they could scrounge up for bedding. Now he was taken to Bloomingdale's. Holtzman led the artist to the section of the large, upmarket department store where expensive new beds were lined up so that customers could determine which one had their desired amount of firmness or softness. Mondrian's rheumatism was acting up, and he walked slowly, his gait awkward, but his patron simply instructed him to take his time and find "the bed that felt best." It was the first time in his entire life he had chosen such a piece of furniture. "I've never had such a good bed," he told Holtzman. Mondrian next selected a couch, a dining table, canvas deck chairs, "and a metal stool with red top and white legs." Everything he picked was visually light, much of it designed principally for outdoor use. Mondrian was delighted, and so was Holtzman, who wrote a check at the cashier's desk and gave the delivery instructions.

Then Holtzman told Mondrian "to choose a record player." The one that had traveled from Paris to London had not crossed the Atlantic. After a moment of hesitation, Mondrian told Holtzman he did not need his own. "Yours is good enough; I'm an old man," he said. It would take Holtzman

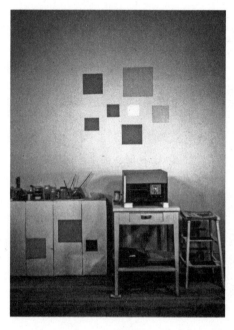

Mondrian even painted the lid of his record player red.

months to prevail, but ultimately he was allowed to equip Mondrian with "a record player and a collection of his favorite discs—all Boogie-Woogie, and the real Blues."

IV

Almost immediately, Mondrian put rectangular forms of solid color on the walls of the one-bedroom apartment at 353 East 56th Street. Setting everything up so that he could get back to work as soon as his paintings arrived from London, he made the living room a studio almost exactly like the previous ones.

Mondrian so hated undulating lines that he did his utmost to eradicate the curved archway at the apartment entrance. Its deviation from straight lines and right angles was unbearable to him. Two people who were firsthand observers of that modified entrance would write about Mondrian's efforts to conceal the arch. Sidney Janis saw the masking of the curves, like every other detail of the apartment on East 56th Street, as part of Mondrian's rare capacity to make his art and living space and way of life consistent:

> The interior of his studio reflects his personal discipline and is of a piece with his paintings. It is brilliantly lighted, carefully planned, simply but ingeniously furnished, clinically clean. The white surfaces of the wall are broken by rectangular color areas of cardboard,—red, blue, yellow, unequal in size—placed to form a typical Mondrian arrangement. To him the oblique is weak and the curve weaker still, so he has covered the curves on his studio doorway with rectangular shapes to eliminate the offending note.

Gerard Hordijk, a fellow Dutchman living in New York, who was a lyrical figurative painter, a generation younger than Mondrian, and whose work slightly resembled Marie Laurencin's, would write Sal Slijper that the studio

> had a lot of light and with all rounded parts hidden. (I was a bit surprised by the symmetry of the yellow and blue block, but when I looked behind it, I saw that it was rounded.) Once, when we went out, he pulled the door closed behind him and said, "Let's wait a moment. I think someone's coming up the stairs and they find it so strange when they look inside."

What befuddled his neighbors was not just that he had obliterated the curve of the entrance arch under a façade of rectangles. Inside his space, he had again mounted panels of primary colors and black so that he could move

them on the white walls, creating a Neo-Plastic haven akin to his studios at 26, rue du Départ and 278, boulevard Raspail and 60 Parkhill Road. Within a few weeks, he was back at work painting.

Once Holtzman was convinced that Mondrian was settled, he and his wife went off to spend three weeks with her family in Kansas City, where they were prospering in the oil business. Mondrian wrote him to say how well everything was going and how appreciative he was. With his chronic need to have another person keep tabs on him, he first gave an update on his health: "The cough is nearly better and I feel more and more at home, all by your good care." Holtzman had hired a cleaning lady for him. Mondrian told his patron, in his English with its traces of Dutch sentence structure, that she "does all she can to make it me easy. Very nice of you to have arranged it so."

Mondrian continued, "Slowly I come back to my inner life that I for months in Europe had not had. I cannot express enough my gratefulness to you both." He hoped, he wrote, that Harry and Eileen had had an easy enough journey, and would not "miss too much our dear New York." Mondrian was elated both by where he was and by the kindness and competence, and perhaps the worship, of the individual who had gotten him there.

V

Nine years younger than Mondrian, born to a financial fortune and social prominence, A. E. Gallatin had as a young man been fascinated with the art and writing of Max Beerbohm, Aubrey Beardsley, and James McNeill Whistler. A high-living bachelor socialite, he hosted countless balls and weddings and charity benefits, and acquired friends who looked like the characters in Beerbohm's stories and Beardsley's illustrations. His name appeared constantly in the society pages of American newspapers. It also showed up in the sports pages because of his passion for automobiles and car racing; he owned some of the winning cars and backed their drivers. Until he was in his forties, he had disparaged almost all modern painting. Then, under the tutelage of Clive Bell, Gallatin became a convert to the idea of two-dimensional painting, and saw that its invocation of a certain general rightness, rather than of personal emotions, could have a profound effect on the viewer. On the same trip to Paris when he first met Mondrian, Gallatin had come to know Daniel-Henry Kahnweiler, Picasso's dealer, and by the time that Mondrian arrived in New York, he had a remarkable collection with significant holdings of both Picasso and Mondrian.

On October 17, Mondrian went to see Gallatin in Lower Manhattan. As usual, he evaluated everything according to its degree of modernism, and the extent of its Neo-Plastic values. Surprised by how old-fashioned Gallatin's

apartment was, he reported to Holtzman that only Gallatin's office was in an acceptable contemporary style. Gallatin, he continued, was "with his niece, a young still old-fashioned sculptor but tending to abstract work." Mondrian instructed the young woman to go further in her eradication of natural subject matter. When she replied that it was difficult to be purely abstract in three-dimensional work, Mondrian held his ground.

But there was something that throughout lunch troubled Mondrian even more than the infidelity to abstraction. While the conversation was mainly about the current situation in London, "a waiter was standing all the time behind us!" The incongruity of a silent servant listening to their conversation about the Blitz and the bombing of homes was painful. He knew that the Holtzmans would understand his discomfort.

Mondrian was grateful that Gallatin had been among the people who worked toward getting him to America but knew that Gallatin's intervention had had no effect. Mondrian told Gallatin "that the consulate took no notice of it." In his gentlemanly way, Gallatin persisted in trying to get credit for helping, and assured Mondrian he had spoken to a member of a decision-making committee. But Mondrian was determined that the host at whose house every guest had a waiter behind him not revel in his own importance, and told Gallatin that the approval for his visa had to come from a different organization. It was only when Holtzman sent an affidavit to the right person that the visa came through.

Gallatin had, the previous year, published a catalogue of his collection. It included four full-page color reproductions of Mondrian's abstract compositions; Gallatin had gems. Gallatin wrote eloquently about the progress reflected in the work: "It is refreshing that Mondrian has not yet reached the

Fernand Léger drawing of A. E. Gallatin, 1931. Gallatin's lifestyle made Mondrian uncomfortable. At lunch in New York, there was one servant per guest; Mondrian was ill at ease with his private waiter behind him.

end of his road; the paintings in this collection show that each succeeding year can demonstrate a sharper intensity, a more eloquent distinction." But the collector had not endeared himself to Mondrian in writing, "There may be many who require a dramatic excitement that is shunned by Mondrian." To Mondrian himself, there was no lack of "dramatic excitement" in the work, especially the most recent one in Gallatin's collection, *Opposition de Lignes, de Rouge et Jaune* from 1937. The black double line verticals spanning the canvas from top to bottom, sprouting a slightly thicker horizontal heading off to the left of it at a crisp right angle, reaching the left edge, have a tragicomic force. The large planc of yellow syncopating with the smaller one makes the most self-consciously shocking Surrealist fantasies timid by comparison.

At least Gallatin had the grace to finish the sentence with "but in times such as these there will always be some who will return to pleasure to an art where everything is at rest, where every shape has been understood and measured." Still, it is no wonder that Mondrian was irritated by the pretentiousness reflected in those waiters in their starched white uniforms, and in Gallatin's insistence on getting at least a small bit of credit for having the influence to get Mondrian to the United States. Mondrian neither measured his lines nor achieved a state of rest. His art went beyond.

Following lunch, Gallatin and his niece and Mondrian went to Gallatin's museum. When the heir to a banking fortune opened the Gallery of Living Art in December 1927, it was the first museum in the world devoted entirely to contemporary art. A family friend had arranged for Gallatin to use a study hall of the main building of New York University on Washington Square for this purpose. Henry McBride—among the most influential, astute, and intellectually dependable art critics in America—had helped Gallatin make his collection and program his exhibitions. Born in 1867, McBride had been the main force behind the success of the 1913 Armory show, the exhibition with which European modernism became vital to the American cultural scene. McBride's articles in the *New York Sun* reached a national audience, and the range of new directions art had taken in Europe and the United States had ardent champions as a consequence of McBride's dissemination of modernism at a time when everything other than traditional painting still had furious foes. McBride had gone on to have a great impact on Mondrian's reception in the United States, not just an acceptance of his revolutionary style but a widespread acceptance of it. Hilton Kramer, one of the major critics of the postwar generation, would say of McBride, who lived until 1962, "What so many others at the time found shocking and even repulsive in modernist art, McBride had the wit—and the aesthetic intelligence—to see as the classic of the future."

With McBride as his guide, Gallatin had acquired, besides his five Mondrians, works by Braque, Gris, Picasso, Léger, Arp, Miró, and other modernists. He installed these artists' masterpieces carefully, with ample wall space surrounding Picasso's triumphant 1921 *Three Musicians*, Léger's *City* of 1921, and Miró's large *Fratellini* of 1927. Mondrian was not impressed; for him these paintings belonged to the dark ages of representation of the known world. But that was not all that irked Mondrian. He also faulted the installation of his own paintings and was distressed by their condition. Mondrian wrote Holtzman, "You know the collection. I told him how my things could be better arranged and promised him to clean later my pictures."

Mondrian had met Gallatin on various occasions when the collector visited Paris, and valued him as a supporter. But the visit to Gallatin's museum was a harsh reminder. It was never easy to accept the idea that someone who esteemed his work also prized a lot of art that belonged to a totally different idiom. And it was not just the paintings by Picasso and the others that were alien to Mondrian. Gallatin himself embodied an approach to life antithetical to his own, and the old-fashionedness was all associated in his mind.

Still, Mondrian was not blind to the realities of life, and the visit to the Museum of Living Art with its founder was a boost. "They were both very nice," Mondrian reported to Holtzman, adding proudly that Gallatin had said "he hoped me to see often." Mondrian then used the correct proofreader's mark to place the "me" after, rather than in front of, the "to see"; he was at the stage of mastering English where, even though he was not entirely able to obliterate his reflex to use Dutch sentence structure, he was sufficiently determined to perfect his new language to make the correction. Mondrian disparaged the paintings Gallatin had from the Ashcan School, and the habits of the rich, whether their traditional furniture or their liveried staff, were antithetical to his taste, but he was delighted to have someone of Gallatin's importance welcome him warmly in the city he intended to make his home for the rest of his life.

"And that is all—it could have been worse," Mondrian wrote to Holtzman in summary of the visit. It inspired him, he allowed, to resume making art as soon as he got home. It was the first time he had done so since he arrived in the United States.

The morning following the lunch at Gallatin's and the visit to the Museum of Living Art, Mondrian ordered a new canvas. It was the first one he had acquired in America, and he specified his usual sort of measurements, which seemed to be one thing while in fact being another, since, at 36½ by 37½ inches, the surface looked like a square while not really being one. Mondrian also stocked up on art supplies that day. While he was eager to have the paintings on which he had been working in London arrive in New

York, by the beginning of November, he was also primed to start afresh. Beyond repainting the canvases he had begun in Paris and London, he had lots of new ideas.

VI

On October 21, 1940, Mondrian, with his usual optimism, wrote Winifred Nicholson, "I am sure Britain will win in the end." Meanwhile, what was not so certain was when the shipment of paintings from London would arrive. On November 4, he wrote Harry and Eileen Holtzman a letter in which his fears were scarcely hidden behind his polite veneer. They were still in Kansas City with the Noonans, Eileen's family, and Mondrian was certainly cognizant of the role they all played in his current good fortune in life. Mondrian started the communication to his young protectors with warm greetings to both of them and his invariable apology for not having written sooner. This was his formula: to begin with an apparent concern for his readers' own well-being, and then to reestablish the understanding, like a pact, that he and they knew that the deepest concern of all three parties was *his* current situation. Mondrian had always done this—with Van den Briel, Slijper, Roth, Oud, the Van Doesburgs, the Nicholsons, and others. It was like priming a canvas before he got to what really mattered to him, which was his art. "I was glad to hear you had a good journey and arrived well in Cansas [*sic*]," he wrote in the warming up before delving into, first, the details of his living situation and of his own health as the essential machinery to his making it, and then the crates of artistic treasures which he was terrified would never reappear.

Mondrian analyzed, in excruciating detail, the possibilities of how a letter about the shipment had gone missing. In London, when he arranged for the paintings to be shipped, he had not yet had an address of his own, and so had given Holtzman's. Mondrian's maid, a "Mrs. Legentil," had heard from a lady staying at the Holtzmans' as a sort of house sitter that the postman had a key to their mailbox, and might have removed a letter from the shipper with some vital information. The workings of his mind were tortuous on the subject; he mentally conjured scenarios that might have resulted in the crate having been lost for all time.

While the specter of his art disappearing forever was haunting him, his health problems exacerbated the uneasiness. "Gastric and rumathic [*sic*] troubles and the cough is not yet disappeared," he wrote Holtzman. The redoubtable Mrs. Legentil had made him a concoction of oysters and onions—both raw—as well as oranges and sugar. Beyond that home remedy, he was taking the medicine the chemist had given him, and would see

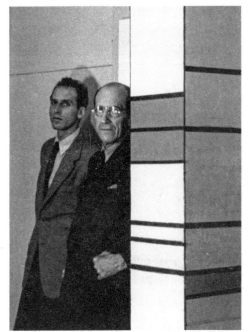

The American painter Harry Holtzman and Mondrian in Holtzman's New York studio, 1941. In 1935, Holtzman had, at age twenty-two, gone to Europe expressly to meet Mondrian. He would eventually pave the way for Mondrian's fleeing to America from war-torn Europe and would become Mondrian's sole heir.

the Holtzmans' doctor if he did not improve. His report was like one he might have given the doctor. His appetite was good. But "Mrs. Legentil has some difficulty with me because she thinks the more one eat [*sic*] the better." Still, he was able to persuade the housekeeper to stop force-feeding him. At least she was willingly giving him "vegetables and cereals and sometimes fish or meat" and separating them by the time intervals specified by the Hay Diet.

The Holtzmans had gone to Kansas in part to vote, and Mondrian said he would be "happy soon after the elections"; he was eager for them to return to New York. Meanwhile, Holtzman was reading Mondrian's latest writing and responding to it enthusiastically. In Mondrian's life, everything was important only to the extent that it abetted or impeded his work, and if, as he feared, his art had gone missing for all time, then, at least, with Holtzman's support, his newest essays might be properly published and disseminate his beliefs to the world.

Mondrian provided the Holtzmans with an ardent summation of the credo that compelled him with such force. Too excited to think cogently in English, he became confused linguistically:

The principle in it is, as you have seen, that I see—of course—in all art something identical, what is eternal and pure expression of Life (élan vital).

Harry Holtzman's wife, the former Eileen Noonan, from a prosperous midwestern family, provided Harry with the financial wherewithal to support Mondrian.

Then there is the always changing of manner of expression of that Life. Thus I believe that it must be in human life also: that there is Life Force, and the several expressions of hope. Then this we see in air a progressive freeing from that what life covets. That it must be the same in human life.

Many will be against such a prospect and many will not see life and Life placed apart—They are right, for life and Life is of course "One." But they are wrong not willing to discern.

It did not occur to Mondrian how unnecessary it was to enumerate this philosophy yet again to Holtzman. No one knew those beliefs better; they, and the beauty of Mondrian's art were the reasons Holtzman had given so much of his energy and fortune to be Mondrian's amanuensis and savior. The young man hardly needed to be told what Mondrian's priorities were. But Mondrian, was, as usual, too compelled to stop. Each time he reiterated the beliefs he had expressed multiple times before, if not in exactly the same words, it was as if they were new to him.

For he doubted that he had done sufficiently well until now: "I am afraid I did not write strong enough the article." Similarly, he needed to improve his painting. Mondrian concluded by saying that while he was waiting for one picture to dry so that he could rework it, he was at work on two more; he had now started a third new canvas since arriving in New York. Even if the shipment never came, he would paint with all his might.

VII

In 1936, Harry Holtzman, Josef Albers, and the Russian-born painter and author of children's books Esphyr Slobodkina had founded the organization American Abstract Artists (AAA), of which Carl Holty soon became chairman. While the word "Abstract" did not necessarily mean "nonorganic" as it did to Mondrian, Mondrian's latest compositions were nonetheless a sterling example of the qualities AAA endorsed. Abstraction was just one of the many artistic advances gaining popularity in the era of modernism, and its proponents felt it was generally relegated to a status of secondary importance at institutions like the Museum of Modern Art and the Museum of Living Art. One of the first things AAA did after its creation was to picket in front of the Modern. They believed that the traditions of post-Impressionism and updated styles of old-fashioned figurative painting were too dominant, and even though the picketers fell out of favor with the Modern's power structure as a result, they held signs and shouted in protest.

Fernand Léger, with whom Mondrian had had a pleasant relationship in Paris, arrived in New York on November 12, 1940. Shortly thereafter, AAA invited both Mondrian and Léger to become members. Mondrian accepted the invitation gratefully. He believed in the organization's essential tenets, even if they were less absolute than Neo-Plasticism. Mondrian wrote Nicholson and Hepworth on January 4, 1941, to say that he had nearly finished two large paintings, and felt impelled to complete at least one so that he could present it at the Fifth Annual Exhibition of the AAA group, which was to open on February 9.

Mondrian's position in the art world was much the same as it had been in Paris. To his admirers, he was a leading voice, the individual who had taken abstract painting to an apogee and whose brilliant use of rectilinear geometry was manifest in some of the best architecture and design of the era. He would be a heroic figure for many in the American Abstract group. But he was an outsider to the establishment of which the Museum of Modern Art was the bastion. In that same letter to his London friends at the start of 1941, he reported that he had not yet seen Alfred Barr since his arrival in New York. The Modern was showing mural paintings by Léger that struck him as old hat. At least, however, there was one of Nicholson's reliefs "well hung nearby a well-placed sculpture of Gabo's," but neither they nor he were center stage.

Still, he felt a stability and inner balance in his new life. He wrote Nicholson and Hepworth at the start of January about the difficulties they all

faced in England—"I am so glad Britain can stand the Nazis but so sorry that these cause so much misery"—and to report that that he had landed on his feet:

> I thought after three months here that my pictures and materials were lost. But now lately I heard that they are arrived now here. I have had really good luck!
> The mutual relationship here [crossed out] of men here [inserted with a caret] is not so different from Europe as I thought. The town I do like for it is so great to see. But I loved London and, formerly, Paris also.

The way he corrected his English by relocating the word "here" demonstrated the perfectionism and high standards that were only intensifying with age whether his concern was his use of language or his dance steps.

As usual, the same day that he wrote to Ben and Barbara, Mondrian sent Winifred a parallel letter, identical except for a few subtle differences in the wording:

> Life here is not that different from life in Europe and persons also. What pleases me very much is the aspect of New York: all is so great. But in those two years I had learned to love London very much, and Paris was, in old time, good also.

Mondrian's life, more than most people's, was based on repetition with variation: in his painting, his writing, the place he lived, the meals he ate. The underlying constant was his rock-solid appreciation for what he had.

The shipment from London finally arrived in mid-December. Mondrian at last had his unfinished compositions to develop further, and his old work he hoped to sell. Now he also had the cartons of art supplies he needed to clean and brighten the five paintings at the Museum of Living Art. Gallatin made special arrangements for Mondrian to be in the exhibition space when it was closed to the public so that he could work away with the rags and cleansers that he knew would remove the grime and soot of New York City without altering the surface of the paint itself. Mondrian was energized. He also used the holiday period to rewrite "Art Shows the Evil of Nazi and Soviet Oppressive Tendencies" in a fresh typescript he titled "Oppression of Art and Life." George L. K. Morris had told him that the *Partisan Review* would only publish it if he improved his English, but he was up to the task.

By this stage of his life, Mondrian was never completely clear of bronchitis or other rheumatoid illnesses. But he was used to his chronic ill health, which he still tried to control with the Hay Diet. The return to work and

the spirit of New York, even as the war in Europe cast its shadow from afar, rejuvenated him.

In February, he sent off one of his two new large compositions to the American Abstract Artists show. When he went to see the exhibition at the Riverside Museum—on Riverside Drive at 103rd Street—he immediately "felt the lines were not strong enough." As soon as the show closed and he got the canvas back to the studio, he set about trying to rectify the problem. Using charcoal directly on the canvas, Mondrian lightly sketched in new lines to get a feeling for how the composition would grow if he painted the black accordingly. Revising the position of the lines, tinkering with the colors, making changes that at first satisfied him but that required his trying yet another possibility, he was again leading the life he wanted.

VIII

On March 1, a piece appeared in the Talk of the Town section of *The New Yorker* titled "Lines and Rectangles." In those days, the short articles in this section of the magazine were left unsigned, but it was known that the anonymous writer was Geoffrey Hellman, an art journalist who delighted in being pithy and glib. Hellman, who specialized in modern art and architecture and focused in particular on the European avant-garde, wanted above all else to be clever and entertaining. In a number of portraits of contemporary painters and architects, he would assume a lofty observation point and mix supposed respect with jabs at what is outside the norm. The result was that his readers, apparently more "everyday sort of people" than his subjects, could have a good laugh at the eccentricities of the oddball being described to them.

Writing for *The New Yorker*, Hellman was addressing some of the most sophisticated people in America. More than any other publication, this was *the* magazine for the country's tastemakers and intelligentsia, and for the sort of people who buy art. Presenting Mondrian, the critic concocted a mix of truths and inventions guaranteed to have the artist regarded as something of a joke. Hellman identifies his subject as

> Piet Mondrian, probably the only painter in the world who hasn't drawn a curved line in twenty years. . . . Anything circular makes him nervous. Once, when he was living in Paris in a house with a curved staircase, he fastened rectangular pieces of painted paper to the balustrades so that he could go up and downstairs with a free mind.

The cocky writer makes Mondrian sound ridiculous. He writes of the artist being in Paris from 1919 to 1938: "During the period between the two

wars he acquired a violent distaste for the country, possibly because so many things in the country are curved."

From there, the portrait that was the first bit of journalism about Mondrian since his arrival in America became even more nonsensical.

It is his first visit, but so far, although he loves jazz, he has been hardly anywhere. He has a collection of boogie-woogie records which he plays, often dancing around the room to their accompaniment all by himself. He likes oranges, and sometimes sucks one while he dances. He is sorry that records and oranges are circular. Mondrian is a bachelor, a hard worker, and a spectacular devotee of solitary life. He has never had a telephone. "I am always happy alone," he told us when we visited him, edging us toward the door. Once, when he had been working for weeks without seeing anyone, a friend called on him. "I am not seeing anyone this week," said Mondrian, edging *him* toward the door.

There are bits of truth scattered within this prattle, and a useful confirmation of the no-telephone detail, but the overall effect was to make an unusual but emotionally grounded man sound like a nutcase.

Mondrian would, in time, write to friends about Hellman's article saying it was why he failed to sell any paintings during his first year in America and that it caused him to be socially ostracized; while the Holtzmans were in Kansas, hardly anyone called on him. The arrogant reportage affected both the market for his work and his treatment by others. The consequences of Hellman's piece were significant, but he was not going to respond and waste his time on what he knew would have been a useless battle. When Geoffrey Hellman made a similarly snide profile of Le Corbusier, the architect went into a tirade against the writer, and demanded retractions and corrections in print. If the controversy was about the tenets of neo-Constructivism, and his foe Van Doesburg or another worthwhile artist, he did not shy away from expressing himself and challenging his opponents. Principles were worth fighting for. To rail out to no avail against what he considered a second-rate mind was not worth doing; he had better ways to use his time.

Settling In

I

In a year, Mondrian would turn seventy. On the one hand he was flourishing, and had happily acclimated himself to his new life, but the hardships of a New York winter, and a mix of bronchial and digestive symptoms, were taking their toll. His new frailty made him even more dependent on Harry Holtzman. One Thursday evening that winter, with bold strokes of the fountain pen—his penmanship deliberately robust and jaunty—Mondrian wrote Harry and Eileen Holtzman together. In his stilted English, he expressed an almost childlike comfort in their concern for him:

> I am so sorry you found me in not good condition but don't bother about, it will come right.
>
> I know that can only buy just alimentation doctors cannot do anything in this; they don't try to help me in that way. They are good for passing things as cough etc.
>
> I feel already better and have been working on the article, Harry's changings I like very much but as I told you I have to change some parts in my writing.
>
> <div align="right">Warm greetings from
Piet.</div>
>
> I send you these lines because I know how much you like to see me well and that so much appreciate.

Mondrian gave the Holtzmans regular updates during their weeks in Kansas. The ebullience of that first letter was quickly overshadowed by anxiety. Mondrian became especially flapped at the prospect of anything going wrong concerning the few services Holtzman had asked Mondrian to render in his absence. Mondrian's English became more prone to errors at such moments:

> From here is no particulars to write. Only your drawing is not fetched like they promised. Last Tuesday Mrs. Legentil tauld [sic] me that she lundi [sic] had waited until 5½. Then she feared that was telephoned; the [crossed out]

The interiors of Mondrian's studio were perpetually changing.

yours was cut off. She had not well slept the whole night by it. I said her the best was to telephone elsewhere. Fortunately she knew the name of the secretary so she got her. But the picture could not be fetched for there was nobody to bring it.

On and on he went. The situation of the pickup was not resolved the following day, and Mondrian enumerated the things that went wrong. With his deteriorating English, he referred to details of his life that Holtzman must have been the only person to grasp. He was doing his utmost to make the most of his situation and to overcome all the limitations of his health and circumstances, but his ramble was confused:

> My finger does not hinder me anymore but there is still a small black spot so that I am not sure the nail won't come off.
> I felt rather tired, it is probably the show, not the coffee, that I can work. Hope you won't miss too much New-York.

Holtzman did not want to wait to leave Kansas before having Mondrian take the initial steps to become a U.S. citizen, and by mid-March he had started the process. Holtzman advised Mondrian to see a lawyer whose name was either McCormick or Cornic—Mondrian uses both names, until settling on "Mr. C."—but then decided that it was beyond Mondrian's abilities to get

to the man's office. Mondrian was grateful for the warning not to hazard the meeting, but explained that although the "letter came just in time," he "had already promised to come to the office." He was not the sort of person to change a plan.

Holtzman's apprehension had been justified. Mondrian bought a map showing New York's public transportation and decided "to take the bus to 1e St" and "then to walk over, . . . it was far too complicated to do this later and at last I found a taxi—in that environment—poor and sad—were no taxis to see." Mondrian's slight ineptitude and his dependence on Holtzman went hand in hand with his resilience; other people his age and in his plight would have panicked.

Mondrian got to the lawyer's office on time, but it was to little avail. He also needed to see a "Mr. Careslon." This was how he spelled the name to Holtzman: in any case, he realized he had better wait for Holtzman's return from Kansas to help with the requisites. Mondrian clearly could not function unaided. The details for which he needed Holtzman had reached a new extreme. At the same time, like most dependent people, the more that Mondrian had to lean on Holtzman, the more he was impelled to exert his own will and became ornery.

Holtzman wanted, while being the one to pay for it, to have Mrs. Legentil do even more housekeeping and cooking and cleaning. Mondrian would have none of it.

That one afternoon [Mondrian crossed out the word "day"] is very sufficient. I suppose she told you that I like custards, but that is not so; she may [he crossed out the word "can"] have thought it because I told her that I like puddings. These I can have in packets as you know.

Now Harry and Eileen I hope that you have it there as good as possible. I miss you here.

A week later, writing the Holtzmans again, Mondrian had the name right: it was Carlson. Mr. Carlson had gone to his apartment "to fill up the papers. With three photographs that I still had from London this will be sufficient for first demand."

It was going to take five years to become an American citizen, but at least the process was underway. "Already I feel less strange in this country," he wrote, only half a year after having uprooted himself from the world where he had spent two-thirds of a century. Above all else, he was grateful to Holtzman, remarkably adaptable, and at the start of springtime entered one of his periods of optimism and believed that he would succeed as a painter after all.

II

In 1941, Mondrian completed *New York*, an oil on canvas, 37 inches high, 36 inches wide, which he had exhibited in an earlier stage at the exhibition of the American Abstract Artists group at the Riverside Museum. In 1942, it would have a further incarnation and become *Boogie Woogie*, but we have some records of it in its previous life. It had a very large white rectangular center, like a vast ocean circumscribed by straight lines. Mondrian placed everything in a way so that nothing succumbs to a mathematical structure or conforms to a system. The flurry of activity around that large whiteness is marvelously unpredictable. Two black horizontal lines stretch across the entire canvas, one just below the top and the other a bit more than two-thirds of the way down, and two verticals of the same width similarly span the canvas, one not far from the right-hand edge, although not as near as the first horizontal is to the top, and the other a bit farther from the left-hand edge. There is a further edge-to-edge light vertical as well, and two light horizontals, but these fall short of reaching the right edge of the canvas. Rather, they stop at the black vertical just near that edge.

The result is a lively dysrhythmia. Another thin dark line is suspended between the two dark verticals, stopping at them with a tensile strength. A series of shorter lines at the bottom also take on the tautness of wires pulled as far as they can stretch. The constant surprises beguile us. Assured and jaunty, it offered an antidote to the realities of American life during this winter when war loomed but was not certain, and the economy, while improved, was still shaky.

Mondrian had brought *New York* to that energized state shortly after the Abstract Artists exhibition closed. When it was returned, unsold, to the two-room flat on East 56th Street, he no longer liked it. Carl Holty, who had seen it in the exhibition, visited a few days after it came back to the studio and saw that Mondrian had made substantial changes. When we compare it to a photograph taken at the exhibition, we understand what the changes were from the previous form. The little dash-like verticals on the bottom had become wider, and short blocky lines had appeared on the right and left sides of the canvas, between the edges and the dark verticals. In addition, the light horizontal at the top now arrived all the way at the right-hand edge, extending it beyond where it had been, and giving it a new presence because it is distinctly in front of the black vertical which previously created its goalpost. And Mondrian had added accents in the color red. The result of these alterations is that the composition came to feel pinned, or anchored, to the bottom and right-hand sides, which had not been the case when it

was shown in the AAA show. The changes had the effect of making the open central space—if it compares to anything, it is a large man-made reservoir—amorphous and weightless, neither near us nor far away.

When Holty visited and asked Mondrian why he had rushed to make substantial changes as soon as the painting returned, the artist replied impatiently. "It was empty as hell. Anybody could see that." Holty felt he was being faulted for not having criticized the work accordingly before Mondrian sent it to the exhibition. Holty understood the reason for "the introduction of these small planes that sort of framed the hollow center. You know, the old Oriental idea of bringing the empty space to light by what you do around it had already hit him." And the capacity of art to create its own light was increasingly Mondrian's quarry.

III

About a month after Geoffrey Hellman's tongue-in-cheek portrait of him appeared in print, Mondrian wrote the Holtzmans that he had seen no one whatsoever, and hypothesized as to why his social situation had dwindled to a standstill. "Perhaps the 'New-Yorker' (article) is the cause of it—not the coffee." It's uncertain whether he meant that his own strong brew put off guests used to their usual weak American coffee or that they would have preferred something else to drink.

Still, Hellman's article stung. Mondrian's English was not yet so nuanced that he would have understood all of Hellman's subtle sarcasm, but in attributing his personal ostracism to the piece, he acknowledged the pain. He was inured to negative criticism of his radical painting style, but not to being depicted as foolish.

Nonetheless, even if the article deterred people from calling on him, it had not stopped his painting. He reported to Holtzman that he was working. In fact, he had clients waiting for him. Having told a friend of Sidney Janis's who wanted "a picture" that he would need to wait, now, at the start of April, he had "4 ready."

Of course, "ready" was not the same as "finished." We will never know what the four paintings were, because Mondrian completed nothing that spring. He went on to tell Holtzman that he still had further changes to make in one of the four, and that in "the large picture" he "took out the red plane and brought in red and blue lines (planes!) with the yellows. Now I do like it; also two others I made but also only still in tape."

Charmion von Wiegand tells of Mondrian's use of the American material that was a wonder for him:

Mondrian began using colored tape and cut-up strips of paper in New York in 1941.

Very soon after his arrival here, Mondrian had been introduced to the use of colored tapes. In Europe he had had to repaint his lines or use strips of plain paper. The tapes were a labor-saving device he liked; he could try out a line, then quickly remove it, or shift its position repeatedly without losing time or soiling the canvas. One of the large American companies manufactured tapes of different width in primary colors as well as in black and gray. They seemed made to order for his work, but because of the wartime paper shortage their manufacture was discontinued. I used to look for rolls of colored tape in art and stationery shops, some of which still had them in stock. Finding a large roll of bright red tape, enough to last months, was an occasion for rejoicing.

What a breakthrough this was for an artist who was forever redoing his paintings by ever so slightly increasing or decreasing the width of the black lines that composed them!

IV

In 1974, on one of the many occasions when I visited Anni and Josef Albers in their simple, functional raised ranch house in Orange, Connecticut, Josef started to talk to me about Mondrian. Josef had revered Mondrian ever since the 1925 publication of the monograph on the artist that had been one of the landmark events at the Bauhaus. Then, in around 1940, the two modernist émigrés from Europe met through the American Abstract Artists group.

Josef told me that he had asked Mondrian to exhibit some of his paintings at Black Mountain College. Sitting in his kitchen over thirty years later, Josef said that Mondrian replied that he would like to send some recent work but that it was impossible to finish anything. He was perpetually changing the widths of the lines, and each alteration required a lot of time, because not only did he have to redo the lines themselves but he then had to repaint the whites and any primary colors that they touched. It took time for the black paint to dry sufficiently before he could make the subsequent changes.

Josef then looked at me with an expression of sheer victory on his face. Anni Albers, arrestingly beautiful and intelligent, smiled approvingly; it was one of those moments when she and Josef seemed like a two-person religious sect, devoted to the artistic qualities that Mondrian exemplified. He continued:

> I said to him, "Mondrian, don't you know that here in America they have this wonderful thing called black electrical tape. And it comes in many widths. You can buy it in what here they call hardware stores. You could get it in the different widths, and try them, and see which one you like, and then remove the tape and paint the lines just the right way, instead of every time having to repaint the line and what is around it."
>
> And the next time we spoke, Nick, Mondrian said to me, "Albers! If only I had known about those tapes before. They would have saved me half of the time I have spent making my work." He told me that if he had had these tapes he would have had by then plenty of paintings to send to Black Mountain.

Maybe Josef Albers was indeed the first person to tell Mondrian about the tapes which Charmion von Wiegand found him using. Perhaps by the time Carl Holty helped Mondrian procure tapes, Mondrian wanted them because he had heard about them from the veteran of the Bauhaus. Or maybe it was an octogenarian's fantasy. All that we know with certainty is that by the

spring of 1941, Piet Mondrian was applying adhesive tape directly to canvas, and that he revered efficacity.

V

Color tapes were the instrument of Mondrian's rebirth.

He took the hues that used to be in isolated blocks—a blue that was formerly inside a square, the yellow of the rectangle higher to the left of it, and the red horizontal hugging the bottom of the canvas like a small child taking a nap—and made them the components of the horizontal and vertical lines that were formerly black. Those lines that used to be the guardians, the makers of the system, the rulers, were now the players. And in their new role, they happily gave up all their obligations and strictness. What had in a former life been boundaries were now celebrants.

And this is how Mondrian would spend the rest of his life: with the colors residing in another territory. His new method demonstrated the control and diligence that enabled him to tell Holty that he hated discipline.

In this period when Mondrian was moving the color into the lines, Sidney Janis wrote an article for the magazine *Decision* quoting Mondrian about the change in his art. "Now it has more boogie-woogie," Mondrian said.

What did this mean? After all, Mondrian had first succumbed to those rhythms based on African music and referred to as "boogie-woogie" in the 1920s. What was the quality of the new form of boogie-woogie performed by Pete Johnson and Meade Lux Lewis and Albert Ammons that made it even more compelling to him?

The three pianos being played simultaneously were, in fact, comparable to the three colors of the lines in Mondrian's new work. Each performed on its own, but they also worked over and under and through one another. Each had its own tone. The pianists performed with right-hand licks—or riffs—and flattened sevenths. What did it mean to hear these? What was it that made this style of music not just Mondrian's taste, but his philosophy?

The horizontal and vertical bands of red, yellow, and blue, so animated in front of the flat white surface of the canvas, were, like the three simultaneous keyboard performances, playful, unplanned, upbeat, and magnificently meaningless. They offered an experience of sheer joy to anyone, anywhere. They came from the heart, and they made the energy of the universe, and a true spiritualism, palpable.

VI

The forty-five-year-old Charmion von Wiegand, a journalist as well as an abstract painter whose work tends toward the occult, was among the most beguiling individuals ever to cross the threshold of one of Mondrian's studios. Her appearance was fetching, and she had spark. Her clearly defined features suited her bold, high-octane manner. Von Wiegand dressed with style in the mode of a rich bohemian, and always wore exotic dresses, finely made of expensive silk from India or the South Seas. Her appearance was a statement. She did not pretend to be from a Calcutta slum, but she differentiated herself from those prim and proper ladies in pink suits and hats with whom she had gone to fancy schools; she identified more with people who treat the water of the Ganges as sacred than with the debutantes at New York cotillions. And we can be certain that Mondrian recognized in her looks the spirit of someone of worldly vision, not confined to Western culture the way that well-heeled New Yorkers of the epoch were.

Whether it was one of the days when Von Wiegand chose to let her wavy hair fly off her head in a seemingly haphazard coif achieved with painstaking care, or wore her hair tight with jeweled bands, or was sporting one of her

Charmion von Wiegand, 1943. Twenty-four years younger than Mondrian, this beguiling journalist, who was also a painter, became obsessed with him. Her journals would provide a vivid portrait of the artist's peculiarities.

elegant hats, she made a strong impression. In her spike heels, she was nearly Mondrian's height and carried herself with an erect, confident posture. Her chiseled chin, delicate nose, and perfectly glossed, thin rosebud lips were alluring, but the coup de grâce was her eyebrows. Whether it was nature or a pencil that put them there, these graceful arches were unusually high above her dancing eyes.

Von Wiegand was the daughter of Karl Henry von Wiegand, a German-born journalist, and Inez Royce. She was born in Chicago and raised in Arizona and California, but her father, a correspondent first for United Press and then for Hearst newspapers, was often on the beat in other places. Karl Henry von Wiegand had a temerity that his daughter inherited in spades. He had interviewed the German crown prince, Wilhelm, shortly after the start of World War I; it was the first time a German noble had spoken to someone from the non-German press since the fighting in Europe had begun. He took two of the flights of the Graf Zeppelin in order to report on the amazing new aircraft, by which time, although he remained married to Charmion's mother, he was accompanied by Lady Grace Drummond-Hay, who would be his romantic partner until she died in 1945. In 1921, Von Wiegand became the first American to interview another soon-to-be prominent German: Adolf Hitler. The prescient newspaperman saw Hitler for what he was long before other people had similar insights. A year ahead of the Beer Hall Putsch—Hitler's first attempt to seize power, resulting in his arrest and being tried and found guilty of treason, after which, in Landsberg Prison, he dictated *Mein Kampf* to Rudolf Hess, who was imprisoned with him—Von Wiegand had had the foresight to label Hitler the "German Mussolini" and to warn his readers that Hitler had the "earmarks of a leader" because of his capacity to appear to be a "man of the people" and his ability to captivate audiences as a dynamic speaker. On June 11, 1940, ten months before his daughter Charmion would meet Piet Mondrian in midtown Manhattan, Karl Henry von Wiegand would interview Hitler again, this time in the headquarters where Hitler based himself as the Führer.

Because of her father's work, Charmion spent three of her teenage years in Berlin. She went back to the United States to attend Barnard College and then switched to the larger Columbia University of which it was a part, so that she could take all the theater and art history and journalism courses that interested her. Without receiving a degree, she dropped out of college to dabble as a playwright. Then, like many children of adventurous parents who are brought up outside the norm, she tried the opposite course and leapt at what seemed like stability. She married a good solid businessman. They bought a home in Darien, Connecticut, a town whose inhabitants were mostly upper-middle-class Protestants where the fathers commuted to New

York and the mothers stayed at home with the children, and Von Wiegand started on the course of being a traditional housewife. It didn't suit her.

In 1925, Charmion von Wiegand decided to undergo psychoanalysis. As she opened herself to her unconscious thoughts, she had memories from her childhood of "colors I had seen in Chinatown . . . in San Francisco . . . the confetti (pink and green) and the red dragons and firecrackers." She considered them a sign that she should become a painter. The first thing Von Wiegand had to do was flee the affluent Connecticut suburbs, and she did so immediately.

Journalism was in Von Wiegand's blood, and in 1929 her father arranged for her to be stationed in Moscow as a journalist for the Hearst press. Now as far away as possible from the world of country clubs and conservative politics that had briefly tempted her, the intrepid Von Wiegand kept readers informed about the young Soviet Union for three years. After going back to New York in 1932, she married a Russian émigré, Joseph Freeman. A left-wing intellectual, he cofounded and edited both the *New Masses* and the *Partisan Review*.

Von Wiegand took up painting more seriously while writing for her husband's magazines and other publications. The influences on her work were a grab bag of non-Western thinking that resembles the potpourri in a new age souvenir shop: "metaphysical images and symbols drawn from theological prismatic color charts, Chinese astrology, tantric yoga, and . . . the symbolic geometry of Buddhism, Hinduism, Taoism, and the I Ching." She was given to dicta like "Art . . . it's a bridge between heaven and earth," and her painting was a mix of mandala-like forms with suggestions of chakra charts, mostly in garish colors. She clearly had looked a lot at Kandinsky and Miró, whose styles she simplified in bright colors.

Von Wiegand assembled small forms, some multifaceted like machine-cut jewels, others organic, to invoke "invisible energies and wisdom which contain their own light and energy." The art suggested "cityscapes, chakra centers, unseen hierarchies, tantric paths and destinations." Eventually, she would devote herself to Mahayana Buddhism and gain an audience with the Dalai Lama to discuss the symbolic role of geometry to express spiritual values.

Von Wiegand's fascination with Theosophy and metaphysical painting, as well as with independent and influential men, led her to get herself commissioned by *The Journal of Aesthetics and Art Criticism* to write a substantial piece on Mondrian about half a year after he had arrived in the United States. When she finally made that first of many visits to Mondrian's apartment-turned-studio, she was, in fact, surprised by how riveting she found him. The man himself, his way of life, and the art that defined him were remarkable

for their coherence. Von Wiegand was as taken by what was straightforward and down-to-earth as by the esoteric, and Mondrian showed both sides. She began work on what would be a substantial and interesting article, for which she recorded important developments in his working method, and from that day on she became a major source on Mondrian in New York.

Writing to Holtzman on April 15, Mondrian had hoped to report on Von Wiegand's visit, but there had been crossed signals. On a Wednesday evening, the meeting having been rescheduled for that day, Mondrian shows what is either abject fear or black humor:

> But she did not come. Probably she is ill, for she should have come
> last Monday, then sent a telegram that she because illness should come
> Wednesday. I hope for her that she is not dead.

VII

The meeting would soon take place, however, and a remarkable, unusual relationship began. On April 26, Mondrian wrote to Holtzman about what was foremost on his mind in that fraught spring of 1941:

> In this time, one must ignore reality's appearance: the events, for not to be
> unhappy and going on. The Nazi always winning, and there seems no other
> solution then that America goes in the war, I think. If that Lindbergh wins
> majority, then America will be later the dupe.

Life and freedom mattered most of all. He believed before others did that the United States should join the war. He knew that the very basis of his art had to change because of the complete disruption to peace and civilization, and he believed that an acceptance of the need for radical action was vital to life.

In 1939, after Germany invaded Poland and Czechoslovakia, Charles Lindbergh took a public stance against the United States providing any military aid to Hitler's foes. At the end of 1940, shortly after Mondrian had arrived in the United States, the aviator spoke publicly in Madison Square Garden in New York and Soldier Field in Chicago, both venues packed with tens of thousands of people, while he reached millions more over the radio that was their main connection with the larger world, to champion "America First." Lindbergh opposed any U.S. action that could be construed as anti-Hitler, and his say-so had enormous influence. In a speech in Des Moines, he identified "the British, the Jewish, and the Roosevelt administration" as the agitators in favor of a war from which America must isolate itself. "The

Jewish race" had come to dominate the motion picture business, the media, and "our government," and, although the persecution of Jews in Germany should not be condoned, these people had to be stopped from wielding their influence. On April 25, the day before Mondrian wrote the Holtzmans about the dangers of Lindbergh's rising power, President Roosevelt gave a White House press conference opposing Lindbergh's stance on neutrality and declaring him a "defeatist and appeaser." Piet Mondrian often considered world events only in regard to their direct impact on him, but this time his vehement opposition to reactionary politics was in perfect accord with his beliefs about the art of painting; courage, conviction, and the overall benefits to a majority of people in the world were essential to all human action.

Mondrian was sanguine about his own situation. His naturalization papers had initially been rejected by the government authorities in charge because he had attached photos that were more than thirty days old, but he had new photos taken promptly, and Mr. McCormick was taking the matter in hand. Mondrian could afford to be confident because, as he well knew, Holtzman was at the helm, and had recruited McCormick on his behalf. He had no fears about his own status, but the specter of reactionary politics, of nationalism and xenophobia, was a danger that could not be ignored. For now, his own art, and everyone else's, had to reflect that urgency, because only then could it be a force for the better. His way of reflecting on the tragic events of the day would be to make paintings that clearly embody unimpeded liberty. He would evoke the forces that unite all people and exclude nobody, as manifest in boogie-woogie, and life in New York, Paris, and London in their former times of peace and freedom. Mondrian's art following his arrival in New York may look no more indicative of current events and a need to respond to present disaster than did his deliberately subject-free paintings of the 1920s and 1930s—but in his own way he had it reflect the heinous occurrences of the era by reflecting liberty.

VIII

The reaction to Geoffrey Hellman's sarcastic article began to die down. In his walk-up space near the East River, Mondrian again started to receive visitors who wanted to see him and his work. Several hoped to buy paintings if they could get the prices down. Others wanted to write about him and disseminate his vision. Young artists, eager to talk, arranged to see Mondrian. Prominent supporters of the few American museums showing modern art came to call.

The architect Armand Bartos brought along his friend G. David Thompson. Thompson would amass one of the greatest of all private collections of

twentieth-century art, but Bartos was on a quest for something for his own smaller assemblage of modern pictures. The dominant issue was the cost. Bartos told Mondrian that he had expected the prices of Mondrian's paintings to be lower than the figures the artist quoted him. After the two rich men left, Mondrian wrote Holtzman, "That is what I expected!" Mondrian had told Bartos a medium-size canvas would be $350, a smaller one $250. When Bartos declined, Mondrian agreed to lower the figure for the smaller one to $200. The architect requested "some days to think it over."

Thompson, at least, was deferential. Moreover, he was enthusiastic about the latest unfinished work and said that he would like to return with his wife. She was recovering from having just had a baby, and he hoped Mondrian would allow them to come together when she was up to it. Thompson, unlike Bartos, did not try to negotiate prices.

Mondrian reported all of these details to the Holtzmans, who were still in Kansas City. He also told them that Charmion von Wiegand had now visited twice and that she was of German background while her husband was Russian. Both had been Communists but had now left the Party. Mondrian felt impelled to tell every detail to the two people who made his daily existence possible.

Mondrian became worried about Charmion von Wiegand's article. The *New Yorker* piece had left its scar. Von Wiegand had told him that her text had to be "light." What that might mean, after the Hellman piece, filled him with fear. Von Wiegand would certainly not be malicious, but he could not afford to be the butt of more mockery.

From the start, Mondrian had told Von Wiegand that he was hoping for an expression of his theories more than for magazine-style entertainment. In response she had assured him that, even if this first article would be oriented toward a broader audience, she would incorporate more of his ideas, in his own language, into a longer piece for a different publication.

Mondrian wrote the Holtzmans that Von Wiegand was "a little 'German' still but seems to me pure." He was proud to tell them, meanwhile, that she had invited him to come for dinner. And concerning her work with him on the article, she "said to come and see me was more important than to do this to Mr. Churchill and other great men."

Then came information which, confused as its expression was, is a vital detail of the history of modern art. "I am very glad that I, at last, have found my painting-expression in the colored lines. With black only I never could get out of what I *not* wanted but painted." Mondrian had no doubt as to what had enabled him to make this breakthrough. He signed off thanking Harry and Eileen Holtzman for allowing him not just to keep painting but also

for giving him an ease and freedom that enabled him to rid himself of those black lines that he now realized he had never really desired, yet had never before been able to shed.

This dropping of black boundary lines in his new work would not prevent his keeping them in the compositions he had started in London when he redid them in New York. But from here forward, Mondrian's jewellike art only grew brighter. This new glistening concurred with Mondrian's realization that he could not continue to avoid some form of representation of the world around him, that he had to respond to, and cease avoiding, the harsh realities of a world at war. His subject was clear. Whether the center of London or the place de la Concorde or the neon of New York's Times Square, he was painting the life of cities in all their magnitude and complexity. Where the black lines remained, they were less constraining; as in the work where Mondrian now freed himself of them completely, he was painting, exuberantly, the animation of the cosmos.

Mondrian had the phenomenal feeling, as he approached seventy, of living with even greater freedom and bliss than ever before.

IX

Armand Bartos continued to haggle. Mondrian wrote Holtzman "that he was most anxious to buy the picture but found the price a little beyond his purse." He offered $150. Mondrian felt he had no choice but to accept, as long as Bartos agreed to lend it to an upcoming solo exhibition which was to take place at the Valentine Gallery in January 1942.

Bartos grabbed the gem at the low price. The day after Mondrian consented, the rich young architect showed up at the artist's studio, check in hand, and left with his prize.

Mondrian had first painted *Composition with Red and Blue* in 1939 when he was in London. It was shown in the *Réalités Nouvelles* exhibition in Paris that year, and we know it in its early state from an installation photo from this show at the Galerie Charpentier. That image of it in its first form was only in black and white, and in layout there is no difference between it and the later stage of the work. Presumably, Mondrian simply changed the locations of a couple of colors. The small canvas as it was when Mondrian sold it in 1941 is infectiously jaunty. Its black lines, all the same width, seem in constant motion. They function more like the strips of paper and tape that Mondrian had recently started to use than as boundaries of the horizontal and vertical rectangles within the painting. They are like the lines that crisscross the unfinished *New York City 2* of 1941 that seemingly extend beyond

the edges of the painting in all directions, serving as continuous drumbeats. Mondrian's earlier black lines seemed to enclose the shapes they define and contain, while here the lines seem to march across the field of white with its blue and red rectangles at the corners of the composition diagonally opposite one another, the red, in the upper left, larger and vertical, the smaller one in the lower-right corner being horizontal.

The balance and imbalance are exceptional. Somehow, the large red in the upper left has equal value to the small blue in the lower right, although the red has more punch. As always with Mondrian's final compositions, the movement is perpetual and the surprises never stop occurring.

With Bartos having whittled down the price, Mondrian remained essentially insolvent. But he no longer appeared to worry about his lack of funds. It was not like the old days when he had to consider abandoning painting and taking another job. Holtzman was there. At the start of May, his great supporter not only sent him a check but, as Mondrian noted in the opening sentence of his letter of thanks on May 6, had posted it via special delivery, and "made haste" to get him "the cheque.—I can only say that I always am in full admiration of you both toward me."

Still, pricing was a big issue. Charmion von Wiegand knew people who would buy small paintings, she said, but who could pay no more than $200. Mondrian had the goal of getting himself financially independent from Holtzman. His patron was in no way pressuring him, but he was determined not to take unfair advantage of Holtzman's generosity. He raised his prices modestly, trying to calculate what the market would bear.

When the Bartoses' collection was sold at Christie's in London in 1983, a 1930 Mondrian that they had bought from Sidney Janis in 1950 sold for $2,156,000. According to *The New York Times*, this was "the highest price ever paid at auction for a work of abstract art. . . . The buyer of *Composition with Red, Blue, and Yellow* was Shigeki Kameyama of Tokyo. Mopping his brow with a handkerchief after his bid was accepted, Mr. Kameyama said he intended to hang the painting in his home study. 'I like it very much' he said. 'I have seen a lot of Mondrians, but this is the best. The artist is not very big in Japan, but from now on he will be.'" That painting was subsequently sold again, at Sotheby's in New York on November 14, 2022, for $51 million.

X

Mondrian's improved mood of early spring began to wane. Bartos's bargaining and his worries about Von Wiegand's piece had dispirited him. By the end of April, he was in one of his phases when everything seemed to make

him grouchy. The painter Fritz Glarner visited on a Sunday: "I should have liked it was by friendship or sympathy only but he had a proposal," Mondrian complained in a letter to Holtzman. In a different mood, he would have welcomed Glarner's suggestion. Glarner had admired an article by Mondrian which Holtzman had "typed and corrected," saying "it was good that it was cultural and humanitary [*sic*]." Glarner wanted it presented the following season at the Museum of Modern Art as a lecture, but to be given by someone other than Mondrian himself. It could not be Holtzman, Mondrian explained, because Holtzman had his own lecture to give. Mondrian continued with details, ending by writing up the right-hand side of the paper and upside down at the top, "The paper is filled up. So I finish. Yours, Piet."

A second piece of paper was out of the question. Neither it nor the extra cost of additional postage was in the realm of possibilities; he would never have been comfortable about such unnecessary expenses.

Discussing the economics of selling paintings, Mondrian resembled his ancestors who had been retailers in The Hague. Dudensing had put his prices up, and Mondrian knew he had to be careful not to compete with the gallery by letting collectors think they could get a deal from him. He questioned Dudensing's price structure, which based the value of a painting on its size, pointing out that he often had to work more on a small picture than a large one, as had been the case with the Bartos canvas. He was still bothered by the price he was paid for it, the problem being not only Bartos's stinginess but that the price had been low to begin with; he should never have followed Dudensing's foolish rule that smaller meant cheaper.

Then, that spring, Sidney Janis wrote asking him to hold "on reserve" the painting he had put into the AAA show. Mondrian wrote back that he could make no guarantee. Janis never paid the asking price, and if someone else offered the full amount at the time of Dudensing's exhibition, he could not sell it for less. The need to be tough with someone he liked had him in the doldrums, and Charmion von Wiegand exacerbated the situation. Wanting to comply with his wishes about her article, she was using a text he had sent her so that she could incorporate his beliefs correctly. Von Wiegand returned it to him slightly edited with changes in the order of some of the words, while he had lent it to her with no expectation that she would dare to make revisions to what he had written. Moreover, Von Wiegand asked if she might submit it to *Kenyon Review* with a short preface by her. Mondrian disliked the proposition not just because of Von Wiegand's presumptuousness in editing him, but while she said she would send him a copy of her "short preface," she did not offer to have him correct any errors she might have

made in it. He groused to Holtzman about the issue. Adding insult to injury, she asked if he would let her keep his original text "as a momento [*sic*]."

Mondrian continued (as always, the spelling errors are his):

> Well, all this is very nice, but not what I intended. I never wrote about my own evolution. But perhaps it is usefull [*sic*] also because I said my work was not a personel [*sic*] conception but for everybody and analogue with Plast. Arts culture etc.

XI

Charmion von Wiegand's version of those first encounters with Mondrian had a different perspective from his. She had initially seen Mondrian's work in the Gallatin collection. She found it too mathematical; her taste was more for Expressionism and Picasso. She had recently written a magazine article about *Guernica*, and her primary interest was in painting with overt drama. But she had decided she had heard so much about Mondrian "that it was time" for her to meet him.

> I was sure, when I went to his studio the first time, that I would find it excessively disciplined. How wrong I was! From the first moment I met Mondrian, I was a total convert to his way of thinking and seeing. Our contact was a rare experience which occurs only once or twice in a lifetime. And from that first meeting, my eyes were transformed. When I went into the street again, I saw everything differently from before: the streets, the buildings, my total visual environment.

It was not just the paintings, or the setting, or the man himself that got to Charmion von Wiegand. She was disarmed by the lightness and charm and grace with which Mondrian embodied his own philosophy. She was yet another person who was struck by the unity of his beliefs with his way of life.

Her second visit was similarly inspiring:

> Yesterday I went again, walked through the little courtyard, rang the bell on the fourth entrance door, climbed three flights of stairs. He met me in the hall, a slight thin man, half bald with sharp ascetic features like a scientist, a white smock on him. He let me into the front room facing First Avenue with its loud traffic. The apartment is a re-done walk-up running through, consisting of two rooms and a passage which is the kitchen. He has made the place into a Mondrian design with just a few deft touches. It is all painted white and on the walls in the front room hang his sketches,

and on one wall rectangles of blue, red, and yellow cardboard. Red pre-
dominates. The sketches are old ones on yellowing paper done in char-
coal, ink, or pencil. There is a table, a single chromium stool with a red
plastic seat, two wooden stools. An easel, drawing board. No bourgeois
upholstery, no ornaments.

He is very cordial and peers at you through glasses with keen dark
eyes that sometimes flash an intense gaze and are again distant and turn
inward. He speaks English tolerably well, as to accent and has an excel-
lent vocabulary—the speech of an intellectual. There was an easel in the
corner with a small picture set on a double frame. It was covered. There
were pictures leaning against the walls.

The painting hidden from view, the eyes turned inward: with Mondrian,
there was always something you could not see.

XII

In Mondrian's first New York summer, Carl Holty procured stretchers on
which he could stretch canvas, but the wedges to tighten the corners did not
fit properly. Mondrian put the stretchers to an alternate use by building a
simple writing desk and worktable with them. In their bare-bones simplicity
and intelligence, these rugged and sound pieces of furniture that were the
result of inadvertent circumstances functioned perfectly. This was Mondri-
an's norm; he needed few ingredients to achieve ingenious results.

Not all of Holty's flawed solutions ended with an upside, however. Holty
was given the task of finding the best materials so that Mondrian could show a
group of early drawings he had made between 1912 and 1918, on his first stay
in Paris and then in Laren. Mondrian wanted to show, and try to sell, some
of these representational sketches, different as they were from all he was now
trying to do. But the cheap and fragile paper on which he had worked back
then was too heavy and dry and therefore at risk of tearing or crumbling, and
now these drawings needed to be mounted on something sufficiently firm.

In 1939, Holty had begun teaching at the Art Students League on West
57th Street. He thought he was doing a favor to both Mondrian and one of
his students by sending over the student with large pieces of sturdy card-
board. The student was the image of a carefree young artist. He had wild,
out-of-control hair and, on the day he went to the studio on 56th Street,
sported a bright red shirt open almost down to his navel.

Holty called in on Mondrian later the same day. He was confident that the
mission had gone well, that he would find the drawings secured on their new
supports and that Mondrian would be content. Holty had not yet realized that

this was "the young-artist type Mondrian disliked at sight." Mondrian was outraged. The cardboard was out of the question; so was the person delivering it. "'How can you send me such a man?'" he hollered at Holty. "'You should know better than that! After all, you are a painter as well as myself.'"

Mondrian had not simply found the student's appearance distasteful. It was inherently wrong, violating important principles.

Holty learned his lesson. He found a shop on Third Avenue that sold building supplies. It was not as likely a source as the art supply store to which his student had gone, but it was run by a clean-cut man of the old-fashioned craftsman mode. Moreover, the man was of Dutch background. His name was Hasbrouck, which was, Mondrian observed approvingly "a fine Dutch name." Hasbrouck provided a sturdy, thick, warm gray building board that Mondrian deemed perfect for drawings on the troublesome paper. The work had "to be moistened on the reverse side before it could be pasted on to the . . . panels. It was like saddling a bronco to control those large sheets of billowing and flopping paper."

When Mondrian ordered the boards, he gave exact measurements for the size of each. Holty had them cut according to Mondrian's precise instructions. But then, once Mondrian saw the drawings mounted, he insisted on changes. His standards for measurement were the same as in his painting; no rules could determine the precise width of the margins, but the proportions had to *feel* right, which required Mondrian judging them with his eye.

The alterations Mondrian wanted were easy enough for Holty to execute when the boards simply had to be trimmed. But when the fit was too tight, and the margins not ample, the boards had to be replaced. Mondrian insisted on "¼" less there and ½" more there." He told Holty that it was better to "'leave the extra space. It will let the drawings expand better. It's better to have a little more room than too little.'" For Mondrian, these nuances made the difference between anguish and contentment.

Like Charmion von Wiegand, Carl Holty willingly worked with Mondrian in what was supposed to be the cool of the evenings during that exceptionally hot summer of 1941. Mondrian did not own a power fan of any sort, and even after nightfall, there was no breeze and the air was muggy. It was difficult to trim the boards and mount the drawings. Holty found it tough to avoid sweating on the artworks and took frequent breaks to cool down. Mondrian was not unappreciative of the effort. To thank Holty for all that he had done mounting the drawings, he gave him one of the largest of them. Holty asked Mondrian why he was doing this. Mondrian replied:

Old artists die, and when they die their pictures get valuable. They should give some to their younger colleagues so that they can get some

advantage from them. Why should only the speculators get rich from a man's work.

Calling Holty a "colleague" was the greatest gift of all.

When they were working on the mats, to reward his diligent helper, Mondrian talked with him about some of the major artists of his lifetime. Holty realized how rare these little discourses were and, fortunately for the rest of us, would later recall them.

Holty asked Mondrian for his "estimate of Cézanne." Mondrian replied, "His biggest contribution was the destruction of the old picture concept, not much else than that." Even if Mondrian credited Cézanne for his break from tradition, Mondrian's arrogant dismissal is surprising. Most of us would expect the restraint and sheer beauty of Cézanne's art, the radical use of whiteness, above all in the watercolors, and the geometricization of form to appeal to Mondrian.

Yet if ever there was an artist who evoked Mondrian's "tragic," it was Cézanne. His art presented the mortality intrinsic in the natural world— evident in the ravages of age on old men's faces, the lithe bodies of naked bathers whose youth is a reminder of the inevitable decline, the trees from which leaves will soon fall. By focusing on representation, even if he achieved it by radical means, and making earthly life so plausible, Cézanne achieved goals entirely different from Mondrian's. And when Cézanne in his later years rendered sights ethereal, he induced an emotional state as melancholic as it is otherworldly. Of course this could not be Mondrian's taste.

One evening, Holty told Mondrian

> that one of his most ardent admirers had placed him historically in the following position: Picasso, Juán Gris, Mondrian. He protested vigorously, "Oh, not Juán Gris! He is much too cold and intellectual!"

In the case of Gris, Mondrian was, as with Cézanne, being perverse. Using those adjectives, he was attacking a painter who in his way was as refined and elegant as he was.

In one of their conversations, Holty brought up Picasso's *Guernica*, an artwork then being discussed more than any other work of the era.

"Mondrian said, 'People fail to realize how pictorial he is,' and when I said that Picasso worked from other impulses than those of pure plastic considerations, Mondrian rejected the idea and added, 'He tried to do what we do, but he didn't do so well at it.'" That Mondrian could write off *Guernica* was remarkable. Franco's forces had destroyed the Basque town only three years earlier.

Holty jumped to the subject of the Barbizon School, and from there to some paintings by Daubigny he had seen in the Mesdag Museum in The Hague. Holty knew his stuff; he was right that Mondrian would be familiar with what he was talking about. Hendrik Willem Mesdag, a Dutch business-man born in 1831 who had become rich young, had been a leading Hague School painter. With his wife, Sientje Mesdag-van Houten, also a painter, he had created a museum in his house. The Mesdags opened their mansion, stuffed to the gills with ornate furniture and rugs and decorative objects and Barbizon paintings, to the public on Sundays during the years when Mon-drian periodically visited The Hague, and Mondrian may well have met the oversized Mesdag, whom Van Gogh called a "veritable mastodon."

Holty had done well to name Daubigny. Charles-François Daubigny was a mid-nineteenth-century artist whose subtle, quiet, atmospheric paintings of farmhouses and woods and the seaside bear an uncanny resemblance to Mondrian's early work. You could slip a Daubigny into a show of Mondri-an's paintings from his Amsterdam years and few people would question its authorship. At the mention of the artist, and the museum, "Mondrian was enthusiastic. 'Do you remember the one,' he asked, 'with the sheep in the snow and the sunlight. *What* a beautiful picture!'"

Mondrian's memory, however, was slightly playing tricks on him. The Mesdag collection has two Daubigny canvases of sheep, but neither has snow in it. And the museum's Daubignys of snow have no sheep. But snow and sheep are paeans to whiteness. And sunlight is universal. Mondrian had mentally created his ideal.

His standards were his own. When he personally knew and liked the artist, he could like figurative painting. When he was ambivalent about the person who made a picture—Van Doesburg—he would not even condone a diagonal line. When he gleaned spirituality—as in Daubigny—traditional representation was not just permissible; he was laudatory about it.

XIII

Von Wiegand made a further visit to Mondrian in early June. Mondrian may initially have had his doubts about working with her, but she was so receptive to his ideas that he decided to show her his original essay on Neo-Plasticism, written in 1920. He told her he had raised nine hundred francs to have it printed privately at a time when he could hardly afford the lentils that were his main source of nutrition. He now wanted as much of his earlier writing as possible translated into English, with her at the helm. His goal was to see the Bauhaus publication devoted to him, as well as manuscripts that had never made it into print, be reborn in his new language. All of it would have more

readers in English. Von Wiegand responded that, while she spoke German, her French was far from perfect and she knew no Dutch. How could she translate from languages she did not know?

Mondrian's answer was "But you have me, and that's all you need."

She wrote a journal entry about the visit. Although scattershot and replete with obtuse references, it captures the particular rapport that she and Mondrian had, the mix of banter and seriousness that was such a rarity in Mondrian's life. Von Wiegand was both willful and tolerant, making Mondrian more jocular and open than usual. Thanks to Von Wiegand, we are brought into his studio as if he were alive.

June 5, 1941

He and his art are one—

He was all dressed up, looking very elegant and European and I was again impressed with that lean, ascetic face, those dark eyes peering through the glasses, the sense of a fiery spirit burning like a bright dynamo behind his eyes. I have seen that look only in the faces of El Greco's portraits—there it is a religious flame, but it is also the hungry search for the Absolute.

Actually Mondrian is very gentle and quiet and reserved; he knows the way, and so he is actually very indulgent to those who do not. He is so sure that he can be very liberal. But inside the power burns and vibrates. Stepping into his front room out of the colorless day was like stepping into the super-charged dynamo, for he had hung up more squares of color on the white walls and great red rectangles sent out rays of warmth, yellow rectangles spread sunlight and blue ones cool shadow. Around the room were new pictures, the powerful forms of great squares vibrating in the small space.

Mondrian was a little shy today and a certain difficulty in speaking English—sometimes it is not as good as other times, but he had a sore throat. We sat on the two stools—his only chairs—at the little table and went over the manuscript, correcting it.

Later we went into the kitchen to get a drink and he squeezed an orange for me and made himself coffee in a pretty little glass drip. And everything was so clean and neat and organized and he loved his frigidaire, altho for some reason he had no ice cubes in it. He says he doesn't cook much when he is working. Several times he said "it is so hard, the work."

I had told him about Art Front and how I had once attacked him in that review Five on Revolutionary Art. And his eyes flashed for a moment—he can be very angry—and then he laughed and playfully

struck at me. So I told him it was only about that old chestnut form and content and how we leftists always thought abstract art was devoid of content.

"What I like about you is your revolutionary temperament," he said and added that he liked Joe for the same reason tho he had not talked with him. He has the most uncanny insight into people. Also like he said that Sydney [*sic*] [Janis] was no longer a business man, but a real intellectual. And implied that Kiesler had fallen back but that Sydney [*sic*] had developed. And then speakin [*sic*] of Kiesler, he said that he had promised him a drawing of the old period and we went back into the bedroom to see it. And it was curious, that the room with the small single bed and nothing in it but the early drawings tacked up around—a cabalistic room with those strange egg-shaped Dutch series with crosses on them. The first time that they had seemed all alike to me but now I saw them as quite individually different in feeling.

Von Wiegand became something between an unpaid assistant and an adherent of a cult. She would regularly shuttle from her downtown apartment to Mondrian's place in midtown, except for the days when she went to the public library to read what was written about him in various books on De Stijl. Photocopiers did not yet exist. Von Wiegand would write out, by hand, any article or part of an essay which she thought warranted Mondrian's response. Then, during their working sessions, Mondrian would alternate between painting and dictating changes in his manuscripts, line by line. He often asked her to give her reactions to what he did on the canvases as she did to what he had said, or others had said about him, in print. Von Wiegand would remember him asking "whether a line should be shifted an inch one way or the other, whether a color plane should be up or down, enlarged in size or decreased. What he was seeking was not aesthetic appreciation, but the spontaneous visual reaction by which he tested his own conclusions." Von Wiegand had the necessary confidence to state her preferences clearly, and not to be flapped if Mondrian then paid no attention to them.

Mondrian handed to Von Wiegand some handwritten notes that constituted a "little statement about his life and work that he had written to make things clear" to his interviewer. That is Von Wiegand's description of it, and, while she was intrigued by this "succinct, if not altogether idiomatic, account of his artistic development," she did not realize, or perhaps care, about how persnickety he was about the language he had used, how reluctant he was to accept any alteration to it. Von Wiegand sent it back to him after she had "spontaneously copied" it "into more legible English." She not only made it more articulate but cleared it up in syntax, grammar, and spelling.

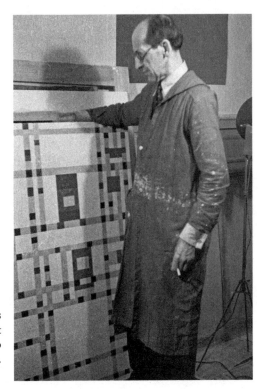

The boogie-woogie paintings were an exciting new development that came following his move to America, 1942–1943.

Their work together was still going full swing that summer. Mondrian was not used to the heat, or the way it can feel in Manhattan, yet he was undaunted by it. Even at midday, he kept painting. With the windows as wide open as they could go, and only an occasional breeze from the East River offering a bit of relief, he continued regardless.

Von Wiegand preferred the evenings to work on their essays together. The studio was a bit more bearable once the sun went down. But invariably, when she arrived, even after a brutally hot July day, Mondrian would still be painting. She would show up in

the cool of the evening. Getting off the bus on First Avenue, I would see Mondrian's rectangles glowing through the open windows. He would be hard at work, bending over his drawing board—which he used flat like a table—operating like a surgeon on one of his white canvases. He used a slender steel bar to steady himself making the lines, and the brush, in his long supple hands, moved with delicate precision and rhythmic energy.

While the rectangles of solid color on the wall remained fixed in place except for the rare occasions when he repositioned them, Mondrian would

tinker microscopically with the new paintings that were his obsession. The impeccable setting, organized to inspire him, allowed him the freedom to keep making changes on the individual artworks. It was as if the combination of order and playfulness surrounding him accorded him a sense of abandon where intuition could rule without risk. An ocean away from his old life, he was in his familiar cocoon. The white walls and large-scaled panels of color that he would move infrequently put him in his universe, and enabled him to keep redoing his paintings in that process that had him in a spell of enchantment as he worked into the evening hours.

Von Wiegand found Mondrian as exacting about their writing as he was about his painting. "He would spend hours on two paragraphs and was always busy looking up words in the dictionary and inquiring as to the exact shade of meaning." He was stubborn and unrelenting. When Von Wiegand told him that something he had written in English was not idiomatic or was difficult to understand, he announced that it was clear to him and that was all that counted. He refused to let her mitigate his repetitiveness or alter the confusing word usage that no one but Mondrian himself could understand.

Mondrian was not pleased with Von Wiegand's text about him. He began a letter to her on July 15 with a complaint about a physical woe only to say he did not dare let it impede his writing to her because it was necessary to stop her immediately from making her text even longer than it already was.

Dear Charmion,

One of my eyes is not quite better but I would not let you wait any longer for you would make the article longer you said.

I think it is just long enough and perhaps good for the public. But going deeper in to the content of my work and the relation of it to life would be, I think, not on the right place.

I don't like the concessions to the public which you did in the beginning of the article. I hope you won't be angry with me!! Sincerely yours,

Mondrian

Greetings to Freeman. What a nice name he has.

Joe Freeman, Charmion von Wiegand's husband, was, after all, among the most tolerant and supportive spouses imaginable.

Von Wiegand and Mondrian did not have an easy time working together to finalize the corrections on the manuscript they had been sending back and forth. He "had a certain difficulty speaking." She attributed this to the shyness which at some moments overtook him, but also knew that he had a sore throat that day. The hiatus in conversation gave her a chance not just to take in the atmosphere but also to study, in an early stage, one of the

new works—one cannot exactly say "paintings"—that revealed the artistic leap Mondrian had made in the few months since he had moved across the Atlantic.

> On one wall, propped up, was a large new picture, all in tapings like a mummy waiting to come to life. It is different from all the others, because it is made entirely of colored lines. It is more brilliant, as if America had already changed his color.

The boogie-woogie was taking new form.

XIV

Following another visit to Mondrian's lair on 56th Street, Charmion von Wiegand decided to give a party for him. She made the arrangements thoughtfully, having Carl Holty fetch Mondrian in his car and inviting only a handful of guests she thought would please him. Among them was Walter Quirt, a young Surrealist who, when Peggy Guggenheim had, unbeckoned, called on him in his studio to offer him a solo exhibition in her new New York gallery, had replied, "I didn't ask for a solo show, and I didn't invite you to my studio." Another was Stuart Davis, in many ways America's most authentic Cubist, who adapted the French style with his own forthrightness, imbuing the bold forms with distinct clarity. Both were a generation younger than Mondrian and admired him immensely.

Mondrian was in good form at the gathering in his honor. Von Wiegand would recall:

> Mondrian seemed to enjoy himself; his step was light, his smile contagious, and he went around the apartment examining everything with interest. Stopping before a landscape hung between two windows which faced the sky line of Lower Manhattan twinkling with lights in the clear night sky, he said, "This is very good indeed." And after a pause, "It is what I have come to destroy."

XV

Von Wiegand describes another visit to the studio:

> Mondrian was cooking his supper but as usual brought me in at once to see the advances in his pictures. I was too hot and tired and told him so. But I saw at once that the Radiant picture had been changed. He had a

fine brought [*sic*] blue in the rectangle with the cross at the lower right side, but by some means, he had expunged all the lyric and personal feeling which I had found so enchanting. The black lines were heavier, the canvas had more force but the lovely rhythm that was so magical had been severely enchained. But perhaps he is right, for that haunting quality does wear thin after [*sic*] while and the other remains—the structure— but still I was sorry and said so.

"No, it is much better this way." He said. "But perhaps I can make the lines a little thinner." [*sic*] was the one concession he admitted. I asked him if the fact that the crossing was not centred in the rectangle bothered him. He said no, but it did me. He had changed it merely by adding one straight black line on the left and one on the right.

On the wall propped on a box was another canvas he was working on and almost finished. It had a very classical effect, because the central section was almost like a long rectangular box with lines cutting it—three I believe, and almost equidistant. A fourth line however took away the symmetry. It had three colors blue, yellow and red in narrow rectangles at the furtherest [*sic*] edge—two on the bottom, one vertical on the left, one horizontal on the right and again a vertical one the top left. It was lovely in color and form. "I like it less" I said "because it is so classical."

"I do too. I prefer this other expression—it is more dynamic" he said of the blue radiant one.

He had also worked on the larger of the pair—the female one. He had already stripped the tape and put on the yellow lines. He showed me that yellow against white was making the background appear yellow by reflection and it was not therefore so pure as the "classical" one, where the yellow rectangle in the lower left was defined by the black line. Then we noticed that the reflection of sunset was casting a warm yellow glow on the paintings which changed them and softened their colors.

He asked if I had had supper and he went in the kitchen to fix his— boiled potatoes, spinach, bacon and salad. I sat on a stool and watched him, asked him if he minded it, but he said no, it did not make him nervous.

Von Wiegand portrays the person and his work as a single entity.

It was a beautiful day quite clear and cool. Mondrian was working when I came and he looked tired and his eyes were red and irritated. He had not been out walking for a long time. He said it was a good time to come and he said he liked my dress, and then he said he was very hungry because he

had not stopped to make lunch. So we went into the kitchen and I wiped a few dishes for him and he made his supper. He always burns the potatoes when I am there. I told him about my trip and we had quite a gossip while he fixed the salad and cut ham. He invited me to eat with him but I was not hungry and wanted only tea, which he insisted on in the midst of eating and jumping up to fix it and buttered me a rusk to go with it.

In the time I was away, it did not seem as if he had worked much. He had done some work on the Radiant picture but it was not finished. "No look, it is more the way you liked it" he said. "I took the blue out—it was too heavy and that has lightened the whole composition." He had left only one tiny blue rectangle, which was like a small bright point. It seemed impossible that this elimination should have made such a difference but it had. He had also worked on the large canvas, the tape had been stripped off, and the lines done in paint. But still I did not see that he had done much until suddenly he turned acavans arnad [*sic*] and I was startled by its brilliancy. About 25–30 inches longwise. It was complete except for small details. Against the blazing white, were set two rectangles of blue and yellow low down balanced by a narrow rectangle elongated on the left of red. The balance was strange and in it I sensed a dissonance that was most curious and violent in expression. I said this and he replied:

"I made that composition in London during the bombings." Then he chuckled that I had noticed this. "I do not like it as well as others, but it will do."

XVI

Charmion von Wiegand was obsessed. She knew Mondrian's various sides as no one else did and accepted all of him. Whether he was warm or reticent, aloof or passionate, he was as unique as his work.

July 20, 1941 for July 13.

He can be so charming when he wants to be. As if there were two personalities—rather dour acetic face with the lids of his eyes dropped, as if he were listening to a voice inside himself, and not knowing you were there; then the flashing of his eyes, the keen appreciation in them, the charming smile and the elegant movements of the long competent hands. He can show the most tender solicitude, the greatest indifference I have known in one human being. And his eyes can flash with indignation and anger.

August 2, 1941 for August 1.

He told me that the AAA had given a cocktail party at George Morris's home when he came and that he had liked "the lady painters" who had been nicer to him than the the [*sic*] men, although they were nice too. He said he did not like to go to parties because of the intrigues and he did not go to the meetings of the AAA—that some of the lady painters did not like Holtzman and that there were differences. But Carl had told me the night before that Holtzman has decided to buy all of M's pictures rather than give him an annuity—this was Eileen's idea. And I feel that M. has such a wonderful patron and is so protected that he should be on good terms. So I said:

"You are fortunate to find a man so understanding and who loves your work so much."

He agreed but when it came to discussing the translations, he said Holtzman was no help and I asked him if the translation should not be given to Holtzman because he knew the English terminology of the theory better, but M. emphatically said no. He said Holtzman was not interested and didn't see things that way. "No, your translation is all right. Don't show it to anyone. No, I don't want Holty to see it either." So there it is. I told him Walter had only seen the edited article and nothing else. And I had showed it to Joe of course. "Oh. Freeman, that is different" he said.

Von Wiegand debunks the myth that Mondrian had the white plaster flower in the Paris studio as an intended substitute for real ones, a deliberate rebuttal of the natural. And she substantiates the story that at least once in his life he had wanted to be not just a husband but a father. Whether or not it was with Lily Bles, Von Wiegand knew, from Holty, that Mondrian had indeed wanted to settle down with a young woman and had suffered deeply when it had not worked out.

I had some flowers from Becky's garden and a vase for them. I knew M. would not like the vase but it was lucky I broght [*sic*] it for when I got there, he said "What more flowers" and he brought me in to see the wonderful chrysanthmus [*sic*] and asters a Swiss woman had sent him—he had them in his little "pot" at the foot of the easel and they were very lovely in color—bronze and yellow and sharp green. "Its [*sic*] like a birthday" he said.

The other night Carl told me [a] story that explains Mondrian's whole attitude to me now. He said that he thinks Mrs. Gelrner [*sic*] told him that Mondrian ten years ago in Paris was planning to get married. He fixed

over his studio, got a bigger bed, and built a cradle. All was ready and then it never happened. When I hear [sic] this a big lump came in my throat—and Carl said "You see he created a whole fantasy." But I knew it was no fantasy and that it had been a terrible blow to him. Suddenly I understood the meaning of my Picture—the Crucifixion motif—and remembered the story he told me that one night when I came back from Cape Cod—about his engagement to a girl, whom he was sure loved him, who came to see him with friends and it was to be announced and then seeing his poverty, she turned him down. I remember his face—the look of suffering and his trembling voice—the unweiling [sic] of his emotions. And I was not really understanding or sympathetic—nor was I sensitive as to why he called his picture "a very personal picture as a personal gift to me." He has been hurt so deeply and now he finds himself on the edge of another hurt—or so he thinks and perhaps thinks correctly— and so he withdrew before he could be attached. And that is why he wanted the picture hung in the bedroom, because he could not bear to have people laughing and being socially occupied in the presence of that picture which had been born out of so much pain. Under that cross lies his love and his hope of a son and of all the personal happiness that the individual desires and longs for no matter how great he is. . . . And the ten years of ill health he spoke to me about and the terrible time in Paris dates from then.

Last night we spoke about Gauguin and his family. I told him what I remembered of the story and how Mrsden [sic] Hartley said he was not talented enough to bring so much pain to his family. And then M. asked me about Van Gogh's—I did not tell him [illegible] as a prostitute—and how he broke it up. But I did not tell it well because I forgot it was when Van Gogh got so ill in the hospital and she started to find money the old way. And it is so moving to think Mondrian had remembered something of the story—that he was prepared to repeat the pattern. Although I am sure that his girl was different—a little clerk in a store I believe.

I almost feel that I have no right to even put this story down—for it is so sacred to him—and someone might read it. And it is why he is sensitive about Joe and so afraid to cause any disturbance between us, because he does not know the real situation.

XVII

On Sunday, August 3, Von Wiegand woke up having "dreamed of a machine which would establish relationships, much like a typewriter. By means of it all painters, draughtsmen, designers, architects, could more quickly find

right relationships, for their work and thus [the] environment could [be] changed at once."

She actually sketched this fantasy which would spread Mondrian's ideas worldwide. She spent the whole day realizing in words and imagery "this beautiful pipe dream" and rushed to Mondrian's to show him the design which was "according to theory—three non-colors, three colors, verticals and horizontals. Finally he chuckled and said: 'That machine idea. It might be something for Holzman [*sic*].'" When she arrived at 6 p.m., he had still been in his smock and painting the composition called "Radiant"; she had apologized for the interruption but said that the idea of the typewriter-like machine had utmost importance. He had not concurred. "'A machine, I hope not for straight line art,' I could see his face cloud over and his eyes flash for a moment. I knew he was furious at the very idea." Mondrian said he might eventually look at what she had written by the device, but that his eyes hurt, and he needed to use the remaining daylight to paint. The put-down devastated her. "'Oh I do everything wrong' said I, immensely hurt and feeling I was let down the elevator shaft."

He told her "the idea is harmful." She argued her case, implored him not to be angry, and he agreed to look at the design.

Von Wiegand next described Mondrian opening a can of tomato juice. He "carefully poured out two glasses. He was so morose looking, like an insulted bald eagle." She was miserable, pained by his disappointment in her. She handed over the sketch, and also gave Mondrian the article she had written about him, even though she now questioned her timing for having done so.

> Then I said I must go and he did not disagree. I left him the article and thought I shouldn't. I felt as guilty as if I had committed a heinous offense. But when I went out, he smiled his lovely smile and I pressed his hand. He seemed to be quite indulgent again as if I had been a backward child.

For Charmion von Wiegand, this machine was a very serious idea. She next told her husband about it. Joe Freeman said that the whole concept was "preposterous," would cost at least $10,000, and would have no audience.

Whether Mondrian looked at the sketch of the machine from her dream, on August 15, Von Wiegand wrote that Mondrian had returned by post the text she felt she had given him at the wrong time. He also responded to an apology she had made for having told him about the device for transposing his ideas.

On Wednesday morning, J. handed me a long envelope with Mondrian's handwriting. I looked at it long and was afraid to open it. I always keep the envelopes because he designs them quite unconsciously. Two horizontal lines under my name on the left side balance the postmark lines on the upper right and it makes a beautiful clear-cut design. Inside was my script returned and marked all over with his handwriting and with it [a] scrap of paper written on both sides and then additions put around the margins.

I read it through several times and then realized I was forgiven—"Thank you for your letter. I am glad you agree with me about that machine" it began. Then he said he had not torn up the script but sent it back because on the whole things in it were good and the first pages about his theory he liked very much (with his changes) and maybe if I liked I could write a short introduction for his essays. He not only had forgiven me but was offering me reparation.

XVIII

On another summer evening in 1941, Joe Freeman invited Mondrian to go to the uptown branch of the nightspot called Café Society. By then, Mondrian had already become a habitué at the original Café Society in its basement setting on Sheridan Square in Greenwich Village. These nightclubs were part of a reinvigorated New York life which had gathered steam shortly before Mondrian arrived in the city. In spite of the war abroad, it was a period of rebirth in the United States, thanks to the recovery from the great financial depression of the 1930s and to the influx of European exiles bringing new energy to America. Barney Josephson, the son of leftist-leaning Jewish immigrants from New Jersey, had opened Café Society to create the sort of political cabaret he had come to know in his travels abroad and which he realized would appeal to people who had formerly lived in Paris and other sophisticated cities. The thirty-six-year-old entrepreneur wanted to feature African American performers, and this was the first racially integrated nightclub in the United States.

Even the Cotton Club, in Harlem, forbade entry to most Black guests. The performers were almost all Black, but, with the exception of a few Black celebrities allowed in the audience, the clientele had to be white. The Kit Kat Club was also segregated. At Café Society Uptown, Black people would share the dance floor with whites. The name Josephson gave his groundbreaking establishment was a deliberate spoof, a mockery of those chic and expensive nightclubs frequented by the crowd Clare Boothe Luce

had named "café society" and Josephson considered pretentious and full of airs. He advertised his establishment as "The Wrong Place for the Right People."

The uptown branch was on 58th Street between Lexington and Park Avenues. Josephson immediately hired Lena Horne and Pearl Bailey to perform at his new premises with its revolutionary policy of treating Black and white clients equally. Even in the so-called sophisticated and liberal northeastern United States, Blacks were not simply segregated; they were ostracized. Seeking hotel accommodations a few years earlier in Hartford, Connecticut, while they performed in the premiere performances of Gertrude Stein and Virgil Thomson's opera *Four Saints in Three Acts*, the all-Black cast was relegated to the only dive that would rent them rooms; "Negroes" were not permitted in nicer places. Josephson was a pioneer.

When Billie Holiday sang "Strange Fruit" at Café Society, Josephson insisted that she leave the stage without doing the encores for which the crowd was clamoring. He would not even allow her to stay to enjoy the continued applause. Rather, he wanted his guests to be left in a daunting silence. The intrepid café owner believed that only then, forced into wordless reflection, would they consider the real meaning of this moment in history.

When Freeman, who shared the politics and ideals of his friend Barney Josephson, and Von Wiegand took Mondrian the few blocks from his studio to the uptown Café Society on that hot night in July 1941, they knew that he was receptive to what poets like Langston Hughes and Léopold Senghor celebrated as "Negro Culture." Black musicians from the West Indies and America's cities and the hot spots of Paris were performing an art rooted in Africa, and were proud to do so. Nothing could have seemed more natural to Mondrian than to listen to music at Café Society, and to dance to it. Mondrian could hardly wait to head to Barney Josephson's lively new establishment.

Mondrian's outing that night to the uptown Café Society with the wonderful friends he had come to know that spring was enhanced by the presence of someone whom he had never met before: Dimitri Mitropoulos. Mitropoulos, a Greek-born music conductor, had prodigious musical talent and an original personal style. He went out in public in a plain white cotton short-sleeved T-shirt, a full decade before James Dean and Marlon Brando made it a fashion icon. His clean-shaven head, commonplace today, was ahead of its time. As an orchestra leader, he was renowned for not using a baton or looking at a printed musical score, and for swinging his arms with the ferocity of a wild man.

Mitropoulos was Mondrian's sort of person. Like all of Mondrian's friends, he was a full generation younger and had dared to break shackles

in his own life. Initially, Mitropoulos had decided to become a monk but reversed his decision when he was forbidden to keep a musical instrument in his cell. Later in life, he would gain renown as the conductor of the New York Philharmonic and become the lover of Leonard Bernstein, but, at the time Mondrian knew him, he was given to saying that he believed in sublimating his sexuality to build energy for the performance of his art.

Mitropoulos made good company on that evening when, at age forty-five, he and the sixty-nine-year-old Mondrian and Freeman and Von Wiegand, the sole woman in the party, went to the hottest place in town to dance the boogie-woogie.

Von Wiegand reports of Mondrian:

> His delight in dancing the boogie-woogie was unfeigned. He asked most earnestly whether I thought he was too old to ask the ladies to dance and seemed much relieved when I said no. He had a wonderful sense of rhythm but liked very complicated steps, and he held me at a disconcerting distance—which did not make dancing with him easy. In the middle of a dance, when the orchestra switched suddenly from boogie-woogie to jazz, he stopped abruptly: "Let's sit down. I hear melody." He adhered to his principles in everything.

Mondrian had made great progress on the dance floor since his days of learning the box step at the Hamdorff. When the beat was boogie-woogie and he had a skillful partner, he took off with such style and flourishes that all eyes turned.

Those glamorous New York nights nourished Mondrian's painting immeasurably. The boogie-woogie stayed inside him, and the acrobatic six-beat music became the lifeblood of his art.

XIX

On one occasion, Harry Holtzman hosted an evening at Café Society Uptown to celebrate Mondrian's emergence from a long bout of rheumatism. Besides Mondrian, the guests were a group of Holtzman's friends, most of them half Mondrian's age. Lee Krasner, a talented abstract artist who would eventually marry Jackson Pollock, was a gamine with bangs and wavy thick brown hair. While not traditionally pretty, with a large nose and thick eyebrows, she had flair and confidence and the desire to be alluring. She "adored" Mondrian, and she and he flirted conspicuously that evening. Krasner made Mondrian feel worshipped, both for his genius and for his innocent sense of fun.

That night at Café Society Uptown, the young Krasner and "the stately

Lee Krasner, c. 1939. Mondrian liked dancing with this young abstract artist who would eventually marry Jackson Pollock. They went to Café Society Uptown, where Hazel Scott was singing and they danced to boogie-woogie.

Mondrian . . . walked to the edge of the dance floor and waited for the right number. When the music changed to a boogie-woogie, Mondrian whispered 'Now' in her ear and together they swung onto the floor." In the old days at the Hamdorff, he had developed a theory that Jewish women danced with more bravado than non-Jews; Krasner was his ideal partner.

Krasner would recall that Mondrian "had a wonderful sense of rhythm and liked very complicated dance steps." She became aware, or at least had the feeling, that everyone there turned to watch the two of them. "I thought, of course they are looking at us. Of course they are looking at us because I'm dancing with Mondrian." She realized that in fact all eyes were on a different couple—"some movie actor and a divine-looking woman"—but to Mondrian it made no difference that these celebrities were next to them. What counted was the boogie-woogie, which penetrated his being.

Hazel Scott was singing that evening. Scott was a twenty-year-old Afro-Caribbean beauty, born in Trinidad, who played the piano with pyrotechnical skill. On the nights when she performed at Café Society Uptown, Scott was one of the hottest tickets in town. Innocently beautiful with the smile of a little girl, yet sophisticated and womanly in her white ermine coat, when she took the coat off to sit at the piano in her black sequin dress and play boogie-woogie, Mondrian was transported.

In 1944, Hazel Scott would write about boogie-woogie. She points out

that it consists of emphasized and unemphasized notes. Some have "a very staccato crisp effect," achieved by "striking the note firmly" on the piano, "but not hard, and lifting the finger from the note as soon as it is struck." Others, "conversely . . . more sustained and less emphatic are produced by striking a note and holding the key down." Scott emphasizes "original improvisation" and writes that "certain parts of melody may be disregarded." She champions "embellishment" and "the chromatic tones *between* the beats." Her advice is to "improvise," and to "use fragments of the right hand . . . and also original figures or rhythmic patterns . . . in all keys . . . invent your own figurations . . . construct as many different types . . . as you can on these harmonic constructions." Freedom and play prevail. Hazel Scott's guide to boogie-woogie—lighthearted, nondidactic, respectful of tradition but in love with its violations—encapsulates the musical form that made Mondrian feel liberated.

Mondrian relished his evenings out, but kept them to one per week. If not to a jazz club or dance hall, he would go to an exhibition opening or the movies. Otherwise he was at home, writing or painting.

Von Wiegand writes:

> He complained that his apartment house was too quiet—he liked to hear voices and the sounds of the radio playing. Later, when he acquired a small phonograph—which he decorated with red rectangles—he liked to play Bach, but more often boogie-woogie. He always played full volume, as if this added to his pleasure. He painted full-volume too.

XX

On September 2, 1941, Charmion von Wiegand reported that Mondrian

> asked me about the Freudian theory and didn't seem to understand what I told him, probably because I didn't explain clearly. And he said: "if you don't separate the moral and the physical, you have homosexuality." Which didn't make any sense to me, unless the inclination existed anyway.

Von Wiegand's "unless the inclination existed anyway" suggests that she believed that Mondrian may have been talking about himself.

Von Wiegand continues:

> But our talk was very friendly and quiet without any emotional undercurrents. I felt that he was very glad to see me and our conflict that had

almost caused a collision was over—chiefly because I had withdrawn from him internally . . .

And we discussed his health, he had been feeling badly and he loves to discuss symptoms and I allayed his fears saying it was merely the tension of the work that caused him stomach disturbances. He never eats regularly or sufficiently.

A week later, she found Mondrian's conditions and spirits greatly improved.

Mondrian then gave me a wonderful command performance of the finished pictures and as he turned them around, one by one, the room seemed to increase in energy and light and I forgot everything else, that I was tired, or melancholy, or worried. It was so amazing and it only came to me after it was all over. "Violent" had been again redone and now had reached a less violent and more harmonious stage but it still is the most startling one. First he showed me the "radiant" one which he has finally finished (almost for the black lines must be redone again) but he likes the composition now—the left side small verticals were removed—and a small vertical added in the right lower corner. It is not as intimate but very free and clear and gay. I think it is very beautiful.

Then we looked at the "female" one of the pair and it still is not finished but Mondrian said: "For two months I've changed those two yellow lines (horizontals) at the bottom every day and I have not yet found the solution." He then asked me what I thought and I found the one too close to the red cross and he pinned it lower. One could have it either way actually. "There is often more than one solution, you know" he said and tried the two lines in various ways, but finally it seemed right and the top line under the red cross was much further down. In watching this process, it comes as a surprise that I can now feel the difference in proportion, that I can sense when it seems right.

"To think that it looked like no more than a plaid handkerchief to me a few months back." "That was not true really" he said. "I noticed the very first time you came that you were seeing the pictures, that they moved you."

XXI

Charmion von Wiegand's obsession, and Mondrian's resistance, were part of a pattern in Mondrian's life that went back to his Amsterdam years. While he seemed indifferent, she became delusional.

On Sunday, September 14, while Freeman was out of town, Von Wiegand took the First Avenue bus uptown to see Mondrian. When she got off at 56th Street, she was surprised to see that Mondrian's apartment windows were dark. This was so unusual that she thought he must have been ill and in bed. But when she anxiously went into the courtyard, she saw that the bedroom windows were dark as well. She anxiously rang the doorbell three times.

But I didn't believe it—because I had his image before me so clearly—coming to the door in his smock, working and detached but always sweet and polite and welcoming me in. And the brightly lighted room with the red rectangles—I had never thought the light went out there. And I felt so impoverished and lost suddenly and remembered how Proust felt when he missed seeing Albertine. So I hopefully wrote a little note on a piece of the brown envelope of the manuscript that I would come back in 15 minutes.

She then killed time in the neighborhood until nearly 10 p.m.

And I walked out the door and looked up and this time the dark windows were even more depressing. And I thought, perhaps, he is ill and has been taken to the hospital, perhaps Holtzman came and took him to the country, and then I felt sure that he was out having dinner, but it was almost ten o'clock. But he often goes late. And it seemed as if the dark windows were like a shut door and the mystery of his personality, on the mystery of his past, of which I know so little and it is a door that I shall never open and never know what is there, all the memories of his past to which I do not belong. Then I thought but you too have a full past—not as long as his—but full of memories of other men and he does not seek to know, and yet you want to tell him, to share it and it cannot ever be done. . . . And how strange that two people can never really know each other in completion, no matter how they try, they remain two forever apart in loneliness, moving in their own orbit, and only in a blinding flash sometimes, it is penetrated and raised above the personal plane, raised to a point, where the boundaries of one "individuality" are resolved into something greater—that is the secret of the work and on that plane alone does one become one.

Von Wiegand walked up to 57th Street when she saw, from behind, a man in a suit; she thought it was Mondrian. The man entered the building and Von Wiegand glimpsed a woman dressed in black.

I heard their voices speaking and they went up the stairs. And I thought how indiscreet of me, you not only do not know his life in the past but also you do not know his life in the present. Perhaps he had someone and that is why he has been looking so well of late. He would never tell you, because he separates you from that part of his life, and again I felt lost and desolate and then I saw the little folded brown note still sticking in the box and I thought "He did not see it, he was hastening to meet her" and then I felt that it was very wrong to come in without notice, although I had done it without remediation, and that this way, the door had opened a crack on his life here which is not shared by me. . . . I rang the bell— three long rings—I had heard the door close upstairs and the man and woman were gone—but there was no answering click and again I rang and then—knew definitely it had not been him but yet my imagination would not give up the idea.

The following morning, she received a note from Mondrian saying that he had been sorry to miss her, but that he had been out for dinner with the Holtzmans.

Von Wiegand told Mondrian about her pursuit of another man whom she mistook for him. He responded that Frederick Kiesler had remarked in front of Harry Holtzman, "Now Mondrian can marry Katherine Dreier and everything will be fine." It was an odd rejoinder. But he went on to say how annoying it was if anyone even joked about the idea of his being married. Von Weigand's obsession with him was a reminder of that painful subject.

An American

Almost exactly a year after his boat had docked on the Hudson River, Mondrian filed his application to become a U.S. citizen. This "Declaration of Intention" had to be submitted in person at the Federal Building on Christopher Street in Greenwich Village. Holty went along to help; there was no way that Mondrian would have been able to grapple with the system on his own.

They waited in a crowded, airless room. It was one of those spaces where people desperate for official approval are herded as if discomfort in grim surroundings is a requisite for the allowance being sought. Mondrian was seated with the group of people packed together under a hanging large cardboard sign with the letter "M." Whenever an Italian name was called, if it slightly resembled the name of a Renaissance painter—like Botticelli or Signorelli—Mondrian would say "Almost a great name."

He and Carl Holty sat there for six hours. Throughout the wait, Mondrian, afraid to miss his moment of summons, not daring even to go to the bathroom or grab something to eat, showed no hint of impatience. Rather, he was intrigued by everything. But when his name was called and it was time to go to the desk to register, Mondrian became tense. Having presented his birth certificate, he was adamant not to use the "Cornelis" as part of his official American identity. He told Holty he had "always hated that name." It proved not to be a problem. A middle name could be stricken out. But then "the young, brown-skinned girl" recording his information said she was not all right with "Piet." "Pete ain't no name. It would be Peter," she informed Mondrian.

It took Holty's intervention to win her over. Holty told the woman that the artist was so famous that there was an entry about him in the *Encyclopaedia Britannica*, and that there he was "Piet."

"No kidding?" she said. Holty had succeeded in convincing the clerk to let the artist's name stand in its pared-down, refined form as he wanted. Having reduced and simplified his name from Pieter Cornelis Mondriaan to

Piet Mondrian, Mondrian was pleased. But Holty felt that the artist's main preoccupation was how "graceful and beautiful" the woman's arms were.

After Mondrian was registered at last, he and Holty met Charmion von Wiegand for coffee at the Jumble Shop, a landmark Greenwich Village restaurant on Waverly Place just off Sixth Avenue. An old-fashioned establishment favored by artists, rumored to have been a speakeasy when it opened in 1930, it served tea and crumpets in keeping with its design as an old English inn. It had a large square bar and a dining room with windows painted by the society portraitist Louis Bouché and murals by the Ashcan School painter Guy Pène du Bois. These artists belonged to the very tradition Mondrian wanted to break, but he was delighted to be in a place so quintessentially American. Having invited Holty and Von Wiegand to thank them for all they had done for him, he insisted on paying the bill.

This was, Mondrian quietly said, a momentous occasion—perhaps more than they imagined. In a soft voice and with the slow cadences he used in English, he told Holty and Von Wiegand that he had dreamed of going to America for longer than anyone else realized.

II

From the start, Holty had been impressed by the ballast with which Mondrian handled life's difficulties. In his everyday existence as in his art, he did his utmost to dismiss, or at least overlook, all that he labeled "the tragic." New York had become a haven for him following the bombardment of London. He had been "considerably shaken up" when he arrived, weakened by one of his periods of poor health during the crossing by ship. But even on his first evening at Harry Holtzman's after reaching the new continent, revived from his long nap in the hotel, Mondrian had focused on all that made New York a different city. He lived in the here and now.

When Mondrian did speak to Holty or others of his young friends about the past, it was to reminisce about the first exhibitions of Cubism and his debates with fellow artists "as they 'scooted along in the new motor taxis' to and from the cafés and the Grand Palais where exhibitions were held." He never bemoaned his penury, his isolation, the vicious attacks on him from art critics, his perpetual health problems, or anything else that marred his Parisian existence. He did not refer to the struggles of his five-year exile in the Netherlands, his lack of a home or studio. To Holty, he "refused to discuss . . . the disagreeable . . . If evil could not be avoided, one could at least 'refuse to extend it through remembrance,' he said."

This is why the single occasion of Mondrian bemoaning an event made a strong impression on Holty. One afternoon at Holtzman's apartment, the

people gathered were startled by an explosion. Someone across the street had turned on the gas jets in his apartment to commit suicide. While waiting to be asphyxiated, he had lit up a last cigarette. It caused much of his apartment to be "blown out into 57th Street with a loud bang." Word quickly spread as to what had happened, and the people at Holtzman's were even more shocked by the story than they had been by the explosion. Having heard the loudest noise of their lives, they were visibly stunned by the bang and the circumstances. "Mondrian was standing alone rather unhappily . . . he . . . disapproved of the morbid excitement the rest of the people were displaying." Holty approached him, and Mondrian simply said, "It wasn't *so* loud. The noise in London was worse."

Mondrian described London during the war to Holty.

He told me that he had been bombed out twice, and that he had feared more for his health—he caught a severe chest cold because of exposure—than for his life. Once after a particularly bad night, with bombers coming over London in wave after wave, Mondrian went to his doctor only to find the ruins of his doctor's house roped off by fire wardens. It turned out that the doctor was unharmed, so "that" wasn't as bad as it might have been. In one raid he lost his bed, a bed Ben Nicholson had loaned him, and he was much embarrassed at not being able to restore the borrowed property. "And Nicholson liked the bed very much." Mondrian said he was lucky that the janitor of his building (the twice-bombed one) was a Russian who "knew what suffering was" and who made tea in the basement after the raids and generally knew how to conduct himself. "He didn't get all excited and neither did his wife." He didn't tell me more and apparently felt no need to speak of this period at all. His reminiscence of the events was spotty and his telling of it in fragments that he didn't even try to organize into a coherent story.

The only thing worth constructing with care was artwork.

III

In early December, Von Wiegand realized that, whatever their relationship had been, it was over. She stayed away for a two-week hiatus.

When she returned, she saw how hard Mondrian had been working, making significant changes to all the pictures. Von Wiegand was impressed but did not allow herself the usual transport she felt in front of his work; she looked at the paintings "quite freshly, although not emotionally because of M's presence and our disharmony which seems still unhealed." Noticing

that some disturbing black spots were now gone in all but one painting, she decided that it was a remark she had made "about those black spots that really angered him most. Or at least, they offered the excuse for breaking up our intimacy." She also consoled herself into thinking that the issue was that Holtzman had been away and was now back. Von Wiegand believed that because of Holtzman's return to New York, Mondrian

> no longer needed me, and secondly because he will not let anyone get to [*sic*] close to him or will he let himself go.
>
> I was upset at his coldness and to take his mind off things, asked him why he put those black lines at the bottom of all the canvases lately. "How do I know why I do things?" he said very crossly. "I just want to understand them." "I don't know" he said curtly. "I like to be alone. You don't seem to understand that I want to be alone." His tone is so harsh and his words sting like a wasp bite. . . . We had come too close and he was withdrawing—breaking things up, the way he breaks up his composition when it gets too personal.

Von Wiegand was wrong, however, in thinking that everything was over. By the start of 1942, she was again seeing Mondrian regularly. She wrote in her journal that on January 6 they spent an evening when he was painting and she was working on his "suppression" essay. At 10:30, he warned her that she would miss her bus, but still she did not leave.

> I love to be in the room with him, we can sit quietly and both working and time evaporates and there is such a wonderful soft humming vibration between us, that gets stronger as the night outside gets quieter and later.

They each had a single cigarette—Mondrian had been ordered to stop—and she left at ten to one in the morning. Mondrian promised to go to bed, as he had been up till four the night before.

It was a bitter cold night. Von Wiegand indeed missed the last bus and so took the subway. "I was in a daze, but I did not feel lonely or unhappy, but warm inside."

The following evening, they got together again to work on one of the essays.

> Mondrian looked so tired, his face seemed thinner and his eyes heavy, but he was in a very good mood and that sweet tenderness which is in him seemed to emanate and radiate through the room.

He went into the bathroom to wash his hands, their thin fragile elegance, their precise and exact articulation, the heavy blue veins that now grow stronger with age, the polished curved nails. Tonight they were scarred and the paint and sicativ [*sic*] had hardened on them and he dislikes that very much. I said my hands were worse and the typewriter had taken all the red lacquer off the edges of the nails. "It should be all the way down, I suppose" he said and added "and I like it very much"—meaning he likes the lacquered nails, which most men don't. He scrubs his hands so hard with sopa [*sic*] and dried them on towel that I thought was so coarse. He showed me the package of sheets that Mrs. Holtzman had sent instead of the red towels he got for Xmas and would not accept because they made him think of blood. "I am too sensitive to have that color in the bathroom" he had explained and was afraid he had hurt my feelings. I assured him he had not. "And now you have percale sheets and should sleep well in them." And he laughed. And I teased him saying that he had Kandinsky compositions all over his smock which had become bright with paint recently.

Few people in Mondrian's life understood him that well.

IV

On March 20, 1942—two months after his seventieth birthday—Mondrian wrote Von Wiegand:

To day [*sic*] I saw the doctor. I have still some injections to take but it is getting better. He said the dentist could do only the necessary and leave the cists [*sic*] in. So I have probably no operation now. Since long I would answer you on your former letter. There is no question of less sympathie [*sic*] but I like to retake my lonely life as it was before I knew you. Of course it is egoist of me but it is a need. I have nothing to explain because I did this from the beginning. The translations have caused a confusion. You know I have only short visites [*sic*] of my friends and so I would suggest you to come only from time to time in the afternoon when you are in the neighbourhood or feel inclined to come. When you think logical you will find me logical also and remain in the same friendship.

Best wishes from Mondrian.

The relationship would continue at this new pace for the rest of Mondrian's life. Von Wiegand periodically hoped to rekindle a different level of passion; Mondrian stayed politely distant.

On January 15, 1943, Mondrian wrote her:

Dear Charmion,

 I just got your letter. In answer on this, I can only repeat that I can not see friends often. So it can not do pleasure to me when you so often come to me as you did. [left unsigned]

The point was clear.

Peggy Guggenheim Again

Peggy Guggenheim had moved to New York from London at about the same time as Mondrian. In October 1941, she decided to open a gallery that she called Art of This Century. Her first exhibition was to consist of the art she had bought most recently, including her Mondrian.

Frederick Kiesler made a remarkable design for the space that Guggenheim rented on 57th Street, and she commissioned three essays for the catalogue of that opening exhibition. Mondrian's "Abstract Art" would appear with André Breton's "Artistic Genesis and Perspective of Surrealism" and Jean Arp's "Abstract-Concrete Art."

Mondrian finished the essay in November 1941. His distinction between the words "Concrete" and "Abstract" brings us face-to-face with his life's goals: "The name concrete opens the doorway to natural expression, that of 'abstract' emphasizes the universal expression of Art." Mondrian's ideal was "the dynamic movement of life in equilibrium solely by means of lines, planes, volumes and pure color, seeking to avoid the creation of all limiting particular forms which evoke particular feelings." As always, he advocated art as a vehicle for replacing personal emotion with something more stable.

II

Mondrian was a bit of a celebrity in New York. Rumored to be a recluse, he was a famous one, and his art had become even better known than he was. The December *Fortune* magazine—a wide-circulation publication read by economically successful Americans in every profession—reproduced Mondrian's 1936 painting then on regular view at the Museum of Modern Art. The text, called "The Great Flight of Culture: Twelve Artists in U.S. Exile," described Mondrian as "probably the hardest of all modern artists to understand." Nonetheless, it highlighted the impact of his "carefully balanced spaces and rectangles" in typography, architecture, and industrial design. "Trademarks, linoleum, offices—even the tabletops at Childs"—looked as

they did because of this "gentle hermit of almost seventy" now living in New York.

"Childs" was a reference to a chain of popular restaurants, with some one hundred and twenty-five locations nationwide. It was the first large-scale restaurant chain, the model of all eating establishments that are just about identical wherever they are, consistent in menu and aesthetic. At its peak, Childs served some thirty million meals a year. Its menu highlights—milk crackers in milk, glasses of buttermilk, buckwheat griddle cakes as well as classic flapjacks, and creamed oysters on toast—were, like its unifying design theme, dependable. The aesthetics, like the food, were purer, and paler in hue, than in the equivalent "everything the same" establishments of today. The tabletops, the same in each branch across the country, were not precise Mondrian reproductions, but with their white backgrounds and design schemes of straight lines parallel to the sides, intersecting at right angles, not a diagonal or curve in sight, and their precise use of small rectangles of solid color, in deliberately imbalanced and playful and rhythmic compositions, they closely resembled his hallmark compositions of the 1930s. Enhancing everyday life, they achieved Mondrian's goal of having the experience of "art" taken from pictures on the wall to the world at large.

Invoking those tabletops, the writers at *Fortune* had zeroed in on how Mondrian's invented vision had infiltrated Americans' daily life. That issue of the large-format magazine—nearly 14 inches high, and just under 11 inches wide—bespeaks the heady optimism Americans still felt prior to the date of publication. The ambiance at Childs—a restaurant for all but the poor— belonged to the fabric of the land. Being the December issue, the magazine arrived in subscribers' households and on the newsstands just before the Japanese attack on an American island in the Pacific caught the country by surprise on December 7. The nation went from observing and preparing for conflict to actively fighting to defend itself earlier than anticipated. But the values embodied by Piet Mondrian's art, in the originals as in the clones on tabletops, were part of an enduring spirit.

III

The notes Mondrian had written for Charmion von Wiegand evolved into his "only explicitly autobiographical essay." Mondrian wrote them to aid Von Wiegand with the article she was then preparing about him. She would eventually help Mondrian turn them into a text called *Toward the True Vision of Reality*, which would appear in the catalogue of his solo exhibition held at the Valentine Gallery in January 1942.

The "Notes for an Interview," never published during Mondrian's life-time, were themselves revelatory. Mondrian sets himself up with an imag-ined interviewer, who reports on the views of an artist simply called "M."

M says . . . that it cannot be emphasized enough that abstraction is not rejection but intensification.

Through the rectangular opposition of straight lines, he expressed the completely balanced reciprocal action of the opposite forces of life manifested in the reality around us.

Thus is established not a new reality but reality as it intrinsically is. For it is clear that the world could not exist without being in true equi-librium. His art can thus be called true realism: Of course it is abstraction from what we see around us in ordinary vision: art is not daily life but its deepest plastic expression.

This abstraction cannot be negation of daily life and surrounding (environment) out of which it has grown: it is its product.

"M" is pretty much the same character as "Z" in the *Trialogue* Mondrian had written nearly two decades earlier. These stand-ins provided an opportu-nity for Mondrian to voice both his goals and what he deemed his achieve-ment. He saw his art as having the equilibrium inherent in the universe. His abstractions were possessed of the centrifugal force that keeps the planets in orbit around the sun and mimicks the rich system whereby oxygen facilitates all of life. Nothing less.

Mondrian as interviewee concludes: "Even in this chaotic moment, we can near equilibrium through the realization of a true vision of reality. . . . It is the task of art to express a clear vision of reality." And that is precisely what Mondrian's own crisscrossing of verticals and horizontals of few colors and slightly varying widths achieve: a vision of life which celebrates oppo-sition, which has the male and female forces functioning in tandem while constantly going in different directions. Clarity has to be invented—as in straight lines and right angles—and then intuition, more than analysis or the processing of information, has to be allowed to flourish. A salubrious wholeness can result.

IV

In his third-floor walk-up, Mondrian was producing further paeans to joy-fulness. The year 1942 was a challenging time in America, but his new coun-try was still a haven. Mondrian was working simultaneously on three of the

new compositions where the color was all in the lines; at the same time, he was revising several of the large canvases he had brought with him from London. Vertical and horizontal lines constituted his universe. Some had color in them; some were in the old black; but all were straight while clearly hand-drawn rather than machine-made, and all had lively meetings at right-angled junctions. For the first time in decades, colors other than primaries, including gray-greens and cream tones appeared on the scene. Mondrian was again in one of his periods of heightened productivity.

This was in spite of substantial challenges. As much as ever, and regardless of changes to his diet, Mondrian was dealing with his usual rheumatoid problems and digestive issues. And with America having entered the war, materials like stretcher strips were in short supply. But Harry Holtzman had put in place a support system that included good doctors as well as people to help him fulfill his everyday needs. Able to focus on making art, Mondrian did so with gusto. The sheer inventiveness, instinct, and rhythm that were inside him were finding their way into artworks of eternal spirit and optimism.

Mondrian was excited by his own progress. Of the first two canvases in which he put all the colors into lines, he "declared" to Charmion von Wiegand that the one he titled *New York City I* was "the best picture he had ever made."

New York City I, measuring about 47 x 45 inches, one of Mondrian's largest abstractions ever, has two painted black lines on it; the rest of the lines are created out of paper strips that Mondrian painted in bright red, yellow, and blue and glued to the canvas he had prepared with a coating of white oil paint. Some of those colored strips are positioned directly on top of the painted lines, occasionally with visible patches and gaps so that we see the underlying black, while most are on their own. The blue mostly stays behind the others, with the red crossing over them, nearer to us. The yellow lines are, by and large, the nearest to us, crossing in front of the reds and blue. There are more of these yellow lines than any other color; ethereal, like sunshine itself, they dance before our eyes.

Mondrian never finished this composition. One band of white masking tape remains, and there are pushpin holes near the edges and even a couple of remaining pinheads. That lack of completion is less relevant than with most painters, since Mondrian's work never has a look of finality but always appears to be part of an ongoing process, but the sense of active experimentation is what makes this composition, which belongs to the collection of the Kunstsammlung Nordrhein-Westfalen in Düsseldorf, especially moving. *New York City I*, which persists in breathing and moving before our eyes, has a particular magic.

Since Mondrian considered this an incomplete experiment, he would never part with it and therefore did not realize a cent for it himself. Harry Holtzman, who inherited it from Mondrian because it was still in Mondrian's studio when the artist died in 1944, sold it to Sidney Janis. Twenty-two years later, Janis sold it to Ernst Beyeler, who very quickly sold this unfinished work to Werner Schmalenbach, director of the Düsseldorf museum. In 2022, it was discovered that an archival photograph taken just after Mondrian died shows it on an easel turned 180 degrees from the way it was presented initially at the Museum of Modern Art in 1945 and, ever since, in Düsseldorf. We will never know for sure which way Mondrian finally intended it to hang. Regardless of that mystery and of the history of the painting as a material commodity, the qualities of the unfinished canvas are certain. By being humble in matter (the painted strips of paper are primitive in the casualness of their execution, their edges rough and their coloring crude), by showing its own process and keeping the physical acts of cutting and gluing alive, *New York City I*, like Matisse's late cutouts, testifies to energy, to courage, to the music of life. Even the heads of the thumbtacks, which remain scattered across the surface, are dematerialized. Bravura emerges with modesty. Color performs a magic act. Right angles nourish not just the mind but, even more so, the heart. Extreme intelligence and rational preparation serve the higher goal of playfulness. Fun is the business of life.

V

While he was working on *New York City I*, Mondrian was experimenting similarly on four other canvases that would still be in his studio when he died. One of these combinations of oil, charcoal, and painted paper strips is now in the Thyssen-Bornemisza Museum in Madrid. Because some of the tapes on it were loose, faded, or torn, Harry Holtzman restored it in 1977. Although Holtzman worked on it only out of necessity, it has a perfection that feels less than authentic. The other three canvases are even more tentative than the work that ended up in Düsseldorf: fascinating evidence of Mondrian's thinking process, but lacking the wholeness of *New York City I*.

Toward the end of 1941, Mondrian reworked his 1939 composition that Armand Bartos had bought but that was still in the studio. Then, at the start of 1942, he entered a phase of reworking almost every one of his abstract compositions that he still owned. The oldest of these was a *Composition with Grid*, which belonged to the phase when his paintings slightly resembled walls of irregular bricks. He had painted it in Laren, in two stages—one in 1915, the second in 1918. His main alterations in 1942 consisted of turning the vertical canvas 180 degrees and eliminating what had been two short

horizontals and now were disruptive short verticals. This painting, which would be owned by Otto Preminger from 1968 to 1980, was then sold to Yves Saint-Laurent, whose heirs sold it at Christie's in 2009 for fourteen million euros. It remains in private hands today.

In preparation for a solo show at the Valentine Gallery, Mondrian also cleaned and altered two splendid compositions from 1935, five large paintings from 1937, two from 1938, three from 1939, one from 1940, and the 1941 *New York/Boogie Woogie*. He was starting new things as well, but, more than anything else, he was revising old work, and he successfully developed these earlier canvases into compositions of renewed vigor.

Except for *New York/Boogie Woogie*, all these paintings had come to New York in the shipment that arrived a few weeks after Mondrian in October 1940. Miraculously, not a single work had been damaged in the two bombings of 60 Parkhill Road, and while Mondrian would never again start a painting in which black lines enclosed colors now that he had begun working with colored lines, he dedicated himself to continuing these canvases in his earlier style.

The Valentine Gallery exhibition, originally scheduled for October 1941, opened in January 1942, accompanied by a catalogue that included *Toward the True Vision of Reality*. The exhibition gave the public a new perspective on Mondrian. He had been written about in magazines for the cultural elite and included in group exhibitions at important museums, but now his art could be seen in a new way. Other than the Paris presentations in a bookstore and a chair exhibition, it was the first time since his 1909 Stedelijk show that Mondrian had his work presented in depth in the city where he was currently working. His audience came to understand the range of his art and the astonishing vibrance of what he was doing with the knowledge that he lived only a few city blocks away.

The front room presented Mondrian's latest canvases arranged with ample space and in elegant relationship to one another. This new work was charged with an optimism and emotional bounty that, especially in the aftermath of Pearl Harbor, raised spirits immeasurably. In the larger gallery that followed, there were fine examples of Mondrian's earlier work, the remounted works on paper included.

The exhibition was a huge success. People who already liked Mondrian's later colorful abstractions were pleased with what they saw. The Museum of Modern Art bought an early *Pier and Ocean* drawing. Peggy Guggenheim purchased three drawings, including *Ocean*. Most importantly, a friend of Charmion von Wiegand's, Mary E. Johnston, from Cincinnati, had the wisdom and courage to buy the smashing *New York 1941/Boogie Woogie 1942* from the front gallery. Katherine Dreier, and H. Gates Lloyd Jr., with his

wife, Eleanor, each bought two large abstract compositions from the late 1930s. In a single coup, Mondrian gained the financial resources to survive without anyone giving him money. Holtzman would still support him if needed, but Mondrian only took such aid when he had to, and the infusion of funds, which felt as if it had occurred overnight, gave the artist an unprecedented sense of well-being.

VI

One of the paintings completed in 1942, in time for the show at Valentine, was *Rhythm of Straight Lines*; 28 inches high and 27 wide, it is also called *Composition with Blue, Red, and Yellow*. It is another treasure that ended up at the Nordrhein-Westfalen in Düsseldorf, for which it was acquired in 1965. In its previous life in Paris, it had been reproduced—in black and white—in an article by Max Bill published in 1938. At the time, its grid comprised mainly four edge-to-edge horizontals of differing widths, at nonformulaic intervals, and seven top to bottom, or bottom to top, verticals, six of the same width, the one farthest to the left noticeably thinner, the intervals also distinctly without a mathematical system. A thick shorter line near the bottom right, between two of the verticals, served as the base for the single area of color. We cannot tell what the hue was, as only a black-and-white photo remains, but it clearly was not very intense. By the time that Mondrian finished this canvas in New York, it had acquired one more black line, a small vertical of about the same length as the short horizontal, very near the right-hand edge, also in the lower right-hand quadrant of the painting, as well as a strip of bright red, alongside the new line, and a panel of luminous sky-like blue to the upper left, seemingly behind a substantial portion of the total grid. The area that was already colored, regardless of what it had been in 1937, was now a strong primary yellow.

Rhythm of Straight Lines never stops pulsing. It moves perpetually with an up-down, left-right, irregular, unpredictable rhythm. The yellow, red, and blue conjure noonday sunshine, a fiery sunset, and the sky, yet they are nothing whatsoever. This canvas suggests resemblances and invites meaning, but, above all, it is a charge of sheer energy.

Mondrian had begun a pendant painting—*Composition with Yellow, Blue, and Red*—in Paris in 1937, reworked it considerably in London in 1939, and finished it in New York in 1941–42 in time for the Valentine show. The painting is another high-wire act. Returned to the artist's studio unsold, it soon found a buyer. Charmion von Wiegand had said to her friend Ella Winter, "There's a poor old man, a wonderful artist of seventy-two [*sic*], who is ill and can't afford a doctor," and with that brokered the sale.

It took gumption and passion to buy the abstract composition. Leonore Sophie Winter Steffens Stewart, a forty-six-year-old Australian-born journalist who opted for "Ella Winter" as her professional name, had both. Having attended the London School of Economics, she was committed to the peace movement and radical causes; in 1930 she had visited the Soviet Union and the following year published the book *Red Virtue*. By then she had married and divorced the left-wing American journalist Lincoln Steffens, once declared a "muckraker" by Theodore Roosevelt, who invented the term to describe him and several other similarly progressive newspaper writers. Winter then married the humorist Donald Ogden Stewart. The Yale-educated Stewart was part of the Algonquin Round Table and a friend of Dorothy Parker and Robert Benchley. He had written the book for *Fine and Dandy*, the first Broadway musical with music composed by a woman, as well as coauthored the screenplays for *The Philadelphia Story*, *The Barretts of Wimpole Street*, and *Holiday*. Stewart and Winter were at the forefront of the fight against fascism. At the same time that she was looking at and buying this painting by Mondrian, Winter was working on her book *I Saw the Russian People*.

The presence of that sumptuous abstraction in the home of Ella Winter and Donald Ogden Stewart put it in front of some of the most interesting, forward-thinking, witty, and erudite people of the era. In 1964, the painting would be acquired by the Tate in London, so that today it is another of those Mondrians available firsthand to the general audience; what was an unsold painting until Charmion von Wiegand encouraged its sale to help the struggling Mondrian ended up with a rosy destiny. Many of the greatest Mondrian canvases on public view today belong to this same group as the two now in Düsseldorf and at the Tate. They are in the collections of

Ella Winter (1963) was an urbane, sophisticated journalist who was married first to the left-wing writer Lincoln Steffens and then to the fashionable humorist playwright Donald Ogden Stewart. She had bought a Mondrian composition two years before she went to his studio to meet him in late December 1943. What was intended as a short visit was so enticing that she stayed the whole afternoon, dropping other appointments as he pulled out early work and talked nonstop about his artistic goals. With *Victory Boogie Woogie* on the easel, uncharacteristically extending a social visit, he was at his peak.

the Museum of Modern Art in New York, the St. Louis Art Museum, the National Gallery of Canada in Ottawa, the Albright-Knox in Buffalo, the Munson-Proctor Institute in Utica, New York, and the Phillips Collection in Washington, D.C.

VII

Carl Holty portrayed Mondrian in 1942:

> He hated things characteristically bourgeois. He refused dinner invitations from those he wouldn't see for better reasons than to eat with them. He liked serious conversations about important matters with one or perhaps two people at a time, but he hated the chance small talk of large informal gatherings. When unavoidable social obligations were concerned, like becoming a citizen of a country one lived in, or speaking the language of that country, he hastened to comply and render unto Caesar—and get it over with.
>
> Mondrian's distaste for conventions frequently came into conflict with his sense of formality. He would, for instance, refuse to remove his jacket in company, no matter how warm the night. "I was raised in Europe, where one learned to suffer," he would remark when urged to make himself comfortable. He hated self-indulgence, but a true Hollander, he loved to drink coffee all day long. To hide this little weakness from himself, he always hid his coffee pot behind a piece of cardboard.

The coffee habit went back at least as far as the farmer's coffee of his Brabant days. It was the perfect addiction for Piet Mondrian: sharpening the mind and renewing his energy.

Except for the two black lines that are almost entirely covered with colored tape in *New York City I*, Mondrian, now that he was composing with colored lines, had excluded black from his art. It was a major advance. To excise the skeleton he had developed painstakingly for two decades was the start of a major new exploration. He had decided, Carl Holty tells us, that black itself, and its use to make rigid subdivisions, was "too tragic and classical."

"Classical," for Mondrian, was a pejorative term. Holty had asked him how he felt about "the Greek idea of the perfect object, the *archetype*." Holty had naïvely assumed that this belonged to Mondrian's objectives. Mondrian lashed back that, to the contrary, a single form of perfection was the antithesis of what he was seeking. "That is what we are against, because that is the key to the classic and tragic finality from which we must free ourselves," Mondrian told Holty.

There was possibly another, unconscious reason for his ridding himself of the black grid that had been his mainstay for the previous twenty years. Mondrian was finally eradicating the last souvenir of Winterswijk, the imprint of looking through the leaded window mullions there. In New York, he had, once and for all, left the past behind.

In that first work with colored strips, Mondrian "worked very rapidly, eternally moving one color after another, always considering the control of the whole surface." He would evaluate the whole composition and then figure out how to animate it further. Holty watched Mondrian delight in moving his pieces of tape around to intensify the overall heartbeat.

There were days when Mondrian was physically unable to work at the easel because the pain and limp caused by his rheumatism hampered his ability to move quickly enough as he added an essential dash of one color or urgently shortened a line. The moment he felt the impulse to reorchestrate the reds, yellows, and blues, he needed to act immediately. He never used the term "arthritis," but his capacity for moving depended on the humidity and, he believed, on his diet. Mondrian was convinced that the salt-free meals he prepared for himself six nights of the week made him better than he would have been otherwise. He would eat whatever was served him on the single evening when he would go to a restaurant or a friend's house, but otherwise he toed the line. His whole existence hinged on the process of making art, and when Holty asked him "whether he wasn't losing good pictures in numbers because of his exigence"—a logical enough question—Mondrian answered, "I don't want pictures. I just want to find things out."

Relishing the unprecedented challenge of composing with color itself, Mondrian now used far more of it than ever before. "He did not want the colors to 'harmonize,' but to remain distinct as forces," Holty tells us. This was harder to manage without the black containing the primary hues. If a red was too close to a blue, it could produce the effect of a purple, just as a blue too near to a yellow might give birth to an apparent green. For Mondrian, any "weakening" of color was a crime.

VIII

Mondrian did not attend the opening of the Valentine Gallery show on January 19, 1942. "Much as he wished to be present, he denied himself that pleasure," because "someone had told him that it was not proper to attend the preview." He thought that this was how things were done in America—or so he said. Lots of artists and collectors and other fans went to the Valentine Gallery that night hoping to see the artist himself; Mondrian later explained

that he was just trying to behave correctly according to the standards of his new homeland. On those rare occasions when he prepared a simple dinner for guests, while adhering to the Hay Diet for himself, he invariably served pastry and ice cream to the others because that was, he said, "what Americans liked." He maintained this habit of a sweet dessert for guests and none for himself even when the only person at dinner with him was Von Wiegand, and he also offered visitors "cocktails" for the same reason.

He did not, however, understand what an American cocktail was. His was V8 juice, even if his guests might have liked something more potent. Not only did he not offer alcohol but he would serve nothing "on the rocks." Mondrian did not believe in ice cubes. Although he had an electric freezer for the first time in his life, he was convinced that anything too cold was bad for the health. If visitors wanted cold water, it came straight from the tap, and could be no chillier than was natural.

He was obsessively fastidious with his new appliances. He maintained a shine on his white enamel stove, and, on one occasion when it had a problem and the repairman came, the visit left him in "a nervous crisis . . . scrubbing the marks of the gas man's feet off the floor, which he kept spotless."

IX

While welcomed by young American admirers like Holtzman, Holty, and Von Wiegand, Mondrian also became part of the circle of European émigré artists forming in New York. Some of them went out of their way to help him gain increased recognition. Shortly before his show at Valentine, Jean Hélion invited him to the opening of an exhibition of Ozenfant's work at the Passedoit Gallery so he could meet "Mrs. Georgette," who ran the gallery. At the opening, Mondrian had friendly encounters with Pierre Chareau, owner of one of his most elegant compositions, as well as Mrs. Ozenfant, whom he had never met before. Mrs. Georgette, who was in her office at the back of the gallery, welcomed him warmly, and he considered her "a very nice old lady, intelligent also." They had a long talk, and she promised she would be the first person to walk into the exhibition at Valentine the moment it opened. Mondrian was heartened as he was with an encounter that evening with Barr, Glarner, Sweeney, and Mrs. Sweeney. Because social outings were rare for him, each conversation was an event he would play over in his mind in the following days.

"It is the advantage of being old to have appreciation but then one is bothered by other things, as ill health," Mondrian observed. A lot of interesting people walked up the two flights of stairs in the small building near

the East River and knocked on the door. A little card over the knob simply said "Piet Mondrian"—engraved in small Roman-style lettering, the name centered, with nothing else on the clean white space, the ink of the name the same matte black as the lines in his paintings. Moholy-Nagy, visiting from Chicago, called in, as did the writer Sigfried Giedion, the abstract filmmaker Hans Richter, and the composer Edgard Varèse. But Mondrian's response to his visitors was not necessarily dependable. He had no interest whatsoever in Varèse. One might have expected Mondrian, given his earlier experience with Russolo and his Bruiteurs, to be happy to see the French composer of electronic music, but the moment after he opened the door and saw who it was, he closed it even more quickly in Varèse's face.

When he went out to parties or exhibition openings, "he never made an effort to attract people, always remaining unassuming, modest, and silent to the point of being inarticulate." He told Charmion von Wiegand that he preferred cocktail parties above all other social events because "you don't have to talk much and don't stay long." It was generally women who understood Mondrian's social functioning best. Aletta de Iongh, Maaike van Domselaer, Winifred Nicholson, and now Charmion von Wiegand cottoned on to his combined warmth and shyness, his awkwardness, the shell he kept around himself in his determined isolation mixed with his need for human interaction. Von Wiegand pointed out that "he appreciated people. . . . He was not given to chitchat, but loved to discuss the problems of art." Varèse had been an exception; when visitors came to Mondrian, he was generally pleased, so long as they came during what were known to be his visiting hours. Mondrian even invited the callers to make suggestions about moving lines or blocks of color in his latest composition. As they sat on a stool near his easel, he then executed their changes using the suggested paints. Then, once the visitors "were gone, he would put it all back and go his own way." But he enjoyed the pretense of the exchange and the sense of empowerment he gave his guests by having them believe that their view mattered.

X

The thirty-eight-year-old Balcomb Greene, one of the best-known members of the American Abstract Artists group, read "Art and Life Towards the Liberation from Oppression" out loud at the third of the AAA's new series of Friday evening lectures. The AAA had scheduled these talks in the auditorium of the Museum of Modern Art, but then the higher powers at the Modern had decided against the organization of pure abstractionists, which had led a noisy strike in front of its entrance six years earlier. They

were not going to encourage the group that placed nonrepresentational art on a pedestal. Forced to use a less auspicious and practical setting than the Modern's auditorium, the AAA was obliged to hold its Mondrian talk, where a blockbuster crowd was anticipated, at the Nierendorf Gallery, five blocks from the museum.

While the Valentine Gallery was on the uptown side of East 57th Street between Madison and Park Avenues, the Nierendorf Gallery was at 18 East 57th on the downtown side between Fifth and Madison. Its seeds had been sown when Karl Nierendorf and his brother Josef had taken over the gallery of J. B. Neumann in Berlin before the rise of the Third Reich. In 1936, the brothers had begun to encounter problems showing modern art. The Nazi regime was inflicting its taste everywhere possible, and Karl Nierendorf had opened a gallery in New York. Josef Nierendorf managed to keep the Berlin establishment, which showed a lot of what would be called *entartete kunst*, alive for only another two years. Now the only outpost of the Berlin institution with its impressive legacy, the New York gallery was a highly respected and well-established showcase of modernism in its agreeable headquarters near the large building built in 1940 by the jeweler Tiffany. But it was neither as practical nor as prestigious a setting as the Modern's impressive auditorium would have been.

Even though it had been announced that someone else would be reading Mondrian's latest treatise on his behalf, the gallery was packed to the gills and beyond. People jammed into the staircase leading to it, and out onto the street. The world was ready for revolutionary change, and Mondrian's

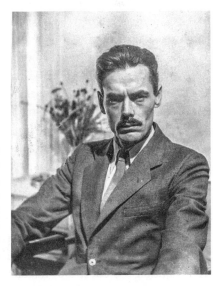

Balcomb Greene, 1935. At nearly age seventy, Mondrian completed his essay "Art and Life Towards the Liberation from Oppression." He had Greene, a thirty-eight-year-old artist, read it for him in public. In Greene's deep voice, the packed audience heard that in art it is necessary to avoid the personal and the psychological.

exaltation of intuition and his championing pure nonrepresentational form offered it. While "one traditional European artist left in a huff, fulminating against such 'dictatorial ideas,' the majority listened with respect."

Mondrian had by then been in New York for a year and three months. Most of the attendees had seen his work in group exhibitions, and many had visited the show which had now been on for three weeks at the Valentine Gallery. They had these marvels of color and line in their minds as they heard the theories behind them, and were primed to be impressed with what was said.

Mondrian's command of English was still so tentative, and his Dutch accent sufficiently strong, that he had done well to ask Greene to read on his behalf. Yet even with Von Wiegand's attempted edits and trims, the narrative was awkward, and not always easy to follow. Despite Greene's eloquent delivery and quality of performance, this was hardly lively entertainment for a winter evening during wartime. But except for that one recalcitrant artist who stormed out, people stayed to the end.

Mondrian's choice of speaker was wise. Greene, aged thirty-eight, was a tall, lean, handsome fellow, with a square jaw, mustache, and a shock of straight black hair. He had, in some ways, Clark Gable's sort of good looks. But he was more rugged than urbane, almost ferocious. He usually wore plain cotton short-sleeved white T-shirts, in public as well as at home, although to read Mondrian's treatise on art and life to the sophisticated audience that evening, Greene was in a coat and tie. Still, even when dressed this way he was like a ruffian in his Sunday best, more like one of the Beat Generation poets than a smoking-jacket type.

Greene had studied English literature at Columbia University and taught it at Dartmouth College before going to Paris at age twenty-seven to study art. In 1936, he had become the first chairman of the American Abstract Artists group. An activist, he was the first president of the Artists Union, and a participant in the Works Progress Administration's Federal Art Project. He had painted abstract murals for the New York City Housing Authority's new Williamsburg Houses, a massive housing project in Brooklyn that put its low-income residents in an envelope of sophisticated modern design.

As Mondrian's mouthpiece, Greene began by giving voice to the audacious task Mondrian had set out for himself in his text: "This essay attempts an objective observation of truth revealed in art and life." Mondrian made clear that what was needed for an artist to be successful was an expression of the absolute, and therefore a subjugation of the self. "Only general truths have value in the culture of mankind, it is necessary to avoid personal or subjective conceptions."

Mondrian called for what was in effect an eradication of the past and a starting all over again. This had been the course of his own life's work. Listening to his words, the audience at Nierendorf presumably pictured the art they had seen across the way in his exhibition, which was in effect a small retrospective; and a few of them may have actually visited the artist's studio, which was the exemplar of the processes Mondrian championed.

Life and art reveal human culture as a progressive continuity of construction and destruction. The tendency to construct is innate in human nature. Self-construction and the construction of his environment is man's first intention. Construction being the predominant force in human nature, it is logical that man opposes destruction with all his power. Nevertheless, the destructive tendency is also innate in man. He tries to avoid destruction but is forced by inner and external factors to destroy.

Discontented with arising construction, he destroys it and constructs anew, it is effected through external forces. When we see that every following construction is better, then the great significance of destruction becomes clear. Without destruction, progress is impossible.

While most of the audience was younger than Mondrian, they shared, regardless of age, the wish for lasting values that could guide humankind beyond the vagaries and hazards of wartime. It was provocative of Mondrian to extol the benefits of destruction given the realities of life at that fraught moment in world history, but he was making a point. Life has to be a perpetual process of renewal.

Mondrian was adamant that it was necessary to understand oppression in order to oppose it. He was referring specifically to self-imposed oppression.

Human life is oppressed by internal causes, both physical and moral, as well as by external factors. We see the facts of oppression in politics, economics and also in domestic life. We see art suffer from the ignorance of the public, educated by incompetent writers, critics, teachers, museum committees, etc. and above all from man's limited subjective vision.

Not that the people listening in the audience at the Nierendorf Gallery would have recognized how personal some of this was to Mondrian, but it spoke to his own battles with physical health as well as with sexual desire, and to his fear of family existence in general ("oppression . . . in domestic life"). His cynicism about so many people in the art world, from "incompetent writers" to "museum committees," was central to his agenda. Still, Mondrian considered it possible for strong individuals to prosper by taking

charge of their personal situations, and he believed that humanity was making progress.

> Throughout history, human life, oppressed by material and physical factors, by particular forms, frees itself from these factors by means of the purification of these forms as well as by the determination of these relationships. The changing conditions of human life in experience, education, science, and technics are reducing the brutish, primitive force of Man and transforming it into a real human force. A less physical animal constitution and a stronger mentality is making Man more "human."

His opposition to the "primitive" and the "animal" was fundamental to him, as was his cry for—the italics are his—"*annihilating the oppression of the past.*"

Enormous willpower was needed to purge one's self of the ill effects of the past, whether personal or historical, but Mondrian voiced not only enthusiasm for aspects of modern life but a celebration of it:

> In general, the past has a tyrannic influence, which is difficult to escape. The worst is that there is always something of the past *within us.* We have memories, dreams—we hear the old carillons; enter the old museums and churches; we see old buildings everywhere. Fortunately, we can also enjoy the modern constructions, marvels of science, technique of all kinds, as well as modern art. We can enjoy real jazz and its dances; we see the electric lights of luxury and utility; the window displays. Even the thought of all this is gratifying. Then we feel the great difference between modern times and the past.

As the strong-jawed, hollow-cheeked Balcomb Greene intoned Mondrian's unusual views, the language might have befuddled some of Mondrian's listeners on that winter evening in 1942, but its gist was persuasive.

Mondrian saw the need for brazen truthfulness in dramatic terms. To think freely and shed the shackles of the past and of the instinctive (as opposed to the intuitive, which Mondrian championed) was a battle, but victory was within the realm of the possible, so long as one eschewed all deceptiveness:

> Plastic art shows that whatever conceals its real content *suppresses* art. Art's *progress* contains and therefore requires deliverance from this oppression. The culture of art is the *continual search for freedom.* As in human life, it is

continually in search of freedom of thought and action. . . . Fortunately everything is moving in a more accelerated tempo, for the light of modern times makes the way clearer.

Listen to boogie-woogie. Look at the reds, yellows, and blues. Worry about whether a painted line gets thicker, not about whether you are sexually aroused. Go by intuition and you will reach nirvana.

XI

On March 7, 1942, Mondrian turned seventy.

The event was international news. Max Bill wrote about it for a Swiss newspaper, and the occasion was covered in Dutch newspapers as well.

Mondrian was riding high in New York. The show at Valentine had been more of a success than he dared dream. The esteem in which he was held at the Museum of Modern Art was immensely significant. His recent compositions were periodically on view there. Even in wartime, when few people could travel for pleasure, this was something, because in no other city—London, Paris, Madrid, Rome—was there much opportunity to see current art. The Stedelijk in Amsterdam was open, but the Netherlands was occupied by the Germans, and an institution showing art officially disdained by the occupying army was not going to flaunt it. New York also had smaller museums that presented the private collections of A. E. Gallatin and Solomon Guggenheim, but nothing rivaled the Modern, and even if Alfred Barr's coolness toward pure abstraction had resulted in Mondrian's treatise being read elsewhere, Mondrian, as he entered his eighth decade of life, was treated as a living master in the great temple of modernism.

In belated honor of the artist's milestone birthday on March 7, in June the Fifth Avenue bookstore Brentano's had a painting by him in the window. The store was a venerable New York institution; Brentano's had been selling books to Americans for nearly a century. Almost directly across the street, Scribner's, an opulent bookstore with an ornate front—its president almost always at the entrance, greeting people in his elegant suit, with his pince-nez delicately perched in front of his eyes—had a window display with a Mondrian in it to announce the upcoming opening of Peggy Guggenheim's *Art of This Century*. This was Mondrian's lively rhythmic *Composition with Red, Blue, and Yellow*, nearly 24 inches high and 22 inches wide, borrowed from the Dudensing Gallery, handsomely presented floating on top of a plain white panel.

It was accompanied by Brancusi's shimmering *Bird in Space*, tiers of

books—one open to a Mondrian reproduction—and a heavily framed Max
Ernst scene of a woman running off as if in flight. Even if the Ernst violated
Mondrian's standards, the overall window fulfilled his goal of making paint-
ings part of a totality. Objects were not to be seen in isolation but as integral
elements of an entirely new visual environment.

Mondrian's recent work was also showing up in group exhibitions in
some of New York's most important commercial galleries. Pierre Matisse,
who had moved to New York and opened a gallery at 41 East 57th Street,
included Mondrian in his *Artists in Exile* exhibition, alongside work by
Roberto Matta, Ernst, Marc Chagall, Léger, André Masson, Ozenfant, and
Pavel Tchelitchew. That same month of his turning seventy, Mondrian had
several works in another exhibition of the American Abstract Artists group
at A. E. Gallatin's Museum of Living Art on Washington Square. At the end
of March, the Museum of Modern Art yet again showed the work Philip
Johnson had given them, as well as *Composition in White, Black, and Red*, the
triumphant 1936 painting Barr had acquired for the Modern when it was
just off the easel. Mondrian's art seemed to be everywhere you turned in
midtown Manhattan those days.

On April 1, *Masters of Modern Art* opened at the New Art Center at
715 Fifth Avenue, between 55th and 56th Streets on the east side of the street.
This showcase for modernism had just been established by the cosmetics
genius Helena Rubinstein. The exhibition was a benefit for the American
Red Cross. Mondrian, content to be invited to participate, lent *Composition
N°5, with Blue, Yellow, and Red*, which he had begun in London in 1938 and
had recently reworked specifically for this event. It was one of his most com-
plex works of the period, with more than the usual number of elements in
taut relationship so that the horizontals have the deliberate precariousness
and stretch of a tightrope, the verticals the élan of an acrobat. When it went
to Rubinstein's show, it was at a point where he was satisfied with it, but he
would revise it further once he got it back, eliminating a horizontal line near
to the center of the composition and lengthening another horizontal so that
it now penetrated a blue rectangle at the upper left.

While he had avoided the opening of his solo exhibition, Mondrian was
willing to attend the opening of this group show. Both Lisette Model and
Fritz Glarner took group photos at the event. In those days, lit cigarettes
were a norm in public art presentations. Mondrian—as usual positioned in
his own bubble, with more space around him than the other people—holds
his smoke in his left hand. In Model's picture, he is flanked by his young
admirers: Burgoyne Diller, Fritz Glarner, and Carl Holty, all smiling. Mon-
drian stands with ramrod posture, in impeccable attire. A white pocket hand-
kerchief is folded in neat triangular peaks, his starched white shirt collar has

crisp edges, and exactly the right amount of shirt cuff shows according to the standards of Savile Row tailoring. He smiles jauntily; hardly ever before, in his whole life, has he looked this happy in public.

No wonder he feels so confident. To his left stands the elegantly dressed, beautifully coiffed Charmion von Wiegand, looking right at him with an adoring smile. She has a white corsage which matches her glistening teeth, and her well-penciled eyebrows are arched to express sheer delight. These people knew how to live with panache.

Of course, there was no avoiding the darkness of the era, especially when ticket sales benefited the Red Cross. America was sending its troops abroad. Families were being torn asunder as millions of young men left home to join the military. The country was receiving shiploads of refugees forced to flee their homelands with the few possessions they could carry with them. Supplies for everyday living, even sugar, were rationed. Yet at the same time, there was a burgeoning of artistic talent, both in urban centers and rural outposts like Black Mountain and Bennington colleges, where painters, sculptors, dancers, and writers were breaking new ground. Few people had much more than the money it took to survive, but they had freedom to take their passions in uncharted directions. They knew that the simple opportunity to make art, without a government censoring it, was one of the greatest possible luxuries in the world. With his work on public view in four different Manhattan locations within walking distance of one another, Mondrian at seventy was riding the crest of this unusual moment in American history.

Without Harry Holtzman and Holtzman's rich wife, Mondrian might easily have been under the rubble of a bomb in London. Instead, he was flourishing. On April 16, 1942, Mondrian wrote a very simple and concise last will and testament. He named Harry Holtzman his sole heir.

XII

Mondrian had been asked to have work in the inaugural exhibition at Peggy Guggenheim's new museum, which would open in the following month. For the most part he lived outside Guggenheim's social orbit, but on at least one occasion he had walked the six blocks downtown and one to the east from his walk-up flat to Guggenheim's triplex residence on Beekman Place, just a block from the hotel in which Harry Holtzman had put him when he arrived in the country two years earlier. Guggenheim had recently married Max Ernst, and they lived in high style.

Marcel Duchamp had arrived in the United States early in the summer. Guggenheim gave a luncheon with Duchamp and Mondrian both present; luckily, Max Ernst's son, Jimmy, who would become a painter in his own

right and for the time being earned his keep as his stepmother's assistant, would describe the event.

When Mondrian arrived at the luxury dwelling which the colorful heiress had turned into a palace of modernism, the other guests were already seated at the regal dining room table. They simply waited while Guggenheim guided the seventy-year-old Dutch artist through her collection, slowly showing him every room on all three floors. As the tour continued, Max Ernst took his usual position seated in a special chair in which only he was allowed to sit. Larger than everyone else's, ornately carved, it resembled a throne. Jimmy Ernst heard Max say to Breton, Duchamp, and Yves Tanguy, "Mondrian is a very nice man. Mais *mon Dieu*, what can one say for those cold abstract arrangements that are the very denial of *la peinture?*" Ernst considered his own art and that of his colleagues to have gone well beyond the limitations of geometric abstraction and the French pictorial tradition, as if both were artifices compared to the Surrealists' explorations of the human unconscious.

Finally, "the courtly gentleman Mondrian" arrived in the dining room with his hostess and, pointing at a large canvas by Miró, asked her who painted it. Jimmy Ernst noted the "patronizing chuckles" of his father and the others at the table with Mondrian's lack of familiarity with work by some of his best-known contemporaries. Mondrian presumably did not observe Breton, Duchamp, Max Ernst, and Tanguy all snickering when he then asked Guggenheim the same questions of a Kandinsky and a Gris. Their banter began to move toward fury; the Surrealists became "ready to pounce as Mondrian chose the extreme end of the table to face them as he characteristically stroked his chin."

Then Mondrian began to hold forth. Everyone held off and maintained surface politeness as soup was followed by salad and then by the main course while Mondrian recited the views he had put forth in his recent essays. His tone was impersonal, but his conviction total. The listeners restrained themselves, avoiding a fight even though most of them disagreed vehemently with Mondrian's proselytizing. The peace lasted through dessert. Then came coffee. André Breton, the mouthpiece of the Surrealists ever since the movement originated in France a decade earlier, suddenly assumed the voice of an inquisitor. Breton turned to Mondrian and focused his eyes hard on him. "Of course, my dear Mondrian, we all respect your aim at a form of painting that seeks to cleanse the vision absolutely of the irrational and that, of course, means dreams as well as reality. We should be very interested to hear your opinion of other painting, let us say Surrealism, which seeks to elaborate these elements rather than erase them."

Initially Mondrian did not respond at all. There was prolonged silence following Breton's inquiry. Then, in the void, Duchamp added: "What, for example, do you think of the work of our friend Yves Tanguy here?" Mondrian's reply, after more thoughtful chin stroking, came firmly, but calmly: "I enjoy conversational games as much as you do, but I shall not indulge in them. I have seen Tanguy's exhibition at Pierre Matisse several times and found it very beautiful but very puzzling. Yves' work is much too Abstract for me."

There was a sputter from Breton: "Too Abstract? For you?"

Mondrian answered readily:

"My dear Breton, you seem to have a very fixed idea about Abstraction. I certainly do not fit into your concept of it and I don't mean to play with words when I say that I consider my way of painting to be a deep involvement with reality. I may well be mistaken in my belief that Tanguy's paintings are getting too cold for me and too Abstract, and I also have no doubt that when he reaches his destination, as I expect to reach mine, we will both discover that we are living on the same planet . . . together. In art the same elevator goes either to the basement or the penthouse."

Tanguy jumped up and embraced Mondrian. "Ça on faut accepter, cher maître, tout à fait." [That, dear master, we must accept without qualifications.] His giggle calmed Ernst and Duchamp, and even Breton seemed to accept Mondrian's defusal of what, a moment earlier, had felt like a raging conflict.

A group photo was then taken in front of Peggy Guggenheim's ornate fireplace. Along with Mondrian, we see Stanley William Hayter, a talented English-born painter and printmaker; Leonora Carrington, a painter who was a major force in the Bloomsbury Group; Frederick Kiesler, the designer of the hostess's small museum; Kurt Seligmann, a Surrealist painter and future art dealer; both Ernsts (Max and Jimmy); Amédée Ozenfant, a post-Cubist painter who twenty-two years earlier had been Le Corbusier's partner in creating *L'Esprit Nouveau*; Breton; Léger; the photographer Berenice Abbott; Guggenheim herself; J. Ferren, an abstract painter heavily influenced by Zen Buddhism; and Duchamp. Mondrian stands toward the back, with more space around him than anyone else. Somewhat isolated, distinctively apart, he is, as always, protecting himself, encasing himself in a void.

Entering His Eighth Decade

A t age seventy, Mondrian was as optimistic as he had ever been in his life. And he was back to the level of productivity of his heyday in Paris. Von Wiegand thrilled to his energy:

> His simple life was now organized around an all-out effort to which his practical needs, daily tasks and association with others were all subordinated. He worked mostly at night, claiming that because of his health—he suffered from bronchitis—the mornings were not good. "There are night people and there are day people," he would say. One knew where he belonged. Frequently he would rest in bed late in the morning, but by afternoon he was "in the work." Around five he would stop to take a little walk and do his shopping in the neighborhood. After his simple meal, and the meticulous washing up, he would set to work in earnest, always going at it slowly, methodically, but with ever-greater intensity as the night wore on.
>
> For years he had worked by gaslight in Paris. Now all his lights were blazing, and back and forth he paced in his slippers (still the pair Gabo had given him in England), trying out a tape, stepping back to see the effect, moving it an eighth of an inch, shifting a rectangle up or down, his head cocked at an angle, evaluating the visual effect—an endless process of establishing new relationships until the bright little room seemed to hum harmoniously with his intent mental activity, to which his steps and movements were an accompanying ritualistic dance. Here was the visible demonstration of the dissolution of opposites—person and object, artist and painting—in a continuous, liberated rhythm from which there appeared something that had not existed before: step by step, the emerging work of art, the equilibrated liberated entity living on its own terms.
>
> On such evenings, shuttling back and forth, Mondrian must have covered several miles, but he was as unaware of this as he was of anyone's presence or of the world outside. If I was present when he became lost in

absorption, I would get up to leave. He would say, "No, stay, be as you are at home," and continue with the work. Or again, "Yes, it is time to go now. You will get into the painting."

Often, harassed by problems that arose in composition he was unable to break through to a solution, "For two months, every day, I have changed that line, and it does not come right," he would say. Or again, "You know there is always more than one solution to a problem." But once the choice was made, it was followed out logically to a definite conclusion. "Oh, the work is so difficult" was the usual plaint. The work moved forward, however, and one by one the European paintings were completed; new color planes and lines were added, and the white backgrounds were repainted in his exact and plastic brushwork. And as he worked, the aspiring austerity of his European canvases was vanishing in a quickened rhythm, vibratory and radiant, the response to the new world of America.

While coaxing his great homages to Paris and London—*Place de la Concorde* and *Trafalgar Square*—toward culmination, Mondrian was moving forward with the two new works that were a severance from his past and a tribute to current American culture and to the future. Both paintings had the unpredictability and sense of release, the ambient joy, that Mondrian deemed miraculous in the music and dance step he had discovered on his first night in America: the boogie-woogie.

These two canvases are both about 50 by 50 inches. The first is *Broadway Boogie Woogie* (see colorplate XV), which he would complete by May 1943 for an exhibition at the Valentine Gallery. The second was a canvas he turned forty-five degrees, so that, like some of the paintings he had done twenty years earlier, it has one of its right-angled corners as a bottom point, with the overall work assuming a diamond shape. He would eventually name it *Victory Boogie Woogie* (see colorplate XVI). The toe-dance position and the floating orientation make it even more weightless than *Broadway Boogie Woogie*.

Because it would be bought the first time it left his studio, *Broadway Boogie Woogie* would go from conception to completion more quickly than was usual for Mondrian. He began it in the middle of 1942, when the first stage was witnessed by Charmion von Wiegand. She had visited Mondrian the same afternoon that he conceived the breakthrough idea. "He came to the door in a mood of suppressed excitement, and pattering back to the bedroom returned immediately, holding out a small sheet of paper. 'Last night I dreamed a new composition,' he said." The charcoal sketch in his hand on an almost square piece of paper—9 by 9⅛ inches—was not that different in concept than the recent *New York City*. Both were complex composi-

tions of multiple colored lines. But now there were some added short dashes, attached to nothing else. They sparked a whole new life.

II

On one hot August day when Von Wiegand was visiting, Mondrian suddenly turned around one of the canvases he had started in London and had shipped to New York. The painting had been leaning against the wall with its back facing out, and Von Wiegand had, until that moment, assumed that it was a new canvas, still untouched and empty. Together, the artist at her side, Von Wiegand looked at a composition that instantly struck her as a masterpiece. Black lines encased two blue and yellow rectangles and a single elongated red one near the top. "I made this composition in London during the bombings," Mondrian told her. "I've tried many times to take it out." He shook his head. "I do not like it as well as the new picture. But now it will have to do."

With "its inexplicable dissonance, it jangled the nerves," Mondrian allowed to Von Wiegand. Now he was in an entirely different frame of mind. There was something in the impression of the painting that recalled the treacherous conditions under which he had painted it. The Blitz was still deeply embedded in Mondrian's mind.

The sirens of the fire engines racing up First Avenue continually bothered him, he said. They summoned memories of the battle zone in which he had previously lived. Then, when he heard the firecrackers exploding on the night of his first July 4 in America, it was "a torment for him."

In preparation for a theoretical aerial attack, he made blackout curtains. Mondrian took precise measurements of all his windows and purchased the right material, each bolt cut to size. He nailed the curtains to the framework at the top of each window and rolled them up impeccably so that, in the event of a bombing raid over First Avenue and 56th Street, he could unroll them and prevent any light from seeping out of his apartment. Rather than increase his fear, this need to cocoon against potential havoc outside delighted him. Security in living conditions was essential to the risky adventure of painting.

III

Fall/Winter of 1942.

This is probably the last time I shall write any diary of my visits to Mondrian. I feel very heavy-hearted but I know our real friendship is at an end. The rest will be only an externality like with other people. . . . Ever since he wrote me last spring, he has been widening the gulf with delibera-

tion and he has cut every communication. . . . M. is very sadistic to me at times and he wants his freedom and has taken it. He is very content now, successful and sought after and does not want to be reminded through me of the time when he was lonely, neglected, and afraid of life here.

This journal entry on October 29, 1942, was not, however, the last that Von Wiegand would write. On December 2, she visited Mondrian and he showed her *Victory Boogie Woogie*. Afterward, she was too excited to let the experience go unrecorded.

He would not let me help him and he carried and set it up and tied it with a piece of rope to the easel. And set up, it began to radiate its colors through the room and the world died away outside and a great silence seemed to come over the room and nothing now existed but this canvas radiating its colors and silencing all the external activity of life. For here was a spiritual activity, an energizing force greater than all the busy preoccupations of everyday life. This is surely his greatest picture and I could not take it inall [*sic*] at once, rather enjoyed the details with an avid pleasure sensuous as eating or loving but greater.

Years ago when I saw Nijinsky as a young girl, I remember his rhythm, so incredibly organized and conscious, yet so free. An organic, animal rhtymn [*sic*] out of the interior of the body and built in the pattern of its structure, Mondrian too has such a divine rhtymn [*sic*],—in himself too, for when the old man is forgotten, and the young man appears ageless and dancing and his eyes light up with such a happy expression and his movements become so graceful and so exquisite. And his picture has the same rhythm, delicate, tender, exquisite and yet strong—a strength that is flexible and full of a controlled joy. These words mean nothing because this plastic activity has no parallels unless it be in a symphonic music. I called his attention to the fact that it was most akin to music and he said yes, that was true.

Mondrian was convinced that he had finished the painting. He told Von Wiegand that the lines had attained all his objectives. This was the pinnacle of what he had been envisioning and nurturing ever since he started working in colored tape.

IV

The next time Von Wiegand visited, the canvas had been stripped, there was no more tape, and no more *Victory Boogie Woogie* as it had been.

It had been destroyed and was in process toward a "new solution." The white plane bore the mark of a struggle; the long colored lines were broken into small rectangles, but by various large planes, and tiny pieces of tape were superimposed everywhere on the surface. This would happen again and again, so that under *Victory Boogie Woogie* lie buried six or seven different solutions, each of which might have been a complete picture.

Mondrian had, for the first time in decades, softened his edges and entered a new domain where small, irregular blocks of light-infused paint shimmer. The composition was still a nexus of horizontals and verticals, but the rows of small squares of yellow, red, and blue lodged larger squares, and the pellucid light gray of the background had triangles and rectangles of a darker gray within it.

On the following visit, Von Wiegand was sure that she would find Mondrian reworking the canvas now that he had torn off the tapes. But he was concentrating on *Broadway Boogie Woogie* instead. "He was just putting a yellow rectangle in the center of a red plane," she would recall twenty years later. Von Wiegand could hardly have been more shocked. She knew that Mondrian never placed two primary colors touching each other—or so she thought. She reminded him that what he was doing was contrary to his "theory."

He answered by asking, "Does it work?"

Mondrian did not wait for Von Wiegand to answer. He stood back to look at *Broadway Boogie Woogie* from a greater distance. "Yes, it works," he declared.

Then he resumed painting. He was silent, and so was Von Wiegand, transfixed as ever when she had the rare privilege of seeing her artistic hero in the midst of composing.

Mondrian finally spoke. "You should know that all my paintings were done first and the theory was derived from them. So, perhaps now we will have to change the theory."

V

In March 1943, the Valentine Gallery organized an exhibition, in which Mondrian showed six large paintings while sharing the space with a second artist. His coexhibitor was a Brazilian sculptress who professionally simply called herself "Maria."

Her full name was Maria de Lourdes Faira Alves Martins Pereira e Souza, and she was married to the Brazilian ambassador to the United States. Forty-nine years old, she was also a poet, designer, and printmaker. She had struc-

tured her life to suit the traveling and official obligations of a diplomat's wife, but she was a serious artist, her success in no way dependent on her husband's position. Two years prior to sharing Valentine's space with Mondrian, she had had a solo show at the Corcoran Gallery, a major museum in Washington.

Why the savvy Valentine Dudensing put Maria and Mondrian together is a mystery. He may have wanted to accentuate the contrast between weightless abstract painting and figurative bronze sculptures; he may have had the idea that Maria's rich friends were potential Mondrian clients and that having her work shown with someone of Mondrian's reputation gave Maria added cachet. Regardless, the pairing had good results. The artists' shortened names worked well for the cover of the exhibition catalogue, a muscular black-and-white design with MARIA in large bold letters over "New Sculptures" and MONDRIAN in the identical strong typeface over "New Paintings." In spite of the exigencies of wartime, the public flocked to the gallery.

Maria was not even a friend of Mondrian's. Her artistic confreres were the Surrealists, her closest allies André Breton, André Masson, Yves Tanguy, Max Ernst, and Marcel Duchamp: the same crowd who had snickered at Mondrian at Peggy Guggenheim's. She had studied with Jacques Lipchitz and Stanley William Hayter, and her sculptures depicted mythological characters in states of emotional conquest and victimization. While Mondrian avoided and disdained such power issues as artistic themes, Maria's subjects included amorphous figures with claws and whiskers, dismembered limbs stretched dramatically, and a cobra curled to strike. Sometimes the bronze was smooth, sometimes rough and pitted; regardless, it represented mortal flesh.

In this alien company, Mondrian's *Trafalgar Square* was on view for the first time. He had started the large painting in 1938, in the period when he had recently moved to London and Herbert Read and Peggy Guggenheim were discovering and encouraging him, and he had finished it only recently. This showstopper was about 57 inches high and 47 wide; having initially been stapled to stretchers, the canvas was now glued to a panel.

Trafalgar Square is exuberance itself. While purely abstract, it has the pulse and haphazardness of that great conglomeration of buildings and arteries around an open gathering space in the heart of London. How wonderful, and telling, that Mondrian chose to identify his vibrant canvas with the ultimate architectural mélange rather than one of London's many squares bordered by rows of matched Georgian houses. Those other squares had the straight lines meeting at perfect right angles that one might expect Mondrian to have preferred, but they were too orderly. The actual Trafalgar

Square, with its irregular outline and multiple architectural styles, has the energy and perpetual life force of human beings converging and intersecting at high speed; multiple actions and reactions occur simultaneously. So it is with Mondrian's painting. The energy is general, and rhapsodic.

Looking at this large canvas, which belongs to the Museum of Modern Art in New York, one imagines a cacophony of sounds. Chirping birds, honking horns, and blaring sirens voice themselves concurrently. The yellows, which are preponderant, are bright in tone audibly as well as visually. The reds, slightly deeper, have more brute force in spite of their limited quantity. Then, miraculously, the blue, while factually present in only two small units tucked alongside different edges of the composition, suggests a vast sea or sky. Of course it is whiteness that we see more than anything else, but if you look at the actual work long enough, the afterimages of the small forms of yellow, red, and blue take over and begin to bounce in it.

Another of the six Mondrian canvases smelling of fresh paint in the 1943 Valentine Gallery exhibition bore a title that, like *Trafalgar Square*, paid homage to a great metropolis where Mondrian had felt happily at home. Mondrian had begun *Place de la Concorde*, although not yet so named, at the start of 1938 when he was still living in Paris. He had continued to work on it in London, and now, having had it for two years and five months in New York, had at last completed it. One of Mondrian's nearly perfect but not quite exact squares, it measures 94 by 94.4 cm. *Place de la Concorde* is lighter than *Trafalgar Square*; the large expanse of yellow at the top is perfect sunshine. The proportions and sizes of the reds and blues—they could be the colors of a printed silk scarf—seem almost random as they dance around the rest of the canvas in unpatterned rhythm. The white is charged with the sense of infinite possibility (see colorplate XIV).

And now there was *Broadway Boogie Woogie* to honor New York.

VI

At some point during the exhibition of Maria and Mondrian at the Valentine Gallery in 1943, a secret negotiation occurred. The sculptor whose biomorphic bronzes stood in the same gallery where Mondrian's six large canvases hung on the walls bought *Broadway Boogie Woogie*. Valentine Dudensing knew this, as did Alfred Barr. But we have no reason to believe that Mondrian did. Maria did not acquire the work for herself, but for the Museum of Modern Art. She gave the painting anonymously, and when the painting went on view in the Modern's *New Acquisitions* show that summer, it is unlikely that anyone in the viewing public was aware of how or why it got there.

The invariably courageous Henry McBride wrote about Maria Martins and Mondrian in an article he published the following year.

> He looked like his own pictures. It could be judged that he lived an intense mental life and weighed all the world values on scales of his own. At the same time and in spite of his age he looked on life with unfatigued eyes. Mme. Martins, the Brazilian ambassadress, herself an artist and young enough to take a certain pride in claiming to be what the psychics call an "old soul," asserted that Mondrian himself was definitely a "young soul." Mondrian smiled at this accusation sadly, uncomprehendingly; but made no denial. Youthfulness of soul is never aware of itself, so perhaps the lady was right.

During the gallery exhibition, Dudensing would occasionally play a boogie-woogie record for those looking at the painting. The music, like the painting, unpredictable and permanently young.

This music born in Africa before its natives were treated as saleable commodities, bought by slave owners and transplanted, now embodied freedom. For Mondrian, *Broadway Boogie Woogie* was the perfect expression of being unfettered and letting go.

VII

On May 6, 1943, Mondrian accepted an invitation to be a juror for the first spring salon at Peggy Guggenheim's Art of This Century Gallery. This new space on the top story of a building on West 59th Street, designed by Frederick Kiesler, had curved walls constructed of South American gum wood; the paintings, which Guggenheim insisted must be unframed, were mostly mounted on baseball bats that could be tilted and protruded a foot or so in front of the curves. Otherwise they were suspended from the ceilings on strings.

Howard Putzel, the paid manager of Art of This Century, had conceived of the juried exhibition. In the summer of 1942, he had been taken to the studio of thirty-year-old Jackson Pollock, whom he instantly deemed "an American genius." None of the other jurors—Alfred Barr, Marcel Duchamp, James Thrall Soby, James Johnson Sweeney, and Max Ernst as well as Mondrian—had heard of Pollock; nor were they inclined to accept his submission as one of the fifty works in the salon. And admission was coveted, the quest of vast numbers of struggling young artists as soon as it was announced. By the day the work was to be presented to the jurors, artists

holding their paintings under their arms stood in line outside the remarkable space Kiesler had designed.

Putzel had persuaded Pollock to submit *Stenographic Figure*, a canvas from the previous year, about 40 inches high and 60 inches wide. An amalgam of highly energized forms, it is painted in unmodulated blues, blacks, reds, and yellows, with imagery suggesting a Picasso-esque woman taking dictation but, above all, a fury of thrusts, waves, and scribbles.

Everyone assumed that Guggenheim herself would ultimately decide which artists were admitted and which were not. It was also taken for granted that Mondrian would probably only vote for practitioners of pure geometric abstraction. Guggenheim, imperious though she might be, venerated Mondrian. So it seemed that the Pollock had little chance of being picked.

On the day that the jurors were looking at what had been submitted for Guggenheim's exhibition, Mondrian was the first juror to show up. He wanted ample time to do justice to every work. While Guggenheim and Putzel were still busy preparing for the full jury to arrive, Mondrian was looking closely and carefully at the paintings already leaning against the walls of the gallery. "Tall and professorial in a double-breasted suit and horn-rimmed glasses, he walked slowly from painting to painting," according to Mondrian scholar Herbert Henkels. Pollock's *Stenographic Figure* stopped him in his tracks. He stood there stroking his chin. Guggenheim "saw him 'rooted' in front of the Pollock and rushed to apologize."

Henkels describes the scene. "Inspecting the work for the exhibition, Mondrian was stunned by the work of another young artist: Jackson Pollock. Guggenheim, who was less enamored of these paintings, was worried at Mondrian's interest in something so different from his own work."

Guggenheim asked rhetorically if the Pollock even qualified as "painting." Mondrian stayed silent while Guggenheim bemoaned Pollock's lack of discipline. Jimmy Ernst witnessed it all firsthand. Ernst quotes Peggy Guggenheim saying, "I don't think he's going to be included . . . and that is embarrassing because Putzel and Matta think very highly of him." But then Mondrian said, "This is the most interesting work I've seen so far in America."

Guggenheim, "stunned," said, "You can't be serious. . . . You can't compare this and the way you paint." Mondrian responded patiently, as if instructing a student: "The way I paint and the way I think are two different things." And then he advised Guggenheim, "You must watch this man."

Just because it points in the opposite direction of my paintings . . . my writings . . . is no reason to declare it invalid. Everybody assumes that I am interested only in what I do in my own work. . . . There are so many

things in life and art that can and should be respected . . . yes, admired . . . I don't know enough about this painter to think of him as "great." But I do know that I was forced to stop and look. Where you see "lack of discipline," I get an impression of tremendous energy. It will have to go somewhere, to be sure. . . . Right now I am very excited.

Guggenheim quickly accepted an idea she had not even considered before. After almost two years of openly deploring Jackson Pollock's art, she instantly changed her view. As each juror entered the room, she pulled him over to the Pollock and said, "Look what an exciting new thing we have here!"

It makes perfect sense that Mondrian would have discerned in Jackson Pollock's work the universality he sought in his own. He was also prescient enough to see, and say, that Pollock had a way to go beyond what he had already achieved in *Stenographic Figure*. One wishes that Mondrian could have lived long enough to know the paintings Pollock produced a decade later. They are mesmerizing in some of the ways Mondrian's own work is: their nonstop pulse, their eternal motion. We feel the presence of what is essential, without an iota of gratuitousness. Mondrian's and Pollock's canvases are part of a great continuum; they extend infinitely beyond the confines of those stretchers on which they are stapled and, while capitalizing on the latest technical advances of the moment in which they were made, are timeless. A theory has been posited that Mondrian only went on the jury to encourage Peggy Guggenheim to accept a sculpture by Harry Holtzman into the show, and that he enthused about the Pollock to demonstrate the open-mindedness that would get her to agree to the Holtzman. Indeed, she did include the Holtzman in the show. But although that depiction of Mondrian as a manipulator has been accepted by many, it seems completely out of character, while his enthusiasm for Pollock is plausible.

Peggy Guggenheim herself, in the various versions of her memoirs, keeps her discovery of Pollock and the presentation of his work at Art of This Century simple. "We had the great joy of discovering and giving one-man shows to Pollock" and others, Guggenheim explains. And "after the first spring salon it became evident that Pollock was the best painter." Putzel and Matta got Guggenheim to help Pollock, who at the time was working in her uncle's museum as a carpenter. And so, from the spring of 1943 until 1947, when she left America, "I dedicated myself to Pollock." He was her "protégé," with Lee Krasner the devoted "intermediary," and, although she thought he was "like a trapped animal who never should have left Wyoming," she gave him $150 a month. She subsequently increased his monthly stipend to $300, commissioned murals, and eventually guided him to the dealer Betty Parsons. It was Mondrian's insistence that made all of this happen.

The dynamics between Mondrian and Guggenheim remained intense. Harry Holtzman would report:

One night in New York, we were returning home from a party in a taxi, with Peggy Guggenheim sitting between us. An old friend and admirer of Mondrian, Peggy was an uninhibited woman to say the least. Peggy leaned her head on Piet's shoulder, snuggling close to him. Piet put his arm around her, and after a moment he bent his head and kissed her mouth arduously and long. "Why Mondrian!" she exclaimed in seeming astonishment. "I thought you were so *pure!*" After we dropped her off at her house, Mondrian was delighted: "They"—meaning the Surrealists— Peggy was then married to Max Ernst—"*they* always call me *pure!*"

VIII

The annual *New Acquisitions* exhibition at the Museum of Modern Art opened on July 28, 1943. Mondrian's *Broadway Boogie Woogie* was a star attraction.

Six days earlier, American troops, led by General Patton, had captured Palermo, in Sicily. Three days after that, Mussolini was arrested, and Italy's King Victor Emmanuel appointed a replacement for him. Yet even though the Allies were showing signs of modest military progress in Italy, German fascism was still wreaking havoc. While New Yorkers looked at art on West 53rd Street, it was a time of wholesale killing in Europe. And war continued to rage as well on the islands of the Pacific. At the start of August, on the same day that nearly three thousand Romani were gassed at Auschwitz when their camp was liquidated, PT-109, the navy vessel on which John F. Kennedy was serving, was sunk off the Solomon Islands. By the end of the month, martial law would replace the government in Denmark, which was occupied by Germany. Things only got worse in September. New York was never the direct target Mondrian had feared it might be when he installed his blackout curtains, but the state of much of the world was dire.

Now more than ever, people craved the uplift afforded by art. To those who were lucky enough to visit the Modern, *Broadway Boogie Woogie* offered pure enchantment. Thanks to the perseverance of its seventy-one-year-old artist, who had painted it in his small studio in walking distance from the museum, and the secret generosity of the Brazilian ambassador's wife, thousands of people could at least briefly set aside their worries and lose themselves in the buoyancy and vibrations of this large square canvas which was unlike anything Mondrian had ever done before.

Alfred Barr wrote the exhibition press release. He explained that *Broadway Boogie-Woogie*, with its "staccato rhythmic excitement," was Mondri-

an's "most important" recent work. While Barr was enthusiastic, Clement Greenberg—considered by some as a god of modern art criticism—thought that it represented a decline in Mondrian's powers. He reviewed the Modern's exhibition in *The Nation*. Calling *Broadway Boogie Woogie* "something a little less than a masterpiece," Greenberg laments the way that Mondrian's palette, while still confined to the three primary colors, presents them more diluted than in his earlier work. He bemoans the loss of the "very neat and precise mechanical execution that used to characterize a Mondrian painting. It is either a failure of manual dexterity, a deliberate effort to be a little more fluid, or simply the impression left by the weak yellow and the purple that appear in a Mondrian painting for the first time."

To a degree, Greenberg subsequently recanted. A small "Art Note" appeared in the October 16, 1943, edition of *The Nation*. In it, Greenberg writes:

> My memory played tricks when I discussed last week the new Mondrian at the Museum of Modern Art. The painting has no orange, purple, or impure colors. Seeing it again, I see that it was the gray which Mondrian uses in a new way for him that made me remember his scarlet and two shades of blue as purple and impure, and the yellow as orange. But I have the feeling that this after-effect legitimately belongs to one's first sight of the painting. The picture improves tremendously on a second view, and perhaps after an aging of six months or so it will seem completely successful.

Still, more people read the original review than its correction. As had too often been the case in the early years, the press was Mondrian's nemesis.

IX

Mondrian was still working on *Victory Boogie Woogie* in the summer of 1943 when Harry Holtzman found him a larger studio. It was across from the open square in front of the Plaza Hotel, a few doors down East 59th Street from Fifth Avenue. In a row of studio buildings the scale of brownstones, this new space was not only larger but had greater daylight than anywhere else he had ever lived. As soon as Mondrian moved in, he did not lose a minute in effecting the usual transformation of his new home. He quickly made his colored rectangles and applied them all over the blank white walls, and assembled simple furniture from fruit crates, which he painted white.

To Charmion von Wiegand, Mondrian appeared to be in a hurry. Motivated by a sense "that time was running out for him," he was "ready and

eager" to start a new painting which was to be "larger, and much better" than anything he had done to date. At the same time, he became uncharacteristically nostalgic. On one occasion when Mondrian and Von Wiegand were sitting on a park bench near the East River, he mentioned "how much the skyline of Queens with its low houses and church spires reminded him of Amsterdam. And several times he expressed the wish to look at the sea again." Still, Mondrian declined an offer to go to the beach. It was out of the question to consider a return trip to Europe that might take him back to the dunes of Domberg; he would not even go as far as Jones Beach or Coney Island.

Mondrian had become less awkward in social situations than when he was younger, but he felt no need to feign tact when someone or something made him uncomfortable. One evening he attended a lecture Carl Holty gave "in an over-decorated apartment (fake antiques) on Sutton Place." It was one of those lavish abodes where the elevator opened directly into the apartment. Perhaps it was that overt mark of wealth which got Mondrian off on the wrong foot. When the hostess greeted him he wrinkled his nose and said, "It smells old in here." Then, after the lecture, he told Holty he had not really liked it, even though the subject was abstract art.

Mondrian was even less diplomatic when Holty introduced him to Iva Litvinov, the wife of the Soviet ambassador to the United States, Maxim Litvinov. Mondrian had no idea that being the ambassador of a world power to Washington was a comedown for Litvinov and his wife. Litvinov had previ-

The artist Fritz Glarner took this photo of the entrance to Mondrian's studio on East 59th Street just off Fifth Avenue. Mondrian moved there in 1943.

ously been Soviet foreign minister, largely responsible for the United States recognizing the Soviet Union in 1933 after sixteen years of refusing to do so following the revolution. But Stalin had subsequently demoted Litvinov for opposing the Stalin-Hitler pact.

It was no surprise that Maxim Litvinov was against collaboration with Hitler. Unusual for someone so high up in the Soviet Union's bureaucracy, he was Jewish; his real name was Meyer Wallach. His father had been an Orthodox Jewish merchant in Bialystok, but Maxim had chosen not to follow suit and, having become a radical revolutionary, was arrested by the tsarist police and deported for five years of hard labor in Siberia. He had fled after a year, and landed in London, where he met Lenin and Trotsky—reaffirming his revolutionary faith—and married Iva Low, daughter of a prominent lawyer. By the time he was in the United States in his position within the Soviet regime, even if he was on a lower tier than when he had been the foreign minister, he had a distinguished past and was well informed on the realities of the situation in Europe. Litvinov had devoted himself to heightening awareness of the Nazi concentration camps, and also to supporting Zionism actively.

None of this, meanwhile, had crossed Mondrian's radar; or, if it had, he did not care. Mondrian, on meeting the wife of the heroic Litvinov, "was offended by the barbaric piece of costume jewelry she was wearing as a necklace. He looked her in the face, smiled sardonically, snapped his fingers at the large red beads around her neck, and said, as if it were an impossibility

Mondrian made most of the furniture in his studio, including this table and the storage unit next to it.

for the Russian ambassador's wife to be bejeweled so flamboyantly, 'Madame Litvinov of the Soviet Socialist Republic?'" He told Holty later that evening that he had seen fit to behave this way because "he hated 'cultural retrogression.'"

This was too much for Holty. Mondrian's decisions about character based on the choice of necklace infuriated the younger man. Holty reminded Mondrian that he, too, had been a socialist at one point in his life. But there was no getting Mondrian to recant, ever. Yes, he acknowledged, he had been a socialist, but "now he hated 'everything that "levels."'" The discussion was over.

X

Mondrian and Sidney Janis regularly went to the Roseland Ballroom, the largest such establishment Mondrian had ever seen. At 51st Street and Broadway, another of those evening spots where the clientele had to be white although the performers were mostly Black, it accommodated over a thousand dancers, among them "hostesses," also called "taxi dancers," who danced with gentlemen for $1.50 an hour. Janis, who had taught ballroom dancing, had long been a habitué. Mondrian may not have been an expert, but he, too, had mastered the basic steps and even some of the exotic ones. For the rest of his life, Sidney Janis would have a twinkle in his eye remembering the many evenings when he and the person he considered the greatest artist of the century would fox-trot or rumba or tango to their heart's content with their paid partners.

Harriet Janis—friends called the former Harriet Grossman "Henny"— was a woman of refined intelligence with rare astuteness about the lives of artists and the processes they developed to achieve their goals. When she wrote about Mondrian following the move to East 59th Street, the reader enters the artist's new abode so graphically that we can breathe its air.

> Mondrian's studio attested to the heroic abnegation of a monk. And yet, because of the large areas of white walls upon which were placed bright spots of cardboard, it was as gay as a child's world. His last place consisted of a kitchen, a painting room and a tiny antechamber. It was furnished with a refrigerator, a victrola radio combination, both gifts, a cot, a drafting table, and an easel which stood like an altar, alone at the end of the almost barren room. It was especially altar-like at night, when the floodlights on either side were centered on it. The few bookshelves and seats were wooden fruit crates painted white and reinforced with thin strips of wood, creating a distribution of areas that gave the eye the same pleasure as do neo-plastic compositions. "They are like my paintings," Mondrian

said of them. The rectangular pieces of cardboard pinned to the walls were parts of a geometric-esthetic game which served him as an experiment in equilibrium, in which relationships were being continually studied. The infinite number of pinholes about these colored areas proved the dozens of times they had been shifted. All of them were separate, there was no overlapping, and there were no lines between them as there were in his pictures. They were floating spaces of color, probably the next step to have taken in his new work.

Harriet Grossman Janis trenchantly captured the unfettered will for pleasure that pervades Mondrian's world. Others might have considered it austere and ascetic; Janis rightly felt that it had the charms and playfulness of a nursery. Mondrian is inside his dreams. The painting is eradicated as object. Rather, the art on prepared canvases and the surrounding environment merge into a coherent totality. Mondrian had invented a new form of adult amusement.

The Janises had two young sons. As a little boy, Carroll Janis loved running wild with his older brother Conrad all over their parents' large Upper West Side apartment. When Mondrian visited, the boys sensed that the septuagenarian was not used to small children. But Carroll had a recollection of having, on at least one occasion, sat on the lap of the amiable artist. Mondrian was tall and Sidney short, but Carroll saw a certain resemblance between them. They were balding in the same manner—their hair brushed back from their high foreheads, celebrating rather than disguising their receding hairlines—and had tied their bow ties impeccably. Carroll knew the orbit of his parents' friends—Picasso and Arp and Léger especially—and Mondrian stood out. He was more even-tempered and comfortable in his skin than the others were, and more natural with children even if they were unfamiliar to him.

Carroll never forgot Mondrian's support of Sidney Janis at a crucial moment. Janis organized, for the Museum of Modern Art, an exhibition of work by Morris Hirshfield, a former shoeshine boy. Janis had discovered Hirshfield and deemed him a natural artist, with a rich and original vision, but he was untutored and unorthodox. When Janis put on the show in the summer of 1943, he knew there would be outcries of disapproval. He alerted Mondrian to the attacks he anticipated.

Hirshfield, like Janis, had been, after years of shining shoes, a garment manufacturer. Having retired from making slippers and dresses at his plant in Brooklyn, the Polish-born businessman, the same age as Mondrian, had only recently taken up painting. In a playful primitive style, he painted lighthearted tigers, nude women, large blossoming flowers, and other fanci-

ful themes, all with a look of circus décor, in the colors of children's finger paints. In his days as a slipper manufacturer, he had used salesman's samples which were made only in left feet; the naked women in his paintings all had two left feet.

Alfred Barr had agreed to have Janis put on the Hirshfield exhibition at the Modern, but by the time the show opened, the very fact of its taking place was swirling in controversy. Some of the museum's trustees considered the paintings substandard, embarrassing for the institution. The critics who had already seen the work disparaged it and were sure to mock it in the mainstream press. Barr was under fire both for the nature of Hirshfield's work and for having allowed Janis to organize an exhibition; while Janis did not yet have an art gallery, he was already a private dealer and had a vested interest.

It was a surprise when Mondrian showed up at the Modern at the very start of the exhibition opening. Most people thought that he never attended social events; the few who knew that he ventured out assumed that it was only when his inner circle of friends was concerned. Accompanied by Harry Holtzman and Fritz Glarner, Mondrian was among the first to arrive. The moment he walked in, he started to extol the merits of Hirshfield's art to Glarner, Holtzman, and a number of other young artists. Sidney Janis, over forty years later, would recall, "As soon as he saw the paintings he began to explain Hirshfield's conception of the two dimensions and all that sort of thing. Instinctively." With his strong voice and distinct Dutch accent, the tall, well-dressed man who served as the arbiter of taste was recognized by all.

After a few minutes, Mondrian positioned himself in one of the few chairs available to viewers. He smiled warmly as his eyes surveyed Hirshfield's paintings. He focused especially on an oversized, amateurly painted canvas of a girl on a foreshortened bright red striped sofa with pigeons around her and a painting of a disproportionately large white angora cat staring imperiously. He also fastened onto a nearby canvas of an elephant bearing an ornate saddle. Piet Mondrian stayed in his position, almost perfectly still, with the look of patent approval and pleasure on his face, throughout the event. He remained until the last visitors had left.

Perhaps he was motivated by personal loyalty. Sidney Janis had bought and championed Mondrian's work, and was his dance hall companion. But, as with Jackson Pollock, Mondrian truly liked the art. Hirshfield was not the master Pollock was, but he was another celebrant. The art of both these painters engages with life in a broad, all-encompassing way, beyond their individual selves. It is neither sardonic nor ironic. Rather, it is reverential, and free of shibboleths.

Much as Mondrian made his agenda for abstraction seem like the only acceptable approach when he proselytized about it, he was again violating his own rules. It had been the same with the paintings of Winifred Nicholson. Forthrightness combined with natural talent could make Mondrian forgo his Neo-Plastic gospel. Like Nicholson, Hirshfield and Pollock appealed to him for being intuitive and refusing to kowtow to other people's dictates.

XI

Mondrian's life in the new studio on 59th Street was devoted almost exclusively to *Victory Boogie Woogie*. He had stopped producing treatises about the Neo-Plastic ideal or revising canvases he had brought from Europe. His existence was now centered on this large canvas perched on a corner.

The name Mondrian gave it and the *Broadway Boogie Woogie* at the Modern honored America's debt to the African heritage of much of its citizenry. Beyond being the specific new musical form developed by Meade Lux Lewis and his friends, boogie-woogie also conjured human dancing and music-making of all people for all of time. While the drumbeats and footsteps were devoid of all obligations to a fixed rhythm or melody, they depended on impeccable execution. This form of dancing represented the goal of modernism to be "universal and timeless," rather than a singular style. Throw in "Broadway" before "Boogie Woogie" and you have not just New York, at its epicenter of neon, but, more than the specific neighborhood, the throngs of people from all over the world who go there. Start with "Victory" and you have the goal of the current war and, more generally, the vanquishing of humanity's enemies. And you have the victory of birth and of life itself. The painting so named is oxygenated to the hilt.

Making *Victory Boogie Woogie* in his new headquarters, Mondrian, while devoted to the present, had not entirely left his past behind. When he had arrived in New York, he had with him a fair number of family photos, including some of his ancestors, and many of the photos that had been taken of him over the years. Moving to 59th Street, he still had those as well as a penciled list of what he packed in his steamer trunk, the specificity of which was remarkable: "1 tablet toilet soap," "½ box kitchen soap" (he crossed out the word "full"), "2 bottles celery salt," "used kitchen utensils," "used carpenters tools," "some underwear," and "serviettes." On that list of the contents, he had also written "Some writing paper and enveloppes," and then crossed out the second "p" of what should have been "envelopes"; he never stopped editing himself.

But the only photo he kept visible in his new studio was the one of Helena Petrovna Blavatsky, who had died over fifty years earlier. When he chose

to look at her image, it was not out of sentiment or to conjure old memories of the Theosophical societies in Amsterdam or Paris. She represented transcendence, not the past; Madame Blavatsky was part of the great "other." She had emancipated herself from materialism into the realm of the spiritual and devoted her life to human well-being.

Otherwise what was visible in the new studio was only what Mondrian needed: a few ashtrays, a coffeemaker, neat clothes to work in and nicer ones for the rare occasions he went to an art opening or a dance hall. Mainly, he had his usual panels of color all around him, and the new creation that was coming to life on the easel.

When he had moved back to Amsterdam from Brabant in 1904, Mondrian had had more copper pots than he could count and gifts from the people of Uden. Forever after, he traveled light. Almost all that mattered was being healthy enough to have the vigor to paint. He was fueled by color and form and by dance steps. The absence of "stuff" did not just mean material objects. If he had emotional baggage, he had dealt with it to his own satisfaction.

This was the ultimate luxury: a fresh start on his own terms. It depended on essential solitude. He wrote the occasional letter to people from the first seventy-one years of his life—Winifred Nicholson, Ben Nicholson, Barbara Hepworth, his brother Carel—but since he had moved to New York two years earlier, the correspondence was greatly reduced. Mondrian's personal communication no longer had the urgency or intensity of the letters when he compared his London friends to the dwarves and forest creatures of *Snow White*, or when he addressed vital issues ranging from Van Doesburg's shifts in thinking to Johanna's Catholicism. He was also done writing treatises on art.

Yet even if he had stripped his life down in the new studio, he still had friends. Harry Holtzman was continuing to grease the wheels of his life, to maintain its structure with a caretaker's loyalty and savvy. Holtzman and other devotees like Charmion von Wiegand and Carl Holty came to see him often enough.

But while Von Wiegand or Holty might make a suggestion, he responded only to his own instincts. Mondrian now could exist immersed in the Neo-Plastic paradise he had created for himself. The cardboard panels of red, yellow, blue, gray, and black which surrounded him, defeating gravity, were a triumph of transcendence.

XII

In November 1943, Mondrian told Holty that his most recent "picture" was "nearly finished." All that was needed was for it to dry, with the latest dashes

of color crystallized. He had it! The movement, the deliberate surprises and oppositions necessary to ongoing movement: all were there. He believed he had achieved the "Victory" of the title.

He received the odd visitor and occasionally went out to openings or a dance hall or jazz club, but mainly he pushed himself to breathe new life into this single canvas. Color, free and clear of subject matter, was his vehicle. In the right amounts, the best position, the perfect pitch, with everything determined not by knowledge or by theory but by some greater force inside and around not just himself but all people, he could make those yellows and reds and blues and whites sing forever. He would liberate his viewers as he was liberated.

But Mondrian's bodily strength was leaving him. He would go for days communicating with no one else. Then, when Holty or Holtzman or Von Wiegand visited, they noticed how wan and frail he had become. He claimed to have no needs except to get *Victory Boogie Woogie* to perform so perfectly that it would be a finished painting.

Yet if he thought he wanted to complete it, he was deluding himself. Conclusion was the enemy.

XIII

On December 15, 1943, Charmion von Wiegand arrived at Mondrian's with two suitcases, one belonging to a friend.

At table, I asked if Mondrian would keep the other bag, as it was cold and I didn't really think I could make it to go home first. He said he didn't want to do so—maybe there was something explosive in it—he didn't like to have stranger's things around. I was rather hurt and said ok . . .

I remember being very depressed that night. It was the sharpness with which Mondrian refused me to leave Grace's bag in his studio. Now I am convinced it was due to his premonition of coming death. He was ready for it. He wanted no unexplained articles in his studio. He wanted all his things together. He lived the last months getting ready for the final event. Not that he really expected it, but he was planning to be ready. Everything was a move toward that. He hoped to finish his picture and to see Sweeney's book finished.

5 January 1944.
And M. had red wine of the house. And we had hors d'oeuvres and chicken and ice cream. And M. was quite playing the host. He always got

more rested and his face became lively after eating. I am sure he never had enough blood, didn't eat properly.

XIV

Shortly after Christmas 1943, Ella Winter arranged to visit Mondrian. She had seen the world, she was well educated and sophisticated, yet she felt a certain trepidation. Winter had known of Mondrian ever since Charmion von Wiegand had introduced her to his art two years earlier, and she had bought *Composition with Yellow, Blue, and Red*, but they had not yet met in person. She was afraid she might say the wrong thing.

The animated, dark-haired sophisticate only had a vague impression of what lay ahead in the studio on 59th Street. The moment she was surrounded by the vibrant planes of color and facing *Victory Boogie Woogie*, she was, however, at ease. Winter ended up staying much longer than the usual maximum of an hour Mondrian accorded the few visitors he permitted past the door. She was enthralled by the "thin, austere, ascetic" artist.

Mondrian encouraged Winter to remain in part because she was so recognizably thrilled with his art. It was unusual for the seventy-one-year-old artist not to feel an urge to rush back to solitude when people called on him, but when he realized Winter's sheer pleasure in his work, he let the experience linger. For Winter it was "such a stimulating afternoon."

Winter had been married to Donald Ogden Stewart for four years. Used to intelligence and wit, she was stylish and urbane, and her true sophistication and unaffected worldliness were part of her impact on Mondrian. He had been uncomfortable with the hovering servants at A. E. Gallatin's and did not give a hoot about the trappings of wealth, but when someone was genuinely cosmopolitan, as well as intrinsically kind, he happily succumbed to the charm.

From the moment she walked into the studio, Winter had been dazzled by the "extraordinary pictures unlike any others, fascinating in their clear, clean, ascetic, geometric quality." In Winter's normal milieu, the most modern art might have been a Raoul Dufy racing scene or a Foujita portrait of one of her hostesses. The typical furniture was Chippendale or Louis XV. Mondrian's white-painted packing crates used as tables and chairs, and the panels of color on the wall, were something else.

She depicts the scene, so totally unlike her usual social encounters:

I kept staring at the black lines and white squares, the small shapes of bright red, blue, and yellow. And then Mondrian started talking to me,

telling his ideas, why he painted the way he did, how the black lines were not exactly the same width, each one—which I then examined carefully and found to be true. How refreshing, I thought afterwards, to meet greatness and not know it for "greatness," a "simple," unencumbered human being, immersed in his work, dedicated and at pains to understand his own attitudes and thoughts, his own creativity.

Ella Winter "stayed and stayed." She let her subsequent engagements drop. And Mondrian kept showing her his old work and talking nonstop about his goals and beliefs. He "brought out chrysanthemums, trees . . . old pencil and ink drawings of decades ago" and elucidated his artistic development for her. He made it sound as if the black lines of his pure abstractions were the ultimate pared-down "essential form" of the trees he had once drawn with many branches.

Winter felt that she learned more in a single afternoon than she would have in years of art school. She succumbed to the force of Mondrian's convictions and the beauty of his achievement. Mondrian was at a high point.

XV

At the start of 1944, Mondrian was again working hard on *Victory Boogie Woogie*. His thinking that he was finishing it the previous autumn had been an aberration. Charmion von Wiegand visited him on January 10 and noticed that the white of the painting had become brighter since her previous visit. A week later, she called in again on East 59th Street. She observed further changes, but also discovered that Mondrian was unwell. His bad cold did not, however, keep him from painting away on the top part of the canvas while saying that he was happy with the rest. He was totally committed to each form and its color down below. He had painted everything in the position he wanted. Toward the pinnacle of the diamond, however, there were "one or two small papers" still attached.

A few days later, Von Wiegand invited Mondrian, Carl Holty, and Stuart Davis to her place for dinner. Mondrian and Davis argued intensely. Davis denigrated Salvador Dalí's work, while Mondrian praised it as "plastic." Then they quibbled about what it meant to live in America. "Mondrian said that he himself would have developed more easily had he been born and raised" in the United States. Davis exploded back, "The hell you would have."

Mondrian was soon declaring the central issue of life to be the supremacy of the spiritual over the physical. Inner well-being mattered more than outer comfort. He gave his personal version of Van Gogh's cutting off his ear:

Van Gogh and Gauguin were having an argument about whether physical pain was worse than spiritual pain. Gauguin claimed it was and Van Gogh claimed it wasn't. Van Gogh said physical pain was nothing and he cut off his ear to prove it right then and there. I would have done just the same. When I was young, I was just as stubborn.

It was nearly dawn when Holty took Mondrian home from Von Wiegand's in a taxi. Mondrian invited Holty up to have a look at the latest incarnation of *Victory Boogie Woogie*. Having been away from it for a few hours, Mondrian saw "new things." When Holty left at 4 a.m., he felt that Mondrian would start making changes on the large canvas rather than go to bed.

XVI

Hans Richter invited Mondrian to a cocktail party scheduled for Tuesday, January 25. Richter was the consummate host, these monthly events being happy gatherings for Breton, Duchamp, Léger, and other experimental artists. Such get-togethers suited Mondrian's need to be out in society in part because, unlike lunches or dinners, they allowed him to arrive and depart at times of his own choosing. Since Richter lived on East 60th Street between Park and Lexington Avenues, it was a short walk, and Mondrian hoped to attend. Two days before, however, he wrote Richter that he was not sure he could make it; yet again, he was battling bronchitis.

He did not show up at the party. The following morning, as soon as it was a reasonable hour, Glarner, Holtzman, and Von Wiegand all went to Mondrian's studio. Each headed there independently, but for the same reason. They were worried about Mondrian's absence at Richter's.

Normally, Holtzman saw Mondrian regularly—they "were discussing a plan to design an ideal nightclub together"—but a few days had lapsed since he last visited. Glarner and Holtzman arrived at almost exactly the same moment. By the time Von Wiegand got there, only a few minutes later, Holtzman had rushed out to get a doctor. Mondrian was in bed, Glarner at his side. Holtzman returned quickly with Mondrian's doctor, Max Trubek. Trubek realized immediately that Mondrian had pulmonary pneumonia and admitted him to Murray Hill Hospital that afternoon.

If Mondrian had been less determined to avoid bothering any of his friends, he would have been diagnosed and treated sooner.

The artist died in the hospital less than a week later, at five in the morning on February 1, slightly over a month before what would have been his seventy-second birthday.

XVII

On January 17, Mondrian had told Von Wiegand he had finished *Victory Boogie Woogie*. Between then and his going to the hospital ten days later, it had evolved into a totally different work.

To stave off death, Mondrian had done the thing in life that animated him more than anything else: moved color around on top of whiteness. Von Wiegand described the transition:

> The picture which had seemed to me complete was covered once again with small tapes and looked as if he had been working on it in fever and with great intensity. It had a more dynamic quality and there seemed to be more little squares in various colors. The earlier picture seemed in retrospect more classical, more serene and less complicated.

But Mondrian was, at heart, neither serene nor uncomplicated. He painted according to his own nature. With all the added colored tapes and papers, *Victory Boogie Woogie* now had "a more dynamic intensity and rest-lessness . . . a more intense staccato movement." No, it was not finished. A well-lived life is never really over. But, like the universe itself, the painted canvas still had a pulse. Its beat will always live on.

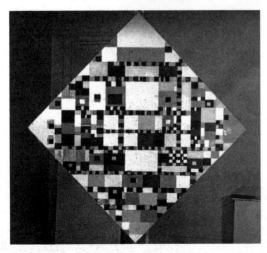

Harry Holtzman took these
photos on February 2, 1944,
shortly after Mondrian died.
When Mondrian left his
studio to go to the hospital, he
expected to return to continue
his work.

Saul Steinberg's vision of Mondrian at work in his studio.

Acknowledgments

Willem van Roij has been an invaluable research assistant for this book, but he has far exceeded what that term implies. Possessed of enormous intellect and dedicated to the particular pleasures of looking at world-class art, Willem has, for the past dozen years, epitomized patience and diligence in helping me to develop a portrait of the complex, often elusive, Piet Mondrian. With energy and tenacity, Willem has also enabled me to present the paintings in what I hope is all their glory. I could not have asked for a more tenacious and thoughtful colleague. And his personal generosity is off the charts.

Vicky Wilson—so brilliant and perceptive as an editor—has made it possible for me to write with a freedom that has been one of the luxuries of my life. After fifty-one years, Vicky left Alfred A. Knopf to write full-time at the end of 2023, but she has remained engaged with this book through its actual publication. As with the five other books I have written with her guidance over a period of forty years, she has been infinitely encouraging and insightful, and given me the chance of trying to realize my goal of extending human pleasure and understanding through the plenitude of art and architecture. I will always be grateful to the lively, worldly Gloria Loomis for having introduced us initially and recognized the potential of the very particular relationship that can exist between a writer and an editor.

Morgan Hamilton, the new editor of this book, and long a partisan of Mondrian's work, has been saintly. Entering the scene at the start of 2024 at a pivotal moment of the book's production, she has engaged in the project wholeheartedly, with gusto and depth. Ben Shields, whom I first encountered as Vicky's assistant, is a true man of letters as well as a perpetually helpful and supportive colleague. He is quick-witted and brilliant, and it has been a delight to work with him on a myriad of elements of the publication. I am also immensely grateful to Cassandra Pappas, the text designer; Jennifer Carrow, the jacket designer; and Edward Allen, the production editor. And my great thanks go to Reagan Arthur, publisher at Alfred A. Knopf, not only for her engagement with details of this book but also for the wonderful long-

time friendship my wife and I continue to enjoy with her and her husband, the gifted artist Scott Beck.

Without the remarkable Josh Slocum—tireless, ever patient, creative in his approach to all problems, and uniquely intelligent and kind—a lot that has happened in my life and with this book in particular would not have been possible. He is an extraordinary individual, and approaches life with cheer and humanism, and with qualities that include a flair for design, an immense gift as a filmmaker, and the profound vision of a talented historian.

Anne Sisco—so astute and diligent as well as droll, and uniquely attuned to the English language—has been wonderful. She has immense personal grace and daunting intelligence. The indefatigable Philippe Corfa, with his unique skills at deciphering even my most frenzied handwriting, has been essential to the completion of this book. He is a remarkable individual: immensely competent, astute, and thorough. Peter Ginna gave sage advice with great acuity and unstinting generosity.

I am grateful to Nick Serota for having suggested, at a time when there was no other biography of Mondrian, that I write one. Nick has been both a supportive reader and a warm and considerate friend, and it has been my good luck to have had him as an ally concerning the activities of the Josef and Anni Albers Foundation as well as my writing.

William Clark has been far more than a "literary agent." Not only has he attended to many details brilliantly but he has been a supportive and caring friend. He gives excellent counsel and enables me to believe in the future with happy anticipation of our next projects together.

Ina Rilke did an extraordinary job translating into English all the material that was originally in Dutch. Given that Mondrian used language in a highly personal and idiosyncratic way, this required imagination and perceptiveness of the highest order; Ina's approach has been of infinite help in making him come alive for the reader. She translated not just the material that ended up in the finished book but a great deal more, all of it vital to my access to Mondrian's complex thought processes and life experiences.

Hans Renders encouraged me to write my doctoral thesis on Mondrian's early years and mentored me in getting my Ph.D. from the University of Groningen. Throughout the process, he was as kind and fun-loving as he was exacting. I am especially grateful to Wietse Coppes, curator for the RKD's Mondrian and De Stijl archives, for introducing me to Willem van Roij and for being such a fine colleague throughout the process of searching for material vital to this book. Martina Yamin, a long-standing friend as well as granddaughter of Martijn Sanders, helped me from the very start, as did her splendid cousin, Ben Sanders. Carroll Janis provided wonderful recollections of knowing Mondrian as a child, and I was lucky enough to

have the chance to discuss my subject in some depth with his father, Sidney Janis. Madalena Holtzman kindly showed me Mondrian's collection of phonograph records—a tremendous experience—and I am grateful for her help concerning the illustrations for this book; she is an exemplar of graciousness and efficiency. Hans Janssen was helpful in showing me the early work.

Real friends are rare, and I consider myself blessed that for over half a century three individuals have made my life more enjoyable and provided balm to my soul. George Gibson, a phenomenal human being whom I first met in 1966, has been unfailingly warm, compassionate, and wise. Sandy Schwartz, whom I have known since our college days, is as he has always been: brilliant, funny, courageous, and emotionally supportive. I first came to know Mickey Cartin when I was about ten years old (and he was nine); among other things, we still laugh ourselves silly together, and his intelligence and ability to connect add to the bounty of my life.

Alan Riding is a newcomer to the scene—we have known each other for only a couple of decades—but what a stalwart and caring friend he is. Pierre-Alexis Dumas, so perceptive on a human scale and so attuned to the splendor of visual art, is, with his warmth and insightfulness, a consistent source of ballast, his wonderful family a bonus to our friendship. Charlie Kingsley—perpetually upbeat, a model of stability and rigor and kindness—has been an ally in matters Albersian for nearly fifty years as well as a great friend on the tennis and squash courts; an exemplar of integrity, he is also enormous fun to be with. Paolo Papone—priest, art historian, skier, rock climber—has been a fantastic mate with whom to explore the human mind. Dario Jucker has guided me in the battle against forgeries of paintings by Josef Albers, with values and principles that are increasingly rare in the world and with an intelligence of the highest order; moreover, he has a fantastic flair for bonding about important matters. A model of personal bravery and perceptiveness, he is a dream of a friend as well as a delightful companion on the ski slopes. David Leiber—a quintessential enjoyer of great food and wine as well as existence itself—adds immense pleasure to what without him would merely be "work." Ruth Agoos Villalovos, beautiful in every sense of the word, changed my life by introducing me to Anni and Josef Albers; I am forever beholden to her for that gift and for so much else. Bruno Racine, so sensitive and gifted, has led to my feeling at home in Paris, and he and his family connect with a warmth and kindness that are life-enhancing. François Gibault, one of the most remarkable people I know—erudite, courageous, and exceptionally kind—has also been marvelous concerning the issue of Albers fakes and in having me honored in France. Stefan Stein has been a fount of understanding, perceptiveness, and insight, always with his keen aesthetic sensibility as well as brilliant and original mind. Aline Foriel-Destezet,

who has been a marvelous companion in the work of Le Korsa (an organization I founded in Senegal), has shared her love of music with rare generosity. Daphne Astor—so astute, vibrant, and caring—has an aliveness and wit and intelligence that I cherish; her support has been unfailing. Fabrice Hergott is a friend with whom I can discuss art, children, sports, and love, always feeling that we could go on for hours more; he has depth and kindness in spades. Hugh O'Donnell and Catherine Hegarty, the most gracious and attentive of friends, are delightful companions in rural Ireland, whether at tennis or swimming in the bracing waters of Prison Cove or with sublime food and wine in the warmth of their dining room. Fiona Kearney's generosity and energy and intelligence have been over the top; she is a dynamo, and the truest of allies. Laura Mattioli helped me believe in the importance of this book ever since its inception some twelve years ago. Louis Valentin's insights about our work in Senegal and his diplomacy and intellectual depth as well as his humor and kindness are a perpetual boon to me. Romain Langlois, while I know him mainly on the squash court, is a connoisseur not just of the pleasures of the table but of life itself, with a rare understanding of the priorities of one's family. Luca Guadagnino has as keen an eye as anyone I have ever met and is always creating with sheer genius; to work with him is a scintillating adventure. Hallie Thorne still has the spirit, intelligence, and ability to encourage she has had since we first worked together in the summer of 1967. John Doyle is not just one of the most delightful people imaginable with whom to play tennis but also a profoundly kind and thoughtful human being. Allen Minor has been a pal ever since our high school days when, memorably, we thrilled to the same breakthrough chapel talks about civil rights; it was with his usual perspicacity and humor that Allen came up with the splendid Saul Steinberg portrait of Mondrian that is now in this book. Ambra Medda always outdoes herself with her exceptional spark and energy and knowledge. Dena Kaye has been sheer fun since my first meeting her when I was eight years old, and her generosity to the people of Senegal has been nothing short of breathtaking. Michelle Obama, while I have met her only once, talked about the impact of art and its importance in our lives in a way that was simply glorious. André Tamone has taught me a lot about why the pleasures of skiing, the purity of all the white and then the ravishing blue, the wonder of fluidity, the merits of letting go, are connected so directly with where this book began.

I am also immensely indebted to numerous individuals in the institutions mentioned in the endnotes and illustration credits; each has contributed to the possibility of realizing this book as I wanted.

To look at the art of Mondrian affords one a very particular form of joy. I associate the sheer pleasure I take in his work, from the best of the early landscapes through the gems of abstraction, with those of my wonderful teachers and friends with whom the experience of looking at art has had such richness. These are people with the rare capacity to understand and share the plenitude of the seeable. I am indebted, in memory, to the following individuals who with open hearts expanded the thrills of the visual world for me during their lifetimes: Irving Katzenstein, the first person I knew who made artistic creation the focal point of his life; Sanford Ballard Dole Low, an enthusiastic high school art teacher, painter, and museum director; Ethel Reuber, whose exigence about the English language and enthusiasm for my work made a lifelong impact; Sam Wagstaff, a brilliant museum curator and generous friend who enabled me to organize a show of artistic masterpieces when I was still in high school; Caroline Fox Weber, my mother, an exemplar of panache, and a fine painter whose love of music connected powerfully with her intoxication with the act of painting, and who understood the priorities of an artist's life; Saul Weber, my extraordinary father, a connoisseur of graphic design who supported my enthusiasm for Mondrian from the time I was ten years old; Joseph Savoie Stookins, a French teacher whose hour-long lecture, when I was a senior in high school, on the Gothic cathedral changed my life forever; Allen Lundie Wise, another great high school teacher, whose respect for the written word and whose teaching of Robert Browning's lines that "a man's life must exceed his grasp" were life-changing; Meyer Schapiro, whose feeling for medieval art was as vital to my university education as was his eye for modernism and who encouraged me to write about what I saw; Jane Rosenthal, who made illuminated manuscripts as magical as they should be; F. W. Dupee, who encouraged me to see Shakespearean themes in modern art; Vincent Scully, who was unequaled in his evocation of the flow of space in architecture; Rufus Stillman, who enabled me to organize the art shows of my dreams in the early 1970s, and had an incredible eye for architecture and the courage to enable greatness to be realized; Herb Agoos, an independent connoisseur of rare aesthetic sensibility; Anni Albers, a pioneering, intrepid, and caring individual who pursued the glories of universal abstraction in much the way that Mondrian did; Josef Albers, whose passion for seeing and for personal integrity has been a mainstay of my life; Leland Bell, a phenomenal painter who provided insight into all that a painter's life can be; Louisa Matthiasdottir, who painted light and evoked visual energy as have few other artists; Nick Ohly, who thrilled to the seeable, and to so much else, and was a prince of a friend; Rosamond Bernier, unique in her flair for evoking the presence of so many of the great artists of the last century, and a devoted friend; Hans Farman, a

fabulous brother to Anni Albers, who had unequaled humor and knew how to extract manna from heaven; Sean O'Riordain, a connoisseur of the human comedy and the most understanding of companions, with whom kayak outings in the Irish Sea were among life's greatest luxuries; Peggy Guggenheim, to see her in Venice was to experience imagination at an apogee, and the installation of her superb Mondrian in her dining room animated the house; Albert J. Solnit, who helped me to delve into the realm of personal truth; Jack Kenney, who demonstrated a rare flair for living and applied philosophical wisdom to all concerning the game of tennis; Jill Silverman, whose enthusiasm for the Wadsworth Atheneum in the 1930s was infectious; John Eastman, to go to an art exhibition with him was to have my senses expanded immeasurably, and he had a rare gift of friendship and a liveliness that feel immortal; Joseph Hirshhorn, a little man who lived on a very big scale and had a Mondrianesque energy; Pearl A. Weber, her wisdom and insight and grace remain mainstays long after her lifetime; Andrea Warburg Kaufman, so generous, so bright, so funny; Leslie Waddington, as much a scholar as he was an art dealer, and always encouraging me with regard to this book; Kay Swift, human vivacity itself, as warm of heart as she was glamorous, and with unique flair as a composer; Lincoln Kirstein, an exemplar of artistic passion and independent thinking; Bettina Warburg, as perceptive as she was philanthropic, and so personally encouraging to me; Frédéric Edelmann, the daring and insightful architecture critic of *Le Monde*, whose review of my *Le Corbusier* enabled me to persevere with the current book, and who became such a kind and entertaining friend; Edward M. M. Warburg, a bright and courageous patron of modernism, so witty and alert to the human comedy; Jackie Onassis, she brought such force and charm to everything she did, and had rare feeling for writing about art; Lee V. Eastman, a person of heart who realized human connections with rare verve, and who sculpted the legacy of Anni and Josef Albers with acumen; Nancy Lewis, an exemplar of warmth and charm with whom every encounter was a boost; Morley Safer, whose joie de vivre, generosity, and passion for visual art are memorable; Dick Lewis, who always gave of himself unstintingly and encouraged me to savor the writer's life; Balthus, who had more in common with Mondrian than you might imagine and whose abilities as a painter were sheer genius; Bette Davis, yes, *her*, for making me feel I could tell a story; Ruth Lord, so alert and charismatic in real life that it is hard to believe that she is no longer technically alive; Regina Tierney, who knew so much about painting, and was such a courageous and perceptive human being; Philip Johnson, a cynic but one with a rare love of classical beauty; Virginia Zabriskie, a remarkable gallerist and a brilliant companion for ice-skating; Cleve Gray, whose

dedication to the artist's life was so remarkable; Hugh Gough, who made the power of the harpsichord come alive with flair; John Richardson, ever amusing, and an example of what it means for a biographer to immerse himself in his subject; Francine du Plessix Gray, whose gift for language made her company as remarkable as her writing; Achim Bourchardt-Hume, whose knowledge of art and emotional depth were vast; King-lui Wu, whose feeling for excellence, whether in cuisine or architecture, made him an exceptional companion; Denise René, so passionate about pure abstraction and so full of earthy perceptions; W. Gray Horton, a painter's son with a flair for the good life who made me at home in the England of Evelyn Waugh; and Rosalie Akst Fox, who opened my eyes to music and poetry and to love itself. I hope that something of each of these remarkable individuals lives on in this book.

Meanwhile, I am grateful in myriad ways to the following people who continue to bring immense joy to my life and who have given me the will to carry on for the twelve years during which I wrote this book. These spectacular individuals grace my existence with heart and soul, and each in his or her own way has contributed to my ability to write this book: Barbara Ryden, John Ryden, Pierre Otolo, Shane O'Neill, Carolina Duran, Allegra Itsoga, Emma Lewis, Matthias Persson, Elsie Childs, Sam Childs, Magueye Ba, Danjoe O'Sullivan, Maimouna Sow, Howard Marks, Nancy Marks, James Costos, Michael Smith, Lo-Yi Chan, Louis Racine, Candace Kraus, Mel Winn, Elisabeth Nijhuis-Wiggers, Clim van Roij, Sabijn van Roij, Tiber van Roij, Hans van Roij, Anne van Roij, Sjoerd van Faassen, Marty Bax, Gina Newfield, Toshiko Mori, Massamba Camara, Veronica Sommaruga, Laura Jacobs, Daniela Bertazzoni, Emma Nordberg, Chris Chan, Tom Nash, Amy Tai, Margaret Jay, Mike Adler, Daniele Reiber, Brooke Rapaport, Richard Rapaport, Alan Yorker, Ellen Weber Libby, Mark Simon, Stefano Donati, Mads Aaserud, John Sornberger, Jaime Yaya Barry, Édouard Detaille, David Roberts, Micky Astor, Fritz Horstman, Thomas Clotteau, Nick Murphy, Jay Eastman, Louise Eastman, Lee Eastman II, Jane Grossman, Didier Schulman, Martien Mulder, Samuel Gaube, Jonathan Laib, Erika Goldman, Alan Cristea, Ruth Lande Shuman, Brenda Danilowitz, Amy Jean Porter, Karis Medina, Samuel McCune, Jeannette Redensek, Kyle Goldbach, Richard Hagemann, Andrew Seguin, Brigitte Degois, Veronique Wallace, Gilles Degois, John Gordon, James MacAuley, Kathy Agoos, Julie Agoos, Peter Agoos, Ted Agoos, Estrellita Brodsky, Dan Brodsky, Giacomo Rossi, Amy Arnsten, Temma Bell, Walter Milla, Tom Doyle, Kippy Dewey, Judy Dobias, Gretchen Kingsley, Giovanni Rossi, Robert Devereux, Jodie Eastman, Prue Glass, Alex Guillaumin, Kristina McLean, Edward Barber, James Green, Julia Garimorth, Manuel Herz, Daniel Humm, Ray Coppinger, Lucas Zwirner,

Monica Zwirner, David Zwirner, Lottie Hadley, Virginia Esteban, Ian Dench, Ray Nolan, Conor Doyle, Mareta Doyle, Tom Selquist, Sam Haverstick, Adhiraj Shekhawat, Lawrence O'Hana, Patrick Dewavrin, Mamadou Kanté, Shannon Hart, Lassana Keita, Ann Smith, Dave Smith, Beth-Ann Smith, Ken Madden, Paul Kiely, Giovanni Hänninen, Alberto Amoretti, Heinz Liesbrock, Maurice Moore, Sara Ohly, Zebedee Helm, Peter Cooper, Tim Prentice, Seamus O'Reilly, Fiona O'Reilly, François Olislaeger, Ascher Fox, Gustave de Staël, Maheshwar Pauriah, Moussa Sene, Jane Safer, Eve Tribouillet, Mary O'Reilly, Olivier Bayrou, Victor Tehehu, Raz Yunus, Aoife Riordain, Morgan Giacalone, Cathy Riordain, Dee Murdane, Jilly Sansone, Laurie Riordain, JoAnn Riordain, Sokari Douglas Camp, Christophe Person, Elena Prentice, Sacha Yankovitch, Philip Rylands, Hannah Starman, Bénédicte Delay, Rupert Taylor, Ariane Coulandre, Brooke Kamin Rapaport, Richard Rapaport, Hadrien Mansour, and Arthur André.

Katharine Weber, with her unique intelligence and pithy humor, has been an extraordinary wife for what will soon be half a century. Lucy Swift Weber has a spark and energy and warmth that have no equal; she is one of the lights of my life. Charlotte Fox Weber is, quite simply, miraculous; if I get started on the subject of her brilliance and her kindness, these acknowledgments will be doubled in length. Robbie Smith has been not just a son-in-law but also a true friend. Charles Lemonides, recently, to my great joy, a son-in-law as well, is as bright as they come. Lisa Sornberger has a generosity of heart and a strength that have made her appearance in my life a source of ineffable happiness. Albert Fox Cahn—immensely intelligent, idealistic, startlingly effective in his work—is a nephew of whom I am immensely proud. Nancy Weber, ever since she hung a reproduction of *Trafalgar Square* in her triangular apartment on Seventh Avenue South in the early 1960s, has been a true partner in the love of Mondrian; when we viewed an early landscape together in a show at the Janis Gallery in the 1970s, we were overcome with parallel emotions. To have a sibling of such kindness and imagination and talent as a writer has been more than fortunate.

And then there are the dedicatees of this book. Wilder Fox Smith: There is no way of expressing how much I love you, and the joy that your kindness, wit, artistry, alertness, and charisma bring to my life. Besides being impressively athletic with a keen sense of the pleasure of sports, you are funny, compassionate, remarkably modest, sharp as a tack, and full of heart. Beau Fox Smith: Even though not yet four years old as I write this, you have a humor and spark and warmth beyond all ken. Your strength of character is sure to

serve you well in life. Like your brother, you are as entertaining as you are energetic, and that is saying a lot. And Wilder and Beau: You are both, of course, the future, and you give me great hope for it. What fabulous human beings you are.

—NFW, Paris, January 2024

Notes

26, Rue du Départ

3 "Art has to be forgotten": Letter (in English) Piet Mondrian to László Moholy-Nagy, June 6, 1939, as quoted in Harry Holtzman and Martin S. James, *The New Art—The New Life: The Collected Writings of Piet Mondrian* (London: Thames and Hudson, 1987), p. 310.

4 "What a contrast!": "Bij Piet Mondriaan: Het kristalklare atelier—Apologie van den Charleston," in *De Telegraaf,* September 12, 1926, as translated in Herbert Henkels, *Mondrian: From Figuration to Abstraction* (Tokyo: Tokyo Shimbun, 1987), p. 30.

5 "The artistic conception": Ibid., pp. 30–31.

6 "As far as I am concerned": Ibid., p. 31.

7 "These dancing exhibitions": Michel Seuphor, "Piet Mondrian: Overpeinzingen en herinneringen," in *Piet Mondriaan: Ter gelegenheid van de tentoonstelling van zijn werk in het Stedelijk Museum te Amsterdam, November–December 1946* (Amsterdam: Stedelijk Museum, 1946), p. 16.

7 "was not, in any case": Peter Alma, "Piet Mondriaan," in *Piet Mondriaan: Ter gelegenheid van de tentoonstelling van zijn werk in het Stedelijk Museum te Amsterdam November–December 1946* (Amsterdam: Stedelijk Museum, 1946), p. 26.

7 "I have seen him dance": J. J. P. Oud, "Mondriaan, de mens," in L. J. F. Wijsenbeek and J. J. P. Oud, *Mondriaan* (Zeist: W. de Haan, 1962), p. 62.

8 "one of those rare cases": J. J. P. Oud, "Piet Mondriaan," in *Piet Mondriaan: Ter gelegenheid van de tentoonstelling van zijn werk in het Stedelijk Museum te Amsterdam November–December 1946,* p. 29.

8 "How refined and fastidious": All ibid.

Beginnings

10 "defend and disseminate": Henkels, *Mondrian: From Figuration to Abstraction,* p. 147.

11 They were unusually old to be still unmarried: During the entire period 1850–1870, men married between the ages of 28.8 and 29.3 on average, women between ages 27.3 and 27.7. Frans van Poppel, *Trouwen in Nederland: Een historisch-demografische studie van de 19e en vroeg-20e eeuw* (The Hague: Stichting Nederlands Interdisciplinair Demografisch Instituut, 1992), p. 24.

12 it was a prosperous place: Mieke Heurneman, *Het A'foort boek* (Bussum: Uitgeverij Thoth, 2009), p. 232.

15 "Oh, no single piece": Abraham Kuyper, "Sphere Sovereignty," in James D. Bratt, *Abraham Kuyper. Modern Calvinist, Christian Democrat* (Grand Rapids, MI: Eerdmans Publishing, 2013), p. 488.

16 that he had sex with female prostitutes: Conrad Kickert is one of the people who assumes Mondrian had sex with female prostitutes. See Marty Bax et al., "De passies van Piet Mondriaan," *Jong Holland. Tijdschrift voor kunst en vormgeving na 1850* 10, no. 2 (1994): 35. There are two stories about Mondrian's alleged homosexuality. The first one is about a fight with a homosexual man from Amsterdam who visited

Mondrian during his stay in Uden in 1904. This story is told by Van den Briel in a letter to J. M. Harthoorn [no date], as cited in Herbert Henkels, ed., *'t is alles een groote eenheid, Bert: Piet Mondriaan, Albert van den Briel en hun vriendschap aan de hand van brieven, documenten en fragmenten bezorgd en van een nawoord voorzien door Herbert Henkels* (Haarlem: Joh. Enschedé en zonen, 1988), pp. 74–75. A more definitive assertion that Mondrian was homosexual was the testimony by Mrs. Van der Hucht, head nurse of the nursing home where Aletta de Iongh lived. Mrs. Van der Hucht said that Aletta de Iongh told her that Mondrian, like De Iongh's husband, was homosexual. See notes by Evert van Straaten from February 22, 1994, in the A. De Iongh archive at the Kröller-Müller Museum, Otterlo.

17 On May 2, 1878: P. Th. F. M. Boekholt and E. P. de Booy, *De geschiedenis van de school in Nederland: Vanaf de middeleeuwen tot aan de huidige tijd* (Assen/Maastricht: Van Gorcum, 1987), pp. 214–216.

18 Kuyper, always a bit less rigid: Henkels, *Mondrian*, p. 147.

Winterswijk

23 "habit of leading his offspring": Robert P. Welsh, "Catalogue Raisonné of the Naturalistic Works (until early 1911)," I, in Robert P. Welsh and Joop M. Joosten, *Piet Mondrian. Catalogue Raisonné* (3 dln [in 2 bnd.]) (Baricum: V + K Publishing/Inmerc; Paris: Cercle d'Art, 1998), p. 143.

23 *Antirevolutionary Also in Your Own Family*: A. Kuyper, *Antirevolutionair óók in uw Huisgezin* (Amsterdam: J. H. Kruyt, 1880).

23 "Families such as those": Ibid., pp. 45–47.

24 "were intended as decorations": Carel Mondriaan to Sal Slijper, January 20, 1946, as quoted in Henkels, *Mondrian*, p. 145.

24 During the summers: Herbert Henkels, *Mondriaan in Winterswijk* (The Hague: Haags Gemeentemuseum, 1979), p. 32.

25 "F. H. Mondriaan, Hairdresser": Henkels, *Mondrian*, p. 154.

25 sold with such success: "There is naturally a reason for Frits Mondriaan's success with the art-collection public." N. H. Wolf, "Frits Mondriaan," in *De Kunst*, no. 5 (1912/13): 4–6, as translated in ibid.

25 When Piet turned fifteen: F. M. Lurasco, *Onze Moderne Meesters* (Amsterdam: C.L.G. Veldt, 1907), n.p.

27 The journalists thrived: See, for instance, N. H. Wolf, "Frits Mondriaan," in *De Kunst* (1912/13): 4–6, as translated in Henkels, *Mondrian*, p. 154: "But I venture to assert that nephew Piet's notions of art are still just as far removed from those of his uncle Frits as they ever were, perhaps even further!" And years later, the same critic, N. H. Wolf, wrote, in "Frits Mondriaan," *De Kunst* (1925): 447, as translated in Henkels, *Mondrian*, p. 154: "He [Frits] also thinks his nephew Piet and his followers . . . have confused buyers, an opinion shared by many non-ultra-modern painters . . . and for which, in view of the facts, there are some grounds of truth."

27 The royal family would acquire: Henkels, *Mondrian*, p. 154.

27 "to his disadvantage": Mondrian to H. P. Bremmer, April 8, 1914, RKD #0613, inv. nr. 19.

28 Mondrian would always maintain: The first time Mondrian mentioned this is in Lurasco, *Onze Moderne Meesters*, 1907. In the last interview he gave shortly before his death Mondrian repeated it; see Jay Bradley, "Piet Mondrian, 1872–1944: Greatest Dutch Painter of Our Time." *Knickerbocker Weekly "Free Netherlands"* 3, no. 51 (1944): 16–24.

28 Pieter Mondriaan thought: "He . . . wanted me to get a job": Ibid., p. 17.

28 His parents obligingly: Carel Mondriaan to Sal Slijper, November 29, 1945, RKD #0150, inv. nr. 131.

29 Piet's assignment was to capture: Ibid.

29 "At the slightest danger": Michel Seuphor, *Piet Mondrian: Life and Work* (New York: Harry N. Abrams, 1956), p. 46. Almost exactly the same story is told by Carel in a letter to Sal Slijper, January 20, 1946, RKD #0150, inv. nr. 133 (footnote 85).

29 At sixteen, Piet made: A1 *Woods with Stream*, 1888, charcoal and crayon on paper, 62 x 48 cm, Kunstmuseum Den Haag. Numbers preceded by A, B, or U before the title refer to the catalogue raisonné of Mondrian's works (Joosten and Welsh, 1998). There is a digital successor online, hosted by the RKD Netherlands Institute for Art History (http://pietmondrian.rkdmonographs.nl).

30 In teaching Mondrian drawing: This Dupuis method was introduced in the Netherlands by, among others, Jan Braet von Überfeldt, whom Piet got to know via his uncle Frits. See Henkels, *Mondrian*, p. 168. Cf. Jan Stap, *Piet Mondriaan: Zijn levensverhaal* (Doetinchem: Erfgoedcentrum Achterhoek, 2011), pp. 22–25.

30 In 1836, Dupuis: Alexandre Dupuis, *De l'enseignement du dessin sous le point de vue industriel* (Paris: Giroux, 1836).

30 The Dupuis method taught: Camilla Murgia, "The Rouillet Process and Drawing Education in Mid-Nineteenth-Century France," *Nineteenth-Century Art Worldwide* 2, no. 1 (2003).

31 Mondrian adhered to Dupuis's counsel: Ibid.

31 Later in his life: "I remember that one day, at Albert Gleizes', on the Boulevard Lannes, he asked if he could change places at the table in order not to see the trees of the Bois de Boulogne. Later, after 1934, the same scene was enacted at Kandinsky's in Neuilly, and again at Arp's, in Meudon." Seuphor, *Mondrian*, p. 74. Cf. Nina Kandinsky, *Kandinsky und Ich* (Munich: Knaur, 1987), p. 178: "Unvergessen ist mir indes Piet Mondrians Besuch in unserer Wohnung geblieben. Es war an einem strahlenen Frühjahrstag. Die Kastanienbäume vor unserem Haus standen in voller Blüte, und Kandinsky hatte den Kaffeetisch so hingestellt, daß Mondrian von seinem Platz aus diese herrliche Blütenpracht sehen konnte. Während wir uns beim Nachmittagstee unterhielten, unterbrach Mondrian plötzlich das Gespräch und sagte: 'Ach, wie entsetzlich!' 'Was ist entsetzlich?' fragte Kandinsky. 'Diese Bäume.' 'Diese Bäume?' 'Ja.' 'Ich wollte Ihnen eine Freude machen. Aber wir können gern unsere Plätze wechseln.' Kandinsky ließ sich auf Mondrians Stuhl nieder und Mondrian setzte sich mit dem Rücken zum Fenster hin."

32 "the proper designing": Welsh, *Catalogue Raisonné* I, p. 144. Henceforth cited as *CR* I.

32 Other qualifications included: Ibid.

32 Fewer women tried: Ibid.

33 Once he was well known: Journalists like Augustine de Meester-Obreen and Henry van Loon mention his certificates in their articles. A.O. [Augustine de Meester-Obreen], "Piet Mondriaan," *Elsevier's Geïllustreerd Maandschrift* 25, no. 50 (1915), II, pp. 396–399. Henry van Loon, "Parijsche brief: Piet Mondriaan," *Hollandsch Weekblad*, no. 35 (1937): 17–20.

34 Braet and Bing had developed: Jan Braet von Überfeldt and Valentijn Bing, *Handeling tot het teekenen naar de natuur en de beginselen der doorzigtkunde* (Amsterdam: Brinkman, 1863–1866).

34 From the Doetinchem station: Stap, *Piet Mondriaan*, pp. 22–25.

34 They were childless: Ibid., p. 25.

35 a still life of a dead hare: A7 *Geschoten Haas* (Dead Hare), 1891, oil on canvas, 80 x 51 cm, Kunstmuseum Den Haag.

35 It has a zing: Hans Janssen feels differently. He writes in his 2016 biography that "the image is done with a hardly practiced painter's hand. The carefulness was more due to a reluctant caution than knowledge and accuracy. . . . The texture of the fur hardly shows any variation and looseness." Janssen, *Piet Mondriaan, 1872–1944* (Boston: Bulfinch Press, 1994), p. 229.

36 "He can . . . do more": "e." "Kunstliefde: Tentoonstelling van Schilderijen III," in *Utrechtsch Provinciaal en Stedelijk Dagblad*, April 27, 1892, as quoted in Welsh, *CR* I, p. 150.

37 a painting of a puppy: A12 *Puppy*, 1891, oil on canvas, 52 x 40 cm, private collection.

37 Once the family learned: Pieter Mondriaan to Her Majesty, the Regent, February 27, 1892, Koninklijk Huisarchief, inv. nr. A47-X-87 nr. 297. This letter is signed P. C. Mondriaan Jr. but the handwriting is most likely his father's.

38 On March 1: The letter from February 27, 1892, has a note written on it, about

the answer to be given, March 1, 1892, Koninklijk Huisarchief, inv. nr. A47-X-87 nr. 297.

38 A committee of academicians: Welsh, *CR* I, p. 116.
38 These included a history: Henkels, *Mondrian*, p. 167; Welsh, *CR* I, p. 116.

Amsterdam

39 Amsterdam in 1892: Peter-Paul de Baar, "Een stad in beweging: Amsterdam, 1892–1912," in Robert Welsh, Boudewijn Bakker, and Marty Bax, *1892/1912 Mondriaan aan de Amstel* (Bussum: Uitgeverij Thoth, 1994), p. 8.
40 In 1892, he reunited: Nel J. Hoek, "Wormser jr., Johan Adam," in P. J. Meertens, ed., *Biografisch woordenboek van het socialisme en de arbeidersbeweging in Nederland* 5 (1992); https://socialhistory.org/bwsa/biografie/wormser.
41 whose household included: J. P. Verhave, "Johan Adam Wormser (1845–1916): Uitgever-boekhandelaar en strijder tegen conservatisme van alle gading," in Paul E. Werkman and Rolf E. van der Woude, eds., *Geloof in eigen zaak: Markante protestantse werkgevers in de negentiende en twintigste eeuw* (Hilversum: Verloren, 2006), p. 171. Cf. Bax, *Mondriaan en zijn vrienden*, p. 24.
41 Mondrian's name would be: For his membership of the Reformed Churches, see J. M. de Jong, "Piet Mondriaan en de gereformeerde kerk van Amsterdam," in *Jong Holland: Tijdschrift voor kunst en vormgeving na 1850* 5, no. 3 (1989): 20–23.
41 a still life of herring: A23 *Still Life, Herring*, 1893, oil on canvas, 66.5 x 77.5 cm, Stedelijk Museum, Amsterdam.
43 It would be Piet's task: Herbert Henkels, *Mondriaan in Winterswijk: Een essay over de jeugd van Mondriaan, z'n vader en z'n oom* (The Hague: Haags Gemeentemuseum, 1979), pp. 28–30. Cf. Welsh, *CR* I, p. 151: "According to tradition [it] had been painted by P. C. Mondriaan Senior. Henkels, however, has convincingly argued that Mondriaan Senior doubtless supplied the overall iconography and specific motifs . . . but that the execution in oil could only have been done by Mondriaan Junior."
43 "I am persuaded": Henkels, *Mondrian*, p. 151.
43 "For I am persuaded": Ibid.
44 "Mr. Mondriaan explained": Minutes of the School Board Meeting, January 31, 1894, as quoted in ibid., p. 152.
45 Mondrian's first portrait: A25 *Dorothy Gretchen Biersteker*, 1894, oil on canvas, 110.5 x 75 cm, Vancouver Art Gallery.
45 Besides being a fellow: Bax, *Mondriaan en zijn vrienden*, p. 26. Cf. Welsh, *CR* I, p. 163.
46 This was the opposite: Henkels, *Mondrian*, pp. 156–157. Cf. Robert P. Welsh, *Piet Mondrian's Early Career: The "Naturalistic" Periods* (New York: Garland Publishing, 1977), p. 181.
46 He knew the building: Marty Bax and Robert Welsh, "De Amsterdamse ateliers van Piet Mondriaan," in Welsh, Bakker, and Bax, *1892/1912 Mondriaan aan de Amstel*, p. 45.
46 *Christ's Heirs*: D. P. Rossouw, *Medeërfgenamen van Christus: Geschiedenis van de vervolgingen der Christelijke Kerk. Met eene voorrede van Dr. Andrew Murray* (Amsterdam: Höveker & Zoon, n.d. [1894]). This book was published simultaneously by the publishing house D. Bolle in Rotterdam, with an alternative title: *Het boek der martelaren of de geschiedenis van de vervolgingen der martelaren.*
47 One astute observer: Peter Ginna to the author, October 30, 2018.
49 *Girl Writing*: A123 *Girl with Bonnet Writing*, c. 1896–97, black crayon on paper, 57 x 44.5 cm, Kunstmuseum Den Haag.
52 He had never before spent: De Baar, "Een stad in beweging," p. 15.
52 Having tried but failed: Welsh, *CR* I, p. 119.
52 It began with: Ibid.
53 On May 27: Janssen, *Piet Mondriaan*, p. 259.
53 The documents remain: Welsh, *CR* I, pp. 119–120.

54 The Royal Wax Candle factory: A189, A190, A191.
55 He proposed that they have: See H. L. C. Jaffé, "Een preekstoel naar ontwerp van Mondriaan," in H. L. C. Jaffé, *Over utopie en werkelijkheid in de beeldende kunst: Verzamelde opstellen van H. L. C. Jaffé (1915–1984)* (Amsterdam: Meulenhoff/Landshoff, 1986), p. 67.
57 Among them were Catharina: Bax, "Mondriaan en zijn vrienden," pp. 26–27.
57 a bookplate: A265 *Ex Libris for H. H. Crabb*, c. 1900–1905, lithograph, 10.5 x 11.8 cm, private collection.
57 Mondrian had collaborated: Bax, "Mondriaan en zijn vrienden," p. 39; Marty Bax, *Web der schepping: Theosofie en Kunst in Nederland. Van Lauweriks tot Mondriaan* (Amsterdam: SUN, 2006), pp. 256–257.
57 A rising sun: Bax, "Mondriaan en zijn vrienden," p. 41.
58 "There is no Religion": H. P. Blavatsky, *The Secret Doctrine* (London: Theosophical Publishing Company, 1888), p. xli.
58 "the archaic wisdom-religion": H. P. Blavatsky, "What Is Theosophy," in *The Theosophist* 1, no. 1 (1879): 3.
58 "to form a nucleus": Josephine Ransom, *A Short History of the Theosophical Society* (Adyar, Madras: Theosophical Publishing House, 1989), p. 155.
58 swapped her first-class ticket: Sylvia Cranston, *H.P.B.: The Extraordinary Life & Influence of Helena Blavatsky, Founder of the Modern Theosophical Movement* (New York: G. P. Putnam's Sons, 1993), pp. 107–109.
59 *On the Lappenbrink*: A68 *Op de Lappenbrink*, 1899, gouache on paper, 128 x 99 cm, Kunstmuseum Den Haag.
60 *Wood with Beech Trees*: A88 *Wood with Beech Trees*, c. 1899, watercolor and gouache on paper, 45.5 x 57 cm, Kunstmuseum Den Haag.
61 *Two Girls in a Wood*: A91 *Two Girls in a Wood*, c. 1898–99, oil on paper, mounted on cardboard, 27.3 x 37.9 cm, Musée Départemental du Prieuré, Saint-Germain-en-Laye.
61 In both canvases: Peter Ginna in conversation with the author, October 30, 2018.
61 dining room ceiling: A133 *Ceiling Decoration: The Four Seasons*, 1899, oil on canvas, 430 x 510 cm, 608 Keizersgracht, Amsterdam.
61 Van de Velde lived: H. L. C. Jaffé, "Een gedateerde plafondschildering door Piet Mondriaan," in Jaffé, *Over utopie en werkelijkheid in de beeldende kunst*, p. 56.
61 The expanse for which Mondrian: The work is painted on canvas and was inserted into the ceiling on the spot. Ibid., p. 57.
62 The ceiling has been restored: It was restored in 1994 by Joop van Litsenburg. See J. H. van Litsenburg, *Restauratie en conservatie van een plafondschildering van Piet Mondriaan in een grachtenpand aan de Keizersgracht in Amsterdam* (Amsterdam: Litsenburg, 1994). Jaffé provided the account that it is three-year-old Hendrik van de Velde, second son of Doctor Van de Velde, who was portrayed as the wingless cherub near the center of the composition. Jaffé, "Een gedateerde plafondschildering," p. 59.
63 These flowers that Mondrian painted: A109 *Upright Chrysanthemum Against a Brownish Ground*, 1900; A110 *Upright Chrysanthemum Against a Blue-Gray Ground*, 1901. Cf. Welsh, *Piet Mondrian's Early Career*, pp. 56–57: ". . . earliest datable representation of the single flower motif by Mondrian . . . there is no reason to think that . . . such a work must de facto relate to either the Dutch or broader European Symbolist movement . . . Mondrian had succeeded in synthesizing a uniquely personal style out of various influences."
65 But never had the vendor: Van den Briel, "Mondriaan's persoonlijkheid" (version 2), in RKD #0613, inv. nr. 2.
65 It was at a performance: "Ik ging naar een uitvoering van Heda [*sic*] Gabler van Ibsen in de Stadsschouwburg . . . ik zat op de goedkoopste rang heel hoog, en toevallig naast M[ondriaan]." Van den Briel to Robert Welsh, December 15, 1967, RKD #0632, inv. nr. 20. This meeting must have taken place in September 1900. *Hedda Gabler* was performed by the theater association Het Nederlandsch Tooneel, at the Stadsschouwburg Amsterdam. See R. G. C. van der Zalm, *Ibsen op de planken: Een enscene-*

ringsgeschiedenis van het werk van Henrik Ibsen in Nederland, 1880–1995 (Amsterdam: Uitgeverij International Theatre & Film Books, 1999), p. 401.

65 At the time that he met Mondrian: Henkels, *'t is alles een groote eenheid*, pp. 147–148.

65 Part of Van den Briel's appeal: Van den Briel, "Mondriaans persoonlijkheid" (version 1), in RKD #0632, inv. nr. 1.

66 Both in the neighborhood: Ibid.

66 He gave art lessons: Bax, "Mondriaan en zijn vrienden," p. 26.

66 but on other nights: Van den Briel, "Mondriaans persoonlijkheid" (version 1), in RKD #0632, inv. nr. 1.

66 And even when he ate: Ibid.

67 "where women painters": Paul Gorter, Frans van Burkom, and Joop M. Joosten, "Mies Maris' vergeten 'Mondriana,' " in *Jong Holland: Tijdschrift voor kunst en vormgeving na 1850* 14, no. 2 (1998): 23.

68 This meant moving: Welsh, *CR* I, p. 203; Janssen, *Piet Mondriaan*, p. 298.

68 charcoal and crayon portrait: A119 *Rinus Ritsema van Eck at the Piano*, 1900, charcoal, crayon, and gouache on paper, 46 x 53 cm.

68 "the energy of the movement": https://www.encyclopedia.com/history/encyclopedias -almanacs transcripts and maps/jaell-marie trautmann.

69 "stronger and more interesting": Tertius, "Utrechtsch Provincial en Stedelijk Daghblad," April 14, 1900, as translated in Welsh, *CR* I, p. 203.

70 All that we know: Seuphor, *Piet Mondrian*, p. 51.

70 Mondrian would claim: Carel Mondriaan to Sal Slijper, January 20, 1946, RKD #0150, inv. nr. 133.

70 a self-portrait: A137 *Self-Portrait*, c. 1900, oil on canvas mounted on masonite, 55 x 39 cm, Phillips Collection, Washington, D.C.

71 "When all the portraits": Van den Briel about Mondrian, as quoted in Henkels, *Mondrian*, p. 178.

71 "that it was an insignificant": Ibid.

71 "Thus do I dare": Welsh, *CR* I, p. 210.

71 "The text is certainly": Seuphor, *Piet Mondrian*, p. 63.

71 On June 1, 1901: Welsh, *CR* I, p. 121.

71 "thorough knowledge of art theory": Henkels, *Mondrian*, p. 170.

72 "The study of a nude model": Translation of comments by the judges of the competition for the Dutch Prix de Rome taken June 17, 1901, with results presented to the jury at a meeting of July 3, in Welsh, *CR* I, p. 206.

72 On July 25, 1901: Bax, "Mondriaan en zijn vrienden," p. 26. Mondrian gave a still life with oranges (A97) as a marriage present to the couple. Welsh, *CR* I, p. 196.

73 Such successful professionals: Welsh, *CR* I, p. 121.

73 But in 1963: Welsh, *CR* I, p. 121 and p. 133 (note 25).

73 "a deep friendship": Ibid.

74 Emotionally shattered: See Albert van den Briel to J. M. Harthoorn, November 18, 1964, as quoted in Henkels, *'t is alles een groote eenheid*, pp. 60–61.

74 Whatever Mondrian told him: Van den Briel, "Mondriaans persoonlijkheid" (version 1), in RKD #0632, inv. nr. 1.

75 "a further issue": Ibid.

75 "the questionable matter": Albert van den Briel to J. M. Harthoorn, November 18, 1964, quoted in Henkels, *'t is alles een groote eenheid*, p. 61.

75 "Something was awry": Ibid.

Brabant and Afterward

76 Allebé sang the praises: Charles de Mooij and Maureen Trappeniers, *Piet Mondriaan: Een jaar in Brabant, 1904/1905* (Zwolle, Neth.: Waanders, 1989), p. 14.

77 Mondrian's book of choice: Van den Briel, "Mondriaans persoonlijkheid" (version 2), in RKD #0632, inv. nr. 2.

77 Mondrian focused on: Van den Briel, "Mondriaans persoonlijkheid" (version 1), in RKD #0632, inv. nr. 1; De Mooij and Trappeniers, *Piet Mondriaan*, p. 17.

77 His greatest triumph: "Hij was ook veehandelaar, en gaf M geregeld een stuk lams-
 vlees als hij voor zichzelf geslacht had." Van den Briel, "Mondriaans persoonlijkheid"
 (version 2), in RKD #0632, inv. nr. 2.

77 *Farm Building at Nistelrode*: A366 *Farm Building at Nistelrode I*, 1904, watercolor on
 paper, 44.5 x 63 cm, Kunstmuseum Den Haag.

78 Since he knew: Van den Briel, "Mondriaans persoonlijkheid" (version 1), in
 RKD #0632, inv. nr. 1; Van den Briel, "Mondriaans persoonlijkheid" (version 2),
 in RKD #0632, inv. nr. 2.

79 "had done all he could": De Mooij and Trappeniers, *Piet Mondriaan*, p. 21. Cf. Van
 den Briel to Welsh, December 25, 1967, RKD #0632, inv. nr. 20.

79 In the old Brabant lingo: Welsh, *CR* I, p. 291.

79 "M had a slightly Jewish": Van den Briel, "Mondriaans persoonlijkheid" (version 2),
 in RKD #0632, inv. nr. 2.

80 Amsterdam experienced: *Graafsche Courant*, July 20, 1904, as quoted in De Mooij and
 Trappeniers, *Piet Mondriaan*, p. 23.

80 Mondrian told Van den Briel: Van den Briel to Harthoorn [no date], as published in
 Henkels, *'t is alles een groote eenheidgroote eenheid*, p. 74.

81 "I arrived in Uden": Ibid.

82 "The young woman came next": All from ibid., p. 75.

83 He realized that: Albert van den Briel to Welsh, *6e mededeling*, in RKD #0632,
 inv. nr. 9.

83 "needed the tension": Albert van den Briel, as quoted in De Mooij and Trappeniers,
 Piet Mondriaan, p. 26.

83 He first needed to earn: February 15, 1905: Mondrian is granted permission to copy
 at the Rijksmuseum a painting by Nicolaes Maes, *Het Gebed zonder Eind*. Welsh, *CR* I,
 p. 124.

83 portraits of their sons: A275 *D. J. Hulshoff Pol*, 1905, Kunstmuseum den Haag; A276
 J. P. G. Hulshoff Pol, 1905, Kunstmuseum Den Haag.

83 Mondrian soon rented: Bax and Welsh, "De Amsterdamse ateliers van Piet Mondri-
 aan," p. 49.

84 The purpose of these illustrations: Mondrian mentions these bacteriological draw-
 ings in the *Knickerbocker Weekly* interview with Jay Bradley: "To make a living I did
 many kinds of work—bacteriological drawings used for textbooks." Bradley, "Piet
 Mondrian, 1872–1944," p. 18. According to Henkels, it started in 1905; see Henkels,
 Mondrian, p. 157. Cf. A. B. Loosjes-Terpstra, *Moderne Kunst in Nederland, 1900–1914*
 (Utrecht: Veen/Reflex, 1987), p. 51. According to Bax, Mondrian gave lessons to Van
 Calcar's wife; see Bax, "Mondriaan en zijn vrienden," p. 31.

86 of the Gein River: UA25 *Aan 't Gein*, 1906.

86 When his brother Willem: Welsh, *CR* I, p. 125. Cf. Seuphor, *Mondrian*, p. 48.

86 In one painting of a mill: A411 *Oostzijdse Mill with Extended Blue, Yellow and Purple
 Sky*, c. 1907–early 1908, Kunstmuseum Den Haag.

86 *Red Cloud*: A569 *De Rode Wolk*, c. 1907, 64 x 75 cm, Kunstmuseum den Haag.

87 *Fen near Saasveld*: A554 *Fen near Saasveld, Large Version*, c. 1907, 102 x 180.5 cm,
 Kunstmuseum den Haag.

87 *Riverscape with Row of Trees*: A497 *Riverscape with Row of Trees at Left, Sky with Pink and
 Yellow-Green Bands: Farmstead on the Gein Screened by Tall Trees*, c. late 1907–1908, 75 x
 120 cm, Kunstmuseum Den Haag.

87 *Summer Night*: A523 *Zomernacht*, 1907, 71 x 110.5 cm, Kunstmuseum Den Haag.

88 His new style: Cf. Marty Bax, *Het prost: Theosofie en Kunst in Nederland, Van Lauweriks
 tot Mondriaan* (Amsterdam: SUN, 2006), p. 261. More recently, a new book about
 Mondrian and Theosophy was published: see Jacqueline van Paaschen, *Mondriaan en
 Steiner: Wegen naar Nieuwe Beelding* (The Hague: Komma, 2017).

88 Among the few books: *Verslag van de voordrachten gehouden door Dr. Rudolf Steiner, voor
 de Nederl. Afd. Theos. Ver. 4–11 maart 1908*. Mondrian's copy is in the Piet Mondrian
 Papers (GEN MSS 1102), Beinecke Rare Book and Manuscript Library, Yale Univer-
 sity, New Haven.

89 "the human soul": Rudolf Steiner, *Theosophy: An Introduction to the Supersensible Knowl-*

edge of the World and the Destination of Man (London: Kegan Paul, Trench, Trübner, 1910), p. xix.

89 A decade later: Carel Blotkamp, *Mondrian: The Art of Destruction* (London: Reaktion Books, 2001), pp. 182–183.

89 *Evening: Haystacks*: A561 *Avond (Evening); Haystacks in a Field*, 1908, 82 x 193 cm, private collection.

89 For the first time: Welsh, *CR* I, p. 127.

89 That September: *Domburgsch Badnieuws* reports Mondrian's arrival at the Strand Hotel during the period September 3–10, 1908: Ibid.

90 It offered tennis: For the artistic milieu around that time in Domburg, see Francisca van Vloten, "Dromen van Weleer: Kunstenaars in Domburg, 1898–1928," in Ineke Spaander, ed., *Reünie op 't Duin: Mondriaan en tijdgenoten in Zeeland* (Zwolle: Waanders, 1994), pp. 11–71.

90 On September 12: *Domburgsch Badnieuws*, September 12, 1908, as translated in Welsh, *CR* I, p. 127.

90 He reports that: Seuphor, *Mondrian*, p. 76.

91 "The first thing to change": Piet Mondrian, *Toward the True Vision of Reality*, 1941, as quoted in Holtzman and James, *The New Art—The New Life*, p. 338. Mondrian's only explicitly autobiographical essay was written in spring 1941 and published as a pamphlet by the Valentine Gallery, New York, in connection with his first exhibition in the United States (January–February 1942).

91 "I forsook natural color": Ibid.

91 *Woods near Oele*: A593 *Bosch (Woods); Woods near Oele*, 1908, 128 x 158 cm, Kunstmuseum Den Haag.

91 "After several years": Mondrian, *Toward the True Vision of Reality*, 1941, as quoted in Holtzman and James, *The New Art—The New Life*, p. 338.

92 "The undersigned painters": Print of letter in Bax, "Mondriaan en zijn vrienden," p. 38; original at Stadsarchief Amsterdam.

93 It is stated consistently: In his 2016 biography, Hans Janssen does have Mondrian present at his mother's funeral. Janssen, *Piet Mondriaan*, p. 373. But NFW believes that this is the result of a conversation several years prior to Janssen's publication of his book when NFW told an astonished Janssen about the fallacy of the rumor that Mondrian was absent.

94 "retenu par l'ouverture": Brigitte Léal, *Mondrian* (Paris: Centre Pompidou, 2010), p. 275.

94 That is why it was astonishing: Carel Mondriaan to Sal Slijper, November 15, 1945, RKD #0150, inv. nr. 130.

94 "So I think": Ibid.

94 In February, the psychiatrist: Jan de Vries and Marijke de Groot, *Van Sintels vuurwerk maken: Kunstkritiek en moderne kunst, 1905–1925* (Rotterdam: nai010, 2015), p. 73.

94 "Mondrian's fall is tragic": Frederik van Eeden, "Gezondheid en verval in kunst," in *Op de Hoogte: Maandschrift voor de huiskamer* 6, no. 2 (1909): 79–85, as quoted in Seuphor, *Mondrian*, p. 81.

94 "What is certain": Ibid.

94 "stupidity and insensibility": Ibid.

95 Trained as a psychiatrist: Jan Fontijn, *Tweespalt: Het leven van Frederik van Eeden tot 1901* (Amsterdam: Em. Querido's Uitgeverij BV, 1999), p. 593.

95 His comments on Mondrian: Frederik van Eeden, "Kunst: Vincent van Gogh," in *De Nieuwe Gids* 6 (1891): 263–270. See also Lieske Tibbe, *Verstrengeling van traditie en vernieuwing: Kunstkritiek in Nederland tijdens het fin de siècle, 1885–1905* (Rotterdam: nai010, 2014), pp. 123–129.

95 "just a matter of taste": Van Eeden, "Gezondheid en verval," *Mondrian*, p. 79.

95 "an acute sporadic": Ibid., pp. 79–80.

95 "simply mindless": All ibid., p. 83.

95 "because they think": Ibid., pp. 83–84.

96 "much love": Letters from Mondrian to Aletta de Iongh, Archive of A. de Iongh, Kröller-Müller Museum, Otterlo, inv. nr. KM 120.999; KM 127.381.

96 In 1920, she gained: A. P. J. van Osta, ed., *Drie Vorstinnen: Brieven van Emma, Wilhelmina en Juliana* (Amsterdam: De Arbeiderspers, 1995), pp. 144–145.
96 It is unclear whether: Evert van Straaten, notes February 22, 1994, in Archive of A. de Iongh, Kröller-Müller Museum, Otterlo.
97 Written about in many texts: Cf. Harry Holtzman in Akiyoshi Tokoro, *Mondrian in New York* (Tokyo: Tokoro, 1993), p. 66.
97 Her father, Abraham: Marco Entrop, "Verliefde ogen zien Mondriaan: Uit het dagboek van Eva de Beneditty," *De Parelduiker* 8, no. 1 (2003): 29.
97 He gave her life: Marco Entrop quotes extensively from Eva's diary; all following quotations are from Entrop, "Verliefde ogen," pp. 28–45.
98 An unbroken twenty minutes: Ibid., pp. 37–38. Cf. Ageeth Scherphuis, "Vrienden over zijn vrouwen, zijn smaak, zijn armoede," n.p.
99 "no time for me": Entrop, "Verliefde ogen," p. 40.
99 "glancing up at me": Ibid.
100 "He will be able": Ibid., p. 42.
100 She would never again meet: Ibid., p. 43.
101 On May 25, 1909: Welsh, *CR* I, p. 128.
101 "special study of physiognomy": Von Wiegand, journal entry, July 10, 1941, for July 8.
102 "The man himself": Ibid.
103 Mondrian captured the moment: A693 *Sea After Sunset*, 1909, oil on cardboard, 62.5 x 74.5 cm, Kunstmuseum Den Haag.
103 In July 1909: Welsh, *CR* I, p. 129.
103 "depraved nephew": Henkels, *Mondrian*, p. 172.
104 Frits Mondriaan also paid: Seuphor, *Piet Mondrian*, p. 45.
104 *Apple Tree*: A673 *Apple Tree, Pointillist Version*, 1908–1909, oil on composition board, 56.8 x 75 cm, Dallas Museum of Fine Arts.
105 At the time that: Welsh, *CR* I, p. 396.
105 Shortly after finishing: Ibid.
106 "visited several times": Bax et al., "De passies van Piet Mondriaan," p. 35.
106 Kickert, whose syphilis: Bax and her coauthors provide a footnote in their published text saying that Robert Welsh, "who got this information from Conrad Kickert," told them all of this in "verbal communication to the writers." Ibid., p. 40, note 12.
106 *Passion Flower*: A145 *Passie Bloem*, c. 1901 (later?). Welsh himself states in *CR* that "no other work of art produced by Mondrian in a naturalistic style has been assigned dates of execution so divergent as has *Passion Flower*. . . . It was most likely produced either circa 1900–01 . . . or else circa 1908." Welsh, *CR* I, pp. 213–214.
107 *Devotion*: A642 *Devotie*, 1908, oil on canvas, 94 x 61 cm, Kunstmuseum Den Haag.
108 "I believe that": Mondrian to Querido in Israël Querido, "Een schildersstudie. Spoor, Mondriaan en Sluijters. Piet Mondriaan," *De Controleur*, no. 20 (October 23, 1909): 1004, as translated in Welsh, *CR* I, p. 129.
108 "Should a painter": Ibid., pp. 129–130.
109 "I observe my work": Ibid., p. 130.
109 "the path of ascension": Ibid.
109 He preferred it: Mondrian to Aletta de Iongh, July 23, 1910, KM 122.429.
110 "And it is rather fun": Mondrian to Aletta de Iongh [no date, August 1910], KM 166.063.
110 "sexual purity": Welsh, *CR* I, p. 130.
110 "every bit of semen": This anecdote is recounted by John Golding in the documentary video *Mondrian: Mr. Boogie-Woogie Man*, directed by Janice Sutherland, BBC London / Phaidon Press, 1995.
111 "I wouldn't be able": Mondrian to Aletta de Iongh [no date, August 1910], KM 124.785.
111 "But most people": Ibid.
111 "How lovely the flowers": Ibid.
111 "That is just superficial": Mondrian to Aletta de Iongh [no date, October 1910], KM 111.937.
111 "spiritism—a means": Ibid.
111 to Leiden to work: Ibid.

112 large blue-and-yellow painting: A708 *Zomer, Duin in Zeeland,* 1910, oil on canvas, 134 x 195 cm, Kunstmuseum Den Haag.
113 "There was no need": C. L. Dake, *De Telegraaf,* May 4, 1910, as quoted in Welsh, *CR* I, p. 467.
113 "no longer the art": Wolf, *De Kunst,* May 14, 1910, as quoted in Welsh, *CR* I, p. 467.
113 "The structure is unsound": Steenhoff, *De Ploeg,* II, as quoted in ibid.
113 "simple dune": Kickert, *Onze Kunst,* May 14, 1910, as quoted in ibid.
114 "too weak and tame": Mondrian to Aletta de Iongh [no date, November 1910], KM 118.578.
114 Mondrian spent Christmas: "With Christmas I will go to Arnhem for a couple of days." Ibid.
114 In an exhibition in Nantes: Joosten and Welsh, *CR* III, p. 25.
115 Van Dongen had gone further: "It was during this early period of experiment that I first went to Paris. The time was around 1910 when Cubism was in its beginnings. I admired Matisse, Van Dongen, and the other Fauves . . .": Piet Mondrian, *Toward the True Vision of Reality* (New York: Valentine Gallery, 1941).
115 He then resigned from Arti: Joosten, *CR* II, p. 98.
115 "would be very instructive": Mondrian to Aletta de Iongh [no date, early May 1911], KM 126.307.
115 He explored the French capital: Blotkamp, *The Art of Destruction,* pp. 57–58; Welsh and Joosten, *CR* III, p. 25; Jan van Adrichem, *De ontvangst van de moderne kunst in Nederland, 1910–2000: Picasso als pars pro toto* (Amsterdam: Prometheus, 2001), p. 28.
115 "I benefit a lot": Postcard from Mondrian to Simon Maris, dated May 19, 1911, RKD #0257, inv. nr.18.
116 Van den Briel identifies: Aleida Loosjes-Terpstra, "Mondriaan in een donkere spiegel," in *Jong Holland* 5, no. 5 (1989): 13.
116 In all three of her: Ideas thanks to Joshua Slocum, in conversation with NFW, December 21, 2020.
117 Those oversized orbs: For the influence of Theosophy on *Evolution,* see, among others, Robert P. Welsh, "Mondrian and Theosophy," in *Piet Mondrian, 1872–1944: Centennial Exhibition* (New York: Solomon R. Guggenheim Museum, 1971), pp. 43–48; Geurt Imanse and John Steen, "Achtergronden van het Symbolisme," in Carel Blotkamp, ed., *Kunstenaren der idee: Symbolistische tendenzen in Nederland, ca. 1880–1930* (The Hague: Staatsuitgeverij, 1978), pp. 30–31.
117 "I think the ordinary": Mondrian to Arnold Saalborn [no date], RKD #0613, inv. nr. 71.
117 "Being alone means": Ibid.
118 On October 9, 1911: Dake, *De Telegraaf,* October 9, 1911, as quoted in Welsh, *CR* I, p. 421.
118 "astral manifestations": Hart Nibbrig to Plasschaert, October 30, 1911, as quoted in Carel Blotkamp, *Mondriaan in detail* (Utrecht: Veen/Reflex, 1987), p. 106. Cf. Welsh, *CR* I, p. 423.
118 "collapsed against the sofa": Mondrian to Schelfhout, June 12, 1914, RKD #0163, inv. nr. 73.
118 "three gigantic blue": *De Controleur,* October 14, 1911, as quoted in Welsh, *CR* I, p. 421.
118 "led us to expect": *Het Nieuws van den Dag,* October 25, 1911, as quoted in ibid., p. 422.
118 "bluish green misses": *Arnemsche Courant,* October 30, 1911, as quoted in ibid., p. 422.
118 "penetrating expression": *Nieuwe Rotterdamsche Courant,* October 12, 1911, as quoted in ibid., p. 421.
118 "However immature": Willem Steenhoff, *De Amsterdammer Weekblad,* October 15, 1911, as quoted in ibid.
119 "Through all of this": Saalborn, *De Kunst,* November 4, 1911, as quoted in ibid., p. 422.
119 "toward the outside": Ibid.

119 It took rare prescience: Cf. Hans Janssen, *Mondriaan in Amsterdam* (Bussum: Uitgeverij Thoth, 2013), pp. 116–117. Janssen claims that Saalborn closely points out the intentions of the artist because Mondrian might have talked about it with Saalborn.

119 What happened over the next year: Karin Lony-Heybroek to Joop Joosten, March 26, 1991, copy in Bax Art Archive.

119 Kickert and Schelfhout attended: Bax, "Mondriaan en zijn vrienden," p. 42, note 80; Welsh, *CR* I, p. 135, note 74.

120 Mondrian's friends approved: "Mondrian, who has just become engaged . . . present his fiancée. He is shortly to be married." Postcard Jan Toorop to Annie Toorop, October 26, 1911, as quoted in ibid., p. 132.

Paris, 1912–1914

121 On Wednesday, December 20: Joosten, *CR* II, p. 100.

121 Simon Maris paid: Gorter et al., "Mies Maris' vergeten 'Mondriana,'" p. 47.

121 Schelfhout bought him his train ticket: L. M. Almering-Strik, *Lodewijk Schelfhout: Nederlands eerste kubist* (Zwolle: Waanders, 2018), p. 55.

121 Bruin, a pharmacist: Hans Janssen and Joop M. Joosten, *Mondrian, 1892–1914: The Path to Abstraction* (Zwolle: Waanders Publishers; Forth Worth, TX: Kimbell Art Museum, 2002), p. 168.

122 "I expect you heard": Mondrian to Aletta de Iongh [no date, heading "33 Avenue du Maine"], KM 112.577.

124 "perhaps the most important": *L'Intransigeant*, April 3, 1912, as quoted in Janssen and Joosten, *Path to Abstraction*, p. 169.

124 He used classic French: Joosten and Welsh, *CR* III, p. 26.

124 *The Large Nude*: B7 *The Large Nude*, 1912, oil on canvas, 140 x 98 cm, Kunstmuseum Den Haag.

125 "Mondrian does his Cubism": André Salmon, "Le Salon des Indépendants," *Paris Journal*, March 20, 1912, as quoted in Léal, *Mondrian*, p. 278.

125 "Such newcomers": André Salmon, "Le Salon des Indépendants," *Paris Journal*, March 20, 1912, as quoted in Janssen and Joosten, *Path to Abstraction*, p. 169.

126 They had their way: For a more detailed description of (the realization of) the exhibition, see Van Adrichem, *De ontvangst van de moderne kunst*, pp. 41–51.

126 *The Sea*: B17 *The Sea*, 1912, oil on canvas, 82.5 x 92 cm, private collection.

126 "That argues for the sea": Mondrian to the Kickerts, August 26, 1912, RKD #0613, inv. nr. 49.

127 "For just a little more": Ibid.

127 "Ah well—perhaps": Ibid.

127 A lady named Catharina: Her official maiden name was Hannaart, but she herself wrote Hannaert. See Martijn F. Le Coultre, *De hut van Mondriaan: Laren–Blaricum, 1914–1919* (Naarden, Neth.: VK Projects, 2015), p. 18. In his correspondence to others, Mondrian refers to her as Mrs. (Katinka) Hannaert, so I choose to keep it that way.

128 They often went: Maaike van Domselaer-Middelkoop, "Herinneringen aan Piet Mondriaan," *Maatstaf* 7, no. 5 (1959), p. 269.

129 "And so Mondrian and J.": Ibid., p. 270.

129 The autobuses had stopped: Ibid.

130 In daylight on weekdays: Ibid., p. 271.

131 "Well, you see": Ibid.

133 Mondrian had two paintings: Joosten and Welsh, *CR* III, p. 27.

133 *Tableau N°1*: B37 *Tableau N°1*, 1913, oil on canvas, 96 x 64 cm, Kröller-Müller Museum, Otterlo.

134 *Tableau N°3*: B33 *Tableau N°3: Composition in Oval*, 1913, Stedelijk Museum, Amsterdam.

134 Combined, they would: Eva Rovers, *De eeuwigheid verzameld: Helene Kröller-Müller, 1869–1939* (Amsterdam: Bert Bakker, 2010), pp. 96–97.

135 "insufficiently authoritative": Sheila Farr, "How a Museum Founder Helped Turn Van Gogh into an International Icon," *Seattle Times*, May 23, 2004.

136 "Because my purpose": Mondrian to H. P. Bremmer, January 29, 1914, RKD #0613, inv. nr 19.

136 "I am not ashamed": Ibid.

137 "reflections on the life": Phyllis Greenacre, "The Primal Scene and the Sense of Reality," *Psychoanalytic Quarterly* 42 (1973): 10–41.

138 "eliminate the external": Ibid., p. 20.

138 "There is a special form": Ibid., p. 26.

138 "He began to paint walls": Ibid., p. 35.

139 "too anarchistic": Mondrian to Bremmer, April 8, 1914, as quoted in Holtzman and James, *The New Art—The New Life*, p. 15.

139 "That may speak well for it": Mondrian to Schelfhout, June 12, 1914, RKD #0278, inv. nr 70, as quoted in ibid.

140 "I am glad criticism": Mondrian to Van Doesburg, May 17, 1920, as quoted in ibid., p. 394.

140 "outside the domain": Mondrian to H. P. Bremmer, January 29, 1914, RKD #0613, inv. nr 19.

140 "Nature (or the visible)": Ibid.

The Netherlands Again

141 On Saturday, July 25: According to the records from the Laren municipal registry, dated April 10, 1916, Mondrian must have arrived in the Netherlands on Saturday, July 25. Joosten, *CR* II, p. 106. The exhibition at Walrecht was originally scheduled from June 16 to July 16 but was later extended to July 31.

141 By the time he reached: For a reconstruction of the Walrecht show, see Hans Janssen, ed., *Mondrian and Cubism: Paris, 1912–1914* (London: Ridinghouse, 2016), pp. 69–145.

141 Remonstrant minister: Joosten, *CR* II, p. 105.

141 "The content has no virtue": Plasschaert, "Tentoonstellingen 2: Mondriaan," *De Amsterdammer. Weekblad voor Nederland* 38, no. 1933 (1914). As quoted in ibid., p. 106.

142 Seuphor makes his account: Seuphor, *Piet Mondrian*, p. 113.

142 "because I will be in Holland": Mondrian to Schelfhout, June 7, 1914, RKD #0278, inv. nr 68.

142 Planning the details: "In Aug. I'll come visit you, but I won't have time to stay over." Mondrian to Schelfhout, June 12, 1914, RKD #0278, inv. nr 70.

142 Additionally, his father: Anco Mali, Bert Booij, and Wim Scholtz, *Pieter Cornelis Mondriaan Senior, 1832–1921: Een gedreven vader* (Amersfoort: Stichting Mondriaanhuis; Winterswijk, Neth.: Vereniging Het Museum, 1994), p. 34.

143 They immediately killed: See, for instance, John Keegan, *The First World War* (London: Hutchinson, 1998); Max Hastings, *Catastrophe 1914: Europe Goes to War* (New York: Alfred A. Knopf, 2013); Ian Kershaw, *To Hell and Back: Europe, 1914–1949* (New York: Viking Press, 2015).

143 Many years later: James Johnson Sweeney, "Piet Mondrian," *Museum of Modern Art Bulletin* 12, no. 4 (1945): 5. Reprinted in James Johnson Sweeney, *Piet Mondrian* (New York: Museum of Modern Art, 1948).

145 "He was so engrossed": A. M. Hammacher, "Piet Mondriaan, 1872–1944," *Kroniek van Kunst en Kultuur* 8, no. 9 (1947): 233. As quoted in Joosten, *CR* II, p. 106.

145 "Day after day": Ibid.

147 "Two paths to the spiritual": Notes in Mondrian Sketchbook I, as quoted in Seuphor, *Piet Mondrian*, p. 117.

147 "When the artist finds": Ibid.

147 "Each man, each thing": Ibid.

148 "Female: static": Robert P. Welsh and Joop M. Joosten, *Two Mondrian Sketchbooks, 1912–1914* (Amsterdam: Meulenhoff International, 1969), p. 16.

148 "Because the female element": Ibid., pp. 18–19.

149 "A man always will be": Ibid., p. 42.

149 "An artist can not truly": Ibid., p. 43.

149 "The positive and negative": Ibid., p. 47.

150 Mondrian wrote Bremmer: Mondrian to Bremmer, January 16, 1917, RKD #0613, inv. nr. 19.

151 which was directly related to: Keziah Goudsmit, "Finding Balance in Art and Music: Piet Mondrian and Jakob van Domselaer's First Compositions," in Janssen, *Mondrian and Cubism*, pp. 63–67.

152 to harvest vegetables: Lien Heyting, *De wereld in een dorp: Schilders, schrijvers en werelverbeteraars in Laren en Blaricum*, 1880–1920 (Amsterdam: Meulenhoff, 1994), p. 209.

152 He told his friends: Van Domselaer-Middelkoop, "Herinneringen," p. 284.

152 Broke as they all were: Mandy Prins, 'Salomon B. Slijper (1884–1971)," in Huibert Schijf and Edward van Voolen, eds., *Gedurfd Verzamelen: Van Chagall tot Mondriaan* (Zwolle: Waanders, 2010), p. 148. Cf. Heyting, *De wereld in een dorp*, p. 180.

152 Middelkoop provides an account: Van Domselaer-Middelkoop, "Herinneringen," pp. 284–285.

154 At that point: Ibid., p. 285.

154 "After all," Mondrian remarked: Ibid., p. 283.

155 "Neo-Plasticism": The word "Neo-Plasticism" is written in different ways in the literature, but I choose to write it this way because it was this way Mondrian wrote it himself in his 1920 eponymous essay, which he also translated into French ("Le Néo-Plasticisme") in 1920. Among Mondrian's papers was an imperfect English translation of the 1923 article "Neo-Plasticism" in another hand. A transcription of it by Mondrian himself is preserved among the Katherine Dreier papers at the Beinecke. From this we can deduce that Mondrian himself preferred "Neo-Plasticism" as the correct spelling.

155 "tried to translate into music": Seuphor, *Piet Mondrian*, p. 134. For the mutual influence of Mondrian and Van Domselaer, see also Goudsmit, 'Finding Balance in Art and Music: Piet Mondrian and Jakob van Domselaer's First Compositions," pp. 63–67.

155 "didn't dare to look": Van Domselaer-Middelkoop, "Herinneringen," p. 286.

155 "sat with a sullen face": Ibid.

155 "Oh, God! How creepy!": Ibid., pp. 286–287.

156 "Nature's a damn lousy affair": Ibid., p. 287.

156 He could not take: The painting was *Composition N°IV*; see Prins, "Salomon B. Slijper," p. 148.

156 Slijper was amazed: Ibid.

156 Salomon went to: Ibid., p. 145.

157 In that difficult period: Ibid., p. 150.

157 But Mondrian knew: "Slijper is a Jewish man, but not an everyday person; he sees good, but of course a large part is speculation. He used to buy a lot from me, for low prices yes, but that was better at the time; others bought altogether not. . . . Sometimes he takes over something from others, but for a small price." Mondrian to Van den Briel, 1925 [no date], as quoted in Henkels, *'t is alles een groote eenheidgroote eenheid*, p. 12.

158 Sunday afternoons: Prins, "Salomon B. Slijper," p. 154.

158 To Gypsy music: Heyting, *De wereld in een dorp*, p. 181.

159 "the similarity between": Jan Greshoff, "Schrijversdagboek: Piet Mondriaan," *Het Vaderland*, January 24, 1957.

159 "so stiff on the dance floor": Betty van Garrel, 'De Mondriaankenner: Salomon Slijper," *Haagse Post*, June 27, 1964.

159 He was dressed: Heyting, *De wereld in een dorp*, p. 209.

159 "We laughed about": Helma Wolf-Catz, *Het doktershuis aan de Torenlaan* (Gravenhage: Nijgh & Van Ditmar, 1981), p. 42, as quoted in Heyting, *De wereld in een dorp*, p. 232.

159 "such a naive": Herman Hana to Victor van Vriesland, June 27, 1917, as quoted in Heyting, *De wereld in een dorp*, p. 232.

160 "pretty dancing shoes": Ibid.

160 "When I asked him": Van Domselaer-Middelkoop, "Herinneringen," pp. 283–284.
160 "the Dancing Madonna": Ibid., p. 284.
160 "found a suitable": Piet Mondrian to Simon Maris, August 19, 1915, RKD #0257, inv. nr. 63.
161 "On June 10 Hamdorff": Mondrian to Slijper, May 24, 1916, RKD #0150, inv. nr. 149.
161 Mondrian liked it: Mondrian to Slijper, 1916, RKD #0150, inv. nr. 171.
162 "Emotion is more superficial": Mondrian quoted in Meester-Obreen, "Piet Mondriaan," pp. 398–399.
162 "He would have loved": Ibid., p. 399.
163 He sent Van Doesburg: B72 *Church Façade* 7, 1915, whereabouts unknown.
163 "As you see": Mondrian to Van Doesburg [no date; October 1915], RKD #0408 inv. nr. 134.
163 "an *abstract* human mind": Ibid.
163 He wrote a poem: Unfortunately, this poem has not been published and is lost. See L128 *Kathedraal I*, October 1915, in Els Hoek, ed., *Theo van Doesburg: Oeuvre catalogus* (Utrecht and Otterlo: Centraal Museum/Kröller-Müller Museum, 2000), p. 654. Cf. Alied Ottevanger, *"De Stijl overal absolute leiding": De briefwisseling tussen Theo van Doesburg en Antony Kok* (Bussum: Uitgeverij Thoth, 2008), pp. 99–105.
163 "Your verse has": Mondrian to Van Doesburg [no date; October 1915], RKD #0408, inv. nr. 134.
163 "To limit his": Theo van Doesburg, "Kunst-kritiek. Moderne kunst. Stedelijk Museum, Amsterdam. Expositie Mondriaan, Leo Gestel, Sluijters, Schelfhout, Le Fauconnier," in *Eenheid: Weekblad voor maatschappelijke en geestelijke stroomingen* 6 (1915–1916): 283, November 6, 1915, as quoted in Joosten, *CR* II, p. 109.
165 Now, in 1916: See Hoek, *Theo van Doesburg: Oeuvre catalogus*. For instance, catalogue number 420 *Portret van Lena Milius*, c. 1915; 470 *Compositie I (stilleven)*, 1916.
165 Van Doesburg declared Milius: Hans Renders and Sjoerd van Faassen, "Agnita Feis: Dichter en beeldend kunstenaar zonder oeuvre. Pacifisme voor alles," *Zacht Lawijd* 16, no. 4 (2017): 67–92.
165 After meeting them happily: For this first encounter, see also Van Domselaer-Middelkoop, "Herinneringen," pp. 276–277.
166 "I have the general impression": Van Doesburg to Antony Kok, February 7, 1916, as quoted in Joosten, *CR* II, p. 109.
166 "He regards mathematics": Ibid.
166 "Mondriaan is not really": Ibid.
166 "When he was no longer": Van Domselaer-Middelkoop, "Herinneringen," p. 286.
167 *Composition in Line*: B82 *Composition in Line*, 1916 (first state).
167 "the greatest possible": Mondrian to Bremmer, July 15, 1916, RKD #0613, inv. nr. 19. Quoted in Joosten, *CR* II, p. 255.
168 "something which is": Mondrian to Slijper, May 3, 1916, RKD #0150, inv. nr. 147. Quoted in Joosten, *CR* II, p. 255.
168 "completely happy with": Ibid.
168 Four days later: Mondrian to Van Assendelft, May 7, 1916, in Joosten, "Documentatie over Mondriaan (4)," p. 219.
168 "more advanced, more universal": Mondrian to Bremmer, July 15, 1916, RKD #0613, inv. nr. 19. Quoted in Joosten, *CR* II, p. 255.
168 "humble opinion": Ibid.
169 He used a little cross: Mondrian to Van Doesburg, July 21, 1916, RKD #0408, inv. nr. 134.
169 "Uh . . . listen": Van Domselaer-Middelkoop, "Herinneringen," p. 282.
171 his particular slant: Joosten, *CR* II, p. 111. Cf. Van Paaschen, *Mondriaan en Steiner*, p. 110.
171 "I stood firm": Mondrian to Van Assendelft [postmarked January 26], 1917, quoted in ibid., p. 111.
171 "if it was any better": Ibid.

172 "So I will have to improvise": Mondrian to Van Assendelft, February 19, 1917, RKD #0154, inv. nr. 3.

172 When the heroic vicar: Mondrian to Van Assendelft, February 22, 1917, RKD #0154, inv. nr. 4.

172 "Be assured that I": Ibid.

172 "I am now reading": Ibid.

173 "The essential thing": Eugène Emmanuel Lemercier, *A Soldier of France to His Mother: Letters from the Trenches on the Western Front* (Chicago: A. C. McClurg, 1917), p. 19.

173 "Dear Mother, less": Ibid., pp. 19–20.

174 *Composition in Line*: B83 *Compositie in Lijn*, 1917 (second state), oil on canvas, 108 x 108 cm, Kröller-Müller Museum.

174 "The main reason": Mondrian to Bremmer, March 7, 1917, RKD #0613, inv. nr. 19. Quoted in Joosten, *CR* II, p. 256.

174 "But with searching one": Ibid.

174 "beginning to like it": Mondrian to Slijper, April 18, 1917, RKD #0150, inv. nr. 182. Quoted in ibid.

174 "The white ground": Mondrian to Bremmer, May 4, 1917, RKD #0613, inv. nr. 19. Quoted in ibid.

175 Each brings the viewer: B84 *Compositie in Kleur A*, 1917, oil on canvas, 50.3 x 45.3 cm, Kröller-Müller Museum; B85 *Compositie in Kleur B*, 1917, oil on canvas, 50/50.5 x 45 cm, Kröller-Müller Museum.

176 "As to the blue": Mondrian to Van Doesburg, May 16, 1917, RKD #0408, inv. nr. 134. Quoted in Joosten, *CR* II, p. 258.

177 "shows the religious": Mondrian to Van Doesburg, July 7, 1917, RKD #0408, inv. nr. 134. Quoted in ibid., p. 256.

178 In November 1917: Sjoerd van Faassen and Hans Renders, "Theo van Doesburg en de oprichting van De Stijl," in *Piet Mondriaan en Bart van der Leck: De uitvinding van een nieuwe kunst; Laren, 1916–1918*, edited by Hans Janssen (The Hague: Gemeentemuseum Den Haag, 2017), p. 142.

178 He insisted that: Seuphor, *Piet Mondrian*, p. 138. Sjoerd van Faassen and Hans Renders mention Van der Leck's claims in Van Faassen and Renders, "Theo van Doesburg en de oprichting van De Stijl," p. 132.

178 "That's the sort of person": Seuphor, *Piet Mondrian*, p. 138.

178 "to awaken aesthetic": Editorial [Theo van Doesburg], "Ter Inleiding," *De Stijl*, no. 1 (1917): 3. Translation quoted in Seuphor, *Piet Mondrian*, p. 141.

178 "meddling with color": Seuphor, *Piet Mondrian*, p. 138.

179 "and first of all": Hans L. C. Jaffé, "Introduction," in *De Stijl, 1917–1931: Visions of Utopia*, edited by Mildred Friedman (Oxford: Phaidon, 1982), p. 14.

179 "authentically modern artist": "Ter Inleiding," *De Stijl* 1, no. 1 (1917): 3. Translation quoted in Seuphor, *Piet Mondrian*, p. 141.

179 "a spiritual community": Ibid.

180 "The life of modern": Piet Mondriaan, "De Nieuwe Beelding in de Schilderkunst," *De Stijl, no. 1* (1917): 2. Translation quoted in Holtzman and James, *The New Art— The New Life*, p. 28.

180 "The life of *truly modern* man": Ibid.

181 "Piet suggested that": Paul F. Sanders, "Herinneringen aan Piet Mondriaan," *Maatstaf* 27, no. 12 (1979): 1.

182 "rather monotonous": Ibid., p. 2.

182 "he started talking": Ibid.

183 "I read those": Mondrian to Willy Wentholt, February 20, 1918, RKD #0787.1.

183 "Willy, of course": Mondrian to Wentholt, March 6, 1918, RKD #0787.4.

183 "Saturday afternoon": Mondrian to Wentholt, March 16, 1918, RKD #0787.5.

184 "Willy, here is": Mondrian to Wentholt, May 24, 1918, RKD #0787.6.

184 "Sunday afternoon": Mondrian to Wentholt, June 9, 1918, RKD #0787.7.

184 "I have prepared": Mondrian to Wentholt, October 1, 1918, RKD #0787.8.

185 "I also struggled": Mondrian to Wentholt, August 6, 1923, RKD #0787.22.

186 *Composition with Color Planes*: B92 *Composition with Color Planes and Gray Lines 1*, 1918, private collection; B93 *Composition with Color Planes and Gray Lines 2*, 1918, lost by fire; B94 *Composition with Color Planes and Gray Lines 3*, 1918, lost by fire.

186 "It is true": Mondrian to Van Doesburg, April 18, 1919, RKD #0408, inv. nr. 136. Translation quoted in Joosten, *CR* II, p. 266.

187 Working at a fever pitch: Mondrian to Van Assendelft, January 6, 1919, RKD #0154, inv. nr. 6. The fifth annual exhibition of the Hollandsche Kunstenaarskring was from February 22 until March 23, 1919. Joosten and Welsh, *CR* III, p. 29.

187 "a regular subdivision": Mondrian to Van Doesburg, June 13, 1918, RKD #0408, inv. nr. 135. Translation quoted in ibid.

187 "I am constantly changing": Mondrian to Van Assendelft, January 6, 1919, RKD #0154, inv. nr. 6. Translation quoted in ibid.

188 "You must keep": Mondrian to Van Doesburg, February 13, 1919, RKD #0408, inv. nr. 136. Translation quoted in ibid.

188 *Composition with Grid 3*: B97 *Composition with Grid 3: Lozenge Composition*, 1918, oil on canvas, diagonal: 121 cm, sides: 84.5 x 84.5 cm, Kunstmuseum Den Haag.

189 He then applied: In many letters to Van Doesburg and Slijper, from September 1918 until January 1919, Mondrian mentions having the Spanish flu. See RKD #0408, inv. nr. 135 and 136; RKD #0150, inv. nr. 189.

189 He had to remove: Hans Janssen told me this when I was with him at the Kunstmuseum, July 7, 2011.

190 "faun-like dances": Heyting, *De wereld in een dorp*, p. 181.

191 "It has something to say": Mondrian to Van Doesburg, undated [April 1918], RKD #0408, inv. nr. 135. Translation quoted in Joosten, *CR* II, p. 268.

191 "pot boilers": Ibid., p. 114.

192 "You must keep in mind": Mondrian to Van Doesburg, February 13, 1919, RKD #0408, inv. nr. 136. Translation quoted in ibid.

Paris

193 He gave notice: Mondrian to Van Doesburg, April 18, 1919, RKD #0408, inv. nr. 136.

193 It was not hard: Letters Mondrian to Slijper, July 21, 1919, and September 12, 1919, RKD #0613, inv. nr. 127.

193 Slijper also agreed: Postcard from Mondrian to Slijper, July 5, 1919, RKD #0150, inv. nr. 196. Letter from July 21, 1919, RKD #0613, inv. nr. 127.

193 And Peter Alma purchased: Mondrian to Van Doesburg, June 30, 1920, RKD #0408, inv. nr. 137.

193 Around ten o'clock: Mondrian to Slijper, July 21, 1919, RKD #0613, inv. nr. 127.

194 "I'll return to France": Seuphor, *Piet Mondrian*, p. 134.

194 "was very dirty": Mondrian to Slijper, July 21, 1919, RKD #0613.

194 "a French friend": Ibid.

195 Since a single egg: Ibid.

195 "Still I am happy": Ibid.

195 "it is as if it is constantly thundering": Ibid.

196 "+ 150 for the drawings": Ibid.

196 They negotiated: Mondrian to Slijper, November 15, 1919, RKD #0613.

196 Finally, Mondrian finished: B102 *Composition with Grid 8: Checkerboard Composition with Dark Colors*, 1919, oil on canvas, 84 x 102 cm, Kunstmuseum Den Haag; B103 *Composition with Grid 9: Checkerboard Composition with Light Colors*, 1919, oil on canvas, 86 x 106 cm, Kunstmuseum Den Haag.

196 Nonetheless, these two paintings: Van Doesburg to Oud, June 24, 1919.

198 "But it could": Mondrian to Van Doesburg, August 21, 1919, RKD #0613.

201 "without him, a number": Letter to Jacques Doucet in Dan Franck, *Bohemian Paris* (New York: Grove Press, 2001), p. 268.

202 On his very first visit: Mondrian to Van Doesburg, August 1, 1919, RKD #0613.

202 "Like most of the Cubists": Ibid.

202 "with my nose": Mondrian to Van Doesburg, August 21, 1919, RKD #0613.

203 "Yesterday I went": Ibid.
203 "So here I am": Ibid.
203 "Let them sputter": Ibid.
204 "I haven't seen Archipenko": Mondrian to Van Doesburg, October 11, 1919, RKD #0613.
204 "So he lives next door": Ibid.
205 "Thank you, and Lena too": Ibid.
206 "I am—I believe": Mondrian to Van Doesburg, no date [November 1919].
206 "wants to exhibit his work": Ibid.
206 "I am quite content": Ibid.
206 "I'm quite pleased": Mondrian to Slijper, November 15, 1919.
207 "My new article": Mondrian to Van Doesburg, December 4, 1919, RKD #0613.
208 By the end of 1920: B104–B114.
208 *Composition with Yellow, Red, Black, Blue, and Gray*: B114 *Composition with Yellow, Red, Black, Blue, and Gray*, 1920, oil on canvas, 51.5 x 61 cm, Stedelijk Museum.
209 In June 1919: Piet Mondrian, *Natural Reality and Abstract Reality: A Trialogue (While Strolling from the Country to the City)*, De Stijl, 1919–1920. Henceforth (and in main text) *Trialogue*.
209 "which begins in the country": Seuphor, *Piet Mondrian*, p. 302.
209 "If it didn't": Mondrian, *Trialogue*, as quoted in Holtzman and James, *The New Art—The New Life*, p. 83.
210 *Summer Night*: A523 *Summer Night*, 1907, oil on canvas, 71 x 110 cm, Kunstmuseum Den Haag.
210 *Fen near Saasveld*: A554 *Fen near Saasveld, Large Version*, c. 1907, oil on canvas, 102 x 180 cm, Kunstmuseum Den Haag.
210 *Composition with Grid 5*: B99, *Composition with Grid 5: Lozenge Composition with Colors*, oil on canvas, 60 x 60 cm, Kröller-Müller Museum.
210 "Pure plastic vision": Mondrian, *Trialogue*, as quoted in Holtzman and James, *The New Art—The New Life*, p. 99.
210 Mondrian told the writer W. F. A. Röell: It was in his article "A Visit to Piet Mondrian" in *Het Vaderland*, published on July 9, 1920, that Röell wrote, "The painter discloses the name of his creation: *Foxtrot*." But the title did not stick, and the only paintings to which Mondrian finally gave the name *Foxtrot* date from 1930 or later. The painting that Röell saw on the easel is known today as *Composition C / Composition with Red, Blue, Black and Yellow-Green* and is in the collection of the Museum of Modern Art in New York.
212 "That he wants to be rid": Mondrian to Van Doesburg, February 9, 1920, RKD #0613.
212 "Besides this being": Mondrian to Sal Slijper, February 9, 1920, RKD #0613.
213 "soft, meaning sensitive": Van den Briel to Welsh, December 25, 1967, RKD #0632.
213 "He appreciated them": Coos Versteeg, *Mondriaan: Een leven in maat en ritme* (The Hague: SDU Uitgeverij, 1988), p. 115.
214 "One could cross": Van Doesburg to Oud, February 24, 1920, Fondation Custodia 1972. A.514, as quoted in Holtzman and James, *The New Art—The New Life*, p. 124.
214 "gave the editor": Ibid.
214 "Ru-h ru-h-h-h-h-h": Mondrian, "Les Grands Boulevards," as quoted in ibid, p. 126.
214 "Time and space move": Ibid.
215 "The sidewalk under": Ibid., p. 127.
215 "What is brought": Ibid.
216 "The flower seller": Mondrian, "Little Restaurant—Palm Sunday," as quoted in ibid., p. 131.
217 "We had a wonderful time": Mondrian to Lena Milius, March 10, 1920.
217 "nothing more than": Joosten, *CR* II, p. 117.
218 "I saw an advertisement": Mondrian to Van Doesburg and Milius, April 19, 1920, RKD #0613.
218 "I have finished": Mondrian to Van Doesburg and Milius, May 5, 1920, RKD #0613.
219 "I forgot to tell": Mondrian to Van Doesburg, June 12, 1920, RKD #0613.
219 "I expect you are very busy": Ibid.

220 "That Miss Steijling": Ibid.

221 "Stieltjes will be paying": Ibid.

221 "Dr. Schoenmaekers had given": Mondrian to Van Doesburg, July 5, 1920, RKD #0613.

221 "In classical and romantic": Mondrian, "Neo-Plasticism: The General Principle of Plastic Equivalence," in Holtzman and James, *The New Art—The New Life*, p. 142.

222 "Although art is": Ibid., p. 134.

222 "This action contains": Ibid.

223 "Through the immutable": Ibid.

223 "It is generally not realized": Ibid., pp. 136–137.

223 "Up to the present": Ibid., p. 137.

224 "In our time": Ibid., p. 145.

224 "Thus, through the new": Ibid., p. 147.

225 Admiring Oud in advance: For Oud, see Ed Taverne et al., *J. J. P. Oud, 1890–1963: The Complete Works* (Rotterdam: NAi Publishers, 2001).

225 "Dear Bob": Mondrian to Oud, August 25, 1920, RKD #0613.

225 "Yes you were right": Ibid.

226 "Well now, here we are": Mondrian to Van Doesburg, September 5, 1920, RKD #0613. The "T." refers to Vantongerloo, whose name can be read as Van Tongerloo.

226 "But he just doesn't": Ibid.

226 "a musician who needed money": Mondrian to Van Doesburg and Milius, October 21, 1920, RKD #0613.

227 "I could have got": Mondrian to Van Doesburg, December 10, 1920, RKD #0613.

227 "My news is that": Mondrian to Van Doesburg, end of December 1920, RKD #0613.

228 "Otherwise I'll look": Ibid.

228 "I could let": Mondrian to Van Doesburg, February 10, 1921, RKD #0613.

228 A painting had been damaged: La Section d'Or—Paris, Kubisten en Neo-Kubisten, Rotterdam: Rotterdamsche Kunstkring, June 20–July 4; 's-Gravengahe: Haagsche Kunstkring, July 11–August 1; Arnhem: Korenbeurs, September; Amsterdam: Stedelijk Museum, October 23–November 7, 1920.

228 "So I haven't written": Mondrian to Van Doesburg, February 10, 1921, RKD #0613.

Continuity

232 "someone here": Mondrian to Oud, August 30, 1921.

233 "the unruly audience" [The]: Carl Van Vechten, as quoted in "Controversial ballet 'Le Sacre du printemps'—'The Rite of Spring'—performed in Paris," accessed January 16, 2024, https://www.history.com/this-day-in-history/controversial-ballet-le-sacre-du -printemps-performed-in-paris.

235 Mondrian was impressed: Joosten, *CR* II, p. 120.

236 "The *pure manifestation*": Mondrian, "The Manifestation of Neo-Plasticism in Music and Italian Futurists' Bruiteurs," 1921, as translated in Holtzman and James, *The New Art—The New Life*, p. 149.

236 "amalgamation of the most dissonant": Ibid.

237 "Dear Does and Nelly": Mondrian to Van Doesburg, no date [mid-1922, certainly after May 5, 1922], RKD #0613.

238 "Everything is dead": Ibid.

238 "I am now making flowers": Mondrian to Van Doesburg, no date [late 1921, early 1922], RKD #0613.

239 "I just received": Ibid.

239 "My dear friends": Mondrian to Van Doesburg, no date [August 1921], RKD #0613.

240 "I have got my work": Ibid.

240 "Great news and fun": Ibid.

241 "Dear Does, now I am told": Mondrian to Van Doesburg, no date [mid-September 1921], RKD #0613.

242 "Then he went to Holland": Mondrian to Van Doesburg, December 1, 1921, RKD #0613.

243 "Fortunately I have": Ibid.
243 "Valmier was the only": Ibid.
243 "I don't know what": Ibid.
243 "They just refuse": Ibid.
243 "I also think Steiner": Ibid.
244 "So now he writes": Mondrian to Oud, December 1, 1921, RKD #0613.
245 "I expect you have received": Mondrian to Oud, December 10, 1921, RKD #0613.
245 "his best artist": Ibid.
245 "because I hadn't yet": Mondrian to Van Doesburg, December 28, 1921, RKD #0613.
245 "Just shows what a difference": Ibid.
246 "Because he doesn't sell": Mondrian to Van Doesburg, February 7, 1922, RKD #0613.
246 "Anyway, I don't mind": Ibid.
247 "eat far more cheaply": Ibid.
247 "You write about sharing": Ibid.
247 "Another *slight* adjustment": Mondrian to Van Doesburg, undated [mid-March 1922], RKD #0613.
247 "Got a card from Rosenberg": Ibid.

Turning Fifty

248 *Composition with Yellow, Red, Black, Blue, and Gray*: B114 *Composition with Yellow, Red, Black, Blue, and Gray*, 1920, oil on canvas, 51.5 x 61 cm, Stedelijk Museum, Amsterdam.
248 "really beautiful": Mondrian to Van Doesburg, dated Monday morning [mid-March 1922], RKD #0613.
248 "far too much": Ibid.
248 "for the second time": Ibid.
249 "We can only ask": Steijling to Oud, April 7, 1922, as translated in Joosten, *CR* II, p. 233.
249 *Tableau III: Composition in Oval*: B49 *Tableau III: Composition in Oval*, 1914, oil on canvas, 140 x 101 cm, Stedelijk Museum, Amsterdam.
249 "It is one of": Peter Alma to the Rijksmuseum, April 20, 1922, as translated in Joosten, *CR* II, p. 233.
249 "to hold out for another year": Mondrian to Slijper, May 3, 1922, as translated in ibid.
249 *Composition with Large Red Plane*: B144 *Composition with Large Red Plane, Bluish Gray, Yellow, Black, and Blue*, 1922, oil on canvas, 54 x 53.4 cm, private collection.
251 *Composition with Blue, Red, Yellow, and Black*: B142 *Composition with Blue, Red, Yellow, and Black*, 1922, oil on canvas, 79 x 49.5 cm, private collection.
252 "I have been working": Mondrian to Van Doesburg, April 4, 1922, RKD #0613.
252 "fits in beautifully": Ibid.
252 "in a few weeks time": Ibid.
253 "Recently I was just": Mondrian to Van Doesburg, dated "Tuesday evening" [April/May 1922], RKD #0613.
253 "It is Ascension Day": Mondrian to Van Doesburg, May 25, 1922, RKD #0613.
253 "I got to know": Ibid.
254 "the purchase for 1500": Ibid.
254 "I also think what": Ibid.
255 "This difference would not": Mondrian to Oud, dated "Monday evening" [August 1922], RKD #0613.
256 *Tableau with Yellow, Black, Blue, Red, and Gray*: B150 *Tableau with Yellow, Black, Blue, Red, and Gray*, 1923, oil on canvas, 54 x 53.5 cm, private collection.
256 The single abstract painting: B149 *Komposition mit Gelb, Zinnober, Schwarz, Blau und verschiedenen grauen und weissen Tonen*, 1923, oil on canvas 83.7 x 50.2 cm, whereabouts unknown.
257 "because the flowers": Mondrian to Slijper, January 25, 1923, as translated in Joosten, *CR* II, p. 125.
257 "putting a lot more work": Ibid.

258 *Blue Chrysanthemum*: C50 *Chrysanthemum*, 1910–1920, watercolor and ink on paper, 26.8 x 22.4 cm, Solomon R. Guggenheim Museum, New York.

258 "spurred Mondrian": Joosten, *CR* II, p. 126.

259 "writing again": Ibid.

259 "Beyond the responsibility": Ibid.

260 *Tableau N°I*: B126 *Tableau N°I with Black, Red, Yellow, Blue, and Light Blue*, 1921, oil on canvas, 96.5 x 60.5 cm, Museum Ludwig, Cologne.

260 "Yellow Brochure": Weber, *The Bauhaus Group*, pp. 79–80.

260 Mondrian's reputation was enhanced: Herman Hana, "Piet Mondriaan, de pionier," in *Wil en Weg* 2, no. 17 (May 15, 1924): 602–608; and no. 18 (June 15, 1924): 635–639.

261 "Paris, 20 May '24": Mondrian to the directors of the Bauhaus, May 20, 1924, Bauhaus Archiv, Walter Gropius/Bauhaus-Verlag/correspondence, folder 9.

262 "It's a long time since": Mondrian to Oud, June 2, 1925, in Joosten, *CR* II, p. 311.

262 "my latest and best canvas": Mondrian to Slijper, June 4, 1925, in Joosten, *CR* II, p. 311.

262 "painted it again": Mondrian to Slijper, March 24, 1926, in Joosten, *CR* II, p. 311.

263 "We had sat together": Sanders, "Herinneringen aan Piet Mondriaan," pp. 1–7.

263 "Once we were on our way": Ibid.

264 "We were talking about": Ibid.

266 "His reply was that I": Ibid.

All the World's a Stage

268 "If we start from technical": Mondrian, "The Neo-Plastic Architecture of the Future," in *L'Architecture Vivante* 3, no. 9 (1925), as translated in Holtzman and James, *The New Art—The New Life*, p. 196.

268 "The new beauty": Ibid., pp. 196–197.

269 "not traditional harmony": All from Mondrian, "The Neo-Plastic Architecture of the Future," in ibid., p. 197.

269 *Tableau N°2*: B166 *Tableau N°2 with Black and Gray*, 1925, oil on canvas, 50 x 50 cm, Kunstmuseum, Bern.

270 "with the utmost fanaticism": Nicholas Fox Weber, *Patron Saints: Five Rebels Who Opened America to a New Art, 1928–1943* (New York: Alfred A. Knopf, 1992), p. 168.

270 in Paris, the De Noailles: Nicholas Fox Weber, *Balthus: A Biography* (New York: Alfred A. Knopf, 1999), p. 364.

273 "The payment is in 4 instalments": Mondrian to Oud, "Sunday evening" [January 10, 1926], RKD #0613.

274 "For some time now": Ibid.

275 "a pretty multicolored": Seuphor, *Piet Mondrian*, p. 194.

276 "They are not my concern": W. F. A. Röell, "Bij Piet Mondriaan," *De Telegraaf*, September 12, 1926.

The Bare Minimum

277 *Lozenge with Two Lines and Blue*: B173 *Schilderij N°1, Lozenge with Two Lines and Blue*, 1926, oil on canvas, 61.1 x 61.1 cm, Philadelphia Museum of Art.

277 "It seems an evolution": Mondrian to Oud, May 22, 1926, RKD #0613, as translated in *CR* II, p. 323.

277 "Number 7035": Joosten, *CR* II, p. 324.

278 "rejected by Hitler": Mondrian to B. Nicholson, December 6, 1939, in ibid., p. 323.

278 *Komposition III*: B171 *Komposition III*, 1926, oil on canvas, 50 x 50 cm, whereabouts unknown.

278 *Schilderij N°2*: B174 *Schilderij N°2, mit Blau, Gelb, Schwarz und verschiedenen hellgrauen und weissen Tönen*, 1926, oil on canvas, 50.1 x 51.2 cm, whereabouts unknown.

278 Another of these canvases: B175 *Composition*, 1926(?), whereabouts unknown.

278 *Tableau N°2*: B177 *Tableau N°2*, 1926, oil on canvas, 50.1 x 50.1 cm, whereabouts unknown.
278 Another work hung as a diamond: B176 *Tableau N°1, Lozenge with Four Lines and Gray*, 1926, oil on canvas, 80 x 80.4 cm, Museum of Modern Art, New York.
280 "Nature as nature": Van Doesburg, *De Stijl* 7 (1926), as translated in *CR* II, p. 134.
281 "Neo-Plasticism makes architecture": Mondrian, "The New Plastic Expression in Painting," in *Cahiers d'Art* 1 (1926): 7, as translated in Holtzman and James, *The New Art—The New Life*, p. 202.
281 "was born in the north": Ibid.
281 "tends to suppress": Ibid.
281 "the new art shows": Ibid.
281 "the universal expressive": Ibid.
281 "The plane suppresses": Ibid.
281 "The equilibrium of pure": Ibid, p. 205.
281 "Precisely through its relationships": Ibid.
282 "the New Plastic": Ibid.
282 "Holland has produced": Katherine S. Dreier, *Modern Art*, (New York: Société Anonyme, 1926), p. 48.
283 "a touch of arteriosclerosis": Mondrian to Oud, February 3, 1927, RKD #0613.
284 "You may imagine": Mondrian to Van den Briel, undated [March 1927], as translated in *CR* II, p. 136.
284 "The positive side": Ibid.
284 "But the first shock": Mondrian to Oud, undated [March/April 1927], RKD #0613.
287 "The chief element": Desiderius Erasmus, *The Praise of Folly*, Goodreads quotes, https://www.goodreads.com/work/quotes/2365807.
287 Mondrian wrote Oud: Mondrian to Oud, undated [March 1927], RKD #0613.
288 "Friday. Dear Bob": Mondrian to Oud, Friday of May 1927, RKD #0613.
288 "Yes, life is still": Mondrian to Oud, May 13, 1927, RKD #0613.
288 "I spotted Mrs. Van Doesburg": Ibid.
289 "no one takes him": Henry van Loon, "Piet Mondriaan, de mensch, de kunstenaar," *Maandblad voor beeldende kunsten* 4, no. 7 (1927): 195–199.
289 "Mondriaan lives the life": Ibid.
292 "Dear Bob and Annie": Mondrian to the Ouds, December 4, 1927, RKD #0613.
292 "all right again now": Ibid.
292 "Yes, danced nervously": *De Telegraaf*, September 12, 1926, as translated in Holtzman and James, *The New Art—The New Life*, p. 217.
293 The Amsterdam mayor: *Nieuwe Rotterdamsche Courant*, August 26, 1926.
295 "No link with the old": Mondrian, "Jazz and Neo-Plastic," in *i10*, December 1927, as translated in Holtzman and James, *The New Art—The New Life*, p. 222.
295 "Man no longer lives": Ibid., p. 219.
296 "In the bar": Ibid., p. 222.
296 "Jazz above all": Ibid.
297 "took up an incredible": Mondrian to Oud, December 4, 1927, RKD #0613.
297 "Dear Van Doesburg": Mondrian to Van Doesburg, December 4, 1927, as translated in Joosten, *CR* II, p. 138.
298 "Perhaps it's not": Mondrian to Oud, "Wednesday evening" [postmark December 15, 1927], RKD #0613.
298 "I haven't got time": Mondrian to Oud, December 19, 1927, RKD #0613.
298 "Under the pretext": Van Doesburg, *De Stijl*, Jubileum-serie, 1927, as translated in Joosten, *CR* II, p. 138.

Rupture

299 "Dear Sal": Mondrian to Slijper, November 14, 1927, RKD #0613.
299 "Things are fine here": Mondrian to Slijper, December 12, 1927, RKD #0613.
300 "Dear Sal": Mondrian to Slijper, January 6, 1928, RKD #0613.

301 "Dear Van Doesburg": Mondrian to Van Doesburg, January 25, 1928, RKD #0613.
301 "Dear Bob and Annie": Mondrian to the Ouds, February 21, 1928, RKD #0613.
302 "But one thing did": Ibid.
303 *Composition with Yellow, Cinnabar*: B149 *Komposition mit Gelb, Zinnober, Schwarz, Blau und verschiedenen grauen und weissen Tönen*, 1923, oil on canvas, 83.7 x 50.2 cm, whereabouts unknown.
303 *Composition with Blue, Yellow*: B174 *Schilderij N°2, mit Blau, Gelb, Schwarz und verschiedenen hellgrauen und weissen Tönen*, 1926, oil on canvas, 50.1 x 51.2 cm, whereabouts unknown.
305 *Composition V*: B192 *Compositie N°I / Composition: V, with Blue and Yellow*, 1927, oil on canvas, 38 x 35 cm, Baltimore Museum of Art.
308 "Roth brought me": Mondrian to the Ouds, April 24, 1928, RKD #0613.
308 "Dear Bob and Annie": Mondrian to the Ouds, July 15, 1928, RKD #0613.
308 "They are very nice": Ibid.
308 "Charley Toorop also": Ibid.
309 "fully recovered": Mondrian to the Ouds, September 25, 1928, RKD #0613.
309 "for the nice price": Ibid.
310 "Van Anrooy has": Ibid.
311 *Composition with Red, Yellow, and Blue*: B187 *Composition with Red, Yellow, and Blue*, 1927, oil on canvas, 38 x 35 cm, whereabouts unknown.
313 Among the paintings that disappeared: B186 *Composition*, 1927; Joosten, *CR* II, p. 330.
314 "the kind services of Stam": Mondrian to Oud, March 14, 1929, RKD #0613.
314 "The first encounter": Van Doesburg, journal entry, May 1929, in Léal, *Mondrian*, p. 306; translation by NFW.
314 "I have also submitted": Mondrian to the Ouds [late September, early October 1929], RKD #0613.
316 "blue and yellow, white and gray": Mondrian to Roth, September 7, 1929, in Joosten, *CR* II, p. 351.
316 Mondrian finished the painting: B217 *Composition with Red, Blue, and Yellow*, 1930, oil on canvas, 46 x 46 cm, Kunsthaus Zürich.
316 Another was bought and given: B215 *Composition N°II, with Yellow and Blue*, 1929, oil on canvas, 52 x 52 cm, Museum Boijmans van Beuningen, Rotterdam.

Lily Bles

318 a Dutch woman gave: Ken Wilkie, "Mondrian and All That Jazz," *Holland Herald* 7, no. 1 (1972): 23–37.
319 At the time that Lily: Ben van der Velden, "Late liefde in jaren 20," in *NRC Handelsblad*, January 8, 1972.
320 "Mondrian often came to visit": Lily Bles quoted in Wilkie, "Mondrian and All That Jazz," p. 33.
320 We know from a letter: Mondrian to Van Doesburg, June 6, 1917, RKD #0613, inv. nr. 25.
320 In 1918, Mondrian told: Mondrian to Van Doesburg [no date] 1918, RKD #0613, inv. nr. 25.
320 The next trace of Dop Bles: Mondrian to Van Assendelft, February 10, 1926, RKD #0613, inv. nr. 14.
321 "Our next meeting": Lily Bles in Wilkie, "Mondrian and All That Jazz," p. 33.
322 "Then," she went on: Ben Dull, "Amsterdam: Mondrian Retrospective," *New York Times*, February 7, 1972.
322 "Around 1930": Ibid.
323 "But that makes it": Van der Velden, "Late liefde in jaren 20."
324 "Because, could we": Ibid.
324 "Over the years": Wilkie, "Mondrian and All That Jazz," *Holland Herald*, p. 33.
324 "Like others who knew him": Ibid.
324 "The meetings between": Ibid.

325 "I may have been": Ibid.
325 "There was a forbidden": Van den Briel to Welsh, comment on text Seuphor, RKD #0632, inv. nr. 26.
326 "This failure to become": Van den Briel to Seuphor, August 13, 1951, from Henkels, *'t is alles een groote eenheid*, p. 24.
326 "One time when I visited": Maud van Loon, "Mondriaan, zoals hij leefde te Parijs," *De Groene Amsterdammer*, December 7, 1946.
327 "The other night Carl": Charmion von Wiegand, journal entry, January 9, 1942—for Tuesday, January 6, 1942 / for Thursday January 8, 1942 (Getty Research Institute, Call Number 990024 Mondrian/Von Wiegand).

Foxtrots and Other Dances

328 *Fox Trot B*: B210 *Composition N°III / Fox Trot B, with Black, Red, Blue, and Yellow*, 1929, oil on canvas, 45.4 x 45.4 cm, Yale University Art Gallery.
328 *Composition with Yellow, Blue, Black, and Light Blue*: B207 *Composition with Yellow, Blue, Black, and Light Blue*, 1929, oil on canvas, 50.5 x 50.5 cm, Yale University Art Gallery.
329 "Experimentierzelle-Zeitseismograf": Carola Giedion-Welcker, "Die Kunst des zwanzigsten Jahrhunderts: Experimentierzelle-Zeitseismograf," *Das Kunstblatt* 14, no. 3 (1930).
330 "triumphant modern architecture": Joosten, *CR* II, p. 145.
330 "This is calculation": Holtzman and James, *The New Art—The New Life*, p. 236.
330 "Those who march": Ibid.
330 "M. Tériade's views": Ibid. p. 237.
330 "One must become": Ibid. p. 238.
331 "Finally, I would like": Ibid., p. 241.
331 "I was sorry to learn": Mondrian to Van Doesburg, March 30, 1930, RKD #0613, inv. nr. 26.
332 "Dear Does": Mondrian to Van Doesburg, July 21, 1930, RKD #0613, inv. nr. 26.
332 "So I am entitled": Ibid.
332 *Composition N°1*: B218 *Composition N°1: Lozenge with Four Lines*, 1930, oil on canvas, diagonal 107 cm, Solomon R. Guggenheim Museum.
335 "to see Mondrian, the Dutch painter": Rebay to R. Bauer, June 3, 1930, quoted in Joosten, *CR* II, p. 352.
335 "(for nobody will like it)": Ibid.
336 "I thank you so much": Mondrian to Rebay, June 6, 1930, quoted in ibid.
336 He also suggested: Mondrian to Rebay, October 10, 1930, quoted in ibid.
337 "Now that I have": Philip Johnson to Oud, undated [Berlin, c. July 1930], quoted in ibid., p. 344.
338 "I was glad to hear": Mondrian to Oud, July 27, 1930, as quoted in ibid.
338 "But its price": Mondrian to Oud [undated], as quoted in ibid.
338 *Composition N°II*: B209, *Composition N°II, with Red and Blue*, 1929, oil on canvas, Museum of Modern Art, New York.
341 "I was very much": Alexander Calder, "Mobiles," in Myfanwy Evans, ed., *The Painter's Object* (London: Gerald Howe, 1937), pp. 63–64, as quoted in Joosten, *CR* II, p. 148.
341 "This one visit": Calder, *An Autobiography*, as quoted in ibid.
341 "I suggested to Mondrian": Calder, "Mobiles," 1937, as quoted in ibid.
341 "It was very lovely": Calder, *An Autobiography*, as quoted in ibid.
341 "Precision and simplification": As quoted in ibid.
344 In 1928, Tschichold wrote: Jan Tschichold, *Die Neue Typographie* (Berlin: Bildungsverband der deutschen Buchdrucker, 1928).
344 "The works of": Jan Tschichold, *Typographische Gestaltung* (Basel: Benno Schwabe, 1935).
344 The painting Tschichold acquired: B221 *Composition with Yellow*, 1930, oil on canvas, 46 x 46.5 cm, Kunstsammlung Nordrhein-Westfalen, Düsseldorf.
347 "Dear Bob and Annie": Mondrian to the Ouds, March (?), 1931, RKD #0613, inv. nr. 63.

348 "Dear Bob and Annie": Mondrian to the Ouds, May 14, 1931, RKD #0613, inv. nr. 63.
348 "to collaborate on a periodical": Holtzman and James, *The New Art—The New Life*, p. 182.

The Fashionable Self

350 Besides Mondrian, Sonia Delaunay: Surprisingly, Holtzman and James, in my eyes the most diligent as well as thorough of the Mondrian researchers of the past, identify what they print in their compendium of Mondrian's writings by saying it is on "an untitled tear sheet from an unidentified French publication, ca. 1930." That is followed by a statement, presumably from Harry Holtzman, that "Mondrian always expressed a lively interest in the evolution of styles of dress" (Holtzman and James, *The New Art—The New Life*, p. 226). Joosten mentions Jacques Heim and his periodical in *CR* II, p. 149. Mondrian's full statement, in fact, appeared in the third issue of the *Revue Heim*, which came out that September. Presumably there are other copies extant, but, after a lot of sleuthing, I know of only a single one—in a specialized Parisian library.
351 The edition of *La Revue Heim*: Piet Mondrian [no title], in *Revue Heim* 3 (September 1931), p. 18.
352 "Fashion is not only": Mondrian, *Revue Heim*, as quoted in Holtzman and James, *The New Art—The New Life*, p. 226.
353 "In fashion, however": Ibid.
354 "All of you, shall we say": Mondrian to Van Eesteren, March 19, 1932, as quoted in Joosten, *CR* II, p. 152.
355 "simultaneously satisfied the eye": Zervos, *Cahiers d'Art* 7, no. 1–2 (1932): 7, as quoted in Joosten, *CR* II, p. 151.
355 "The dimensions of all": Ibid.
356 The show at Zak: *Exposition d'art hollandais contemporain*, Paris: Galerie Zak, May 27–June 10, 1932. See Joosten and Welsh, *CR* III, p. 37.
356 "because people don't understand": Mondrian to Van Eesteren, June (?) 1932, as quoted in Joosten, *CR* II, p. 152.
358 "a nice, free diversion": John Brooks, "Why Fight It?," *New Yorker*, November 12, 1960, p. 70.
358 Janis bought *Composition with Red and Blue*: B239 *Composition with Red and Blue*, 1933, oil on canvas, 41.2 x 33.3 cm, Museum of Modern Art, New York.
359 "sad to see it leave": As recalled by Sidney Janis, quoted in Joosten, *CR* II, p. 367.
359 "If we clearly see": Mondrian, "The New Art—The New Life," in Holtzman and James, *The New Art—The New Life*, p. 255.
361 "is not only the culmination": Ibid., p. 256.
361 "equivalence of the two": Ibid., p. 257.
361 "Only through equivalent": Ibid.
361 "purer mutual and individual": Ibid., pp. 258–259.
361 "The mutual separation": Ibid., p. 259.
362 "the enormous influence": Ibid., p. 262.
362 "Every day we witness": Ibid.

The Certainty of Art

364 *Lozenge Composition with Four Yellow Lines*: B241 *Lozenge Composition with Four Yellow Lines*, 1933, oil on canvas, diagonal: 112.9 cm, Kunstmuseum Den Haag.
365 "was separate from the art": Mondrian to Jean Gorin, January 31, 1934, in Joosten, *CR* II, p. 155.
365 *Composition Blanc et Bleu*: B244 *Composition N°I / Composition C. 1934 / Composition (Blanc et Bleu)*, 1936, 1934/1936, oil on canvas, 121.3 x 59 cm, Kunstsammlung Nordrhein-Westfalen, Düsseldorf.

367 "What do I want to express": Mondrian as quoted in Joosten, *CR* II, p. 156.
369 "He's a true artist": Ibid., p. 158.

The Support System

372 "knew in an instant": Christopher Andreae, *Winifred Nicholson* (London: Lund Humphries, 2009), p. 49.
373 "saw that wide cloud": Ibid., p. 47.
373 "the swing of the moors": Ibid., p. 49.
373 "up the isle": Ibid.
373 "like a monk": Ibid.
373 "We do absolutely nothing": Caroline Maclean, *Circles and Squares: The Lives and Art of the Hampstead Modernists* (London: Bloomsbury Publishing, 2020), p. 5.
373 "utter paint fiends": Andreae, *Winifred Nicholson*, p. 51.
376 It was a safer place: Charles Darwent, *Mondrian in London* (London: Double-Barrelled Books, 2012), p. 5.
376 "such beautiful works": Ibid.
376 "Those are my paintings": Ibid.
377 "if it is worth your coming": Ibid., p. 17.
377 "down into thousands": Ibid., p. 19.
378 "sitting at a café table": Joosten, *CR* II, p. 155.
378 "would be pleased": Darwent, *Mondrian in London*, p. 20.
378 "Mondrian lived alone": Ibid., p. 23.
379 " 'No,' Mondrian answered": Ibid.
380 "When one thought of visiting Mondrian": Winifred Nicholson quoted in Charles Harrison, "Mondrian in London: Reminiscences of Mondrian by Miriam Gabo, Naum Gabo, Barbara Hepworth, Ben Nicholson, Winifred Nicholson, Herbert Read," *Studio International* 172, no. 884 (1966): 286.
381 "probably burnt in transportation": Joosten, *CR* II, p. 370.
381 "We all need opposition": Mondrian to Ben Nicholson, February 17, 1935, in ibid., p. 159.
381 "has demonstrated scientifically": Mondrian to Carel Mondriaan, March 2, 1935, in ibid., p. 160.
381 "It just goes to show": Ibid.
382 *Medical Millennium*: William Howard Hay, *The Medical Millennium* (Kessinger Publishing, 1927). Mondrian's copy was the seventeenth printing, from October 1933.
382 "And you're just in time": Joosten, *CR* II, p. 160.
382 "slowly closed the pressure cooker": Ibid.
382 "off balance": Ibid.
383 "The room was chilly": Ibid.
383 "He can't do": Ibid.
384 "always go out for a meal": Ibid.
384 *Composition: N°III*: B194 *Composition: N°III, with Red, Blue, and Yellow*, 1927, oil on canvas, 38 x 35.5 cm, private collection.
384 "Women always spoil me": Joosten, *CR* II, p. 160.
384 "the hardest time of my life": Ibid.
385 "The bare necessities": Ibid., p. 162.
386 "With all its apparent scope": Myfanwy Evans, "Dead or Alive," *Axis* 1 (January 1935): 3.
386 *Composition N°II*: B256 *Composition (N°II) Bleu-Jaune*, 1935, oil on canvas, 72.3 x 69.2 cm, Hirshhorn Museum and Sculpture Garden, Washington, D.C.
386 *Composition N°IV*: B258 *Composition (N°IV) Blanc-Bleu*, 1935, 1934/1935, oil on canvas, 99 x 70.3 cm, Wadsworth Atheneum, Hartford.
387 "Those arrangements of rectangular": Joosten, *CR* II, p. 162.
388 *Composition with Double Line and Blue*: B259 *Composition with Double Line and Blue*, 1935, oil on canvas, 71.1 x 68.9 cm, Beyeler Collection, Basel.

388 *Composition in Gray and Red*: B255 *Composition (N°I) Gris-Rouge*, 1935, oil on canvas, 56.9 x 55 cm, Art Institute, Chicago.

388 "Mondrian was very fussy": Joosten, *CR* II, p. 163.

390 "a hard-boiled audience": Letter of November 27, 1934, in Edward Burns, *The Letters of Gertrude Stein and Carl Van Vechten* (New York: Columbia University Press, 2013).

390 *Composition in Blue and Yellow*: B256 *Composition (N°II) Blue-Jaune*, 1935, oil on canvas, 72.3 x 69.2 cm, Hirshhorn Museum and Sculpture Garden, Washington, D.C.

391 "make it more pure": Joosten, *CR* II, p. 378.

391 "search for false ease": Holtzman and James, *The New Art—The New Life*, pp. 283–284.

391 "Let us rejoice to live": Ibid., p. 285.

391 "We are all part of life": Ibid.

393 *Composition Blanc et Bleu*: B244 *Composition N°I/Composition. C. 1934 / Composition (Blanc et Bleu), 1936*, 1934/1936, oil on canvas, 121.3 x 59 cm, Kunstsammlung Nordrhein-Westfalen, Düsseldorf.

394 "full of faults": Mondrian to Lux, September 6, 1934, in Joosten, *CR* II, p. 371.

394 "It has improved a lot": Mondrian to Barr, January 26, 1936, in ibid.

396 "Whether it is possible": Darwent, *Mondrian in London*, p. 42.

396 "looked too easy to do": Ibid., pp. 38–39.

397 "There were a number": Kenneth Clark, *Another Part of the Wood: A Self-Portrait* (London: John Murray, 1974), p. 19.

397 "unfortunately, I have not got": Ibid.

397 "Mondrian's work is most penetrated": Myfanwy Evans, "Abstract Art: Collecting the Fragments," *New Oxford Outlook* 22 (November 1935): 261.

398 "further contributions": Myfanwy Evans, *Abstract & Concrete* catalogue, quoted in Darwent, *Mondrian in London*, p. 46.

398 "a jolly leg-pull": *The Daily Mail* quoted in ibid.

398 "Nobody who has worked": *The Daily Express* quoted in ibid.

399 "very glad that Mondrian": Winifred Nicholson to Ben Nicholson, undated letter [1936], in Joosten, *CR* II, p. 163.

399 The painting Helen Sutherland bought: B254 *Composition B (No.II), with Red*, 1935, oil on canvas, 80 x 63.2 cm, Tate Gallery, London.

399 "The question of survival": Mondrian to Ben Nicholson, May 4, 1936, in Joosten, *CR* II, p. 377; translation by NFW.

Boulevard Raspail

401 "My studio is another": Mondrian to Winifred Nicholson, June 17, 1936, in Joosten, *CR* II, p. 165.

401 "I saw with pleasure": Ibid.

402 "constructivism, or, in any case": Mondrian to Ben Nicholson, October 5, 1936, in Joosten, *CR* II, p. 165.

402 "rightly against all": Ibid.

403 "the painting with the three colors": Mondrian to Winifred Nicholson, October 14, 1936, in Joosten, *CR* II, p. 382.

403 "I thank you greatly": Mondrian to Gray, November 30, 1936, in Joosten, *CR* II, p. 382; translation by NFW.

403 "One can wash it": Mondrian to Gray, December 5, 1936, in Joosten, *CR* II, p. 382.

404 *Composition en Blanc, Noir et Rouge*: B269 *Composition en Blanc, Noir et Rouge*, 1936, oil on canvas, 102 x 104 cm, Museum of Modern Art, New York.

405 "There is so much confusion": Mondrian to Winifred Nicholson, September 4, 1936, in Holtzman and James, *The New Art—The New Life*, p. 288.

405 "I too think that": Ibid.

406 "Chère Winifred": Ibid.

407 "the constructive trend": Holtzman and James, *The New Art—The New Life*, p. 288.

407 "Although art is fundamentally": Mondrian, "Plastic Art and Pure Plastic Art," 1936, in ibid., p. 289.

408 "generally considered": Museum of Modern Art press release, 1937, in Joosten, *CR* II, p. 166.
409 "take some time to enjoy": Mondrian to Carel Mondrian, June 1, 1937, in ibid., p. 167.
409 "completely apart and is more": Ibid.
410 "lapses in the editors' discrimination": George L. K. Morris, "Modernism in England," *Partisan Review,* December 1937, p. 69.
410 "painters who write abominably": Ibid., p. 70.
410 "essays by creative artists": Ibid.
410 "followed the path": Henry van Loon, *Hollandsche Weekblad,* August 28, 1937.
411 "But he abhors anything": All in ibid.
413 *Composition with Red, Blue, and Yellow*: B274.310 *Blanc et Rouge. 1937 / Composition with Red, Blue, and Yellow, 1937–42,* 1937/1942, oil on canvas, 60.3 x 55.2 cm, Museum of Modern Art, New York.
414 "disgusted" him: "Cela me dégoute" in a letter to Ben Nicholson, September 7, 1938, in Joosten, *CR* II, p. 169.
414 "Send it to me": Ibid.
415 "I am so deeply saddened": Ibid.
415 "The rest which I'm leaving": Mondrian to Carel Mondriaan, October 28, 1938, in Joosten, *CR* II, p. 170.
416 On September 15: Mondrian to Ben Nicholson, September 15, 1938, Tate Gallery Archive 8717/1/2 (copy at RKD #0613).
417 "chaotic, revolutionary, inspiring": Harrison, "Mondrian in London," pp. 285–292.
417 He wrote Ben Nicholson: Mondrian to Ben Nicholson, dated "Dimanche soir" [September 1938], Tate Gallery Archive 8717.
417 Mondrian gave the Van Loons: Maud van Loon, "Mondriaan, zoals hij leefde te Parijs," in *De Groene Amsterdammer,* December 7, 1946. Cf. Mondrian to Carel Mondriaan, October 28, 1938; Janssen, *Mondriaan in het Gemeentemuseum,* p. 259.
417 On September 20: The sources vary on Mondrian's exact date of travel. Some historians give reasons for believing it was the 21st, as Winifred Nicholson recalled many years later, and Mondrian's French visa was stamped on September 19, but in the catalogue raisonné Joosten provides a range of reasons that seem correct.
417 "Mondrian on the other side": Harrison, "Mondrian in London," pp. 287–288.
418 He would write Carel: Letter to Carel, October 28, 1938: "An easel I sold to acquaintances in Paris. The other I had to leave behind on the boat! Doesn't bother, because I work on that table and to see I put the work on a stool against the wall." Cf. Darwent, *Mondrian in London,* p. 56.
418 Thirty years later: Harrison, "Mondrian in London," p. 287.

London

420 "a Mondrian in space": Harrison, "Mondrian in London," p. 290.
421 "oughtn't to be in London": Nicholson to Leslie Martin, September 28, 1938, as quoted in Sophie Bowness, "Mondrian and London," in *Mondrian/Nicholson in Parallel,* edited by Christopher Green and Barnaby Wright (London: Courtauld Gallery, 2012), p. 62n.
421 He would write Carel: Mondrian to Carel Mondriaan, October 28, 1938, Carel Mondriaan Papers (GEN MSS 1097), Beinecke Rare Book and Manuscript Library, Yale University.
421 Folding X-shaped trestles: Ibid.
422 "The landlord has had": Mondrian to Carel Mondriaan, October 2, 1938, RKD #0929.
422 "the greatest film ever made": Roger Ebert, "Walt and El Grupo," *Chicago Sun-Times,* October 21, 2009.
422 "The dwarves don't have": Postcard from Piet to Carel Mondriaan, October 10, 1938, Beinecke (GEN MSS 1097).
423 "pair of warm carpet slippers": Harrison, "Mondrian in London," p. 289.

423　by some accounts was a bookcase: Joosten, *CR* II, p. 170.

423　by others a cupboard: Bowness, "Mondrian and London," p. 53.

423　"into his Montparnasse studio": Harrison, "Mondrian in London," p. 288 / *CR* II, p. 170.

423　"climbed up the walls": Ibid.

423　"I myself had once": Harrison, "Mondrian in London," p. 289.

423　"Ben and Barbara": Mondrian to Winifred Nicholson, October 10, 1938, RKD #0613.

424　"the news of the *meeting*": Mondrian to Ben Nicholson, dated "Friday afternoon" [October 1938], Tate Gallery Archive 8717.

425　*Trafalgar Square*: B294.322 *Compositie. 1939 / Trafalgar Square. 1939–43*, 1939/1943, oil on canvas, 145.2 x 120 cm, Museum of Modern Art, New York.

425　*Composition N°4 1938–42*: B285.313 *Composition of Red and White: Nom 1. 1938 / Composition N°4 1938–42, with Red and Blue*, 1938/1942 (second state), oil on canvas, 100.3 x 99.1 cm, Saint Louis Art Museum.

427　*Composition with Red*: B292 *Composition N°1, with Gray and Red. 1938 / Composition with Red*, 1939, oil on canvas, 105.2 x 102.3 cm, Peggy Guggenheim Collection, Venice.

429　"When it's enough": Virginia Pitts Rembert, *Mondrian, America, and American Painting* (New York: Columbia University Press, 1970), p. 26, quoted in Joosten, *CR* II, p. 170.

429　"of everything that forms": Mondrian, "The Necessity for a New Teaching in Art, Architecture, and Industry," 1938, in Holtzman and James, *The New Art —The New Life*, p. 311.

429　"what surrounds it: space": Ibid., p. 312.

430　"an aesthetic whole": Ibid.

430　"The academy is fatal": Ibid., p. 314.

430　"proportions and mutual": Ibid., p. 315.

430　"*pure relations and forms*": Ibid., p. 317.

432　"instead of talking about art": Peggy Guggenheim, *Confessions of an Art Addict*, 1997, pp. 56–57, as quoted in Joosten, *CR* II, p. 171.

432　"but somehow I doubted": Ibid.

432　It was Read who had selected: Joosten, *CR* II, p. 171.

432　*Trafalgar Square*: B294.322 *Composition. 1939 / Trafalgar Square. 1939–43*, 1939/1943, oil on canvas, 145.2 x 120 cm, Museum of Modern Art, New York.

432　"with the utmost grace": Harrison, "Mondrian in London," p. 288.

432　"knew he preferred": Ibid.

433　"a pillar of strength": Ibid.

433　"with utter equanimity": Ibid.

433　"Mondrian seemed to love": Ibid.

433　"[Mondrian] was dressed in dark": Margaret Gardiner as quoted in Darwent, *Mondrian in London*, p. 79.

434　"had his baked potatoes": Harrison, "Mondrian in London," p. 288.

434　The effect of entering: Ibid., p. 289.

434　"used to tease Mondrian": Ibid.

435　"a real smock": Ibid.

435　"he bought that and two": Ibid.

435　"he remarked that all small children": Ibid., p. 290.

435　"He had been totally neglected": Ibid., p. 292.

436　"terrible": Simon Grant, "Hello from 'Sleepy,'" *Tate Etc.* 20 (2010).

437　But Mondrian still felt: Joosten, *CR* II, p. 171.

437　"About the world situation": Mondrian to the Nicholsons, October 1, 1939, Tate Gallery Archive.

437　In November, A. E. Gallatin: (*Mondrian*). New York: Gallery of Living Art (New York University), November–December 4, 1939.

437　"But it is nice to hear": Mondrian to Ben Nicholson, December 6, 1939, Tate Gallery Archive.

437 "I have difficulty with an ear": Mondrian to Winifred Nicholson, December 24, 1939, RKD #0613.

438 "We have to transform": All from Mondrian, "A New Religion," c. 1938–1940, in Holtzman and James, p. 318.

439 "The new religion is faith": Ibid., p. 319.

439 "The first thing to understand": Mondrian, "Liberation from Oppression in Art and Life," in Holtzman and James, *The New Art—The New Life*, p. 322.

439 "progressive reduction of forms": Ibid., p. 328.

439 "that real freedom is not mutual": Ibid., p. 327.

439 "the substitute that compensates": Ibid., p. 330.

440 "It is too green": Harrison, "Mondrian in London," p. 288.

440 "a saint in Hampstead": Ibid., p. 289.

440 *Composition N°2 1938*: B284 *Composition N°2 1938 / Composition of Red, Blue, Yellow & White: Nom III, 1939*, oil on canvas, 44.6 x 38.3 cm, Museum of Contemporary Art, Los Angeles.

441 "England will win the war": Harrison, "Mondrian in London," p. 288.

441 "to get the old pictures better": Mondrian to the Nicholsons, February 17, 1940, Tate Gallery Archive 8717.

441 "But on the whole": Ibid.

441 "refreshing for my painting": Mondrian to Barbara Hepworth, April 14, 1940, Tate Gallery Archive 965, as quoted in Bowness, "Mondrian and London," p. 58.

442 "a colossal military": Winston Churchill, June 4, 1940, https://winstonchurchill.org /resources/speeches/1940-the-finest-hour/we-shall-fight-on-the-beaches/.

442 "I did not lose my confidence": Mondrian to Winifred Nicholson, July 4, 1940, RKD #0613.

442 "Might the Nazis come in": Darwent, *Mondrian in London*, p. 80.

442 "The one thing I do want": All in ibid.

443 "My windows were blown in": Mondrian to Nicholson and Hepworth, September 13, 1940, as quoted in Joosten, *CR* II, p. 173.

444 "My article won't do me much good": Mondrian to Hepworth, July 4, 1940, Tate Gallery Archive 965, as quoted in Joosten, *CR* II, p. 173.

445 Shortly after he landed: Ibid.

New York

447 "Mondrian's response was immediate": Recollections of Holtzman in Rembert, *Mondrian*, p. 33, as quoted in Joosten, *CR* II, p. 173.

448 "Just think of it": Carl Holty, "Mondrian in New York: A Memoir," *Arts Magazine* 31, no. 10 (1956–1957): 21.

449 "He said he'd rather be": Recollections of Holtzman in Rembert, *Mondrian*, p. 33, as quoted in Joosten, *CR* II, p. 173.

450 "the bed that felt best": Ibid.

450 "I've never had such a good bed": Ibid.

451 "a record player and a collection": Ibid.

451 "The interior of his studio": Sidney Janis, "School of Paris Comes to U.S.," *Decision* 2, no. 5–6 (November–December 1941): 89, quoted in Joosten, *CR* II, p. 173.

451 "had a lot of light": Gerard Hordijk to Slijper, August 21, 1945, as quoted in ibid.

452 "The cough is nearly better": Mondrian to Holtzman, October 19, 1940, RKD #0740, inv. nr. 108.

452 "does all she can": Ibid.

452 "miss too much": Ibid.

453 "It is refreshing": [Gallatin], *The Museum of Living Art* (cat.), 1940, as quoted in Herbert Henkels, "'There Is Too Much Old in the New': Mondrian's Late Work: A Sketch," in Akiyoshi Tokoro, ed., *Mondrian in New York* (Tokyo: Galerie Tokoro, 1993), p. 18.

454 "but in times such as these": Ibid.

454 "What so many others": Kramer Hilton, "Foreword: A Note on Henry McBride," in
 Henry McBride, ed., *The Flow of Art* (New Haven, CT: Yale University Press, 1997),
 p. xi.

455 "You know the collection": Mondrian to Holtzman, October 19, 1940, RKD #0740,
 inv. nr. 108.

455 "And that is all": All ibid.

456 "I am sure Britain": Mondrian to Winifred Nicholson, October 21, 1940, RKD #0613,
 inv. nr. 62.

456 "I was glad to hear": Mondrian to the Holtzmans, November 4, 1940, RKD #0740,
 inv. nr. 109.

457 "The principle in it": Ibid.

459 "well hung nearby": Mondrian to Nicholson and Hepworth, January 4, 1941,
 RKD #0613, inv. nr. 61.

460 "I thought after three months": Ibid.

460 "Life here is not": Mondrian to Winifred Nicholson, January 4, 1941, RKD #0613,
 inv. nr. 62.

461 "felt the lines": Charmion von Wiegand, "Mondrian: A Memoir of His New York
 Period," *Arts Yearbook* 4 (1961): 57, as quoted in Joosten, *CR* II, p. 174.

461 "Piet Mondrian, probably the only": [Geoffrey Hellman], "Lines and Rectangles,"
 New Yorker, March 1, 1941, p. 8.

462 "It is his first visit": Ibid., p. 11.

Settling In

464 "My finger does not hinder me": All from Mondrian to the Holtzmans, March 10,
 1941, RKD #0740, inv. nr. 111.

465 "letter came just in time": Mondrian to Holtzman, March 18, 1941, RKD #0740,
 inv. nr. 112.

465 "to take the bus": Ibid.

465 "That one afternoon": Ibid.

465 "to fill up the papers": Mondrian to Holtzman, March 23, 1941, RKD #0740,
 inv. nr. 114.

466 *New York*, an oil on canvas: B299.319 *New York. 1941 / Boogie Woogie. 1941–42*, oil on
 canvas, 95.2 x 92 cm, private collection.

467 "It was empty as hell": Carl Holty, interview with Paul Cummings, 1968, as quoted in
 Joosten, *CR* II, p. 403.

467 "the introduction of": Ibid.

467 "Perhaps the 'New-Yorker'": Mondrian to Holtzman, April 3, 1941, RKD #0740,
 inv. nr. 115.

467 "took out the red plane": Ibid.

468 "Very soon after his arrival": Von Wiegand, "Mondrian: A Memoir of His New York
 Period," p. 61.

473 "metaphysical images and symbols": *Charmion von Wiegand: Spirituality in Abstraction,
 1945–1969* (New York: Michael Rosenfeld Gallery, 2000).

474 "But she did not come": Mondrian to Holtzman, April 15, 1941, RKD #0740,
 inv. nr. 116.

474 "In this time, one must ignore": Mondrian to Holtzman, Friday evening [postmarked
 April 26, 1941], RKD #0740, inv. nr. 117.

476 "some days to think it over": Ibid.

476 "I am very glad": All Mondrian to Holtzman, in ibid.

477 "that he was most anxious": Mondrian to Holtzman, April 30, 1941, RKD #0740,
 inv. nr. 118.

477 *Composition with Red and Blue*: B293.304 *Composition of Red, Blue and White [Nom II].
 1939 / Composition with Red and Blue. 1941*, 1939/1941 (second state), oil on canvas,
 43.5 x 33 cm, private collection.

478 "the cheque": Mondrian to Holtzman, May 6, 1941, RKD #0740, inv. nr. 119.

478 "highest price ever paid": Jon Nordheimer, "A Mondrian Surpasses $2 Million," *New York Times*, June 28, 1983.

479 "The paper is filled up": All from Mondrian to Holtzman, April 30, 1941, RKD #0740, inv. nr. 118.

480 "as a momento": Mondrian to Holtzman, May 6, 1941, RKD #0740, inv. nr. 119.

480 "I was sure, when I went": Margit Rowell, "Interview with Charmion von Wiegand, June 20, 1971," in *Piet Mondrian 1872–1944: Centennial Exhibition* (New York: Solomon R. Guggenheim Museum, 1971), pp. 77–78.

482 "'You should know better'": Holty, "Mondrian in New York," p. 18.

482 "a fine Dutch name": Ibid.

482 "to be moistened": Ibid.

482 "¼" less there and ⅛" more there": Holty, diary notes of March 2, 1944, as quoted in Joosten, *CR* II, p. 176.

482 'leave the extra space': Ibid.

482 "Old artists die": Holty, "Mondrian in New York," p. 17.

483 "His biggest contribution": Ibid.

483 "that one of his most ardent": Ibid.

483 "Mondrian said, 'People fail'": Ibid.

484 "Mondrian was enthusiastic": Ibid.

485 "June 5, 1941": Charmion von Wiegand, journal entry, June 5, 1941.

486 "whether a line should be shifted": Von Wiegand, "Mondrian: A Memoir of His New York Period," p. 60.

486 "into more legible English": Ibid., p. 58.

487 "the cool of the evening": Ibid., p. 61.

488 "He would spend hours": Ibid., p. 60.

488 "Dear Charmion": Mondrian to Charmion von Wiegand, July 15, 1941, Von Wiegand archives.

489 "On one wall, propped up": Von Wiegand, "Mondrian: A Memoir of His New York Period," p. 58.

489 "I didn't ask for": Nancy Worssam, "Walter Quirt: One of the Most Vibrant Artists You've Never Heard Of," *Seattle Times*, May 1, 2015.

489 "Mondrian seemed to enjoy": Von Wiegand, "Mondrian: A Memoir of His New York Period," p. 59.

489 "Mondrian was cooking": Von Wiegand, journal entry, August 15, 1941, for August 13.

490 "It was a beautiful day": Von Wiegand, journal entry, August 28, 1941.

491 "July 20, 1941": Von Wiegand, journal entry, July 20, 1941, for July 13. Von Wiegand often put two dates on her journal entries: the date of writing and the date of the events being described.

492 "August 2, 1941": Von Wiegand, journal entry, August 2, 1941, for August 1.

492 "I had some flowers": Von Wiegand, journal entry, September 3, 1941, for September 2.

494 "Then I said I must go": Von Wiegand, journal entry, August 3, 1941.

495 "On Wednesday morning": Von Wiegand, journal entry, August 15, 1941.

497 "His delight in dancing": Von Wiegand, "Mondrian: A Memoir of His New York Period," pp. 59–60.

498 "walked to the edge": Henkels, "'There Is Too Much in the New': Mondrian's Late Work: A Sketch," p. 24.

498 "had a wonderful sense of rhythm": Ibid.

499 "asked me about the Freudian": Von Wiegand, journal entry, September 2, 1941, for September 9.

500 "Mondrian then gave me": Von Wiegand, journal entry, September 10, 1941, for September 9.

501 "But I didn't believe it": Von Wiegand, journal entry, September 14, 1941.

502 "I heard their voices": Ibid.

An American

503 "Almost a great name": Holty, "Mondrian in New York," p. 17 [phrases reversed in order by NFW].
503 "always hated that name": Ibid.
504 "graceful and beautiful": Ibid.
504 "as they 'scooted' ": Ibid.
504 "refused to discuss": Ibid.
505 "blown out into 57th Street": Ibid.
505 "He told me that": Ibid., pp. 18–19.
506 "no longer needed me": Von Wiegand, journal entry, December 13, 1941.
506 "I was in a daze": Von Wiegand, journal entry, January 6, 1942, for January 1.
506 "Mondrian looked so tired": Von Wiegand, journal entry, January 6, 1942, for January 3.
507 "To day [*sic*] I saw the doctor": Mondrian to Von Wiegand, March 20, 1942.
508 "Dear Charmion": Mondrian to Von Wiegand, January 15, 1943.

Peggy Guggenheim Again

509 "The name concrete opens": Mondrian, "Abstract Art," in Holtzman and James, *The New Art—The New Life*, p. 331.
509 "the dynamic movement": Ibid., p. 333.
509 "probably the hardest": "The Great Flight of Culture: Twelve Artists in U.S. Exile," *Fortune* 24, no. 6 (1941): 103.
510 "only explicitly autobiographical essay": Mondrian, "Notes for an Interview," in Holtzman and James, *The New Art—The New Life*, p. 336.
511 "M says . . . that it cannot": Ibid., pp. 336–337.
511 "Even in this chaotic": Mondrian, *Toward the True Vision of Reality*, in Holtzman and James, *The New Art—The New Life*, p. 341.
512 "the best picture": Von Wiegand, "Mondrian: A Memoir of His New York Period," p. 61.
515 "There's a poor old man": Ella Winter, *And Not to Yield: An Autobiography* (New York: Harcourt, Brace & World, 1963), p. 232.
517 "He hated things": Holty, "Mondrian in New York," p. 19.
517 "too tragic and classical": Ibid., p. 20.
517 "the Greek idea": Ibid.
517 "That is what we are against": Ibid.
518 "worked very rapidly": Ibid.
518 "I don't want pictures": Ibid.
518 "He did not want the colors": Ibid.
518 "Much as he wished": Von Wiegand, "Mondrian: A Memoir of His New York Period," p. 62.
519 "what Americans liked": Ibid., p. 61.
519 "a nervous crisis": Ibid.
520 One might have expected: The story would be told in 1980 when Charmion von Wiegand was interviewed for a documentary film about Mondrian in New York. Presumably she was inside the apartment and witnessed the affront firsthand.
520 "he appreciated people": Von Wiegand, "Mondrian: A Memoir of His New York Period," p. 62.
522 "one traditional European": Ibid., p. 63.
522 "This essay attempts": Mondrian, "Art and Life Towards the Liberation from Oppression," in Louis Veen, ed., *Piet Mondrian: The Complete Writings: Essays and Notes in Original Versions* (Leiden, Neth.: Primavera Pers, 2018), p. 513.
524 "Throughout history, human life": Ibid., p. 515.
524 "In general, the past has": Ibid., p. 517.
524 "Plastic art shows": Ibid., p. 518.

528 "Mondrian is a very nice man": All in Jimmy Ernst, *A Not-So-Still Life* (New York: St. Martin's Press, 1984), quoted in Joosten, *CR* II, p. 178.

528 "the courtly gentleman": Ibid.

529 "My dear Breton": Ibid., pp. 178–179.

Entering His Eighth Decade

530 "His simple life": Von Wiegand, "Mondrian: A Memoir of His New York Period," pp. 61–62.

531 "He came to the door": Ibid., p. 64.

532 "I made this composition in London": Ibid., p. 61.

532 "This is probably": Von Wiegand, journal entry, October 29, 1942.

533 "He would not let me help him": Von Wiegand, journal entry, December 4, 1942.

534 "It had been destroyed": Von Wiegand, "Mondrian: A Memoir of His New York Period," p. 64.

534 "He was just putting": Ibid.

534 "You should know that": Ibid., pp. 64–65.

535 *Trafalgar Square*: B294.322 *Trafalgar Square*, 1939–1943, oil on canvas, 145.2 x 120 cm, Museum of Modern Art, New York.

536 *Broadway Boogie Woogie*: B323 *Broadway Boogie Woogie*, 1942–1943, oil on canvas, 127 x 127 cm, Museum of Modern Art, New York.

537 "He looked like": Henry McBride, "The Death of Mondrian: An Implacable Puritan Whose Researches Had Far-Reaching Results," *New York Sun*, February 5, 1944.

537 "an American genius": Steven Naifeh and Gregory White Smith, *Jackson Pollock: An American Saga* (Aiken, SC: Woodward/White, 1989), p. 443.

538 "Inspecting the work": Henkels, " 'There Is Too Much Old in the New': Mondrian's Late Work," pp. 20–21.

538 "I don't think he's going": Ernst, *A Not-So-Still Life*, p. 241.

538 "This is the most interesting work": Naifeh and Smith, *Jackson Pollock*, p. 444.

538 "Just because it points": Ernst, *A Not-So-Still Life*, pp. 241–242.

539 "after the first spring salon": Guggenheim, *Confessions of an Art Addict*, p. 105.

539 "like a trapped animal": Ibid., p. 106.

540 "One night in New York": Harry Holtzman, "Introduction: Piet Mondrian New York Studio, 1943–1944," in Tokoro, *Mondrian in New York*, p. 66.

540 "staccato rhythmic excitement": Alfred H. Barr, *Museum of Modern Art Exhibits New Acquisitions* (New York: Museum of Modern Art, 1943), p. 3.

541 "very neat and precise": Clement Greenberg, "Art," *The Nation* 157 (1943): 416, as quoted in Joosten, *CR* II, p. 181.

541 "My memory played tricks": Greenberg, *The Nation* 157 (October 16, 1943): 455, as quoted in Joosten, *CR* II, p. 181.

541 "that time was running": Von Wiegand, "Mondrian: A Memoir of His New York Period," p. 65.

542 "how much the skyline": Ibid.

542 "in an over-decorated": Holty, "Mondrian in New York," p. 19.

542 When the hostess greeted: Ibid.

544 "now he hated": Ibid., 19–20.

544 "Mondrian's studio attested": Harriet Janis, "Notes on Piet Mondrian," *Art and Architecture* 62, no. 1 (January 1945), as quoted in Joosten *CR* II, p. 181.

546 "As soon as he saw": Henkels, " 'There Is Too Much Old in the New,' " p. 20.

549 "At table, I asked": Von Wiegand, journal entry, December 15, 1943.

549 "And M. had red wine": Von Wiegand, journal entry, January 5, 1944.

550 "extraordinary pictures": Ella Winter, "I Bought a Klee," *Studio International* 172, no. 879 (1966), as quoted in Joosten, *CR* II, p. 181.

550 "I kept staring": Ibid.

551 She observed further changes: Rowell, "Interview with Charmion von Wiegand," pp. 84–85.

551 Mondrian praised it: Holty, "Mondrian in New York," p. 21.

552 "Van Gogh and Gauguin": Ibid.

552 Two days before, however, he wrote Richter: "Dear Richter, Thank you for your wishes and invitation. I suffered from bronchitis and am not yet sure if I can come on the party. Then you'll hear from me later. Cordially Mondrian." Mondrian to Richter, no date [January 23, 1944], RKD #0613, inv. nr. 69.

552 "were discussing a plan": Holtzman, "Introduction: Piet Mondrian," p. 67.

553 "a more dynamic intensity": Rowell, "Interview with Charmion von Wiegand, p. 85.

Bibliography

Adrichem, Jan van. *De ontvangst van de moderne kunst in Nederland, 1910–2000: Picasso als pars pro toto*. Amsterdam: Prometheus, 2001.

Alma, Peter. "Piet Mondriaan." In *Piet Mondriaan: Ter gelegenheid van de tentoonstelling van zijn werk in het Stedelijk Museum te Amsterdam, November–December 1946*, 25–28. Amsterdam: Stedelijk Museum, 1946.

Almering-Strik, L. M. *Lodewijk Schelfhout: Nederlands eerste kubist*. Zwolle: Waanders, 2018.

Andreae, Christopher. *Winifred Nicholson*. London: Lund Humphries, 2009.

Baar, Peter-Paul de. "Een stad in beweging: Amsterdam, 1892–1912." In *1892/1912 Mondriaan aan de Amstel*, edited by Robert Welsh, Boudewijn Bakker, and Marty Bax, 8–21. Bussum: Uitgeverij Thoth, 1994.

Barr, Alfred H. *Museum of Modern Art Exhibits New Acquisitions*. New York: Museum of Modern Art, 1943.

Bax, Marty. *Het web der schepping: Theosofie en kunst in Nederland. Van Lauweriks tot Mondriaan*. Amsterdam: Uitgeverij SUN, 2006.

Bax, Marty. "Mondriaan en zijn vrienden." In *1892/1912 Mondriaan aan de Amstel*, edited by Robert Welsh, Boudewijn Bakker, and Marty Bax, 22–42. Bussum: Uitgeverij Thoth, 1994.

Bax, Marty, and Robert Welsh. "De Amsterdamse ateliers van Piet Mondriaan." In *1892/1912 Mondriaan aan de Amstel*, edited by Robert Welsh, Boudewijn Bakker, and Marty Bax, 43–54. Bussum: Uitgeverij Thoth, 1994.

Bax, Marty, Simone Niemeyer, and Harmen Snel. "De passies van Piet Mondriaan." *Jong Holland: Tijdschrift voor kunst en vormgeving na 1850* 10, no. 2 (1994): 32–41.

Blavatsky, H. P. *The Secret Doctrine*. London: Theosophical Publishing Company, 1888.

Blavatsky, H. P. "What Is Theosophy." *The Theosophist* 1, no. 1 (1879): 2–4.

Blotkamp, Carel. *Mondrian: The Art of Destruction*. London: Reaktion Books, 2001. (First published as *Mondriaan. Destructie als kunst* [Zwolle: Waanders, 1994].)

Blotkamp, Carel. *Mondriaan in detail: Mondriaan en de architectuur, de triptieken, de eerste ruitvormige schilderijen, Mondriaan en Rudolf Steiner*. Utrecht: Veen/Reflex, 1987.

Blotkamp, Carel, et al. *De Stijl: The Formative Years, 1917–1922*. Cambridge, MA: MIT Press, 1986. (First published as *De beginjaren van De Stijl, 1917–1922* [Utrecht: Reflex, 1982].)

Boekholt, P. Th. F. M., and E. P. de Booy. *De geschiedenis van de school in Nederland: Vanaf de middeleeuwen tot aan de huidige tijd*. Assen: Van Gorcum, 1987.

Bois, Yve-Alain, Joop Joosten, Angelica Zander Rudenstine, and Hans Janssen. *Piet Mondrian, 1872–1944*. Boston: Bulfinch Press, 1994.

Bowness, Sophie. "Mondrian and London." In *Mondrian/Nicholson: In Parallel*, edited by Christopher Green and Barnaby Wright, 41–63. London: Courtauld Gallery, 2012.

Bradley, Jay. "Piet Mondrian, 1872–1944: Greatest Dutch Painter of Our Time." *Knickerbocker Weekly "Free Netherlands"* 3, no. 51 (1944): 16–24.

Braet von Überfeldt, Jan, and Valentijn Bing. *Handeling tot het teekenen naar de natuur en de beginselen der doorzigtkunde*. Amsterdam: Brinkman, 1863–1866.

Briel, Albert van den. "Mondriaans persoonlijkheid" (version 1). Manuscript (RKD—Nederlands Instituut voor Kunstgeschiedenis, Den Haag, Archief Robert Welsh, #0632, inv. nr. 1).

Briel, Albert van den. "Mondriaans persoonlijkheid" (version 2). Manuscript (RKD—Nederlands Instituut voor Kunstgeschiedenis, Den Haag, Archief Robert Welsh, #0632, inv. nr. 2).

Brooks, John. "Why Fight It?" *New Yorker*, November 12, 1960.

Cranston, Sylvia. *HPB: The Extraordinary Life & Influence of Helena Blavatsky, Founder of the Modern Theosophical Movement*. New York: G. P. Putnam's Sons, 1993.

Darwent, Charles. *Mondrian in London*. London: Double-Barrelled Books, 2012.

Domselaer-Middelkoop, Maaike van. "Herinneringen aan Piet Mondriaan." *Maatstaf* 7, no. 5 (1959): 269–293.

Dreier, Katherine S. *Modern Art*. New York: Société Anonyme, 1926.

Dupuis, Alexandre. *De l'Enseignement du dessins sous le point de vue industriel*. Paris: Giroux, 1836.

Ebert, Roger. "Walt and El Grupo." *Chicago Sun-Times*, October 21, 2009.

Eeden, Frederik van. "Gezondheid en verval in kunst." *Op de Hoogte. Maandschrift voor de huiskamer* 6, no. 2 (1909): 79–85.

Eeden, Frederik van. "Kunst: Vincent van Gogh." *De Nieuwe Gids* 6 (1891): 263–270.

Entrop, Marco. "Verliefde ogen zien Mondriaan: Uit het dagboek van Eva de Beneditty." *De Parelduiker* 8, no. 1 (2003): 28–45.

Ernst, Jimmy. *A Not-So-Still Life*. New York: St. Martin's Press, 1984.

Evans, Myfanwy. "Abstract Art: Collecting the Fragments." *New Oxford Outlook* 22 (November 1935): 259–261.

Evans, Myfanwy. "Dead or Alive." *Axis* 1 (1935): 3–4.

Faassen, Sjoerd van, and Hans Renders. "Theo van Doesburg en de oprichting van *De Stijl*." In *Piet Mondriaan en Bart van der Leck: De uitvinding van een nieuwe kunst; Laren, 1916–1918*, edited by Hans Janssen, 117–145, 164–166. The Hague: Gemeentemuseum Den Haag, 2017.

Farr, Sheila. "How a Museum Founder Helped Turn Van Gogh into an International Icon." *Seattle Times*, May 23, 2004.

Fontijn, Jan. *Tweespalt: Het leven van Frederik van Eeden tot 1901*. Amsterdam: Em. Querido's Uitgeverij BV, 1999.

Franck, Dan. *Bohemian Paris: Picasso, Modigliani, Matisse, and the Birth of Modern Art*. New York: Grove Press, 2001.

Garrel, Betty van. "De Mondriaankenner: Salomon Slijper." *Haagse Post*, June 27, 1964.

Gorter, Paul. "Piet Mondriaan en Simon Maris: Een teruggevonden vriendschap." *Vrij Nederland*, January 24, 1998.

Gorter, Paul, Frans van Burkom, and Joop M. Joosten. "Mies Maris' vergeten 'Mondriana.'" In *Jong Holland: Tijdschrift voor kunst en vormgeving na 1850* 14, no. 2 (1998): 22–35; no. 3 (1998): 35–47.

Goudsmit, Keziah. "Finding Balance in Art and Music. Piet Mondrian and Jakob van Domselaer's First Compositions." In *Mondrian and Cubism: Paris, 1912–1914*, edited by Hans Janssen, 63–67. London: Ridinghouse, 2016.

Grant, Simon. "Hello from 'Sleepy': Document: Mondrian in London." *Tate Etc* 20 (2010). https://www.tate.org.uk/tate-etc/issue-20-autumn-2010/hello-sleepy.

"The Great Flight of Culture: Twelve Artists in U.S. Exile." *Fortune* 24, no. 6 (1941): 103.

Greenacre, Phyllis. "The Primal Scene and the Sense of Reality." *Psychoanalytic Quarterly* 42 (1973): 10–41.

Greshoff, Jan. "Schrijversdagboek: Piet Mondriaan." *Het Vaderland*, January 24, 1957.

Giedion-Welcker, Carola. "Die Kunst des zwanzigsten Jahrhunderts: Experimentierzelle, Zeitseismograf." *Das Kunstblatt* 14, no. 3 (1930): 65–70.

Guggenheim, Peggy. *Confessions of an Art Addict*. Hopewell, NJ: Ecco Press, 1997.

Hana, Herman. "Piet Mondriaan, de pionier." *Wil en Weg* 2, no. 17 (May 15, 1924): 602–608; no. 18 (June 15, 1924): 635–639.

Harrison, Charles. "Mondrian in London: Reminiscences of Mondrian by Miriam Gabo, Naum Gabo, Barbara Hepworth, Ben Nicholson, Winifred Nicholson, Herbert Read." *Studio International* 172, no. 884 (1966): 285–292.

Hellman, Geoffrey T. "Lines and Rectangles." *New Yorker* 17, no. 3 (1941): 8–10.

Henkels, Herbert. *Mondriaan in Winterswijk: Een essay over de jeugd van Mondriaan, z'n vader en z'n oom.* The Hague: Haags Gemeentemuseum, 1979.

Henkels, Herbert. *Mondrian: From Figuration to Abstraction.* Tokyo: Tokyo Shimbun, 1987.

Henkels, Herbert. *'t is alles een groote eenheid, Bert: Piet Mondriaan, Albert van den Briel en hun vriendschap aan de hand van brieven, documenten en fragmenten bezorgd en van een nawoord voorzien door Herbert Henkels.* Haarlem, Neth.: Joh. Enschedé en zonen, 1988.

Henkels, Herbert. "'There Is Too Much Old in the New': Mondrian's Late Work: A Sketch." In *Mondrian in New York*, edited by Akiyoshi Tokoro, 12–43. Tokyo: Galerie Tokoro, 1993.

Heurneman, Mieke. *Het A'foort boek.* Bussum: Uitgeverij Thoth, 2009.

Heyting, Lien. *De wereld in een dorp: Schilders, schrijvers en werelverbeteraars in Laren en Blaricum, 1880–1920.* Amsterdam: Meulenhoff, 1994.

Hoek, Els, ed. *Theo van Doesburg: Oeuvre catalogus.* Utrecht and Otterlo: Centraal Museum/ Kröller-Müller Museum, 2000.

Hoek, Nel J. "Wormser jr., Johan Adam." *Biografisch woordenboek van het socialisme en de arbeidersbeweging in Nederland,* edited by P. J. Meertens, 1992. https://socialhistory.org /bwsa/biografie/wormser.

Holty, Carl. "Mondrian in New York: A Memoir." *Arts Magazine* 31, no. 10 (September 1957): 17–21.

Holtzman, Harry. "Mondriaan's persoonlijkheid." In *Piet Mondriaan: Een dokumentatie.* Amersfoort: Zonnehof, 1973.

Holtzman, Harry, and Martin S. James. *The New Art—The New Life: The Collected Writings of Piet Mondrian.* London: Thames and Hudson, 1987.

Imanse, Geurt, and John Steen. "Achtergronden van het Symbolisme." In *Kunstenaren der idee: Symbolistische tendenzen in Nederland, ca. 1880–1930*, edited by Carel Blotkamp, 21–35. The Hague: Staatsuitgeverij, 1978.

Jaffé, Hans L. C. "Introduction." In *De Stijl, 1917–1931: Visions of Utopia,* edited by Mildred Friedman, 11–15. Oxford: Phaidon, 1982.

Jaffé, Hans L. C. *Piet Mondrian.* New York: Harry N. Abrams, 1985.

Jaffé, H. L. C. "Een gedateerde plafondschildering door Piet Mondriaan." In *Over utopie en werkelijkheid in de beeldende kunst:. Verzamelde opstellen van H.L.C. Jaffé (1915–1984),* edited by H. L. C. Jaffé, 56–65. Amsterdam: Meulenhoff/Landshoff, 1986.

Jaffé, H. L. C. "Een preekstoel naar ontwerp van Mondriaan." In *Over utopie en werkelijkheid in de beeldende kunst Verzamelde opstellen van H.L.C. Jaffé (1915–1984),* edited by H. L. C. Jaffé, 66–75. Amsterdam: Meulenhoff/Landshoff, 1986.

Jager, Henk de, Hendrik G. Matthes, and M. H. J. Schoenmaekers. *Het beeldende denken: Leven en werk van Mathieu Schoenmaekers.* Baarn, Neth.: Ambo, 1992.

Janis, Sidney. "School of Paris Comes to U.S.," *Decision* 2, no. 5–6 (November–December 1941): 85–93.

Janssen, Hans, ed. *De Uitvinding van een Nieuwe Kunst: Piet Mondrian en Bart van der Leck, Laren 1916–1918.* The Hague: Gemeentemuseum, 2017.

Janssen, Hans. *Mondriaan in Amsterdam.* Bussum: Uitgeverij Thoth, 2013.

Janssen, Hans. *Mondriaan in het Gemeentemuseum Den Haag.* The Hague: Gemeentemuseum, 2008.

Janssen, Hans., ed. *Mondrian and Cubism: Paris, 1912–1914.* London: Ridinghouse, 2016.

Janssen, Hans. *Piet Mondriaan: Een nieuwe kunst voor een ongekend leven: Een biografie.* Amsterdam: Hollands Diep, 2016.

Janssen, Hans, and Joop M. Joosten. *Mondrian, 1892–1914: The Path to Abstraction.* Zwolle: Waanders Publishers; Fort Worth, TX: Kimbell Art Museum, 2002.

Jong, J. M. de. "Piet Mondriaan en de gereformeerde kerk van Amsterdam." In *Jong Holland: Tijdschrift voor kunst en vormgeving na 1850* 5, no. 3 (1989): 20–23.

Jonkman, Mayken, and Jacqueline de Raad. *De onstuitbare verzamelaar J.F.S. Esser: Mondriaan Breitner Sluijters e.a.* Zwolle: Waanders, 2005.

Joosten, Joop M. "Documentatie over Mondriaan (4): 17 brieven van Piet Mondriaan aan ds. H. van Assendelft, 1914–1919." *Museumjournaal* 18, no. 4 (1973): 172–179; no. 5 (1973): 218–223.

Joosten, Joop M., and Robert P. Welsh *Piet Mondrian: Catalogue Raisonné*. II: Joop M. Joosten, Catalogue Raisonné of the Work of 1911–1944.

Kandinsky, Nina. *Kandinsky und Ich*. Munich: Knaur, 1987.

Kramer, Hilton. "Foreword: A Note on Henry McBride." In *The Flow of Art: Essays and Criticism of Henry McBride*, edited by Henry McBride, xi. New Haven, CT: Yale University Press, 1997.

Kuyper, Abraham. *Antirevolutionair óók in uw Huisgezin*. Amsterdam: J. H. Kruyt, 1880.

Kuyper, Abraham. "Sphere Sovereignty." In *Abraham Kuyper. Modern Calvinist, Christian Democrat*, edited by James D. Bratt. Grand Rapids, MI: Eerdmans, 2013.

Léal, Brigitte. *Mondrian*. Paris: Centre Pompidou, 2010.

Le Coultre, Martijn F. *De hut van Mondriaan: Laren–Blaricum, 1914–1919*. Naarden, Neth.: VK Projects, 2015.

Lemercier, Eugène Emmanuel. *A Soldier of France to His Mother: Letters from the Trenches on the Western Front*. Translated with an introduction by Theodore Stanton, M.A. Chicago: A. C. McClurg, 1917.

Litsenburg, J. H. *Restauratie en conservatie van een plafondschildering van Piet Mondriaan in een grachtenpand aan de Keizersgracht in Amsterdam*. Amsterdam: Litsenburg, 1994.

Loon, Henry van. "Bij Piet Mondriaan." *Nieuwe Rotterdamsche Courant*, March 23, 1922.

Loon, Henry van. "Parijsche brief: Piet Mondriaan." *Hollandsch Weekblad*, no. 35 (1937): 17–20.

Loon, Henry van. "Piet Mondriaan, de mensch, de kunstenaar." *Maandblad voor beeldende kunsten* 4, no. 7 (1927): 195–199.

Loon, Maud van. "Mondriaan, zoals hij leefde te Parijs." *De Groene Amsterdammer*, December 7, 1946.

Loosjes-Terpstra, A[leida]. B[etsy]. *Moderne Kunst in Nederland, 1900–1914*. Utrecht: Veen/Reflex, 1987.

Loosjes-Terpstra, Aleida [Betsy]. "Mondriaan in een donkere spiegel." *Jong Holland* 5, no. 5 (1989): 4–15.

Lurasco, F. M. *Onze Moderne Meesters*. Amsterdam: C. L. G. Veldt, 1907.

Maclean, Caroline. *Circles and Squares: The Lives and Art of the Hampstead Modernists*. London: Bloomsbury Publishing, 2020.

Mali, Anco, Bert Booij, and Wim Scholtz. *Pieter Cornelis Mondriaan Senior, 1832–1921: Een gedreven vader*. Amersfoort: Stichting Mondriaanhuis; Winterswijk: Vereniging Het Museum, 1994.

McBride, Henry. "The Death of Mondrian: An Implacable Puritan Whose Researches Had Far-Reaching Results." *New York Sun*, February 5, 1944.

McBride, Henry. "Difficulties in Modernism: Fixed Opinions Are No Help in an Ever-changing World." *New York Sun*, January 22, 1944.

Meester-Obreen, Augustine de. "Piet Mondriaan." In *Elsevier's Geïllustreerd Maandschrift* 25, no. 50, II (1915): 396–399.

Mooij, Charles de, and Maureen Trappeniers. *Piet Mondriaan: Een jaar in Brabant, 1904/1905*. Zwolle: Waanders, 1989.

Morris, George L. K. "Modernism in England." *Partisan Review* 4, no. 1 (1937): 69–70.

Murgia, Camilla. "The Rouillet Process and Drawing Education in Mid-Nineteenth-Century France." *Nineteenth-Century Art Worldwide* 2, no. 1 (2003).

Naifeh, Steven, and Gregory White Smith. *Jackson Pollock: An American Saga*. Aiken, SC: Woodward/White, 1989.

Osta, A. P. J. van, ed. *Drie Vorstinnen: Brieven van Emma, Wilhelmina en Juliana*. Amsterdam: De Arbeiderspers, 1995.

Ottevanger, Alied. *"De Stijl overal absolute leiding": De briefwisseling tussen Theo van Doesburg en Antony Kok*. Bussum: Uitgeverij Thoth, 2008.

Oud, J. J. P. "Mondriaan, de mens." In *Mondriaan*, edited by L. F. J. Wijsenbeek, 61–81. Zeist, Neth.: W. de Haan, 1962.

Oud, J. J. P. "Piet Mondriaan." In *Piet Mondriaan. Ter gelegenheid van de tentoonstelling van zijn werk in het Stedelijk Museum te Amsterdam, November–December 1946*, 29–34. Amsterdam: Stedelijk Museum, 1946.

Paaschen, Jacqueline van. *Mondriaan en Steiner: Wegen naar Nieuwe Beelding.* The Hague: Komma, 2017.

Poppel, Frans van. *Trouwen in Nederland: Een historisch-demografische studie van de 19e en vroeg-20e eeuw.* The Hague: Stichting Nederlands Interdisciplinair Demografisch Instituut, 1992.

Prins, Mandy. "Salomon B. Slijper (1884–1971)." In *Gedurfd Verzamelen: Van Chagall tot Mondriaan,* edited by Huibert Schijf and Edward van Voolen, 144–171. Zwolle: Waanders, 2010.

Ransom, Josephine. *A Short History of the Theosophical Society.* Adyar, Madras: Theosophical Publishing House, 1989.

Rembert, Virginia Pitts. *Mondrian, America, and American Painting.* New York: Columbia University Press, 1970.

Renders, Hans, and Sjoerd van Faassen. "Agnita Feis: Dichter en beeldend kunstenaar zonder oeuvre. Pacifisme voor alles." *Zacht Lawijd* 16, no. 4 (2017): 67–92.

Rossouw, D. P. *Medeërfgenamen van Christus: Geschiedenis van de vervolgingen der Christelijke Kerk. Met eene voorrede van Dr. Andrew Murray.* Amsterdam: Höveker & Zoon, 1894.

Rovers, Eva. *De eeuwigheid verzameld: Helene Kröller-Müller, 1869–1939.* Amsterdam: Bert Bakker, 2010.

Rowell, Margit. "Interview with Charmion von Wiegand June 20, 1971." In *Piet Mondrian 1872–1944: Centennial Exhibition,* 77–86. New York: Solomon R. Guggenheim Museum, 1971.

Sanders, Paul F. "Herinneringen aan Piet Mondriaan." *Maatstaf* 27, no. 12 (1979): 1–7.

Scherphuis, Ageeth. "Vrienden over zijn vrouwen, zijn smaak, zijn armoede." *Vrij Nederland Special Haags Gemeentemuseum,* 1994.

Seuphor, Michel. *Het vergankelijke is eeuwig. Een theatertekst met decors van Mondriaan met een inleiding van Henri-Floris Jespers.* Antwerp: Uitgeverij Jef Meert, 1999.

Seuphor, Michel. *Piet Mondrian: Life and Work.* New York: Harry N. Abrams, 1956.

Seuphor, Michel. "Piet Mondrian: Overpeinzingen en herinneringen." In *Piet Mondriaan: Ter gelegenheid van de tentoonstelling van zijn werk in het Stedelijk Museum te Amsterdam, November–December 1946,* 14–22. Amsterdam: Stedelijk Museum, 1946.

Stap, Jan. *Piet Mondriaan: Zijn levensverhaal.* Doetinchem, Neth.: Erfgoedcentrum Achterhoek, 2011.

Steiner, Rudolf. *The Story of My Life.* London: Anthroposophical Publishing Company, 1928.

Steiner, Rudolf. *Theosophy: An Introduction to the Supersensible Knowledge of the World and the Destination of Man.* London: Kegan Paul, Trench, Trübner, 1910.

Sweeney, James Johnson. "Piet Mondrian." *Museum of Modern Art Bulletin* 12, no. 4 (1945): 2–12. (Reprinted in James Johnson Sweeney, *Piet Mondrian* [New York: Museum of Modern Art, 1948].)

Taverne, Ed, Cor Wagenaar, and Martien de Vletter. *J. J. P. Oud, 1890–1963. The Complete Works.* Rotterdam: NAi Publishers, 2001.

Tibbe, Lieske. *Verstrengeling van traditie en vernieuwing: Kunstkritiek in Nederland tijdens het fin de siècle, 1885–1905.* Rotterdam: nai010, 2014.

Tokoro, Akiyoshi. *Mondrian in New York.* Tokyo: Tokoro, 1993.

Tschichold, Jan. *Die Neue Typographie.* Berlin: Bildungsverband der deutschen Buchdrucker, 1928.

Tschichold, Jan. *Typographische Gestaltung.* Basel: Benno Schwabe, 1935.

Veen, Louis, ed. *Piet Mondrian: The Complete Writings: Essays and Notes in Original Versions.* Leiden: Primavera Pers, 2018.

Velden, Ben van der. "Late liefde in Jaren 20." *NRC Handelsblad,* January 8, 1972.

Verhave, J. P. "Johan Adam Wormser (1845–1916) Uitgever-boekhandelaar en strijder tegen conservatisme van alle gading." In *Geloof in eigen zaak: Markante protestantse werkgevers in de negentiende en twintigste eeuw,* edited by Paul E. Werkman and Rolf E. van der Woude, 161–190. Hilversum, Neth.: Verloren BV, 2006.

Versteeg, Coos. *Mondriaan: Een leven in maat en ritme.* The Hague: Sdu uitgeverij, 1988.

Vloten, Francisca van. "Dromen van Weleer: Kunstenaars in Domburg, 1898–1928." In

Reünie op 't Duin: Mondriaan en tijdgenoten in Zeeland, edited by Ineke Spaander, 11–71. Zwolle: Waanders, 1994.

Vries, Jan de, and Marijke de Groot. *Van Sintels vuurwerk maken: Kunstkritiek en moderne kunst, 1905–1925*. Rotterdam: naio10, 2015.

Weber, Nicholas Fox. *Balthus: A Biography*. New York: Alfred A. Knopf, 1999.

Weber, Nicholas Fox. *The Bauhaus Group: Six Modern Masters of Modernism*. New York: Alfred A. Knopf, 2009.

Weber, Nicholas Fox. *Patron Saints: Five Rebels Who Opened America to a New Art, 1928–1943*. New York: Alfred A. Knopf, 1992.

Welsh, Robert P. "Mondrian and Theosophy." In *Piet Mondrian, 1872–1944: Centennial Exhibition*, 35–51. New York: Solomon R. Guggenheim Museum, 1971.

Welsh, Robert P. *Piet Mondrian's Early Career. The "Naturalistic" Periods*. New York: Garland Publishing, 1977.

Welsh, Robert P. "Sacred Geometry: French Symbolism and Early Abstraction." In *The Spiritual in Art: Abstract Painting, 1890–1985*, edited by Edward Weisberger, 63–87. New York: Abbeville Press, 1986.

Welsh, Robert P., and Joop M. Joosten. *Piet Mondrian: Catalogue Raisonné*. I: Robert P. Welsh, *Catalogue Raisonné of the Naturalistic Works (until early 1911)*. II: Joop M. Joosten, *Catalogue Raisonné of the Work of 1911–1944*. III: Joop M. Joosten and Robert P. Welsh, Appendix (3 dln [in 2 bnd.]). Blaricum: V + K Publishing/Inmerc; Paris: Editions Cercle d'Art, 1998.

Welsh, Robert P., and Joop M. Joosten. *Two Mondrian Sketchbooks, 1912–1914*. Amsterdam: Meulenhoff International, 1969.

Wiegand, Charmion von. "Mondrian: A Memoir of His New York Period." *Arts Yearbook* 4 (1961): 57–65.

Wilkie, Ken. "Mondrian and All That Jazz." *Holland Herald* 7, no. 1 (1972): 23–37.

Winter, Ella. *And Not to Yield: An Autobiography*. New York: Harcourt, Brace & World, 1963.

Winter, Ella. "I Bought a Klee." *Studio International* 172, no. 879 (1966): 20–27.

Worssam, Nancy. "Walter Quirt: One of the Most Vibrant Artists You've Never Heard Of." *Seattle Times*, May 1, 2015.

Zalm, R. G. C. *Ibsen op de planken: Een ensceneringsgeschiedenis van het werk van Henrik Ibsen in Nederland, 1880–1995*. Amsterdam: Uitgeverij International Theatre & Film Books, 1999.

Consulted Archives

Harry Holtzman Papers. General Collection, Beinecke Rare Book and Manuscript Library, Yale University, New Haven, CT

Koninklijk Huisarchief, Den Haag

Kröller-Müller Museum, Otterlo, Archief A. De Iongh

Noord-Hollands Archief, Haarlem, Archief Rijksakademie van beeldende kunsten, nummer toegang 90

Piet Mondrian Papers, General Collection, Beinecke Rare Book and Manuscript Library, Yale University, New Haven, CT

RKD—Nederlands Instituut voor Kunstgeschiedenis, Den Haag Archief ds H. van Assendelft, nummer toegang 0154

RKD—Nederlands Instituut voor Kunstgeschiedenis, Den Haag Archief H. P. Bremmer, nummer toegang 0836

RKD—Nederlands Instituut voor Kunstgeschiedenis, Den Haag Archief Theo and Nelly van Doesburg, nummer toegang 0408

RKD—Nederlands Instituut voor Kunstgeschiedenis, Den Haag, Archief van de werkgroep Mondriaan correspondentieproject en aanvullingen daarop door Herbert Henkels, nummer toegang 0613

RKD—Nederlands Instituut voor Kunstgeschiedenis, Den Haag Archief Simon Maris en familie, nummer toegang 0257

RKD—Nederlands Instituut voor Kunstgeschiedenis, Den Haag Archief Lodewijk Schelfhout, nummer toegang 0278

RKD—Nederlands Instituut voor Kunstgeschiedenis, Den Haag Archief Sal Slijper, nummer toegang 0150

RKD—Nederlands Instituut voor Kunstgeschiedenis, Den Haag Archief Willem Steenhoff, nummer toegang 0171

RKD—Nederlands Instituut voor Kunstgeschiedenis, Den Haag, Archief Robert Welsh, nummer toegang 0632

Index

ILLUSTRATION CREDITS

241 RKD – Netherlands Institute for Art History, The Hague, Archive Theo and Nelly van Doesburg
251 RKD – Netherlands Institute for Art History, The Hague, Archive Theo and Nelly van Doesburg
257 RKD – Netherlands Institute for Art History, The Hague, Archive Joop Joosten. Artwork © 2024 Mondrian/Holtzman Trust.
259 Kunstmuseum Den Haag
263 Stadsarchief Amsterdam
266 RKD – Netherlands Institute for Art History, The Hague
273 gta Archives/ETH Zurich, Alfred Roth. Artwork © 2024 Mondrian/Holtzman Trust.
274 Kupferstich-Kabinett, Staatliche Kunstsammlungen Dresden, photo: Herbert Boswank
275 RKD – Netherlands Institute for Art History, The Hague. Artwork © 2024 Mondrian/Holtzman Trust.
279 © Ministère de la Culture – Médiathèque du Patrimoine / André Kertész /dist. RMN
280 © Ministère de la Culture – Médiathèque du Patrimoine / André Kertész /dist. RMN
280 © Ministère de la Culture – Médiathèque du Patrimoine, Dist. RMN-Grand Palais/Art Resource, NY
291 © Ministère de la Culture – Médiathèque du Patrimoine / André Kertész / dist. RMN
305 RKD – Netherlands Institute for Art History, The Hague
307 Archiv der Zürcher Hochschule der Künste. Artwork © 2024 Mondrian/Holtzman Trust.
311 Museum Boijmans Van Beuningen
316 RKD – Netherlands Institute for Art History, The Hague. Artwork © 2024 Mondrian/Holtzman Trust.
329 Digital Image © CNAC/MNAM, Dist. RMN-Grand Palais / Art Resource, NY; Artist: Freund, Gisèle (1912–2000) © Copyright Gisèle Freund-RMN
335 The Solomon R. Guggenheim Foundation/Art Resource, NY. Artwork © 2024 Mondrian/Holtzman Trust.
337 The Collection of Fostin Cotchen (www.fostinum.org) © Van Vechten Trust
339 Digital Image © CNAC/MNAM, Dist. RMN-Grand Palais / Art Resource, NY. Artwork © 2024 Calder Foundation, New York/Artists Rights Society (ARS), New York.
343 Zuri Swimmer/Alamy Stock Photo
351 Album/Alamy Stock Photo
352 Het Nieuwe Instituut, Rotterdam, Archief Charles Karsten. Artwork © 2024 Mondrian/Holtzman Trust.
355 RKD – Netherlands Institute for Art History, The Hague
357 The Museum of Modern Art, New York, The Sidney and Harriet Janis Collection (a gift to the Museum of Modern Art). Artwork © 2024 Mondrian/Holtzman Trust.
368 RKD – Netherlands Institute for Art History, The Hague, Archive Piet Mondriaan
369 RKD – Netherlands Institute for Art History, The Hague, Archive Piet Mondriaan
372 Trustees of Winifred Nicholson
387 Frances Lehman Loeb Art Center, Vassar College, Poughkeepsie, NY / Art Resource, NY. Used with permission of The George Platt Lynes Estate.
424 Hulton Deutsch via Getty Images/Getty Images
427 Peggy Guggenheim Collection, Venice (Solomon R. Guggenheim Foundation, New York) 76.2553 PG 039. Artwork © 2024 Mondrian/Holtzman Trust.
431 Farabola/Bridgeman Images. Artwork © 2024 Mondrian/Holtzman Trust.
447 Piet Mondrian Papers, General Collection, Beinecke Rare Book and Manuscript Library, Yale University
449 Carl Holty papers, circa 1860s–1972. Archives of American Art, Smithsonian Institution.
450 © 2024 Mondrian/Holtzman Trust

453 National Portrait Gallery, Smithsonian Institution. Artwork © 2024 Artists Rights Society (ARS), New York / ADAGP, Paris.

457 © 2024 Mondrian/Holtzman Trust

458 © 2024 Mondrian/Holtzman Trust

464 © 2024 Mondrian/Holtzman Trust

468 RKD – Netherlands Institute for Art History, The Hague. Artwork © 2024 Mondrian/Holtzman Trust.

471 RKD – Netherlands Institute for Art History, The Hague, Archive Joop Joosten. Artwork © 2024 Mondrian/Holtzman Trust.

487 Kunsthaus Zürich, Collection of Photography, Bequest of Louise Glarner, 1979. Copyright: © Estate of Fritz Glarner, Kunsthaus Zürich. Artwork © 2024 Mondrian/Holtzman Trust.

498 Maurice Berezov, ca. 1939–1940. Jackson Pollock and Lee Krasner Papers, circa 1914–1984, bulk 1942–1984. Archives of American Art, Smithsonian Institution. Artwork © 2024 The Pollock-Krasner Foundation/Artists Rights Society (ARS), New York.

516 Wolf Suschitzky © Estate of Wolf Suschitzky courtesy FOTOHOF archiv

521 Artists' Union (New York, NY). *Art Front* magazine, December 1935. Balcomb and Gertrude Greene papers, circa 1880s–2009. Archives of American Art, Smithsonian Institution.

542 Kunsthaus Zürich, Collection of Photography, Bequest of Louise Glarner, 1979. Copyright: © Estate of Fritz Glarner, Kunsthaus Zürich.

543 Kunsthaus Zürich, Collection of Photography, Bequest of Louise Glarner, 1979. Copyright: © Estate of Fritz Glarner, Kunsthaus Zürich.

554 © 2024 Modrian/Holtzman Trust

555 © 2024 Modrian/Holtzman Trust

556 Saul Steinberg, *Untitled*, 1952. Ink on paper, 14⅜ x 19⅞ in. Private collection. Originally published in *The New Yorker*, November 1, 1952. © The Saul Steinberg Foundation/Artists Rights Society (ARS), New York.

Insert

page

1 Kunstmuseum Den Haag. Artwork © 2024 Mondrian/Holtzman Trust.

1 Kunstmuseum Den Haag. Artwork © 2024 Mondrian/Holtzman Trust.

2 Kunstmuseum Den Haag. Artwork © 2024 Mondrian/Holtzman Trust.

2 © Collection Kröller-Müller Museum, Otterlo, Netherlands – Photo by Rik Klein Gotink. Artwork © 2024 Mondrian/Holtzman Trust.

3 Collection Stedelijk Museum Amsterdam. Artwork © 2024 Mondrian/Holtzman Trust.

3 © Collection Kröller-Müller Museum, Otterlo, Netherlands – Photo by Rik Klein Gotink. Artwork © 2024 Mondrian/Holtzman Trust.

4 Kuntsmuseum Den Haag. Artwork © 2024 Mondrian/Holtzman Trust.

4 Kunstmuseum Den Haag. Artwork © 2024 Mondrian/Holtzman Trust.

5 Museum of Modern Art. Artwork © 2024 Mondrian/Holtzman Trust.

5 Collection Stedelijk Museum Amsterdam. Artwork © 2024 Mondrian/Holtzman Trust.

6 The Philadelphia Museum of Art / Art Resource, NY. Artwork © 2024 Mondrian/Holtzman Trust.

6 Digital Image © The Museum of Modern Art / Licensed by SCALA / Art Resource, NY. Artwork © 2024 Mondrian/Holtzman Trust.

7 HIP/Art Resource, NY. Artwork © 2024 Mondrian/Holtzman Trust.

7 Image courtesy Dallas Museum of Art. Artwork © 2024 Mondrian/Holtzman Trust.

8 Digital Image © The Museum of Modern Art / Licensed by SCALA / Art Resource, NY. Artwork © 2024 Mondrian/Holtzman Trust.

8 Kunstmuseum Den Haag. Artwork © 2024 Mondrian/Holtzman Trust.

A NOTE ON THE TYPE

This book was set in Janson, a typeface long thought to have been made by the Dutchman Anton Janson, who was a practicing typefounder in Leipzig during the years 1668–1687. However, it has been conclusively demonstrated that these types are actually the work of Nicholas Kis (1650–1702), a Hungarian, who most probably learned his trade from the master Dutch typefounder Dirk Voskens. The type is an excellent example of the influential and sturdy Dutch types that prevailed in England up to the time William Caslon (1692–1766) developed his own incomparable designs from them.

Composed by North Market Street Graphics,
Lancaster, Pennsylvania

Printed and bound by Lakeside Book Company,
Harrisonburg, Virginia

Designed by Cassandra J. Pappas